Artists and Illustrators

of the

OLD WEST

1850 - 1900

ARTISTS AND ILLUSTRATORS OF THE

OLD WEST

1850 ~ 1900

By *ROBERT TAFT*

AUTHOR OF

PHOTOGRAPHY AND THE AMERICAN SCENE

and

ACROSS THE YEARS ON MOUNT OREAD

CHARLES SCRIBNER'S SONS, *NEW YORK*

To: **D O R O T H Y**

CONTENTS

List of ILLUSTRATIONS

The numbers assigned to the illustrations are *Plate* numbers. All illustrations will be found following page 383.

🦌 PREFACE *and Acknowledgments* 🦌

The West has been a theme in the national consciousness since we began our existence. *The West,* too, has had a varied geography since the nation began. To the Revolutionary hero, *The West* was Ohio and Kentucky; to the Mexican War soldier it was Texas and California; to the Civil War veteran it was Kansas and Nebraska and the region beyond. But in the half century beginning in 1850, the West had its most rapid growth and some of its most dramatic episodes.

The story of these five decades has been told from many points of view. In this book there have been retold the actual experiences of a number of artists and illustrators, most of whom personally witnessed some part of the marvelous transformation of the region beyond the Mississippi—chiefly the Plains and the Rockies—in the half century extending from 1850 until 1900. Together with the pictures of these pictorial reporters this volume will serve, it is hoped, to give glimpses of this aspect of our past life not ordinarily found in conventional histories. Our story will not be strictly chronological for it has seemed best to consider each individual and his entire contribution to Western illustration before introducing new characters on the scene. The *original* efforts of these artists and illustrators have been introduced usually as the individuals themselves first made their appearance on the Western scene and this method thus serves to carry through some continuity in the development of our Western story.

The pictures selected as representative for our purpose vary greatly in quality—from the finished production of artists of recognized merit to the crude sketches of untrained amateurs. Many times, too, much of the original work of the artists has long been lost and we are dependent solely upon reproduction of originals in the illustrated press, where again quality of reproduction varies greatly. From a historical standpoint also the pictures themselves are of varying quality; my own suggested standards of judgment upon their historical worth I have elaborated at various points in the chapters which follow and especially in the notes at the end of this volume.

Although not every artist or illustrator who traveled beyond the Mississippi and who recorded the life of the West from 1850 to 1900—with some minor excursions in both directions from these dates—will be found in this volume, a very considerable number—many virtually unknown—have found a place in these pages. On the other hand, some of the best known names

of the period, Remington and Russell, for example, have not been treated in detail save for special episodes. There exists for a number of these better known individuals, biographies or reviews of their work which have been cited either in the body of the book or in the notes, and whose titles may be located by the interested reader through the index.

Much of the material included in the present volume was published originally as a series of articles in the *Kansas Historical Quarterly* from 1946 to the present.* The material from this series, however, has been completely rearranged, condensed in some places, expanded in others, illustrations removed and added, and corrections and consideration of criticisms have been made. Since much of the material here presented is the result of some fifteen or twenty years of intermittent research, the sources upon which the material is based are included in the extensive "Sources and Notes" at the end of the volume. Thousands of notes have been made, thousands of letters have been written, and thousands of miles have been traveled in collecting this source material. Its inclusion, it is hoped, will make the volume of value to the historian, to the artist of the modern day who essays the past Western scene, to the collector, to the bibliographer, to the researchers for the press and motion picture industry—and especially to the increasing number of individuals who have an intense interest and admiration of the Old West.

I am indebted to a great many persons for aid in the preparation of this volume. To many of them I have made specific acknowledgments in the text and notes. I am especially indebted, however, to the staff of the Kansas State Historical Society, including Kirke Michem, Nyle Miller, Harold Henderson, Forrest Blackburn, Miss Helen McFarland, Mrs. Lela Barnes, and particularly to Miss Louise Barry. Miss Caroline Wenzel of the California State Library, Mrs. Anne McDonnell of the Montana State Historical Society, Dr. James C. Olson of the Nebraska State Historical Society, my colleagues, Professors James C. Malin and John H. Nelson of the University of Kansas, Miss Llerena Friend of the Barker Texas History Center, University of Texas, Professor Elmo Scott Watson of the University of Denver, Miss Bertha L. Heilbron of the Minnesota Historical Society, Miss Grace Mayer of the Museum of the City of New York, Mr. Paul Vanderbilt

* Several publications have appeared in the past few years which have drawn heavily on the research published in the series of articles mentioned above. I am pleased, of course, that my work has been thought of sufficient value for inclusion in such works. One can but wonder, however, at the complete lack of elementary courtesy of these so called authors in acknowledging the source of their information.

of the Library of Congress, Mr. Bernard DeVoto, Cambridge, Massachusetts, Dr. Paul North Rice and the New York Public Library, Mr. George M. Hall, Hyattsville, Maryland, and Dr. George C. Groce of Washington, D.C.—all have gone out of their way to furnish me information, aid and encouragement beyond the ordinary civilities of answering routine questions. To all of these enumerated I am most sincerely grateful. I must, however, acknowledge my very great debt to Miss Ina T. Aulls of the Western History Department, Denver Public Library, my most important single source of information. Through her wisdom there has been accumulated an invaluable store of information for the use of the social historian in general and for the student of early Western artists in particular. Not only has Miss Aulls made this material available to me on several visits to Denver but she has answered my many letters most cheerfully and provided many transcripts of items which my notes did not fully cover. I acknowledge her aid with my most profound thanks. I am grateful to Miss Mari Sandoz for permission to quote from her copyrighted work *Old Jules,* on page 117; and to the Macmillan Company for the use of lines from their copyrighted work *The Song of the Indian Wars* by John G. Neihardt, on page 129.

With this array of talent behind me it is difficult to see how any mistakes, either of omission or commission, could possibly have been made; but I realize only too well that many have been made. For these errors I alone am responsible.

ROBERT TAFT

UNIVERSITY OF KANSAS
Lawrence
August 18, 1951

Artists and Illustrators

of the

OLD WEST

1850-1900

We are the Ancient People; **T H E**
 Our father is the Sun;
Our mother, the Earth, where the mountains tower **W E S T**
 And the rivers seaward sun;
The stars are the children of the sky,
 The red men, of the plain;
And ages over us both have rolled
 Before you crossed the main;—
For we are the Ancient People,
 Born with the wind and rain.

—*From* EDNA DEAN PROCTOR, *The Song of the Ancient People*, 1893.

I dream of the wide, wide prairies
Touched with their glistening sheen,
The coyotes' cry and the wind-swept sky
And the waving billows of green!
And oh, for a night in the open
Where no sound discordant mars,
And the marvelous glow, when the sun is low,
And the silence under the stars!
 Ho, wind from the western prairies!
 Ho, voice from a far domain!
 I feel in your breath what I'll feel till death,
 The call of the plains again!
 The call of the Spirit of Freedom
 To the spirit of freedom in me;
 My heart leaps high with jubilant cry
 And I answer in ecstasy!

—*From* ETHEL MACDEARMID, "The Call of the Plains," 1928.

Good God can it be you made this place,
 This desolate desert land,
This dreary waste where even the air
 Is filled with the shifting sand?
And far away as the eye can reach only the sage brush grows,
 Gnarled and twisted and hideous,
While the eternal west wind blows.
 Oh God, what a place! Yet off to the north
Stand the mountains clouded with snow.
 Majestic and awful and towering
Guarding the desert below.

—*From* MARGARET DELANEY, "The Desert Land," 1928.

Chapter One

John M. Stanley and the
Pacific Railroad Surveys

*The great mineral wealth of California, and the advantages which its
ports and harbors, and those of Oregon, afford to commerce, especially
with the islands of the Pacific and Indian Oceans, and the populous
regions of Eastern Asia, make it certain that there will arise in a few
years large and prosperous communities on our western coast. It, there-
fore, becomes important that a line of communication, the best and
most expeditious which the nature of the country will admit, should be
opened within the territory of the United States, from the navigable
waters of the Atlantic on the Gulf of Mexico to the Pacific. Opinion, as
elicited and expressed by two large and respectable conventions, lately
assembled at St. Louis and Memphis, points to a railroad as that which,
if practicable, will best meet the wishes and wants of the people.*
 —*From the* Annual Message *of President Zachary Taylor before*
 Congress Dec. 27, 1849.

January 1, 1850, opened the new year auspiciously in New York City.
The day was clear and mild, New Year's parties were numerous and gay as
the socially minded hurried from one hostess to the next, getting mellower
as the afternoon advanced. For those not socially inclined Barnum's American
Museum could be visited; or one could attend a special afternoon perform-
ance of Christy's Minstrels, "The first to harmonize negro melodies"; or
moving panoramas, huge painted canvases that slowly passed before the
seated audience enabled the New Year's day visitor to pass away an hour or
so as he viewed the noble Hudson or the ancient Nile, or the Astor House
Riot of the previous year.

On that same day, Horace Greeley, one of the leading editors of his time,
was to write in the *Tribune*—"1850 will complete the most eventful half
century recorded in history. The coming year is pregnant with good for all
Humanity, and so must be a happy one."

As the year commenced in Washington, however, there were signs that all was not happiness and light. The two houses of Congress convened for the first time in the New Year on January 3. The House immediately got into a wrangle over the election of its officers. It took twenty ballots to elect a clerk of the House and, earlier, sixty-three ballots had been required to elect a Speaker.[1] Sectional differences between northern and southern members governed every action and the seeds of discord were being lavishly sown.

In the Senate, on its opening day of the year, Senator Foote of Mississippi notified his colleagues that "on Monday next" he would ask their consideration of a resolution asserting the expediency of establishing a territorial government for California, Deseret and New Mexico. Foote began the discussion of his resolution on January 16. It provided not only for the organization of territorial government in California, Deseret (Utah) and New Mexico but it also included a clause which would have established, with the consent of Texas, a new state, Jacinto, to be formed from the eastern third of Texas.[2]

Senator Foote's proposal was, of course, based on the competing claims of free and slave states but failed to muster sufficient support. President Zachary Taylor, however, in a message to the House on January 21, reported that he had recommended to both California and New Mexico that they prepare state constitutions and submit them to Congress together with "a prayer for admission into the Union as states." [3]

The final action taken by Congress as a result of all this agitation was to admit California as a state on September 9, 1850, and to organize New Mexico and Utah as territories on the same day.

As this discussion suggests, the American West of 1850 was a vastly different country from the West of today. True, in many respects it is physically the same, but socially and geographically, and from the standpoint of numbers and material development, it has greatly changed. In fact, if we take the first of the year 1850 as our point of measurement, the entire West at that time was scarcely more than embryo, an outline only faintly suggestive of the changes to come. West of the Mississippi there were but five states when the year began: Texas, Louisiana, Arkansas, Missouri, and Iowa. In these five states, according to the census of 1850, lived over 90% of all the inhabitants of the West. But all the inhabitants of the West in 1850 made up a population that numbered some two million souls, not greatly different than the population of present day Kansas. Even in California, which as we have pointed out was admitted as a state during 1850, the population recorded was a scant 93,000. Fifty-eight thousand of this number claimed they were miners and only seven thousand "females" could be found within its border by the takers of the census! [3a]

With the exception of Texas, there were, in 1850, no Plains states. For the spread of plain and prairie, of hill and upland which now makes up many of our states was included in a huge realm that stretched from the northern border of Texas to the southern border of Canada. It had no name save "unorganized territory"; but in speech and writing it was usually called "The Indian Country."

A century ago there were, perhaps, a dozen or so struggling colleges in the states beyond the Mississippi with students numbering less than a thousand. But most surprising of all to many of us, in comparing the West of a century ago with the West of the present, is the fact that in 1850 there was not one mile of railroad beyond the Mississippi although there were some eight thousand miles of track in the states east of the Mississippi.[4]

Not that railroads were unthought of for the region beyond the Mississippi! As a matter of fact, one student, after an extensive consideration of the problem, concluded that by 1850 the idea of a transcontinental railway was firmly established and that "both in Congress and out, it is clear that the construction of a railway to some point on the Pacific Coast was generally accepted as a work of the near future by the close of the first half of the nineteenth century."[5]

The rapid growth of California, of the Oregon Country, the establishment of the "New Mormon settlement by the Great Salt Lake, beyond the Rocky Mountains" had convinced many that the Far West of the 1850's was "now on the golden shores of the Pacific."[6]

Communication to and defense of the western shores and intermediate points were matters forming the basis for arguments in favor of railroad construction. War with England or France would cause loss of California and Oregon, one interested group pointed out in a memorial to Congress.[7] As for more rapid communication with the country beyond the Mississippi, this need can best be shown by quotation of two contemporary accounts. A Panama newspaper item, reprinted shortly thereafter in a Washington paper, stated:

"The mails which are now going up to San Francisco have been brought here by the indomitable perseverance of Capt. McLean from New York in sixteen days will reach San Francisco in Forty Days—the shortest trip ever made. Glory enough for one day"[8]; and a dispatch from St. Louis (dated December 28, 1849) indicates the slowness and difficulty of travel on the Plains:

"Mr. J. H. Kirkland arrived in this city yesterday from a journey across the Plains. He left the city of Salt Lake, in company with thirty-five others, on the 19th of October. The party were not molested by the Indians on the

route, nor did they meet with any accident. The snow on the Plains was very deep, or the party would have reached here several days sooner." [9]

Small wonder, then, with communication *to* and *from* the West a matter of months that there was a loud and insistent demand, backed by many in the East, for a better method.

The question was not shall a railroad be constructed to meet this demand, but how and where? Which raised problems in turn that were complicated by inflamed sectional feeling, and by personal and commercial antagonisms.[10]

How violent these antagonisms actually were, can be seen from the fact that when Congress convened in 1853, practically the entire session was devoted to heated debate on legislation which would make possible the construction of a railroad to the Pacific. At least four bills were considered, all of which were amended or substituted, but none of which could secure sufficient support to insure its passage. As a result of the extended and partisan debates in Congress, interest in a Pacific railway throughout the country reached a fever heat, and Congress, no doubt painfully aware that some progress on the question must be made, finally approved a measure which appropriated $150,000 for a survey of possible routes that a railroad could successfully follow to the Pacific.[11]

In this measure, Congress instructed army engineers to carry out the work involved in such surveys and it fell to Jefferson Davis, Secretary of War in the cabinet of President Franklin Pierce, to draw up the general plans for the surveys. Four general routes to the Pacific had been under consideration from time to time in public and Congressional discussions:

(1) A southern route beginning at a point on the Red River of eastern Texas and extending westward somewhere near the Texas-Mexico border; frequently called the 32nd parallel route.

(2) A route beginning at Fort Smith, Arkansas, and extending westward through present Oklahoma, New Mexico and Arizona to California; frequently called the 35th parallel route.

(3) A central route beginning either at Kansas City, Missouri, or Council Bluffs, Iowa, and extending westward to California through the Central West.

(4) A northern route beginning at St. Paul, in the newly organized territory of Minnesota and extending north and west and terminating at Seattle in Washington Territory.

Actually some six surveys were at work on parts of these and alternate routes in the period 1853–1854, the over-all plan for which was comprehensive in scope. Not only were the individual surveys instructed to examine carefully the country through which each passed with a view for establishing feasible routes for railroads, but the nature of the country as revealed by its climate, by its geology, by its plants and animals and by the character and degree of development of its native inhabitants were to be observed and recorded. All such facts would be of value in making an estimate of the ability of the country through which a railroad might pass to support a population which would naturally be expected to come with the railroad.

To further these ends, each survey party included among its group, in addition to surveyors and civil engineers, geologists, botanists, zoologists, naturalists, astronomers, meteorologists, artists, physicians, and topographers. In order to reduce the size of the personnel, a number of the members of each party served in dual capacities. Even so, since in addition to the scientific personnel, cooks, teamsters, and assistants had to be provided as well as a military escort, the individual parties at times assumed very considerable proportions. That the military escort provided was essential but inadequate becomes only too apparent when it is realized that the leader of one of the surveys, Captain Gunnison, and his artist, Richard H. Kern, together with a small party of soldiers, were ambushed by Indians and slain while on survey in central Utah in 1853.[12]

Preliminary reports of all surveys were published from time to time but the complete reports with revisions and additions of the work of subsequent surveys were published in a magnificent and comprehensive twelve volume work with the imposing title, *Reports of Explorations and Surveys to Ascertain the Most Practicable and Economic Route for a Railroad from the Mississippi River to the Pacific Ocean.* These volumes, published by the Federal Government between 1855 and 1861, constitute probably the most important single contemporary source of knowledge on Western geography and history and their value is greatly enhanced by the inclusion of many beautiful plates in color of scenery, native inhabitants, fauna and flora of the Western country. Ironically enough the publication of this monumental work cost of the government over $1,000,000; the surveys themselves $455,000.[13]

These reports, with earlier versions, are invaluable firsthand sources for the historian of today, and created tremendous interest at the time they were published. They were discussed in the newspapers, talked about in Congress, in homes, on the street, and were reviewed at length in the contemporary magazines. *The North American Review,* for example, one of the leading

magazines for intellectuals of the 1850's, devoted over 25 pages to a review of these reports. The impression they produced can best be realized by quoting the editors of the *Review.*

> Before the accession of California [stated the review] the western possessions of the United States were looked upon as a sort of fairy land basking under the influences of a most delightful climate, and enriched by the choicest gifts of nature. Gigantic herds of buffaloes, and troops of wild horses of comely proportions and unsurpassed fleetness, roaming at large over pastures whose verdure never paled, were said to meet the eye of the traveler at every turn. Plains of immense extent and unparalleled fatness lay at his feet, while ever and anon rich clumps of woodland, gentle flowing rivulets, invited him to shelter and repose. Farther on these became interspersed with hills and ravines, highly picturesque in effect, terminated in the remote distance by the snow-clad elevations of the Rocky Mountains, which were again succeeded by gentle slopes of arable land, whose western limits were washed by the waves of the Pacific.

The report of the surveys tended to dispel these illusions, based as they were on a more accurate knowledge of the country than had before been available. In fact, the *Review* went so far as to state after studying the reports: "We may as well admit that Kansas and Nebraska, with the exception of the small strip of land upon their eastern borders, are perfect deserts, with a soil whose constituents are of such nature as for ever to unfit them for the purposes of agriculture, and are not worth an expenditure of angry feeling as to who shall or who shall not inhabit them. We may as well admit that Washington Territory, and Oregon, and Utah, and New Mexico, are with the exception of a few limited areas, composed of mountain chains and unfruitful plains; and that, whatever route is selected for a railroad to the Pacific, it must wind the greater part of its length through a country destined to remain for ever an uninhabited and dreary waste." [14]

Despite all the information available in these reports—and all the discussion brought on by their publication—mounting sectional antagonism was destined to prevent immediate decision on "the best" route to the Pacific. Not until the Civil War was well advanced was the actual work of construction undertaken, and not until 1869 was the first of the Pacific railroads, that following the central route, completed.[15]

We are here concerned, however, with the illustrations of these reports rather than the developments that led eventually to the construction of the road. Their pictorial value was early pointed out. Senator James Harlan of Iowa, even before the entire set was issued, for example, called the attention

of his fellow senators to these views. Speaking in the Senate on January 6, 1859, he said:

> But lest some Senators and members of Congress might not be able to read and comprehend them [the reports of the Pacific railroad surveys], they have been illustrated. Every unusual swell of land, every unexpected or unanticipated gorge in the mountains has been displayed in a beautiful picture. Every bird that flies in the air over that immense region, and every beast that travels the plains and the mountains, every fish that swims in its lakes and rivers, every reptile that crawls, every insect that buzzes in the summer breeze, has been displayed in the highest style of art, and in the most brilliant colors.[16]

Although the Senator spoke with more eloquence than truth in describing the illustrations, they were—and are—truly wonderful. Large in size, pleasing in color, and plentiful in number they have excited admiration for nearly a century; and—as the Senator suggested—they conveyed a wealth of information about an unknown country in a language even the simplest mind could understand.

The illustrations in the *Report* which we shall consider are the so-called "views"; these are of greatest general interest. But it must be kept in mind, as indicated by Senator Harlan, that many scientific (geological, zoological, botanical) illustrations were also included. Many of the illustrations for the geological reports are woodcuts reproduced in the text and a few of these are of sufficient general interest to mention specifically, as has been done later. The "views" are for the most part full page lithographs and are printed in two or three colors on heavy paper, much heavier than the paper used for the text. Many are printed in brown and black, some in green and black and in still others, a third color, blue, has been added. The lithography was either a two-plate or three-plate printing process as can be readily seen where the various color plates failed to register exactly in the successive printings. The lithography was done by A. Hoen Co. (Baltimore), J. Bien (New York), Sarony and Co., or Sarony, Major and Knapp (New York), and T. Sinclair, Philadelphia. Evidently, because of the large number of plates required, the same illustration was occasionally lithographed by different firms. As a result, slight differences in views occur, as the lithography was all hand work. Impressions from the same stone vary also, depending upon the number of impressions made and on the amount of ink present at each impression. The crediting of illustrations to the original artist occasionally differs, too, in the different printings. Some of these differences, especially where there are regularities in differences, will be discussed in connection with

special illustrations. Although most of the views are lithographs, an important exception occurs in connection with a group of thirteen illustrations by F. W. Egloffstein in volume eleven. This group is made up entirely of steel engravings and is described in the notes in connection with the work of the artist.

The illustrators for the volumes, all of whom were members of the various survey parties, were eleven in number and included: John C. Tidball, Albert H. Campbell, Richard H. Kern, James G. Cooper, John M. Stanley, John Young, Gustav Sohon, F. W. von Egloffstein, H. B. Möllhausen, W. P. Blake, and Charles Koppel. Möllhausen's part in the survey will be considered in the next chapter, and comment on many of the remaining illustrators has been made in the notes to this work.[17] The artist of the northern survey route, however, John M. Stanley, deserves more than mere mention for at least two reasons: he is represented by more plates than any other artist employed in any of the surveys, and no early Western artist had more intimate knowledge by personal experience of the American West than did Stanley.

Born in New York State in 1814, he spent his boyhood in that state. When he was twenty he moved to Detroit and the following year he began painting portraits and landscapes. No record of any artistic training exists, but from 1835 until 1839 he apparently made his living as an itinerant artist in Detroit, Fort Snelling (where he painted Indians), Galena, and Chicago. He then moved East. No definite record of his wandering exists for the next few years, but in the early spring of 1842 an advertisement of the firm of Fay and Stanley appeared in Washington (D. C.) papers. Although positive proof that the Stanley of this firm was John M. Stanley is lacking, the circumstantial evidence for this fact is excellent. The advertisement announced that Fay and Stanley were prepared to take daguerreotype likenesses and would offer instruction and complete outfits for the practice of the art. Evidently in his three years in the East, Stanley—if it be granted that he was the Stanley of our interest—had acquired a knowledge of the new art for it had been introduced into this country in the fall of 1839. Certain it is that Stanley later made use of daguerreotypy on at least one of his western expeditions.[18]

Sometime during the summer or fall of 1842, Stanley decided to go to the Indian Country with Sumner Dickerman of Troy, New York, for the express purpose of painting the American Indian of the West. Whether he was influenced by his predecessor Catlin who had achieved by 1842 a considerable reputation with his collection of Indian pictures, is unknown. Dickerman's part in the enterprise, too, is not known with certainty. He probably helped

to finance the expedition and certainly he was the companion and helper of Stanley for several years.[19]

In the fall of 1842 the two arrived in Fort Gibson (present Oklahoma) and Stanley immediately set up a studio. Fort Gibson, established in 1824, was an important post on the early southwestern frontier, and in many respects an ideal one for Stanley's purpose. Through it passed an almost continuous stream of frontiersmen, border characters, and Indians of many tribes. Located in the Cherokee country it was easily accessible to Seminoles, Creeks, Osages, Chickasaws, many of whom had been forced to migrate by the government in the years preceding Stanley's first visit. Visits, too, from the native plains Indians further west were also frequent and Stanley never lacked for subjects. Four of these visitors, two Pawnee Pict chiefs and the wife and child of one of them, were among Stanley's early subjects. Stanley wrote concerning them:

> On the arrival of the two chiefs and this woman at Fort Gibson, we took them to our studio for the purpose of painting their portraits. They very willingly acceded to my wishes, and manifested by signs that they wanted something to eat. We accordingly had as much meat cooked as would appease the appetite of six men, which they ate in a short time, and then asked for more. We again provided about the same quantity, which, to our astonishment, they also devoured. It was the first meat they had eaten for some five or six days.[20]

But Stanley's great opportunity came the following spring when a grand Indian council was called to convene at Tahlequah by the celebrated Cherokee, John Ross. Tahlequah, the capital of the Cherokee Nation, was only some twenty miles from Fort Gibson, but Stanley moved his studio to the Indian town and during the four weeks session of the Council and the succeeding summer months, was exceedingly busy recording the scenes and the participants of the Indian gathering.

By June 1, 1843, several thousand Indians from a wide circle of the Indian country were present and an observer of the scene has left us the following interesting account of the events witnessed:

> Every variety of dress can be seen here from the well dressed person down to the almost naked Osage. Plumes and feathers are worn with profusion and in every shape that can be imagined; hand kerchiefs of every color, silver bands for the arms, head and breast; medals, beads and hunting shirts of every shape and color; in truth, I cannot give you anything like a correct idea of the great variety of dress worn by the tawny sons of the forest. We have almost as great a variety in the color of persons as we have in dress. Where nature has not given the color,

paint is used to supply the deficiency. Besides the various Indian Tribes there are persons from almost every nation. Here are Germans, Scotch, Irish, English, Spanish and various other nations. I have no doubt if strict inquiry was made, not excepting some of the sable sons of Africa.[21]

Stanley painted one such meeting of the Council, the resulting painting being one of the few surviving Stanley pictures. It is now owned by the National Museum and has been called by one authority "one of the most valuable and important Indian pictures in existence." [22]

Late in the fall of 1843, Stanley accompanied Governor P. M. Butler, the U. S. Agent to the Cherokees, to a council held for the Comanche and other "wild prairie Indians" who had been for some years a source of trouble near the boundary of the Texas Republic and the United States. Texas commissioners were supposed to be present but failed to appear, but the council was held on the "head-waters of the Red River" (in present southwestern Oklahoma) and Stanley was able to secure a number of Comanche Indian portraits and landscape views.[23]

It seems probable that from the fall of 1842 until late in April, 1845, Dickerman and Stanley lived continuously in the Indian country. In the fall of 1845 they were in Cincinnati, where Stanley was actively engaged in finishing some eighty-three Indian paintings preparatory to public exhibition.[24]

The gallery was opened for public exhibition on January 19, 1846, and the Stanley portraits were on display in Cincinnati until February 14. Advertisements of the event announced "Season tickets admitting a gentleman and one lady $1, can be procured at the door.—This collection can be seen by gas light as well as day light." [25]

Stanley soon became restless and leaving the future exhibition of the Gallery to Dickerman, he again started west. He was in St. Louis in the spring of 1846, and a few weeks later was in Independence, Missouri, ready to start out over the Santa Fe Trail for new scenes.[26] He joined Col. S. C. Owen's train which included the famous Josiah Gregg, whose *Commerce of the Santa Fe Trail* published in 1844 has become a western classic. Gregg continued with the train only a hundred miles or so and then turned back to join another venture but the train also contained another writer whose diary many years later also became well known. Susan Magoffin's diary, like Gregg's *Commerce of the Prairies,* is among the most valued written records of the Santa Fe Trail. Susan, a young bride of nineteen, noted in her diary on June 20, 1846, that Stanley was a member of the same train after wishing that an artist could portray the many interesting and novel scenes as the train lay encamped at Council Grove (in present central Kansas).[27]

Unfortunately, if Stanley made any sketches along the Santa Fe Trail, they have been lost. Before he started on the overland expedition, however, he had made an excursion from Independence to the Kansas River where he painted Keokuk, the celebrated chief, and others of the Sauk and Fox tribe.[28]

Owen's train reached Santa Fe on August 31, 1846. The Mexican war was then only several months old and Col. Stephen W. Kearny and his troops who reached Santa Fe about the same time as the Owen train, promptly took over the city from the Mexican government and planned to go on to California to aid in its conquest. Reorganization of Kearny's troops was made at Santa Fe and a scientific staff was added which included Stanley as the artist of the expedition.[29]

Kearny's troops left Santa Fe on September 25 for the long overland trip to California which was reached in December. On December 6 a pitched battle between the troops and Mexicans some forty miles east of San Diego caused severe casualties, as well as extreme hardship and sufferings, but reinforcements appeared at an opportune moment and the goal of San Diego was reached on December 12. Stanley managed to retain his sketches during the six days of battle and hardship and was taken aboard the U. S. sloop *Cyane* at San Diego where he was able to prepare some of them for publication and to finish others in oils. A number of his sketches were reproduced lithographically in the official report of Kearny's long march to the sea.[30] The plates in general are very crudely done in black and white, the most interesting one being "San Diego from the Old Fort." The *Cyane*, with Stanley aboard, arrived in San Francisco in the early spring of 1847 and here Edwin Bryant, the author of the well-known *What I Saw in California* included Stanley's sketches in the California sights that came before his eyes. Writing in 1848, he stated:

> Mr. Stanley, the artist of the Kearny expedition completed his sketches in oil, at San Francisco; and a more truthful, interesting, and valuable series of paintings, delineating mountain scenery, the floral exhibitions on the route, the savage tribes between Santa Fe and California—combined with camp-life and marches through the desert and wilderness—has never been, and probably never will be exhibited. Mr. Stanley informed us that he was preparing a work on savage tribes of North America, and of the islands of the Pacific, which when completed on his plan, will be the most comprehensive and descriptive of the subject, of any that has been published.[31]

Two of these paintings "Indian Telegraph" (smoke signal) and "Black Knife" (Apache) have been known for many years. Recently (1952) Stanley's grand-daughter, Mrs. Dean Acheson, discovered fourteen small paint-

ings (9½ x 12½ inches) by Stanley; all are labeled and dated and most of them are signed by Stanley. I have seen photographs of nine of these paintings and four of the nine are undoubtedly the originals of some of the illustrations appearing in the official report of the Kearny expedition. These facts make it apparent that all fourteen Stanley paintings belong to this important group of pictorial records of the Kearny expedition. The remaining Stanley paintings of this period apparently were destroyed by fire in 1865 when over two hundred Stanley paintings were lost.[32]

After finishing the sketches and paintings of the Kearny expedition in 1847, Stanley spent the next several years in further wanderings making sketches for his proposed Indian portfolio. He was in Oregon by July 8, 1847 and was busily occupied for some months making portraits of the Northwest Indians. Late in November, he started for the famous Whitman mission to paint the portraits of Dr. and Mrs. Whitman. When within six miles of the Mission, he was met by two friendly Indians who informed him of the Whitman massacre and warned him that his own life was in danger. With the aid of an Indian, he made his way with great caution to Fort Walla Walla where he was one of the first to report the massacre.[33] Stanley continued his excursions in the Northwest until the summer of 1848 and his extensive Indian Gallery acquired many additions. About August 1 he took ship for the Hawaiian Islands—the Sandwich Islands. His painting career was again resumed on the Islands where portraits of Kamehameha III and his queen were made and which are still on display in the Government Museum, Honolulu.[34] Stanley lived in Honolulu for over a year but on November 17, 1849, he sailed for Boston.

Upon Stanley's return to the United States, his Indian Gallery was enlarged and he seems to have spent most of 1850 and 1851 in displaying the Gallery in a number of eastern cities.[35] Early in 1852, he took his collection of Indian paintings to Washington where he made arrangements with Joseph Henry, secretary of the Smithsonian Institution, for their free display in the library room of the Institution. Here they remained for over a dozen years, the gallery being gradually enlarged by Stanley until it numbered some two hundred paintings. The Gallery attracted considerable public interest, not only among visitors to Washington, but among residents of the city and members of Congress.[36]

Stanley's purpose in bringing his Gallery to Washington for free display was primarily to interest members of Congress in their purchase by the government and thus to establish a national gallery. He had spent ten years of his life in travel, adventure, toil, and labor in securing the 150-odd paintings that made up the collection at the time of its first display in the Capitol.

The private exhibition of the gallery although it may have given him a living did not return him anything on the investment he had made, which in 1852, Stanley estimated was $12,000. This sum gave him no return for his time and labor but had been spent for materials, transportation, insurance, and traveling expenses.

Catlin had urged the purchase of his Indian Gallery by Congress without success and had taken it abroad where it was rumored it was to stay. Stanley felt that his collection was more representative of the western Indians and certainly he had traveled far more in the American West than had Catlin. Capt. Seth Eastman, himself an Indian artist of note, saw Stanley's Gallery when it was brought to Washington in 1852 and wrote Stanley "that I consider the artistic merits of yours far superior to Mr. Catlin's; and they give a better idea of the Indian, than any works in Mr. Catlin's Gallery."

With such encouragement, Stanley was able to bring his Gallery to the attention of the Senate Committee on Indian Affairs, who recommended its purchase for $19,200. The question of its purchase was debated in the Senate and although strongly urged by Senator Weller of California and Senator Walker of Wisconsin, the purchase bill was defeated 27 to 14 when it came to a vote in March, 1853.[37]

Stanley continued to urge the purchase of the Gallery even after the initial defeat of the first measure and apparently it was discussed in Congress a number of times but all such attempts failed. The Smithsonian itself was asked to buy this collection but lack of funds prevented such a move. Stanley added to the Gallery, however, and by 1865 it numbered some 200 portraits. A fire on January 24, 1865 in the wing of the Institution which housed the Gallery caused the destruction of all but five of the paintings. Not only did Stanley suffer a heart-breaking loss but the nation suffered an irreparable loss in its historical portraiture.[38]

Stanley's career before 1853 has been described in some detail to show his importance as a western illustrator and to show that he was by far the best equipped both by ability and experience, of any of the artists that accompanied the Pacific Railroad Surveys.

Early in 1853, Isaac I. Stevens, an army engineer and head of the Coast Survey Office in Washington, applied to President Franklin B. Pierce for the governorship of the newly organized Territory of Washington, which had been formed from the northern half of Oregon Territory. In his application to President Pierce, Stevens stated that if the President could find any one better qualified for the place, it was the President's duty to appoint that person. Evidently Pierce thought Stevens the best qualified man for the place for one of his first acts as President was to send Stevens' name to the Senate

for confirmation as governor of the new territory. Stevens' commission was issued March 17. The duties of the position were arduous enough for in addition to the governorship, Stevens was also superintendent of Indian affairs for the territory. Not satisfied with his dual role of governor and Indian commissioner, Stevens also applied to Secretary of War Jefferson Davis for the position as head of the northern railroad survey, and received the commission for this task on April 8.[39]

Such combined responsibilities would have given pause to most men but not to Governor Stevens. Stevens was exceedingly energetic, able and ambitious and doubtless would have become a figure of greater national importance than he achieved but for the bullet that ended his life, when, as major general, he personally led a charge against Confederate forces at the battle of Chantilly, September 1, 1862.

However, as soon as Stevens' appointment as head of the northern survey was confirmed, he started with characteristic thoroughness and vigor to make his plans for the survey. His chief assistant was Capt. George B. McClellan, who achieved greater prominence than his chief in the Civil War, and who was directed to start the survey from the Pacific Coast side. Stevens organized his own party to begin the survey at the eastern terminus of St. Paul and on May 9, 1853, left Washington for the West. His companion as he left Washington was John M. Stanley whom Stevens with good judgment had selected as the artist for the expedition.

How extensive Stevens had made his plans and carried them through since he received his appointment on April 8, can be judged by the comment of the St. Paul correspondent to the New York *Tribune*. Writing on May 25, two days before Stevens and Stanley arrived in the frontier town, he stated:

> Gov. Stevens is said to be a regular go-ahead man and so far the work shows for itself. His men, baggage, and about 150 mules have already arrived, and the work has been going on for over a week. How he has managed so to expedite his affairs is a problem.
>
> The shipments of merchandise and emigration to St. Paul this spring have been enormous; so that many of our merchants, who purchased even in the winter, have not yet received their supplies. The Governor has crowded them off and hurried his effects along. It is not easy to define how much the people of the West admire such a character. Ten years is a lifetime here, and twenty, time out of memory.[40]

Stevens and Stanley arrived in St. Paul on the evening of May 27. The camp established by Stevens' vanguard was about an hour's ride from St. Paul and one can gain some idea of the drive and intensity of the survey's commanding officer when he recorded in his official diary: "Starting from

St. Paul at 3½ a.m. on the 28th, I reached our camp in about an hour, and had the pleasure of rousing the gentlemen of the expedition from their sleep." [41]

Completion of organization for the start of the survey required over a week and in that interval Stanley was busy. A sketch of St. Paul and one of the celebrated "Minne-ha-ha, or the Laughing Water"—made immortal by Longfellow—are among Stanley's efforts which have survived as illustrations in the official report.

At St. Paul, too, an assistant artist, Max Strobel, was employed to aid Stanley. Before the expedition started a St. Paul reporter saw some of Strobel's efforts and wrote: "I have already seen some of the artist's work and can promise the public when Gov. Stevens' Report is made up and given to the world, there will be something as pleasing to the eye as to the mind." [42] Strobel, however, could not stand the intense pace and effort upon which Stevens insisted and turned back from the expedition before it was long on its way westward.[43] Little else is known about Strobel although one of his sketches (a view of St. Paul) is known in lithograph and a comment "Mr. Strobel is a very accomplished artist and on his return from the Stevens survey has rendered valuable service to Minnesota by his sketches of the Minnesota river from Lac qui Parle to Traverse des Sioux" shows that he is worthy of inclusion in our group of western artists. In the fall of 1853, he joined Fremont's expedition at Westport and apparently withstood the hardships of that winter overland journey. None of his work on this expedition, or that made subsequently, is known at present.[44]

Stevens had his organization of the survey completed by June 6 and his command started the westward journey in various groups. The general route of the expedition was that made famous by its predecessors fifty years earlier, Lewis and Clark; a route which has been concisely summarized as "up the Missouri and down the Columbia." It is true that little of the journey was by water—as of necessity it could not be from the nature of the survey—and the starting point, St. Paul, was some distance from the Missouri River.[45] The expedition, however, headed westward across Minnesota Territory and into (present) North Dakota where the route of the expedition roughly paralleled the Missouri.

Much of the country traversed was mapped for the first time and even after Lewis and Clark's trail was actually picked up, the only guide to the region were the notes of those classic early explorers. Fort Union, the famous frontier outpost on the Missouri, and 715 miles distant from St. Paul, was reached on August 1.

Stanley has left us some notable illustrations of a number of the incidents

in the seven or eight weeks of this part of their western journey, some thirteen plates in the official report representing his work. Three of these illustrations are of particular interest: "Herd of Bison, Near Lake Jessie," "Camp, Red River Hunters," "Distribution of Goods to the Assiniboines."

The first of these illustrations is particularly important as it is one of the few pictures still extant made by an actual observer of the enormous number of the buffalo on the western plains before the day of the railroad. A writer to whom Stanley talked concerning this picture recorded Stanley's comments in the paragraph:

> The artist in sketching this scene, stood on an elevation in advance of the foreground, whence, with a spy-glass, he could see fifteen miles in any direction, and yet he saw not the limit of the herd.
> Who can count the multitude? You may only look and wonder! Or, if you seek to estimate the "numbers without number," what sum will you name, except "hundreds of thousands"?

And Stevens, who, unlike Stanley, had never seen the buffalo in their natural range, was also greatly impressed.

> About five miles from camp [he wrote] we ascended to the top of a big hill, and for a great distance ahead every square mile seemed to have a herd of buffalo upon it. Their number was variously estimated by the members of the party—some as high as half a million. I do not think it any exaggeration to set it down at 200,000. I had heard of the myriads of these animals inhabiting these plains, but I could not realize the truth of these accounts till today, when they surpassed anything I could have imagined from the accounts which I had received. The reader will form a better idea of this scene from the accompanying sketch, taken by Mr. Stanley on the ground, than from any description.[46]

The party at the time these vast herds of buffalo were first encountered was traveling westward through present east-central North Dakota (Griggs County) and were approaching the Missouri river country proper.

A few days after Stanley sketched the buffalo (July 10), the survey encountered a large train of Red River hunters who were coming southward on a hunting and trading expedition from their settlement of Pembina almost on the Canadian border. The Red River hunters were Europeans: Scotch, Irish, English, Germans, with Indian wives and their half-breed children. Over thirteen hundred persons were in the train and they carried their belongings in the well-known Pembina carts, two-wheeled affairs, and housed themselves at night in over a hundred skin lodges.

The men dress usually in woolens of various colors [wrote Stevens]. The coat generally worn, called the Hudson Bay Coat, has a capot attached to it. The belts are finely knit, of differently colored wool or worsted yarn, and are worn after the manner of sashes. Their powder horn and shot bag, attached to bands finely embroidered with beads or worked with porcupine quills, are strung to sashes, in which is tobacco mixed with kini-kinick, (dried bark of the osier willow scraped fine) a fire steel, punk, and several flints. Add to these paraphernalia a gun, and a good idea will be formed of the costume of the Red River hunter.

The women are industrious, dress in gaudy calicoes, are fond of beads and finery, and are remarkably apt at making bead work, moccasins, sewing and etc.[47]

Stanley's sketch shows their camp. Only a few of the hunters and one of their carts appear in the sketch although Stevens noted that there were over 800 of the carts in their train. The camp was visited with interest by the members of the survey and at evening when the two expeditions camped together a band of Chippewa Indians who were traveling with the hunters entertained the whites with a prairie dance. The caravans passed on, the survey forging north-westward, the hunters, in part at least, going on to St. Paul for trade.[48]

The survey was now nearing Fort Union and four days before their arrival at the post, they reached an encampment of some twelve hundred Assiniboines. Stevens, in his role of Indian commissioner, met them in council, heard their speeches and complaints, and distributed to them supplies from his store of goods carried for such purpose. Stanley was one of the group selected by Stevens to the council and he took the opportunity to add to his store of sketches.[49]

As the survey neared the famous frontier outpost of Fort Union, Stevens ordered a dress parade of his forces as they marched upon the fort. A Philadelphia Quaker, who was a member of the survey, wrote home the day after their arrival (August 2). Unfortunately Stanley made no sketch of the event but the Quaker's lively account still conveys, after nearly a hundred years, some of the color and interest of the grand entry.

We arrived here yesterday afternoon [he wrote his sister] and were received with a salute of 13 guns. During the march in, the governor took his horse, the first time in several days, and rode at the head of the Column. An American flag, made on the way, to the manufacture of which I contributed a red flannel, was carried in the foreward rank, and flags, with appropriate devices, representing the parties carrying them, were respectively carried by the various corps. The Engineer party, a large locomotive running down a buffalo, with the motto "Westward

Ho!" Our meteorological party—the Rocky Mountain, with a barometer mounted, indicating the purpose to measure by that simple instrument, the height of those vast peaks, with inscription "Excelsior." The astronomical party had a device representing the azure field dotted with stars, the half-moon and a telescope so placed as to indicate that by it could these objects be entirely comprehended. Teamsters, packmen, hunters, and etc., also carried their insignia, and thy brother acted as "aid" to the governor in the carrying of orders.[50]

The survey remained at Fort Union for over a week while animals were rested, supplies added, and plans made for the weeks ahead. Stevens offered any member of his party an honorable discharge at this point and a return to St. Louis but so interested had the members of the survey become and so accustomed to Stevens' intensity, that not a man took up the offer. Here at Fort Union, too, we have the first direct statement of Stanley's activities with the daguerreotype. "Mr. Stanley, the artist," wrote Stevens, "was busily occupied during our stay at Fort Union with his daguerreotype apparatus, and the Indians were greatly pleased with their daguerreotypes." [51]

Doubtless he made daguerreotype views of the fort itself but no record of these—or of his original sketches—is now available. The fort itself appears in the background of one of Stanley's illustrations of the official report and is among the few views of this famed outpost now extant.

Fort Benton, also on the Missouri, the next stopping place on the route of the survey was reached on September first, some three weeks being required to make the trip from Fort Union. Stanley's activities in this interval are represented by nine illustrations, including several Indian councils, and a view of Fort Benton. The last view shows the general character of the country around Fort Benton. Indian tepees beyond the fort, however, are drawn taller than the fort itself—possibly an error of the lithographer—so that the fort itself suffers by comparison (a much more interesting view of Fort Benton itself was made by Gustav Sohon, who also contributed to the Stevens report, but whose work is described briefly in the notes).

It was at Fort Benton, however, that Stanley's most interesting experience of the entire trip was begun. Stevens continually stressed the importance of satisfactory relations with the Indians through whose country the railroad might pass. To this end, the many councils and distribution of goods with the tribes encountered had been made. At St. Louis he had induced Alexander Culbertson who had lived in the Indian country for twenty years, to accompany him and had appointed him special agent to the Blackfoot Indians.[52] The move was an exceedingly fortunate one in several ways for Culbertson's experience and the fact that his wife was a Blackfoot saved the

survey several times from difficulties with the Indians. Stevens, Stanley, Culbertson and others left the main command at Fort Benton to visit the Piegans, one of the tribes of the Blackfoot confederacy, who were reported encamped some one hundred fifty miles north of the fort. They had not gone far when a messenger overtook them to announce that an advance party from the Pacific Coast detachment had arrived from the west. Stevens and Culbertson turned back to arrange further plans for the survey but Stanley volunteered to proceed to the Piegan village as Stevens was intent on inviting all the Blackfeet to a grand council at Fort Benton.

With an interpreter, three voyageurs, and a Blackfoot guide obtained at the fort, Stanley pressed further north in search of the Indian camp. On the third day after leaving Stevens, Stanley wrote in his report:

> The first rays of the sun found us in the saddle prepared for a long march. But one day more remained for us to find the Piegan camp. The night had been clear and cold, silvering the scanty herbage with a light frost; and while packing up, the men would stop to warm their fingers over a feeble fire of buffalo-chips and skulls. After a short march of twelve miles, we reached the divide between Milk and Bow rivers.
> At 1 o'clock I descended to a deep valley in which flows an affluent of Beaver river. Here was the Piegan camp, of ninety lodges, under the Chief Low Horn, one hundred and sixty three miles north, 20° west of Fort Benton.
> Little Dog conducted me, with my party, to his lodge, and immediately the chiefs and braves collected in the "Council Lodge," to receive my message. The arrival of a "pale face" was an unlooked for event, and hundreds followed me to the council, consisting of sixty of their principal men. The usual ceremony of smoking being concluded, I delivered my "talk," which was responded to by their chief saying, "the whole camp would move at an early hour the following morning to council with the chief sent by their Great Father." The day was spent in feasting with the several chiefs, all seeming to extend their hospitality; and while feasting with one chief, another had his messenger at the door of the lodge to conduct me to another.[53]

Early the next morning, the Piegans broke camp and "in less than one hour the whole encampment was drawn out in two parallel lines on the plains, forming one of the most picturesque scenes I have ever witnessed," wrote Stanley. Stanley reported, too, that he had been able to secure a number of sketches while on the northern trip, the most interesting of those surviving being "Blackfeet Indians [hunting buffalo] Three Buttes."[54]

Stanley was gone for eleven days on this side excursion and shortly after his return to Fort Benton, the survey again started westward. The detailed

description of the remaining journey becomes complex, as there were many side excursions and a number of divisions made of the party. Stevens, too, was anxious to assume his territorial duties, so with several of his party, including Stanley, he left the main command and pressed on to Fort Vancouver (present Vancouver, Washington) which was reached on November 16. As they left Fort Benton on September 22, the last thousand miles of the journey were covered in about seven weeks. Their route in general from Benton was southwest to Fort Owen (present Stevensville, Ravalli County, western Montana), northwestward to the Coeur D'Alene Mission (present Cataldo, Idaho, on U. S. 10), northward to Fort Colville (near present Colville, Washington), and then down the Columbia to Fort Vancouver, Stevens and Stanley descending the Columbia in a canoe from Fort Walla-Walla (some twenty-five miles west of the present city of Walla-Walla) to Vancouver. Capt. McClellan's party working eastward was met on October 18 at Fort Colville where Stevens remained several days discussing and planning with McClellan the future work of the survey. Several days had also been spent at the Coeur D'Alene Mission just before McClellan was met and one of the most attractive of the many illustrations in the official reports is Stanley's sketch of the Mission.[55]

The last stage of the survey is illustrated by some thirty Stanley sketches in addition to the sketch of the Mission.[56] Among the more interesting of these views are "Fort Owen," "Fort Okinakane," "Hudson Bay Mill," "Chemakane Mission," "Old Fort Walla-Walla" and "Mount Baker."

Very shortly after the arrival of Stevens and Stanley at Fort Vancouver, Stanley was dispatched to Washington with the preliminary Stevens reports of the survey. The return trip was made by ship down the coast to the Isthmus, across the Isthmus, and then on the *Star of the West* to New York City, where Stanley arrived on January 9, 1854. He then went on to Washington.[57]

Stanley's return to Washington marked the end of his western adventures. The remainder of his life was spent as a studio artist in Washington, Buffalo, and lastly in Detroit where he died in 1872.[58]

One additional episode in Stanley's life, however, should be described because previous biographers of Stanley have overlooked it and because it is important in the story of western illustration. It was over a year after Stanley's return to Washington in January, 1854, before work was begun preparing the field sketches as illustrations for Stevens' final report.[59]

Stanley did use his field sketches almost immediately for the preparation of a huge panorama of western scenes for public exhibition. By summer the panorama was well under way and Stanley's studio was "Daily the resort of

our most distinguished citizens who express the greatest admiration of this grand panoramic work." [60] The work, consisting of forty-two episodes, went on display in Washington on September first. Two hours were required to view it and a twenty-three page handbook *Scenes and Incidents of Stanley's Western Wilds* describing the panorama, which was primarily a depiction of the northern survey route, could be purchased at the door of the National Theatre for ten cents after the admission fee of twenty-five cents had been paid. The Washington papers were generous and fulsome in their praise of these Stanley pictures. In addition to display in Washington and Georgetown, it was exhibited in Baltimore for three weeks, and finally it was reported in the Washington press to be on the way to Boston and to London for exhibition.[61]

Like most of Stanley's *original* work it has disappeared. It would be beyond price at the present day.[62]

Chapter Two

Heinrich Balduin Möllhausen

From my earliest youth primeval forest and Indians had an indescribable charm for me. In spare hours I read only those books that included descriptions and adventures in the new world; even my own beautiful homeland pleased me best in its record of primitive times, when sturdy shepherds and huntsmen, with their noble forms unconcealed—like the "woodsmen" in heraldry or the Germans of Tacitus—roamed freely in the virgin woods where dwelt the aurocks and the stag, the bison and the gazelle, the wild boar and the unicorn, the chamois, and, what is more, the dragon.—Rudolph Friederich Kurz, Journal, 1851.

In the great flood of German immigrants to this country in the early half of the nineteenth century, there were considerable numbers who found their way westward. Many established homes and eventually became absorbed in the American life stream. Others stayed but for a time and then returned to the fatherland, and still others were casual visitors. A few of each of these groups were articulate and have left personal narratives or written descriptions that are records of more or less value. One has only to recall, among our Western visitors, the names of Duke Paul William of Württemberg, Prince Maximilian of Wied, Frederick Wislizenus, Rudolph Kurz, Friederich Gerstäcker, Julius Fröbel, Friedrich Strubberg, Captain B. Schmölder, George Engelmann (for whom the Engelmann spruce is named), as well as Heinrich Balduin Möllhausen, to appreciate their contributions to early Western literature.[1] Although some of these German writers have been dealt with individually, a comprehensive study of their contributions, which in toto would number hundreds of volumes, and of the effect of these contributions on German life and immigration to America remains to be made.[2]

Several of this group have also contributed to the pictorial record of the West but we are here concerned primarily with the work of H. B. Möllhausen (sometimes called Balduin, sometimes Baldwin; the Heinrich is

seldom used).[3] Möllhausen not only wrote personal narratives describing his three exploring trips in Western America, made many sketches "from nature" during these periods, but as the result of his personal experiences in the West, gave the major share of his adult life to the profession of letters. He wrote no less than forty-five novels or books of short stories (some novels ran into as many as six volumes). To be sure, this literary output was not confined to the Western scene as a background, but the original impetus for Möllhausen's career came from his Western experiences. Indians, the plains, Utah and the Mormons, gold and California, the Santa Fe trail, the Civil War, the South, the Great Lakes, the sea were all used in his literary output. So frequent were the parallels between Möllhausen and Cooper that Barba, his biographer, calls Möllhausen "the German Cooper." [4] It seems probable that Möllhausen's work, like Cooper's, was strong in description of scenery and surroundings, but the characters introduced were stiff and stylized, and Möllhausen's plots were frequently complicated and bizarre.

The narratives of personal experience written by Möllhausen are, however, documents of first-rate importance and the illustrations he drew to accompany them enhance their value. In addition, these narratives contribute to our biographical knowledge of the author. The sketches made by Möllhausen are here of primary concern and can conveniently be treated according to his three trips to America.

First American Visit, 1849–1852

Möllhausen was born January 27, 1825, near the city of Bonn. His father, the possessor of a restless disposition, was a wide traveler and also possessed "an uncontrollable desire for collecting copper engravings"; [5] factors which undoubtedly played a part in the younger Möllhausen's career. After his father's early death, Möllhausen was reared by relatives, receiving some schooling at Bonn. He also seems to have early shown a talent for drawing but received no special training other than that given in the school at Bonn. After several years in military service, Möllhausen sailed for America in 1849.[6] There is little record of Möllhausen's life for much of this three-year period (1849–1852) but he appears to have lived for a time in Belleville, Ill. (near St. Louis), and to have spent considerable time as a hunter in the region of the Kaskaskia river in southwestern Illinois.[7]

In the spring of 1851, however, he heard that his countryman, Prince Paul of Württemberg, was outfitting an expedition to the Rocky Mountains and he applied to Prince Paul for permission to accompany the expedition. The permission was granted and the outfit was on the plains of Nebraska (the

Platte river country) "when the spring sun was drawing out millions of buds among the herbs and grass." [8] Prince Paul's expedition, however, encountered such serious Indian and transportation difficulties that the trip was given up at Fort Laramie and the return to civilization was begun in the fall of that year (1851). Indians killed one of their four horses, fodder was scanty, they became almost buried in a snow storm which killed their remaining horses, and the two travelers were forced to make camp on Sandy Hill creek "where it falls into the Big Blue." [9] Here the eastbound stage for Independence, Mo., passed them but as the stage had room for but one passenger, Prince Paul and Möllhausen drew lots to see which should go. Chance decreed that Möllhausen was the one to stay until help could be sent back. The help failed to materialize and Möllhausen remained alone in his camp from the latter part of November until early in January. During his enforced stay, huge wolf packs, additional snow storms, illness so severe that he became unconscious, and hunger so violent that he was reduced to eating frozen wolf meat, were Möllhausen's lot. But the culminating drama was one that almost cost him his life. Toward the end of his stay he had forced himself to the top of a distant hill for observation, when to his horror he discovered two Pawnees creeping with extreme caution and stealth upon his camp, unaware of his presence on the observation point. After hastily preparing for their arrival, he shot one Indian and mortally injured the second. Shortly after this experience, a friendly band of Otoes on the way to their villages at the mouth of the Platte passed by and Möllhausen joined them as they journeyed eastward. After traveling for four weeks, Möllhausen reached the settlement of Bethlehem on the Missouri.[10] At Bethlehem,[11] Möllhausen was again in the presence of white company, where he reveled in the homely satisfactions of "sitting by their warm fireside, eating good bread, drinking a glass of whisky-punch, and entertaining my hosts with the story of my adventures . . ." [12]

But after he re-outfitted at Bethlehem, Möllhausen returned to his Oto friends for a few days and then proceeded to the fur-trading post and nearby Presbyterian mission at Belle Vue.[13] The post trader, Peter Sarpy,[14] welcomed him with open arms and Möllhausen spent over three months with him. He even contemplated marrying a beautiful young half-breed, a niece of Sarpy, and settling down to a life on the frontier. A letter from Prince Paul, however, urged him to come at once to New Orleans, and as funds were provided, Möllhausen took passage in a river boat for St. Louis and New Orleans.[15]

Möllhausen had as a result of this first trip, therefore, over a year's experience on the Western frontier with adventure and harrowing experience

sufficient to satisfy the most rabid seeker of thrills. Further, he was able to put on paper some of the scenes which he had viewed. An exact catalogue of Möllhausen's pictorial records resulting from the experiences of this first trip to America is not possible, but some estimate can be made when one considers his total pictorial output. In 1939, the Staatliches Museum für Volkerkunde in Berlin possessed an original sketchbook of Möllhausen's containing 99 pencil sketches and 33 water-colors made on his American excursions.[16] In addition, his work has been reproduced in lithographic form in a number of volumes.

The original work of Möllhausen unfortunately has been largely destroyed, having been burned during the conquest of Berlin in April, 1945.[17] The United States National Museum, Washington, however, possesses eight original pen and ink drawings and one original water-color sketch by Möllhausen.[18]

Paul Hudson, museum curator, Morristown National Historical Park, Morristown, N. J., examined Möllhausen's collection in Berlin in 1939 and copied the titles of a number of the sketches which are listed in the notes.[19]

Fortunately the writer secured in 1939 photographic reproductions of several of the Möllhausen sketches. The titles of these sketches as received from the Berlin museum include:

 V: "Oto-Handler auf der Pelztauschstation in den Council Bluffs," 1852.
 VIII: "Fort Roupideau, Scott Bluffs," 1851.
 XIV: "Sioux," 1851.
 XV: "Choctaw, Chickasaw, Cherokee," 1853.
 XXV: "Übergang der Expedition über den Colorado," 1854.
 XXIX: "San Felipe, Rio Grande, Neumexico," 1853.[20]

In addition, Dr. Charles L. Camp of the University of California wrote me that he photographed several dozen original Möllhausen sketches in Germany "several years ago." [21]

Altogether, when the copies of the originals are considered and the reproductions of Möllhausen's originals as lithographs are counted, a sizeable collection is available for the student.

Of this work, those resulting from Möllhausen's first trip to America include V (probably No. 14 of the Hudson list; see notes), VIII (possibly No. 15 of the Hudson list), and IV (probably No. 9 of the Hudson list) of the writer's list.[22] In addition to this list of subjects, pictorial records of Möllhausen (note that these were made on his first American trip) are to be found as chromolithographs in his *Diary,* published in 1858.[23]

SECOND AMERICAN TRIP, 1853–1854

After spending nearly four months among the Omahas near Belle Vue, Möllhausen rejoined Prince Paul either in St. Louis or New Orleans and spent several months in those places. In the fall of 1852, at the request of the German consul at St. Louis, he took charge of a consignment of animals for the Berlin zoo. He arrived in Berlin on January 6, 1853, and soon made the acquaintance of the celebrated geographer, Alexander von Humboldt, who became much interested in the young man and in the stories of his travels and in his sketches of Indian and frontier life.[24] Von Humboldt encouraged Möllhausen to continue his travels, and after a four months' stay in Berlin in which he perfected himself "in some branches of artistic study" he returned to the United States with glowing recommendations from von Humboldt and other German dignitaries.[25] He arrived in New York on May 3, 1853, went immediately to Washington and one week later had been appointed "topographer or draughtsman" to Lt. A. W. Whipple's surveying expedition along the 35th parallel through the southwestern United States.[26]

Whipple's expedition was one of those already listed in the first chapter as part of the Pacific railroad surveys. Whipple and his party left Fort Smith on the Arkansas river, near the western boundary of Arkansas, on July 15, 1853. The route in general lay through Indian territory, across the Llano Estacado of Texas, through New Mexico territory to Albuquerque, through the petrified forest, south past the San Francisco mountains, across Bill Williams' fork of the Colorado, the Colorado itself, through the torrid stretches of the Mojave desert, and across the Coast range. The expedition eventually arrived at the Pueblo de Los Angeles, some nine months after its start, on March 21, 1854.[27]

Möllhausen's experiences on this trip were published in the various editions of his *Diary* (cited in notes 6 and 23). The *Diary*, however, is more than a logbook of travel, for Möllhausen has included in it an extended account of his own earlier experiences in the West, of stories gathered along the way, with stray bits of history and previous exploration thrown in for good measure. In his account, too, he occasionally refers to himself as "the German naturalist." Möllhausen appears to have had some training in natural history and indeed on his third trip to America was appointed "artist and collector in natural history" on still another government expedition.[28] His chief scientific interests, however, were in the native tribes. Many of his illustrations in the official reports of the two government expeditions with which Möllhausen was connected, depict Indians and Indian modes of life. Choctaw, Creek, Cherokee, Shawnee, Delaware, Wichita, Comanche, Kiowa, Zuni, and

Mohave were all recorded by his pencil and constitute important ethnographic records for the present day.

A number of the original drawings made by Möllhausen on the Whipple expedition have recently (1950) come to light and are now deposited in the Oklahoma Historical Society. Included in this original material are nine paintings and some twenty-four drawings, the latter mostly on sheets measuring 9 x 14½ inches. A number of these drawings were apparently those used for the lithographic illustrations in Whipple's official report and in the various editions of Möllhausen's own diary.[29]

In Whipple's official report, Möllhausen, A. H. Campbell, and Lt. J. C. Tidball contributed most of the illustrations. Twenty-two full-page lithographs in color (or tinted) measuring approximately 6 x 9 inches in the print (the pages are quarto), some sixty-five woodcuts in the text as well as a number of geological and elevation cross-sections, make up the illustrated portion of the book. Leaving the last, the purely technical illustrations, out of consideration, ten of the lithographic illustrations are credited directly to Möllhausen, two indirectly, and another almost surely resulted from Möllhausen's work. (It should be pointed out that credit for illustrations varies somewhat from volume to volume.) The remainder are credited to F. B. Meek (two fossil drawings), three to A. H. Campbell, three to J. C. Tidball and one to an unknown "F. S." Of the sixty-five woodcuts, a number are uncredited and it is difficult to trace the source. In Part III, thirty-five of the woodcuts appear to be credited to Möllhausen.

It can thus be seen that Möllhausen was the principal illustrator of the report. Some of the noteworthy full-page illustrations included in the report as typical of Möllhausen's work would include:

1. "Fort Smith, Arkansas," Part 1, *facing* p. 5.
2. "San Francisco Mountain" (From Leroux's river), Part I, *facing* p. 80.
3. "Rio Colorado Near the Mojave Villages" (depicts the crossing of the expedition), Part II, front.
4. "Navajos" (Two mounted warriors), Part III, *facing* p. 31.
5. "Mojaves" (Three painted natives), Part III, *facing* p. 33.
6. "A Conical Hill, 500 Feet High" (Valley of Laguna), Part IV, *facing* p. 25.

The "San Francisco Mountain" listed above, is not credited in all volumes to Möllhausen but since practically the same view appears in the *Diary* (both the German and the English editions) it is virtually certain that Möllhausen drew the original sketch upon which the lithograph was based.[31] The lithographic work was done by three firms: T. Sinclair, Philadelphia; A. Hoen and

Co., Baltimore, and Sarony and Co. (or Sarony, Major, and Knapp), New York. The same subject in different copies of Whipple's report has been reproduced by different lithographers. This is particularly true of T. Sinclair and Sarony, Major and Knapp. For example, one copy of the report which I have examined had Möllhausen's view, "Canadian River Near Camp 38" (Part I, *facing* p. 30), lithographed by Sarony, Major and Knapp, and another copy had the same view lithographed by T. Sinclair. As a result, the tinting in the two views is different and the detail and outlines vary somewhat. For that matter, the tinting of the colored views varies somewhat from copy to copy even when by the same lithographer, depending presumably upon the number of copies that were made in a run and how frequently the stone was inked.[32]

One or two other irregularities in the illustrations may be noted while we have them under discussion. "View of the Black Forest," after A. H. Campbell's sketch, does not appear in the index of illustrations of Part II. In some volumes it appears in Part II, *facing* p. 32, lithographed by Sarony and Co., and in one copy I examined it possesses as lovely a color as I have ever seen in a two-color impression (black and brown).

To cite still another irregularity, the illustration, "Bivouac, Jan. 26," is listed in the index of illustrations to Part I as *facing* p. 95 and in some copies appears in this position; in other copies it appears as *facing* p. 90. The most striking irregularity is the fact that in some copies this illustration is credited to J. C. Tidball and in others to Möllhausen. There are differences in detail and it may be that the difference in crediting is proper, but I am inclined to think the double credit is an error and that it would be difficult to decide who should be given credit for the illustration. Both views were lithographed by T. Sinclair.

The initials of Möllhausen are also cited irregularly in the caption to the illustrations. One such case has already been described in the notes, but the most curious one occurs in the case of the frontispiece illustration in Part II, "Rio Colorado Near the Mojave Villages, View No. 2." In two copies this is credited to "R. R. Möllhausen," in another to "H. R. Möllhausen" and in a fourth (correctly) to "H. B. Möllhausen." The lithography in all four cases is credited to Sarony, Major and Knapp.[33]

Many of the woodcuts as already remarked, are uncredited, although in Part IV ("The Geology of the Route"), all woodcuts are credited to the respective artists in the index to the illustrations. One woodcut in Part I (p. 85) can be credited to Lieutenant Tidball, from a statement appearing in the text itself (p. 84). Other woodcuts in Part I may possibly be those of Möll-

hausen if comparison of the illustrations in the report with those in the *Diary* are made. Included in this group are:

1. "Petrified Tree Near Lithodendron Creek," p. 74. This view is somewhat similar to the frontispiece of volume 2 of the *Diary*. A. H. Campbell was present, however, and it possibly could have been drawn by him, but Lieutenant Tidball appears to have been absent when the party crossed the petrified forest area.
2. "Cereus Giganteus, on Bill Williams' Fork," p. 101. In the *Diary*, v. 2, *facing* p. 219, is the full-page woodcut "Cereus Giganteus." Here the two views are dissimilar—the chief similarity being in the titles.

Probably, however, this illustration was the work of Tidball as an original drawing of similar title is among the material of the recently discovered Whipple collection.

Whipple mentions Möllhausen a number of times in the official report and from the official record we can secure additional information concerning the activities of the German artist. Under date of September 29, 1853, while in present New Mexico, Möllhausen is recorded as one of the party making side excursions to the north of the main line of the survey while the rest of the group proceeded with the main survey directly to Albuquerque.[34] Several weeks later, while approaching the pueblo of Laguna and although not specifically mentioning Möllhausen, Whipple writes "As we approached the town, the Germans of the party almost imagined themselves in 'Fatherland.' "[35]

In February, 1854, while approaching the Colorado river near the mouth of Bill Williams' Fork (present Arizona), Whipple makes mention of the fact that Möllhausen sketched "several singular trees and shrubs. . . ." A little later, Indian inscriptions and figures were observed on the cliff walls of a rugged canyon. "Some of the most interesting among them were sketched by the artist," reports Whipple.[36]

In the same month, while the expedition was engaged in crossing the Colorado river, Möllhausen had a chance to play the hero's role. A barge capsized and William White, one of the surveyors, and a small Mexican boy were nearly drowned, but "the exertions of Mr. Möllhausen succeeded in extricating them from beneath the boat."[37] Möllhausen himself records the incident but modestly says that when the boat in which he and White were riding overturned in midstream, "I was the only one of the party who could swim, and I had to make great exertions to get Mr. White to where he could lay hold of the tow rope."[38] Möllhausen does describe the crossing of the

river by the expedition in great detail, especially the interest shown by an audience of hundreds of Mohaves who were out for a gala day.

The last reference made to Möllhausen in the official report occurs on March 12, 1854. Möllhausen accompanied a party sent out to search for a lost Mexican herder who was a member of the expedition. They were either in or near the Mohave desert and in that desolate country found only the bloody clothes of the missing Mexican riddled with arrows; the body of the Mexican, murdered by Pai-Utes, was not found.[39]

THIRD AMERICAN TRIP, 1857–1858

The members of the Whipple expedition, after renewing their outfits of clothing in Los Angeles, a town which "varies between two and three thousand" in population, pressed on to the Pacific coast port of San Pedro. On their overland journey from Fort Smith on the Arkansas to San Pedro on the Pacific, they had traveled 1,892 miles, according to their viameter— a necessary instrument for a surveying expedition. On March 24, 1854, they boarded the coast steamer *Fremont* for San Francisco "the most important place on the western coast of the American continent. . . ."[40]

A few days later, six members of the party including Möllhausen took passage on the steamer *Oregon* for Panama, bound for New York. After a troublesome crossing of the Isthmus, the remainder of the ocean voyage on the steamer *Illinois* was uneventful and New York was reached on April 28, 1854, almost exactly a year having elapsed since Möllhausen had left there.[41]

After several months spent in New York and Washington, presumably in completing his sketches for the official report, Möllhausen returned to Berlin in August of 1854. Humboldt was again greatly interested in the account of Möllhausen's travels and in the new sketches which the young German brought back with him from his far-flung journey through the American Southwest. He arranged an interview for Möllhausen with King Frederick William IV of Prussia, who was himself greatly interested in art. As the result of this interview, King Frederick appointed Möllhausen custodian of the libraries in the royal residences in Potsdam, a title which Möllhausen held until his death in 1905.[42] This position in effect was a subsidy for there were almost no duties and Möllhausen was free to follow his own inclinations. During his stay in Berlin between the second and third trip to America he was married to the daughter of Humboldt's secretary and, in addition, devoted a considerable part of his time to the preparation of the *Diary* (see note 6 for full title) which apparently was ready for the press by the summer

of 1857. At this time he received a letter of appointment from Lt. J. C. Ives, a member of the Whipple expedition, offering him a position as assistant on a government expedition to be sent out for the exploration and survey of the Colorado river of the West.[43] Möllhausen needed no urging to join Ives and left Berlin on August 12, 1857, for his third set of adventures in the New World.

The Colorado river of the West (now simply the Colorado river) was "the largest stream with one exception, that flows from our territory into the Pacific," Ives wrote. It drained an area then estimated at more than 300,000 square miles. Very little was known about the river in 1857 and the government was especially desirous of securing information on the navigability of the stream from its mouth as far inland as possible. The practicability of supplying frontier army posts in New Mexico and Utah territories by this route were to be particularly studied, as it was hoped that the long stretches of land transportation, then the only method in use, could be avoided, or at least lessened.[44] The Mormon war of 1857–1858 was under way at the time the expedition was organized and the need for supplying the Southwestern posts of Fort Defiance and Fort Buchanan more efficiently was of major concern to the army.

Möllhausen landed in New York on September 1, 1857, went to Washington, and then returned to New York where he embarked for San Francisco by way of Panama with Dr. J. S. Newberry and F. W. von Egloffstein, a Bavarian topographer, also members of the expedition. On October 22, they joined Lieutenant Ives, the leader of the expedition, in San Francisco.[45] Here the expedition was divided into several parties. Möllhausen and Egloffstein, under P. H. Taylor, the astronomer of the expedition, left for San Pedro and Fort Tejon (California) and then crossed the desert to Fort Yuma on the Colorado river. Another party, under Newberry, went to San Diego to collect mules to be used for transportation, and they then crossed the desert to Fort Yuma. Ives, himself, with a small steamer to be assembled on the Colorado, left San Francisco by water, rounded the Lower California peninsula and sailed up the Gulf of California to the mouth of the Colorado.

The parties were assembled at Fort Yuma, near the Mexico–U. S. border and some 150 miles by river above the mouth of the Colorado, on January 9, 1858. A delay of the Ives party near the mouth of the Colorado had occurred, as it was necessary to assemble there the small steamboat, appropriately called the *Explorer*, to be used in the up-river trip. The *Explorer* was eventually made ready, and, loaded with six weeks' provisions at Fort Yuma, departed on January 11.[46]

After two months' travel they reached what was considered the head of

navigation, some 530 miles above the mouth of the Colorado.[47] After return-
ing down the river to Beale's Crossing, Ives reorganized his party, and, with
a group of about forty-five, the exploration of the river was continued by
land, the *Explorer* returning downstream to Fort Yuma. On March 23, 1858,
the overland party started out and by April 3 were near the "Big Canyon,"
at present known as the Grand Canyon. A week later Ives reported he believed
they were opposite the most stupendous portion of the canyon. The going
was rough, the tortuous side canyons misleading, grass for the mules was
scarce, water difficult to find and the sun oppressively warm, but still they
kept on, mapping, taking observations, recording the geology, vegetation and
sparse fauna of the rugged Southwestern wilderness.

On April 13, as the mules had been nearly two days without water, an
attempt was made to descend into the canyon, after discovering a downward
Indian trail, which, viewed at some distance, looked so tortuous and steep
that "a mountain goat could scarcely keep its footing. . . ." Closer inspection
showed that the path, though narrow and dizzy, had been selected with some
care, so down they started. But let Lieutenant Ives tell the hair-raising story:

> I rode upon it [the trail] first, and the rest of the party and the train
> followed—one by one—looking very much like a row of insects crawling
> upon the side of a building. We proceeded for nearly a mile along this
> singular pathway, which preserved its horizontal direction. The bottom
> of the canyon meanwhile had been rapidly descending, and there were
> two or three falls where it dropped a hundred feet at a time, thus greatly
> increasing the depth of the chasm. The change had taken place so
> gradually that I was not sensible of it, till glancing down the side of my
> mule I found that he was walking within three inches of the brink of a
> sheer gulf a thousand feet deep; on the other side, nearly touching my
> knee, was an almost vertical wall rising to an enormous altitude. The
> sight made my head swim, and I dismounted and got ahead of the mule,
> a difficult and delicate operation, which I was thankful to have safely
> performed. A part of the men became so giddy that they were obliged
> to creep upon their hands and knees, being unable to walk or stand. In
> some places there was barely room to walk, and a slight deviation in a
> step would have precipitated one into the frightful abyss. I was a good
> deal alarmed lest some obstacle should be encountered that would make
> it impossible to go ahead, for it was certainly impracticable to return.
> After an interval of uncomfortable suspense the face of the rock made
> an angle, and just beyond the turn was a projection from the main wall
> with a surface fifteen or twenty yards square that would afford a foot-
> hold. The continuation of the wall was perfectly vertical, so that the trail
> could no longer follow it, and we found that the path descended the
> steep face of the cliff to the bottom of the canyon. It was a desperate
> road to traverse, but located with a good deal of skill—zigzagging down

the precipice, and taking advantage of every device and fissure that could afford a foothold.[48]

They soon found that the mules could not accomplish the descent and there was nothing to be done but to retrace their dizzy and weary way to the top where the packs and saddles were removed from the mules and they were started for the nearest water—thirty miles distant. Nothing daunted, the next morning Ives, Lieutenant Tipton, Egloffstein, Peacock and a dozen of the men explored the bottom of the canyon on foot.

Further progress along the Colorado river was soon barred by the extent and magnitude of side canyons and further reconnaissance and lack of water led the party to turn south away from the canyon toward the welcoming pine shade and cooler weather of the San Francisco mountains. Farther east, as supplies ran short, a division of the party was made. Lieutenant Tipton, Möllhausen and the larger number of the soldiers and the pack-train headed east toward Fort Defiance.[49] Lieutenant Ives, Newberry, Egloffstein and ten men again turned north in the hope that they could make further surveys.[50] The two parties separated on May 6, 1858, and on May 14, Lieutenant Tipton and his party arrived at Fort Defiance. About a week later they were joined by Lieutenant Ives and his command and the expedition came officially to an end.[51]

Möllhausen, Newberry, Peacock and von Egloffstein decided to return east by the overland route; Lieutenant Ives, however, returned to Fort Yuma. The eastbound party was in Albuquerque by June 1 and in Santa Fe on June 12, 1858.[52] From Santa Fe, the famous Santa Fe trail was followed through northeastern New Mexico, and then through Kansas to Fort Leavenworth which was reached on July 24, 1858. Möllhausen and Newberry, in haste to be back home, took the river boat to St. Louis, and then traveled by train to New York and Washington, and completed their transcontinental trip across the United States. After finishing his work in Washington, Möllhausen sailed for Berlin on September 1, 1858, never to return to the United States.[53]

PICTORIAL RECORDS OF THE THIRD TRIP

In addition to the original Möllhausen sketches listed, illustrations by Möllhausen appear in his *Reisen* (*see* note 45) and in the official report of Ives. The full-page illustrations in the *Reisen*, twelve in number, are tinted woodcuts (plus one map) and measure approximately 5 x 7¾ inches.[54]

The illustrations in the Ives official report are credited chiefly to Möll-

hausen and von Egloffstein and are of four types: full-page lithographic reproductions in single color (nine in number); five full-page steel engravings; seven full-page lithographic illustrations in color; and sixty-nine woodcuts (41 in Part I and 28 in Part III) in text. In addition, there are three pages of paleontological engravings, maps, and eight excellent lithographic outline lithographs folded in (about four pages in width).

The volume is of quarto size so the illustrations are of generous dimensions. The seven lithographic illustrations in color are all credited to Möllhausen and are of the Indians encountered along the path of the expedition. The remaining full-page illustrations are credited, with two exceptions, to either Möllhausen or von Egloffstein, although several have been redrawn by J. J. Young, probably the artist on Lt. Williamson's survey of 1855. (The lithographs are credited to Sarony, Major and Knapp; the steel engravings are not credited in the three copies of the report I have examined.)

The two exceptions are a photograph taken by Ives and a sketch by Ives which was redrawn by von Egloffstein. One of the steel engravings is credited by Möllhausen, the rest to von Egloffstein. Of the remaining full-page lithographic illustrations, six are credited to Möllhausen, one to von Egloffstein. All of the panamoric views are by von Egloffstein and the woodcuts are the work of both these two illustrators although the individual illustrations are not credited.[55]

One significant feature of the illustrations in the reports of the Ives expedition is that they doubtless include the first pictorial records of the Grand Canyon. Von Egloffstein's panoramic views are especially notable in this connection, but several of the steel engravings in the official report are excellent records and are beautifully engraved. The Möllhausen view in the *Reisen,* "Schlucten in Hoch Plateau und Aussicht auf des Colorado-Canon," although rather crudely reproduced (woodcut), belongs also in the "first" class and appeared in print at the same time as the official Ives report.[56]

MÖLLHAUSEN'S REMAINING YEARS

As already pointed out, Möllhausen's Western experiences formed the basis of his career as a writer. After writing an account of his travels with Ives (the *Reisen*), there appeared from his pen a series of short stories and sketches in 1860. In 1861, a four-volume novel, *Der Halbindianer* (*The Half-Breed*), and *Der Flüchtling* (*The Fugitive,* a sequel to *Der Halbindianer*), also in four volumes, were published. The scene of action in the first novel ranged all the way from Missouri overland to California and in the second an even greater scope of Western territory was encompassed. From the time

of these two novels until his death in 1905, an almost ceaseless flow of narratives by Möllhausen took place. Even at the end of a long life, his memories of the American West remained a powerful and pervading influence. In 1904, at the age of 79, he could write with effusive exuberance and self enchantment:

> The Prairie—There has always been a strange, mysterious charm about this word. . . . Even in extreme old age these recollections make the blood run faster and with renewed enthusiasm through the veins, for they bring to mind the days when one recognized no other master but Him who created the beauty of the prairie and the creatures and things that live on it—days when he light-heartedly braved the numbing blizzard and, with equal defiance, the cunning, red-skinned foe, and the prairie fire, that rages on with the speed of the wind, or faced the mountain-bear descending into the valleys. When one thinks of those days, one wishes to be up in the clouds or beyond them, even higher, so that one could embrace with a single glance the old familiar hunting-grounds from the icy North down to the blue Gulf of Mexico, from the moving Mississippi to the long range of the Rockies; one would like to push back the inevitable onward march of civilization, before which the shaggy buffalo and the brown hunter disappeared, and, with them, the last of the romance of the "Far West." [57]

Chapter Three

William Jacob Hays and W. M. Cary

> *As I have been speaking of rivers I shall give a short geographical description of the Missouri, which I am inclined to call my river, as I have often ascended and descended it during the last four years, traveled along its banks, and crossed almost all its tributaries from the mouth of the Yellow Stone to the place where the mighty river mingles its turbid stream with that of the peaceful Mississippi. I have drunk the limpid waters of its sources, and the muddy waters at its mouth, distant more than three thousand miles from each other. The prodigious length of its course, the wildness and impetuosity of its current have induced the Scioux to call it "the Furious." Whenever I crossed this magnificent river the sensations which I experienced bordered on the sublime, and my imagination transported me through the world of prairies which it fertilizes, to the colossal mountains whence it issues.*
> *—Father De Smet, in a letter, July 14, 1841.*

William Jacob Hays, known chiefly as a painter of animal life, owes his reputation as an artist to material gathered on a trip up the Missouri river in the summer of 1860. His work is but little known at present, but in his prime (1855–1875) he received considerable recognition both at home and abroad. Tuckerman devotes over a page and a half to his work and dismisses the work of George Bingham in five lines and the work of John James Audubon in a dozen lines;[1] yet the latter two are far better known at present than is Hays. A London paper in 1865 commenting on one of Hays' pictures then on display in London, said: "English artists must look to their laurels, or America will rob them of some of them in landscape and animal painting in which they have hitherto held their ground almost undisputed."[2] *The Art Journal* in 1875 called Hays "one of the most able painters in the country."[3] S. G. W. Benjamin in his review of American art stated that "William Hayes

[*sic*] showed decided ability in his representations of bisons, prairie dogs, and other dogs. Weak in color, he yet succeeded in giving spirit and character to the group he painted, and holds among our animal painters a position not dissimilar to that of Mount in *genre*." [4] The only modern comment on Hays with which the author is familiar is his biographical sketch in the *Dictionary of American Biography*; [5] the inclusion of his name in this distinguished work is in itself recognition of the fact that Hays was important in his day.

We are here not so much concerned with his reputation as an artist as we are with his Missouri river trip of 1860 and the graphic materials he gathered. There are still extant sketch books, letters, and contemporary newspaper accounts that are important in adding to our store of knowledge of the pictorial and written record of the old West.[6]

Hays was born on August 8, 1830, and died March 13, 1875, spending most of his life in New York City.[7] He received some training under the artist John Rubens Smith and had begun exhibiting by 1852, one piece—"Head of a Bull-dog"—winning him considerable renown.[8]

Hays has left no evidence available to the writer that would indicate a reason for selecting the Missouri river route for his westward travels. It can be pointed out, however, that even as late as 1860 the upper Missouri country was, by virtue of small steamboats and the absence of railroads, the most accessible region for an examination of the flora, fauna and aborigines of the Far West. It was no unknown country, for fur traders and visitors had exploited or described this region so extensively that it was internationally famous. The region, as a fur-trading country, had passed its prime when Hays visited it in 1860. In its heyday, the 1830's and 1840's, the upper Missouri country witnessed some of the most extraordinary spectacles of the past American scene. Here lived, at Fort Union, Kenneth McKenzie, Scotch "Emperor of the West," who "ruled over an extent of country greater than that of many a notable empire in history." [9] Scarcely less picturesque in the fur trade was James Hamilton, an English "gentleman," reticent and fastidious, with a scorn and hatred of the native Indians; and Lucien Fontenelle, fur-trade partisan, leader of the mountain brigades of fur hunters and trappers. Up the Missouri before the Hays trip came an almost ceaseless flow of notables for sport, for science, for humanity, for art, or for adventure: [10] Prince Paul of Württemberg; Maximilian, Prince of Wied, with his artist Karl Bodmer; a young son of President William Henry Harrison; the famous Audubon, naturalist and artist, and still others, including "Blackrobe," Father Pierre-Jean De Smet. Of powerful physical build, of forceful personality and singleness of purpose, De Smet traveled up and down the Missouri river, crossing and re-crossing the Rocky Mountains, establishing Indian

missions, and spreading his peaceful doctrine from St. Louis to the North-west coast from 1838 until his last trip to the Indian country in 1870. To further his work, he wrote a number of accounts of his missionary experiences in the years 1841–1863.[11]

Probably, however, the most important visitor of all to the upper Missouri country as far as spreading knowledge of this region goes, was George Catlin, author and artist. Without making any critical examination of his work as an artist or as an author, it can be said that Catlin was the great publicist for this region. As a result of a trip to the upper Missouri in 1832, there was published in 1841 his book (of varying title) [12] which in its earliest edition was called *Letters and Notes on the Manners, Customs, and Conditions of the North American Indians* . . . "with four hundred illustrations, carefully engraved from his original paintings." Between 1841 and 1860, this book in various modifications was published in nearly 20 American, English, German, French and Belgian editions.[13]

In addition to this book, Catlin published in the same period a fascinating set of large colored lithographs, the *North American Indian Portfolio*, also in several editions.[14] It is no small wonder, with this record of publication, that I find Catlin's name the most frequently mentioned in biographical accounts of later artists of the West or for that matter one of the most frequently referred to authorities on the early history of the upper Missouri country. If one could make a guess, then, at Hays's incentive for his Western trip, a very good one would be that a knowledge of Catlin was an important factor in making his final decision.

Whatever the cause, the desire to broaden his field presumably led Hays to turn West, and in the spring of 1860 he arrived in St. Louis accompanied by one Terry,[15] and made plans for his trip up the Missouri river. The artists left St. Louis May 3, 1860, on the steamboat *Spread Eagle* which was accompanied by two small "mountain" steamboats, the *Key West* and the *Chippewa*.[16] On May 9 Hays wrote his father as follows:

On board Steamer "Spread Eagle" May 9th, 1860

Dear Father,

We are now about 350 miles on our way. The thermometer has fallen from 90° to 50°. Stoves and over coats comfortable, the wind is blowing a gale and it looks like a sand storm on shore, yesterday it blew so hard that the steamers were blown ashore and remained so for nearly five hours, so that we only made thirty miles all day—when they get out of fuel and there should happen to be no wood yard near, they send men ashore to cut it, at night this is done by fire light, the effect is very pic-

turesque. It is not likely that we will reach fort Randall in less than a fortnight. There is some chance of trouble with the Sioux as they are dissatisfied with last years pay, but as our party numbers about 600 men I think they will find it dangerous to molest it; however I hope they will try it. The troops are under the command of Major Blake of the dragoons,[17] a fine old gentleman, who with the other officers is a graduate of West Point and has seen service in Florida, Mexico, and the Indian country. I am very well, and the time passes very pleasantly, give my love to all.

<div align="center">Your affectionate son,
W. J. Hays</div>

P.S. It is hard to write the boat shakes. we expect to reach Lexington today when I will mail this letter.[18]

Two days later the *Spread Eagle* reached Fort Leavenworth and Hays again wrote his father:

<div align="center">On Board Steamer
"Spread Eagle" May 11th, 1860</div>

Dear Father

To day we reached Fort Leavenworth, and remained there several hours, I spent the time walking around the fort, which is no fort at all, but simply an enclosure with barracks and parade ground. Tomorrow we expect to reach St. Joseph where I shall mail this.

Our progress has been slow as the river has never known to be so low as now. At Fort Leavenworth they have had no rain since February, and further up the river none in eighth months. The weather today is very warm. I hope you have sent me some papers to Fort Randall.

All well, give my love to all

<div align="center">Your affectionate son
W. J. Hays</div>

A. B. Hays, Esq.

The frontier and river towns of St. Joseph and Sioux City were passed as was Fort Randall, a military post about thirty miles (by land) above the entrance of the Niobrara river into the Missouri (in present Charles Mix county, South Dakota).[19]

Terry and Hays apparently made no stops of any length, however, until they reached Fort Union on the Missouri river, three or four miles above the mouth of the Yellowstone river.[20]

The date of arrival at Fort Union—over 1,800 miles by boat from St. Louis —is established as June 15 in Hays' letter of June 20 (reproduced later). The trip from St. Louis to Fort Union was a tedious one as they traveled up the river—westward across Missouri, northward between Iowa and Nebraska

territory, northwesterly through the present Dakotas to the junction with Yellowstone river, near the boundary line of present Montana and North Dakota. The time necessary to make the upriver trip to Fort Union (from St. Louis) varied considerably. Records show that in the later 1840's the time required was from forty to forty-four days,[21] but Larpenteur in 1864 reported that he left St. Louis on March 26, and did not reach Fort Union until May 31.[22] The length of Hays' trip from St. Louis to Fort Union (May 3 to June 15) thus appears to have been of average duration. Hays wrote his father again from Fort Stewart on June 20, the letter giving some of the interesting details of his upriver trip:

> Fort Stewart, Upper Missouri
> June 20th, 1860
>
> Dear Father
> My last letter was dated Fort Pierre.[23] I was present at a grand council between the Indian agent and about six hundred of the Sioux Indians who are friendly to the whites, since then I have been present at two more councils viz Forts Clark and Berthold, I have seen the Rees, Mandans, Gros Ventres, and Assinoboines The day before we reached Fort Union we saw the first buffalo, the same afternoon we met two buffaloes swimming in the river and soon killed them. There was a perfect volley of balls poured into them. They were taken on board. The meat was very good. We have had plenty of elk, antelope and deer meat. A gentleman on board shot a big horn or mountain sheep from the deck of the steamer with a soldiers musket at the extraordinary distance of more than six hundred yards. We arrived at Fort Union on the 15th but finding that there were no buffalo near Mr. Terry and myself concluded to go on to Fort Stewart, about eighty miles further up the river. Here we bid good bye to our soldier friends, and with much regret for our intercourse had been of the most agreeable kind.
> The Spread Eagle will go on as far as the water will permit, and then transfer her freight and passengers to the Key West and Chippewa, and then return to St. Louis. I will send this letter by her. Mr. Terry and myself will remain at Fort Stewart until the return of the Key West and Chippewa from Fort Benton and then return with them home. The Sioux Indians who threatened to wipe us out probably concluded that discretion was the better part of valor for we saw nothing of them. The weather has been very fine and I have been very well. give my love to all
>
> your affectionate son
> (signed)
> W. J. Hays
>
> A. B. Hays, Esq.

The original sketches made by Hays on this trip and examined by the author are of two types. One set was made on sheets of drawing paper varying slightly in size. The largest ones in this group measure 10″ x 14″. (Several sketches may appear on a single sheet, however.) The second set was made in a small notebook measuring about 2″ x 4″. In many cases the larger sketches are dated. It should be remembered, of course, that these are field sketches, many of them hurriedly done. The best finished ones are the sketches of Fort Union (the only one in the author's possession; all others are the property of Hays's grandson, H. R. Hays, of New York City. *See* note 18), and of a fawn elk. The pencil lines in a number of the sketches are so lightly drawn that they would be lost in reproduction. As a group, however, they are important because they portray a number of the trading posts of the upper Missouri, for some of which there are no other pictorial records; they are also important for the few buffalo sketches included in the group. Field sketches of buffalo when they still survived in considerable numbers are relatively few.

A list of the more important of twenty-three field sketches with the legends as written by Hays follows:

Large Sketches

1. "Mouth of the Yellowstone—*Fort Union*. Upper Missouri, June 16, 1860."
2. "Interior of Fort Stewart, Upper Missouri, June 22nd, 1860."
3. "Fawn elk. Upper Missouri, Fort Union, July 11th, 1860." Two views, excellently drawn in pencil but too light in tone to reproduce.
4. "Fort Clark, July 14, 1860" (upper view on sheet) and "Fort Primeau, Upper Missouri, July 14th, 1860" (lower view).
5. "Fort Pierre—July 18th, 1860—On the Missouri" (lower part of sheet; upper part shows faint outlines of hills).
6. "Old Fort Pierre. July 18, 1860—on the Missouri—"
7. "Fort Randall, Missouri River, July 19th, 1860."
8. "Sioux City, July 20th, 1860—(From the Missouri River)."
9. "St. Joseph, Missouri River, July 25, 1860—."
10. Two sketches on one sheet (not dated). The upper view shows a herd of buffalo crossing a large stream, presumably the Missouri river; the lower view shows a large herd of buffalo advancing slowly toward the observer on the open prairie.
11. Lower half of sheet. Snags in a large stream (presumably the Missouri river), with the river bank, brush and trees, and hills in the background.

Small Sketchbook

12. Small group of buffalo crossing small stream on the prairie.

13. "Fort Kip[p]" (exterior view).

14. "Fort Union, Upper Missouri, July 11, 1860." The sketch occupies two opposite pages (therefore 2″ x 8″) and shows the panorama of the country from behind Fort Union looking toward the Missouri and the hills across the river.

15. "Fort Stewart, Upper Missouri, June 20, 1860" (exterior view).

16. "The man who looks everywhere—Crow War Chief." The only portrait in the group.

The first sketch in the above list was made the day after Hays' arrival at Fort Union. The original sketch is dated "June 16, 1860." It is in general agreement with other sketches and information concerning Fort Union, one of the most historic structures that ever existed on the upper Missouri (see note 25). The fort itself—not a military post but one of the chain of posts belonging to the American Fur Trading Company [24]—was an important one in the company's empire, and enclosed a space 220′ x 240′.[25] Two blockhouses (for some reason called "bastions" in the literature of the West) occupied diagonal corners of the enclosure; one blockhouse being shown in the Hays drawing. The detail of this blockhouse, including the oddly-shaped weather vane on its top, corresponds with a view of 1864 drawn with perspective from above to show the interior arrangement, and reproduced by Coues.[26] In the Hays drawing, too, the outline of several roofs, chimneys, etc., appear in a manner corresponding to the 1864 view, which Coues ascribes to "a soldier, name unknown."

Early views of Fort Union were made by the pioneer artists of the upper Missouri, Catlin (1832),[27] and Karl Bodmer (1833).[28] Both of these views are distant ones so that their chief use is in obtaining an impression of the surrounding country. A sketch of Fort Union drawn in 1858 by Carl Wimar, a St. Louis artist who had preceded Hays up the Missouri River by three years, is one of six illustrations on one page appearing both in Wimar's biography and in the life and letters of Father De Smet.[29] I have also found a reference to a painting of Fort Union made by Isaac Sprague, an artist of Audubon's retinue who made the trip up the Missouri in 1843.[30] The painting was made for Alexander Culbertson, for many years head at Fort Union, but whether the painting still exists is unknown.

As already mentioned in Chapter One, there is also a tinted lithographic illustration of Fort Union by J. M. Stanley in Stevens' Pacific railroad report

of 1853.[31] Fort Union, in the Stanley illustration, is shown as part of the background [32] and its detail is not carefully drawn, but in general it agrees— as far as can be seen—with the Hays and Coues views.

Hays' other sketch of Fort Union (listed as No. 14) is small and roughly drawn, showing the fort only in outline as it appeared from the hills behind the fort, as are the distant views of Catlin and Bodmer. There is still another Hays illustration of Fort Union. It is a small oil painting somewhat larger than the pencil sketch (No. 1) but taken from the same viewpoint, save it shows a small strip of the river in the immediate foreground. It is subdued in color but pleasant in appearance and finished in more detail with respect to surroundings than is the sketch. It was probably painted from the pencil sketch after Hays returned home.

The views of Fort Stewart (No. 2 and No. 15) are apparently the most hurriedly done of the group. The exterior view (No. 15) shows simply a small stockade; the interior view is reproduced in this book. The chief importance of the sketches lies in the fact that they probably are the only sketches of Fort Stewart extant; at least they are the only ones with which I am familiar.[33]

Hays' letters indicate that Fort Stewart was the western limit of their voyage, and from the information in his letters and the dates on his sketches, he and Terry stayed there from about June 19 to July 9, and in this interval of nearly three weeks many sketches were doubtless made, far more than have survived. Doubtless, too, many of these were animal sketches used for Hays' later paintings. Fort Kipp (No. 13 on our list) was made in this interval as it was a small trading post only 200 yards from Fort Stewart.[34]

The down-river trip from Fort Stewart was begun on July 9 on the *Key West,* but a stop for a day or so at Fort Union is indicated by the date of two of his sketches, July 11, 1860 (sketches Nos. 3 and 14). Other incidents of his return trip are given in a letter to his mother, written aboard the *Key West* on July 21, 1860.

> On board steamer "Key West"
> Missouri River July 21st, 1860
> Dear Mother
> I left Fort Stewart on the 9th of July and arrived at Fort Randall on the 19th where I received Sarah's letter of the first of July and two letters from Father together with newspapers they were very welcome I assure you. On my way down the river I saw thousands of buffalo they covered the bluff and prairie as far as we could see. Until this last month there had been no rain in this part of the country for about a year, but since then they say they have never known so much, the consequence is the mosquitoes literally swarm, at Fort Stewart I lived under a mosquito

bar for five days and nights, only leaving it to eat and then hurrying back as quick as possible it was a relief to get on board of the steamboat again. As we had no soldiers on board coming down the river we thought the Siouxs would take advantage of it to attack us, so we prepared for war, three cannons were kept loaded with grape for more than a week, while every man on board kept his fire-arms loaded and ready for use at a moments notice, but we passed through their country without seeing a living creature all as still as the grave. . . .[35] I hope you will keep the Great Eastern in New York until I arrive or I shall be obliged to go to England to see her. I have no news to tell you. My journey is nearly over I hope to be in St. Louis on the first of August so far I have met with no accident or mishap have not lost a day by sickness in fact I never felt better in my life. I will write from St. Louis as I do not know how long I shall stay there or what route I shall take home give my love to all

<div align="right">Your affectionate son
(signed)
W. J. Hays</div>

Mrs. S. P. Hays
P.S. I will mail this at St. Joseph

The sketch of the buffalo crossing the Missouri (No. 10, upper view) may be the result of the observation of "thousands of buffalo" he saw on the downriver trip. Hays seems to have realized, as he started homeward, the importance of making pictorial records of the forts along the Missouri, and for several of the forts, the sketches obtained are the only ones available as far as the author's studies go. The dates of these sketches in each instance correspond to their geographical position as the *Key West* steamed with comparative swiftness down the Missouri.

Thus, the sketches of Fort Clark and Fort Primeau (No. 4) are dated July 14, 1860, three days after the sketch at Fort Union (No. 14). These two forts according to Coues were only 300 yards apart.[36] Fort Clark, one of the most important trading posts of the fur trade, was located on the Missouri some fifty-five miles above the present Bismarck, N.D.[37] The only other sketch of Fort Clark with which the author is familiar was drawn by Carl Wimar, although Bodmer on his trip up the Missouri with Prince Maximilian in 1833 had sketched a distant view which suggests a faint outline of the Fort.[38]

"Fort Pierre" (No. 5) and "Old Fort Pierre" (No. 6) are dated July 18, 1860, as they should be, for both forts lie down the Missouri from Forts Primeau and Clark and were in the vicinity of present Pierre, S. D. The Pierre forts again were close together (three miles apart) [39] but there appears to be some confusion in the names of the two forts which should be explained.

Fort Pierre, or Fort Pierre Chouteau, named after the head of the American Fur Company in St. Louis, was established in 1832 and was "the finest and best equipped trading post on the upper Missouri with the exception of Fort Union." Like Fort Union, it was an important and historic spot. At this post many of the Indian trails, both east and south, were centered. "Here [i.e. in or near the site of Fort Pierre] Lewis and Clark had their first serious encounter with the Sioux; here were found the headquarters of various tribes, in the form of evidences of a winter camp, in 1810, when the Hunt-Astoria expedition and the Lisa party halted on their way up the Missouri; here Catlin found the center of the Sioux country in 1832; here Fremont and Nicollet ended their up-river journey in 1839; here the Raynolds expedition took its departure from the Missouri in 1859. To old Fort Pierre [as headquarters] came the Indian missionaries . . . in the process of laying foundations for civilizing the Indians in this region." [40] For a quarter of a century its history and trade made it a byword in the Missouri river country. In fact, Frederick T. Wilson states, "The words 'Fort Pierre' were in themselves a phrase. They included anything and everything between the Great Bend [of the Missouri] to the Cheyenne, and between Jim river and the Black Hills. A recognition of this fact will explain many otherwise contradictory passages in the history of the plains." [41] The United States army bought Fort Pierre for a supply depot in 1855 but found it inadequate and it was abandoned in 1857.[42] Soon the demolition of Fort Pierre was underway, and Capt. W. F. Raynolds, of the United States Army Corps of Engineers, noted in his diary under date of September 10, 1860: "As we passed old Fort Pierre, I noticed that but little was left of the structure, the remains consisting of the shell of one row of houses, and the demolition of this was in progress, the material being used in the new fort." [43]

In the meantime (1857) a trading post was built three miles above "old" Fort Pierre on a bluff at the edge of the river. Like the "old" fort, it contained two "bastions" fifteen feet in height at diagonal corners of the stockade. "This small establishment soon became known as Fort Pierre, though it was a most unworthy and insignificant successor to the original. . . ." [44] It would appear, therefore, that Hays in his two sketches of the forts has incorrectly titled them. "Old Fort Pierre" (No. 6) as labeled by Hays is doubtless the new Fort Pierre just described, and the Hays sketch "Fort Pierre" is really the remains of "old Fort Pierre" as suggested by the Raynolds' comment. There are no other sketches of the "new" Fort Pierre extant as far as the author knows. Of "old" Fort Pierre a number of illustrations are available. Catlin painted or sketched it in 1832,[45] Bodmer in 1833,[46] Kurz in 1851,[47] Wimar in 1858,[48] and Charles E. De Land [49] possessed still another view.

Although Hays could not record old Fort Pierre in its original form he saw its site and in its neighborhood saw the grand council of the Sioux on the upriver trip (*see* his letter of June 20, 1860).

The downward trip was now progressing swiftly. Fort Randall, 150 miles below Fort Pierre,[50] was passed the day after leaving Fort Pierre, for the Pierre sketches are dated July 18 and the Fort Randall (No. 7) sketch was made on July 19. Although the sketch has an odd perspective (doubtless it was done hurriedly as the *Key West* stopped momentarily) it is the only sketch of this military post—the only *military* post above Fort Leavenworth on the Missouri in 1860—that I have ever seen.[51]

The day after leaving Fort Randall the *Key West* passed Sioux City (July 20, sketch No. 8) which was 175 miles below the fort [52] and Hays apparently made the sketch of the town from the small steamboat; in a similar manner the sketch of St. Joseph was made on July 25.[53] (Sketch No. 9).

On July 27, 1860, the *Key West* docked at St. Louis with her crew, her passengers, "1,800 packages of buffalo robes, furs, peltries, etc., and a young grizzly bear." [54]

One more Hays sketch of the 1860 trip deserves brief mention. The tremendous number of snags—fallen tree trunks with their huge exposed roots—in the Missouri (No. 11, undated) were always an object of wonder to travelers up the lower Missouri. Bodmer drew them.[55] Not only a source of wonder to travelers, they were a source of continual despair to the river pilots, and being "snagged" was the usual end of the Missouri river boats, according to Coues. Such was the fate in 1862–1863 of the *Spread Eagle,* which carried Hays up the Missouri.[56]

How long Hays remained in St. Louis after his return we do not know, but the probabilities are that it was not long. In the fall of 1860, however, a reporter visited him in his studio in New York City and wrote: "Mr. Hays is engaged on a very spirited picture, the result of his recent trip to the Rocky Mountains, representing a herd of buffaloes scampering wildly over the prairies." [57]

Outside of the fact that the reporter considered the West and the Rocky Mountains as one and identical, the brief item shows that Hays was soon at work after his return from the Western trip. The painting referred to above is probably one of Hays' best known paintings, "The Herd on the Move." Although the picture suggests movement, "scampering wildly over the prairies" is overdoing the motion depicted. Hays himself described the painting in this manner:

The Herd on the Move

By the casual observer this picture would, with hardly a second thought, be deemed an exaggeration, but those who have visited our prairies of the far West can vouch for its truthfulness, nor can canvass [*sic*] adequately convey the width and breadth of these innumerable hordes of bison, such as are here represented coming over a river bottom in search of water and food, their natural instincts leading them on, constantly inciting them to this wandering life, since vegetation would be quite exhausted were it not for the opportunity thus afforded for renewal. As far as the eye can reach, wild herds are discernible; and yet, farther behind these bluffs, over which they pour, the throng begins, covering sometimes the distance of an hundred miles. The bison collect in these immense herds during the Autumn and Winter, migrating South in Winter and North in Summer, and so vast is their number that travelers on the plains are sometimes a week passing through a herd. They form a solid column, led by the strongest and most courageous bulls, and nothing in the form of natural obstructions seems ever to deter their onward march, they crossing rivers and other obstacles from which a horse would shrink. The soil of the river bottoms—unlike the prairie proper which begins at the bluffs in the distance—is very rich, and vegetable growth very luxuriant. In the foreground is represented the sweet briar, or wild rose; and in the middle distance, the light tints which look like water is the artemesia, or wild sage.[58]

"The Herd on the Move" was on exhibition in New York City during the winter of 1861–1862, and for many years thereafter its whereabouts was unknown. In 1946, I published an article on Hays describing the painting and following the publication of the article, I received a most interesting letter from Professor Walter P. Webb, the distinguished historian of the University of Texas. Webb wrote me in part (Nov. 6, 1946):

"In 1938 I went to London to deliver the Harkness Lectures at the University of London, and while there visited all the old bookshops I could find. In one I saw a painting which obviously was American. The shopkeeper did not know how he obtained it and set a very moderate price on it. Though I realized that it ought to be in America, where it would be appreciated, I could not quite bring myself to purchase it. Later I could not forget it and often regretted that I did not bring it home.

In 1942 I returned to England, this time as Harmsworth Professor of American History at Oxford. Very early I got around to the shop and there was the painting, a little dimmer in the dreary fog of wartime London. This time I was a little better heeled (having left my family at home in Texas) and so I bought the picture with the understanding that it would be shipped after the war when lumber for crating and ship space were available.

Two weeks before the picture came, now some three or four months ago, your article on Hays came. I read it with great interest and realized that I had a Hays. Since the painting was too big for my home—and appeared to have more value than a professor ought to have hanging on a non-fireproof wall—I decided that it should go to some museum where many people might have the opportunity of seeing it.

A chance trip took me to San Antonio and I went to see a collector who is buying historical American paintings. He came to Austin the next day and for the first time I took the front off the crate. He took the painting and I shipped it to the Thomas Gilcrease Foundation at Tulsa, Oklahoma where you may see it if you wish. It is the picture described (but not reproduced) in your study. Evidently the Herd on the Move was left in England when Hays was there after the Civil War. There is little doubt that this painting was seen by thousands of Americans, but it remained for a student of the Plains to recognize its significance and bring it home. I am glad to have it in the West rather than have it go to New York.

In the spring of 1862 Hays was at work on a companion piece to "The Herd on the Move." He called it "The Stampede"; it measured six by three feet.[59] The original painting is now in the American Museum of Natural History, New York City, but is referred to by that institution, for some unknown reason, as the "Buffalo Hunt." Hays' description of the piece follows:

The Stampede

The immense herds of Bison which roam over the prairies are sometimes seized with fright, from some real or imaginary cause, and the panic, beginning perhaps with but few, is at last communicated to the whole herd, when, with headlong fury, they dash and drive each other on, in wildest fear. The picture represents the arrival of a herd, during one of these panics, upon the brink of one of the small cañons, or ravines, which everywhere intersect the prairies, and are generally invisible until their edge is nearly approached. The foremost animals, despite their fear, discover their danger and frantically struggle to retain their foothold, but the immense pressure of the terror-stricken creatures in the rear renders it impossible; they are forced forward, and plunge into the ravine, their bodies serving as a bridge for the rest of the herd, which continues its mad career until exhausted. A stampede is the great dread of emigrants crossing the plain, as it is almost impossible to prevent the cattle and horses from being carried off with it. The soil of the rolling prairie is chiefly sand and clay, which, baked dry by the intense heat, is raised by the wind in intolerable clouds of dust. The vegetation is principally buffalo grass, amid which flourish the most delicate wild flowers; in the foreground may be noticed the cactus opuntia, or prickly pear, which, in this region, is found in abundance.[60]

Hays himself lithographed "The Herd on the Move" in 1863, and it was published by Goupil and Company. The lithograph measured 36" x 18" and a contemporary account stated that it "admirably reproduces the color of the original painting." "The Stampede" was reported to have been engraved for reproduction but I have no proof that this was ever done.[61]

The painting which is most frequently referred to as Hays' masterpiece is "The Bull at Bay" or "Bison at Bay" or occasionally as "The Wounded Bison." It depicts a wounded bison separated from the main herd which can be seen retreating in the middle distance, the bull being surrounded by coyotes. It was probably painted in 1864 or 1865 and was first exhibited in London. It is now owned by the American Museum of Natural History.[62]

Although regarded by Hays' contemporaries as his masterpiece, it was, nevertheless, severely criticized in its day. A critic, who modestly signed himself "Rembrandt," wrote an extended criticism of the painting in the spring of 1866 when it appeared on exhibition in Goupil's gallery in New York City.[63] "Rembrandt," who claimed that he himself had been on the plains, criticized the painting on the grounds that the habitat of the buffalo was incorrectly depicted (especially because it showed *long* grass and wild flowers in the foreground), that the depiction of the animal himself was incorrect from an anatomical standpoint, and that in the real buffalo country "The monotony of the color of the grass is varied by multitudinous patches of 'buffalo chips,' from two to three feet in diameter, which appear like white spots all over the ground," which Hays had failed to depict. He further went so far as to intimate that the picture was a forgery, i.e., presumably copied from a painting by another artist.

The effect of this harsh criticism brought immediate response from Hays,[64] who defended himself on all points save that of the buffalo chips for, he said, "as they are by no means a pleasant adjunct to a picture, I did not introduce them." [65] "Rembrandt" offered a rejoinder to Hays' letter on the same page and cited a number of authorities to prove his point. The citations, with one exception, however, were from travelers on the Great Plains hundreds of miles south of the upper Missouri country. The exception mentioned above was Audubon, whom Hays disposed of in the letter published below. "Rembrandt" also offered to submit the difference of opinion to a committee of three whose decision would then be published.

Among the Hays correspondence available to the writer are copies of several letters to S. D. Bruce, one of the editors of *Turf, Field and Farm*.[66] The day after the Hays-"Rembrandt" argument was published, Hays wrote Bruce (in part) as follows (the letter is dated April 29, 1866):

The authorities that he [the critic] quotes are all good, but do not conflict in any way with my picture. After a million buffaloes have been feeding, it is very likely that the grass would be cropped short, but it is a very large country that the buffaloes range over; and a man may cross the plains several times and never have the opportunity of seeing a buffalo, some seasons they are very plenty in some places, the next in the very same place, there will be few or none; I have been in places where the buffalo had made their first appearance late in the season, by this time the grass had attained its full height, (and it was the *home* of the buffalo nevertheless).

Your critic charges me with quoting incorrectly. If I understand the English language, I had a right to infer, from his words, that he meant that I had represented the long "luxuriant grass of the river bottoms." However I will take his own words "some indications of long grass and wild flowers," there is not a single flower represented in the picture, the plants are all faithful portraits made on the spot, and among others is represented the buffalo grass that he speaks of. The wolves in my picture are the small variety known as the coyote. They are about sixteen to eighteen inches in height, and as they are creeping nothing would be seen of them but the head and upper part of the body. He says that the wolves "only show themselves after nightfall" and "do not pursue buffaloes while in flight from the hunter" if this does not mean that wolves do not pursue the buffalo in the daytime I don't [know] what does.

Your critic has by no means proved that the rolling prairie is the *only home* of the buffalo, and I defy him to do it.

My authority for the description of the hump, is my own personal examination of many individuals, and by careful drawings which I have made from the skeleton, it is nothing new or extraordinary. It is well known to naturalists, and anatomists, although it may not be to your critic. and your critic has misunderstood Richardson, he does not say, nor does he mean that the hump stops at the first dorsal vertebra. Your critic must be joking when he refers to Audubon's plate of the buffalo. Audubon's written description is correct. He brought back a skin. this was set set up by a taxidermist in New York who found it very difficult to do anything with it as he had no skeleton to place in it. Mr. Audubon made a reduced drawing from this with the camera lucida, the specimen was afterwards sent to Europe. And this is the carefully prepared plate, by which he attempts to judge my picture. Your critic has no right to assert that I have not given careful study and consideration to the picture. he knows nothing about it. The decision of a committee cannot alter the facts of the case, but if it would be any satisfaction to him I will name Mr. Wm. Hart and Mr. W. H. Beard, two of our best artists, Dr. Flint of New York and Dr. Rimmer of Boston, two of our best anatomists, and Major Genl. G. H. Warren, U. S. Engineers, who made an exploration of the country when I made my studies.[67]

Evidently this letter was sufficient to quiet "Rembrandt" for he made no attempt to take up Hays' offer of a committee.[68] The letter does show that Hays was an important observer of detail, a statement that is borne out by sources of information other than the above letter. He was a naturalist and published several papers in professional journals.[69] The first of these papers, "The Mule Deer," which carries a plate drawn by Hays, includes measurements of a deer which Hays states that he secured from a specimen obtained while in the upper Missouri country. In addition, I have examined a manuscript biography of Hays prepared by a member of his family shortly after his death[70] in which mention is made of carefully drawn field sketches of the various species of plants Hays observed on his upper Missouri trip and which were subsequently used as the basis of the flora depicted in his paintings.

Although "Herd on the Move," "The Stampede" and "The Bull at Bay" were regarded as the best of Hays' work subsequent to the Missouri river trip, a number of others, also based on this trip, are known to have been produced but whether they are still extant is unknown.

The list of paintings includes:

1. Western Plains.
2. Study of a Buffalo's Head.
3. Camp on the Prairie.
4. Buffalo Hunt.
5. Fire on the Prairie (1869).
6. Antelope's Head.
7. Elk's Head.
8. Rocky Mountain Goat.
9. The Upper Missouri.
10. Prairie Dog Village (1862).
11. Head of Rocky Mountain sheep.
12. Three portfolios of field sketches [71] (one included 33 studies of bison; another a group of "Western scenes"; and the other, studies of antelope and deer).

In addition to these paintings, the New York Public Library owns a Hays painting entitled "Rocky Mountain Hares"; Washington University (of St. Louis) possesses one without title but it depicts a herd of buffalo by moonlight; in addition, the American Museum of Natural History possesses another Hays painting called by it, "Group of Buffalo, 1860."

Hays probably did not possess the skill with the brush that he did with the pencil, at least as far as his animals go. His sketch of the fawn elk [listed as No. 3 on p. 41] which is drawn with care and real skill is well-nigh perfect

to anyone who has seen one of these creatures. His paintings of Western animals are not so well done from the standpoint of draftsmanship. The Hays paintings that I have seen also bear out Benjamin's criticism (page 37) that Hays was weak in color. His paintings do have value, however, because they are the work of a professional artist and are based on careful and personal observations. Isham, a twentieth century historian of American art, dismisses Hays in a single sentence, but in mentioning him calls attention "especially [to] some western landscapes which with their great herds of buffalo have now a historic interest." [72]

In addition to his Western trip, Hays also made a trip to Nova Scotia, according to Downes,[73] to study its faunal life, and a number of trips to the Adirondacks. From these trips, there resulted a number of paintings of deer, caribou, and moose.[74] For the last several years of his life, Hays was in ill-health and lived an extremely quiet life. His death occurred at the comparatively early age of forty-five. The fact that his pallbearers included such notable personages in the artistic profession (for their day), as W. H. Beard, S. R. Gifford, W. Whittredge, William Hart and others scarcely less notable, indicates that he was highly esteemed by his contemporaries.[75]

The year after Hays and Terry traveled up the Missouri, three other young men, W. H. Schiefflin, E. N. Lawrence, and W. M. Cary all of New York City, left St. Louis on a similar excursion. The tale of their adventure reads like the description of a boyhood idyll. St. Louis was left on May 12, 1861, on the same *Spread Eagle* that had carried Hays. The *Chippewa* also left at the same time on the up-river trip. The two river boats reached Fort Union by the middle of June and the three youngsters transferred to the *Chippewa* which was to continue on up the river to Fort Benton. Before Benton was reached, it suffered the fate of many of the river boats of earlier days for it caught fire and its boiler exploded. Fortunately no one was injured but the entire party aboard the *Chippewa* had to return to Fort Union on a hand-made flat boat.

They remained at Fort Union for six delightful weeks—hunting, visiting the Indians encamped about the Fort, and making friends with them, and taking side excursions of several days out on the prairie with their new-found friends.

About August 12 they joined a train of ox-wagons bound overland for Fort Benton. The train was captured by a band of Crows who would undoubtedly have plundered it save for the presence of a fur company official who was recognized by the Crow chief. The train was allowed to proceed to Fort Benton where the three New Yorkers spent another two weeks. On a

bright September morning the three city boys with a guide and cook again started on their westward journey, this time for the crossing of the mountains. After traveling nearly three hundred miles they fortunately fell in with Lt. Mullan's surveying command—he of the Pacific railroad surveys—and were able to continue on with the Mullan party. A stop was made at the Coeur d'Alene Mission but they soon traveled on, reaching Walla Walla about November first. After resting for a week, the New Yorkers left for Portland and then—by water—for San Francisco. Cary started out for home immediately by way of the Isthmus but the other two spent some time in California.[76]

Cary made many sketches on this western trip and, combined with a later western experience in 1874, spent a life-time depicting the West as he recalled it.[77] He was not only a most prolific illustrator of western scenes but transferred many of his recollections and imaginings to canvas in oil. A number of his western paintings are now to be found in the Gilcrease Foundation, Tulsa, Oklahoma.

Cary's western illustrations began appearing in the national illustrated papers in the late 1860's and continued to appear for nearly thirty years. Among the more valuable historically of his numerous output were "Stampede by Sioux Indians at Fort Union" (1868), "Fur Traders on the Missouri Attacked by Indians" (1868), "Pictures from the Plains" (11 illustrations, 1871), "Indians Killing Buffalo in the Missouri River" (1874), "Mandan Women Carrying Bull Boats" (1875), "Exodus from the Black Hills" (1875), and "Wagon Trains at Helena, Montana" (1878). It seems probable that all of these pictures listed above were the result of direct observation but many of Cary's illustrations were imaginary scenes suggested by events current at the time of their depiction.[78]

Chapter Four

Theodore R. Davis and Alfred R. Waud

Our coach was a great swinging and swaying stage, of the most sumptuous description—an imposing cradle on wheels. It was drawn by six handsome horses, and by the side of the driver sat the "conductor", the legitimate captain of the craft; for it was his business to take charge and care of the mails, baggage, express matter, and passengers. We three were the only passengers, this trip. We sat on the back seat, inside. About all the rest of the coach was full of mail-bags—for we had three days' delayed mail with us. There was a great pile of it strapped on top of the stage, and both the fore and hind boots were full. We had twenty-seven hundred pounds of it aboard, the driver said—"a little for Brigham, and Carson, and 'Frisco, but the heft of it for the Injuns, which is powerful troublesome 'thout they get plenty of truck to read."
—Mark Twain, Roughing It, 1871.

The early sixties were years of intense effort for the American nation with the public interest focused almost exclusively on the heart-breaking struggle between the North and the South. Following the close of the Civil War, however, the tempo of westward migration was greatly accelerated. During the war the Far West had increased rapidly in population, and even the immediate trans-Mississippi West had felt increasing growing pains. But border troubles, the threat of Indians and the lack of rapid methods of transportation retarded large population shifts to the Great Plains West. Cessation of hostilities, the continually recurrent outbreaks of gold and silver mining "fever", the impetus given by the Homestead Act of 1862, accompanied by renewed interest and effort in building Western railroads beyond the Missouri river,[1] brought a flood of immigrants to the plains. "The most astonishing migratory movement which has characterized any

54

age or nation," reported the *Kansas Weekly Tribune* of Lawrence, at the threshold of the Great Plains.[2] The *Tribune* account went on to state:

> The disbandment of our immense armies is throwing back upon society hundreds of thousands of young and middle aged men, whose business ties have been broken and fortunes shattered by the war, who are now returning to earnest effective labor for the repair of the waste of the past four years. They find, as a general thing, their places occupied, themselves, though personally held in grateful remembrance, pressed out of the commercial circles in which they once moved, and compelled, often with nothing but their undaunted will, to begin anew the battle of life, which before the war had been so well commenced. It is but natural that these men should cast about them and seek new fields for their energy, new scenes and better auspices for the recuperation of their crippled estates, or that the glowing West, the fame of whose riches pervades and eclipses the far East, should become the goal of their ambitions and hopes. . . .
>
> These are the men to build up rich and prosperous communities upon the great plains and in the pleasant valleys of the West. Let them come. No other country can give them so good a home or so grand a welcome. Though often poor in all else, they bring with them the inestimable riches of strong arms to labor, clear heads and honest hearts, and above all, that unquenchable love of liberty and national integrity which made them invincible as soldiers in action, and will make them uncompromising as citizens in all that pertains to the good of the State.

To be sure this eulogy was partly promotional, partly prophetic, and partly descriptive of contemporary affairs. But there is abundant evidence that a rising tide of immigration was moving west at the close of the war. The population of Kansas, for example, increased from 107,000 in 1860 to a figure nearly three and one-half times as great ten years later and much of this gain came in the last half of the decade.[3]

The tide of immigration carried along with it interested and observant spectators, as well as future settlers, among whom were reporters and illustrators of the expanding Western scene. Students of the West will recall, among others, the well-known travel accounts of Bayard Taylor, Henry M. Stanley, Samuel Bowles, and A. D. Richardson, stories based on personal observation in the years 1865–1867, to emphasize the point.[4]

The Western artists and illustrators, who recorded this period (1865–1867) in pictures, are not so well known. Included among the group, however, we can list the names of T. R. Davis, Alfred E. Mathews, H. C. Ford, J. F. Gookins, H. A. Elkins, A. R. Waud, W. H. Beard and Worthington Whittredge, all of whom, with one exception, crossed the plains to the Rocky

Mountains in 1865 or 1866.[5] Probably there were others, but this group is
sufficiently representative to consider here. Davis, Mathews, Ford, Gookins
and Waud were Civil War veterans or observers and had recorded in pic-
ture many scenes of that struggle.

Gookins, Ford and Elkins, all residents of Chicago in 1866, formed a party
early in the summer of that year and started out from the Missouri river
(probably from Omaha) where they joined an emigrant train on an over-
land trip by wagon to Denver and Colorado. Gookins had eight sketches
resulting from his trip published in *Harper's Weekly* in the fall of 1866.
They were titled:

> "Storm on the Plains."
> "Preparing Supper [on the Plains]."
> "Fort Wicked."
> "Denver."
> "Emigrants Attacked by Indians."
> "Indian Massacre."
> "Assay Room, U. S. Mint at Denver."
> "Pike's Peak." [6]

Some of the experiences of the party in crossing the plains and an ex-
planation of his sketches are given in an accompanying letter by Gookins,
who wrote:

> Our party of eight (including three artists) had quite an adventurous
> trip over the Plains. One of our mishaps I have sketched; it is entitled
> "Storm on the Plains." A hurricane took down our tents and blew over
> heavy loaded wagons, on the night of the 9th June, near Cottonwood,
> Nebraska. Fortunately no serious damage resulted to any one, though
> many in the train were badly frightened. Ford says that just as he was
> crawling out of the tent his ears were saluted by a piercing wail and
> the pathetic cry of "Oh, have you seen my baby!" He looked back and
> saw the tent down with his wife under it, turned his head, and lo!
> over went our wagon with the horses down under it; and here was a
> woman before him wringing her hands and screaming for her baby.
> "Les joyeuses" are our ladies who, doffing fashionable attire, have en-
> livened the camp by their cheerful presence, and have made us, hungry,
> tired souls, much happiness with appetizing cookery. Though you have
> published one or two street scenes in Denver I send the one herewith,
> which gives a good view of the mountains beyond. It is a different
> view from any hitherto published, and I think from a better point.
> "Fort Wicked," Colorado, is noted as a ranche where a brave man
> and wife named Godfrey held over two hundred Indians at bay for
> two days during the troubles last year—killing many and wounding
> others, and finally driving them off.

The tide of emigration and enterprise is setting hitherward at an astonishing rate, yet it is not to be wondered at when one sees the immense wealth of this region. Denver, a city of seven thousand inhabitants, is well built, and is the commercial centre of a mining region where already over twenty millions of capital are invested in quartz mills and the like. It hardly needs the eye of a prophet to discern that as the prospective terminus of the Eastern Branch of the grandest national highway of the world—the railroad to the Pacific—and as the great outfitting place for trains for Montana, Idaho, and Utah, its growth must be rapid and its destiny that of a great city.

Messrs. Bayard Taylor, Wm. H. Beard, Whittredge, and Major-General Pope, are traversing this region. I have only met Beard; but expect to meet him and Mr. Taylor in the South Park, whither I am now journeying.

By courtesy of Fred Eckfeldt, Esq., Melter and Refiner, United States Branch Mint, at Denver, I was shown through all the departments of that establishment, and send a sketch of the Assay Room.[7]

Little record of other Western pictures by Gookins is available. Several paintings were listed as on exhibit in the spring of 1867.[8]

Of the Western work of Ford still less is known. He is best remembered today for a series of twenty-four etchings on the missions of California which he published in 1883 with descriptive letter press.[9]

Elkins became widely known in the Middle West for his paintings of Colorado and California scenery. As his work was primarily landscape, he is not of immediate concern to us here.[10]

Worthington Whittredge, the best-known artist of the group, was, like Elkins, primarily a landscape artist. Several of his paintings which resulted from his Western trip of 1866 and subsequent trips, for Whittredge visited the West several times, were "South Platte River Looking Toward Long's Peak," "On the Plains, 1865[6?] Cache la Poudre River," "Indian Encampment," "The Emigrant Train," "Santa Fe" and "The Rocky Mountains." Probably his best-known work of this period is the first of those listed above and now owned by The Century Association of New York. The title now is, "Crossing the Ford, Platte River, Colorado." [11]

William Holbrook Beard was the traveling companion of Bayard Taylor and is mentioned a number of times in *Colorado: A Summer Trip*. I have seen no sketches or paintings resulting from Beard's trip across the plains to the Rockies in 1866, but *The Rocky Mountain News*, Denver, December 11, 1866, refers to W. H. Beard who "last summer . . . painted so vividly most of our exquisite mountain scenery. . . ." [12]

The earliest of the group of artists mentioned above to cross the plains

after the cease of hostilities was T. R. Davis, but Waud did not lag far behind. Both Waud and Davis were doubtless the most prolific illustrators of Civil War scenes. Both began as field artists for *Harper's Weekly* at the beginning of the war and both covered the war for its entire duration. At the war's close in 1865, the *Weekly* in a brief article paid tribute to its staff artists, naming Waud first, and Davis second as the principal illustrators of that tragic period in the nation's history.[13] Even today there exist in the Library of Congress nearly 2,300 *original* Civil War field sketches of A. R. Waud and his brother William, many of which were redrawn on wood and published in *Harper's Weekly* during the period of 1861–1865.[14]

ALFRED R. WAUD

Unfortunately, examination of these original sketches revealed that none deals with Alfred Waud's later experiences which included several Western trips. As a result of these trips, however, there were published in the years after 1865 a very considerable number of Western illustrations signed "A. R. Waud" or, more frequently, "A. R. W." Many were probably imaginary, some were probably based on photographs or on sketches of other artists, but several of the illustrations are important, and as his name appeared so many times in the field of Western illustration in the period 1865–1875, he rightfully occupies a place in this book.

Of striking personal appearance, Waud attracted comment wherever he went. An English correspondent, G. A. Sala, who visited the Army of the Potomac in January, 1864, saw Waud in action and the picture he presented so impressed Sala that he described Waud in some detail. He wrote:

> There had galloped furiously by us, backwards and forwards during our journey, a tall man, mounted on a taller horse. Blue-eyed, fair-bearded, strapping and stalwart, full of loud, cheery laughs and comic songs, armed to the teeth, jack-booted, gauntleted, slouch-hatted, yet clad in the shooting-jacket of a civilian. I had puzzled myself many times during the afternoon and evening to know what manner of man this might inwardly be. He didn't look like an American; he was too well dressed to be a guerilla. I found him out at last, and struck up an alliance with him. The fair-bearded man was the "war artist" of *Harper's Weekly*. He had been with the Army of the Potomac, sketching, since its first organization, and doing for the principal pictorial journal of the United States that which Mr. Frank Vizetelly, in the South, has done so admirably for the *Illustrated London News*. He had been in every advance, in every retreat, in every battle, and almost in every reconnoissance. He probably knew more about the several campaigns, the rights and wrongs of the several fights, the merits and

demerits of the commanders, than two out of three wearers of generals' shoulder-straps. But he was a prudent man, who could keep his own counsel, and went on sketching. Hence he had become a universal favorite. Commanding officers were glad to welcome in their tents the genial companion who could sing and tell stories, and imitate all the trumpet and bugle calls, who could transmit to posterity, through woodcuts, their features and their exploits, but who was not charged with the invidious mission of commenting in print on their performances. He had been offered, time after time, a staff appoinment in the Federal service; and, indeed, as an aide-de-camp, or an assistant-quartermaster, his minute knowledge of the theatre of war would have been invaluable. Often he had ventured beyond the picket-lines, and been chased by the guerillas; but the speed and mettle of his big brown steed had always enabled him to show these gentry a clean pair of heels. He was continually vaulting on this huge brown horse, and galloping off full split, like a Wild Horseman of the Prairie. The honors of the staff appointment he had civilly declined. The risk of being killed he did not seem to mind; but he had no relish for a possible captivity in the Libby or Castle Thunder. He was, indeed, an Englishman,—English to the backbone; and kept his Foreign Office passport in a secure side-pocket, in case of urgent need.[15]

In April, 1866, *Harper's Weekly* announced that it was sending artists through the South to depict the results of war and to show "the rising of a new world from chaos." [16]

The artists sent, it soon became apparent, were none other than A. R. Waud and T. R. Davis. They did not travel together, but before they returned to the source of their pay checks both crossed the Mississippi and made pictorial exploration of the West. Davis went south through the Atlantic coastal states and then turned west; Waud headed for the Mississippi by way of the Ohio river and then went further south and west.

Both artists were allowed a freedom in reporting their travels that makes their work, at this late date, of particular value to the historian; for they were allowed to publish descriptive and signed notes in addition to their illustrations. In these notes they frequently identified the actual locality where sketches were made, or contributed information that throws considerable light on their activities and upon their illustrations. If such a practice had been universally employed, it would have saved much research and guesswork for historians of the present day.

Waud's first group of illustrations on this Western trip were of Cincinnati, Louisville and Nashville. Although not Western towns according to present-day definition, they were "the West" of 1866. Concerning Louisville, Waud had the interesting comment:

A stranger from the East naturally wonders at the extensive interest which whisky holds in countries bordering on the Ohio. Here the people that distill the liquor are not at all ashamed of their business. The denizens of the more Eastern States have a sneaking consciousness that the distilling business is not compatible with respectability, and evince a cowardly spirit in fabricating excuses for their indulgence in the fiery juice. Now in the West a man takes his whisky "like a man" without reference to his doctor, a stomach-ache, or a cold. As churches are the prominent institutions in an Eastern town, so here the still-house overshadows all its neighbors and proudly takes the first rank. . . .[17]

Waud also noted, and the comment has a most familiar ring, that as a result of the war, Nashville and Louisville were "troubled with heavy rents and a scarcity of houses."

Waud continued down the Ohio to Cairo where the steamer *Ruth,* "one of the finest river boats," was taken to Memphis and there, after crossing the river, a journey was made to Little Rock, Ark. The trip into Arkansas—which was really in the trans-Mississippi West, be it noted—resulted in several interesting illustrations: a view of Little Rock itself; another was made of a group of colored volunteers of the Union army being mustered out and was sketched "standing before the office of Colonel Page, Quarter-master" in Little Rock (the volunteers created quite "a furor among the resident colored females. . . ." Waud observantly noted); and, of course, the series included an illustration of the famed "Arkansas Travelers," who were shown, Waud noted with some regret, without their fiddles.[18]

It is possible that on this trip Waud traveled into Texas and certainly he was in central and western Louisiana, as is shown by his notable illustration depicting the Acadians of Louisiana whom he sketched from life. They were, of course, the descendants of French Canadians immortalized by Longfellow in *Evangeline.* Other illustrations also are identified as western Louisiana. The illustration which is most typically "Western," however, is his "A Drove of Texas Cattle Crossing a Stream." [19] Unfortunately, the illustration was not accompanied by the comments of Waud himself as it was published some time after his return to New York.[20] The note accompanying the illustration (the author is not credited) identified the locality as western Louisiana or Texas. Its importance lies in the fact that it is the first Western cattle drive illustration which I have found in the national illustrated press.[21] The cattle drives from Texas, as is well-known, had been carried on for some years but they did not begin to attract wide attention until after the Civil War. The note which accompanied this illus-

tration is also important for the reason that the description, probably furnished by Waud, reads:

> Vast numbers of these cattle are driven on foot to the Mississippi River, and, after crossing it, into the interior of the cotton States. . . . A drove of five hundred cattle is usually accompanied by a dozen men, drivers, cook, etc., mounted upon mustang ponies, a wild set, who plunge in and out of rivers, or rush in among stampeders in the most reckless way. . . .[22]

Notice that no mention of *cowboys* is made, for that word, with the connotation it now carries, was nearly a generation away from popular use.

Another illustration, in somewhat the same class as that of the cattle drive, is " 'Creasing' Mustangs in Texas." [23] Here the locality is identified as an area east of the Sakatcho mountains.[24]

The sketches described above in the text and notes included the important contribution made by Waud to the field of Western illustration in the several years following the close of the war. Most, if not all, were the result of direct observation.[25] Waud continued to publish, however, in the years following his return from the South and West a considerable number of illustrations, based upon his familiarity with the region he had visited and supplemented by his imagination. One of the most interesting of this group was the illustration, "Pilgrims of the Plains." [26] It depicted a large group of emigrants with their ox-drawn wagons pulling up into the familiar circle for the evening encampment. T. R. Davis, however, had an illustration with the same title and theme mentioned later, and which on the whole is more pleasing than is Waud's sketch and Waud may have used the Davis illustration as the basis for his effort.[27] Waud did show a colored teamster in his illustration which suggests that Waud may have observed some such scene on his Southwestern tour.

In possibly somewhat the same category as "Pilgrims of the Plains," is Waud's excellent sketch, "Building the Union Pacific Railroad in Nebraska," which appeared in A. D. Richardson's well-known book, *Beyond the Mississippi.*[28]

It is probable that Waud did not sketch this view "on the spot" but redrew it from photographs. The John Carbutt photographs, made along the Union Pacific railroad in the fall of 1866, were available to Waud and much of the detail in the illustration checks with that shown in the photographs. Waud, however, has produced a much more interesting and inclusive view than is shown in any of the photographs and it is the best view of early Western railroad construction that I have examined.[29]

Waud used this same material apparently to prepare another illustration that appeared in *Harper's Weekly* a few years later, "Railroad Building on the Great Plains." [30] The note which accompanied this illustration discussed only the building of the Union Pacific and the Central Pacific but Waud has the legend "Northern Pacific" drawn on one of the freight cars. In many respects it is like the illustration in the Richardson book save that the observer sees the work at a somewhat different angle in the latter illustration.

It is possible that this last sketch was based in part upon direct observation. Waud was one of a number of artists employed in the preparation of the elaborate two-volume work, *Picturesque America,* edited by William Cullen Bryant and published in the early 1870's.[31]

Waud had a number of illustrations in this publication of the "Lower Mississippi" and also of the "Northwest" (Wisconsin, Minnesota and the Dakotas). One account of his work stated that the material for these illustrations was obtained on a trip to the South and to the West in 1872.[32]

As the first volume of *Picturesque America* was published in 1872 it seems probable that the material for the "Lower Mississippi" illustrations was obtained before this date. The "Northwest" illustrations might well have been secured at this time. Still another trip to this region may have been made by Waud, for there appeared in 1880 and 1881 a number of his illustrations of Dakota territory, although here again he may have supplemented his first-hand knowledge of this region with photographs.[33]

After 1882, Waud's illustrations in *Harper's Weekly* and *Harper's Magazine* virtually disappear. In fact, the last decade of his life seems to have been spent in an effort to regain his health. He died at Marietta, Ga., on April 6, 1891, where he had gone to recuperate his failing strength.[34]

THEODORE R. DAVIS

Davis had already acquired a considerable knowledge of the West by the time he and Waud were sent on their Southern tour of 1866. Not many months after the surrender of the last Confederate troops in the spring of 1865, *Harper's* sent Davis to Denver to report on the activities on the plains and in the mountains. The ambitious attempt of D. A. Butterfield to establish rapid stage transportation from the Missouri river (the end of the railroad) to the bustling mining districts of Colorado territory, and the rumors of a rising tide of Indian troubles as Western immigration mounted and railroads advanced, were doubtless among the factors responsible for Davis' assignment.

Davis arrived in Atchison, the eastern terminal of the Butterfield Overland Despatch, in mid-November, 1865, and at 8 a.m., November 17, left Atchison in company with three other passengers who, with himself, as Davis said, were "four persons entirely innocent of any knowledge of the plains. . . ."[35]

The members of this party included Gen. W. R. Brewster, vice-president of the Butterfield company; Lawrence Hasbrouk of Kingston, N. Y., and apparently Davis' traveling companion, and William M. Calhoun, probably a resident of Atchison.[36]

The greenhorns of the plains rapidly became initated to its wonders. Davis, the cook of the party, discovered that buffalo chips made a wonderful fuel; in fact, he affirmed "that there is no better broiling fuel than a perfectly dry 'buffalo chip'." Davis, too, although inured to the hardships of campaign life during the Civil War, found his ingenuity taxed in sleeping on top of the Concord coach, but this method he preferred to the cramped quarters inside the coach. He did not disclose, however, how he prevented himself from rolling off the top of the swaying coach as it lumbered along across the plains at night. His real test, however, was yet to come.

Two days before Davis and his party had started, a B. O. D. coach with L. K. Perrin, a correspondent of the New York *Times,* and one Fred Merwin, the company messenger, had left Atchison.[37] The third day out from Atchison, the Davis party met Perrin who, with others, had escaped when the Indians attacked the coach at Downer station still farther west. The messenger had been killed and the stock driven off.[38]

After finding that the Indians were on the warpath, the Davis party returned to the nearest station, sent back to nearby Fort Fletcher (southeast of present Hays) for a guard and then camped for the night. A detail of five cavalrymen and a company of infantry joined them later that night. The next day the party and their escort passed Downer station and saw that the other coach and the station had been completely destroyed. About a day later the infantry turned back but the party was joined by a surgeon and four soldiers in an ambulance.

As the coach, ambulance and cavalrymen reached another of the plains stations, Smoky Hill Spring, the quick eye of Davis detected a band of Indians charging down upon them. But let Davis tell the story in his modest way:

> The coach containing Gen. Brewster, Mr. Hasbrouk, Mr. Perrin and Mr. Davis, of *Harper's,* was within a few moments drive of the Station (Smoky Hill Spring) when Mr. Davis saw a band of Indians charging on the coach, less than sixty yards distant. . . .

Mr. D., the moment that he gave the alarm, picked up his rifle and sent its contents at the most gaudily gotten up Indian, who not liking the dose ran off. On the other side of the coach, Gen. Brewster was peppering away at a white man, who seemed to be the leader of the party [possibly Bob Brent], a half-breed. . . .

This reception the Indians did not like, so ran off. We had by this time reached the station with the coach, when we saw that another band of "red skins" had gone for the stock. Seeing this, one of the stock herders, a brave man, had made an effort to drive the stock toward the station. While doing this, one of the Indians had charged on him, driving arrows at him meantime. The Indian was within a few paces of the stock herder when Mr. Davis sent the interior arrangements of his Ballard rifle into Mr. Indian's back, causing a series of very curious gyrations on the part of the Indian who was tied to his horse, so saved his scalp. By this time there was not an Indian within a half mile of us, so we were at liberty to look about to discover what the next move was to be. . . .[39]

They soon discovered that the ambulance and four occupants, which had become separated from the coach, were in need of aid and the cavalrymen went to their rescue. The ambulance was abandoned and the Indians soon had the mules and swiftly put fire to the vehicle. The combined party retired to the adobe station where they were besieged overnight by the redskins. The siege continued well into the next day but the travelers were finally reenforced the next noon by a large army detachment. The Indians fled and under strong guard the coach eventually arrived in Denver after fifteen days on the plains.[40] "Cooper might have *his* Indians; we did not care for their company," was Davis' dry comment on his experience.

With such a wealth of experience, the sketchbook of Davis was well filled upon arrival in Denver and a number of these experiences found their way into pictures in *Harper's Weekly* and *Harper's Magazine*.[41] Unfortunately, the originals of all of these sketches save one have disappeared. In a small pocket notebook carried by Davis on this trip of 1865, there is the faded outline sketch of the "Interior of the Adobe Fortification at Smoky Hill Station." [42]

Davis made Denver his headquarters for the next several months, taking side trips during his stay to the mining districts of Colorado in the neighborhood of Central City and to Santa Fe in New Mexico territory. He met with a ready and hospitable reception from the newspaper fraternity of the mountain West. Possessed of a buoyant and sunny disposition, he made friends wherever he went. No journey was too fatiguing to allay his interest in new sights and new experiences, and any danger lent added zest to all his numerous enterprises.

It was not long before the newspapers were referring to "our gay and festive friend," "a gentleman of an extremely happy turn of mind," and when he left Central City, a paper stated—"he has made hosts of friends, we are assured, and that his charming manners entitle him to them, we will not gainsay. He goes, and with him a full share of public esteem." [43]

With such winning ways to aid him, Davis had only to ask and the sights of the Western world were opened to him. The mines and ranches and many of the novel sights were recorded in picture and shortly these sketches were appearing in the weekly issues of *Harper's*.

Views of Denver, including one of Blake street (practically contemporary with the view of Mathews discussed later), of Central City, of Santa Fe, of Navahoes weaving a blanket on the famous Maxwell ranch and others appeared in print.[44] Probably there were many in Davis' sketchbooks that were never published.

Davis left Denver for "the States" on February 18, 1866. The return trip was again made over the Butterfield route but this time without the wild excitement of the out-going trip and only "five days and four hours" were necessary to make the crossing of the plains.[45]

The next major assignment that concerns us was the Southern and Southwestern tour already mentioned in connection with Waud; a tour to determine the effects of war and the recovery from war. As already pointed out, Davis started his assignment by visiting Southern states along the Atlantic seaboard, but the part of the journey that is of interest to us comes from the fact that he turned west when he arrived in the deep South, stopped at New Orleans and then went on into Texas.[46] The Western illustrations included views of the cities of Houston and Galveston, and one particularly interesting, "The Dry-Goods Drummer on His Travels.—Scene on the Galveston and Houston Railroad.—'Here's Jeff, Fellows!'" It depicted a bar on the moving train with an unreconstructed rebel lifting a drink to the defunct Confederate president—doubtless a sight particularly irritating to Davis, who had undergone the vicissitudes of a four-year campaign with the Union army.[47]

Davis was given a breathing spell for a few months after returning from his Southern trip. But one day—April 2, 1867, according to Davis—he met Fletcher Harper on Broadway who, without further ado, asked, "Why are you not with General Hancock's Indian expedition?" Davis needed no other direction and inside half an hour—if we can believe Davis—he had gathered his "sketchbook, pet 'Ballard,' and a few minor necessaries" and was on his way West.[48]

Indian troubles on the plains of Kansas and Nebraska were gradually

becoming worse as the last half of the 1860's advanced. The westward tide of migration was rapidly rising as the railroads slowly but steadily forged their way into the hunting grounds of the Indians. Depredations on settlers, on stage lines and on railroad construction parties became more numerous as the Indian resisted this encroachment. The newspapers of the West clamored for greater and greater aid from the army and for the extermination of every redskin. ". . . Lo, his squaws and papooses, and his relatives and tribe, [will be found to be] a set of miserable, dirty, lousy, blanketed, thieving, lying, sneaking, murdering, graceless, faithless, gut-eating skunks as the Lord ever permitted to infect the earth, and whose immediate and final extermination all men, except Indian agents and traders, should pray for" was doubtlessly the nearly universal, if not humanitarian, opinion of the frontier on the Indian question.[49]

Urged by the press and state officials, the army decided to send Gen. W. S. Hancock, commander of the Department of the Missouri, upon the plains early in 1867 with so large a force that it would either awe the Indians or precipitate an immediate Indian war. Hancock had actually invited Davis to accompany this expedition in a letter written March 10, 1867, and it was apparently this letter that led to Fletcher Harper's question quoted above.[50]

Since the Davis trip of 1865 to Kansas, the railroad had advanced to Junction City, about a third of the way across the state. In early April, 1867, he was in this town but found that Hancock was already out on the plains and reported to be camped near Fort Larned (near the present town of Larned). The Santa Fe stage was about to leave Junction City as Davis arrived and as it would take him to his destination, he secured transportation as the only passenger. The company messenger and the driver were the only other occupants of the stage but many mail bags containing public documents filled most of the available space. In fact so weighted was the vehicle with "Pub. Docs.," as Davis called them, that it soon stuck fast in fording the Smoky Hill river near Fort Harker. Help from the fort got them out but they had scarcely started on their way before a heavy late snow set in. By nightfall they were stuck in a snowdrift with the thermometer rapidly falling. After a council of war, it was decided that the driver should unhitch his mules and attempt to make the next station, leaving Davis and the messenger "to guard the treasure and the Pub. Docs." "On leaving us," reported Davis, "the driver gave vent to the longest, most emphatic, and unsurpassable bullwhacker oath that it has ever been my bad fortune to listen to. Coming, as it did, from a man who had nine chances out of ten of freezing to death before morning, it was simply horrible." The oath must have been

a gem of its kind if Davis, after four years of war and several years of extended travel, could classify it as the "most emphatic" he had ever heard.

The two—Davis and the messenger—passed a bleak night alone in the coach with the only food "corn in two states: the liquid extract, bottled; and one single hermetically-sealed can of the corn in a solid state, half-cooked." Aid did reach them in the morning, however, and in due time Davis reached Hancock's command encamped near Fort Larned. Here a fruitless council with Indians led to the decision to break camp and to march west some twenty-five or thirty miles until they were near a large Indian village. At this locality General Hancock with Generals A. J. Smith and G. A. Custer, who, with the Seventh cavalry, had joined Hancock's command, met Roman Nose, the celebrated war-chief of the Cheyennes and halted near their village. Again the council with the Indians was unsatisfactory and Custer was ordered the next day to surround the village but found that most of the Indians had fled during the night. Upon receipt of news, however, that one of the stage stations had been burned and station men killed by Indians, Hancock had Smith destroy the village by fire.

Moving on, Hancock had further councils with the Kiowas and Arapahoes but all proved elusive or made unsatisfactory promises. The command was finally marched to Fort Hays (near present Hays) where Hancock left the Seventh cavalry under Custer to protect the frontier and the stage stations in this neighborhood.

Davis had been with Hancock during all these marchings and counter-marchings and when Hancock left, Davis remained with Custer, his pencil continually busy.

Custer's command was called north early in June to stem further Indian depredations, and marches to Fort McPherson (about 100 miles west of present Kearney, Neb.) and up the Platte river were made.

On this trip Davis witnessed several Indian skirmishes with the Sioux under their chief Pawnee Killer, and he was with the command when they found the remains of Lt. L. S. Kidder and ten men who had been sent from Fort Sedgwick (in present northeastern Colorado) with orders from General Sherman to Custer. Kidder's detachment had been surrounded by Indians (in present Sherman county, Kansas) and destroyed. Custer reached Fort Wallace (in present Wallace county, Kansas) early in July where he decided to allow his troops a few days' rest after their extended campaign on the plains. He, himself, with a considerable detachment, left Fort Wallace and pushed east to Fort Hays, Davis accompanying the detachment. Any decisive Indian engagements seemed unlikely and as cholera had made its appearance in frontier posts, Davis decided to give up the

Indian campaign and early in August left Fort Harker by rail, which the Union Pacific, "Eastern Division," had reached during his travels on the plains.[51]

The campaign, as far as settling the Indian problem went, was a failure and the frontier press was not reticent in calling attention to this state of affairs. "Gameless, scalpless, and . . . a stupendous imposition" the Westernmost newspaper of the Plains proclaimed it.[52]

The frontier was obviously expecting too much of our small regular army which had its own problems in plenty. There is little doubt, however, that their tactics might have been improved. "H—1," a plainsman is reported to have said, "talk about regulars hunting Indians! They go out, and when night comes they blow the bugle to let the Indians know that they are going to sleep. In the morning they blow the bugle to let the Indians know they are going to get up. Between their bugle and great trains, they manage to keep the red-skins out of sight." [53]

Whatever the military value of the campaign, Davis had secured a first-hand knowledge of Western warfare as it was then practiced; an opportunity for observation that was almost unique in the annals of American illustration. From his summer's experience on the plains—nearly four months in the saddle, extending over a distance which Davis estimated as some three thousand miles—there resulted many, many illustrations which appeared both in *Harper's Weekly* and in *Harper's Magazine*. Among the more notable of these illustrations we may list "The Coach in the Storm," "Lodges of the Chiefs in the Indian Village Captured by General Hancock," near Fort Larned; "Sutler's Store at Fort Dodge, Kansas," "The Indian War—General Custer's Scouts," "Buffalo-Hunting on the Plains by Officers of the United States Army" (some of the sketches in this group, Mrs. Custer related, were drawn in General Custer's tent at Fort Hays), "Camp Pets of the Seventh United States Cavalry," and a sketch of Davis himself in his buckskin uniform dated, "Fort Harker, August 3d '67." [54]

Five other illustrations, not connected with the Indian war, were undoubtedly made by Davis on his trip to the plains in the summer of 1867. One of these was a picture of a beaver dam on the Pawnee fork of the Arkansas river which Davis viewed on his travels of that summer; another was a sketch of buffalo shooting from the trains of the Union Pacific railroad which Davis may have seen near Fort Harker; still another was the full-page illustration, "Prairie-Chicken Shooting in Kansas," also witnessed after Davis's return to eastern Kansas, and lastly, two farming scenes—plowing on the plains of Kansas.[55]

In the next few years after Davis's return to the East, however, many

Western illustrations continued to come from his pen. Not only did illustrations appear but Davis contributed two more articles on the West to *Harper's Magazine*: "The Buffalo Range" and "Winter on the Plains." [56]

There is no evidence that Davis made other trips west of the Mississippi than those already described. Nevertheless, a number of illustrations of Indian troubles on the plains in 1868 credited to Davis appeared in *Harper's Weekly*. These must be regarded as fictitious, for Davis was simply using his imagination and his past experience in producing them. These illustrations centered primarily on Custer's Indian campaign of late fall, 1868, and particularly on the battle of the Washita, which occurred on November 27, 1868. It is quite certain that Davis was in the East during this campaign and the notes which accompanied all of these illustrations carefully refraining from mentioning that the scenes were drawn by an eyewitness.[57]

To my mind one of the most interesting of all of Davis's Western illustrations is his full-page view, "Pilgrims on the Plains." Although doubtless it depicts no actual event, Davis undoubtedly viewed similar scenes on his Western trips of 1865 and 1867. In fact, in his article, "A Stage Ride to Colorado," he stated: "Long trains of 'prairie schooners'—a name by which the plainsman designates the huge canvas-covered wagons used for the transportation of freight across this ocean of land—were passed so frequently as to become too familiar to occasion remark. The trains give a picturesqueness to the plains that greatly enhances the journey across." [58]

True, Davis was here discussing the freight trains, but undoubtedly emigrants and emigrant trains which his illustration depicted were seen many times. The illustration itself appeared shortly after the ceremony of the joining of the rails of the Central and Union Pacific railroads and supposedly called attention to a mode of travel that would soon be a thing of the past, once the transcontinental railroad began its regular operation. It was many years, however, before horse, mule or ox-drawn emigrant trains were to disappear from the plains.

One of the last of the Davis Western illustrations was his "Slaughter of Buffaloes on the Plains." [59] Here again, he was using his observations of earlier travels to draw the picture.

Davis continued to contribute to *Harper's Weekly* for some years after the buffalo illustration mentioned above but few, if any, were Westerns. His contributions to the *Weekly* ceased about 1884 and from this date until his death in 1894 he was engaged in free-lance work. About 1880 he moved to Asbury Park, N. J., and his studio on the beach became well-known. His Western experiences continued to interest him during his remaining years,

and in the last few years of his life he attempted to work up into two articles some of his recollections of those years.[60]

His early career had indeed been adventurous. It is unfortunate that a complete biography of Davis has never been written. Even in 1867 *Harper's Weekly* was able to give this brief resume of his career:

> Mr. Davis has been a traveling correspondent of the *Weekly* since March, 1861. His first trip in our service, through the South with Mr. W. H. Russell, was made a short time before the commencement of the war, and is considered by Mr. Davis as the most dangerous journey he ever made. During the war Mr. Davis witnessed the capture of Port Royal; the battle between the *Monitor* and *Merrimac*; the conflict at Shiloh; the capture of Corinth; the first bombardment of Vicksburg by Porter; the battle of Antietam; the surrender of Vicksburg; the seizure of Morris Island; the battle of Chickamauga; the siege and battle of Chattanooga; the Atlanta campaign and the Grand March to the sea, and thence through the Carolinas. He was present at the laying of the Atlantic Cable; rode 2600 miles in a stage-coach across the plains; and for the last six [four] months has been roving over the plains with General Custer after the Indians.[61]

And this brief summary of the six most active years of his life does not state that during the war he was twice wounded. On one of these occasions he is reported to have held off surgeons at the point of a pistol from amputating a leg!

Small wonder then that as the years advanced Davis cared to travel less and less. The effort of intense living in these six years may well have contributed to a relatively early death, for he died in 1894.

About his skill as a draftsman and artist we do not know a great deal as his original work is almost nonexistent. Many of the woodcut reproductions of his work are extremely crude but he, of course, was not responsible for the final appearance of his illustrations. He had some art training, according to one brief account of his life, under Herrick, presumably of Boston or New York. The work of American art historians, however, has been so meager and so poor that we have no knowledge of Herrick. Possibly he was H. W. Herrick, an illustrator whose work will be found occasionally in the 1860's.

It is probable, too, that Davis received informal art instruction from James Walker with whom he became well acquainted very early in his career. Walker, Davis's senior by some 20 years and familiarly called "Pop" by Davis, was achieving a considerable reputation as a battle painter when Davis first met him. A veteran of the Mexican war, Walker depicted on

canvas the storming of Chapultepec, a painting which received wide acclaim in its day. Later he became still better known for two Civil War canvases, "The Battle of Lookout Mountain" and "The Third Day of Gettysburg." It seems reasonable to suppose, considering the mutual interests of the two men, together with Walker's more extensive experience in the profession, that Walker would be an important influence on the younger man's career.[62]

Davis was connected with at least one Civil War panorama, "The Battle of Missionary Ridge," either as designer or adviser. Late in life he wrote an account of "How a Great Battle Panorama Is Made." Born in Boston in 1840, he crowded into his fifty-four years experiences that few other American artists and illustrators could equal in number and variety.[63]

Chapter Five

Alfred E. Mathews

Our party celebrated the Fourth of July, 1874, on the dividing ridge of the Rocky Mountains (near Georgetown, Colorado Territory) at least 13,000 feet above the level of the sea. There we loosed the American eagle, and with polysyllabic speech and patriotic songs moved him to soar and scream. We straddled the back bone of America, sat down on the ridge pole of the continental water-shed, ate sardines from California and crackers from Boston, and drank from two ice-cold rivulets which flowed from the same snow-bank, the one to the Atlantic and the other to the Pacific. The occasion was inspiring. Of course we did and said all those patriotic things which are customary on such occasions; the speeches being the result of a geometrical progression beyond ordinary patriotic remarks in proportion to our elevation, and proving us the greatest, freest, wisest people in the world. Whether the British lion howled and the effete despotisms trembled, is not known; but it is to be presumed they did. The real enjoyment was in the trip to the summit.
—J. H. Beadle, Western Wilds and the Men who Redeem Them, 1877.

The most important, from a pictorial standpoint, of the artists who made the Western journey after the close of the Civil War was Alfred E. Mathews. Mathews was a native of England, born at Bristol on June 24, 1831. His father, Joseph Mathews, a book publisher, brought his family to America when Alfred was two years old.[1] The family settled at Rochester, Ohio, upon their arrival from England, and Alfred Mathews spent his boyhood in the Buckeye state.

A family letter, dated December 11, 1845, written to William Mathews, one of seven children and who was working in Cincinnati, indicates that the Mathews family was musically and artistically inclined. Most of the members of the family added their own notes to the letter, revealing that several of the children made oil paintings and that most of them played musical instruments. At the time the letter was written Alfred was a young-

ster of fourteen, but he was already an individualist as is revealed by the note he wrote as his contribution in the family letter to William:

Dear William
I was glad to hear that you are so confortably situated with a prospect of doing well. I should like if you could get me in a store in Cincinnati next year. I am going to learn Dutch this winter. I am learning my books at home because I can't agree with my schoolmaster he sent me out to get a switch to whip me with because I did not get my grammar good, and I fot pa said I should stay at home and studdy my books. I remain yours affectionately,
Alfred E. Mathews

Apparently he made considerable progress by "studdy" at home for his grammar improved and in a few years he was learning the trade of type-setting in the office of the New Philadelphia *Ohio Democrat,* owned by his brother, Charles. Whether he received any instruction in art during this early period of his life is uncertain, but by the time he was twenty-five he was engaged in the combined profession of itinerant book seller and artist as is shown by the following letter written to an aunt:

Ravenna, Ohio, May 6, 1856
Dear Aunt:—
Some weeks ago I had the pleasure of receiving a letter from you, sent to my brother Wm. T. Mathews, artist. I should have written before, but thought best to defer it until my brother, the Doctor, went to England. I am still at the same business as when I last wrote you, traveling with books and am at present in northern Ohio, among the Yankees.
Last year I was in the state of Maine. The scenery in that state is beautiful; there is such a beautiful combination of lakes and mountain scenes. Before being in Maine, I was in Vermont and New Hampshire, and visited the celebrated White Mountains. By the Doctor I sent you a daguerreotype of what is called "The Old Man of the Mountain." It is from a sketch I took myself and is considered an exact representation of it. It is certainly one of the greatest curiosities in this country. Some part of the day is more favorable than others for viewing it, according to the position of the sun. I took this in the most favorable time, when it looked most like the human face. I also send Miss Gillett two (2) pictures, a winter scene and a blue linnet (my own work) which you will please give her, with my love. I hope to visit you before many years. Indeed I shall be traveling all the time for 2 or 3 years yet; for my health will not admit of confinement.
I go to Kentucky on the first of July next, and in the fall further south. It is much better in the south for my business than in the north,

and the climate will agree with me, as I have weak lungs. In selling books I make from $1.50 to $3.00 and even $5 per day; but expenses are high and I have been subject to many delays, so I shall not think of settling in business yet. I stay among the Yankees altogether, as they are a reading community, and I have been with them so much that they consider me the very embodiment of a Connecticut Yankee. I look forward with considerable pleasure to my contemplated trip south and shall probably stay there some time. I leave here the fore part of summer, because my business will not pay here in haying and harvest time. So I shall go where they are through with such work. I send you a drawing of the head of a Moose, which I took while in Maine. I had the head of one of those animals hanging in the barn to look at. I spent a week or 10 days very pleasantly at Moose Head Lake. They had plenty of moosebeef, (the very best of meat) and lake trout.

Mt. Kinneo, situated in the centre of it, is 753 feet high, perpendicular. The hotel there is quite a resort for travelers in summer. I took a drawing of the Mountain which I sold to the landlord for $5.00. I fill up odd times with such work and find it profitable. The other day I sold one the size of a sheet of note paper for $3.00, a group of 3 birds, which took me four (4) hours to make.

I will write you when I go south, and give you a full account of the workings of slavery.

<div style="text-align: center">Your Affectionate Nephew,
Alfred E. Mathews</div>

The letter is intensely interesting from several points of view but primarily because it gives an insight into the life and character of A. E. Mathews. Obviously he was an artist in feeling; he liked to travel; he was not very robust (he died at the age of forty-three), and he was observant and shrewd.

The projected Southern trip mentioned above was made, for he was teaching a country school in Tuskaloosa county, Alabama, when the Civil War broke out. With considerable difficulty he worked his way north to his father's home in Ohio where, in August, 1861, he enlisted in "Capt. Cotter's battery." [2] Later he was transferred to the 31st regiment of the Ohio Volunteer infantry with which he served for three years. Mathews participated in the siege of Corinth, the battles of Stone River, Lookout Mountain and Missionary Ridge.

His skill with the pencil was recognized, for his talents were used in preparing topographic maps and drawings for army use. More important at the present day, however, are a number of Civil War scenes, drawn from direct observation by Mathews and later lithographed. The Library of Congress has some thirty-five lithographs and the Denver Public Library thirty. A comparison of the titles in these two libraries shows that there are

thirty-eight different titles now known.[3] The scenes reproduced by Mathews in these lithographs are of events occurring in the period 1861–1864.

That some of these lithographic views, at least, were highly regarded is borne out by the following brief letter from no less a person than Gen. U. S. Grant:

> Headquarters Department of the Tennessee
> Vicksburg, Miss., Aug. 9, 1863
>
> Private A. E. Mathews, 31st Ohio Vols.
>
> Sir—I have examined the Lithographs of views taken by you of the "Siege of Vicksburg," and do not hesitate to pronounce them among the most accurate and true to life I have ever seen.
>
> They reflect great credit upon you as a delineator of landscape views.
>
> U. S. Grant,
> Major Gen. Com'd'g Dept.

After his term of service expired, Mathews used his talents in preparing for exhibition a panorama of the campaign in "the Southwest." That is, he depicted on canvas the capture of Vicksburg, the battles of Stone River, Lookout Mountain and Missionary Ridge and concluded by showing Sherman's march to the sea. How extensively this panorama was exhibited we do not know, but an undated clipping from a Steubenville, Ohio, newspaper states that "the audience, particularly the soldiers, who were in many of the battles represented, were delighted and gave repeated evidence of satisfaction" when the panorama was exhibited in that city.

The panorama was probably on exhibit in 1864 and early in 1865 but it is doubtful if it brought Mathews any great return. In any event by the time the war was over in the spring of 1865, Mathews' wanderlust had returned and he again commenced his travels. Evidently the westward migration caught his fancy, for the next definite record of his movements places him in Nebraska City, Nebraska Territory, in the summer of 1865. Here Mathews made a number of sketches, at least four of which were subsequently lithographed. The Nebraska State Historical Society possesses Mathews lithographs of Nebraska City with the following imprints:

1. "Nebraska City. The Landing and City as Seen from the Iowa Side of the Missouri River, in 1865. Sketched by A. E. Matthews."
2. "Nebraska City. View on Main Street—Looking West. Sketched by A. E. Matthews."
3. "Nebraska City. View of Main Street—North Side. Sketched by A. E. Matthews."

4. "Nebraska City. As Seen From Kearney Heights in 1865. Sketched by
A. E. Matthews." [4]

Nebraska City in 1865 was one of the important eastern terminals of the
overland freighting business. Located on the Missouri river, enormous
quantities of supplies were carried by water from St. Louis to this river
port, where the slow westward trek by ox train began. Here it was that
the celebrated firm of Russell, Majors and Waddell established one of their
bases for the transportation of supplies across the plains to Colorado, New
Mexico and Utah. The highway terminating at Nebraska City was one of
the most important in the period 1860–1869 between the Missouri and
Mississippi rivers and the Rocky Mountains. Known as the Oregon Trail
Short Line and the Steam Wagon Road, it was one of the shortest and best
roads from the Missouri to the Rockies.[5] Mathews in 1865 must have seen
Nebraska City at its height as a freighting center—his views of Main Street
show that it was indeed a busy place. In one of the views (No. 3 above)
some dozen prairie schooners hauled by the usual six-yoke ox teams are
represented, as well as a wealth of homely detail that makes his views of
importance to the social historian. How faithfully the sketches were copied
by the lithographer it is hard to tell, as no original sketches of Mathews
are known to exist.[6]

It is obvious from the lithographs that Mathews' sense of perspective and
proportion was none too good, that his buildings and human figures are all
too frequently stiff and formal, but the mass of detail introduced and the
portrayal of small incidents lend genuine interest to his work. For example,
in one view a dog fight is portrayed, in another a flock of sheep and several
cows can be seen following an emigrant's covered wagon, from under the
rear canvas of which peers the face of a small traveler. Mathews seems to
have been particularly successful in portraying the mood and habits of
dogs, for there is scarcely a view in which some lifelike attitude of the
friend of man cannot be distinguished.[7]

In the fall of 1865, Mathews left Nebraska City for Denver, either join-
ing one of the freight trains or going by overland stage across the plains.
Doubtless sketches were made en route, but no lithographic record of the
trip is known as yet to the writer. Mathews arrived in Denver on November
12, for *The Rocky Mountain News* of the next day reports:

> We received a call this morning from Mr. A. E. Mathews, an artist,
> typo and soldier, who arrived here yesterday with the purpose of
> making sketches of the scenery in town and country, to be lithographed
> and furnished to subscribers. He showed us several of his pictures of

scenes of interest in and around Nebraska City and other places, which are as true to nature as it is possible to make them, and bear the marks of an Artist's hand. He is spoken of in the highest terms by the river papers, and has recommendations from Gen. Grant and other eminent officers with whom he served as a soldier, and also as an Artist for the New York illustrated papers. We bespeak for him, a liberal patronage from our business men, and the lovers of the beautiful, upon whom he may call. He commences his labors in this city this morning.[8]

Mathews not only went to work in Denver but within a month he was out in the mines and mills of the nearby mountains securing sketches of this important Colorado industry.[9] By early March of 1866, lithographic reproductions of four of his sketches were available. They included a bird's-eye view of Denver and three street views in the same city: one of Laramie Street, one of Blake Street and one of F Street. The local press reported on them very favorably and stated that all views "—are natural to the life. Among the familiar objects represented are Estabrook's splendid black-horse team, and the ubiquitous old sorrel nag and chaise of the lamented Dr. McLain." [10]

Several weeks later, Mathews had received from his lithographer, Julius Bien of New York, another set of lithographs. These were from his sketches of Blackhawk, Nevada, Central City and the Snowy Range.[11] Both this set and the previous group of Denver lithographs were undoubtedly separates from the views which were later collected and published as the celebrated *Pencil Sketches of Colorado*. Although this work was not available in Denver until October, 1866,[12] the book itself is dated "May, 1866." It is of generous dimensions, 19 x 31½ inches, and the sixteen full-page lithographs themselves are approximately 16 by 8 or 9 inches. Eight of the lithographs were printed two on a page and twelve of them four to a page.[13] The lithographs are followed by twelve pages of text, which describe briefly the subject of each of the thirty-six lithographs with some additional background material.

This pictorial record of Colorado is an important historical document. Although here again Mathews' sense of perspective is faulty and the stiffness of his building is all too apparent (many look as if they had been drawn with a ruler), the wealth of detail in his city and street views is invaluable to the social historian. Dress, transportation (in one of the lithographs, there can be counted seven or eight types of wheeled vehicles), the miscellany of everyday street life, and the methods, equipment and detail of Colorado mining, are all faithfully recorded, or as faithfully as Mathews could for he made a fetish of validity in his pictures. As far as

the writer is aware, there has never been any criticism (contemporary or recent) on this score. Comparison of the Denver street scenes with photographs of the same period is interesting, for the photographs, as do the lithographs, show that vehicular traffic was something of a problem even in 1866. To maneuver a six-yoke ox team through such congestion must have been more of a problem than edging forward in a car against the traffic lights of present-day Denver streets. Probably the greatest difference to be noted in comparing Denver photographs of 1865 with the Mathews lithographs is the fact that in the lithographs all the buildings are in good repair and the general appearance is far tidier.

It will be noted in Mathews' street views, however, both of Nebraska City and of Denver, that although some stores are very distinctly marked with the name of the proprietor, other buildings are conspicuous by the blank space where the owner's name should appear. Undoubtedly this omission was intentional on Mathews' part. Some of his income must have have come from the contribution of store owners who were willing to pay for the privilege of having their names show boldly in the completed lithographs—a conclusion supported by the comment of *The Daily Rocky Mountain News*: "We bespeak for him [Mathews] a liberal patronage from our business men. . . ."

Pencil Sketches of Colorado sold originally for $30 a copy, but it has become one of the scarcest items of Western Americana and a good copy today will bring $350 to $400.[14]

During the summer and fall of 1866, Mathews continued his labors in Colorado. He spent over a month in the neigborhood of Colorado Springs, sketching the well-known Pike's Peak region, the Garden of the Gods and surrounding country, as well as making visits to the mines of southern Colorado.[15] This trip was followed by sketching tours to the headwaters of Clear Creek, to Long's Peak and to South and Middle Parks.[16] Some of these sketches were reproduced lithographically and do not appear in any of his better-known bound works (i.e., in *Pencil Sketches of Colorado* and the three books remaining to be described). Apparently Mathews was none too well satisfied with the lithographic reproduction of his sketches. Contemporary newspaper reports made such statements and they are further supported by the fact that Mathews did much of the actual lithographing of his later work.[17]

The winter of 1866–1867, Mathews spent in the East, presumably in visiting relatives in Ohio, and in a business trip to New York City for the purpose of supervising the lithography of additional sketches.[18] He was back in Denver late in May, 1867, to start another season's work.[19] The

earlier part of the season saw him sketching in Colorado but in the fall he spent a month or so in Montana securing material upon which his second well-known book of lithographs was based, *Pencil Sketches of Montana.*[20] The editor of *The Montana Post* saw the sketches resulting from Mathews' tour of Montana and was favorably impressed, for he wrote: "Having looked over many familiar scenes we can say that his pen has truthfully portrayed them and the work [that is, Mathews' proposed book of lithographs] will be one eagerly sought for." Among the sketches seen by the editor were views of "Beaver-Head Rock," Stinking Water valley and ranges, "Virginia City," "Union City," "Bald Mountain," Madison valley and range, "Exit of the Yellowstone From the Mountains," the Yellowstone valley, "Three Forks," "Head Waters of the Missouri," "Helena," "The Hangman's Tree," "Prickly Pear Canyon," "Fate of the Mountains," "Bear Tooth Mountain," "Great Falls of the Missouri," "Fort Benton," "The Palisades," "Citadel Rock," "The Church, Castle and Fortress," the ruined castle, "Fort Cook," "Dear Lodge Valley" and Gold Hill mountains.[21]

Many of these titles appear in *Pencil Sketches of Montana*, which Mathews, evidently not satisfied by his experiences in the publication of the companion Colorado volume, lithographed himself. The lithography was done in New York City, where Mathews spent the winter of 1867–1868, and where he maintained a studio at 470 Broadway.[22]

During the winter, however, Mathews not only made the lithographic plates for *Pencil Sketches of Montana* but he was also actively engaged in designing and preparing a panorama of Rocky Mountain scenery for exhibition. It is quite probable that Mathews himself did not make the giant paintings for the panorama but had them made by professionals in the trade from his own drawings and under his personal direction.[23]

About June, 1868, both *Pencil Sketches of Montana* and the panorama were ready for public view and Mathews started again for the West. The first exhibition of the panorama—of which I have note—was held in Omaha.[24] Two weeks later it was on exhibit in Denver, and for much of the summer and fall of 1868 Mathews was engaged in exhibiting the panorama in Colorado and Montana.[25]

The panorama was well received wherever exhibited. Its exhibition, according to *The Rocky Mountain News*,

gave the very greatest satisfaction. The scenes are well chosen, embracing many of the finest in Colorado, Utah and Montana, they are true to life, we thought we recognized the brands of our old camp fire by the big rock, left front, Chicago lakes, they are well sketched and painted and the arrangement for exhibiting, showing one complete

scene at once and no more, is perfect. Mr. M. accompanied the suc-
ceeding scenes with a running descriptive lecture, much of it couched
in eloquent and beautiful language.[26]

The Daily Miners' Register thought that "The best piece, perhaps, is that
sketched from Gold Lake, in Ward district, twenty-eight miles north of
here. Grey's peak and other scenes were good. As a whole, the panorama is
far superior to most such exhibitions. It might be better said that few equal
it. It gives an excellent insight to Rocky mountain scenery. . . ."[27] *The
Montana Post* recommended the Mathews panorama "as one of the finest
works of art ever exhibited to the people of the Territory. The scenery in
the panorama is purely western, much of it is in Montana, and all the
beauty and grandeur of this American Switzerland is transferred to the
canvas with a master's touch."[28]

To be sure, many of these descriptions and comments are eulogy of a
home product, but it must also be remembered that the panorama was then
a form of art and amusement popular and well-known even in the "un-
cultivated West"—the forerunner of the modern motion picture. One, too,
must consider the fact that if the paintings departed appreciably from the
observer's belief in reality—one of the criteria of art in that day—the home
audiences would have been one of the first to detect and criticize the work.

To stimulate attendance at his exhibitions, Mathews made it a practice to
distribute individual lithographs and occasionally complete volumes of his
bound lithographs to patrons of his lecture and panorama.[29] It is therefore
surprising to find that his lithographs are so rare today.

That the exhibitions were successful is shown by the following letter
written by Mathews to his sister while the panorama was on exhibit during
the summer of 1868. It is interesting not only from the light it sheds on
the exhibition of the panorama but also on other contemporary affairs.

> In Camp on the North Fork of the Platte
> Dacotah, Aug. 15, 1868.
>
> Dear sister, Eliza:—
> Since arriving in the Territory I have been so busy as to neglect my
> correspondents. I am now on my way to Montana. The panorama
> proved a great success in Colorado; but I was sick most of the time,
> which prevented my giving it the necessary attention; and that eat up
> the profits, by long delays. Receipts were from $58. to $117. per night,
> and sometimes we had to close the doors and refuse to admit more in
> consequence of the crowd. There is no good chance to invest on the
> railroad this year; it has all been anticipated. The only good chance I
> have yet seen was in Georgetown, Colorado, in the silver-mining dis-
> trict. But there is as yet no title to be had to the lots and will not be

for some time, until sold by the government. This town is bound to grow very rapidly, as the mountains are very rich in silver, and it will be the terminus of a railroad. The best chance I can see here is raising cattle or sheep, as it costs comparatively nothing to keep them—they feed on grass all winter. I shall likely go into it myself soon. The next best investment would be in farm land near Omaha. Land can be had within 7 miles of Omaha for $8.00 to $10.00 per acre, that will in a few years be very valuable. The trouble is that within the last few months the increase in lots in promising towns has been anticipated; in some places the titles are insecure, without living on the land. I learn that within the past year they have anticipated a rise in San Francisco and property is very high. I will write again soon and describe the country through which I have passed. Write soon and direct to Virginia City, Montana.

In haste, your affectionate brother,
A. E. Mathews.

It seems probable that the panorama was on exhibit in the East during the winter of 1868–1869 (in fact this purpose of Mathews is stated in some of the references given in note 25), but I have seen no direct statement of such exhibit. At any rate, Mathews exhibited it in Colorado again in the summer of 1869, but he finally sold it late in the fall to Dr. J. E. Wharton of Denver.[30]

Pencil Sketches of Montana, the other production of Mathews during his winter's stay in New York in 1867–1868 was a 95-page book. It included thirty-one lithographs, four of which are folding views (26½ x 47 centimeters) and twenty-seven are full-page ones (13½ x 22 centimeters). Most of the lithographs are black and white although some have a green tint added. Mathews was his own lithographer, so that in this work we have direct examples of his draftsmanship. One of the sketches (*see* p. 83 of *Pencil Sketches of Montana*) is attributed to P. Tufts.[31]

The book bears the date 1868 and was known in Denver by July of that year.[32] It sold for $17 a copy.[33] As in the case with *Pencil Sketches of Colorado*, *Pencil Sketches of Montana* has now become very scarce and is one of the most sought after items of Western Americana. One copy was sold for a record price of $770 and good copies will bring at present (at retail) $350 to $400 each.[34]

The last of the pictorial books for which Mathews is best known is *Gems of Rocky Mountain Scenery*. He did, however, publish toward the close of his life, a fourth volume, *Canyon City, Colorado, and Its Surroundings*. It is not well known and contains but five views.

Gems of Rocky Mountain Scenery was again solely the work of Mathews. He was the artist, lithographer and publisher. Its publication date was

almost coincident with the celebration of the joining of the rails of the Union Pacific and Central Pacific railroads. It may be that Mathews had this fact in mind when he published the book, for its title page states that it contained "views along and near the Union Pacific Railroad." It is, however, the least interesting of the Mathews books. Mathews was neither a skillful draftsman nor lithographer and his defects became all too apparent in his purely landscape work. It was the only one of his works to receive severe contemporary criticism. *Putnam's Magazine* reviewed the work as follows:

> It [Gems of Rocky Mountain Scenery] is a large but thin quarto, containing twenty full page illustrations selected by Mr. Mathews from a series of drawings made by him in Colorado, Idaho, Montana, and Utah, from the fall of 1865 to the winter of 1868, and executed by himself on stone. Having however imperfect an idea of the scenery of the Rocky Mountains, derived from the glowing accounts of travellers, and the paintings of Bierstadt and Whittredge, we had no idea that it could be so belittled as it is here. Either Mr. Mathews is no artist, or he is no lithographer; or, being both, it is not within the power of lithography to reproduce the larger forms of nature. As a rule there is no distance in the back-grounds of Mr. Mathews, no minuteness in his foregrounds, and nowhere the slightest sign of magnitude. Even in the mere matter of light and shade, his drawings are below mediocrity. Mr. Mathews courageously publishes his own work.[35]

Although *The Rocky Mountain News* defended Mathews against this criticism on the ground that his views were faithful to nature and that New Yorkers regarded all outsiders with no favor,[36] the criticism of *Putnam's*, despite the mention of Bierstadt's mammoth canvases as a possible criteria of other work, is well taken. Lack of perspective, of proportion and of proper use of light and shade were Mathews' defects. He is best in his street views with their wealth of detail and it is unfortunate that he did not make more of this type of sketch—the pictorial history of the West would have been greatly enriched if he had.

Lack of such detail has reflected itself in the current price of *Gems of Rocky Mountain Scenery* as compared to his other two well-known works. A good copy will bring, at present retail prices, $75 to $100. It was listed when published in 1869 at $15 a copy but sold in Denver the same year at $10 "owing to the present hard times." [37]

If the sketches in *Gems of Rocky Mountain Scenery* are not as good pictorial history as are some of the other records of Mathews, the book does furnish in its introduction an excellent description of Mathews' method

of work and of the loving labor which he expended in collecting and making his sketches. Mathews wrote:

> The lithographs embodied in this work are selections from a series of sketches made by the artist while sojourning in Colorado, Idaho, Montana and Utah, from the fall of 1865 to the winter of 1868. During this time he made many excursions of more or less duration, from Denver in Colorado, Helena and Virginia City in Montana, and Salt Lake City in Utah; the entire distance accomplished being about 6,000 miles; remaining, however, but one winter in the mountains. These expeditions were performed, excepting during one summer, entirely alone, and principally with ponies; but on two or three occasions on snow-shoes and in a small boat. One pony was used for riding—the other carried a small, light tent, bedding and provisions. Equipped in this way the artist was prepared to camp wherever and whenever so inclined—the tent being a perfect security against wild animals at night.
>
> The pictures represent actual localities; and as they have been drawn on stone from the sketches by the artist himself, have lost none of their original truthfulness.
>
> It will be observed that quite a large number of the scenes represented are located in Colorado; this is because a larger proportion of the sublime and beautiful mountain scenery of the great Rocky Mountain belt cluster together in this incomparable State. The Territories represented are arranged in alphabetical order.
>
> It would require many, very many, volumes to represent the half of the numerous, grand and awe-inspiring views that are scattered so profusely throughout the entire length of this vast belt of mountains; so that an apology for leaving out some justly celebrated and comparatively well known localities is, perhaps, scarcely necessary.[38]

In the fall of 1869, Mathews acquired an extensive tract of land near Cañon City, Colo., where he planned to go into stock raising on a large scale, a project which, as his letter of 1868 (previously quoted) shows, had been under consideration for some time.[39] So enthusiastic did he become over prospects around Cañon City that he traveled extensively in the East during the summer of 1870 attempting to enlist an extensive colonization here. To this end, *Canyon City, Colorado, and Its Surroundings* was published in 1870. Its five lithographs, a panorama of Pike's Peak (said to be one of his finest lithographs), a view of Cañon City and three scenes in Fremont county, are supplemented with twenty-four pages of text that extoll the virtues of Colorado, so that the volume is essentially an emigrant brochure. "He has issued but a small edition for private distribution, and none for sale." [40] Doubtless Mathews took copies with him on his travels, for not only was he in the East in the summer of 1870 in the interests of

his colonization project, but the following year saw him in England for the same purpose.[41]

Despite Mathews' labors, his colonization scheme was not a success.[42] However, he continued to make Cañon City his headquarters until the fall of 1872. He spent the winter of 1872–1873 in southern California "in the neighborhood of San Diego, Los Angeles, San Bernardino, and other prominent points, and brings back some admirable sketches of scenery and cities. They will be published soon." [43] Just how many of these California views were reproduced lithographically is problematical. Harry T. Peters in his volume, *California on Stone* (Garden City, N. Y., 1935), p. 162, lists two: "California Golden City [looking east]" and "Oceanic Steamship Company Steamers Mariposa and Alameda." In 1949, Mr. Glen Dawson, a book dealer of Los Angeles, wrote me that he had secured two additional West Coast lithographs by Mathews made in San Francisco in 1873: a view of Los Angeles and one of Santa Barbara. The prints of these two views measured 16¾ by 8¼ inches and with margins about 21 by 14 inches.

An inquiry about these Mathews views was sent to an even dozen California institutions possessing picture collections of Californiana. It brought replies that no copies of original Mathews lithographs of California were owned. The Mariners Museum of Newport News, Va., however, possesses a copy of the second lithograph listed in the Peters' book. Other institutions, including the Library of Congress, New York Public Library and the American Antiquarian Society reported that none of these lithographs were among their holdings. They are therefore to be regarded as extremely scarce.[44]

The last pictorial work published by Mathews was a geological map of the world, representing various geological epochs with suitable views depicting the animals and plants of each age. This work, some three feet wide by four and a half feet long, was reproduced lithographically in Cincinnati and was widely publicized in the press as an easy way to learn geology.[45] Mathews had long been interested in geology and had spent a number of years on the preparation of the map. After its publication he even began lecturing on geology, using, in addition to his map, large paintings of the reptilian mammoths of the past.[46]

Mathews' Cañon City venture had been given up by this time, for he is referred to as a resident of Denver in the spring of 1874, but he shortly became restless and looked for other activities. By May of 1874, he had acquired a mountain home near Longmont and with his usual enthusiasm in a new project, he was hard at work in the beginnings of a trout industry. In midsummer he wrote his sister:

On the Big Thompson,
August 14th, 1874.

Dear Sister Eliza:—

The only place I can stay, without ill health, is in the mountains; and I have here the most beautiful place I have ever seen; and shall no doubt stay here. Wild fruit is very abundant and of superior kinds, and the river is full of trout. The water is cool and wholesome. My quarters are more comfortable than I have had, most of the time, for some years. I hope you have recovered your health, which Charley informed me was poor when he left. Remember me to his wife. If she could stay a short distance in the mountains, it would be far better. There is a beautiful place just above this, which could be bought for $50 or $150, where about 10 cows could be kept, and if Mr. Clark thinks of going to the mountains, it would be a good location. We go or send to the post office once in two weeks; and I write in a hurry, as I have an opportunity to send.

Your affectionate Brother,
A. E. Mathews

Although he may have found a close approach to an earthly paradise, Mathews was not destined long to enjoy it. In the fall of this year (1874) he was taken violently ill—probably it was an acute case of appendicitis— and far removed from any source of medical care, he died before a doctor, sent for by friends and neighbors, could arrive. His death occurred on October 30, 1874.[47]

"The death of Mr. A. E. Mathews," reports a Denver paper, "removes from active life a well-known Coloradan, and a gentleman who was most widely respected. He was an artist of no ordinary merit, and had sketched more of our Rocky Mountain scenery than any of his contemporaries. Industrious and economical, he had by fortunate investments amassed considerable property. He was a man of liberal culture and ideas; kind and genial in manner; a warm friend and a man who had no enemies and many friends. His name should be enrolled among the pioneers whom Colorado should remember with honor."[48]

Chapter Six

The Joining of the Rails

The Pacific Railroad unlocks the mysteries of Our New West. It opens a new world of wealth, and a new world of natural beauty, to the working and the wonder of the old.—Nowhere are broader and higher mountains; nowhere richer valleys; nowhere climates more propitious; nowhere broods an atmosphere so pure and exhilarating; nowhere more bountiful deposits of gold and silver, quicksilver and copper, lead and iron; nowhere denser forests, larger trees; nowhere so wide plains; nowhere such majestic rivers; yet nowhere so barren deserts, so arid steppes.

—Samuel Bowles, Our New West, 1869

One of the most important of all events in the history of the trans-Mississippi West was the completion of the first coast-to-coast railroad and the attendant ceremony and celebration at Promontory Point, Utah, on Monday, May 10, 1869. Not only was there celebration as the ceremony of driving the golden spike was completed, but the nation breathlessly followed the event as each stroke of the silver mallet was flashed by wire to all the cities of the country.

The final "Done!" was received in the East at 2:47 P.M. and Mayor A. Oakey Hall of New York City shortly thereafter ordered a hundred-gun salute fired in Central Park. A thanksgiving service at Trinity church attended by huge crowds was a feature of the New York festivities. In Philadelphia a battery of "steam" fire engines was assembled in front of Independence Hall and as the final word was received a bedlam of steam whistles, ringing bells and wild cheers spread over the city. In Buffalo, crowds sang "The Star-Spangled Banner." In Chicago an impromptu parade seven miles in length, which the Chicago *Tribune* estimated contained "1626 horses and 3252 human beings," soon got under way on that happy day. At night the "new" *Tribune* building was ablaze with lights to cap the city's jubilation.

Omaha staged a day-long celebration. An elaborate and carefully planned parade was held in which nearby towns participated by sending members of gayly attired fraternal orders and fire companies. Probably the fire company—beg pardon, H. & L. Co. No. 1—of Fremont would have been awarded the prize, if a prize had been given for the most colorful group, for their uniforms consisted "of black broadcloth pants—blue opera flannel shirts, with black velvet collars and facings—the whole trimmed with gold lace with, also, a gold star on either side of the collar, a handsome red and white morocco belt and fatigue cap." In the evening an elaborate display of fireworks was capped by a grand ball in the capitol building. Visitors came from miles around, the city streets were overflowing to celebrate the great event, but the Omaha *Republican* in reporting the happenings of the day thankfully remarked that there was no rowdyism and drunkness, usual to American celebrations, "and we have to chronicle no accident with its harrowing details, no melee with its sickening consequences, no lists of crime; and we may well be proud of so commendable a fact."

If the occasion was one for rejoicing in the East and the Middle West, the citizens of California could scarcely contain their joy. In fact, so eager was the desire to celebrate that San Francisco and Sacramento held their jubilation two days before the rest of the country, and on Saturday, May 8, the day was ushered in for San Franciscans by salvos of artillery, booming of cannon and the terrific screeching of whistles. The same day, Sacramento celebrated so thoroughly that the *Daily Union* could do little but report "the affair was very Magnificent." [1]

Not since Lee's surrender, four years earlier, had the nation been so profoundly moved. "At noon today," stated the New York *Tribune* in its editorial columns, "the last rail is to be laid on the great National railway that unites the Atlantic and Pacific Oceans, and marks the crowning triumph over the continent that the Puritan and the Cavalier entered three centuries ago." [2]

With the eyes of the nation thus so acutely focused on the great national railway, it is not surprising that newspaper and magazine editors hurriedly sent out reporters and writers to describe for their readers the wonder of travel from coast to coast on iron rails. One of the best-known of the writing fraternity to draw this assignment was A. D. Richardson of the New York *Tribune,* and in less than ten days after the rails were joined, he left New York City for San Francisco. In a lengthy series of articles to the *Tribune* he described in considerable detail his experiences as he traveled from coast to coast.[3] According to Richardson, the distance he covered was

3,313 miles (from New York to San Francisco) and the fare on this early transcontinental tour was $193.82.

Less than fifty California-bound passengers were on the train as they left Omaha. Emigrants, Richardson pointed out, were waiting for lower fares. The trip from coast to coast could be made in six days but nine days was the more usual time when the through road was first opened.[4] Moreover the rails really weren't continuous, for at Council Bluffs, because of the lack of a bridge across the Missouri river, the passengers disembarked on the eastern shore of the river and were loaded into

> twelve mammoth omnibuses, and express and baggage wagons. The two mail wagons are so piled with sacks of letters and papers that they look like loads of hay. All these huge vehicles are crowded upon one ferry boat; we drop down half a mile, rounding the great, flat, naked sand-bank; then land, a drive along a plank road, with water on each side, into the just-now muddy streets of Omaha. The through passengers are transferred to the Union Pacific train, and in half an hour are again whirling Westward. . . .[5]

Although the rails were continuous through Promontory Point, the "town" was the end of the Union Pacific and the beginning of the Central Pacific and passengers were forced to change cars in Richardson's day. Travelers were advised to be wary of Promontory. It was, as Richardson described it, "30 tents upon the Great Sahara, sans trees, sans water, sans comfort, sans everything." [6] Other contemporaries condemned it in still harsher terms:

> Sodom [wrote the editor from a neighboring town] had its few, peculiar besetting sins; Promontory presents a full catalogue, with all the modern improvements, dips, spurs, angles, and variations. The low, desperate, hungry, brazen-faced thieves there congregated would contaminate the convicts of any penitentiary [sic] in the land.—It would be a mercy to the traveling public, especially that portion coming west, and a relief to the honest mechanics of Promontory, and the moral sentiments of the age, if the cleansing element of fire would sweep the Godforsaken town from the face of the earth.[7]

If the traveling public read at all, they would have reason to make their stay in Promontory as short as possible. The final discomfort in traveling from coast to coast in 1869 was encountered at the western end of the line, for rail reached only to Sacramento. The remainder of the trip could be made to San Francisco by steamer down the Sacramento river or by rail to Vallejo and then by ferry across the bay. The Vallejo railroad, however,

was a private affair not connected with the Central Pacific and although it was the shortest and quickest way to San Francisco, its existence was not disclosed to transcontinental passengers.[8]

Despite these difficulties of travel, Richardson was quick to assure his readers that the combined roads were as safe to travel as any in the United States and that passengers taking sleeping cars would have a comfortable trip.[9] In fact, as another traveler pointed out, "the Pullman saloon, sleeping and restaurant cars of the West—as yet unknown in the Atlantic States . . . introduce a comfort, even a luxury, into life on the rail, that European travel has not yet attained to. . . ."[10]

Richardson was no new observer of the West, for he had a first hand acquaintance with it, not only from previous travel but from actual frontier life and one of the most moving passages of his overland account was written when he recalled his earlier travels:

> Memories of seven journeys in bye gone years, and from the Missouri to three mountains—on horseback and in vehicles—usually occupying a week, and always full of adventure. The wagon-train, the coach, the pony-expresses, the buffalo-hunt, the Indian panic, the camp-fire, the reading aloud in the tent by flaming candle of a chilly evening, the sleeping upon the ground under the blue sky through many a pleasant night—all these belong to a faded past. Instead, we hear [have?] the palace car in its purple and fine linen; the conductor with his pouch demanding our tickets; the black porter with his clothes-brush, waiting for our "quarter," the railway eating-house with its clattering dishes, and the smooth running train for one night and one day [Richardson was referring to the trip from Omaha to Cheyenne.] The gain is wonderful in time and comfort; the loss irreparable in romance and picturesqueness.[11]

JOSEPH BECKER

All of which sets the stage for Joseph Becker. Although writers in considerable number made the Western journey shortly after the joining of rails, pictorial reporters were few and far between, or at least the record of their work is extremely meager. The most celebrated painting of the joining of the rails, "Driving the Last Spike", for example, was not made on the spot but was based on many photographs. It was the work of Thomas Hill of California and was first displayed in San Francisco in 1881. It now hangs in the California State Capitol, Sacramento.[12]

Probably there was no publisher who was as sensitive to public demand and tastes as Frank Leslie; his policy was based on the maxim: "Never

shoot over the heads of the people." If such a policy led to no improvement in public taste, its record, at least, reflected the common level of achievement and culture during the years that Leslie published his numerous periodicals. The great public interest aroused by the completion of the transcontinental railroad was Leslie's signal to send a staff artist to *picture* events along the line of travel, and in the fall of 1869 Joseph Becker started west on an assignment from Leslie.

Becker, born in 1841, joined Leslie's staff as an errand boy in 1859. In constant contact with the pictorial reporters on the staff, he became interested in sketching and was taught the rudiments of the art by staff members. Leslie himself, a skilled engraver, took an active interest in the youngster and encouraged him to practice long and hard. By 1863, he was an artist on Leslie's staff and as the demand for field artists was insatiable, he was sent with the Army of the Potomac and followed the campaigns from Gettysburg to Appomattox. Many of his war drawings were, of course, reproduced in *Frank Leslie's Illustrated Newspaper,* but in 1905 Becker stated that he had many original Civil War sketches and studies that had never been published.[13] Becker continued for many years after the close of the war on the Leslie staff, and from 1875 until 1900 he was head of the Leslie art department.

Becker left New York City on his Western trip about the middle of October, 1869, some five months after the joining of rails, so that some of the early difficulties of transcontinental travel had disappeared, but the journey was unique in its kind. The enterprising George Pullman had prevailed upon the management of the Union Pacific and the Central Pacific to permit a through Pullman train to run from Omaha to San Francisco without the necessity of changing trains at the junction point of Promontory. The Central Pacific had completed their line from Sacramento to San Francisco so that with the innovation of the Pullman car, rail service had been considerably improved in five months. The *Alta California* of San Francisco described the new service as follows:

After Tuesday next a Pullman special train, with drawing-room and sleeping cars, will leave San Francisco at 7:30 a.m. every Monday, and Omaha every Tuesday, at 9:15 a.m., stopping only . . . [for necessary] fuel and water. The fare, including double berth in sleeping car, will be $168 in currency between San Francisco and Omaha. Meals will be served on the train as follows: Breakfast, from 7 to 9, $1; lunch, from 11 to 2, at card prices; dinner, from 4 to 6, $1.50. Passage tickets, drawing-rooms, sections and berths can be secured at the Pacific Railroad offices at either end, by telegraph, letter, or personal application.

One of these special trains, which left Omaha on the 18th [actually October 19], will reach this city to-day, and will leave on the return trip for Omaha on Monday next, arriving there on Thursday, and connecting with Eastern trains due in New York on Sunday. The trip across the Continent will, according to this schedule, be made in six days.[14]

Becker was on the first of these special trains, the one which left Omaha on October 19th. The train arrived in San Francisco on the evening of October 22, making the run in eighty-one hours.[15]

The pictorial records of Becker's trip began their appearance in *Leslie's* with the issue of November 13, 1869.[16] It is a sentimental drawing with the legend "Good-Bye" and shows a mother holding her baby up to be kissed by a be-whiskered engineer in the locomotive cab. The illustration bears the sub-title, "An Incident on the Union Pacific Railroad at Omaha."

Very few of these Western illustrations were credited directly to Becker. In a few, to be cited later, Becker is specifically mentioned in the legend. In two, his initials appeared. After the series was under way, individual illustrations appeared under the general title, "Across the Continent," followed by the specific title of the illustration and the credit line "From a sketch by our special artist." Occasionally in the series, an illustration will be found which bears the signature of some other artist. Thus the signature "Bghs" (Albert Berghaus) appeared on several; however such signatures but indicate the fact that the original sketch was redrawn, probably on the wood block itself, by the second artist. A few of the illustrations belonging to the general series, "Across the Continent," were credited to photographs by A. J. Russell but the others to "our special artist." I have assumed that all, with the exception of the photographs, are to be credited to Becker.[17]

Becker spent some time in California working on still another aspect of life in 1869. Leslie was greatly interested in the Chinese question as were many other Americans of that day. The importation of Chinese laborers into California beginning in the middle 1860's was producing a social and economic problem as the wave of Chinese immigration advanced eastward. Leslie's feeling about the Chinese is doubtlessly reflected in the general title of a series of illustrations appearing in his *Newspaper*, "The Coming Man." Here again the illustrator was Becker, for Leslie had instructed him to make the Chinese a matter of special study when he reached California.[18]

After spending six weeks in California, Becker returned east over the transcontinental route but took time out to leave the main line at Ogden for a side trip to Salt Lake City, for the Mormons were also a subject of

general and extreme American interest. As a result, many Utah sketches appeared among the Becker illustrations. It is possible, too, that Becker made a hasty side trip from the main line of the Union Pacific at Cheyenne to Denver.[19]

Altogether, if we exclude the Chinese illustrations (cited in Note 18), there resulted from Becker's trip some forty Western illustrations.[20]

Of all of these illustrations, the most interesting and most revealing of the times is "A Station Scene on the Union Pacific Railway". The station may be Omaha or—more probably—it is a composite view of several scenes witnessed by Becker, for here are portrayed the bustle, confusion and interests of many and varied individuals. Emigrants, pleasure-seeking travelers, soldiers, plainsmen and prospectors, Indians, card sharps, mining speculators, Chinese coolies, a Jewish peddler (When will the fascinating story of the Jew on the frontier be told?), a Negro caller and many others not so easily identified carry on their roles against the background of the station, a hastily constructed water tower and a billowing canvas "Hotel and Dining Room." The opening of the railroad made easier access to the mining regions of the West and every new discovery brought a rush of passengers intent on making sudden fortunes.[21]

Others of particular interest in the series include those showing the equipment of the first Pullman special, "the Hotel Express Train", those of Promontory Point which do nothing to relieve its reputation as a God-forsaken town, and the two large illustrations, "Snow Sheds on the Central Pacific Railroad, in the Sierra Nevada Mountains" and "Passing Through the Great Salt Lake Valley" which bears as an addition to the legend, "The Country as Seen From the Observation Car of the Pacific Railroad Hotel Express Train." The "Observation Car" was simply the rear platform of the last coach but Becker later claimed that the desire of travelers to observe scenery on this trip suggested the idea of an observation car. "I furnished designs," wrote Becker in 1905, "for this to Mr. Pullman, which afterwards were utilized. I may therefore fairly claim to have been the inventor of what is now a feature of all great railways." [22]

The illustration showing snowsheds in the Sierra Nevadas is of additional interest as Becker later made a painting based on the illustration. In 1939, the painting was on exhibit at the Metropolitan Museum of Art under the inconceivably stupid title of "The First Transcontinental Train Leaving Sacramento, in May, 1869." An examination of the two pictures shows that they are but little different.[23]

The last two of the Becker illustrations mentioned above do not have the series title, "Across the Continent," but from the subject matter and the

accompanying text clearly belong with the group. The title of No. 39 (*see* Note 20) is in error, however, for it should read "Early Morning at Laramie [not *Fort* Laramie]." The failure to distinguish between Laramie, Wyo., and Fort Laramie is an error that has been made innumerable times since 1870.

After Becker became head of Leslie's art department in 1875, his opportunities for travel were greatly reduced and, as far as I have been able to determine, his Western illustrations were confined solely to his experiences of 1869.[24]

Chapter Seven

Western Excursions

Sir, I wish I had the talent to tell what I have seen—Over and over, upon one of the best managed railroads between the Atlantic and the Pacific, according to my personal experience, I have seen unhappy groups of immigrating families after days and days of detention or of travel upon the great railroad lines, after sleepless nights, looking more dead than alive. I have seen many a young mother, after sleepless nights spent by her in an effort to snatch some repose for her flock of little ones, stretched out upon the hard bench so exhausted that she had lost for the time all ideas of comeliness and almost of decency.—I ask my associates—to join with me in securing for these immigrants on the long lines of travel from the sea-board to the great West where they go to help to lay the foundations of our future greatness, some conveniences of needful rest, some conveniences for decent cleanliness, some protection against hardships which I seek in vain to describe and which are enough to afflict the heart of any thinking man with commonest impulses of humanity to witness or even to know that they exist and are not at once remedied.
—Hon. Eugene Casserly of California in the U.S. Senate, June 4, 1872.

The completion of rail to the Pacific made easier access to a vast new country, and the artistic and pictorial exploration of the western domain soon became a popular subject for magazine publishers. Many editors sent staff artists on tours of western discovery but we shall select—in addition to the pioneer travels of Joseph Becker just described—only two of these tours; one sponsored by *Harper's Weekly* and the other a few years later, by the Harper brothers' chief competitor, Frank Leslie.[1] The illustrators sent by the Harpers were Paul Frenzeny and Jules Tavernier; those accompanying Leslie himself on a western tour were Harry Ogden and Walter Yeager, whose work we will consider in a subsequent chapter. The work of several other traveling illustrators of this same period has been described in the Notes.

94

FRENZENY AND TAVERNIER

In the fall of 1873 *Harper's Weekly* commissioned two artists, Paul Frenzeny and Jules Tavernier, to make a series of sketches on an expedition that took them from the Atlantic to the Pacific. Their Western trip probably began early in September, 1873, in New York City and was finished in San Francisco sometime in the summer of 1874. Illustrations made on the expedition, however, are found in the *Weekly* for the years 1873, 1874, 1875, and 1876. The *Weekly,* modestly subtitled *A* [not *The*]*Journal of Civilization,* announced the expedition by stating:

> . . . our artists, Messrs. Frenzeny and Tavernier, will tell the story—of an extensive tour, commencing at New York and intended to include the most interesting and picturesque regions of the Western and South-western portions of this country. These gentlemen will not restrict themselves to the ordinary routes of travel. They will make long excursions on horseback into regions where railroads have not yet penetrated, where even the hardy squatter, the pioneer of civilization, has not yet erected his rude log-cabin; and the pictorial record of their journeyings will be a most valuable and entertaining series of sketches.[2]

The *Weekly* was correct, for the illustrations are still "a most valuable and entertaining series of sketches" and give us pictorial records of the West—towns, living conditions, transportation, industries of plain and mountain, emigrant life, Indian troubles and affairs, and minor but revealing incidents of Western life—that are nowhere else available. It is true that most of them are crudely rendered because of the medium employed for reproduction (the woodcut); an original pencil sketch, however, signed by Tavernier alone, has been found as have several water colors by Frenzeny and will be discussed later. Sufficient evidence has been assembled to show that most, if not all, of the illustrations are authentic and were made from direct observations of the scenes depicted.

Jules Tavernier at the time of the overland expedition was a young French artist of twenty-nine. Born in Paris in 1844, he was for a time a student of Felix Barrias and had achieved some artistic reputation in France before the Franco-Prussian war in which he fought. One account has it that he was Communist and was exiled from France a few months after the conclusion of the war.[3]

Tavernier came to this country in 1871 and soon was illustrating for the newly-established New York *Graphic* and for *Harper's Weekly.*[4]

Of Paul Frenzeny less biographical information is available save that

deducible from his published illustrations and a few scattered newspaper references.[5]

Frenzeny was, like Tavernier, a Frenchman. He had served in the French cavalry and had spent several years in the mid-sixties under Marshal Bazaine in Mexico. As a result he was an excellent horseman, an accomplishment which no doubt was of considerable value to him on his Western excursion. Frenzeny had been in this country longer than Tavernier for his first published sketches in *Harper's Weekly* appeared in 1868.[6] Between this date and 1873, about twenty Frenzeny sketches appeared in the *Weekly*, and were of varied character but included a number of New York City views and sketches made in the Pennsylvania coal belt.[7]

Frenzeny's partnership with Tavernier began before the Western trip, for there are two illustrations with their joint signatures in the *Weekly* prior to September, 1873. One was a double-page and fanciful group of drawings devoted to "Spring" and the other a full-page illustration, "Circus Coming to Town." [8]

The division of labor in this partnership can only be guessed at. Comparison of the sketches by the individuals with those bearing the joint signatures is of little aid, as the wood engraver reduced nearly all illustrations to the same level. The work of Winslow Homer, C. S. Reinhart, T. S. Church, Sol Eytinge, Jr., and many others whose illustrations appeared in the same years as those of Frenzeny and Tavernier might all have come from the same pencil as far as the draftsmanship was concerned, after the engraver was through with them. Only the bold lines and grotesque figures of man and animal in the cartoons of Thomas Nast bear any individuality during this period. The magnificent wood engravings that appeared in the 1880's had few counterparts in the middle 1870's.

As the woodcut reproductions of the work of Frenzeny and Tavernier are of little aid, other information must be sought. It is known that Frenzeny was an excellent pencil artist and Tavernier a "colorist" interested in large masses, abilities which suggest that Tavernier was responsible for background and composition and Frenzeny for the foreground detail.[9] It is probable, too, that many of the illustrations used by the *Weekly* were drawn directly on the wood block by the artists before being sent to New York. In fact, one Denver paper reported "The artists draw their sketches on wood before sending them to the engraver." [10] If this procedure was the one followed, probably Frenzeny with his skill with the pencil drew the major portion of the sketch on wood, using a mirror as an aid to transpose the necessary reversed sketch on wood. The usual signature that appears in many of their reproductions is "Frenzeny & Tavernier," although at times

the signature is reversed or changed in other ways. That the artists redrew their sketches on wood is borne out by an examination of their signatures, for rather frequently a letter, either N or Z is reversed.[11] The reversal would be one more readily made by artists unaccustomed to drawing in reverse than by professionals trained for such work in the wood engraving plant. For their combined efforts the Harper brothers are said to have paid the two artists $75 for a full-page illustration and $150 for a double-page one.[12] As we shall see, they sold sketches to other concerns and to individuals as they traveled westward.

In many ways, Frenzeny and Tavernier were alike. Volatile and excitable, susceptible to their surroundings, imaginative and extravagant, they were a queer pair to send on a westward journey to a country as foreign to Paris and New York as could be imagined. Frenzeny soon after he reached the plains, acquired a pointer—Judy, by name. He became greatly attached to the dog and although she was not particularly intelligent, she had a valiant defender in her owner. One can but wish that a good observer and reporter had been in the background as these two eccentric characters and their dog traveled by train, by stage coach and by horse over the plains and mountains of the West and in localities where it was still wild and woolly. Despite their highly individual personalities, their pictorial reporting is surprisingly complete. The commonplace in the West was unusual to them and they recorded it as they saw it. It might also be pointed out that they possessed an unusual sympathy for the humbler class of individuals seen on their trips; workers, emigrants, pilgrims of the plains in search of new homes, were all treated pictorially with kindness and understanding.[13]

The first two illustrations in the Frenzeny and Tavernier series were made in New York City itself, but dealt with Western emigration which was then rapidly increasing. "An Emigrants' Boarding House in New York"—a double-page illustration of one of "the better class" houses, and "The Emigrant Wagon—On the Way To the Railway Station"—a single-page illustration depicting the transportation of emigrants from the boarding house to the cars for the Western migration, were the subjects treated.[14] It was the custom of the *Weekly* to make comment on its illustrations, the citation to such a comment being included with the legend beneath the illustration. Occasionally the comment gives useful additional information concerning the subject of the sketch, especially when it is apparent that the information was supplied by the artists themselves.

The two initial views were followed by illustrations in and around Pittsburgh, dealing with the manufacture of iron.[15] Included in this same series

was an illustration depicting a secret meeting of coal miners—the locality not specifically stated, other than "in Pennsylvania." [16]

The first of the trans-Mississippi sketches appears in the issue of *Harper's Weekly* for November 8, 1873, but to aid in understanding the work of the artists, their general route west from the Mississippi should be traced before giving consideration to the individual illustrations. They apparently crossed the Mississippi river at Hannibal, Mo. From Hannibal, the pair traveled on the Missouri, Kansas and Texas Railway across Missouri to Fort Scott and Parsons, Kan. They proceeded on the same railroad across Indian territory to Denison, Tex., the terminus of the railroad. Construction of the line to Denison had been completed only a few months before the arrival of Frenzeny and Tavernier. After their visit at Denison, the artists turned northward across the Indian territory and eventually reached Wichita— probably accompanying a cattle drive at least part of the way. From Wichita the general route was west along the Santa Fe railroad through southern and western Kansas to the railroad terminus at Granada, Colo. By stage they then traveled to Pueblo, Colo., and then by rail to Denver. They remained in Denver during the winter of 1873–1874, then visited Fort Laramie in Wyoming territory, the Red Cloud Agency in Nebraska and finally returned to the Union Pacific railroad traveling west to San Francisco, after a side trip to Salt Lake City.[17]

The sketches for the November 8 issue of the *Weekly* include eight illustrations, one of them a left-over from the iron manufacturing scenes at Pittsburgh, previously mentioned. The seven remaining views are obviously scenes in southeastern Kansas, "A Sunny Home on the Neosho River," "Herding with Comfort" (depicts a settler with an umbrella herding a few cattle on the prairie), a street scene entitled "A Market Day in Parsons City—18 Months Old," "Taking Water in the Prairie" (locomotive and train on a treeless plain), "Prairie Chickens for Sale," "A Surprise Party," and "Going to Church"—the last three illustrations depicting various incidents of settler life. Unfortunately there are no Parsons City newspapers available for this period as newspaper comment is one of the valuable methods for checking on the accuracy of the scenes depicted. The next group of sketches (four on one page) belong geographically to the above group of seven.[18] They include "In the Emigrant Train," "Switched Off," "Building the Log-Cabin," and "Laying the Fences." The first two are emigrant scenes and were probably made along the Missouri, Kansas and Texas Railway. The first shows the interior of a passenger car at night filled with emigrants and their belongings; the second, "Switched Off," depicts a group of emigrants "sketched from an actual scene," the text tells us, huddled

about a closed depot and waiting in the rain for their connecting train. "In this case," the description reads, "the emigrant party, which included old people, delicate women, and children, were compelled to remain all night exposed to a cold, drenching rain." The pictured plight of the distressed travelers may have been due to the lack of coordination in the recently organized M. K. & T. (a combination of many smaller systems) or to the fact that "emigrant cars" were frequently attached to freight trains and the emigrant cars switched off at way stations so that additional freight could be added to the trains; emigrant travel apparently being regarded as a third or fourth-class mode of transportation.[19]

The Frenzeny and Tavernier sketches listed below are those found in the *Weekly* showing scenes in Indian Territory and Texas and secured as the artists traveled by the M. K. & T. to Denison, Tex.[20] As can be seen, they are not arranged according to the chronological order of their appearance in the *Weekly* but are grouped geographically. The appearance of the sketches in the *Weekly* undoubtedly would be determined solely by the availability of the sketches (dependent upon the promptness of the artists in sending them to New York), and the needs of the individual issues of the *Weekly*.

1. "United States Signal Service—Watching the Storm," Fort Gibson, I. T. (about ⅔ p.).
2. "In the Indian Territory," seven outline sketches on one page, including Fort Gibson.
3. "Vigilance Court in Session" (full page).
4. "An Oasis Along the Track" (the cover page).
5. "Arkansas Pilgrim," from Arkansas to Texas through Indian territory (about ½ p.)
6. "Arkansas Pilgrims in Camp" (about ½ p.).
7. "A Freshet in the Red River, Texas" (about ½ p.).
8. "Sugar-Making in Texas" (about ½ p.).
9. "A Deer Drive in the Texas 'Cross-Timber'" (double page).
10. "A Saturday Noon in a Southwestern Town" (the cover page).
11. "The Texas Cattle Trade—Guarding the Herd" (about ½ p.).
12. "Calling the Night Guard," interior of bunk house (about ½ p.).[20a]

The M. K. & T. ran in a line southwesterly across eastern Indian Territory, Fort Gibson being nearly half-way to the Texas line.[21] The army, then in charge of weather reports and surveys through its signal service, maintained a weather station at Fort Gibson, the only one in the southern plains region until Santa Fe, N. M., was reached. The first illustration on the list depicted observers on the tower of the station watching the approach of a storm; a small vignette showed the interior of the station.

"An Oasis Along the Track," probably also sketched in Indian Territory, shows a mule-powered pump at a lone way station, storing water in a reservoir for future train use.

The end of the M. K. & T. track, as already pointed out, was in Denison, Tex., when Frenzeny and Tavernier traveled west in 1873. Denison was four or five miles south of the Red river, the boundary between Indian Territory (Oklahoma) and Texas, and on the Old Texas road that came down from Fort Gibson. Before the coming of the railroad, the Old Texas road was the highway of travel for southern-bound emigrants and still earlier for the Forty-niners.[22] These facts, together with the Denison illustration previously noted, indicate that several of the remaining sketches listed above were made in or near the vicinity of Denison. There is no precise information now available, save that furnished by the *Weekly* illustrations themselves, how much farther into Texas the artists traveled than the border town of Denison. They apparently spent little time in the town of Denison itself, as Mr. E. R. Dabney of the University of Texas library has searched for me the files of the Denison *News* for 1873 and 1874 without finding any mention of the names of Frenzeny and Tavernier.

"A Freshet in the Red River, Texas," the two "Arkansas Pilgrims," the "Vigilance Court in Session" (locality stated as near the Indian Territory-Texas boundary)—all, it is reasonable to assume, fall in such a group. Denison, too, or the nearby country, marked the beginning of some of the important northward cattle trails,[23] and the two sketches of the Texas cattle trade may have been sketched not far from Denison. "Calling the Night Guard" is more than faintly suggestive of Remington's illustrations made many years later. "A Saturday Noon in a Southwestern Town" is not identified save that it was "a border town", but the watermelons and the negroes in the sketch fix its locality as Texas without much doubt. It possibly may be a view of Denison itself. Unfortunately the store signs do not yield a positive method of identification.

The most impressive illustration of this group is the double-page "A Deer Drive in the Texas 'Cross-Timber'." As Denison is near the western edge of the Eastern Cross Timbers, this sketch also could have been based on the artists' impressions of the vicinity near Denison. An exceptionally good word description of the Cross Timbers and of deer hunting accompanies the illustration which strongly suggests that part of the material was a report of the artists' own experience.

"The camps at night," the report reads in describing a deer hunt of several days, "present a very picturesque appearance. Bright fires illuminate the scene, the horses are picketed in the rich grass, hunters and hounds

gather in groups about the fires, and songs and stories and feasting are kept up till late in the night. Then, rolled in blankets, the men lie down to sleep, and silence reigns in the great forest."

KANSAS

Upon the completion of the Texas part of the Frenzeny-Tavernier "expedition," the artists turned north again and returned to Kansas. Their first sketches on their return were probably made in and near Wichita, then the cattle-shipping center of this Western industry. The complete list of Kansas sketches, with the exception of those described earlier, and again arranged geographically, include:

1. Nine sketches on Wichita and the cattle trade.
2. "A Kansas Land-Office" (cover page).
3. "Fighting the Fire" (about ½ page).
4. "A Prairie Wind-Storm" (full page).
5. "Limestone in Kansas" (about ½ page).
6. " 'Busted!'—A Deserted Railroad Town in Kansas" (about ½ page).
7. "Curing Hides and Bones" (about ½ page).
8. "Slaughtered For the Hide" (cover page).
9. "An Under-Ground Village" (about ½ page).[23a]

Fortunately, for the first group of sketches listed above, we have valuable contemporary comment which appeared in the Wichita *Eagle* for April 30, 1874. The comment reads:

Wichita and her trade has been immortalized by illustration. For some months past *Harper's Weekly* has contained pictorial sketches of the west and southwest, drawn by Frenzeny and Tavernier. Many of these delineations were of scenes connected with the life of the cowboy and the hunter. The supplement of that paper for May 2nd contains nine pictures, all relating to the cattle trade. No. 1 shows the process of branding with a hot iron the initials or the monogram of the owner. No. 2 represents a long winding herd enroute for Wichita. No. 3 represents Clear Water on the Ninnescah, in this county, with John Dunscomb's store in the foreground, and Ward, McKee and Co's grocery store in the back, with a lot of boys scattered around in conversation, while their horses are feeding out of a trough in front of the awning of John's place. No. 4 represents the milling process, or a "rodeo" in which thousands of head of cattle are rounded up and circled around and around—so often witnessed here. No. 5 shows the process of "cutting out" cattle from the main herd. No. 6 shows a camp of cattle men out on the herd grounds, west of Wichita. The sun is

just rising as the boys are taking their breakfast. In the dim distance is the herd. Two are coming off the night-watch, and others in camp are preparing to take their place through the day. No. 7 shows the cars, pens, and the way the cattle are loaded for eastern markets. No. 8 is a view of Main street, Wichita, from its intersection with Douglas avenue looking north. While it does not do that street justice it is nevertheless recognizable. The last cut represents a party of drovers who have sold out their cattle, bought a Moser wagon, loaded in their outfit and are bidding the Wichita boys good bye until another season. The illustrations are vivid and true to life and to the character of the scenes represented, showing that the artists had studied their subjects.

Comment on this group of pictures, possibly the most important set of the entire series, also was made in the *Weekly* which called Wichita "the grand central station for the cattle trade" and pointed out that the drive from Texas through Indian territory took four to five months.

The second of the Kansas sketches, the "Land Office," is a most interesting one as it represents a typical "industry." It also was made at Wichita, for the map in the background bears the legend "Sedgewick [sic] County." Wichita, it should be remarked for non-Kansans, is located in Sedgwick county. It will be noted that it was published much later than the other Wichita sketches, a fact supporting our argument on page 99.

It has been possible to determine with considerable exactness from two sources when these Wichita illustrations were actually sketched. The Emporia *News* of October 17, 1873 reported on that day:

Paul Frenzeny and Jules Tavernier, representing Harper's Weekly, are here for the purpose of making sketches of the scenery here for the pages of the great illustrated paper. They have been to Wichita for some days taking various views of that city, and of droves of Texas cattle, etc. We trust every favor will be shown the talented artists during their stay with us. The enterprise of the Harpers in sending artists this far into the west to make sketches for their great favorite illustrated paper is worthy of special note, and we are glad that the Weekly is well patronized here.

From this comment, it appears that Frenzeny and Tavernier were in Wichita during the first few weeks in October, 1873, but we can be more precise about the date than "the first few weeks." The Wichita Public Museum possesses an original pencil sketch signed only by Jules Tavernier in the lower right corner of the sketch; dated in the upper left corner "Oct. 6, 1873"; and in script on the lower left corner is the notation "Maine [sic] Street from Eagle Bloc [sic]." The view is of Wichita and is the only orig-

inal sketch included in the Frenzeny-Tavernier portfolio of 1873–1874 which has been located; a portfolio which must have contained hundreds of sketches which would now be priceless.[24]

This Wichita sketch was probably bought by some interested citizen of Wichita as there is additional evidence that the artists sold sketches locally as they made their way West. The existence of the lone Wichita sketch and the fact that no Emporia sketches appeared in *Harper's*, although the *News* comment indicates that the artists were at work in that town, shows this fact quite clearly.

Although no sketches of Emporia appeared in the *Weekly* it is quite possible that sketches 3 and 4 of our Kansas list were made near Emporia. Prairie fires were of common experience in the days when much of the open country was unplowed and grass-covered. Autumn fires when the grass was tall and dry at times reached magnificent and terrifying proportions. Indeed, the Emporia *News* reported prairie fires in nearly every issue during October and November in 1873 and on November 14 reported, "Prairie fires have blackened the prairies almost all around us. . . ."

"A Prairie Wind-Storm," depicting a pioneer woman in a horse-drawn wagon, her husband attempting to calm the terror-stricken horses at the approach of a dark and violent storm, is again an incident that was common in the fall on the open prairies. The illustration recalls the far from easy life that our early settlers experienced.

The locality of "Limestone in Kansas" I have not been able to identify with certainty but I believe that it must be either Fort Scott or Florence. The illustration shows a row of huge lime kilns where "was made two-thirds of all the lime used in the state." Statistical data is lacking that would enable us to determine which of the two towns was meant but more probably it was Fort Scott.[25]

The next four sketches on our Kansas list (Nos. 6, 7, 8 and 9) are to my mind the most interesting of the entire Frenzeny and Tavernier series. They were made as the artists traveled west from Emporia on the Atchison, Topeka and Santa Fe (which as all Westerners know, does not start from Phil-i-del-fee-aye, as a recent popular tune has it). Our evidence for this statement must be proved as no localities are given in the *Weekly* for these illustrations. In the first place the scenes are those of southwest Kansas through which the Santa Fe, in local parlance, made its way. In the second place, the Denver papers, in noting their arrival in that city, state that the artists came from *southern* Colorado,[26] as they would if they traveled the Santa Fe. The only other route to Denver would be by way of the Kansas Pacific which would have brought them into Denver directly from the east.

Emporia was on the main line of the Santa Fe and not the Kansas Pacific. The trip west from Emporia would mean retracing their "steps" as far as Newton [27] for we have seen that Emporia was reached after the artists had been in Wichita. To clinch our argument, that the trip was made through southwest Kansas on the Santa Fe, we can point out that the two artists registered at the American House in West Las Animas, Colorado territory, early in November, 1873.[28]

West Las Animas was on the stage route from the end of the Santa Fe rail (which in the fall of 1873 was at Granada, C. T., twelve miles west of the Kansas-Colorado line) and Pueblo (133 miles west of Granada), in southern Colorado, where rail connections could again be made on the Denver and Rio Grande to Denver,[29] some one hundred miles or more north of Pueblo. Therefore, there can be little doubt that the Santa Fe was the route traveled by the artists to railhead.

"Busted," I am assuming, was the first of these sketches made on the westward trip from Emporia. As can be seen it is at least partly imaginative but the sense of haunting forsakenness created by the illustration makes it one not easily forgotten. I first saw the picture over twenty years ago and its image has frequently flashed across my memory in the intervening years. It was in fact, the illustration that started my first work on these artists. Goldsmith in nearly four hundred lines was not able to produce the feeling of utter desolation that can be obtained by a single glance at this illustration of the Great Plains' version of "The Deserted Village."

The deserted town may be a composite view based on several such towns seen by the artists—for Kansas has had its share of "busted" towns—but there is record of a town whose description fits surprisingly well with the illustration. In July, 1872, the town of Zarah, Barton county, was quite a little village and the first town in the county. It was about a mile east of a military reservation on which was located Fort Zarah.[30] The Santa Fe railroad reached Great Bend, about three miles west of Zarah, on August 5, 1872,[31] but missed Zarah by about a mile and Zarah disappeared within a year or so.

"Curing Hides and Bones," I am reasonably sure, was drawn at Dodge City late in October, 1873, for it compares with considerable exactness to the description given by Robert M. Wright, one of the founders of Dodge City and the author of *Dodge City, The Cowboy Capital* (Wichita, 1913, p. 156), which reads:

> One of Dodge City's great industries was the bone trade. It certainly was immense. There were great stacks of bones, piled up by the rail-

road track—hundreds of tons of them. It was a great sight to see them. They were stacked up way above the tops of the box cars, and often there were not sufficient cars to move them. Dodge excelled in bones, like she did in buffalo hides, for there were then ten times the number of carloads shipped out of Dodge, than out of any other town in the state, and that is saying a great deal, for there was a vast amount shipped from every little town in western Kansas.

The fall and winter of 1872–1873 saw professional buffalo hunting reaching its height,[32] and in the fall of 1873, Col. R. I. Dodge, after riding out from Fort Dodge, some four or five miles from Dodge City, wrote:

> Where there were myriads of buffalo the year before, there were now myriads of carcasses. The air was foul with sickening stench, and the vast plain, which only a short twelvemonth before teemed with animal life, was a dead, solitary, putrid desert.[33]

The buffalo were not yet gone in the fall of 1873 but they were farther removed from the lines of the railroads; and the illustration, "Slaughtered for the Hide," shows a scene of wholesale slaughter of the buffalo almost as bad as that suggested by Colonel Dodge. "Our artists spoke with hunters on the plains, who boasted of having killed two thousand head of buffalo apiece in one season. At this rate of slaughter, the buffalo must soon become extinct," read the description accompanying "Slaughtered for the Hide." [34]

The last of the group of Kansas sketches, "An Under-Ground Village," is unique. I know of no other illustration by any artist which depicts this aspect of town life on the Great Plains. At first glance, one might think that the illustration was the result of the fantastic imagination of the artists but evidence is available which shows that the illustration was probably based on fact. The dugouts which constitute the underground village, were common habitations of the early settlers on the plains. Illustrations of individual dugouts are fairly common; it is the collection of a number of these dugouts together that constitute the uniqueness of the illustration in question.[35]

In a country devoid of timber, yet supplied with an endless quantity of "moving" air, the dugout at first was almost a necessity. If the reader wonders about the nature of a dugout, the following description by a traveler, who made a Western trip but a short time before Frenzeny and Tavernier, can be quoted. The dugout, he reports, "is simply a burrow with a pitched roof of sod, seldom having a window, the door answering this purpose, however inelegant in appearance, is truly a snug place in

which to spend the blustery winter days. There your plainsman can lie
back at his ease on his bed of robes, and think it a bed of roses and hear
with philosophic calmness the peltings of the rude storm without." [36] The
plainsman's philosophic calmness was no doubt rudely interrupted from
time to time as he scratched vigorously, for dugouts soon became the
habitation of insect as well as human population. *"The land of the free—"*
went the ditty of the dugout dwellers of the 1870's:

> *The land of the bedbug, grasshopper and flea,*
> *I'll sing of its praises, I'll tell of its fame*
> *While starving to death on my government claim.*

Another observer who traveled west from Dodge City on the Santa Fe
also saw dugouts along the line of the railroad. "On the morning after my
arrival in Dodge City," he wrote late in 1872, "I got into a caboose car
and went eighty miles further, within a very short distance of Fort
Aubrey.[37]. . . Twenty miles apart, out in this wild country, there are
stations, consisting of a water-tank and a dugout. The dugouts are simply
holes in the ground, or cellars with roofs over them. They are the most
convenient houses for this windy country that can be built, and are exceed-
ingly warm; they are used as boarding houses for the section hands, and at
present for eating houses for those who may travel on construction trains." [38]

Subsequent newspaper accounts, written a few years later, report dug-
outs at Dodge City, Lakin and Kendall; the last two towns being west of
Dodge City on the Santa Fe.[39]

There is thus ample evidence that dugouts existed along the line of the
Santa Fe westward from Dodge City and the question naturally arises as
to whether the illustration depicted any of the towns along the railroad.
If it does, the town must be one of three: Dodge City, Sargent (now
Coolidge), Kan., or Granada, Colo., the end of rail. Our reason for this
conclusion is that the illustration, as can be seen, depicts a depot and these
three towns were the only ones that possessed frame buildings as depots
(at the time of the artists' visit).[40] I do not believe that the underground
town could be Dodge City as Dodge had a hotel and dance hall by 1873
(see note 38), and these were probably above ground. It is possible, of
course, that more of the town than is actually depicted in the illustration
existed but did not appear from the viewpoint that the artists selected.

I believe, too, that the illustration was probably not Granada for a con-
temporary newspaper account states that the town contained in August,
1873, "about fifty buildings,[41] built mainly in a row about 80 feet north of
the railroad track." [42] If the artists did not purposely foreshorten the fore-

ground, the illustration could not represent Granada as the distance from tracks to "town" in the illustration is quite obviously less than 80 feet.

The only remaining alternative then is that the illustration shows the town of Sargent and we will therefore tentatively assign the illustration to this locality.[43] Some reader, I trust, will be able to produce evidence that will establish the locality of the "Under-Ground Village" with certainty.

COLORADO TERRITORY

The Frenzeny-Tavernier sketches made in the centennial state, as these artists continued on from Kansas, can be listed as follows:

1. "Staging in the Far West."—Four illustrations on one page entitled: "Throwing Out the Mail"; "Taking the Morning 'Slumgullion'"; "Calling For the Relays," and "Home Station on the Plains."
2. "Mining in Blackhawk, Colo." (nine illustrations on two pages).
3. "Gold and Silver Mining, Colorado—A Honey-Combed Mountain" (about ⅓ page).
4. "On the Way To New Diggings—Halt in a Rough Pass of the Rocky Mountains" (double-page).
5. "Irrigation in Colorado—Letting Water Into a Side Sluice-Way" (cover page).
6. "Trout-Hatching in Colorado" (about ⅓ page).
7. "A Bear Hunt in the Rocky Mountains" (about ⅓ page).
8. "Returning To Camp From a Bear-Hunt" (about ⅓ page).
9. "Shooting Antelopes From a Railroad Train in Colorado" (full page).
10. "A Bird Colony [Swallows] on Lake St. Mary" (about ⅓ page).[43a]

Although the individual sketches of "Staging in the Far West" are not identified as to locality I have assumed that they belong to the Colorado group. If I am correct, the originals were then made on the stage route between Granada, the railhead of the Santa Fe, and Pueblo. As we shall see, the two artists made at least one other stage trip (from Cheyenne to Fort Laramie) but the architecture of the building seen in "Throwing Out the Mail" is so distinctly of the Mexican type that southern Colorado seems surely indicated.

The stage route between Granada and Pueblo was well over 130 miles.[44] The trip between the two towns was made three times a week in both directions so that several days were required for the passage.[45] As is evident from the information available, Las Animas or more exactly West Las Animas, was one of the way stations. Possibly the sketch "Home Station on the Plains" was that at Pueblo but the mountains in the background

seem somewhat exaggerated if this is the case. The artists do not seem to have stopped at Pueblo (or at least no mention is made of them in the Pueblo *Chieftain*), but went directly to Denver on the narrow-gauge Denver and Rio Grande which had been completed in June, 1872.[46]

The artists were at West Las Animas sometime during the week of November 1–8, 1873, from the record in the Las Animas *Leader,* but they arrived in Denver on November 5, 1873.[47] These dates would mean that, at the longest, four days were required to make the trip from West Las Animas to Denver, but the time of course might be less—depending on their arrival and stay at West Las Animas. Further, since they were at Emporia on October 17 and in Denver on November 5, the entire trip from Emporia was made in slightly less than three weeks. How much of this time was employed in stop-overs to make sketches and how much in traveling we do not know for certain but the travel alone could probably have been accomplished in a week or less.

The artists spent the winter in and around Denver, for there is frequent mention of them in the Denver press, the first notice appearing the day after their arrival and the last on March 20, 1874. They were in and out of Denver on numerous side excursions but rented a studio in "Schleier's block" for much of their work.[48]

All of the sketches which are included in the Colorado list, with the exception of the first group, were probably made on these side excursions. The second, "Mining in Colorado," is identified in the text as the works of the Boston and Colorado Smelting Company at Blackhawk, some twenty-five or thirty miles west of Denver. The text of nearly a column in the *Weekly* describes at some length the details of the smelting process.[49] The third illustration is not identified as to locality but shows many individual miners with their own shafts literally honeycombing the side of a mountain; a sight that the author saw repeated some dozen or more years ago when "the great depression" brought back again the individual "miner."

"On the Way To New Diggings," a long mule train in the bend of a mountain road, is the best engraved of all the Frenzeny-Tavernier illustrations and is most realistic in its appearance. "Our artists," wrote *Harper's Weekly* in its comment, "traveled for several days with such a party, and the picture we give is an accurante transcript of an actual scene, both as regards the picturesque and romantic pass where the halt has taken place and the figures and costumes of the miners." [50]

That the artists recorded many phases of the life and activities through which they passed is shown again by the illustration, "Irrigation in Colorado." Again not identified as to locality it could represent many of the

irrigation projects of that day which directed water from the Front Range down into selected areas on the plains.

The illustration, "Trout-Hatching in Colorado," is not signed nor is it credited to Frenzeny and Tavernier in the text of the *Weekly.* I have assigned it to these artists, however, not only because it fits naturally in the group but because an item from a Denver paper (*Daily Times*, March 20, 1874) reads:

> A number of invited guests, making all together quite a good-sized party, among whom were Messrs. Paul Frenzeny and J. Tavernier, of *Harper's Weekly*, made a flying visit, yesterday, to Alderman James M. Broadwell's artificial trout ponds, situated some ten miles down the Platte.

The illustration, "Returning To Camp From a Bear-Hunt," identified as "a lake in the Rocky Mountains," possibly may depict one of the artists, for one of the three figures is arrayed in a costume quite obviously different from the other two. The action of "Shooting Antelopes From a Railroad Train" took place on the plains near Kit Carson, Colorado, some 150 miles east of Denver on the Kansas Pacific. Incidentally, this full-page illustration is unique in that it is the only one with which I am familiar which shows the destruction (not hunting) of antelope from a train. There are many sketches and illustrations showing the destruction of buffalo from passenger trains of the Kansas Pacific, but no other one showing similar "sport" in the case of the antelope.

The last illustration on the Colorado list, No. 10, shows that the artists visited Estes Park during their stay in Colorado, for the text so locates the lake.[51]

A number of other sketches were made in Denver, according to newspaper accounts. A double-page illustration was actually prepared on the wood block, ready for the *Weekly's* engravers, but it was never published. The several views drawn on the block included a view of Denver, one in Clear Creek canyon, a street scene showing "Larimer street from Sixteenth street west, with the distant foothills in the background" and lastly a view in the Garden of the Gods at Colorado Springs.[52] "The whole presents a fine grouping of views, and will do more to give easterners an intelligible idea of this section than would half the letters written upon them," comments the reporter for the *Rocky Mountain News* who saw the sketches.

The view of Denver mentioned above was a reduction of a large water color prepared by the artists, a "view taken from near General Bearce's residence, and Cherry Creek, the water works, the full sweep of the city,

the plains beyond, and the mountains—showing Pike's Peak and the Buffalo back to the left. The sketch is finely touched with water colors." [53] The water color was offered for sale at $250 and was on exhibition at "Richards and Co.'s." "The blue of the mountains is most artistically rendered, while Denver is given the air of a metropolis," reports another Denver paper.[54]

WYOMING AND NEBRASKA

In this group there are but three illustrations that were published in the *Weekly*. Records of other work of the artists, however, are available. The three in the *Weekly* are:

1. "Driven From Their Homes—Flying From an Indian Raid" (about ⅔ page).
2. "An Indian Agency—Distributing Rations" (about ⅓ page).
3. "Indian Sun Dance—Young Bucks Proving Their Endurance by Self-Torture" (double page).[54a]

"Driven From Their Homes" is described by the *Weekly* as an incident of the Indian troubles of early 1874 and depicts settlers in wintry weather seeking army aid on the road between Fort Russell (near Cheyenne, Wyoming territory) and Fort Laramie. The illustration appeared in the issue of April 11, 1874; the action shown occurred "a few weeks since." These statements agree with the known facts about the Indian troubles around Fort Laramie in February and early March of 1874.[55] However, if the scene depicted was an actual one, it meant that the artists made the trip to Fort Laramie and then returned to Denver, for, as we have seen, they were in Denver on March 20. As there is evidence that the artists were in Fort Laramie and the Red Cloud Agency in Nebraska in May and June of the same year, there may be some doubt whether the scene was actually witnessed by the artists. It is possible, of course, that the artists made the relatively short trip from Denver to Cheyenne by rail and were on the trail from Fort Russell to Fort Laramie for only a short distance and then returned to Denver, a second trip northward being made later in the year.

The second and third of the illustrations listed above were made at the Red Cloud Agency, Nebraska, some 145 miles northeast of Cheyenne and 75 miles northeast of Fort Laramie.[56] They were drawn in May or June of 1874 and were sketched on the spot. "The Indian Sun Dance," one of the earliest illustrations of this ceremonial I have seen, was that of the Oglala Sioux which in the early 1870's was held near the Red Cloud Agency.[57]

The description and the illustration of the dance given in the *Weekly* corresponds in general with that given in the standard authorities.[58]

The self-torture, as part of the *public* ceremony, the large and roofless enclosure, the tall center pole and auxiliary side ones, the time of occurrence (June), and the earpiercing of children are all well-known facts of the ceremonial and are shown in the illustration or stated in the text of the *Weekly*. The great number of spectators of the dance is also in agreement with the fact that the Red Cloud Agency was one of the largest of its day. Its reported population in the middle 1870's ranged all the way from 9,000 to 16,000 individuals.[59] Schwatka who saw the sun dance the following year reported that it was "the grandest sun-dance within the memory of the oldest warrior" and that 15,000 to 20,000 spectators witnessed it. Schwatka also reported that the enclosure for the dance "looked not unlike a circus tent, the top of which had been ruthlessly torn away by a cyclone," certainly an apt description of the enclosure depicted by Frenzeny and Tavernier.[60]

The original sun dance sketch made by Frenzeny and Tavernier in 1874 was in the possession of "Deejay" Mackart of San Francisco as late as 1892.[61] Its present location, if still in existence, is unknown.

"Distribution of Rations" is another sketch not signed or credited, but since the *Weekly* stated that it was an occurrence at the Red Cloud Agency, I feel certain that it was drawn by Frenzeny and Tavernier.[62] There are several newspaper references in later years to Frenzeny and Tavernier's experiences in the Indian country of Wyoming and Nebraska, for apparently Tavernier was fond of recalling them.[63] Not only was he fond of recalling them but the material gathered in 1874 was later used by Tavernier in a number of paintings which include:

1. Store of Post Trader, Fort Laramie, 1874.[64]
2. Attacked by the Indians.[65]
3. Meeting Between Spotted Tail and Red Cloud.[66]
4. Gathering of the Clans at Red Cloud Agency.[67]
5. A Sioux Encampment.[68]

UTAH AND CALIFORNIA

1. "Mormons at the Communion Table" (about ⅓ page).
2. "Brigham Young's Wives in the Great Mormon Tabernacle" about ½ page).
3. "Quarrying Stone For the New Mormon Temple" (about ⅓ page).
4. "A Fresh Supply of Wives—Going Out to the Settlements" (full page).

 5. "Reading a Ukase in a Mormon Settlement" (about ⅓ page).
 6. "Indians Trading at a Frontier Town" (about ⅓ page).
 7. "Two Bits To See the Pappoose" (about ⅓ page).
 8. "Chinese Fishermen in San Francisco Bay" (½ page).
 9. "Sketches in 'China-Town,' San Francisco" (six illustrations on one page).
 10. "The Suburbs of San Francisco" (six illustrations on one page).[68a]

"Two Bits To See the Pappoose" and the Mormon sketches give us the clue to the continued westward journey of the partners. The first sketch (the "pappoose" was a Shoshone) shows the "Union Pacific Hotel" in the background and suggests that possibly the stopping place was either Ogden or some point east of Ogden, as the Central Pacific and the Union Pacific still had a junction at Ogden in 1874. "Indians Trading at a Frontier Town" is in the same category as the above illustration, for the text indicates that it was drawn at a railroad town; the Indians depicted, however, are Utes and the locality of the scene may have been east of Ogden as the large Ute reservation in 1874 was in western Colorado.[69]

The first two of the Mormon sketches listed above are not signed nor are they credited in the text accompanying them to Frenzeny and Tavernier. Nevertheless, I am assuming that they belong to these artists as they fit naturally into the series both with respect to time and place. A side excursion from Ogden to Salt Lake City on the Utah Central Railway is obviously also indicated. Although the Mormon sketches themselves are not unsympathetic, the text accompanying the five illustrations is anti-Mormon; a reaction, of course, which was well nigh universal throughout the rest of the United States and which was very freely stated in the highly moral *Harper's Weekly*. It is possible that the first sketch, "Mormons at the Communion Table," was imaginary, for it is doubtful if the artists would be permitted to view such a religious ceremony. Possibly, too, this fact accounts for the lack of signature or of credit for the illustration, and for "Brigham Young's Wives in the Great Mormon Tabernacle" which appeared on the same page.

The three California sketches mark the illustrative conclusion of the transcontinental tour of Frenzeny and Tavernier.[70] Both artists obviously had arrived in San Francisco very considerably in advance of the publication date of even the last of the San Francisco sketches. Although no newspaper comment has been found as yet on their arrival in San Francisco, Frenzeny had been elected a member of the famed Bohemian Club of San Francisco on August 4, 1874, and Tavernier on October 6, 1874.[71] As the reputation of these artists, based on the extensive series of illustrations

in the *Weekly*, was already established, I am inclined to think the difference in election dates means that Frenzeny arrived in San Francisco before Tavernier. At any rate, both were on the Pacific coast by the fall of 1874, and by spring of the following year mention of both artists' work, especially Tavernier's, was fairly common in the San Francisco press.[72]

UNCLASSIFIED ILLUSTRATIONS

Two of the Frenzeny-Tavernier series we have not discussed as yet. The first, "Temperance, Industry, and Happiness," is easily disposed of.[73] It is one of a pair of those contrasting "moral" illustrations in which the *Weekly* frequently indulged. It is possible that the subject, a farmer, his family and his homestead, was a topic suggested by the artists' Western trip. Its opposite, in case the reader is interested, was a scene in a tavern, "Intemperance, Idleness, and Misery." It was not drawn by Frenzeny and Tavernier.

The second illustration, "Watching For Montezuma," is said to have been based on a legend of the Moquis (Hopi) Indians.[74] As the scene depicts the pueblo-dwelling Hopi of northwestern New Mexico or northeastern Arizona, I doubt if it was based on actual observation. I have found, as yet, little evidence of a visit to this region by the artists.[75] It should be remembered, however, that the two men are known to have been in Denver nearly five months and possibly longer, and I have by no means accounted for all of their time while in that city. An excursion of two or three weeks from Denver would be a possibility. If such a trip occurred, the scenes of "Staging in the Far West" might be assigned to this suggested period. Tavernier, later in life, produced a painting of nearly the same title, "Waiting For Montezuma," [76] and still later, another one, "The Coming of Montezuma." [77] Both of these, however, were imaginative, as they depicted life of the ancient Aztecs. Photographs, without doubt, of the New Mexico-Arizona region were available in Denver and these may have served as the basis of the original illustration and the Tavernier paintings.

LATER LIFE OF THE ARTISTS

The Bohemian life of San Francisco and the California country itself held both artists in that region for some years; Tavernier for nearly the remainder of his life and Frenzeny for some five or six years.

Tavernier soon became the boon companion of many California and San Francisco artists of note, including Julian Rix, Joe Strong (a brother-in-law of Robert Louis Stevenson), Amadee Joullin and others. He was, in

fact, from the newspaper accounts of his day, the Bohemian of Bohemians and the tales of his behavior have been retold many times more recently but in many scattered sources. His most striking characteristic was a detestation of work. "He painted grand pictures in the air with his thumb and grew quite enthusiastic over their value, but it was not until the screws of material existence had tightened upon him to the last thread that he would put these inspirations on canvas," reported one of his friends. The sheriff was continually at his heels, for he was always in debt and to escape them he finally made his way to Hawaii in 1884.[78] Here he painted Mauna Loa and the colorful landscape of the islands but he again became so deeply in debt that he was not permitted to leave. He died in Honolulu on May 18, 1889, of alcoholism.[79]

"Poor Tavernier!" wrote one of his Bohemian Club friends. "The sheriff was continually taking possession of his studio so that he lived more or less in a state of siege. His friends had to go through mysterious rites, give certain knocks on the door and be inspected through peep holes before they could get in. Finally the sheriff made a clean sweep, and Jules' friends, of whom he had many, and none stauncher than fellow-artists as poor as himself, raised the money to send him to the islands. He died there a few years after and the Club erected a granite shaft over his grave in memory of their love for him personally and for his great genius." [80]

Although Tavernier was adverse to work many paintings in the period 1874–1884 are known to have been made. They include landscapes, cartoons, portraits, figure pieces, etc. Among them, in addition to those already listed, are a number which are of interest in the history of the West, some probably based on the trip of 1873–1874.[81] They include the following:

1. The Pioneer, 1877.[82]
2. The Indian Dance, 1878.[83]
3. Frontier Man (unfinished), 1879.[84]
4. Sketches of Northwest Indians, 1882.[85]
5. The Rodeo (1884–1885).[86]

Of Frenzeny's final years we know less than of Tavernier. He took an active part in the affairs of the Bohemian Club of San Francisco up until 1878.[87] His companionship with Tavernier continued apparently as long as he stayed in California.[88] A number of his own illustrations (that is, signed by himself alone and not joint work with Tavernier) appeared in *Harper's Weekly* for the years 1876, 1877 and 1878. They all deal with aspects of life in California and Nevada. The Chinese several times received Frenzeny's attention and one illustration in particular is notable, "A Chinese

Reception in San Francisco." It appeared as a double-page drawing in the *Weekly* for June 9, 1877. The Nevada sketches may have been obtained on his westward trip to the coast with Tavernier. The most interesting one of this group is an illustration of a "Camel Train in Nevada" showing remnants of the camel herd introduced into this country in 1856. Several of the Frenzeny sketches depict southern California, one, "Sunday Sports in Southern California," shows a version of the rough and callous pastime of the frontier, "The Gander Pull." [89]

In 1879 Frenzeny began a series of sketches in the *Weekly* depicting Central America.[90] As a sketch of Coney Island appears in the same year it seems reasonable to assume that he returned to New York City by way of Central America in 1879.[91] From 1880 to 1887 about thirty of his sketches appear in *Harper's Weekly*. Some of these illustrations are of New York scenes, others, of California, and there are still others which are apparently based on his trip of 1873–1874. A number of the illustrations, as the 1880's advanced, are exceptionally good. The art of wood engraving was rapidly reaching its heyday and the individual character of the artist becomes more and more apparent. The Western sketches of Frenzeny appearing in the *Weekly* during the 1880's are of sufficient importance to list:

1. "Muster-Day on an Indian Reservation," from a scene which the artist witnessed on the plains (½ page). Recently (1951) the original water color upon which this illustration is based was found by the Eberstadts of New York City, specialists in Western Americana. At the same time the Eberstadts also found the original and amusing Frenzeny "The Big Medicine Man". No reproduction has been found. Through their courtesy they are reproduced among the illustrations to this volume.
2. "Winter Life on the Plains (two illustrations on one page).
3. "After the Thaw—Victims of a Prairie Snow-Storm" (about ⅓ page).
4. "Fresh from West Point" to the plains (⅓ page).
5. "Taming and Training the American Mustang" (11 illustrations on double page).
6. "An Indian Funeral—Off for the Happy Hunting Ground" (double page).
7. "On the Rio Grande—Surrendering a Prisoner To the Mexican Authorities" (½ page).
8. "Smuggling on the Rio Grande" (about ½ page).[91a]

A few illustrations by Frenzeny appear in *Leslie's Weekly* for the period 1882–1887 but in 1889 he illustrated Harrington O'Reilly's book, *Fifty Years on the Trail; A True Story of Western Life,* recounting the Western experiences of John Nelson, a character of considerable fame in his day.[92]

Over a hundred illustrations appear in the book, and in the introduction, dated May, 1889, O'Reilly quotes Frenzeny as saying "[Illustrating this book] has given me more pleasure than any work I have ever undertaken for it is so graphic that it recalls, without any effort on my part, scenes which I am able to draw, not from imagination, but from personal observation;" the only direct quotation now available from either Frenzeny or Tavernier. After the publication of the O'Reilly book, Frenzeny drops completely from view and although my search has been extensive no further information is available at present concerning him.[93]

Chapter Eight

Indigenous Artists: Henry Worrall

By the first of July Mirage Flats was settling up, a covered wagon here, a dugout and the square patient faces of oxen there. Strips of nigger-wool sod lay straight and flat as bands of metal or greened into rows of two-speared, heat-curled corn. By now no plough would penetrate the brick-hard soil. Dry-land whirlwinds picked up bits of grass and weeds, tossed them high in the air, dropped them capriciously back upon the prairie, and zig-zagged on. Heat dances and illusionary lakes riffled away the noon hours on the whitish horizon. Already some of the settlers turned their bronzing faces from these signs of aridity and, with a deepening of the sun scowl between their eyes, lifted the lids of their water barrels, wondering how long before the rising yellow sand bars of the Niobrara would choke the little channel a man now could almost jump across.

*—Mari Sandoz, Old Jules.**

In the first half of the fifty years of pictorial history that we are here describing, relatively few artists made their homes in the West of the Great Plains. Denver had a considerable art colony by the late 1870's or early 80's as did St. Louis, Kansas City and Santa Fe. Beyond, on the shores of the Pacific, California could enumerate a considerable group of individuals who made art a profession. The majority of those professionals either were interested in the grand scenic spectacles of the mountains or were conventional artists not interested in general in portraying the incidents of every-day Western life. A notable exception was Henry Worrall, of Kansas, although there were many amateur, and a few professional artists, whose work will still occasionally be found either in the original or as (many times) uncredited illustrations in national pictorial magazines. Worrall was one of the better known of this little known group and for that reason has been included here.[1]

If Worrall is typical of this group of indigenous artists, the Kansas background, too, against which he worked was to some extent the typical art

* Copyright, 1935. *Courtesy*, the Author.

experience of the earlier West. In the three or four decades following the establishment of Kansas territory in 1854, few Kansas artists attempted to depict life in Kansas; a situation not particularly surprising since Kansas, in this period, had few artists of any kind. In these decades, the prairie wilderness was transformed into an agricultural state of growing importance in the economy of our United States, and the transformation—physically, economically and politically—required the almost undivided attention of our predecessors. To be sure, there was cultural growth, especially in the fields of education, of journalism, and of music, but on the whole the energy of these earlier Kansans was directed chiefly to the establishment of farms, homes and villages, to the building of railroads, to combating inclement weather and voracious insects and to a participation—at times a quite vociferous and rugged participation—in the politics attendant upon the formation of a new territory and state created on the virgin and spacious plains of the great West.

It is not surprising, therefore, that Kansas—and many other Western states and territories—could enumerate but few artists among their citizens. Worrall, in fact, was the only Kansas artist and illustrator in the period under consideration to achieve recognition on anything approaching a national scale for his portrayal of Kansas life.[2] He was born in Liverpool, England, on April 14, 1825, and immigrated to this country with his family in 1835. After a precarious boyhood spent in Buffalo and Cincinnati, he came to Kansas in the late 1860's.[3] There is no record that Worrall had art training of any kind. He had been a glass cutter in Cincinnati and as a young man had achieved a local reputation as a guitar player and teacher and composer of guitar pieces. In fact, one of his compositions, *Sevastopol,* which he sold to a publisher in Cincinnati for $15, subsequently became exceedingly popular and sold thousands of copies. In 1868 Worrall arrived in Topeka, where he made his home until his death in 1902. It was not long before he became a local celebrity and the Topeka newspapers had frequent comments on his activities. By the time Kansas celebrated its first quarter-centennial of statehood in 1886 Worrall was a public figure known throughout the state. One of the state's notables, for example, in addressing the quarter-centennial celebration, stated that Kansas women were able to discuss "all the artists from Henry Worrall to Praxiteles"; a comment which unwittingly reveals the public attitude toward art in 1886—for art in Kansas and the West in 1886 was a matter discussed only by women.[4]

Worrall was a man of many talents, as the above discussion may have suggested and as his subsequent history shows. He established an extensive vineyard, took part in many public musical activities and within a year

after his arrival in Topeka was making oil portraits. In addition he delivered illustrated lectures with gusto and felicity, and played pranks on his friends.[5] In fact, his puckish humor appears to have been one of his predominant traits for it appears frequently in his illustrations, many of which are caricatures.[6] To add a still more personal touch concerning the buoyant character of this Kansan, so well-known in his day but now virtually forgotten, we can quote from a letter of one of his friends and pupils, J. W. Valentine. Mr. Valentine writes, "Many times he, an old gray-haired man, and I, a fifteen-year-old, went serenading the girls of Bethany college and other girls over Topeka, about midnight. He played the guitar accompanying my violin playing. He said this fun reminded him of when he was a young fellow in Cincinnati and he enjoyed it." [7] Worral must have really enjoyed life!

We must return, however, to Worrall's career as a pictorial recorder of past Western life. His fame in this field lies in the fact that he was an occasional contributor to *Harper's Weekly* and to *Frank Leslie's Illustrated Newspaper* as well as a contributor to many minor and local publications. He is probably best known, however, as the illustrator of two very important books of Western history: McCoy's *Historic Sketches of the Cattle Trade* and W. E. Webb's *Buffalo Land*. In addition, Worrall made a number of original sketches and paintings which have never been published.

ILLUSTRATIONS IN *Harper's Weekly* AND *Frank Leslie's Illustrated Newspaper*

Worrall's work in these two pictorial journals recalls many interesting incidents of past Kansas life. A few of this group, however, are illustrations made in the neighboring states of Colorado and New Mexico (then New Mexico territory). As published, these illustrations were many times redrawn by other artists; either because the draftsmanship was not satisfactory or because the dimensions of the drawings submitted by Worrall to these publications did not suit their page sizes.[8] The illustrations listed chronologically include:

1. "Through the Veta Pass—The Ascent on Dump Mountain—Grade, 217 Feet Per Mile" (about ½ page), (1877).
2. "The John Brown Monument, Osawatomie, Kansas" (six sketches on one page as follows): "John Brown's Cabin"; " 'Old' John Brown"; "Oration on the Battle Ground of Osawatomie"; "Dedication of the Monument"; "The Monument at Osawatomie," and "Dinner on the Battle-Field," (1877).

3. "The First Public Inauguration of a Governor in Kansas, January 13, 1879—The State-House in Topeka" (about ½ page), (1879).

4. "The Colored Exodus—Scenes at Topeka, Kansas" (three illustrations on one page as follows): "Terminal Station of the Colored Exodus—Floral Hall and Secretary's Office, Now in Use as Barracks—Fair Grounds"; "Religious Services in the North Wing of Floral Hall"; "Group in the South Wing of Floral Hall" (probably redrawn by W. P. Snyder), (1879).

5. (a) "Assembly of Races on Plaza of Las Vegas. Celebration at Las Vegas, New Mexico, the Terminus of the Railroad (N.M. and S.P.R.R.) on July 4, 1879"; (b) "Pueblo Indians Selling Specimens of Native Pottery" (two illustrations on one page), (1879).

6. "The Old Santa Fe Trail and Railroad Switchback Over Raton Pass Near Trinidad," (1879).

7. "Scenes in Santa Fe, New Mexico" (three sketches on one page, one redrawn by Charles Graham, as follows): "General View of Santa Fe"; "The Only Protestant Church in Santa Fe," and "The Oldest Inhabited House in the United States," (1879).

8. "Royal Gorge in Grand Canyon of the Arkansas" (full page), (1880).

9. "Departure of the 'Corn Train' From Wichita, Kansas" (about ½ page), (1884).

10. "Cattle in a Blizzard on the Plains" (full page), (1886).

11. "The Kansas Trouble at Topeka" (full page), "On the Spot," "South Side of Capitol Square—Military Guarding the Arsenal," (1893).

12. "The Opening of the Cherokee Strip, September 16, 1893" (eight sketches on one page, several redrawn by Graham and others, as follows): "Orlando, September 14th.—Selling Water at the Railroad Station . . ."; "Wichita, September 13th.—Selling Water to 'Strippers' on the Train . . ."; "Orlando, September 14th.—'Come On, You Thirsty People, Five Cents For All You Can Drink . . .'"; "Ten Minutes Before the Great Rush— . . . Near Arkansas City"; "Site of the Future City of Perry, Showing United States Land Office . . ."; "Registration Booths on the 'Line,' South of Arkansas City, September 15th"; "On the 'Registration Stools' At the End of the Line, Arkansas City, September 15th," and "The Grand Rush At Noon of September 16th . . .", (1893).

13. "Irrigation in Southwestern Kansas" (full page, redrawn by G. W. Peters), seven sketches credited to "H. Worrall and Photographs (1894) [9]

Illustrations 1, 5, 6, 7 and 8 of the above group were obviously drawn on out-of-state excursions. Worrall traveled extensively over Kansas and

into southeastern Colorado in the employ of the Atchison, Topeka and Santa Fe railroad and the above illustrations probably resulted from such excursions. Veta Pass is in southeastern Colorado, about a hundred miles southwest of Pueblo [10] and the engineering feat involved in running the Denver and Rio Grande railroad over the steep ascent of Veta Pass was regarded as one of the marvels of the 1870's.[11] The illustrations listed as Nos. 5, 6, and 7 were also probably made at the same time despite the difference in the place of publication. Here the illustrations resulted from the completion of the railroad to Las Vegas.[12]

The illustrations listed under No. 2 were drawn in connection with the dedication of the John Brown monument at Osawatomie on August 30, 1877. The monument was dedicated on the twenty-first anniversary of the battle between Proslavery and Free-State men, the latter supposedly led by Brown.[13] Ex-Gov. Charles Robinson was the chairman at the dedicatory services and Sen. John J. Ingalls, the leading orator of Kansas, delivered the main address.[14]

"The First Public Inauguration of a Governor in Kansas" (No. 3) was drawn on January 13, 1879, "a bitterly cold day," and shows Gov. John P. St. John delivering his inaugural address on the east steps of the state house. Governor St. John, who probably had a larger mustache than any other Kansas governor (a photograph of St. John is also reproduced with the above illustration showing him with a mustache of truly magnificent proportions), described in his address the progress of the state, pointing out that "now" (1879) the state's population was 900,000, that it possessed 2,300 miles of railroads, 4,500 schoolhouses, and "a population intelligent, patriotic and enterprising, and with almost boundless natural resources within her boundaries, Kansas may well look forward to a future of still greater prosperity." [15]

"The Colored Exodus" (No. 4) shows the terminal station in Topeka arranged to receive the immigration of colored people from the South. In the late 1870's the immigration reached its flood tide and thousands of Negroes—many of them destitute—reached Kansas in the hope of finding new homes and improved fortunes in the state where John Brown had achieved his fame. As many as eleven Negro colonies were established in Kansas, one of them far out on the Great Plains northwest of Kinsley, Edwards county. Senator Ingalls is reported to have said: "I do not think there is any class prejudice or any feeling of hostility to the colored people that would prevent their being cordially welcomed as an element of our population. We have an area of about 81,000 square miles, comprising

55,000,000 of acres of arable land, not more than one-tenth of which has been reduced to cultivation. The remainder is open to settlement under the Homestead Act, requiring five years' residence before title can be secured, and I am inclined to think we could absorb 100,000 of these people without serious injury or inconvenience."

The lack of capital and the rigors and vicissitudes of Kansas climate in time discouraged the majority of these immigrants and they drifted on. One of these Negro colonies has survived, however, to the present day and Nicodemus, Graham county, is the only all-Negro town in the state.[16]

"Departure of the 'Corn Train' From Wichita" (No. 9) records a turn in the economic affairs of the state. In 1874, after the great grasshopper infestation, Kansas had solicited aid for many citizens of the state made destitute by the insect damage.[17] In 1884, ten years later, Kansas was able to repay her debt in part when great floods in the valley of the Ohio river made homeless and hungry many inhabitants of the valley. Kansans listened to the appeal for help and sent a train of thirty-one carloads of corn, payment "with interest" as the gayly decorated cars proclaimed.[18]

"Cattle in a Blizzard on the Plains" (No. 10) is a graphic reminder of the great blizzards occurring in the winters of 1885–1886 and 1886–1887. In fact, so disastrous were the blizzards that the resulting wholesale loss of cattle ruined many cattlemen. Theodore Roosevelt's ranching venture in the Dakotas, for example, came to an abrupt halt in 1887 after the great blizzards of the two winters left him with scarcely an animal and with a loss of nearly $50,000.[19]

"The Kansas Trouble at Topeka" (No. 11) recalls the profound interest which Kansans then and now take in their politics. The two contending parties (Populist and Republican) of 1893 each had their own legislature and each refused to recognize the other. Open warfare nearly resulted but the affair was finally settled in favor of the Republicans.[20]

"The Opening of the Cherokee Strip" (No. 12) with Worrall's sketches "made on the spot," record pictorially the opening of "the last great body of arable land in the United States." Although dramatic in retrospect it was called at the time "the most disgraceful and disorderly scramble that has ever occurred in the distribution of public lands." Worrall's sketches are not the only graphic recordings of this event but they are probably the best known.[21]

The last group of the sketches listed above (No. 13), recalls the fact that many attempts have been made to irrigate the arid lands of the High Plains. Waters from mountain streams, from the rivers of the High Plains

and from artesian wells have all been used in many such experiments since the tide of Western immigration began.[22]

One other illustration appearing in a national publication should, however, be mentioned in this group of Worrall's work. Thomas Nast, the well-known illustrator, published in *Harper's Weekly* for August 10, 1872,[23] a cartoon, "The Cat's-Paw.—Any Thing to Get Chestnuts," showing Boss Tweed (the monkey) wearing a Tammany collar using a cat's-paw to take hot chestnuts from a stove, the Goddess of Liberty looking on. The claim was made in a Topeka paper that Worrall had sent to *Harper's Weekly* a cartoon illustrating the fable of the monkey using a cat's-paw to take hot chestnuts from the fire with Uncle Sam looking on.[24] The cartoon had been photographed by Knight of Topeka before it was sent to the *Weekly*. The *Weekly* never acknowledged the receipt of the drawing but after three months the Nast cartoon appeared with the same composition but the figures changed to suit Nast's campaign against the Tweed ring; the title still remained the same as that used by Worrall, "The Cat's-Paw.— Any Thing to Get Chestnuts." This account in the Topeka paper complained not only of the Worrall-Nast cartoon but of the "smouging" of other Worrall pictures by both *Harper's Weekly* and *Frank Leslie's Illustrated Newspaper*.

The reference to *Leslie's* in this account strongly suggests that a group of important Kansas illustrations appearing in *Leslie's* for 1871–1872 were the work of Worrall. The group are sometimes credited "By our special artist" and several have the signature "Bghs" appearing on them. "Bghs" was Albert (Alfred?) Berghaus, a member of the *Leslie's* art staff who undoubtedly redrew the signed illustrations. The possible Worrall sketches includes:

"Shooting Buffalo on the Line of the Kansas Pacific" (full page, *Leslie's*, June 3, 1871, p. 193);
"Loading Cattle at Abilene," (*ibid.*, August 19, 1871, p. 385);
"Buffalo Hunt of Grand Duke Alexis," (*ibid.*, February 3, 1872, p. 325);
"Whiskey on the Plains," (*ibid.*, February 3, 1872, p. 328);
Cartoons on the Buffalo hunt by Grand Duke Alexis, "By our special artist, from a telegraph pole," (*ibid.*, February 10, 1872, p. 349).

The illustration for which Worrall achieved his greatest local fame was a caricature, "Drouthy Kansas." It appeared originally as the cover page of the *Kansas Farmer* for November, 1869, although it had received mention

before this date,[25] and had been photographed by Knight,[26] the well-known Topeka photographer, and distributed as card photographs.

Strictly speaking, this caricature probably does not deserve recognition in this book as it does not depict any real scene in past Western life. To neglect it, however, would render our study of Worrall far from complete. Caricature was Worrall's strongest point, for he was not a skillful drafts-man, but his ever-present sense of humor found its outlet in line drawings whose figures were readily recognizable and whose humor was particularly suited to the taste of Westerners. If Worrall's caricatures do not contribute greatly to our pictorial knowledge of past Western life they do contribute to our knowledge of Western taste and humor.

"Drouthy Kansas" will illustrate this point. It was drawn in 1869 when the climatic reputation of Kansas still suffered from the drought of 1860.[27] The late 1860's in Kansas, however, were years of heavy rainfall and good crops, facts to astonish the Eastern visitors who still heard the persistent tales of 1860. A group of Cincinnati friends of Worrall who came to Topeka in 1869 were evidently of the frame of mind described above. Before their arrival, Worrall made for their benefit the large charcoal sketch "Drouthy Kansas." It depicted men climbing ladders and using hatchets to cut ears of corn from huge stalks; watermelons so big that two men could stand on them; sweet potatoes that required a derrick to lift them from the ground, and wheat fields yielding fifty bushels to the acre. In the middle distance a river was shown swollen in flood with rain coming down in sheets and in the background a clearing sky and rainbow. The caricature proved im-mensely popular; it was talked about in the press, it was printed on the cover page of an issue of the *Kansas Farmer* and used as a broadside in advertising the same publication; it appeared in the widely distributed *Resources of Kansas,* by C. C. Hutchinson, published in 1871 as a handbook to attract settlers to Kansas, and it was painted on the drop curtain of Liberty Hall, an auditorium and theater in Lawrence. It was "the best ad-vertisement for Kansas that was ever published" reported several Kansas papers.[28] The tide of enthusiasm for the cartoon finally turned, however. After the grasshopper year and drought of 1874, residents from the grass-hopper belt made long journeys to cuss "the man who got up that 'picter'. ". . . Delegations waited on him to inform him that, had it not been for the diabolical seductiveness of that picture they would never have come to Kansas to be ruinated and undone by grasshoppers." [29] Other caricatures by Worrall we shall discuss later but it can be remarked in passing that this form of "art" constituted Worrall's most characteristic output.

Historic Sketches of the Cattle Trade
AND *Buffalo Land*

Historic Sketches of the Cattle Trade by Joseph G. McCoy was published in Kansas City in 1874.[30] It has been called by competent students a "classic work" and "one of the most valuable accounts of the cattle trade." [31] The point which concerns us in this classic of the West is the fact that a statement on the title page reads "Illustrated by Prof. Henry Worrall, Topeka, Kas." The illustrations, some 126 in number (plus 20 or 22 full-page advertisements as mentioned in note 30), include 57 portraits, 53 views and 16 cartoons. The portraits were undoubtedly drawn on wood from photographs as were probably several of the illustrations listed as views. Most of the views are full-page and depict aspects of ranching, cattle drives, the packing house industries, and life in cattle towns, especially Abilene, the end of the Texas cattle trail in the early days of cattle shipping. The wood engravings are poor but nevertheless retain considerable value and interest. Some are purely imaginary; [32] others are given legends which do not correspond to fact. On page 94 is the full-page illustration, "Col. O. W. Wheeler's Herd, En Route for Kansas Pacific Railway, in 1867." Obviously either the legend is incorrect or it was not drawn from life, for again, it may be remarked, Worrall was not in Kansas in 1867. Many years later, however, McCoy reproduced this illustration in an autobiographical sketch with the legend "Herd on the Trail Enroute to Wichita. Sketch Drawn in 1873 by Prof. Henry Worrell [*sic*] of Topeka." [33] Comparison of this illustration with the Frenzeny and Tavernier illustration of a trail herd approaching Wichita, also drawn in 1873,[34] shows some surprising similarities. The trailing herd depicted in both cases shows the same form, a long sinuous line of similar curves with cowboys at intervals on both sides of the herd. One might guess that one illustration was drawn from the other but this possibility seems unlikely as both were published at practically the same time.[35]

Very probably the explanation of the similarity in the illustration, coupled with McCoy's statement, lies in a news item in the Topeka *Commonwealth* (October 11, 1873), which states "Paul Frenzeny and Jules Tavernier, artists and correspondents of *Harper's Weeky* [*sic*], in company with Prof. Worrell [*sic*], the well known artist of Topeka, are in Wichita for the purpose of taking sketches of that town and vicinity." It is thus a distinct possibility that the two illustrations depict the same scene. In some respects the Worrall illustration is the better of the two from the standpoint of factual knowledge. It shows a broader sweep of characteristic country and depicts

the cattle as longhorns and not the Eastern cows of Frenzeny and Tavernier. The long horns of the longhorns, if the reader can gather my meaning, are not anatomically correct even in the Worrall illustration, but as already pointed out, the wood engravings in McCoy are all poorly executed so we have no way of determining whether the fault lies with the engraver or with Worrall.[36]

McCoy, in his autobiographical sketch previously noted, also reproduced and made comment in the legend on another of the Worrall illustrations. The illustration appeared originally under the title, "Winter Herding Upon the Upper Arkansas River.—Dennis Sheedy's Camp." [37] In the autobiographical account it appears under the title, "Camp Scene; Herd Awaiting Buyer on Kansas Range.—Sketch From Life Drawn in 1872 by Prof. Henry Worrell." [38]

In W. E. Webb's *Buffalo Land*, Worrall's characteristic good humor appears in numerous caricatures and cartoons.[39] In fact this feature is even more pronounced in the Webb book than it is in McCoy and for good reason.

Buffalo Land is essentially a story of the humorous and sporting adventures of a group of individuals on the Great Plains of Kansas and Colorado. Webb has given fantastic and fictitious names to the members of his party and their story is told with a levity that is sometimes marked by a grisly humor. For instance, the party met a plainsman in a Topeka hotel who regaled them with the story of Western justice meted out to a mule thief. Webb gives the plainsman's account in verse

> We started arter that 'ere pup,
> An' took the judge along,
> For fear, with all our dander up,
> We might do somethin' wrong.
>
> We caught him under twenty miles,
> An' tried him under trees;
> The judge he passed around the "smiles,"
> As sort o' jury fees.
>
> "Pris'ner," says judge, "now say your say,
> An' make it short an' sweet,
> An', while yer at it, kneel and pray,
> For Death yer can not cheat.
>
> "No man shall hang, by this 'ere court,
> Exceptin' on the square;
> There's time fur speech, if so it's short,
> But none to chew or swear."

> An' then the thievin' rascal cursed,
>> An' threw his life away,
> He said, "Just pony out your worst,
>> Your best would be foul play."
>
> Then judge he frowned an awful frown,
>> An' snapped this sentence short,
> "Jones, twitch the rope, an' write this down,
>> Hung for contempt of court!" [40]

There is no evidence, either internal or external, that Worrall was a member of Webb's party, but with such text to guide him, Worrall must have found an illustrative job that fitted his own tastes and talents to a high degree, and "Hung for Contempt of Court" was one of Worrall's illustrations.[41] It should be remarked that Worrall, in addition to possessing a sense of humor in agreement with the context of *Buffalo Land,* was also well acquainted with and had participated in just such excursions as the Webb party undertook. The illustrations in *Buffalo Land* (with the exception of a few credited as "From a Photograph") are therefore all imaginary but were drawn by one well qualified for the task. As in *Historic Sketches of the Cattle Trade* the illustrations are reproduced through the medium of the wood cut. Although still crude, as judged by modern standards, the engraving was better done in the Webb book than in McCoy's.

It should not be thought, however, that Webb's book and the Worrall illustrations are of value only as part of a history of American humor. The very frequent reference made to the book by present-day writers on plains history of the 1870's is well deserved, for *Buffalo Land* had other aspects than simply humorous ones. The characters, whether real or fictitious, traveled through a real land where characteristics were ably and truthfully described. Extensive appendices are also given in the book for the benefit of homeseekers, sportsmen and would-be ranchers. "The information given concerning the matters treated of we can endorse as being entirely authentic; and it is information of interest and value, to Kansas and to the country at large. . . . The book is profusely illustrated from designs by Professor Henry Worrall, of Topeka—all of them good, and some of them, particularly the frontispiece, of striking excellence," reports *The Kansas Magazine* on the first appearance of the book.[42] Later in the same year *The Kansas Magazine* commented again on *Buffalo Land*:

> Mr. Webb's book is written in a fresh and vigorous style, and gives the first really correct and satisfactory idea of the Plains country that has been published. It embraces the results of extensive personal ex-

periences and observations within the last three years, and is not a mere reproduction, in a new garb, of what Greeley, Richardson and others saw and heard in their flying trips across the continent. Everything desirable to be known about the interesting region between the Missouri River and the Rocky Mountains, for any purpose whatever, is told in a manner that leaves nothing to be guessed at; and the illustrations, from original designs of Professor Worrall, of Topeka, add materially to the naturalness and general attractiveness of the work.[43]

The Worrall illustrations in *Buffalo Land* despite their imaginary character, we can therefore conclude are interesting and valuable—if humorous—records of past Western life.

Henry Worrall died in Topeka on June 20, 1902, at the age of 77. According to one of his well-known contemporaries, T. C. Henry, he was "a man whose unique public services Kansas should honor." [44] Important and useful as were his many contributions to the state, his public services have been until now long since forgotten. This brief review of some of those contributions is a belated reminder to present-day Kansans of a predecessor who gave generously of his time and talents in the state's development. "All his life has been devoted to art. His ability, taste and judgment have often been of great service to the people of Topeka and Kansas and he did much for the advancement of art in the middle West," was the judgment of the Topeka *Herald* in commenting on Worrall's life.[45]

Chapter Nine

Custer's Last Stand

JOHN MULVANY, CASSILLY ADAMS AND OTTO BECKER

> *The wounded day bled ashen in the West;*
> *The firing dwindled in the dusk and ceased;*
> *The frightened stars came peeking from the east*
> *To see what anguish moaned. The wind went down—*
> *A lull of death. But yonder in the town*
> *All night the war drums flouted that despair*
> *Upon the hill, and dancers in the glare*
> *Of fires that towered filled the painted dark*
> *With demon exultation, till the lark*
> *Of doom should warble.*
> > John G. Neihardt—"High Noon on the Little Big Horn,"
> > *from* The Song of the Indian Wars.*

What painting—or its reproduction—has been viewed, commented on and discussed by more people in this country than has any other? Rosa Bonheur's "The Horse Fair"? Landseer's "The Stag at Bay"? The "September Morn" of Paul Chabas? Willard's "Spirit of '76"? "Washington Crossing the Delaware" by Emanuel Leutze? Hovenden's "Breaking Home Ties"? [1] Doubtless each amateur connoisseur will have his own candidate for this position of honor but the writer's nominations for the place are two figure paintings of the same subject, John Mulvany's "Custer's Last Rally" and Cassilly Adams' "Custer's Last Fight." Mulvany's painting, completed in 1881, was for ten or a dozen years displayed, known, and admired throughout the country. Chromolithographic copies of the painting can still be occasionally found. The Adams painting, done in the middle 1880's, was lithographed in modified version by Otto Becker and published by the Anheuser-Busch Company of St. Louis in 1896, and is still distributed by that concern. Copies can be viewed in barrooms, taverns, hotels, resturants, and museums throughout the country. It is probably safe to say that in the

* Copyright, 1925, The Macmillan Company, and used with their permission.

fifty years elapsing since 1896 it has been viewed by a greater number of the lower-browed members of society—and by fewer art critics—than any other picture in American history. To be more specific, the writer on a bus trip to St. Louis in the summer of 1940, stopped for rest and refreshment at a tavern in a small mid-Missouri town. On one wall of the tavern, a busy rest stop for bus lines traveling east and west, was "Custer's Last Fight." Each bus that came to rest disgorged its passengers, many of whom found their way into the tavern. As each group entered, some one was sure to see the Custer picture with the results that there were always several people— sometimes a crowd—around it, viewing it, commenting on it, and then hurrying on. Probably hundreds of people saw this picture every month. When one considers that 150,000 copies have been published and distributed since the picture was first published in 1896, it is evident that "Custer's Last Fight" has been viewed by an almost countless throng. Kirke Mechem, for many years secretary of the Kansas State Historical Society, tells me that a reproduction of the painting in the Memorial building close to his work room, is likewise viewed by a constantly changing daily audience. The picture fascinates all beholders, for after viewing it and passing on to examine other pictures and exhibits, a return is made to see again "Custer's Last Fight." "It is the most popular by far of all our many pictures," reports Mr. Mechem.

Why? The scene is totally imaginary, for no white witness survived the Custer tragedy. Postponing for the moment the detailed consideration of Mulvany's and Adams' masterpieces, it can be pointed out that the fundamental reason for the popularity of these pieces is the event itself, the event centering around the great climacteric of Custer's life.

Doubtless the name of George Armstrong Custer will be the center of controversy as long as this country honors its military heroes. Few individuals in the nation's history have had the spectacular and varying career that became Custer's lot. At twenty-three he was a first lieutenant in the United States army assigned to General McClellan's staff who were then assembling the famed Army of the Potomac. Overnight, Custer rose from first lieutenant to brigadier-general of volunteer cavalry. Two years later, he was a major-general. The close of the Civil War brought almost as abrupt downward changes and nearly disaster to his fortunes. From major-general to captain, from hero to deserter were his downward steps. The desertion was followed by suspension, but eventually reinstatement to his regiment (the 7th cavalry, organized in 1866) started him again on his upward way. At the battle of the Washita against the Plains Indians in 1868 he again

gained the eye of the nation. It was not long, however, before he incurred the displeasure of President Grant and was ordered detached from his command. At the last moment the order was rescinded and as lieutenant-colonel in command of the 7th cavalry, he led his command in that long-remembered battle above the Little Big Horn river on June 25, 1876. On the bare Montana uplands, that bright and burning summer day, Custer and his immediate followers entered Valhalla with a drama and suddenness that left the nation shocked. Not a man in that group survived as the Sioux and their allies gave battle. Small wonder that the tragedy of the Little Big Horn has been told by writer, poet and painter in the days since 1876, for here are the elements that should rouse imagination. Indians, the great West, the boys in blue, great tragedy and no living white observer to witness the culmination of a spectacular career!

And imagination has been used. So much so that it is difficult to trace the events of that day. Students of Custer and of the battle of the Little Big Horn have appeared in number. The event still attracts attention and each contribution, as it has appeared, has been almost immediately the subject of extensive adverse criticism or praise.[2]

Pictures of Custer's Last Stand have not often been the subject of serious consideration. The student of art, if he has ever condescended to look at such pictures, politely sniffs the tainted air because, it is true, few of such pictures have any artistic merit. There are, however, some exceptions as will be subsequently pointed out. The professional historian, since such pictures must be figments of the imagination, relegates them to the limbo of worthless things. It remains therefore, for the interested busybody who has nothing else to do to consider their worth, if worth they have. As historical documents, pictures of Custer's Last Stand are admittedly worthless,[3] but any product of man's endeavor which has attracted the attention of millions of his fellows must certainly have some worth. Such pictures have kindled imagination and speculation, have developed observation and criticism [4] and have renewed and aroused interest in our past. In any well-rounded system of history, then, the consideration of such pictures has a place, even if a humble one. Are they not closer and more vital to our American way of life than is Chinese art or the primitive masters? If the art historian or teacher feels that it is his duty to improve the artistic sense and taste of his fellow man, why cannot "popular" pictures—rather than being held up to scorn—be used as a starting point in such a program of education? The wide appeal of such pictures would insure a large audience and therefore a more fertile field for the zealous in

art. The strength and weakness of such pictures are easily pointed out, and interest in art might be readily stimulated by this method rather than by the use of more conventional ones.

It can, however, be pointed out that there is now available abundant source material for the critical examination of such pictures if the observer is so inclined. Maps and photographs of the terrain upon which Custer fought his last battle are accessible to the interested critic or artist, as are details of equipment of both Indians and soldiers.[5] Description of many incidents, for which there is good evidence, are also available.

Dustin, one of the careful students of the battle of the Little Big Horn, writes in this connection:

> Pictures have a proper place in history, provided they are true to life, and many have been painted and drawn of "Custer's Last Battle" and related scenes. In some of the most thrilling, officers and men are represented fighting with sabers and clothes in full dress uniforms, the former with shoulder knots, cords, and aquillettes, and the latter with brass shoulder scales. Custer himself has been depicted arrayed in a short jacket, an enormous red tie, and long red hair falling over his shoulders. In fact, not a saber or sword was carried in this fight, and the dress was the ordinary fatigue uniform, although some of the officers, among them Custer, wore comfortable buckskin coats. The men were armed with the Springfield carbine and Colt or Remington revolver, while many of the officers had rifles of different patterns, belonging to them personally.[6]

Custer's long hair, mentioned above by Dustin, had been cut before his last campaign,[7] and it seems possible from accounts of surviving Indian participants of the battle, that Custer fell early in the final stages of the fight,[8] although some artists have depicted him as the final survivor.[9] It is true that the body of Custer was found near the summit of a ridge overlooking the Little Big Horn river surrounded by the bodies of forty or fifty of his men and of many horses. Dustin describes the scene as follows:

> Custer himself was lying on the slope just south of the monument, face upwards, head uphill, right heel resting on a dead horse, his right leg over a dead soldier lying close to the horse. The right hand was extended and looked as though something had been wrenched from his grip. The body was stripped but not mutilated in any way, and it was with difficulty that the wounds were found which caused his death. One was in the left side of the head through the ear; another on the same side under the heart, and a third in the right forearm.[10]

For Indian equipment and costumes there is available the extensive description of the Cheyenne warrior, Wooden Leg, who took part in the battle.[11] According to Wooden Leg, warbonnets were worn by twelve of the several hundred Cheyenne warriors present, of which ten had trails.

> Not any Cheyenne fought naked in this battle. All of them who were in the fight were dressed in their best, according to the custom of both the Cheyennes and the Sioux. Of our warriors, Sun Bear was nearest to nakedness. He had on a special buffalo-horn head-dress. I saw several naked Sioux, perhaps a dozen or more. Of course, these had special medicine painting on the body. Two different Sioux I saw wearing buffalo head skins and horns, and one of them had a bear's skin over his head and body. These three were not dressed in the usual war clothing. It is likely there were others I did not see. Perhaps some of the naked ones were No Clothing Indians.[12]

Wooden Leg also described his own preparations for battle, "I got my paints and my little mirror. The blue-black circle soon appeared around my face. The red and yellow colorings were applied on all of the skin inside the circle. I combed my hair. It properly should have been oiled and braided neatly, but my father again was saying, 'hurry,' so I just looped a buckskin thong about it and tied it close up against the back of my head, to float loose from there." [13]

For weapons Wooden Leg had a six-shooter and lariat, and his war pony had a blanket strapped upon its back and a leather thong looped through its mouth. Bows and arrows, however, were the usual weapons of the Indians, many securing their first guns from their fallen enemies.[14]

Indian witnesses of the battle have also reported important incidents of the tragic fray which artists of the event could—or have—used in their portrayal. Many of the attacking Indians advanced up numerous side gullies, thus protecting themselves from the fire of the soldiers.[15] In this manner, the total losses among the Indians were kept exceedingly low considering the magnitude of the engagement. Only about thirty Indians were killed,[16] but the portion of the 7th cavalry under Custer's immediate command, which was wiped out, numbered some two hundred and twenty.[17] If many of the Indians fought dismounted, probably a greater number on horseback circled the fight. "We circled all round him [Custer]" is the brief statement of Two Moon, another Indian survivor. Two Moon also recalled that "The smoke [over the battlefield] was like a great cloud, and everywhere the Sioux went the dust rose like smoke." [18]

Several of the paintings of the Custer battle have apparently utilized another recollection of Two Moon. "All along," states Two Moon, "the

bugler kept blowing his commands. He was very brave too." [19] The bugler was doubtless Chief Trumpeter Henry Voss, killed in action.[20]

Still another incident of the battle which has not yet found its way into any picturization of Custer's final hour, as far as the writer knows, was the recollection of Rain-in-the-Face, a Sioux, still another survivor. Rain-in-the-Face told Charles A. Eastman, the well-known Sioux writer, that Tashe-namani, an Indian maiden whose brother had been killed in an engagement with General Crook shortly before the battle of the Little Big Horn, took part in one of the charges against Custer. "Holding her brother's war staff over her head, and leaning forward upon her charger, she looked as pretty as a bird. . . . 'Behold, there is among us a young woman,' I shouted. 'Let no young man hide behind her garment.'" [21]

Scalping of the dead and dying soldiers, depicted in some of the pictures of Custer's Last Stand, was a fact. Known mutilation of the dead soldiers' bodies, however, was the work of boys, women and old men when the field was won for the Indians.[22]

Much more might be written concerning factual aspects of the battle but what has been written above will enable us to make some judgment— if we must stick to facts—in the various portrayals of the battle scene; or the brief review, made above, might indicate the way for some artist of the future whose talents, ambition and imagination might lead him to attempt another version of Custer's Last Stand.[23]

Since the Mulvany and Adams paintings and the Becker lithograph are by far the best known of this group of battle paintings, their history, with some information concerning the artists, will be given in some detail.

John Mulvany

Mulvany, an Irishman by birth, was born about 1844 and came to this country when twelve years of age. As a boy, after his arrival in New York City, he worked around the old Academy of Design and evidently picked up some training in drawing and sketching. Judging from the meager information concerning his early career, he joined the Union army at the outbreak of the Civil War and continued his sketches in the field. At the close of the war he had enough money to take him abroad, where he became an art student in the famous centers of Dusseldorf, Munich, and Antwerp. He achieved considerable success as a student, winning a medal for excellence at Munich. At Munich he was a student of Wagner and of the famous Piloty, well known for his historical paintings, including a number of battle scenes. Later he went to Antwerp where he studied under De

Keyser, the Flemish painter of battle pieces.[24] He returned to this country in the early 1870's and was for a time a resident of St. Louis, Chicago, and Cincinnati. After the great Chicago fire of 1871, Mulvany went farther West and lived near the Iowa-Nebraska border where he began accumulating Western material. His first painting of note, "The Preliminary Trial of a Horse Thief—Scene in a Western Justice's Court," was exhibited before the National Academy of Design in 1876.[25]

As a resident of the West, Mulvany, like countless other Americans in 1876, was shocked by the Custer tragedy, and his interest in Western life doubtless led him to contemplate the Custer battle as a theme for his brush. In 1879, after establishing headquarters in Kansas City, he visited the Custer battlefield, made sketches of the terrain and visited the Sioux on reservation. Mulvany also studied, according to his own account, the dress and equipment of the United States cavalry and obtained portraits and descriptions of General Custer and his officers. "I made that visit," he stated two years after the trip to the Little Big Horn, "because I wished to rid the painting of any conventionality. Whenever nature is to be represented it should be nature itself, and not somebody's guess. I made myself acquainted with every detail of my work, the gay caparisoning of the Indian ponies, the dress of the Indian chiefs and braves; in fact, everything that could bear upon the work." [26] For two years he worked on his masterpiece, which he named "Custer's Last Rally." The work of painting was done in Kansas City, although Mulvany seems to have made other Western trips in this period as well as occasional excursions to nearby Fort Leavenworth for the purpose of consulting army officers at that post.

The painting was nearly complete by the end of March, 1881, for on March 18, the reporters of the Kansas City newspapers, some twenty in number, were invited to view the work.[27] The painting which the twenty gentlemen of the press beheld with awe and admiration was an enormous work, measuring 20 x 11 feet with figures of herioc size. In describing it, one of the journalists wrote:

> Custer is, of course, the central figure. He is depicted as standing below, and a little to the right of his favorite horse, in the middle of the barricade formed by the few soldiers who participated in the final hopeless struggle. In his left hand, which is extended at full length, is a revolver, which he is aiming at some unseen foe, while with his right he grasps a glittering saber, holding it tightly at his side. His face expresses all that a man would feel when confronted by certain death. Despair is crowded out by undaunted courage; the thought of personal danger seems to have been sunk in hatred for a bloodthirsty foe, and a subdued expression in the eyes shows that pity for the gallant boys

in blue, whom he has hurried to impending doom, is struggling hard for supremacy. His face is flushed with the heat of battle, his broad-brimmed hat lies carelessly on one side, and the long yellow locks, which added so greatly to his manly beauty, are tossed impetuously back. He stands erect, undaunted and sublime. Near him, kneeling upon the ground, and with bandaged head from which blood is spurting, is Capt. Cook, adjutant of the regiment, and a warm friend of Custer's. Cook darts a glance of hatred at the red devils and has his hand upon the trigger of his rifle waiting for a chance to shoot. In the immediate foreground are two Sioux Indians, both dead. One lies with his face turned upward to the June sun, and a more hideous countenance could not be found if a search was made from Dan to Beersheba. The face was covered with paint, the ears and nose are pierced, a gaudy bonnet of eagles' feathers adorns the head, and the features are horribly savage, even in death. The artist has been true to nature in his treatment of the redskin. The breech clout and moccasins and head-dress are faithfully delineated.

The general plan of the painting is that of a semi-circle of soldiers intrenched behind dead and dying horses and surrounded by an innumerable horde of Sioux warriors. With the exception of three officers and perhaps half a dozen privates, the soldiers' faces cannot be seen as they are turned to the foe. The barricade is irregular in outline, but preserves some semblance of a circle. The men kneel behind the horses, which have either been killed by the Indians or which the soldiers have themselves killed for shelter, and from this partial cover are making

As Brave a Defense as They Can.

Outside of the enclosure a countless host of savages are pouring a deadly fire upon the little band. The artist has graphically delineated that phase of Indian fighting which is most characteristic of the race. It is well known that an Indian never exposes his person unless the odds are overwhelmingly in his favor. Custer being in such a hopeless minority the foe expose themselves recklessly, and present many fine targets for the blue coats, not seeming to realize that some stray shots may wander that way and hurry them to a timely grave.[28]

Mulvany told his guests that he was planning to take the picture East for exhibition and reproduction, and shortly the painting was in Boston. The fact that such a work of art had been produced in the West itself did not go unnoticed, and we find the same journalist commenting, as he brings his description of Mulvany's painting to a close:

That such a work has been produced in Kansas City shows that art is not neglected even in the midst of the great commercial activity that

so distinctively marks this growing metropolis. The effect upon other artists here cannot but be beneficial. Of course nothing can be predicated of the reception that Mr. Mulvany's work will meet in the East, but it is fair to presume that it will create the favorable impression that it so richly deserves.[29]

Mulvany, with "Custer's Last Rally", reached Boston in April, 1881, and apparently at the suggestion of friends, some changes in composition were made. Mulvany, therefore, rented a studio in "Kenneday Hall in the Highlands" and proceeded with the suggested alterations. The size of Custer's figure was reduced somewhat; his hair shortened and his face strengthened. After those changes had been made, Mulvany invited the art critics and journalists of the city to examine his work. Edward Clements of the Boston *Evening Transcript* was evidently very favorably impressed after seeing it, for he wrote the following intelligent account:

> The magnificent bravery of the artist's purpose in this picture and the sustained power as well as heroic pluck with which he has bent himself to a great subject are allowed to make their effect upon all who appreciate what it is to project and *carry out* an extended composition like this. . . . To multiply the figure or two of the ordinary achievements of our artists by twenty or forty (as in the case of this huge canvas, containing more than two score of figures) would give but a slight notion of the comparative strength drawn upon to complete such a picture as this of Mulvany's. It is not a mere matter of posing studio models. The subject cannot be posed except in the artist's imagination, and not there until after the creative effort, the "sheer dead lift" of invention which calls it into being. Custer and his command were cut off to the last man, and only the confused boastings of the Indians engaged in the slaughter furnish the material for the artist's detail. To call up the counterpart of the Indians' account, to fill the reflex of their war dance brag with the heroism of the devoted three hundred, must be the work of fervent and sympathetic artistic imagination. . . .
>
> The fighting here portrayed is real, not only in its vigor and desperation, but in fidelity to the facts of modern and contemporary American fighting. Conventional battle-pieces of European art could indeed have furnished but little help in a picture of a death struggle with Indians, had it not been the artist's chief purpose to make an original and American composition. It is a grim, dismal melee. No beautiful uniforms, no picturesque flags, no regular formation of troops into ranks, squares or lines of battle are available to give color, balance and form to the composition, the white puffs of carbine shots and the dense cloud of dust almost concealing the overwhelming cloud of savages, whose myriad numbers it awfully suggests, form the background against which the army-blue trousers and dark blue flannel shirts of these fighting soldiers can add but little richness of color. The highest tint

is in Custer's yellow buckskin suit. . . . The picture will go straight to the hearts of the people, especially in the great West.[30]

Such favorable comment brought the painting its first publicity in the East and although it was not publicly exhibited in Boston, it was soon shipped to New York City for exhibition and was there placed on view in the summer of 1881. No less a personage than Walt Whitman, that constant protagonist of Americanism, saw it on a day's visit to New York and was profoundly impressed. What is more important to us now, Whitman described his impressions, which we shall quote at length. The quotations which we have already made from the Kansas City and Boston papers, and which we shall make from the New York *Tribune*, in which Whitman's account appears, seem well justified. In the first place they are intrinsically interesting and important, for they reveal what was felt and thought at the time Mulvany's picture was first placed on display. Possibly more important, however, is the concern of the individual writers—possibly an apologetic concern—with American art and American themes in art. That Whitman showed this interest and concern is not surprising, for ten years previously, in 1871, he had published his *Democratic Vistas* in which was written: "I say that democracy [i.e., America] can never prove itself beyond cavil, until it founds and luxuriantly grows its own forms of art, poems, schools, theology, displacing all that exists, or that has been produced anywhere in the past, under opposite influence"; a statement which throws considerable light on the following description of the Mulvany picture, written in his characteristic and irregular prose style:

I went to-day to see this just-finished painting by John Mulvany, who has been out in far Montana on the spot at the Forts, and among the frontiersmen, soldiers and Indians, for the last two or three years on purpose to sketch it in from reality, or the best that could be got of it. I sat for over an hour before the picture, completely absorbed in the first view. A vast canvas, I should say twenty or twenty-two feet by twelve, all crowded, and yet not crowded, conveying such a vivid play of color, it takes a little time to get used to it. There are no tricks; there is no throwing of shades in masses; it is all at first painfully real, overwhelming, needs good nerves to look at it. Forty or fifty figures, perhaps more, in full finish and detail, life-size, in the mid-ground, with three times that number, or more, through the rest—swarms upon swarms of savage Sioux, in their war-bonnets, frantic, mostly on ponies, driving through the background, through the smoke, like a hurricane of demons. A dozen of the figures are wonderful. Altogether a Western, autochthonic phase of America, the frontiers, culminating typical, deadly, heroic to the uttermost; nothing in the books like it, nothing

in Homer, nothing in Shakespeare; more grim and sublime than either, all native, all our own and all a fact. A great lot of muscular, tan-faced men brought to bay under terrible circumstances. Death ahold of them, yet every man undaunted, not one losing his head, wringing out every cent of the pay before they sell their lives.

Custer (his hair cut short) stands in the middle with dilated eye and extended arm, aiming a huge cavalry pistol. Captain Cook is there, partially wounded, blood on the white handkerchief around his head, but aiming his carbine [pistol] coolly, half kneeling (his body was afterward found close by Custer's). The slaughtered or half-slaughtered horses, for breastworks, make a peculiar feature. Two dead Indians, herculean, lie in the foreground clutching their Winchester rifles, very characteristic. The many soldiers, their faces and attitudes, the carbines, the broad-brimmed Western hats, the powder-smoke in puffs, the dying horses with their rolling eyes almost human in their agony, the clouds of war-bonneted Sioux in the background, the figures of Custer and Cook, with, indeed, the whole scene, inexpressible, dreadful, yet with an attraction and beauty that will remain forever in my memory. With all its color and fierce action a certain Greek continence pervades it. A sunny sky and clear light envelop all. There is an almost entire absence of the stock traits of European war pictures. The physiognomy of the work is realistic and Western.

I only saw it for an hour or so; but it needs to be seen many times—needs to be studied over and over again. I could look on such a work at brief intervals all my life without tiring. It is very tonic to me. Then it has an ethic purpose below all, as all great art must have.

The artist said the sending of the picture abroad, probably to London, had been talked of. I advised him if it went abroad to take it to Paris. I think they might appreciate it there—nay, they certainly would. Then I would like to show Messieur Crapeau that some things can be done in America as well as others.

Altogether, "Custer's Last Rally" is one of the very few attempts at deliberate artistic expression for our land and people, on a pretty ambitious standard and programme, that impressed me as filling the bill.[31]

How long the painting remained on display in New York City we do not know. The next record of its public exhibition comes from Louisville in December, 1881. Here again it met with great popular favor if we may judge by newspaper accounts. The *Courier-Journal,* with a fulsome rhetoric that surpassed any of its competitors, reports:

A poet of the brush who has walked out to meet the new sun of American art upon the upland lawn of the West has just come back with his inspiration to lay before the country. We refer to John Mulvany and his historical painting of "Custer's Last Rally," now on exhibition

at the Polytechnic Library building. We do not care to know just how large the canvas is; it is enough to know that it is large enough to contain the genius of battle. We do not care to lessen the glory of the painter's work by applauding his art. Who would put a rule to the Raphaeles or measure the lines of Homer? These are not results of Art, they are the realizations of genius. And upon Mulvany's canvas one can see the poetical magnificence of that slaughter in the lonely valley of the Little Big Horn as it appeared to the mind of genius. It breathes the spirit of mortal hate, of heroic sullenness, and that matchless courage jeweling the sword of Custer, which even in its fall "Flashed out a blaze that charmed the world." [32]

"Custer's Last Rally" was next reported on exhibit in Chicago where it was shown during August and September of 1882. We could again quote at length from the Chicago press for this period, for the painting and John Mulvany were mentioned many times during the exhibition in Chicago.[33] Enough has already been quoted (the reactions in the Chicago press were similar to those already given) to establish the fact that the Mulvany picture had a wide popular appeal. Indeed, thirteen years later the Chicago *Inter Ocean,* when Mulvany stopped off in the Windy City after a visit to the Pacific coast, commented "Mr. Mulvaney [*sic*] needs no introduction to a city in which his magnificent work, 'Custer's Last Charge,' was exhibited. . . ." [34]

One of the Chicago newspaper accounts of 1882, however, mentions another Western painting which should find its way into our record. Mulvany rented a studio while in Chicago and had on display there other pictures in addition to the "Last Rally." One was called "The Scouts of the Yellowstone." The painting depicted in the foreground two kneeling figures, rifles in hand, with another scout in the background holding three horses. The figures were set on a hilly landscape with a river in the distance, the highest land represented in the picture just catching the reflection of the sun. The foreground figures were said to be the same as two of the soldiers portrayed in "Custer's Last Rally." [35]

"Custer's Last Rally" was likely exhibited in many American cities other than these already described. It was again on exhibit in Chicago in 1890 and it was probably sent abroad for display.[36] Doubtless on one of its trips to Chicago, the painting was lithographed in color. The Kansas State Historical Society fortunately possesses one of the lithographs which is on display in its museum. The lithographic print itself (without mat) measures 34⅜ inches by 18½ inches. The signature "Jno. Mulvany, 1881" appears (hand-printed) in the lower right hand corner of the print and below [in

type, also lower right] the name of the lithographer "D. C. Fabronius, Del.," and lower left [in type] "Jno. Mulvany, Pinxt." The copyrighted print (no date) was published by the Chicago Lithographic and Engraving Company. Comparison of this print with a photograph of the original painting in the writer's possession shows that, with minor changes, the figures and surroundings were faithfully copied. The lithograph is subdued in color but whether the original colors are correctly reproduced, I do not know as I have not seen the original painting. I also have no information on the number of copies of the lithograph that were published.

The history of "Custer's Last Rally" from 1890 until the early 1900's is obscure. At the latter date it seems to have been purchased by H. J. Heinz of Pittsburgh[37] and was, in 1940, still in the possession of the H. J. Heinz Company of Pittsburgh which kindly measured the painting and supplied me with the photograph which is here reproduced.[38] Several years after Mr. Heinz purchased the original painting of "Custer's Last Rally" he commissioned Mulvany to paint a duplicate (for $200) and which Mr. Heinz is reported to have taken to London for exhibition.[39] Mulvany had a long career, but in his later years he seems to have depended upon portrait work for a living. Liquor, however, got the best of him, and in May, 1906, he ended his existence by plunging into the East River. "From a fine physique of a man," reported the New York *Times*, with "handsome features and a kindly countenance, he had sunk to a ragged derelict, uncertain of a night's lodging or a day's food."[40]

Despite Mulvany's tragic end and despite the fact that he is today virtually unknown, he played a real and not an unimportant part in past American life. The wide response and enthusiastic reception accorded "Custer's Last Rally" is proof enough of the statement above. But Mulvany has other claims to a place in American history. Samuel Isham, the historian of American art, points out that William M. Chase exerted a very considerable influence on American painting during the last quarter of the nineteenth century. Chase was greatly stimulated by examining the work of Mulvany. So much so that Chase went abroad and studied under Piloty and Wagner at Munich, both of whom had been Mulvany's teachers.[41]

More recently, G. V. Millet, an artist of Kansas City, has suggested that Remington, who as a very young man lived in Kansas City in the early 1880's, knew Mulvany and "Custer's Last Rally," and was influenced by these contacts.[42] It does not seem probable that Remington knew Mulvany personally, as Remington did not move to Kansas City until 1884 and Mulvany by that time had moved on.[43] Although Remington was probably

not acquainted with Mulvany during his stay in Kansas City it is not at all unlikely that he had seen and marveled at "Custer's Last Rally" as did thousands of other Americans of that day.

It seems reasonable, too, that Mulvany's painting of the Custer tragedy suggested the theme to other artists. It was the first of some twenty attempts with which I am familiar and, being widely known, served as the incentive for subsequent artists, including possibly Cassilly Adams.

CASSILLY ADAMS AND OTTO BECKER

Our fund of information concerning the life and work of Cassilly Adams is not as extensive as is that concerning Mulvany. Adams is not listed in any of the biographical directories of artists, but through fortunate contact with a daughter-in-law and a son of Adams, some fundamental information has been secured.

Cassilly Adams, a veteran of the Civil War, was born at Zanesville, Ohio, July 18, 1843, the son of a lawyer, William Apthorp Adams, who traced his ancestry back to the John Adams family of Boston. The elder Adams was himself an amateur artist and he saw that his son Cassilly secured an art education at the Boston Academy of Arts. Later (about 1870) Cassilly Adams studied under Thomas S. Noble at the Cincinnati Art School.[44] Some time in the late 1870's, Adams moved to St. Louis where he secured work as an artist and an engraver and for a time had a studio with Matt Hastings, a well-known St. Louis artist.[45]

During the summer of 1940, the writer spent a week in St. Louis making the rounds of the libraries, art galleries, art dealers and art writers of the city newspapers but found no one who had any information concerning Cassilly Adams and his work. I was finally referred to William McCaughen, a retired art dealer of that city. McCaughen told me that he and Adams had belonged to the same social club in the early 1880's but even the information that he could supply me about Adams was meager. McCaughen recalled one other painting (in addition to "Custer's Last Fight") executed by Adams, "Moonlight on the Mississippi." McCaughen also stated that he had arranged the original sale of "Custer's Last Fight" to a saloon owner in St. Louis but could not recall the sale price. For the information available on the painting of this famous piece, we are dependent upon the memory of William Apthorp Adams, son of Cassilly Adams. The son states that he himself saw his father painting the picture in a studio at the corner of 5th and Olive Streets (St. Louis). Over a year was taken in the painting and the figures "were posed by Sioux Indians in their war paint and also by

cavalrymen in the costumes of the period." [46] The painting was produced for two associate members of the St. Louis Art Club, C. J. Budd and William T. Richards, who promoted the painting for exhibition purposes, stimulated no doubt by the success of the Mulvany picture. The date of the painting has not been fixed with certainty but it was made about 1885. The promoters then exhibited it about the country, according to Mr. Adams, in Cincinnati, Detroit, Indianapolis, and Chicago, "at 50c admission for adults and 25c for children under 15 years of age. Charles Fox, a brother of Della Fox, the actress, was the advance agent. My father traveled with the exhibition part of the time." [47] The exhibition of the painting did not realize the profits expected by the promoters and the sale of the picture was arranged by William McCaughen as noted above. The painting was on display in the saloon for several years and achieved a very considerable local reputation. Here, a St. Louis reporter saw it and later commented:

> In 1888, when the writer of these lines was a reporter in St. Louis, the original painting [Custer's Last Fight] . . . hung on the wall of a saloon near Eighth and Olive streets—at the "postoffice corner." The place was a sort of headquarters for city and visiting politicians, and reporters assigned to political work were expected to visit it in their news-gathering rounds; but aside from this fact, there were many who visited the place especially to see the picture, which was a very large one, and was valued at $10,000. [48]

The owner of the saloon died and his heirs unsuccessfully attempted to conduct the business for a time but eventually creditors took over the place. Chief among the creditors was the brewing firm of Anheuser-Busch, Inc., of St. Louis, whose claim against the saloon is said to have amounted to $35,000. Important among the assets of the saloon was the painting of "Custer's Last Fight" which Anheuser-Busch acquired, and which has doubtless given rise to the frequently-quoted statement that Adolphus Busch of the Anheuser-Busch company paid the above sum for the painting. [49]

Adams' painting of the Custer fight, like that of Mulvany's, was of large size. The painting proper measured 9'6" by 16'5". [50] There were, however, two end panels when the painting was first displayed. One depicted Custer as a small boy in his father's shop playing with toy soldiers. The other panel portrayed Custer dead on the field of battle and facing the setting sun. [51]

Upon acquiring the painting, Adolphus Busch had it lithographed in color and printed for distribution. The lithograph was copyrighted in 1896, so that evidently some time elapsed between the acquisition of the painting and its reproduction.

Busch decided eventually to give the painting to the 7th cavalry and in February, 1895, offered the painting (more exactly three paintings, as the two end panels were included) to the officers of the famous regiment. The officers unanimously agreed to accept the offer and on March 28, 1895, two representatives of Anheuser-Busch formally presented the paintings to the regiment at Fort Riley.[52]

In May, 1895, headquarters of the 7th cavalry was transferred from Fort Riley to Fort Grant, south of the San Carlos Indian Agency, Arizona,[53] and then in the next few years to still other posts. Apparently in these moves the painting was lost and not found again until 1925 when it was rediscovered in bad condition, in an attic of a storage building at Fort Bliss, Texas.[54]

There was some discussion on the part of army officials concerning the restoration and disposition of the painting and it was suggested that it be hung in the office of the chief of cavalry in Washington. Nothing was done and the painting again disappeared from view. In 1934, Col. John K. Herr, commanding the 7th cavalry, took his regiment on a twenty-one day practice march which included abandoned Fort Grant, Ariz., in its tour. In prowling through the abandoned camp, "Custer's Last Fight" was again rediscovered and returned to Fort Bliss, headquarters of the 7th cavalry.[55] The painting had been folded and torn and its image was badly cracked. Estimates on restoring the painting were secured by officers of the 7th cavalry but as they ranged from $5,000 to $12,000, too great a sum for regimental funds, no immediate steps were taken in its restoration. Finally it was restored by the art division of the WPA in Boston and returned in 1938 to headquarters of the 7th cavalry at Fort Bliss.[56] The painting was then hung until 1946 in the officers' club building at Fort Bliss, Texas. On June 13, 1946, Associated Press dispatches reported that the painting was destroyed by fire.[57]

From this brief history of the painting it can be seen that it never achieved very wide recognition.[58] "Custer's Last Fight" owes its chief claim to fame, therefore, to the lithographic reproduction published by Anheuser-Busch.

A comparison of the original painting reproduced here with the lithograph will show immediately that considerable differences exist between the two pictures. As a matter of fact, the lithograph is far more realistic in depicting the topography of the battlefield than is the Adams painting.[59]

A number of the figures in the two pictures are similar, but the most surprising difference is the fact that the two represent quite different viewpoints. In the lithograph, the background shows the valley of the Little

Big Horn river and the river itself, while in the painting the slope behind
Custer rises abruptly in a steep hill. A comparison of the figure of Custer
in the two pictures also shows marked difference. In the painting, Custer
is lunging forward with his saber; [60] in the lithograph Custer is swinging
the saber back over his shoulder in preparation for a desperate blow.

In considering these—and other—differences, two facts must be kept in
mind: First, the lithograph was reproduced on stone by a second artist;
and second, the painting was "restored," as pointed out previously, in 1938.
The original printing of the lithograph [61] bears as part of the legend (in
print) the words "Taken From the Artist's Sketches. The Original Painting
by Cassilly Adams." The original printings of the lithograph also have the
signature (in script and on the print itself) "O. Becker" in the lower right-
hand corner. Further, the original lithograph was prepared for publication
by the Milwaukee Lithographic and Engraving Company (Milwaukee,
Wis.) as is likewise stated in type as part of the legend. A query directed to
the Milwaukee Public Library brought the interesting response that Otto
Becker, a lithographer by trade, was so listed in the city directories of
Milwaukee for the years 1890–1896, inclusive.[62]

Following this lead further, correspondence was established with Miss
Blanche Becker of Milwaukee, daughter of Otto Becker. Miss Becker
wrote at length concerning the work of her father, who was foreman of
the art department of the Milwaukee Lithographic and Engraving Com-
pany. A letter written by her father in 1933 states: "I painted Custer's Last
Stand in 1895. The original painting is still in my possession, but unfor-
tunately, I was forced to cut it into pieces so that a number of artists could
work on it at the same time, making the color plates." [63] The oil painting
was subsequently patched together and restored by Mr. Becker and it was
then acquired by Anheuser-Busch. The restored painting measures 24″
by 40″ and is now on display at the offices of Anheuser-Busch in St. Louis.[64]
Becker, a one-time resident of St. Louis, had become acquainted with
Adolphus Busch and after the acquisition of the Adams painting by Busch,
plans were made to lithograph the painting. If we can believe the legend
on the original painting "after the artist's sketches," Busch presented several
sketches of Adams' work to Becker and Becker would therefore have the
right of selecting and making his own composition.[65]

Part of the differences between the two pictures can thus be satisfactorily
accounted for. There is the added possibility that in the restoration of the
Adams painting in 1938, still other differences were introduced. The paint-
ing, after its several discoveries, was admittedly in bad condition and
apparently at the time of restoration there was no one who knew the

original painting.[66] The Library of Congress has a photograph of the Adams painting which was recorded as being received on April 26, 1886, when application for copyright on the painting was made.[67] A comparison of this photograph with the photograph of the painting after its restoration shows that there are differences, especially in the background, although the detail in the foreground is essentially the same in the two photographs.[67]

It seems probable, in considering all of these facts, that the differences between painting and lithograph are due (principally) to original differences produced in the lithography and to minor subsequent differences arising in the restoration.

Since the lithograph, however, is the picture that is better known, the differences noted above, after all, are of minor importance. Some 150,000 copies of the large print have been distributed by Anheuser-Busch since the lithograph was first published in 1896, and in 1942, copies were being mailed out to servicemen and others at the rate of two thousand a month.[68] With this wide distribution of the lithograph it is probably safe to say that few dealers in the products of Anheuser-Busch have been without a copy of the lithograph and doubtless most of them have displayed the print. Some thirst emporiums may have had their original copies on display for the fifty years of the print's existence; especially if they faithfully followed the instructions reportedly sent out with early copies of the lithograph, "Keep this picture under fly-netting in the summer time and it will remain bright for many years."

How many have seen and viewed the lithograph is, of course, any man's guess. An examination, however, will soon show that it is no work of art— if by work of art we mean an object of beauty. But it is indeed a picture that tells a powerful, if melodramatic and horrendous, tale. Be it recalled, however, that it is no more terribly melodramatic or horrendous than was the event itself. Troopers are being brained, scalped, stripped; white men, Indians and horses are dying by the dozens; Custer with flowing red tie [69] and long ringlets is about to deal a terrible saber blow to an advancing Indian who in turn is shot by a dying trooper; and hundreds of Indians are pictured or suggested in the background.[70]

A careful survey of the lithograph is enough to give a sensitive soul a nightmare for a week. No doubt many a well-meaning imbiber who has tarried too long with his foot on the rail and his eye on the picture, has cast hurried and apprehensive glances over his shoulder when a sudden yell from a passing newsboy brought him too swiftly back to the day's realities. The writer has one of these lithographs in his back laboratory which is occasionally shown to students, friends, and fellow university pro-

fessors. The reaction of those who have never seen the picture before is always interesting to observe. Incredulous first glances are always followed by study of all the gory details. "Holy H. Smoke! That's awful," was the comment of one university professor as he instinctively rubbed his bald dome. If not the best liked of all American pictures, it doubtless has been the most extensively examined and discussed of any.

Other events have also added to the fame of this remarkable picture. For example, not long after first publication, Adolphus Busch presented a copy of the lithograph to Gov. E. N. Morrill of Kansas. Morrill, who served as governor from 1895 to 1897, upon retiring from office gave the picture to the State Historical Society. Just when it was put on display in that institution there is apparently no definite record, but from the activities of the late Carrie Nation in the early 1900's, there arose a considerable interest because the name of the brewer appeared in large letters beneath the lithographic print of "Custer's Last Fight." The prohibitionists of the state began to sit up and take notice when one of their number called attention to the fact that a beer advertisement was appearing in one of the State's public buildings. The notice became notoriety when on January 9, 1904, Blanche Boies, one of Carrie Nation's faithful followers, entered the State Historical Museum, then in the State House, with an axe in her hand and the light of grim determination in her eye. She advanced on the offensive advertisement of Messrs. Anheuser and Busch and crashed her axe through the picture. Secretary Martin of the Historical Society hastily called the police who politely escorted Blanche to the city jail where she languished until bailed out by her friends. The Topeka papers gave Blanche a very handsome writeup for her efforts and the press of the State followed suit. One account called attention to the fact, however, that such excursions were nothing unusual of this disciple of Carrie Nation, for she "had wielded her hatchet with destructive effect on numerous occasions in Topeka's illicit pubs." [71]

Blanche's well-intended efforts in protecting the morals of Kansas citizens were, alas, in vain. Some one immediately wired Anheuser-Busch for a new copy of "Custer's Last Fight" and the brewers responded promptly with the copy which now hangs in one of the hallways of the State Historical Society's building. Mr. Martin, however, did have the foresight to opaque out the names of the donors which appear on the legend beneath the picture.

Many other artists have attempted the depiction of the Custer battle scene. A list of a number of these artists may be found in the various sources cited in the notes [72] but the most satisfactory of all attempts in

this writer's judgment is that by W. R. Leigh, *Custer's Last Fight,* the original painting of which is now in the Woolaroc Museum, Frank Phillips' Ranch, Bartlesville, Okla.[73] The beautifully modeled foreground figures of Indian warriors and horses are shown realistically, and the imaginative effect in portraying Custer and his command dimmed by the clouds of battle dust is in keeping with the fact that many of the realities of the Custer battle are obscured by the passage of years and the battle of words since 1876.

Chapter Ten

The Leslie Excursion of 1877

Harry Ogden and Walter Yeager

> *It was a wonderfully new picture for us, the great plains rolling away on either side in apparently illimitable extent, clad in their richest shades of russet and tawny gold in the distance, and the tender grass and moist black earth close at hand, a wild mass of thunder-clouds crowding up from the south, and the low-hanging trail of smoke from our engine sweeping away northward like a troup of spirits, and (a) little lonely band of Omahaws riding slowly away into the storm, casting uneasy glances backward at the flying train.*
> —Mrs. Frank Leslie, A Pleasure Trip from Gotham to the Golden Gate, 1877.

The practice of newspapers and magazines in sending artists and illustrators on long excursions to the West has resulted in some of our most important pictorial records of this region. In addition to those of Joseph Becker, the travels of A. R. Waud and T. R. Davis in 1866 and 1867, and the extremely valuable series of illustrations secured by Frenzeny and Tavernier have already been described.[1]

The most elaborate, the plushiest, the *ne plus ultra* in the way of pictorial excursions to the West, however, was that of no less a person than Frank Leslie himself in the spring and summer of 1877. By 1877 Leslie was a person of real consequence in these United States. He was publishing well over a dozen periodicals, including the best-known of the group, *Frank Leslie's Illustrated Newspaper,* which on occasion sold as many as four hundred thousand copies an issue—a remarkable figure for its day. His *Frank Leslie's Historical Register of the United States Centennial Exposition* of 1876 was one of the most sumptuously illustrated volumes ever published and of which he was justly proud. He owned an elaborate country estate, Interlaken, on Saratoga lake, complete with formal gardens, terraces and steam yacht, where he and his wife entertained on a prodigal and lavish

scale, and where, the year before he made his Western trip, he had been host to the Emperor and Empress of Brazil. And lastly, his wife, Miriam Florence Leslie, formerly Mrs. Squier, formerly Mrs. Peacock, nee Miriam Florence Follin, was a charming, vivacious and very articulate young woman—articulate in five languages.[2]

On April 10, 1877, Leslie, with a party of eleven friends and employees, left New York City for the West over the New York Central and Michigan Southern railways in an elaborate, highly-decorated and magnificent Wagner sleeping car. To do full credit to the occasion, however, one must read the contemporary report of the departure:

On Tuesday evening, April 10th, a large party of gentlemen and ladies, prominent in literary, artistic and social circles, assembled at the Grand Central Depot in Forty-second Street, to bid farewell to Mr. and Mrs. Frank Leslie, who were about starting on a trip to California and the Pacific Coast. Mr. Leslie was accompanied by several artists, photographers and literary ladies and gentlemen connected with his publishing house, and it is his intention to visit every locality of special note on the route, with a view to illustrating the grand highway between the Atlantic and Pacific Oceans on a scale never heretofore attempted. The public may congratulate itself that it is about to acquire a new and more extended familiarity with the magnificent scenery of the Great West. Mr. Leslie's party numbers twelve in all. They started in a special Wagner Palace Car, which Mr. Wagner, out of compliment to its enterprising occupant, named the "Frank Leslie." At Chicago, which was reached on Thursday, April 12th, the party were transferred to a Pullman Hotel Car, and arrangements have been perfected permitting this vehicle to lie over at any point Mr. Leslie may indicate for as long a time as suits his convenience. In this manner the artists and writers, as well as those who accompany the expedition in the character of pleasure-seekers only, will have ample opportunity afforded them of making a deliberate survey of all points of interest, and of acquiring intelligent and lasting impressions of what they observe, very different from the fleeting ideas which tourists are usually obliged to catch at in the hurried transit of ordinary travel. Everything deserving of reproduction will be carefully and accurately noted, and will in due time be brought into the intimate acquaintance of the readers of *Frank Leslie's Illustrated Newspaper*, accompanied by competent descriptive text. On reaching San Francisco, the party will make their headquarters at Warren Leland's magnificent Palace Hotel, while they prosecute their search for the picturesque in the glorious Yosemite region, and possibly northward as far as Vancouver and the Columbia River.

The scene in the depot at the starting, represented in our illustration, was one of genial excitement. Judging from the number of champagne

baskets and significant-looking hampers placed on board the "Frank Leslie" car, it was evident that its temporary proprietor had a full appreciation of what would tend to the inner comfort of his companions, while the luxurious appointments of the carriage itself promised all that could be demanded for their physical ease. Upwards of a hundred persons were in attendance to wish the party a pleasant journey, and as the last whistle sounded, and the huge train gradually acquired motion, loud cheers arose from the group on the platform, responded to by waving of hands and handkerchiefs from the inmates of the car, and accompanied by a deafening chorus of exploding signal-torpedoes, which Mr. Wagner had, without announcing his intention, caused to be placed on the tracks, in front of each wheel of the "Frank Leslie." [3]

The party of twelve included, besides Mr. and Mrs. Leslie, Mr. and Mrs. C. B. Hackley, presumably friends of the Leslies; Bracebridge Hemyng ("Jack Harkaway"), and E. A. Curley, Leslie writers; Miss G. A. Davis, a friend of Mrs. Leslie and later a well-known illustrator; H. S. Wicks, Leslie's business manager; W. K. Rice, a son of Gov. A. H. Rice of Massachusetts, probably also a guest of the Leslies; W. B. Austin, a staff photographer; and Harry Ogden and Walter R. Yeager, staff artists of the Leslie publications.[4]

As a result of the trip, which extended from coast to coast, there appeared in *Frank Leslie's Illustrated Newspaper* nearly two hundred illustrations, the majority of which are scenes of Western interest. Most of the illustrations are to be attributed to sketches by Ogden and by Yeager or to the joint efforts of the two. A few are obviously based on photographs, and undoubtedly Ogden and Yeager employed Austin's photographs freely in preparing their final illustrations for publication.[5]

The party arrived in Chicago on April 13, went to the Grand Pacific Hotel and spent two days viewing the Windy City. Many evidences of the great fire were still evident, but the party agreed that Chicago was "a city of magnificent beginnings, a thing of promise." [6]

Not only are there many illustrations of this transcontinental journey, but there are also extensive written descriptions. Mrs. Leslie described her experiences in book form, and the individual issues of *Leslie's* for many weeks carried considerable text with the illustrations. The written descriptions are not signed but were probably either Jack Harkaway's or Edwin A. Curley's contribution to history. The descriptions are written with real skill and are in general entertaining and informative. Considering the elaborate and sumptuous character of the expedition, one might expect condescension on the part of the writer toward his audience. Such an attitude is completely lacking, for the writer is able to convey his very real interest

in the unfolding panorama about him. The interest, no doubt, was genuine, for few of the party had been West before and the Great West was still a fabulous country to the untraveled in 1877. Read, for example, the description of their journey as they left Omaha and were fairly launched into the Great West:

> The chief beauty and interest of the Plains, so far on our journey, is borrowed from their relation to the sky. The Platte Valley, with its absence of marked features and strong lights and shadows, is something like an expressionless human face; to which, on this windy April afternoon, our first one "out" from Omaha, the rolling cloud shadows lend life and change and incessant variety. Great masses of white cumuli pile up in the blue, trooping westward like ourselves, before a strong, driving wind; the sun wakes hot on the tawny and brown mat of last year's grass, and, as far as eye can reach, there is no shade and no motion in the landscape, except from these hurrying clouds.
>
> The long, parallel lines of smooth, shining rail, and the diminishing ranks of telegraph-posts, stretching away from our track as we sit on the rear platform, are wonderfully important and suggestive features in the scene. Watching all day, you will scarcely see a curve in that long "iron trail"; only now and then, for a few miles, a side-track travels with us, and unites at some little station or round-house. Soon after Fremont is left behind us, we find vast excitement in the approach on one of these switches, of a train bound East; every window full of heads and arms, chiefly feminine and infantile, for all the men, as the engines "slow up" and stop, seize the opportunity to rush out and exchange greetings on terra firma. Our photographer, diving into the curtained section which has been set apart for the storage of bags, hampers and instruments, rummages wildly for his plates and chemicals. Our artist, constituting himself assistant, snatches the camera and disappears; and presently there is diffused over the easy, lounging group of dusty passengers, brakemen in shirt-sleeves, and trim, gold-buttoned conductors outside, a universal and frigid atmosphere of "sitting for their picture." Everybody strikes a hasty attitude and composes his features; the engineer reclines gracefully against his cow-catcher, and all the hands, with one instinctive impulse, seek sheltering pockets, while artist and photographer shift their tripod from spot to spot, hit the happy point of sight at last, and fix the picture. And then there is a scramble for the platforms again, and the engines, with a puff and a wheeze, start their muscles and sinews of iron. In another minute there is only a trail of brown smoke hanging over the plain beside us, and we are once more alone on the great empty waste.[7]

Mrs. Leslie's account of the trip, too, is interesting, but it was difficult for her to forget that she was a member of the *literati*, had traveled widely and could converse in almost any language. Nevertheless she was out-

spoken on occasion, so much so that she laid up considerable future grief for herself, but she did make on occasion some very observing comments on life and manners of the Western scene.[8] That she was a woman of spirit and executive ability was proved on at least one occasion when the party was stranded in a three-room cabin on the way to see the big trees of California. Despite the incredulous amazement of her party she "rustled up" a supper for the travelers and made the best of affairs when the party of twelve were forced to sleep in a single room.[9]

Because of the wealth of pictorial material published concerning this overland trip, no attempt will be made to discuss each picture individually or, for that matter, to catalogue them. A number of the more interesting illustrations and experiences of the party, however, properly form a part of our study and will be included here.[10]

Only one picture appeared to illustrate the trip from Chicago to Council Bluffs, but beginning at the latter place there are illustrations to depict almost every phase of the journey.[11] The "Arrival at Council Bluffs," for example, is interesting from several viewpoints. For many years after the completion of the line from Omaha to San Francisco, Council Bluffs was the principal point of transfer between the roads coming from Chicago and the East, which it continued to be until the early 1880's. The bridge across the Missouri river between Council Bluffs and Omaha, lacking in Richardson's and Becker's day, had been completed by 1872, but the travelers changed trains at Council Bluffs.[12] It was therefore an important "junction." Any reader who traveled American railroads fifty years or more ago will recall with nostalgia the interest, excitement and bustle of railroad travel at that time, for, although the illustration is of 1877, a quarter of a century later the scene was scarcely changed.

Crossing the river to Omaha, one entered the Union Pacific depot and in "A Character Scene in the Emigrant Waiting-Room of the Union Pacific Railroad Depot at Omaha" there is a worthy companion piece for Joseph Becker's "A Station Scene on the Union Pacific Railway," drawn eight years earlier.

To the eyes of the Easterners, the group at the depot were individuals— in some cases literally—of a different world.

> Men in alligator boots [recorded Mrs. Leslie], and loose overcoats made of blankets and wagon rugs, with wild, unkempt hair and beards, and bright resolute eyes, almost all well-looking, but wild and strange as denizens of another world.
> The women looked tired and sad, almost all of them, and were queerly dressed, in gowns that must have been old on their grand-

mothers, and with handkerchiefs tied over their heads in place of hats; the children were bundled up anyhow, in garments of nondescript purpose and size, but were generally chubby, neat and gay, as they frolicked in and out among the boxes, baskets, bundles, bedding, babies'-chairs, etc., piled waist high on various parts of the platform. Mingling with them, and making some inquiries, we found that these were emigrants bound for the Black Hills, by rail to Cheyenne and Sioux City, and after that by wagon trains.[13]

Although Mrs. Leslie may have had her geography slightly mixed (she probably meant Sydney rather than Sioux City) her description as well as the sign in the illustration, "Lunch Baskets Filled for 25 Cents Take Notice Black Hillers", recalls the ever recurring and frequently changing part that mining—especially of those seductive metals, silver and gold—has had in the development of the West. In the spring of 1877 the discovery of immense deposits of gold-bearing quartz, coupled with earlier discoveries in the Black Hills, had set a wild stampede underway toward Deadwood, and the Leslie party was in excellent position to observe the migration. The two most important stations on the Union Pacific making stage connections for the Black Hills—some two hundred and fifty miles north of the railroad—were Sydney and Cheyenne. And Yeager and Ogden were busy with their sketchbooks recording the incidents of the mining boom as the Leslie party traveled on west from Omaha. Particularly notable are the illustrations, "A Fitting-out Store for Black Hills Emigrants, at Sydney" and "A Party of Gold Miners Starting For the Black Hills [from Cheyenne]." [14]

The visitors found Cheyenne to be particularly interesting, and their interest, aroused by frequent descriptions of "Hell-on-Wheels," was in no way diminished when they stepped off the strain and into the celebrated frontier town:

And now, not without some little excitement [wrote Mrs. Leslie], we arrived at Cheyenne, as it is styled upon the maps, the Magic City of the Plains, the City on Wheels, the Town of a Day, as romancists call it, or in yet more vigorous vernacular, H-ll on Wheels, which latter is, perhaps its most popular name among its own inhabitants. In view of this reputation, our conductor strongly advised against any night exploration, at least by the ladies of the party, of the streets and shops of Cheyenne, stating that the town swarmed with miners *en route* for, or returning from, the Black Hills, many of them desperadoes, and all utterly reckless in the use of the bowie-knife and pistol; or, at the very least, in the practice of language quite unfit for ears polite, although well adapted to a place which they themselves had dubbed with so

suggestive a name. This opposition, was, of course, decisive; and the three ladies, as one man, declared fear was a word unknown in their vocabulary, that purchases essential to their comfort were to be made, and that exercise was absolutely necessary to their health.[15]

So the men went along. Not only did the ladies visit several frontier stores but they were invited to visit the town's leading theatre and gambling establishment—and not a man of the party was shot or a woman insulted!

For two or three blocks [reads the *Leslie Weekly* account] the main street of Cheyenne keeps up a character of solid respectability with neat brick buildings, a large hotel and an attractive show of shop-windows; but it soon drops such mimicry of the "effete East," and relapses into a bold disregard of architectural forms and proprieties. The oddest examples of this are in the two theatres, owned and "run" by an enterprising citizen, who also keeps one of the largest gambling establishments in town; and who, with the generous courtesy of a Western man, gave the ladies of our party a full exhibit of the same by daylight—the masculine members having studied it during the hours of darkness. The larger of the theatres—"variety shows" in the fullest sense of the term—connects with the gambling-rooms and bar, in a long, low brick building, which hangs out numerous flaming red signs under the moonlight. Entering the bar-room, the curious visitor is confronted by a glittering show of chandeliers, fresh paint, cheap gilding and mirrors, and some extraordinary frescoes, supposably of Yosemite views, which blaze in every conceivable gradation of color over the bar itself. Turning to the right, we enter a passage leading to the parquette, or pit, of the theatre; a narrow flight of stairs passes up to what, in the East, would be the dress-circle; but in the Cheyenne house is a single tier of small boxes, open at the back upon a brightly lighted passage-way. At the head of the stairs is another and smaller bar, from which the waitresses procure strong drinks, to be served to order in the boxes aforesaid; and over the staircase is posted a gentle hint, couched in the words; "Gents, be Liberal"— a hint not likely to be ignored in Cheyenne, we fancy.

From these little boxes, gay with tawdry paintings and lace hangings, we look down upon as odd a scene as ever met critical New York eyes. The auditorium departs from the conventional horseshoe pattern, and is shaped rather like a funnel, expanding at the mouth to the width of the stage. It is so narrow that we, leaning out of one box, could almost shake hands with our opposite neighbors. The trapezes, through which the wonderful Mlle. Somebody is flying and frisking like a bird, are all swung from the stage to the back of the house, so that her silken tights and spangles whisked past within a handsbreadth of the admiring audience, who can exchange civilities, or even confidences, with her in her aerial flight. Below, the floor is dotted with round tables and darkened with a sea of hats; a dense fog of cigar-smoke floats above

them, and the clink of glasses rings a cheerful accompaniment to the orchestra, as the admiring patrons of the variety business quaff brandy and "slings," and cheer on the performers with liberal enthusiasm. The house, for all its cheap finery of decoration, its barbaric red and yellow splashes of paint, and *bizarre* Venuses and Psyches posing on the walls, is wonderfully well-ordered and marvelously clean; the audience, wholly masculine, is unconventional (let us put it courteously), but not riotous. As for the performance, it is by no means bad, and the trapeze feats are indeed exceptionally startling and well executed. The hours of entertainment are from 8 P. M. until 2 A. M., while the doors of the connecting gambling saloon are never closed.[16]

Illustrations of the Cheyenne theatre and of "Bucking the Tiger" are real pictorial contributions to Western history—the West of a very real melodrama.[17]

Not so melodramatic but equally interesting is the view, "Scene in Front of the Inter-Ocean Hotel." The scene depicted was busy Central Avenue, then the principal east-west thoroughfare of Cheyenne, with the large hotel—a building of respectable proportions in any city—in the background. (The Inter-Ocean Hotel was one block west of the present day Plains Hotel, for many years another well-known landmark of Cheyenne.) [18]

The party left the main line of the Union Pacific at Cheyenne for side trips to Denver and Colorado Springs. A very elaborate reception was tendered the party at Denver by prominent Colorado citizens including Gov. John L. Routt and Ex-Governor Gilpin, but few if any illustrations of the side excursion appeared in *Leslie's*.[19]

One of the few illustrations, however, that was credited to Harry Ogden alone, was made on the trip to Colorado Springs. The Springs in 1877 was legally a temperance town but the thirsty traveler could still satisfy his wants by ways that were devious if not direct and Ogden sketched the method and it was described in words for the benefit of succeeding fellow travelers:

Close to the depot [reads the *Leslie Weekly* account] is a hostelry yclept the Pike's Peak House, where an announcement in English and German informs the wayfarer that meals can be had for the moderate sum of forty cents. Entering the house, one finds an empty room; a door in a wooden partition admits into an inner apartment, where four Hoosiers are playing the interesting game of the "devil amongst the tailors." Presently a German approaches and inquires what is wanted, and being informed that there exists a laudable desire for lager-beer, he replies: "Shust put a quarter in dot hole, and de beer gomes up quick!" Accordingly the tourist approaches a wooden wall, and perceives a slit in the board, dirty from use. He drops in a twenty-

five cent piece and says, addressing no one in particular and speaking in a very sepulchral tone, "a quart of beer." With magic celerity a sliding panel is revealed, which goes up, and on a bracket there appears a jug of the foaming beverage. Taking it out, imbibing the contents, and replacing the jug and glass, the panel slides back into its place, and the truly Arabian Nights' entertainment is at an end. Subsequently the traveler is informed that anything in any quantity in the drinking line can be obtained in the same mysterious manner at this oasis for the thirsty traveler in the Temperance Desert.

President Barnard, of Columbia College, the Rev. Dr. Armitage, and a number of other gentlemen, left New York City on the 18th for a trip to the Rocky Mountains, stopping at Denver and Colorado Springs. This information will be valuable to them in case they should require any stimulants, as it will enable them to satisfy their thirst promptly and without embarrassing inquiries; for even their distinction will not secure them exemption from the Territorial liquor laws.[20]

Returning to Cheyenne, the westward journey of the party resulted in a considerable number of illustrations before reaching Ogden, when another side trip was made to see Salt Lake City and President Brigham Young. The towns of Sherman (at the top of the pass between Cheyenne and Laramie), Laramie itself, Carbon, Fort Steele, Rawlins, Green River, Hilliard and Evanston all sat briefly while the artists sketched them, and illustrations of each Wyoming town appeared in due time in the pages of *Leslie's*. One small illustration, "Emigrants Camping Out at Night, near Bryan [in western Wyoming]," is particularly appealing as it shows a group of overland travelers—the canvas-covered wagons still in use eight years after rails were joined—about a camp-fire, its smoke rising into a moonlit sky.[21]

Utah illustrations appeared in considerable number but many are of familiar landmarks, including Echo and Weber canyons, the Devil's Slide, Thousand-Mile Tree and Lake Point on Great Salt Lake. "The Arrival at Ogden Junction" is of interest as it calls attention to the fact that since 1869 the junction point of the Union Pacific and Central Pacific had been changed from Promonory Point to Ogden and that the Utah Central railroad had been completed from Ogden to Salt Lake City.[22] The real reason for the trip to Salt Lake City was to see Brigham Young, and Leslie soon had an interview arranged with the head of the Mormon organization. Mrs. Leslie took a spirited part in the interview. In fact, if we are to believe her, the discussion with Brigham would have amounted to nothing more than comments on the weather if she had not participated. As Mr. Leslie did not make much progress in conversation, Mrs. Leslie turned to Mr. Young and said, "Do you suppose, Mr. President, that I came all the way

to Salt Lake City to hear that it was a fine day?" To which the astute president replied, "I am sure you need not, my dear, for it must be fine weather wherever you are." The ice thus being broken, Mrs. Leslie proceeded to ask the head of the Beehive house some exceedingly frank questions on Mormonism, including a question as to whether Mormon husbands did not prefer some wives over others. To which, the Mormon president replied with good humor: "Well, perhaps; human nature is frail, but our religion teaches us to control and conceal those preferences as much as possible, and we do—we do." [23]

Both the Leslies were greatly impressed with the Mormon organization and the marvels wrought by its members in transforming the desert. "Certainly, polygamy is very wrong," wrote Mrs. Leslie, "but roses are better than sage-brush, and potatoes and peas preferable as a diet to buffalo grass. Also school-houses, with cleanly and comfortable troops of children about them, are a symptom of more advanced civilization than lowly shanties with only fever-and-ague and whisky therein." Frank Leslie put it in even stronger terms when he said in an interview on his return to the East—"the thriftiest, most contented and happiest people west of the Mississippi are the Mormons, and I for one do not want to see them treated with injustice." [24]

If Mrs. Leslie was impressed with the Mormons she certainly was not with Indians of the West who began to appear at railroad stations through Nevada as the party continued their westward journey beyond Salt Lake City. Shoshones and Piutes were all the same to her and, as Chinese laborers in considerable number also made their appearance along the railroad as they traveled further west, it was almost inevitable that she should make a comparison of the two races. "Ill as their odor may be," wrote Mrs. Leslie of the Chinese, "in Caucasian nostrils, we must say that their cleanly, smooth, and cared for appearance was very agreeable in contrast with the wild, unkempt and filthy red man." [25]

A few illustrations of the Indians encountered through Nevada are recorded in the pages of *Leslie's*. Illustrations of other aspects of Nevada life are copious. Towns, scenery and a particularly exhaustive pictorial study of the silver mines of Virginia City are presented. Leslie must have been extraordinarily fascinated by the silver mines, for not only is the pictorial reporting extensive but written description in abundance is provided. In fact, Leslie with one of the artists—whether it was Ogden or Yeager is not indicated—were the only two members of the party of twelve to descend the shafts of the mines at Virginia City to see mining operations at first hand. Mrs. Leslie, on the other hand, was greatly bored by the entire

visit and so unfavorably impressed with Virginia City, itself, that there resulted an unfortunate comment in her account of the trip.[26]

The depiction of several incidents of travel from Wyoming westward along the main line of the transcontinental road reveal still other aspects of Western travel in 1877. One group of illustrations shows various phases of the long-continued war between railroads and those United States citizens who have long been known as "tramps." "Tramps Throwing Conductor From a Train," "A Night Camp of Tramps Near Bryan [Wyo.]," "Tramps Riding on the Trucks Underneath the Cars" and "Clearing the Rear Platform on an Overland Train" were, with the exception of the first, reportedly observed by the artists of the Leslie party.[27]

For the protection of baggage and express against the still more vicious customers, railroad highwaymen, it was customary to carry a stand of arms in the baggage car, and one of the observant artists sketched "A Baggage-Master's Armory" to record this phase of travel in the past. Cross-country excursion parties, too, were still in vogue nearly ten years after the completion of transcontinental rails, and one such excursion party—in addition to the Leslie party—had their special car which, for some of the journey at least, made up a part of the train which included the Leslie special car. "Nebraska Editorial Party Publishing a Paper on Board a Train," a half-page illustration, shows not only the professional classification of the Leslies' fellow travelers but is an unwitting comment on a profession, the members of which, doubtless more than any other, enjoy a bus man's holiday.

A type of illustration, however, which never fails to arouse interest is one depicting the ordinary occupations of ordinary people—like ourselves—and the Leslie artists secured it in "Weary Passenger Settling for the Night," but the illustration might better be called "Trying to Sleep at Night in a 'Day' Coach." The Leslie party in order to reach the Nebraska editors in the special car passed through three day coaches as the evening was well advanced. By the dull light, Mrs. Leslie noted "we could see the poor creatures curled and huddled up in heaps for the night, with no possibility of lying down comfortably; but men, women, bundles, baskets, and babies, in one promiscuous heap." [28]

The excursion train at last crossed the Sierra Nevadas, coasted across the Central Valley and eventually reached Sacramento and San Francisco. Many illustrations record the last stage of the overland trip, including a huge double-page one, "The Excursion Train Rounding Cape Horn at the Head of the Great American Canon." [29]

Mrs. Leslie thought that this view from Cape Horn was the most impressive of all on the cross-country trip.

But of all the scenery of the entire route [she wrote], nothing can compare with the Great American Canon, heralded by the rounding of Cape Horn, where the railway clings to the face of a precipice, with a thousand feet of crag above and two thousand feet below; a river winding dimly through the ravine, and giant pine trees dwarfed to shrubs as we look down upon their crests. No blood so sluggish, no eyes so dull, no heart so numbed and encrusted by worldliness but that they must be stirred and thrilled, as few things in this world can stir its favorite children, by the sensation of thus flying like a bird across this precipice, over the depths of this frightful abyss, suspended, as it were, between heaven and the inferno; . . .[30]

Still another wonder, however was to confront them when they reached San Francisco, for the party immediately upon their arrival went to the newly completed Palace Hotel, according to one Californian at least, one of the seven wonders of the world. Even the blasé New Yorkers were forced to admit the hotel, with accommodations for twelve hundred guests and with its three great courts occupying a city block, was "magnificent." [31]

In fact, Mrs. Leslie was so obviously impressed with California that she devoted over half her book to the subject, as well she might, for the Leslies were entertained by California royalty on a royal scale: by Ex-Governor Stanford; by Senator Sharon at his one and one-half million dollar country house, Belmont; by Mayor and Mrs. Bryant of San Francisco; by William T. Coleman, the owner of San Rafael valley, and by the famous "Lucky" Baldwin, who inveigled the party to travel south to Los Angeles, from which Baldwin took them to his wide-flung ranch at Santa Anita. All of the famous wonders of California were visited too, including the redwoods and the big trees, the geysers and Yosemite. San Francisco itself was explored for its famous sights, especially by many trips to Chinatown, to the Barbary Coast, to Cliff-House and to Seal Rocks.[32] About a month was spent in California, but, oddly enough, relatively few illustrations appeared for this part of the Leslie trip. Several illustrations of the Chinese of San Francisco were published in Leslie's, and several additional California views were used in Mrs. Leslie's book, but apparently Frank Leslie decided that mining in Nevada was of more popular interest than the sights of California, or possibly he felt that California scenes were by 1877 better known than were those of silver mining.[33]

The return trip from California was begun about the last of May, for the party was in Omaha on June 2. It seems to have been largely anticlimax, as neither Mrs. Leslie nor the Newspaper had much to say concerning it.[34]

The two artists of the party were both young men at the time the Leslie trip was made. Walter Yeager was 25 and had been on the Leslie staff for

three years. He was a native of Philadelphia and had received training at the local Academy of Fine Arts. Shortly after the Western trip he accompanied Mrs. Leslie to the Bahamas, and a number of his illustrations resulting from this trip appeared in *Leslie's*. About 1880, he left the Leslie staff and moved to Philadelpia where he became head of the art department of George W. Harris Co., lithographers. Still later he became a free-lance artist and illustrated for a number of periodicals and books. He died in Philadelphia on April 17, 1896.[35]

Harry Ogden, the other artist of the Leslie team of 1877—in his later years known more formally as Henry Alexander Ogden—was a member of the Leslie staff from 1873 until 1881 and then resigned to become a free-lance artist. He received considerable art training at the Brooklyn Institute, the Brooklyn Academy of Design and the Art Students League of New York and made a specialty of portraying historic costumes and uniforms. His illustrations appeared in many books and magazines, notably the military illustrations in the *Pageant of America*. He died at Englewood, N. J., on June 15, 1936, in his eightieth year.[36]

Chapter Eleven

William Allen Rogers and
Mary Hallock Foote

In preparing for the journey to Leadville, we advise the purchasing of a half-dozen woolen shirts, of the heaviest flannel, or even soft woolen cloth—if you are going to camp out it can scarcely be too thick—take a like number of pairs of drawers of the same material with you. Have a sailor's collar to your woolen shirt, and a silk or merino sailor's handkerchief, discarding the linen and paper collars, stand-up or turn-down. Of course if you are never going to venture out of the city of Leadville these directions need not apply; but if you intend looking at the mines, you will find much of the ordinary wearing gear of the eastern society out of place here. Don't think of bringing a "stovepipe" hat to Leadville. There has never been a half dozen worn in its streets since its foundation, and half of these were demolished by the miners. There is no place among the mining camps where it would be convenient.
—C. W. Waite, A Complete Illustrated Guide to the Wonderful Mining Country, Leadville, Colorado, 1879.

William Allen Rogers joined the art staff of Harper Brothers in 1877, at practically the same time as Charles Graham, whose western illustrations we shall consider in the chapter which follows, and the two were associated for many years. In 1877, the head of the Harper's art department was that wise, farsighted and insistent taskmaster, Charles Parsons, about whom no less an authority than Joseph Pennell wrote, "his name will never be forgotten as one who helped greatly to develop American Art." [1]

In 1877 all hands in the art department had a very active share in transferring original sketches, drawings or photographs to the wood block—more exactly wood blocks—preparatory to the making of the engraving from which a final illustration was to be printed. Edwin Austin Abbey drew in the foreground figures, for example; Rogers the middle distance figures

162

and background, and T. R. Davis the architectural features; all drawings being reversed, as compared to the original drawings, from right to left. On a large illustration, to hurry the process along, the wood block was divided into as many as thirty-six pieces, and after the general outline had been drawn in on the undivided block, separation was made into the individual pieces and they were passed from one artist to another. Team work of a high order was necessary, especially at the edges where the blocks joined. When all thirty-six were complete, they were bolted together in one piece and sent to the engravers, who cut away all but the lines of the drawing. The engraved wood block then went to the electrotype room where a wax impression of the wood engraving was made. Finally, from the wax mold, the metal printing block carrying the reversed image of the original sketch or drawing, was electrotyped. A far cry from the high-speed optical processes of producing illustrations in the modern magazine! [2]

With such extensive individual work needed in the preparation of illustrations, a large staff of artists was constantly employed by a publishing firm such as Harper's, and on their staff in the 1870's and 1880's there appeared many names notable in American art. In that goodly company besides those already mentioned were A. B. Frost, C. S. Reinhart, Howard Pyle, W. L. Snyder, Thomas Nast and others, all of whom were Rogers' associates in his early days at Harper's.

Rogers' claim to fame rests largely on his ability as a cartoonist. He was, in fact, the successor of Nast after Nast broke relations with Harper's in the 1880's. Relatively early in his career, however, Rogers made several Western trips, and the sketches and illustrations resulting from these trips give him a place in this book.

Rogers was born in Springfield, Ohio, in 1854. His father died at an early age leaving the family more books than money. The books fascinated young Rogers and he pored over them by the hour, taking special delight in those that were illustrated. At thirteen he went to work as a railroad check clerk, keeping a daily record of empty freight cars as they passed through the yards. Here he found Mike Burke, the fireman of the switch engine in the yards, and a friendship was soon struck up between the two. Mike, previous to his railroad days, had been employed as an artist to paint scrolls and small landscapes on the headboards of threshing machines, and it was not long after his friendship with Rogers was formed that he was instructing the youngster in this craft. These impromptu lessons with "red chalk" were all the art training that Rogers received, according to an account in his autobiography. His mother, however, an enthusiastic amateur painter, doubtlessly played an important part in directing his boyhood

activities. Under the direction of his mother and Burke, he had made sufficient progress by the time he was fourteen that he had published a series of cartoons in a Dayton, Ohio, newspaper, and when sixteen his skill had developed sufficiently to secure professional employment in an engraving house in Cincinnati. From this time (1870) until he joined Harper's staff in 1877, he was employed as engraver or artist in several Western cities and toward the end of this period, he was in New York, where for a time he worked on the celebrated but short-lived *Daily Graphic*.[3]

Rogers' first important out-of-town assignment with Harper's came in the fall of 1878 when he was sent to cover the visit of President Hayes to the Minnesota State Fair at St. Paul and the Northwestern Fair in Minneapolis. While in St. Paul he made the acquaintance of a "grizzled old soldier" whom he does not name but who may well have been General John Gibbon, commander of the Department of Dakota, who then had his headquarters in St. Paul.[4]

Gibbon, assuming that he was Rogers' new-found friend, suggested that a trip to the Northwest would reveal a land he had never seen and far different than any he had ever imagined. The trip would not only be valuable to Rogers, Gibbon argued, but its pictorial representation in *Harper's* would be valuable to the new country just opening for settlement. The "Northwest" of Gibbon's day was Dakota territory—present North and South Dakota.

The West had become so much a part of the national consciousness by this time—it was two years after Custer's defeat on the Little Big Horn—that the opportunity gave Rogers "visions of the wild life of the plains" that dazzled his imagination. He had no authorization from Harper's to make any such trip but the temptation became too great and he wired Harper's that he was going. Gibbon provided letters to commanders of military posts, to owners of stage routes and to post traders, and went over the map of the region with him in such detail and enthusiasm that Rogers did not wait for a reply to his wire. It came after he had left and said, "come back at once."[5]

The Northern Pacific railroad had advanced by 1878 as far as Bismarck, Dakota territory, and after a stop at Fargo on the Red river, the boundary between Minnesota and the territory, Rogers went on to Bismarck.[6]

Bismarck was then a frontier town, the outfitting point for overland stage and freighting lines going north and west, and particularly for the Black Hills country, to which there had been a mad rush after the discovery of gold three years earlier.

Rogers spent some time in Bismarck, taking in the novel sights. He

noted the freight trains of as many as ten prairie schooners coupled to-
gether and drawn by many yoke of oxen; Indians trading buffalo robes on
the streets; and especially the frontier theatre. An acquaintance took him to
the evening performance and Rogers described a number of the patrons:

> A couple of men came in who seemed to be bosom-friends. One
> was small and light, the other a tall, burly fellow. The little man is
> under sentence of hanging, the other the sheriff. Near by, on the other
> side, sat "Chang," a noted desperado, who has killed several men about
> here when he had nothing else to do. As the acting is not remarkably
> interesting, the audience furnish a part of their own amusement. One
> of the small lads of the town is pasting a notice of next week's opening
> of the regular season on the proprietor's back. When performers are
> scarce, the leading lawyer of the town performs on the trapeze. It is
> due to his influence that the condemned man has the liberty of the
> place.[7]

At Bismarck, Rogers was fortunate enough to secure passage on an army
ambulance going to the Standing Rock Indian Agency some sixty-five miles
south and across the Bad Lands. The Agency (Sioux) was located near the
site of present Fort Yates, N. D., and Rogers spent three weeks here view-
ing the activities of the army post and those of the tribesmen. Some of his
best Western illustrations resulted from this visit: "Shooting Cattle at
Standing Rock Agency," "Indian Dance, Standing Rock Agency, After Dis-
tribution of Rations," "An Indian Village, Near Standing Rock" (a group
of seven illustrations on one page), and best of all, "A Barber's Shop at
Standing Rock, Dakota Territory—An Indian Chief Having His Hair
Dressed," the dressing being done in the white man's barber shop.[8]

Rogers undoubtedly made many other sketches at this time which were
never reproduced. The only original drawing of this period which I have
located is in the Library of Congress. It is a portrait wash-and-pencil draw-
ing with the inscription "Kill-Eagle-Wam-ble Kte. Standing Rock. D. T.
Oct. 78." It appears to be the same individual depicted in the barbershop
illustration.

Rogers returned to Bismarck by stage, and if the novelty of the new
country was wearing off, his return trip was enlivened by the fact that the
only other passenger was an insane man! After considerable difficulty,
Rogers and the driver were able to deliver their charge to the railhead at
Bismarck where he was being taken for treatment.

But Rogers' Western "leave" was not yet over. Returning by rail to Fargo,
he attempted to obtain transportation down the Red river to Fort Garry
(present Winnipeg, in the province of Manitoba). He spent some days in

Fargo waiting for a river boat and during that time his pen was busy. "Fargo, Dakota—Head of Steamboat Navigation on the Red River" published several years after his return, belonged to this period, and the particularly striking "Forest Fire on the Banks of the Red River," were among the results of his stay at this pioneer outpost, "the jumping off point for the Canadian Northwest." [9]

The northern-flowing Red river had so little water in it that steamboats could not reach Fargo, and Rogers was forced to take a branch line railroad to Grand Forks where he was able to get passage on a small and dilapidated old craft which eventually made Winnipeg.

The experiences already accumulated by Rogers hadn't prepared him for his Canadian encounter. He was soon in a state of mind like that of Alice in Wonderland. "From the nineteenth century I had dropped as from clouds, into the seventeenth or eighteenth," he wrote.[10]

For here at Fort Garry, or Winnipeg, was one of the great depots of the Hudson Bay Company. The turrets and towers of the fort looked down on a motley array of voyageurs, Indians and traders in strange and fantastic garb. In front of a store, in place of barrels of potatoes and cabbages, were heaped a great pile of moose heads with their huge and spreading antlers. Rogers was not long in recording the scenes before him. Much of this material was used in illustrating an article on "The Honorable Hudson Bay Company" in *Harper's Magazine,* although the most interesting of the group appeared in *Harper's Weekly,* "Traders at Fort Garry, Manitoba." [11]

By this time winter was rapidly coming on, the telegram from Harper's "come back at once" had finally caught up with him, and Rogers decided that his three-months' vacation had come to an end. Return was made to Fargo by stage, river boat and branch rail, where the reality of Northern Pacific rail lines again assured him that he was back in civilization.

Upon arrival in New York, Rogers went immediately to Harper's where he was met by Parsons who greeted him in a most doleful manner. Fletcher Harper apparently had taken the "leave of absence" in none too kindly a manner. Parsons agreed, when Rogers walked in, to make a last plea for their wandering illustrator. In Parsons' absence, Rogers spread his three-months' accumulation of sketches around the office on tables, chairs and desks, and when Parsons returned with a still more melancholy look upon his face, Rogers' one-man exhibit was ready. Parsons paused on the threshold and his mouth dropped open. The melancholy air disappeared as if by magic as eager and interested examination of the sketches began. The day was saved for Rogers and his position on the Harper's staff was no longer open to question.[12]

The following fall, as the result of this Western trip, Harper's sent Rogers and A. A. Hayes, an illustrator and writer team, on a fully authorized Western excursion, a trip which took them to Colorado and New Mexico. Part of the time they traveled together and part of the time separately. Hayes wrote pleasantly and extensively of their joint trip and Rogers has left an account of some of his own experiences.[13]

The westward journey of the pair was made from Kansas City to Pueblo, Colo., over the newly-constructed Santa Fe railroad which had been completed over this distance only two years at the time of their trip. The railroad lines paralleled in part the old Santa Fe trail and the contrast of these two trails and the rapid development of southern Colorado were factors which caused Harper's to send out their representatives to "New Colorado." Then, too, the booming mining developments around Leadville were matters of public interest in the late 1870's, and before the two returned, Leadville and the mines were visited.

At Pueblo, Rogers ran into so real a Western difficulty that he bought himself a six-shooter for protection, with results that might have been tragic but which actually turned into a comedy of errors. The Denver and Rio Grande railroad that ran from Pueblo to Denver was the center of a struggle between rival factions of trainmen. Rogers was spied at the Rio Grande station by one of the groups who thought they had been ill-treated by the Denver papers. With his sketchbook under his arm, he was mistaken for a reporter on the offending paper. The irate trainmen immediately started for him with the yell: "Here's that damned reporter for the Denver *News*. Let's get him." His notebook was snatched from him as he made a hurried departure on the train; and this experience led him to buy the six-shooter upon his arrival in Colorado Springs, the shopkeeper obligingly loading the weapon for him.

Two days later he returned to Pueblo with the gun in his pocket and ready for any trouble. Sure enough the same gang was out and the man who had stolen his sketchbook recognized him. Rogers had some difficulty getting to his gun as he beat a hasty retreat across the tracks but was followed by only the one man. As he dodged around a freight car the gun was out, and Rogers undoubtedly felt as if he were making "Custer's Last Stand." His pursuer called "Don't shoot" and explained haltingly and brokenly that he had found out his error and was simply attempting to return the stolen sketchbook. Rogers shakily accepted the book, shuddering at the nearness of his escape from tragedy. The real comedy in the situation was delayed for several days when, on visiting a ranch, Rogers and several of his friends decided to have target practice. His six-shooter was brought

out, aimed and the trigger pulled, but the report was only a dull click. The obliging shopkeeper in Colorado Springs had loaded his rim-fire gun with center-fire cartridges! [14]

In Hayes' entertaining account of the Colorado experiences of the two, he always referred to Rogers as the "Commodore," and not to be outdone in military titles, referred to himself as the "Colonel," although both admitted with some regret that they had no troops, no regiment, no staff.

From Pueblo, Hayes and Rogers set out, first on burro-back, but later and more thankfully in a buckboard, for a cattle ranch in the foothills of the Front range, a ranch belonging to one "Uncle" Pete Dotson. Here Hayes acquired statistics to show the profit that could be made in the cattle business—for the era of the huge cattle ranches of the early 1880's was based in part on reports such as Hayes made—and Rogers had his first opportunity to sketch cowboys and range cattle. The results are none too good for Rogers was not adept at drawing animals, and his horses and cattle are poorly proportioned in relation to background and are usually clumsy and awkward in appearance. However, there are some quite acceptable illustrations of other life around the ranch. "Old Antonio," a Mexican foreman on the ranch is most interesting.[15] In several of these and in succeeding illustrations, especially those that depict the activities of the two visitors, the latent talent of Rogers as a caricaturist becomes quite apparent. "Crossing the Huerfano," for example, shows the two clinging to a nearly submerged vehicle in the swollen river, Hayes in cutaway coat, top hat and eyeglass, and Rogers with his sketchbook under his arm, arrayed in English tweeds and derby.

Somewhat later a sheep ranch on the plains near Colorado Springs was visited, and in the illustration "Supper with the Herder," Hayes and Rogers appear in these same costumes, with Rogers sporting a monocle in the one-room kitchen and living-room of the sheepherder. "Morning at the Ranch," however, is realism of a high order for it shows the dilapidated shack of the herder against the bleak and forsaken background of the High Plains.[16]

Their journey to the mines and mountains of Colorado took them first to the small town of Rosita, west of Pueblo, on the eastern side of the famed Sangre de Cristo range. Here with considerable misgiving they were lowered, by means of a huge iron bucket, five hundred feet to the bottom of a bonanza silver mine.

After safely making the descent and the ascent from the mine, their path led by other small and curious mining towns. Then they turned north, where by train they eventually reached Red Hill, one end of the Leadville

stage line. Here transportation was provided in the form of a spring wagon drawn by four mules which kept in advance of the heavier stage coaches. They went past Fairplay, even in 1879 an old mining camp, to the foot of Mosquito pass. Their ascent to the pass was over a road which even the stage drivers acknowledged to be extra hazardous, "a fact which the passengers were willing to admit as they started the descent toward Leadville."

Leadville itself, following an important silver discovery the year before in 1878, was found to be "not a city, or a town, or a village, but an overgrown mining camp." Hayes wrote:

> Let the reader picture to himself a valley, or gulch, through which runs a stream, its banks rent and torn into distressing unshapeliness by the gulch miners of old days. Close around are hills, once wholly, now partially, covered with trees, which, having been mostly burned into leafless, sometimes branchless, stems, furnish surroundings positively weird in their desolation. Around, at a greater distance, rise lofty mountains, and between the town and one of the ranges flows the Arkansas. Along a part of the length of two streets (six inches deep in horrible dust, which one of the local papers declares will breed disease) are seen rows of the typical far Western buildings, some large, some few of brick, one or two of stone, very many small, very many of wood. Outside of these are mines and smelting-works, smelting-works and mines, stumps and log-cabins, log-cabins and stumps, *ad infinitum*.[17]

Unfortunately Hayes did better with his pen in describing Leadville than did Rogers with his pencil, for the four illustrations of the overgrown mining camp are disappointing. In one, Rogers let his puckish humor get away from him as he depicted a story current at the time, "A Wall Street Man's Experience in Leadville," and the remaining three only meagerly portray the life of Leadville in 1879. Only a few months before Rogers visited Leadville, however, another artist, Edward Jump, had recorded pictorially the mining town. Jump's illustrations, which appeared in *Leslie's Weekly*, are far more satisfying than are Rogers'.[18]

If the Rogers' illustrations of Leadville are not all that can be desired, he atones for his omissions by his somber and striking view, "Freighting on Mosquito Pass," and by two illustrations appearing later in the Hayes series of articles, "Manitou-Pike's Peak" (a night-view) and "Mountain of the Holy Cross."[19] In fact, it is in this kind of work that Rogers appears to the best advantage—a distant and striking view with foreground detail that lends added interest and value to his illustrations.

In the last of the Hayes' articles, return is made to the Santa Fe trail

itself, and Hayes reviews various stages in the development of the trail during the early 1800's until the completion of the rail in the late 1870's. Like the four other articles it is illustrated by Rogers.[20] All but one of the illustrations, however, are imaginary, most of them having been drawn to represent the episodic development of the trail as given by Hayes. The one exception is "First Store in Lakin," a dugout in the small town of Lakin in southwestern Kansas. Other sketches on the plains were made by Rogers but were not reproduced. For example, Hayes states that the partners stopped at Fort Dodge, and farther west

> we went down to the bank of the river [Arkansas] to get a sketch of Bent's Fort—a famed post in the old days. The main structure was one hundred and eighty by one hundred and thirty-five feet, and the walls were fifteen feet high and four feet thick. It is now deserted and in ruins; and the only information which we had to guide us in our search for a fortification (it cannot be seen from the train) which was in its glory when the Army of the West marched to Mexico, was the statement that it was near the 549th mile-post on the Atchison, Topeka, and Santa Fe Railroad.

Although no sketches of Fort Dodge or Bent's Fort appear among the published illustrations of Rogers, his Western illustrations continued to appear several years after his return. "The Settler's First Home in the Far West," while idealized and probably imaginary, was the result of his Colorado trip, for this illustration shows a settler, his family and his home against a background of mountains in the distance.[21]

"Among the Cow-Boys—Breaking Camp," however, Rogers identified as an actual scene, which took place at a roundup on the Cuchara river in southern Colorado. The note accompanying the illustration read:

> Probably few persons who are not immediately interested in the subject have any idea of the enormous proportions to which the cattle trade of our Great West has grown. The tendency to go into business seems to be also growing. The amount of capital represented in some of the herds is sufficient to supply a national bank.[22]

Three other cowboy illustrations appeared in *Harper's Weekly*, "Life in a Dug-Out," "Betting on the Bull Fight" and "Lassoing and Branding Calves," with the prefix "The Cowboys of Colorado," and are also to be attributed to Rogers' Western trip of 1879. The note accompanying the second of these illustrations used the term "cowboy" somewhat uncertainly, as if the writer were not quite sure his readers would understand, and the

note with the last of these illustrations stated: "The 'cow-boys' of the Rocky Mountain regions are a race or a class peculiar to that country. They have some resemblance to the corresponding class on the southern side of the Rio Grande, but are of a milder and more original type." [23]

As Rogers had established himself as a Western artist by 1882, it was but natural that when a cowboy sketch drawn by Frederic Remington came in, the task of redrawing it was assigned to Rogers. This illustration, "Cow-Boys of Arizona—Roused by a Scout," was captioned to fit events transpiring in Arizona at the time of publication, for neither Remington nor Rogers had been in Arizona by 1882.[24]

The last of the illustrations resulting from Rogers' Colorado trip were four sketches, "Mining Life in Colorado," which depicted prospectors in in the spring leaving their winter camp for excursions into the hills.[25]

After this group of sketches, no further Western illustrations by Rogers appeared for a number of years, but in 1890 one of the best of all Rogers' "Westerns" was published. Apparently Rogers made a trip West again, this time on the Northern Pacific, for the illustration, "Harvest Hands on Their Way to the Wheat Fields of the Northwest" was made at Casselton, just west of Fargo, N. D. The illustration records the fact that the wheat farm was taking over the buffalo range. Since Rogers' visit in 1878 to the same country, many great bonanza wheat farms—some of them containing single fields as large as thirteen thousand acres—had developed, and the annual migration of workers to the wheat fields had been established.[26]

Still later, the discovery of gold at Cripple Creek, Colo., led to a series of illustrations. The silver mining sketches in and around Leadville made earlier by Rogers had established him as the mining expert on Harper's staff and he was delegated to cover the latest developments of the 1890's. Of the six resulting illustrations, the most entertaining is "In the Lobby of the Palace Hotel, Cripple Creek," as it shows a wide diversity of types and personalities. Reaching Cripple Creek was still a task in 1893, for the final stretch had to be made by stage, either from Divide, Colo., the nearest point to Cripple Creek some eighteen miles away, or from Colorado Springs, where the stage route covered the twenty-five miles of the magnificent—it is still magnificent—Cheyenne road.[27]

Several years later Rogers made still another Western excursion. The only illustrations resulting from this trip, as far as I know, were a group of five, "Sketches in Santa Fe, New Mexico," which Rogers, in a brief note accompanying the group, stated were made "one afternoon." [28]

As the century approached its end, the West—especially the Great Plains West—felt that it had achieved maturity, a feeling that found expression in

the Trans-Mississippi Exposition at Omaha in the fall of 1898. Fifty years prior to the exposition, the West had been largely a trackless waste; in a half century the new agricultural problems presented to the ingenious settler had been at least partly solved, and a number of new states had been added to the Union; states which formerly had been the home of the buffalo and the red man.[29]

The exposition, however, as far as our story goes, is of interest because Rogers, "the special artist of *Harper's Weekly* for the Exposition" was able to record its activities and especially its contrasts. The most notable of these contrasts appeared in the Rogers' illustration, "Scene at the Indian Congress," where braves in paint and feathers, some of whom undoubtedly not many years prior to the exposition had been on the warpath against the whites, are seen mingling with the crowds of other visitors in conventional dress, all against the background of the elaborate exposition buildings.[30]

The trip to the exposition, however, was but the beginning of a greatly extended tour of the West made by Rogers in 1898–1899. Continuing on from Omaha, Rogers visited eastern Oregon and the newly-developed mining regions of the Sumpter and John Day country, California, and then returned east by way of Arizona, Texas and Colorado. The resulting illustrations show Rogers at his technical best. Illustrations by this time, 1899, were reproduced in facsimile by halftone and are therefore exact copies, as far as form goes, in black and white. Most of the illustrations of this period were reproductions of water colors. Among the more notable and interesting of these, the last Rogers Western illustrations, were: "Conquering a Desert in Southern Arizona," "A Faro Game at El Paso," and "A Winter Stage-Route in the Mining Regions of Eastern Oregon." [31]

After 1900, Rogers' work was devoted almost exclusively to cartooning. His activities, friendships and a philosophical consideration of this period will be found in his cheerful, if rambling, autobiography, *A World Worth While*. He died in Washington on October 20, 1931.[32]

MARY HALLOCK FOOTE

When Rogers and Hayes were in Leadville in the summer of 1879 they made a "pilgrimage to a long, low cottage that stood on rising ground in the outskirts of the town." The cottage was the home of Mary Hallock Foote whom Rogers called "one of the most accomplished illustrators in America." [33]

Mrs. Foote, however, was not at home, for she had accompanied her

husband, a mining engineer, on a two-weeks' prospecting trip. The pair of visitors had to leave without paying their respects to the talented lady, who was not only an illustrator but a well-known novelist as well.

As the circumstances described above suggest—her home in a mining camp and her prospecting trip into the mountains with her husband—this feminine artist got her material for both novels and illustrations at first hand; she was known for her Western novels and her Western illustrations. Indeed, in the period which we are considering, she is the only woman who can claim company among the men in the field of Western picture.

Mary Hallock was born in Melton, N. Y., in 1847, and as a young woman received art training at Cooper Institute in New York City. She began a professional career as an illustrator shortly after the close of the Civil War. She did some work for Harper's but the first illustrations I have found credited to her were in A. D. Richardson's *Beyond the Mississippi*, published in 1867. Oddly enough her illustrations in this volume were of Western scenes, although she did not go west until she married Arthur De Wint Foote, a young mining engineer, in 1876.[34] After her marriage her life was spent almost completely in the West, moving with her husband from one mining location to another; first to California, then to Colorado, then to Mexico (where on a summer visit she traveled on horseback a distance of two hundred and fifty miles in six days), then to Idaho, and finally back to California. Here Mrs. Foote spent nearly a third of her long life—she lived to be ninety-one—in the town of Grass Valley. She therefore had a more intimate knowledge of the West and its many aspects then it was the fortune of most women to possess.

Her first Western experiences are reported in two articles appearing in *Scribner's Monthly*, both written and illustrated by Mrs. Foote, which described the life at the California town of New Almaden—a center of mercury mining—and the coast town of Santa Cruz.[35]

As might be expected, homely incidents of life among the Mexican and Cornish miners, among the "every-day" residents of a California coast town, of picturesque and contrasting scenery and surroundings, were the burden of these articles and illustrations. She wrote:

> The East constantly hears of the recklessness, the bad manners, and the immorality of the West, just as England hears of all our disgraces, social, financial and national; but who can tell the tale of those quiet lives which are the life-blood of the country,—its present strength and its hope of the future? The tourist sees the sensational side of California—its scenery and its society; but it is not all included in the Yo Semite guidebooks and the literature of Bret Harte.

From California, the Footes moved to the lead and silver mining camp at the rough and boisterous Colorado town of Leadville. Helen Hunt Jackson, the celebrated pleader of the Indian cause, heard that Mrs. Foote was there and she and her husband went from Denver to pay their respects.

From Mrs. Foote's Colorado experiences there followed a number of illustrations and three novels.[36] The first of the Colorado illustrations appeared in "The Camp of the Carbonates," a factual article on Leadville by Ernest Ingersoll published in *Scribner's Monthy*.[37] Of the seventeen illustrations, six were drawn by Mrs. Foote and the remaining eleven were by J. Harrison Mills, at that time an artist of Denver.[38]

Mrs. Foote's three novels, all of which appeared serially in *The Century*, used the mining country of central Colorado as a background. Only the first, however, *The Led-Horse Claim*, was illustrated by Mrs. Foote.[39] All of these novels were romances and were highly popular in their day. Mrs. Foote, in 1922, correctly estimated their worth when she stated that they were written "from the woman's point of view, the *protected* point of view." Cecil was the heroine of her first novel, but "What a silly sort of heroine she would seem today [1922]. Yet girls were like that, 'lots of them' in my time." [40]

Forced from Colorado by ill health, the Footes returned East for a year or so, but in 1883 they moved to Idaho, where Mr. Foote served as engineer on an irrigation project. The next ten years were spent in the "Gem" state.[41]

Here again, as a result of her Idaho life, Mrs. Foote produced illustrations, short stories and novels with a local background. Her most notable novel of this period was *Coeur D'Alene*.[42]

It was from her Idaho experiences, too, that her most notable contribution to Western illustration arose. During 1888 and 1889, *The Century* published a series of eleven full-page illustrations, "Pictures of the Far West," each accompanied by a brief note, both illustrations and notes the work of Mrs. Foote.

These illustrations were beautifully engraved woodcuts, for this period marks the golden age of American woodcut illustration; a period which produced magazine illustrations which have never been excelled, and *The Century* was the leader in its field. By title, this notable group of Mrs. Foote's illustrations included:

 "Looking for Camp."
 "The Coming of Winter."
 "The Sheriff's Posse."
 "The Orchard Wind-Break."
 "The Choice of Reuben and Gad."

"Cinching Up."
"The Irrigating Ditch."
"The Last Trip In."
"Afternoon at a Ranch."
"A Pretty Girl in the West."
"The Winter-Camp—A Day's Ride From the Mail." [43]

Of these illustrations, the three that have the greatest appeal are "The Coming of Winter," "The Choice of Reuben and Gad," and "The Last Trip In." The first depicted a settler's cabin and the family, father, mother and child; in the second, resorting to the use of Biblical names, Mrs. Foote showed a small group of settlers arriving at the promised land, a mountain valley; and in the third, she portrayed wagons reaching the home camp with the final supplies for the winter's stay; all scenes which Mrs. Foote had ample opportunity to observe.

Those described so far do not constitute Mrs. Foote's sole contributions to Western illustration. There were many others, chiefly illustrations for her novels or short stories, of which there were quite a number.[44] Some of these illustrations are of considerable interest, however, and one in particular is quite striking, "On the Way to the Dance" which accompanied a short story written by Mrs. Foote.[45]

As far as I have been able to determine, none of Mrs. Foote's original Western sketches are in existence at present. In 1940, Arthur B. Foote, a son wrote me;

Quite a number of her drawings appear in the two volumes *Proofs from Scribners Monthly and St. Nicholas,* published by Scribner's & Co., 1880, and *Selected Proofs from Scribner's Monthly and St. Nicholas* published by the Century Co. in 1881. There are very few original sketches in existence. Most of her drawings were made directly on the wooden blocks that were engraved, and the later ones reproduced by photogravure were not returned by the publishers.[46]

Mrs. Foote lived for over thirty years in Grass Valley, Cal., but several years before her death on June 25, 1938, she went to live with a daughter at Boston, Mass.[47]

Chapter Twelve

Charles Graham and Rufus F. Zogbaum

" 'Them beans is a little hard, ain't they?' says Doc Peets, while
we-alls is eatin', bein' p'lite an' elegant like. 'Mebby they don't get
b'iled s'fficient?'
" 'Them beans is all right,' says the War Chief of the Red Dogs. 'They
be some hard, but you can't he'p it none. It's the altitood; the higher
up you gets, the lower heat it takes to b'ile water. So it don't mush up
beans like it should.'
" 'That's c'rrect every time,' says Enright; 'I mind bein' over back
of Prescott once, an' up near timber-line, an' I can't bile no beans at
all. I'm up that high the water is so cold when it b'iles that ice forms
on it some. I b'iles an' b'iles on some beans four days, an' it don't
have no more effect than throwin' water on a drowned rat. After per-
sistent b'ilin', I skins out a handful an' drops 'em onto a tin plate to
test 'em, an' it sounds like buckshot. As you says, it's the altitood.' "
—*Alfred Henry Lewis*, A Wolfville Thanksgiving, 1897.

During the 1880's there was a rising tide of interest in the plains
country and the Rocky Mountains.[1] This interest was reflected in the
illustrated press of the decade. *Harper's Weekly*, for example, at that time
the best known of American illustrated papers, used an increasing number
of Western illustrations, and it was in this decade that the first of the
Western illustrations by Frederic Remington and by Charles M. Russell,
the most celebrated of the artists of the West, appeared in the pages of
this "journal of civilization." [2]

Further discussion of the increasing fascination with the West as the
1880's advanced will be found in the succeeding chapter which describes
Remington's initial venture into the region beyond the Mississippi. Reming-
ton's Western illustrations, however, did not appear in any great number
in this periodical until after 1885, and only one of Russell's appeared during

the decade. But there were other Western illustrators who had achieved a considerable reputation in this field before Remington and Russell. Among these were W. A. Rogers, whose work we have just described, Charles Graham, Henry Farny and Rufus F. Zogbaum.

Farny will be considered in a later chapter. Graham was the most prolific of Western illustrators during the 1880's, and Zogbaum's work probably influenced later Western illustrators. We shall therefore consider their work here.[3]

CHARLES GRAHAM

Nearly every issue of *Harper's Weekly* from 1880 until 1893 contained a full page or a double-page spread by Graham. Presidential inaugurations, political conventions and other events of national interest were covered by this pictorial recorder. His most favored subject, however, were city views, and he made sketches of many of the cities of the United States. As most of the illustrations were signed or credited in print to "Charles Graham" his name, was, in that period, one of the best known in the country. Yet today his name is virtually unknown. He is not listed in any of the biographical directories of artists nor in the usual sources of biographical information, and none of the leading libraries of the country to which I wrote was able to furnish the simplest and most fundamental facts concerning him. Only by a circuitous correspondence extending over several years was a daughter of Graham located, and even she could not add much to my store of information.

Graham was a Westerner himself, for he was born in Rock Island, Ill., in 1852. He had a natural aptitude for drawing but never received any formal art training. One of his most memorable experiences as a young man was obtained as a topographer with a surveying party for the Northern Pacific railroad in the early 1870's. The Northern Pacific had reached Bismarck early in 1873, and surveys for the westward extension of the road were pushed into Montana and Idaho during the summer of that year. It seems probable that Graham was a member of that survey. Extensive army protection was provided for the surveying parties as Indian troubles— culminating in the Custer tragedy of 1876—were of common occurence.[4] Graham several times used his recollection of experiences on this trip in his subsequent drawings. Whether he made any sketches at the time is not now known.

Graham's professional career began as a scenic artist for Hooley's Theatre in Chicago, followed by several years' work in a similar capacity in the

principal theaters of New York City. About 1877 he joined the art staff of Harper Brothers and contributed for some fifteen years solely to their publications, chiefly the *Weekly*.[5]

After 1892 Graham became a free-lance illustrator, contributing drawings to *Harper's, Century, Collier's* and the New York *Herald,* and he did some work for the American Lithography Company. He took up oil painting late in life, his previous work being either from the pencil or by water colors. He died in New York City on August 9, 1911.[6]

Although Graham published literally hundreds of sketches, we are here interested primarily in those depicting the Western scene. At the outset it should be stated that Graham was an illustrator and not a historian. He made a number of Western tours in addition to his original trip of 1873 with the Northern Pacific survey, and on such journeys his pencil recorded many views which later became the bases for illustrations. In addition, photographs, the rough sketches of other artists and previously published illustrations were all, without doubt, used in the preparation of particular illustrations.

Without doubt, too, imagination provided detail in the preparation of many of the illustrations which finally found their way into print. All of which is to say that the event depicted in a given illustration was many times not an eye-witnessed event, although from the title one could easily fall into the error of believing that such was the case. To be specific, one of Graham's full-page illustrations was published on the cover of *Harper's Weekly,* v. 31 (1887), September 3, "In Pursuit of Colorow." Colorow, the Ute chief, had left the reservation and was on the warpath and the event was big domestic news. Graham, it is almost certain, was not in Colorado at the time, but he had been there and his sketch book undoubtedly contained Rocky Mountain scenes. The illustration shows a band of horsemen riding up a steep and rocky mountain road. The picture simply called attention to the news event but was not factual pictorial reporting.

A few months later a second Graham illustration with a background not greatly different was entitled, "Packing Cord-Wood Over the Rocky Mountains." Although the backgrounds in the two illustrations are not identical, the chief differences in the two are in the figures depicted on the mountain road. Further, in the text in connection with the second illustration, (the *Weekly* stated) "taken on the spot by one of our artists." [7]

It seems necessary to explain this point at some length, for the practices of the pictorial press in the days before high-speed photography and half-tone reproduction were far different from those of today, since now the

public insists on factual reporting, both pictorial and written. Indeed, in the early history of the pictorial press one occasionally encounters the depiction of an event before the event itself had transpired.

It should also be realized that Graham was not the only illustrator who used these methods which are contrary to current practice. For example, a Remington illustration in *Harper's Weekly*, (v. 30 (1886), September 25, p. 617), was titled, "The Apache Campaign—Burial of Hatfield's Men," and depicted an event in the Apache war of the Southwest. The *Weekly* further stated that it was a "sketch . . . made on the spot." Yet, an examination of Remington's own diary (in the Remington Art Memorial, Ogdensburg, N. Y.), kept on this trip to the Southwest, shows that Remington did not arrive on the scene until nearly a month after the event. Under date of June 15, 1886, Remington recorded in his diary the story of the Hatfield fight and the burial of several of Hatfield's men who were killed, as told to him by one "Private Kelly" of Fort Huachuca (in present southern Arizona) who had been one of the participants. As Remington did not reach Arizona until June 6, and the fight and burial depicted occurred on May 15 and 16, it is obvious that he was not an eyewitness of the event, even though the sketch may have been "made on the spot."

It is only by careful study that any conclusion can be reached about the authenticity of many scenes depicted in the illustrated press of the period we have under consideration and many times the information available is not sufficient to reach a decision.

Possibly the greatest value of Graham's Western illustrations at the time they were made was the emphasis which his town and city views placed on the fact that the West was growing up; that not all Western life was cowboy and Indian melodrama. The value of these illustrations at present therefore is that they show the development of the West.

In order to justify the importance attached to his illustrations, let us consider those facts that show that Graham had firsthand acquaintance with the West.

One of Graham's early Western illustrations in the *Weekly* depicted "Ree Indians Crossing the Missouri in 'Bull Boats.'" A descriptive text accompanying the illustration reported that "our artist states that he once saw a band of these Indians defeat almost double their number of Sioux." [8] As the only Western experience that Graham had undergone prior to this time was that with the Northern Pacific survey in 1873, it seems plausible that this illustration was based on his memory, or possibly even a field sketch made at that time. In either case, Graham may have been aided by

the illustrations of George Catlin and of Karl Bodmer, both of whom had drawn somewhat similar scenes, and their sketches were doubtless known and available to Graham.

Between the appearance of the above illustration in 1878 and the fall of 1883, Graham had several additional Western illustrations printed.[9] Whether these were based on direct observation, it is difficult to tell. In the fall of 1883, however, Graham had a number of illustrations depicting various phases of the celebration attendant upon the completion of the Northern Pacific railroad. Here there is positive evidence that Graham was present and these pictorial records we can reasonably believe are authentic.[10] Particularly notable, from a historical standpoint, is an illustration showing the driving of the golden spike on September 8, 1883, connecting the eastern and western links in the Northern Pacific system; an event of almost as great importance as was the joining of the Union Pacific rails with those of the Central Pacific fourteen years earlier.

Possibly the illustration "'Banking Up' for Winter in Dakota" belongs to this same group of sketches.[11] In any case the scene depicted recalls an annual event of importance in the life of the early settlers on the northern plains.

It seems possible that Graham may have returned east by way of California and Colorado, over the Union Pacific, for there appear in the course of the next several years illustrations that confirm such a conjecture. "Felling the Red-Wood Trees of California"; "The Cliff House and Sutro Park, San Francisco, California"; "A Herd of Antelopes Delaying a Railway Train," the locality of which is identified as near Green River, Utah; "A Snow-Slide in the Rocky Mountains," which is identified as near Aspen, Colo.; "'The Antlers,' Colorado Springs," and "Irrigation in Colorado," form a series which, although not appearing in chronological order, might well have been the result of such a return trip.[12]

In January of 1887 Graham made a winter trip to Yellowstone Park in company with the well-known photographer of the park, Frank J. Haynes.[13] The party made a tour of the park on snowshoes and had the memorable experience of being "holed up" in the wilderness one night by a severe blizzard.

Following the Yellowstone Park trip, or possibly immediately preceding it, Graham again visited Colorado, for there appears a notable group of illustrations of the city of Denver which are not only pleasantly decorative but are also well engraved. The Denver views were followed by a number of most interesting Colorado and Utah sketches, including: "Manitou, Colorado"; "Sketches in Utah"; "Cimarron, Colorado"; "A Burro Party,

Pike's Peak"; "An Avalanche in the Rocky Mountains," and "The Great Loop on the Denver and Rio Grande Railroad." [14]

Here we have a group of illustrations that certainly revealed a new aspect of the West to interested residents of the East. The *Weekly* remarked in connection with the Denver illustrations, "There is nothing Western about Denver . . . a pushing city of 60,000 . . .," and expressed amazement at a well-known citizen of Philadelphia who had been heard to say, "Indians must be pretty bad around Denver now." Then with the enthusiasm of a modern press-agent, the editorial writer concluded:

> The Denver man is content with this fine city, fresh and bright from his own hands— . . . away from her he is never quite at ease, for . . . there comes to him the inevitable longing to again walk down her wide shaded streets, to hear the soft gurgle of running water, and to rest his eyes upon the massive beauty of the mountains hanging like huge purple clouds athwart the western sky . . .[15]

After these illustrations of 1887 and 1888, no Western illustrations of Graham's appeared until 1890 when another group of South Dakota, New Mexico and Pacific Coast sketches was published.[16] A number of these are particularly striking and some were dated and the locality given by Graham—an unusual practice, but one which would make the work of the biographer far easier if it had been universally followed by all illustrators and artists. "The Opening of the Sioux Reservation—Newly Arrived Settlers in the Territory," depicts the arrival of settlers on the eleven million acres of the Sioux reservation in South Dakota opened to settlement February 10, 1890; "A Hunter's 'Shack' in the Rocky Mountains"; sketches in and around Santa Fe and Las Vegas; "Harvey's Ranch—The Highest in America," and to my way of thinking one of the best of all of Graham's illustrations, the "Interior of the Church at Acoma, New Mexico, During the Harvest Feast;" all record various and different aspects of life in the West of many decades ago.[17]

Graham was back in New York City by early 1891, when a fire virtually destroyed "the Gilsey block on upper Broadway . . .," a building in which his studio was housed. Only by a miracle did Graham's belongings escape unscathed. The *Weekly* in commenting on Graham's narrow escape remarked:

> The destruction of Mr. Graham's studio, with its fittings, would have been a great and irreparable loss, containing as it does his large collection of quaintly curious relics and models. Here he keeps the scraps and portfolios of twenty years of artistic work in a wide and varied

field, many of the drawings depicting scenes of Western frontier life in an epoch now passed. With these is a large amount of fresh material gathered in Western journeyings through the past summer and autumn for *Harper's Weekly*.[18]

One can only express regret that these portfolios and sketches are now no longer available. Valuable pictorial records that would add to our understanding of past life and to the enjoyment of our present one are now as hopelessly lost as if they had been consumed by fire sixty years ago.

With these illustrations, Graham's career as a Western illustrator comes virtually to an end. During the next few years, 1891, 1892 and 1893, Graham's time was devoted almost exclusively to depiction of the Columbian World's Fair in Chicago. During 1891 many illustrations by Graham of proposed plans for the fair were published in *Harper's Weekly*; in 1892 Graham's pen recorded voluminously the progress in the construction of fair grounds and buildings, and in the year of the fair itself, as we have already pointed out, he served as an official artist of the exposition.[19]

A number of California sketches appeared in the years he lived in California, probably 1893–1896, including the very celebrated "Midsummer Jinks of the Bohemian Club of San Francisco in the Redwoods." [20]

The few scattered Western illustrations of Graham's that appeared between 1891 and 1900 which are worthy of note in our record include:

"Behind Time," probably an imaginary scene of a train delayed by snow or rain or other difficulties in the Rockies or Sierras.
"Over the Rockies in an Observation Car."
"The Great Glacier of the Selkirks, Manitoba."
"Busk Tunnel, Colorado,"—on the Colorado Midland railroad about twenty miles from Leadville.
"A Sand Storm of the American Desert,"—one of Graham's best, the reproduction of a water color.[21]

After 1900 Graham appears to have devoted most of his time to the study of oil painting and his artistic labors resulted in the production of many Dutch and English scenes which are outside the scope of the present study. Appraisal of Graham's work as artist and illustrator is extremely meager. Pennell lists him as one of the American illustrators whose work could be studied with advantage, and his book, *Pen Drawing and Pen Draughtsmen*, included one of Graham's drawings. W. A. Rogers, who knew Graham well, stated that Graham had the finest sense of perspective of any man he ever knew. Rogers, who was himself well acquainted with the West, made the following interesting comment on Graham's Western illustrations:

Graham never quite broke loose from the scenic foreground; but if one will pass over the inevitable tree and rock in the foreground of his pictures of the Sierras and the Rockies one must admit that no truer pictures were ever made of the mountains in all their naked ruggedness.[22]

RUFUS FAIRCHILD ZOGBAUM

Zogbaum was primarily a military and naval artist, but as a result of his Western trips, made for the purpose of recording life in the United States army, there resulted a number of important Western pictures in addition to his military ones.

Zogbaum was born in Charleston, S. C., in 1849. An aptitude for drawing, which became apparent early in life, created a desire for an artistic career. His family was opposed to art as a profession, but he persevered in his ambition and the years 1878 and 1879 found him enrolled in the Art Students' League in New York City. He went to Paris in 1880 and entered the studio of Leon J. F. Bonnat, a celebrated French figure painter, best known for his small pictures of Italian life. Zogbaum said some years later:

> . . . That was rather a queer apprenticeship for a young man who was to paint soldiers and sailors; but I was lonely in Paris and had friends at Bonnat's, so I went there.
> During my two years in Paris I saw the work of De Neuville and Detaille, and that decided me to paint military scenes. . . . In 1883 I went West and brought back a number of magazine articles, for various publishers. . . . I furnished both text and pictures. The illustrated newspapers also took up a great deal of my time. . . . life in a New York studio seems rather tame after years of outdoor existence upon the plains.[23]

The Western experiences to which Zogbaum refers included a trip—possibly several trips—to present Montana in the middle 1880's and a trip to present Oklahoma in 1888. As Zogbaum stated, he not only made many sketches on these trips, but he wrote frequently of his experiences so that we have a fuller record of his life in the West than we do of many of the artists and illustrators with whom we are concerned. Exasperatingly enough, Zogbaum could, with very little additional effort, have been more definite about time and place, but it was the style of writing in those days to refer coyly to a person by description rather than by name and to adopt fictitious names for localities.

From the first of his Western trips to Montana, there resulted the articles:

"A Day's 'Drive' With Montana Cow-Boys," "A Night on a Montana Stage-Coach," "Across Country With a Cavalry Column," and "With the Blue Coats on the Border." [24]

Despite the statement made by Zogbaum in the interview previously quoted that he first went to Montana in 1883, it seems more probable, after a study of those articles and the illustrations which accompany them, that he first visited Montana in the summer of 1884 and probably repeated these visits to the territory in several subsequent years. [25]

The first of the articles is, in effect, an idealized story of an incident told from the standpoint of an artist; color, poses of cowboys and animals, scenes and views, impressions and odors are written into the account. The incident upon which the account was based was the transfer of a herd of cattle from one feeding ground to another through a narrow mountain canyon. The locality—other than Montana—is not given and Zogbaum makes no direct statement that he was there, although it is obvious that he was an observer. The illustrations, like the description, are idealized, although it is obvious again that Zogbaum noted detail most carefully. In fact, in all his Western illustrations, Zogbaum tended to idealize characters and scenery. His horses are sleek, well-fed and well-groomed animals, his foreground scenery conventional.

But Zogbaum, unlike Graham, was willing to get off the beaten track and undergo the rigors of life on the trail, in camp and on stagecoach and, as a result, secured material that is of more than ordinary interest. He took the stage, possibly from Helena, for example, for some unknown destination and chose to sit with the stage driver. Their way led up a steep mountain road. It was night and a violent rainstorm broke upon them before they crossed the range. But Zogbaum stuck to his seat and even held the reins as the driver got out to make adjustments to harness and coach. His conduct was approved by the driver who informed Zogbaum that he had no tenderfoot ways about him "like some o' them Eastern fellers that have been raised with lots of servants about them, and think God Almighty's sun only shines for them. Dignity will do very well in the East . . . but ther' ain't no room for it here. A man's got to rustle here, youbetcherlife." [26]

Having thus placed his stamp of approval on his passenger, the driver needed no urging to spin yarn after yarn for Zogbaum, the storm having abated, and wound up by telling a hair-raising story of having been held up once in "Arizony." This yarn made so much of an impression on Zogbaum that, taken with his ride in an actual stagecoach, one of his most famous illustrations, "Hands Up," resulted. It appeared as a bold double-page illustration in *Harper's Weekly* for August 29, 1885 (pp. 568, 569),

and depicts the robbery of a stagecoach. It was not Zogbaum's first Western illustration in the *Weekly*, however, for two earlier ones had appeared: "General Grant's Death—The News in the Far West," and "Sheridan on the Plains." Both were imaginary scenes, but the background, no doubt, was supplied by Zogbaum's observations in Montana.[27]

The two articles, "Across Country With a Cavalry Column" and "With the Blue Coats on the Border," show how much farther Zogbaum left the beaten trail in Montana. The first related his experiences "winding over the trackless prairie through the gray sagebrush," after traversing tracts of cactus desert, fording streams, climbing over mound-shaped buttes, crossing stretches of alkali dust and sticky mud, and plodding by the shadow of giant mountains.

> Days pass in this way [wrote Zogbaum]. We cross the great plains, almost imperceptibly reaching a higher altitude day by day; we march over the divides and move up through the foot-hills, higher and higher into the mountains. Once, under the shadow of a huge mountain peak, we camp near a small military post, the officers of which bring their families to visit us, and it is a novel sight to our eyes to see delicate and refined ladies and pretty little children seated around our camp-fire, and listening to the lively music of a really excellent string-band, made up from among the enlisted men. Sometimes the line of our march takes us through great canons, by the sides of and through roaring streams, over steep and dangerous mountain trails, where the wagons often experience delay and difficulty in passing.

It has been possible to identify this expedition with considerable certainty, for a study of the Secretary of War's report for 1884 shows that an extensive movement of troops was under way in Montana in the summer of that year. The one accompanied by Zogbaum was the cross-country journey of the 2nd cavalry under Col. J. P. Hatch. These troops left Fort Custer in southeastern Montana on May 24 and traveled overland by way of Fort Ellis (possibly the post referred to by Zogbaum in the quotation given above) and Helena to Missoula, near the Montana and Idaho border, which they reached on June 18. At Missoula they entrained for duty in the Pacific Northwest.[28]

Zogbaum used some fifteen sketches to illustrate his account of this trip and some are very effective. "Taps," "A Moment's Halt," and "The Ford," are all striking illustrations, although as usual his horses are all beautiful animals and his men all well attired, athough in a variety of costumes. Zogbaum, however, called attention in his writing to both of these features for he commented on the excellent mounts provided by the army. When

abroad, Zogbaum had visited a number of European troops and as a result was greatly concerned over the informality of dress affected by the frontier troops. He noted slouch felt hats, forage caps, white sun helmets, a cowboy hat and even a civilian straw hat among the headgear worn by cavalrymen, with an almost equal latitude in many of the other accessories of dress.

> We cannot help smiling [he wrote] as we think of what the astonishment of some of our European friends—the natty English artilleryman, the dashing French chasseur, or closely buttoned, precise German dragoon—would be, could they be dropped down here in front of this command, and how they would inwardly comment in no very favorable terms on the appearance of Uncle Sam's troopers in the field. And we cannot help but ask, and we do so in all good feeling, would it not, without carrying the "pomp and circumstance" of military life to the extreme that our more warlike neighbors do, be of equal practical benefit to the comfort and health of the soldier, and more productive of a feeling of soldierly self-respect, if a little more uniformity, a little more attention to details, and greater regard for appearance, even in the field, and on such rough service as our little army, unlike the European services, is so constantly engaged in, were insisted on.[29]

It is doubtful if Zogbaum's advice had any effect in producing a nattier appearance of the U. S. troops as they plodded across the dry and dusty Western sagebrush plains, but at least the artist had done his best to make neater and more attractive soldiers.

In "With the Blue Coats on the Border," Zogbaum continued the account of his travels through Montana. He may have wanted a more idyllic world but he was a glutton for punishment in seeing what there was of the Montana world of 1884, for this account described a horseback ride from an army post—possibly Fort Maginnis—northward to the Missouri river, a forty-mile ride made in a driving rain. Here, when the Missouri was reached, he caught a river boat and descended the river to another army post. Here again Zogbaum did not identify the locality but it seems certain that the army post was Camp Poplar River, near the Fort Peck reservation and agency for Sioux and Assiniboines.[30]

On the down-river trip, too, Zogbaum heard of the work of the vigilantes, those roused ranchmen of Montana, who, infuriated by the constant loss of cattle and horses, took the law into their own hands and destroyed a number of the thieves. Zogbaum even saw one of the bodies of the desperadoes as it hung from a tree beside the river.[31]

With these sights, Zogbaum's Western sketchbook must have been bulg-

ing at the seams, but after several days spent at the army post he resumed his down-river journey, past more Indian villages and trading posts, until a railroad to the East was reached.

The most notable of the illustrations published with the article included: "The Vigilantes" (showing a group of cattlemen with a burning ranch house in the distance); "A Race With the Boat" (an Indian camp and two Indian boys mounted on a horse), and "The Captives" (rustlers captured by a squad of soldiers; an event which Zogbaum witnessed).[32]

It seems probable that Zogbaum visited Montana again in several subsequent years, as a steady stream of his Montana illustrations appeared in the years 1885, 1886 and 1887, and on a number of occasions he wrote of other Western experiences. He had, however, covered so much Montana territory in 1884 that his accumulated notes and field sketches would have been sufficient to supply the background material for all this published work. But he had, as we have already pointed out, in his published interview of 1895, spoken of "years of outdoor existence upon the plains," which, if he was correctly quoted, makes it certain that he spent more than the one summer in Montana. His additional experiences, as he describes them, also lend support to this belief.[33]

Among these experiences related by Zogbaum are tales of trout fishing, prairie-chicken shooting, overland travel on the Northern Pacific and campfire stories, all, of course, with appropriate illustrations.[34]

Montana illustrations and others of the "Northwest" appearing in the illustrated press of the period, some of which were not accompanied by articles written by Zogbaum, included:

1. "Indian Warfare—Discovery of the Village."
2. "Shooting Prairie-Chickens in Montana."
3. "Trout-Fishing in Montana."
4. "Painting the Town Red."
5. "The Modern Ship of the Plains."
6. "The Old Bone Man of the Plains."
7. "After the Blizzard."
8. "The Prairie Letter-Box."
9. "Wheat-Harvesting in Dakota."
10. "A Horse Auction on the Frontier."
11. "Cavalry Caught in a Blizzard."
12. "The Scout."
13. "A Present to the Company Commander." [35]

All these illustrations appeared in *Harper's Weekly* between 1885 and 1889. Three of them were huge double-page pictures ("Painting the Town

Red," "After the Blizzard," and "Cavalry Caught in a Blizzard"); all the rest were large full-page ones, several occupying the cover page, with the exception of the small "Shooting Prairie-Chickens in Montana." Outside the intrinsic interest of the illustrations themselves, the ones listed above and those previously discussed are important because they set a pattern for Western illustrations for a good many years to come. They called attention by their sheer number to the activities of the army in the West and to other aspects of Western life. Sporadic illustrations of Western army activities had, of course, appeared before the Zogbaum sketches, but his plan to combine both writing and illustration placed a greater emphasis than ever before on this phase of American life. Then, too, his cowboy sketches added to a mounting and intense interest that was to develop into a grand American obsession. True again, there had been earlier illustrators of the cowboy. We have already called attention to the illustrations of Frenzeny and Tavernier and of Henry Worrall in the early 1870's who had depicted activities of cowboys. W. A. Rogers, it will be recalled, also had published cowboy illustrations as early as 1879 and 1880, but the great flood of cowboy illustrations did not come until Zogbaum had set the pattern.

Probably the most important of the Zogbaum illustrations in this respect was his large and vigorous, "Painting the Town Red." If there had been earlier portrayers of the activities of cowboys than Zogbaum, this illustration was one of the earliest, if not the earliest, to show the cowboy at *play*. Four cowboys are depicted at full gallop through the main street of a small frontier town. One cowboy is shown reaching for the flying queue of a hastily retreating Chinaman, another is quirting his horse to still greater speed, a third is yelling, and the fourth is blazing away into the air with his six-shooter. Soldiers, Indians, prospectors and less picturesque citizens line the street.

Such a view crystallized and confirmed the popular conception of the cowboy. The appearance of this large and bold illustration in the most widely read pictorial magazine of its day set the mold for future writers and illustrators. Frederic Remington, for example, the best known of the Western illustrators, "borrowed" Zogbaum's theme a few years later for his "Cow-boys Coming to Town for Christmas," which is almost a duplicate of Zogbaum's picture.[36]

Remington, of course, early made the cowboy a subject of his illustrations. His professional career really dates from 1886, and in that year his first cowboy illustration appeared.[37] It was his well-known "In From the Night Herd," and it was not long before other of his illustrations in the same field followed.[38]

Other artists and illustrators, too, could follow the path laid out by Zogbaum and then by Remington without the necessity of personal inspection, for art magazines were advertising: "Cowboy, Round-up and Cattle Photographs—Sixty Subjects. Splendid Studies for Painting. Send for Circular. Harve and Breckans, Box 410, Cheyenne City, Wyoming." [39] Even one of the greatest of American painters of the nineteenth century, Thomas Eakins, became interested in painting the cowboy after some months spent in the Bad Lands of Dakota territory in 1887.[40]

In addition to "Painting the Town Red," several other Zogbaum illustrations in the group listed on page 187 deserve more than mere listing. "The Modern Ship of the Plains" and "The Old Bone Man of the Plains," for example, again record a different and, at that time, a changing aspect of life in the West.

The first of these two illustrations shows the interior of a westbound emigrant car. The emigrants—Germans, Scandinavians, Scotch, English, Irish—were housed in a car of a Northern Pacific train that had left St. Paul for the "Wild West" (Zogbaum's words) at "four p.m. . . . on a bright afternoon in May." [41] If we can accept the date of the illustration, the year was 1885.

Zogbaum, feeling at peace with the world, left his comfortable Pullman and pushed his way through the cluttered vestibule of the emigrant car. He noted that no attempt had been made at ornamentation or upholstering in the car, "but everything seems strong and well made." He commented on the fact that overland emigrants not many years earlier had been forced to undergo the trials and rigors of ox-train travel across the plains and that by contrast the "new" method was luxury. Well, probably it was. But only a very few years before Zogbaum had made his observations, a Scotch emigrant had written his experiences of actual travel in an overland emigrant train. If Zogbaum stressed the relative luxury of the emigrant or if we think too highly of the importance and the glamour of the Old West, let's listen to the counter statement of the dour Scotchman:

> All Sunday and Monday we travelled through these sad mountains, or over the main ridge of the Rockies, which is a fair match to them for misery of aspect. Hour after hour it was the same unhomely and unkindly world about our onward path; tumbled boulders, cliffs that drearily imitate the shape of monuments and fortifications—how drearily, how tamely, none can tell who has not seen them; not a tree, not a patch of sward, not one shapely or commanding mountain form; sage-brush, eternal sage-brush; over all, the same weariful and gloomy colouring, greys warming into brown, greys darkening towards black; and for sole sign of life, here and there a few fleeing antelopes; here

and there, but at incredible intervals, a creek running in a canon. The plains have a grandeur of their own; but here there is nothing but a contorted smallness. Except for the air which was light and stimulating, there was not one good circumstance in that God-forsaken land.

When night advanced, the weary travelers sought rest:

The lamps did not go out; each made a faint shining in its own neighborhood, and the shadows were confounded together in the long, hollow box of the car. The sleepers lay in uneasy attitudes; here two chums alongside, flat upon their backs like dead folk; there a man sprawling on the floor, with his face upon his arm; there another half seated with his head and shoulders on the bench. The most passive were continually and roughly shaken by the movement of the train; others stirred, turned, or stretched out their arms like children; it was surprising how many groaned and murmured in their sleep; and as I passed to and fro, stepping across the prostrate, and caught now a snore, now a gasp, now a half-formed word, it gave me a measure of the worthlessness of rest in that unresting vehicle. Although it was chill, I was obliged to open my window, for the degradation of the air soon became intolerable to one who was awake and using the full supply of life. . . .

"An eloquent word painting" you say? It should be, for it was written by one of our masters of the English language, Robert Louis Stevenson.[42]

In "The Old Bone Man of the Plains," Zogbaum added another invaluable aspect of changing conditions to our store of knowledge of past Western life. The bone picker—a gatherer of buffalo bones—was following in the wake of the vanished herds which by 1887 (the year the illustration was published) had virtually disappeared from the face of the plains. The uncounted millions which once roamed the Western world lay as whitening bones among the sagebrush and the buffalo grass.[43]

Zogbaum's next Western experiences carried him to the Indian territory and the Oklahoma country. The efforts of the Boomers to open this section of the West to white settlement had been continued almost without letup during the 1880's, and the federal government had at last announced that on April 22, 1889, the country would be thrown open to land-hungry emigrants. The great Oklahoma rush followed.[44]

Zogbaum visited this region late in 1888 and there appeared in *Harper's Weekly* a group of Oklahoma illustrations which have the appearance of field sketches—including the titles:

"A Chase After Boomers."
"A Crossing on the Canadian."

"Relay House on the Mail Route Between Fort Reno and Oklahoma."
"An Oklahoma Well."
"Camp of the 5th U. S. Cavalry at Taylor's Springs Near Guthrie."
"Near the Cimarron." [45]

These were soon followed by a number of other illustrations depicting incidents in the same region, including:

1. "Cheyenne Scouts at Drill."
2. "Arrest of an Illicit Trader in the Indian Territory."
3. "A Picket Post in the Indian Country."
4. "A Beef Issue in the Indian Territory."
5. "On the Road to the Agency."
6. "Indian Freighters."
7. "A Policeman."
8. "A Farm-House."
9. "Running the Wild Turkey in the Indian Territory." [46]

The first of these illustrations, according to *Harper's Weekly*, was made by Zogbaum "with his customary fidelity to facts derived from personal observation." Other similar comments on Zogbaum's work can be found. Even if he tended to idealize his subjects, his details are in general correct.[47]

Zogbaum described some of his experiences on this trip to Oklahoma in an article, "Life at an Indian Agency," and five of the illustrations listed above (Nos. 4 to 8, inclusive) accompany the article.[48] The agency was located at Darlington, near Fort Reno, Oklahoma. The Indians, Southern Cheyennes and Arapahoes, received a beef distribution every Monday at Darlington at "an isolated spot on the prairie, some distance from the agency," and his written description continued:

Wagons—sometimes of the newest and most approved patterns, at others the veriest rattletraps to be found on four wheels, filled with squaws and drawn by all kinds of teams, from the piebald, wall-eyed, pink-nosed ponies, to the patient and more or less broken-down mules, occasionally both horses and mules hitched to the same outfit—are crowded around the rough "corral" or fenced-in space on the prairie where the cattle are herded together, and over which, far up in the clear air, ragged-winged buzzards are circling. Mounted Indians gallop up, some armed with revolvers, others with carbines, and perched high up on the backs of their horses, ready for the exciting sport of pursuing and slaughtering the wild-eyed, long-horned Texas steers, that move restlessly about the narrow limits of the corral, bellowing nervously as if in dread anticipation of their doom. . . .
Rapidly following one another, the brutes are released one by one through the gate opened at intervals by a nimble policeman, who fre-

quently has to exert all his agility to escape the angry sideward thrust
of their horns as the cattle rush through the narrow opening. Some of
them dash frantically out over the plain, bellowing furiously and
throwing up the dirt and dust with the sharp points of their cloven
hoofs; others stop for a moment bewildered, foaming at the mouth and
snorting with fear and rage, and then gallop away. Indians mount
rapidly and start after, revolver or carbine in hand, and a regular
hunt in all directions over the rolling prairie in front of us begins, as
the maddened brutes vainly endeavor to escape from their ruthless
pursuers. . . .

Zogbaum, who had been driven out from Fort Reno in an army ambu-
lance to witness the "Wild West" hunt, was well satisfied with his trans-
portation. It provided excellent accommodations for making notes and
sketches even though the Indians were none too expert marksmen and the
Texas steers no respecters of "government ambulances or 'special artists'."

The four illustrations included directly with this article (Nos. 5 through
8 in the list above) are particularly interesting, as they have the appearance
of field sketches made on the spot and are therefore, from our point of
view, of primary historical importance.

In the late 1880's and early 1890's there appeared a considerable number
of Zogbaum "Westerns." Most of these are of so general a character that,
although of interest, no definite locality other than *West* can be given them.
A few of the more striking ones, several double-page, included:

1. "Cavalry on the March—Danger Ahead."
2. "A Bad Crossing."
3. "Clearing the Way."
4. "Meeting With the Old Regiment."
5. "The Corporal's Christmas Dinner." [49]

Beginning about 1895, Zogbaum began illustrating Western fiction, short
stories for the most part, written by various authors. Some of these illus-
trations are most interesting as Zogbaum was utilizing his knowledge of
Western travel, adventure and study as the background for these imaginary
situations.[50]

In a somewhat similar group were illustrations made by Zogbaum for
factual articles written on the West, particularly the military West. One of
these, "The Defeat of Roman Nose by Colonel Forsyth on the Arickaree
Fork of the Republican River, September, 1868," was drawn to illustrate
an article by Gen. F. V. Greene on "The United States Army." [51] It is one
of the few *original* Western drawings or paintings of Zogbaum's that I
have been able to locate, although it is known that Zogbaum held at least

one exhibition of his original work, several of the pictures being Western scenes in water color.[52] The original of the Colonel Forsyth battle picture is a wash drawing, measuring 15⅝ x 11¼ inches and is now in the prints division of the Library of Congress.

As the 1890's advanced, Zogbaum devoted more and more of his talent to purely military and naval scenes. With the coming of the Spanish-American war his Western illustrations practically disappeared. As a military artist he won wide renown. In fact, so celebrated did he become that Kipling wrote a poem concerning his work, after both he and Zogbaum visited Capt. Robley Evans, the celebrated naval hero.[53]

Despite the fact that Zogbaum was a well-known figure of his day, there has appeared no adequate biography since his death in New York City on October 22, 1925.[54]

Chapter Thirteen

Remington in Kansas

It may safely be said that nine-tenths of those engaged in the stock-business in the Far West are gentlemen. Here is a fascinating, health-restoring and profitable occupation for the great army of broken-down students and professional men, and in crowds they are turning their backs upon the jostling world to secure new life and vigor upon these upland plains.

—*George R. Buckman in* Lippincott's Magazine, 1882.

Among the many diverse, interesting and entertaining social phenomena that have made up the past American scene and its life, one of the most curious—and, in retrospect, one of the most romantic—was the wholesale migration to the plains of the Great West in the early 1880's. The professional historian has catalogued this emigration as one of the factors making up the life of that age, but the phenomenon itself deserves more than mere cataloguing, for it is an important—exceedingly important—movement that was to affect profoundly American life and American culture in subsequent years.[1] That this judgment is more than mere rhetoric becomes apparent when one considers the careers of a single quartet of Western emigrants. The most notable of the quartet was the young and bespectacled Theodore Roosevelt whose cattle-ranching career of several years began in the Dakotas in 1883 and who two years later was to write that the open-air life of the ranchman was "the pleasantest and healthiest life in America." Roosevelt's ranching life led eventually to the leadership of the Rough Riders and their part in the war with Spain. The ultimate reward of the spectacular leader of the Rough Riders was his elevation to the White House.[2] Emerson Hough, the second of our quartet of the West, began his professional life (the study and practice of law) in a cow camp at White Oaks, New Mexico territory, in 1881. His experiences at White Oaks laid the foundations for a career as a noted chronicler of the West,

which probably reached its zenith in one of the greatest of our motion picture plays *The Covered Wagon*.[3] The third member, Frederic Remington, ventured his patrimony in a sheep ranch in Kansas in 1883, and the fourth member was Owen Wister who made his first trial of ranch life in Wyoming in 1885. In *The Virginian*, Wister's most popular book, he created characters and lines that live to the present day.[4] One has only to recall Wister's line—now used so much as to be threadbare—"When you call me that, smile," to appreciate the point.

Of these four men, only Roosevelt and Wister were known to each other previous to their Western life. None of their trails crossed in their early years in the West, but in later life all became very intimately acquainted with each other and with each other's work. Roosevelt and Wister were to become Remington's most ardent admirers and protagonists; Hough, on the other hand, was doubtless Remington's severest critic. All four, however, were extremely active and articulate exponents of the West and its life.

For every one of this articulate quartet, however, there were thousands of inarticulate embryo ranchers in the West before 1885. Although Mr. Buckman's estimate that ninety percent of these newcomers were "gentlemen" may be unduly optimistic, it is probably true that the sunshiny atmosphere of the wide open spaces was rent by many a curse with a pronounced Harvard accent. Cursing, indeed, seemed to be almost a necessary requirement of the difficult life of the West, a fact recognized by that genial philosopher and fount of considerable wisdom, Mr. Dooley, a contemporary well known to the quartet mentioned above. "No wan," points out Mr. Dooley, "cud rope a cow or cinch a pony without swearin'. A strick bringin' up is th' same as havin' a wooden leg on th' plains."[5] This sage observation is given added point when it is recalled that the inability of the future leader of the Rough Riders to use some of the stronger parts of speech in the Saxon language nearly led to discrediting him as a rancher. At his first round-up, Roosevelt urged one of his hands to head off cattle that were making a break for freedom with the shrill cry "Hasten forward quickly there!" The roar of laughter that followed was echoed at many a campfire and Roosevelt almost became the laughing-stock of the country round about, but his vigorous character eventually weathered the near disaster.[6]

More pertinent, however, than the question of language on the plains, is the question "What brought this great influx to the former haunts of the buffalo?" The answer to this question is too long and involved to consider in detail here. The immediate causes in each case were doubtless as numerous as the immigrants themselves but there are certain broad aspects of

the problem that we can point out and which will not be irrelevant in understanding Remington and the success that he later achieved.

The building of the railroad westward and the removal of the Indian barrier were of fundamental importance in the westward migration. Once the main barrier was down and access to the vast new country was easier, the trek began. Adventurers, big-game hunters, settlers in search of cheap land, health-seekers, gold-seekers, enterprising young politicians, restless young men—these and many other types—joined the army of the new forty-niners. Leading the van was the world-roaming, inquisitive Englishman. Many of this class were sportsmen, but England's need of beef was also an important factor in the westward surge, so important that a Royal Commission was sent from England in the late 1870's to study cattle raising on the plains. As a result of its favorable report—and even before—many Englishmen were among those who sought the plains of the New World. "The American cattle-trade is exciting much interest in England, where two of our most pressing needs just now are cheaper meat and outlets for our boys" is, for example, the preface of a contemporary account in an English periodical.[7] If the Englishman started the trail west, the whole world soon followed suit and representatives from nearly every civilized nation of the globe could be found on the prairies and plains of the West.

Why our countrymen—the Easterners—joined this march to the West is not as readily explained. Emerson Hough in later life ironically attributed the "discovery" of the West to three well-known Americans and infers that these three were responsible for the great interest in this region. "Buffalo Bill, Ned Buntline and Frederic Remington," writes Hough with feeling, tinged no doubt by envy, "ah, might one hold the niche in fame of e'er a one of these tripartite fathers of their country! It is something to have created a region as large as the American west, and lo! have not these three done that thing?" [8] Hough, of course, was referring to the West created in the minds of the Easterners by the above trio, for the West, it scarcely needs be said, was discovered long before Remington's day. Hough's commentary, however, is revealing in that it serves to emphasize the part that Remington played in American life during his heyday (1890–1909). But what was the lure that led Roosevelt, Hough and Wister to the West? Remington felt that Catlin, Gregg, Irving, Lewis and Clark aroused his incentive for the Western venture.[9] Their influence, I am sure, was supplemented by still other sources; sources that consciously or unconsciously affected many Americans who migrated to the plains in the early 1880's. In the first place, there was considerable popular literature, both in book and periodical form on the subject, preceding and contemporary

with the beginning of the decade in question. Such books as Col. R. I. Dodge's *The Plains of the Great West* (published in England as *The Hunting Grounds of the Great West*), Vivian's *Wandering in the Western Land,* Campion's *On the Frontier* (Campion made his Western venture as a result of interest aroused by Catlin's paintings), and *Camps in the Rockies* by W. A. Baillie-Grohman were all published between 1877 and 1882, several being sufficiently popular to require publication of more than one edition.[10] The periodical literature, too, of this same interval contains numerous articles on the West and its attractions; many times illustrated by artists from first-hand observations.[11] Some of these Western illustrations have already been discussed in preceeding chapters and others will have our attention later. But probably more important than the books, periodicals and illustrations of the period was still another source of information—the newspapers. One can scarcely pick up an issue of an Eastern newspaper of almost any decade after 1850, without finding news items from the West concerning Western migrations; accounts of Indian troubles; tall stories of frontiersmen and highwaymen and letters from homesteaders, miners and travelers—some of it authentic, much of it garbled and a great deal of it lurid reporting of imaginary events. In fact, so terrible was the reporting in many cases, that Western inhabitants complained of the treatment they received at the hands of Eastern newspapers. Robert Strahorn, a Westerner and free-lance writer, who wrote under the pseudonym of "Alter Ego" for the *Rocky Mountain News* of Denver, and other newspapers, commented on his colleagues in the East in the following acid vein:

> Of manners and morals of western people generally, much is said that is far beyond the pale of truth. Nearly every eager itemizer, from the manager of a representative eastern paper down to the senseless and superficial scribbler for the eastern backwoods press, comes to the new west with mind literally charged with glowing absurdities and with an unyielding determination to realize these absurdities. Why this should be is partly explained by the fact that eastern readers demand experiences from the western plains and mountains which smack of the crude, the rough and the semi-barbarous.[12]

The Indian question, especially, Strahorn pointed out, was invariably overworked by these Eastern correspondents who saw Indians behind every clump of sage brush, menacing the traveler at every step in his journey across the plains.

No doubt, the cause of this extraordinary interest in the Western Indian that the Eastern newspaper reporter displayed was greatly stimulated by

the appalling military disaster that overwhelmed Custer and his command on the hills above the Little Big Horn river in the summer of 1876—the centennial year.[13]

Custer's defeat certainly had the effect of focusing the attention of the entire world upon the Western region and the newspaper interest in this event and succeeding Indian questions is readily understandable, no matter how imperfectly they were reported. The considerable volume of Western literature—in newspaper, periodical and book—makes it apparent then that the West had been "discovered"—in whatever sense the word may be used—long before Remington's day. The West was early a part of the national consciousness, and the events and literature in the decade from 1876 to 1886 had developed a consuming interest in the life of the plains. No matter, for our present purpose, if the great bubble of an abundant ranch life burst with sickening suddenness in the terrible winter of 1886–1887 and if the migration from the plains was almost as rapid as the earlier emigration to the Western land; for, despite the bursting of the bubble, this consuming interest was shared by a large audience, and there were many in that audience who had partaken of that life. By the late 1880's the time was opportune for still other chroniclers who could recall and recapture the life just passed with pen, pencil and brush. They soon appeared and among them was Remington. The fact that he was fortunate enough to have lived for a time this life on the plains, led naturally, if not directly, to his mature achievements as one of the country's leading illustrators.

The year that Remington lived in Kansas was the only time that he established residence on the plains, although in subsequent years he made frequent Western trips for inspiration and fresh material. In this respect he was unlike Charley Russell, whose work has frequently been compared with that of Remington. Russell spent most of his life as a resident of the West and worked for some years as a cowhand. As a result, his work is frequently more exact, as far as detail goes, than was that of Remington, who was primarily interested in action rather than exact detail—an important point to keep in mind in comparing the two artists.[14]

The Kansas experience, however, was not Remington's first Western venture. Late in the summer of 1881, as a youth of nineteen, he had spent some weeks on the plains of Montana and that trip had apparently cast its spell over the youngster.[15] Some sketches had resulted from this trip and one had been published by *Harper's Weekly* in 1882 which was used, however, to illustrate an incident of life in the then Arizona territory.[16]

A year and a half spent at the Yale Art School was terminated early in

1880 by the death of his father who left him a patrimony of several thousand dollars.[17]

After he quit school, Remington corresponded with a Yale friend, Robert Camp of Milwaukee. Camp was graduated with the class of 1882 and late in the same summer went to south-central Kansas to try his hand at sheep-ranching, one of the many individuals in the Western migration of the early 1880's. Remington, if he could have followed his own interests, would doubtless have found his way to the cattle range and established his own cattle ranch. But the initial venture in a cattle ranch on any save the most modest scale, was an expensive business. Theodore Roosevelt, for example, in lesss than a year invested over eighty thousand dollars in establishing his cattle ranch in the Bad Lands of Dakota.[18]

Remington had no such sum to invest and Camp, in his correspondence, pointed out that a sheep ranch could be established with the small patrimony that Remington had available.[19] Further, Camp described the country where he had made his establishment, and life on his ranch with such enthusiasm that Remington was soon eager to join his friend. Camp made the necessary arrangements for the purchase of a small ranch adjoining his own on the south, and early in the spring of 1883 Remington left Albany for a farewell visit to his family at Canton and then set out for the plains of Kansas.[20]

The Kansas "ranch," the purchase of which Camp had arranged for Remington, was a quarter section (one hundred and sixty acres) in northwest Butler county. Butler county is—and was also in Remington's day—a huge rectangle of land, so large that it has been humorously referred to as "the State of Butler." It is a rolling upland that lies on the extreme western edge of the Flint Hills, a high escarpment running north and south which roughly divides the eastern third of Kansas from the remainder of the state. The escarpment rises abruptly from the prairies on its eastern side but slopes upward gently on the western side, merging again into prairie level, and still farther west—much farther—becomes eventually the High Plains. The Flint Hills proper are vast swells, treeless but covered with bluestem grass, and form one of the great natural pasture lands of the world. Sheep and cattle raising and grazing had begun in the eastern Flint Hills almost with the opening of Kansas territory in 1854. As settlers moved west after the Civil War, the stock industry gradually moved with the migration. In the late 1870's after a year or so of extremely dry weather and the failure of grain crops, greater attention was directed to the utilization of the natural resources of the country, especially the native grasses. As a result, a considerable boom in the raising of sheep developed

in the western Flint Hills. Butler county and its neighbor to the south, Cowley county, became the leading "sheep counties" of the state.[21] A good many young bachelors were attracted by this boom, among whom was Robert Camp; and shortly after, Remington arrived.

The immediate country where Camp and Remington had their ranches— if farms of 160 acres could be called ranches—was a sloping plain with almost no trees save along the water courses. Most of the water courses— deep gashes giving rise to steep bluffs—were dry except during the wet seasons, although the principal one, the Whitewater river, usually was a flowing stream. Their immediate neighborhood was well settled so that the country could by no means be regarded as frontier. Ten years earlier there had been frontier difficulties with horse thieves and vigilantes, and the then-cowboy capital, the rough and turbulent town of Newton,[22] was only fifteen miles to the west of Remington's ranch. But these difficulties had long disappeared by the time Remington arrived. They had left their effects, to be sure, on the country. The language was that of the horse and cow country and the sheep ranchers rode horses as extensively as their neighbors to the west and wore the characteristic "chaps" as well. The sheep country, too, was still largely unfenced, each farm owner fencing a patch of his land for his "corral." It should be noted that in the early 1880's there was no odium attached to sheep ranching, nor any of the conflict between sheep and cattle interests which was so widely publicized later in Western history.

The Camp and Remington ranches joined each other. El Dorado, the county seat, was twenty miles south. Peabody, the nearest town on the railroad, was some ten or twelve miles to the north. It was from here that the young men laid in most of their supplies and carried on their business transactions—the trips to town, of course, being made at infrequent intervals by horse. A tiny settlement, Plum Grove, was within three miles of Remington's ranch, but the settlement consisted only of a general store— Hoyt's store—a school-house, and two or three houses.[23]

Camp and Remington soon struck up an acquaintanceship with two other young bachelors and the four soon became inseparable in their enterprises and sports. One of this group was James Chapin, a youngster from Illinois, who "ran" another sheep ranch nearby. And, of course, the ubiquitous Englishman was present. Remington, in an account of his Kansas experiences, designated him only as "Charlie B———," probably a pseudonym to hide the real name of one of that small army of remittance men then scattered over the West. Remington wrote:

Charlie B——— was your typical country Englishman, and the only thing about him American was the bronco he rode. He was the best fellow in the world, cheery, hearty and ready for a lark at any time of the day or night. He owned a horse ranch seven miles down the creek, and found visiting his neighbors involved considerable riding; but Charlie was a sociable soul, and did not appear to mind that, and he would spend half the night riding over the lonely prairies to drop in on a friend in some neighboring ranch, in consequence of which Charlie's visits were not always timely; but he seemed never to realize that a chap was not in as good condition to visit when awakened from his blanket at three o'clock in the morning as in the twilight hour.[24]

Strange, isn't it, that Charlie was able to wander over the prairies at night without danger from the redskin; or wasn't it still stranger that friends visited casually back and forth at their own free will whenever fancy struck them? It can thus be seen that life on a Kansas sheep ranch was a far more prosaic affair than life in the West was so luridly built up to be by the newspapers of the period. To be sure, to Remington's New York friends in Albany and Canton, Kansas was really West and doubtless they felt it would require all of Remington's ingenuity and strength to keep his scalp from being lifted by the savage redskin on week days and great skill with the weapons provided by Mr. Colt to prevent his massacre by the Bad Men of the West when he went to town on Saturdays. Probably, too, Remington himself was not unwilling that his Eastern friends should have this impression. Not long after his arrival in Kansas, he wrote a hasty note from Peabody to William Poste, a legal friend in Canton, N. Y., who had examined some papers for him:

May 11, '83, Peabody

Poste
 Dear Sir—
 Papers came all right—are the cheese—man just shot down the street—must go
 Yours truly
 Frederic Remington [25]

The tantalizing effect of this note on the recipient can readily be imagined and it certainly would do nothing to relieve the popular impression of the West, an effect which young Remington was trying to perpetuate, for an examination of Peabody newspapers shows no such catastrophe recorded.

Remington probably arrived in Kansas early in March of 1883. He was met in Peabody by Robert Camp, who was eager to take the new arrival

on a tour of inspection. The Camp ranch was first visited, but Remington was impatient to see his own property, and so without further delay they were off to the Remington place. There he found a small frame house of three rooms, a well, two barns and a good-sized corral. The main part of the house, a story and a half high, consisted of a long living room below and a bedroom above. Built on the north side was a single room, a gable-roofed affair, that served as the kitchen.[26] The barns were chiefly for horses and considerable remodeling and extension was necessary for conversion to sheep. Remington had arrived early enough in the spring to witness lambing and sheep-shearing on the Camp ranch, so he soon had some idea of the trials and tribulations of his new business. That Camp had really gone into sheep raising on a considerable scale is seen from the fact that Remington witnessed a wool clipping amounting to some seven thousand pounds.

As soon as he had gained some idea of his new undertaking, Remington set to work. Almost his first move, necessarily, was the purchase of horses. Although sheep raising was the principal business of the region, horses came first in the interests of the ranchers and every chance meeting at Plum Grove or Peabody was an opportunity to discuss the merits of horses, to maneuver a swap of the animals or to promote a horse race whenever a newcomer of any reputation put in his appearance. Every rancher kept a small string of horses for work and play. Upon the advice of Camp, several were purchased and finally Remington was able to secure, after considerable dickering, a most unusual animal of which he became very fond. She was "a nervous little half-breed Texas and thoroughbred, of a beautiful light gold-dust color, with a Naples yellow color mane and tail." She was promptly named Terra-Cotta, although to the other boys on the ranch, who had not had the advantage of a year and a half at the Yale art school, she was called Terry. After the horses were purchased, a ranch hand, Bill Kehr, was employed. Bill was still younger than his employer and was really more a boon companion than a hand. Bill also had several horses; one of them, Prince by name, was in appearance a grey sleepy old plug, but his appearance belied his character for he was really a speedy animal and his owner had been able to use Prince's undistinguished outlines for his own advantage on several occasions. In fact, Prince had so much of a local reputation that it was hard to match him up for a race. Jim Chapin, the friend of Camp and Remington, had acquired a horse, Push-Bob, with a reputation for speed, about the time Bill Kehr went to work for Remington. A good deal of discussion as to the relative merits of Prince and Push-Bob took place in the evenings after the chores were

done, but the owners were cautious about putting the horses to the actual test. The race was eventually run but not until late fall under circumstances that were unusual, to say the least, and with a most disconcerting outcome; but we must postpone for the moment this story until we get Remington well started on his ranching career.[27]

With his horses purchased and a ranch hand employed, Remington plunged eagerly into the task of getting the ranch in operation. A large sheep shed was erected at the top of a slope overlooking his range, many hundreds of sheep were purchased, and supplies were freighted from Peabody. Kehr, being accustomed to ranch work, took the lead in getting most of these tasks accomplished, leaving Remington the task of looking after horses and herding the sheep, although Remington was always able to get relief from the latter task by employing one of the many neighborhood youngsters—and his dog—to stand guard while he went about occupations more to his liking. Remington also had to do the cooking for the ranch. He prepared the meals for Kehr and himself as well as the not-infrequent callers. An idea of the cooking may be had from a story told about the daughter of a neighboring rancher. Her hospitable mother had sent her over to Remington's one day with two loaves of freshly baked bread. As the youngster entered the bachelor's kitchen, Remington dumped a large basket of dirty potatoes into a huge pot on the stove, covered them with water, and kindled the fire beneath them. "Why, Mr. Remington," she exclaimed, "don't you wash the potatoes before you cook them?" Remington regarded the youngster gravely and replied, "Wash them? I should say not. I've tried them both washed and unwashed and they taste better unwashed. Have you ever tasted boiled unwashed potatoes?" The bewildered youngster agreed that she never had. "Well you tell your mom to cook them that way and you'll see—and besides, it takes time to wash them." [28]

Fortunately for Remington and his boarders, the monotony of a diet of unwashed potatoes could be varied with canned sardines and canned tomatoes; and doubtless the pile of empty tin cans outside Remington's corral grew steadily larger with the months.

As spring advanced, Remington had more time to roam the prairies and he grew more enthusiastic about his new life. The quarter-section directly west of his was offered to him and he promptly bought it. The toil and drudgery of ranching were easily forgotten in the momentary enthusiasm. This *was* the life, and how he did enjoy it. "The gallop across the prairie," he wrote in describing an early morning run to Bob Camp's place, "was glorious. The light haze hung over the plains, not yet dissipated by

the rising sun. Terra-Cotta's stride was steel springs under me as she swept along, brushing the dew from the grass of the range. . . ." [29]

His rising exuberance as his new life developed was in marked contrast to his behavior when he had first reached the Kansas ranch. Several acquaintances who knew him then recalled that he was inclined to be melancholy, "moody beyond anything I had ever seen in man" reported one of his friends. "In his moments of despair he was not only morose but recluse. He hid from the majority of all his fellows save one, a chap of his own age, James Chapin, who hovered near as something of a guardian angel." [30] The cause of this attitude is now hard to ascertain. All his life Remington was inclined to be volatile—for a time intensely enthusiastic, then despairing; but as he grew older this behavior gradually disappeared. Possibly the youthful Remington, when he first reached Kansas, had been disappointed in love or it may have been that one of his chief interests in life—drawing—had as yet brought him little satisfaction, or the death of his father, all may have played a part. But in the development of his new life the melancholia wore off and Remington soon became more jovial and was well known and popular over the countryside. Many of the children of the period recall the interest he took in them. His drawing, too, was by no means neglected, for he spent considerable time with his sketch book. He sketched his ranch, his sheep, his neighbors and their activities. He went to Plum Grove and sketched the preacher who visited the school-house on Sundays and the sketch was then passed around the audience. A neighbor bought a trotting horse and Remington drew the horse. Bob Camp's cook was greatly pleased when Remington drew for him on rough wrapping paper a sketch of a cow defending her calf from the attack of a wolf. Many evenings a crowd would gather at the Remington ranch and Remington would sketch the individuals as they "chinned" with one another or as they boxed, for boxing was a favorite sport of the young ranchers. Few cared to put on the gloves with Remington as he was almost in the professional class and his opponents were always in for a good mauling when they fought with the ex-Yale football player.[31]

The work of the ranch was so well settled into routine that by July Remington was getting restless again. Leaving the ranch in Bill Kehr's hands, Remington, together with a friend from Peabody, George Shepherd, decided to take a look at the country south and west. Just how extended a trip—on horse, of course—they made at this time is now unknown. They probably went down into Indian territory, not many miles south of Butler county and then may have gone west into New Mexico territory and back by way of Dodge City. At any rate, Remington had made a horseback trip

of some distance into the Southwest—a further exploration of the Western scene.

He was back on his ranch before many weeks, for his uncle Lamartine came out to visit him early in the fall. It was an unfortunate and tragic trip for Lamartine, for he and Frederic, in returning one day from the twelve-mile trip to Peabody were caught in a violent plains' rainstorm. Exposure to the elements led to an illness for the elder Remington that eventually developed into tuberculosis and led finally to his untimely death. To the burly young rancher, hardened by an outdoor life of many months, the storm was just a passing incident and without effect. It was with genuine regret, however, that he put his ailing uncle on the train for home, for he and Lamartine, not greatly separated by years, had many interests in common.[32]

It was shortly after his uncle left in mid-October, 1883, that one of Remington's most memorable experiences in Kansas occurred. He had ridden up to Bob Camp's ranch with James Chapin one evening, and after supper the three, together with Camp's cook, gathered around the kerosene lamp on the kitchen table. As Jim leaned his chair back against the wall, he suggested, "Look here, boys, what do you say to running jacks tomorrow?"

"I seconded the motion immediately," wrote Remington in recalling the evening, "but Bob, the owner of the ranch, sat back and reflectively sucked his big pipe, as he thought of the things which ought to be done. The broken fence to the corral down by the creek, dredging the watering holes, the possibilities of trading horses down at Plum Grove and various other thrifty plans weighed upon his mind; but Jim continued,—'It's nice fall weather now, dry and cold; why a hoss will jest run hisself to death for fun; that old Bob mule scampered like a four year ole colt all the way to Hoyt's grocery with me today, and besides, there hain't nothing to do, and the jacks is thicker'n tumble weeds on the prairie.'"

With Remington's added urging, Bob Camp was soon won over and the sport was planned for the next day. "Jacks," it should be pointed out, are jack rabbits, animals that have "the most preposterous ears that ever were mounted on any creature but a jackass" according to Mark Twain, who also remarked that the jack rabbit, when really frightened, "straightens himself out like a yardstick every spring he makes." At any rate, coursing the jacks was a thrilling chase, but usually not a very dangerous one—for the rabbits. They were coursed by using dogs—usually fleet-footed greyhounds—to rout the rabbits out of their cover and on to the range. There the chase was taken up by the mounted hunters, each armed with a lance, a light pole

some six feet in length. The object of the chase was to touch the rabbit with the lance, a feat not often accomplished. The chase consisted of quarter- or half-mile dashes in the open, followed by a sudden swerve in the line of the chase as the rabbit broke for cover. This was usually a slew (a depression) filled with tall grass, or a rough creek bed—a deep gash in the prairie ordinarily dry but containing dwarf willows. Coursing jacks was thus excellent training in horsemanship even if other gains were meager.

The hunt arranged by Chapin and Remington included seven horsemen; for, in addition to the original trio, there were John Smith, who furnished the greyhound, "Daddy," by name; Bill Kehr, Remington's ranch hand, who was riding Prince; Phip, Bob Camp's cook, who really should not be called a horseman since he was riding "Bob," a mule somewhat advanced in years and who at various times in his long career had "elevated some of the best riders in that part of the country toward the stars"; and, lastly, Charlie B———, the Englishman, on a blue mare and rigged out in regulation English hunting togs, with the exception of the red coat, which several years' experience in the West had taught him was not appreciated for its true worth. Remington was mounted, of course, on his favorite, Terra-Cotta, and Bob Camp on a dependable but not speedy mare, Jane, by name. Jim Chapin was riding Push-Bob, Prince's much-discussed rival; in fact, one of the reasons for arranging the hunt seems to have been the chance offered to get more real facts on the relative merits of the two horses.

The party assembled at Camp's corral, moved down across a dry branch of the Whitewater river that cut across Bob's quarter, up the bluffs and out on to the open range. They had not gone far until

> "There's a jack—take him, Daddy," came a quick cry from Johnnie, and the next moment Johnnie's big bay was off. There goes the rabbit, the dog flies after. "Go on, Terra," I shouted, loosing on the bit, hitting her lightly with a spur, and away we went, all in a ruck. Old Prince was shouldering heavily away on my right, Push-Bob on my quarter, Jane off to the left, and Phip at a stately gallop behind—the blue mare being left at the post as it were.
>
> The horses tore along, blowing great lung-fulls of fresh morning air out in snorts. Our sombreros blew up in front from the rush of air, and our blood leaped with excitement. Away scurried the jack, with his great ears sticking up like two antique bed-posts, with Daddy closing the distance rapidly, and our outfit thundering along some eight rods in the rear. Down into a slew of long grass into which the rabbit and dog disappeared we went, with the grass snapping and swishing about the legs of our horses. A dark mass on my left heaves up, and "ho—

there goes Bob head over heels." On we go. "Hope Bob isn't hurt—must have put his foot into a water-hole," are my excited reflections. We are out of the slew, but where is the rabbit and the dog?

"Here they go," comes from Phip, who is standing on the edge of the slew, farther down toward the bluffs of the bottoms, where he has gotten as the result of a short cut across.

Phip digs his spurs into the mule, sticks out his elbows and manifests other frantic desires to get there, all of it reminding one strongly of the style of one Ichabod Crane, but as we rush by, it is evident that the mule is debating the question with that assurance born of the consciousness that when the thing is brought to a vote he has a majority in the house.

The rabbit dodged, doubled in its tracks when out on the plain again, and came almost directly at Remington who lunged with his lance but missed as Kehr and Charlie swept by. This time the rabbit made for a dry creek bed. Kehr and Charlie crashed together as they went down into the bed and both were unhorsed. Remington, attempting to head off the rabbit, chose to go over a high bluff above the creek. But the descent was so steep that Terra's knees bent under her and both she and her rider went down. Remington was thrown to the bottom with such violence that he lay stunned on the ground, but soon he and Terra were up again. To continue the comedy of errors, another rabbit was run out of the creek and made straight for Phip mounted on his mule. Phip prepared to deal the fatal blow, but as he made ready the mule spied the rabbit coming at him, shied violently and sent his rider sprawling and cursing on the plain.

The riders slowly gathered for a council of war. Bob Camp was the last to arrive, "a sketch in plaster," since the spot where he had been unhorsed was a hole of soft blue mud. After a breathing spell, the horsemen were out for another round. One rabbit had been run down and another was started. It made its escape through the corral of a newly settled rancher, "old" John Mitchner. John came out with a hospitable "how-de boys" and asked them to dinner, an invitation which was eagerly accepted. While waiting for John's boy to cook up a meal of bacon and eggs, the conversation turned to horses. As the hunters looked over John's stock in the corral, Jim Chapin began to "rib" the old man about his horses and John replied, "Wall, my hoss stock ain't nothin' to brag on now, because I hain't got the money that you fellers down in the creek has got fer to buy 'em with, but I've got a little mare down thar in the corral as I've got a notion ken run some shakes." This statement was an open invitation for a race and in practically no time Jim had wagered Push-Bob against old John's little mare. Bill Kehr

promptly joined in. "I'll bet Prince can beat either of you," he said. "I'll ride him, and we'll all three run, the winner to take both, . . . and it's a good time to see whether Prince or Push-Bob is the better horse."

They agreed, and dinner was forgotten as old John went into the corral for his horse. When he led her out, so old and decrepit did she seem, cupidity got the best of the remaining hunters. Remington put up his favorite Terra-Cotta against another mare and her colt in old John's corral; Bob Camp bet Jane against four head of John's cattle; Jack Smith entered his horse in the wagering; and Charlie, the Englishman, staked his blue mare against a likely looking three-year-old in the old man's string. Only Phip on his mule was immune to the fever and he expressed his doubts in no uncertain manner. But his voice was lost in the excitement as the three horses came into line for a quarter-mile race. Remington was to fire the starting shot. Charlie and Bob, together with old John's son, rode out on the plain and marked the finish line and acted as judges. But let Remington tell the story of the race.

The three racers came up to the scratch, Bill and Jim sitting their sleek steeds like centaurs. Old Prince had bristled up and moved with great vim and power. Push-Bob swerved about and stretched his neck on the bit. The boys were bare-footed, with their sleeves rolled up and a handkerchief tied around their heads. Old John came prancing out, stripped to the waist, on his mare, which indeed looked more game when mounted than running loose in the corral. The old man's grey, thin locks were blowing loose in the wind, and he worked his horse up to the scratch in a very knowing way. We all regarded the race as a foregone conclusion and had really begun to pity old John's impoverishment, but still there was the interest in the bout between Prince and Push-Bob. This was the first time the victors of the Whitewater bottoms had met, and was altogether the greatest race which that country had seen in years. How the boys from the surrounding ranches would have gathered could they have known it, but it is just as well that they did not; for as I fired the gun and the horses scratched away from the mark, Old John went to the front and stayed there to the end, winning by several lengths, while Prince and Push-Bob ran what was called a dead heat, although there was considerable discussion over it for a long time afterwards. There was my dear little Terra gone to the hand of the spoilsman, and the very thought almost broke my heart, as I loved that mare as I shall never love another animal. I went back to the corral, sat down and began to whittle a stick. It took Bob and Charlie a half an hour to walk the quarter of a mile back to the ranch. Bill and Jim said nothing kept them from flying the country to save their horses but the fact that they had no saddles.

The six stood disconsolately looking through the fence of old John's corral as he herded in his newly acquired string. Then he reminded them of dinner, but for some reason they had lost their appetites, and with a last look at their former mounts they started dejectedly for home, ten miles distant. Phip and old Bob were used to good advantage, for all the saddles were piled on the mule.

"Every man in this country will know this inside of two days," was the disheartening comment as they got under way. The full force of this observation became only too apparent that evening when Remington and Bill Kehr rode down—on new mounts, of course—to Hoyt's grocery at Plum Grove to renew their larder. As they approached the front of the store and looked through the window, they saw by the pale light of the lone lamp, old John perched on a sugar barrel. He had quite an audience and as he reached the climax of his story, there arose a shout of laughter which was probably heard in El Dorado, twenty miles distant. Bill and Remington looked at each other and quietly decided to go hungry the next day as they turned their horses about and headed for home without going into the store.[33]

If this episode lingered long in Remington's memory, still another one, following the horse race by a month or so, must have been equally well remembered—and remembered with still greater regret—for it was probably one of the causes leading to his withdrawal from ranch life. A Christmas eve party had been arranged for the residents of Plum Grove and the ranchers and settlers in its outlying territory. That night saw the schoolhouse crowded to its small capacity. Remington and all "the boys" were there and so was a prominent member of the community who had incurred their dislike. It is probable that a few drinks had made the boys more boisterous and careless than usual, for as they saw the bald head belonging to the object of their dislike well up in the front of the audience, the target was irresistible. Large paper wads and small balls of mud began to fly toward the gleaming bald dome. Such conduct was, of course, immediately reprimanded, and the guilty parties were asked to leave the schoolhouse. The public reprimand left its sting and made the culprits more obstreperous than ever. As they gathered outside the building, one of them spied a pile of straw. It was hastily piled outside the window and set blazing with a cry of "Fire! Fire!" A near panic resulted. The crowd poured from the doors and even from some of the windows, but fortunately, it was not disastrous. The affair naturally aroused considerable feeling, and the more staid members of the community swore out warrants for the arrest of the perpetrators of

the thoughtless prank. The *Walnut Valley Times*, published at El Dorado, even noted the event in its columns:

> Some of the youngsters up in Plum Grove [northwest Butler county], on Christmas eve., at an entertainment in the schoolhouse, behaved in most unseemly manner, judging by report, and got up a row which assumed almost the proportions of a riot. The matter has culminated by a suit in the district court; Fred Pennington [Remington], Wm. Kehr, John Smith, Chester Farni [Harris?] and Chas. Harriman being the defendants. The first trial resulted in the disagreement of the Jury. Another trial is set for February 4th. The boys are a little "wild and wooly" occasionally in the northwest.[34]

The *Times* account is essentially correct save that the matter was adjusted in the justice court before Justice Charles E. Lobdell rather than in district court. We have Lobdell's word for it that after a two-day trial in which the jury disagreed, the case was dismissed upon the payment of costs, which, along with the attorney's fees and all other expenses, were borne by Remington. One of the attorneys referred continually to Remington as "Billy, the Kid," an allusion which evidently greatly disturbed young Remington, as well it might. In fact, the whole affair was a source of considerable embarrassment to him and he doubtless wished many times that he had not been so foolish and reckless. Up to this time, he had been popular in the community, but, as a result of the prank, which easily might have had a far more serious and tragic conclusion, he was looked upon with less favor. If Remington felt guilty and brooded over the affair at the time, his sins have long since been forgiven.[35] The story above has been told in Butler county many times since that day, but always with forbearance and with pride—a pride that young Remington was part of its life for a time and that his experiences on the prairies contributed to his knowledge of Western ways and of Western horses.

It was not long after the conclusion of the trial that Remington decided to give up ranching. The bad light in which the schoolhouse incident had placed him was no doubt a contributing reason. But there were other and probably more important ones. In the first place, Remington was not cut out to be a rancher. "He didn't take a great deal of interest in the actual work of the sheep ranch," is the statement by which Robert Camp, now in his eighties, sums up his recollections of Butler county days and Frederic Remington.[36] Sheep ranching could go along smoothly in pleasant weather, especially when boys of the neighborhood could be hired to herd the flock, leaving the boss free to roam as his fancy dictated. But there was hard work, too. It was a herculean task to protect the bleating animals from the sudden

northern blasts of wintry weather. The sheep had to be dipped several times a year, an extremely dirty, stinking and disagreeable task, and at lambing time almost constant attention for weeks had to be given to the majority of the flock. In addition to these more or less routine drawbacks, there were the troubles of shearing and the selling of the wool. Unfortunately for Remington, the price of wool took a tremendous slump in the early spring of 1884, the first time he had any for sale.[37]

As a result of these mounting difficulties—and the embarrassment of the trial—Remington began looking for a purchaser for his property. He found one before many weeks, sold his two quarter-sections, his sheep and remaining horses, and by May of 1884, after a year of life on the Kansas plains, he quit the ranch.[38]

Chapter Fourteen

Artists of Indian Life: Henry F. Farny

Look at me. I was raised on the land where the sun rises—now I come from where the sun sets. Whose voice was first sounded on this land? The voice of the red people, who had but bows and arrows. The Great Father says he is good and kind to us. I don't think so. I am good to his white people.—My face is red; yours is white. The Great Spirit has made you to read and write, but not me. I have not learned.—When we first had this land we were strong, now we are melting like snow on the hillside, while you are grown like spring grass. Now I have come a long distance to my Great Father's house—see if I have left any blood in his land where I go. When the white man comes to my country he leaves a trail of blood behind him. Tell the Great Father to move Fort Fetterman away and we will have no more trouble. I have two mountains in that country—the Black Hills and the Big Horn Mountain. I want the Great Father to make no roads through them. I have told these things three times: now I have come to tell them the fourth time.
—*Red Cloud*, before Secretary of the Interior Cox,
Washington, June 3, 1870.

The American Indian, especially the Indian of the West, has long been a subject for the artist's brush. The opinions of artists and of art critics upon the Indian as a theme in art, however, have been extremely varied, ranging all the way from gushing acceptance to rabid and outspoken distaste. For the moment we are not concerned with the pictorial record for purposes of ethnography, which was the primary object of George Catlin, the pioneer painter of the Western Indian, and of his successors; rather we are concerned with the Indian as a subject, who, when treated with skill, knowledge and imagination, gave rise to pictures of genuine artistic merit—that is, to pictures of beauty.

That the opinion of the profession has varied greatly can be seen from the

212

two following comments, both now nearly a century old. In 1856 the editor of *The Crayon*, a pioneer art journal in this country, devoted two columns to a discussion of "The Indians in American Art." He wrote:

> We should rejoice to see the Indian figure more often on our canvas, and the costumed European less. As it is, what with the romancer and the so-called historical painter, he [the Indian] stands a chance of figuring on the picture canvas as a kind of savage harlequin, lost in a cloud of feathers and brilliant stuffs; or else in the other extreme, hung about with skulls, scalps, and the half-devoured fragments of the white man's carcass. All this is dramatic enough, but it is not the truest color of the historical Indian, absorbed in his quiet dignity, brave, honest, eminently truthful, and always thoroughly in earnest, he stands grandly apart from all the other known savage life.[1]

It is difficult to say whether this grandiloquent plea for the Indian in art had any effect on the profession as it was constituted in 1856. It is true that several Eastern artists made Western trips about this time, notably J. F. Kensett and Eastman Johnson.[2]

A few years later, however, the art critic of the New York *Tribune,* hearing that Johnson was considering still another Western trip wrote:

> We regret to learn that Mr. Eastman Johnson intends going off on an extended tour at the North-west for the purpose of making sketches among the half breeds and Indians who live beyond the confines of civilized life. We cannot but think that he might find better subjects for his pencil in the back slums of the Atlantic cities.[3]

Whether this caustic comment deterred Johnson or whether his failure to sell pictures resulting from his earlier Western trips was the important factor, we have no way of knowing; in any case Johnson's trip was abandoned.

"The Rocky Mountain school" as Hartmann, one of the historians of American painting, called it, originated about the time the matters described above were under discussion. Albert Bierstadt, logically to be regarded as the leader of this school, made his first Western trip in 1859, for example.[4] But the artists of this school were interested in the West only as it presented panoramic and melodramatic stretches of plain and mountain scenery, and the Indian was only introduced occasionally to lend color and add interest. Many of the canvases of William Cary, whose work was described briefly in Chapter Three, were of Indian subjects, but here again the Indian was used to record a way of life or to tell a story.

In fact, before 1890 there were very few artists who considered the Indian as a subject of artistic imagination. Possibly the best-known names in this

select group were: George de Forest Brush, De Cost Smith, Edwin Willard Deming and Henry F. Farny. Smith and Deming, although they had begun work before 1890, did not achieve their wide recognition until after 1890 (as a matter of exact fact, not until after 1900) and belong to a later story than ours; Farny, although known as an "Indian artist," was an artist of a far wider Western scene and we shall consider his work in some detail in the pages that follow. Brush, on the other hand, completed the phase of his career that warrants mention of his name here in the decade of the 1880's.[5]

He was born in Shelbyville, Tenn., in 1855, and by the time he was 16 was attending art school in New York City at the Academy of Design. This training was followed by six years (1874–1880) in the studio of the cele-brated Gerome, painter of "Gladiators Before Caesar," in Paris. He thus had a technical training far beyond that of most painters who essayed the Western scene. On Brush's return to this country, he set out to portray the Indian, and once wrote:

> But in choosing Indians as subjects for art, I do not paint from the historian's or the antiquary's point of view; I do not care to represent them in any curious habits which could not be comprehended by us; I am interested in those habits and deeds in which we have feelings in common. Therefore, I hesitate to attempt to add any interest to my pictures by supplying historical facts. If I were required to resort to this in order to bring out the poetry, I would drop the subject at once.[6]

And it is "poetry" for which Brush's oil paintings are truly notable. Brush spent some time during the early 1880's in the West and in Canada. He was on the Crow reservation (present Montana), on various Sioux reserva-tions, and apparently saw a few of the survivors of the fast disappearing Mandans, that tribe on the upper Missouri made well known to posterity by Lewis and Clark and George Catlin.[7]

Among the best known of Brush's paintings resulting from these travels and studies are: "Mourning Her Brave," "The Sioux Brave," "The Indian and the Lily," "The Silence Broken," "The Ball-Game," "The Aztec Sculptor," "The Weaver," "Dawn," "Evening," "Killing the Moose" and best of all "The Picture-Writer." The last painting Brush said "is supposed to be a scene in the interior of a Mandan lodge." It depicted a native artist tracing a design on a buffalo robe.[8]

Despite the wide acclaim given many of these pictures, few art patrons were interested in their purchase. Brush, therefore, decided to change both his theme and his manner and in 1890 he went abroad again for further training. On his return he devoted himself almost exclusively to the por-trayal of mother and child and of beautiful women where he again won

distinction for the skill of his draftsmanship and for his studied dignity of manner. Neuhaus has called him "A unique and distinguished figure in our art." [9]

If only a few artists have devoted extended portions of their careers to the Indian theme, there have been sporadic efforts in this direction by a considerable number of the profession. One of the most striking of these instances occurred just at the time the frontier in American history had ceased to exist—or at least had been officially read out of existence in the famed statement of the bureau of the census in 1890. Furthermore, the mass attack—if such it can be called—of the artists on the Indian occurred in connection with this same census. Following the suggestion of Thomas Donaldson, the compiler of the massive but heterogeneous report on George Catlin, the census bureau sent out a group of "special agents" to take the census of 1890 among the Indians. Among these special agents were the artists Julian Scott, Peter Moran, Gilbert Gaul, Walter Shirlaw and Henry R. Poore.[10]

From the efforts of this group, and many others, there resulted the voluminous document *Report on Indians Taxed and Indians Not Taxed*.[11] Within its 683 pages will be found one of the most exhaustive sources of information on the American Indian ever published. In addition to statistics (which show that there were Indians in every state of the Union and the District of Columbia), history, condition, ethnology, legal status, a review of Indian wars and many other topics will be found on its pages. Of immediate concern to us, however, are the illustrations, for, in addition to many maps, there are numerous photographs and many examples of the work of the five artists mentioned above. The majority of the illustrations appear in black and white but there are also included elegant reproductions in full color of nineteen paintings; in addition, there are two tinted illustrations. For these reasons, it is astonishing that this volume has not become one of the most sought after items of Western Americana, but up until the writing of this account, this volume can still be secured at a very moderate price. Among the color illustrations, for example, are found a striking portrait of Sitting Bull, painted from life by Gilbert Gaul in September, 1890, a few months before the death of this chieftain, probably the best-known Indian in American history; an equally interesting portrait of Washakie, chief of the Shoshones, and almost as well-known a name as Sitting Bull, painted near Fort Washakie, Wyo., in 1891, by Julian Scott; and a portrait, also by Scott, of a very beautiful Indian girl of the pueblo of Sichumnaui, Ariz., in 1891. Although most of the color illustrations are portraits (twelve out of nineteen), there are color reproductions of "Pack Train Leaving Pueblo of

Taos, New Mexico," by Poore; "Sioux Camp.—Standing Rock Agency, North Dakota, September, 1890," by Gaul; "Hunting Party of Shoshones.—Shoshone Agency, Wyoming, August, 1890," by Moran, and "Issue Day" at the Kiowa, Comanche and Wichita agency, Oklahoma, 1890, by Scott. All these color reproductions are full pages, the print size being about seven by nine inches on a page nine by eleven and one-half inches. The largest illustrations in the volume, however, are two folding reproductions in color of paintings by Walter Shirlaw measuring seven by eighteen inches: "The Race.—Crow Indians.—Crow Reservation, Montana, August, 1890," and "Omaha Dance.—Northern Cheyennes.—Tongue River Agency, Montana, August, 1890." In these paintings, almost impressionistic in design, Shirlaw has recorded aspects of Indian life against the sweep and color of the vast Montana plains and hills.

Of the five artists represented in the volume, Scott had credit for most of the illustrations both in color and in black and white, being represented by over thirty drawings or paintings. Moran had three; Shirlaw and Gaul, two each, and Poore only one. Each artist, however, had to double in brass, for in addition to their artistic labors, each prepared a report on at least one Indian agency. Thus Scott reported on the Moqui pueblos of Arizona, Poore on sixteen New Mexico pueblos, Shirlaw on the Tongue River agency (Northern Cheyennes) and the Crow agency, Gaul on the Cheyenne River and Standing Rock agencies and Moran on the Shoshone agency.[12]

Several of this group had been in the West previous to their government employment in 1890; Shirlaw is reported to have been on the plains for six months in 1869 and Poore was probably in Colorado about 1878. Moran had made several Western journeys before 1890.[13] Of these, his trip in 1881 was probably the most extensive. In August he accompanied a party led by Capt. John G. Bourke which visited a number of the Indian pueblos in (present) New Mexico and Arizona. The party was interested primarily in the ethnological aspects of the Pueblo Indians as has been described by Bourke himself in his well-known book, The Snake-Dance of the Moquis of Arizona.[14] . . . Bourke mentioned Moran many times in his account, including the comment, after the ascent of a trail up a mesa, "Mr. Moran made excellent sketches of this romantic trail, as he had already made of everything of interest seen on our trip." Unfortunately none of these sketches, or paintings resulting from these sketches, have been located and even the illustrations in Bourke's book were by Sgt. A. F. Harmer, already referred to in this book.[15]

Moran's interest in the Indian is thus apparently largely ethnographical. As for the other artists of the 1890 census we have judgment on the Ameri-

can Indian as an art subject from Gaul and Shirlaw. Gaul, some years after his return, said he thought Indians were "very picturesque" and that "they were a good deal like the white men—that some were very good fellows and some were very bad." [16]

Shirlaw, when queried on the same point, is reported to have said, "The red Indians are undoubtedly pictorial and perhaps semi-picturesque." Hartmann, who reported this statement, interpreted it in this manner:

> The verdict, overexacting as it may seem, comes nearer to the truth than one may imagine at the first glance. These Western tribes, with their characteristic make-up, their wild way of living, and their peculiar ceremonious rites, contain for the artist all the elements of the pictorial, but even to the layman they can hardly claim to be as picturesque as, for instance, the Arabian horseman whom Schreyer paints.[17]

Just what Shirlaw did mean in his brief comment is uncertain. De Cost Smith also considered Shirlaw's comment and stated, "I think I know what he meant. He felt that the heavy striped blankets and wide-flapped leggings obscured the figure, which was true, though in their camps there was ample opportunity to see them in various degrees of nudity from partial to complete." [18] Whatever Shirlaw meant, the number of his Indian pictures is limited, but he did describe in some detail—and painted—the melodramatic death of an Indian warrior, a scene that he himself witnessed while in the West in 1890.[19]

HENRY F. FARNY

A huge man, over six feet in height, broad shouldered, bulky in the waistline, an inveterate storyteller, renowned as an after-dinner speaker, a man with innumerable friends, alive with interest in life; such is an epitome of Farny in his prime. Friend of Gen. U. S. Grant, of Gen. Nelson Miles, of President Theodore Roosevelt and of many other celebrities, his artistic labors were widely known in his day. Joseph Pennell, toward the close of the 19th century, listed him as one of a half-dozen or so American artists, the technique of whose work students could study with advantage and referred to him "as one of the most original, if erratic, of American artists." [20] Even abroad Farny won recognition, having been awarded a medal at the Paris exhibition of 1889.[21]

Farny spent most of his mature years at his studio in Cincinnati but he made many Western journeys in search of material, especially from 1880 until 1900, and his fame rests largely on the Western pictures of this period.

He has another claim to fame, however, for he was the illustrator, in the late 1870's, of the celebrated McGuffey readers.[22]

Farney was born in Ribeauville, Alsace, in 1847. His father was a prominent Republican, in opposition to the Napoleonic party which came to power in 1852. When the Farny family were forced to flee, they found their way to this country, and from 1853 until 1859 lived in the pine forests on the headwaters of the Allegheny river in western Pennsylvania. During the impressionable years of boyhood, young Farny came in contact with the Indian, for a Seneca in hunting costume appeared in the Farny dooryard, much to the consternation of the youngster. But the warrior was hunting a meal and not game, and after he had been fed, proved so agreeable a companion that young Farny made many visits to the Seneca camp not many miles away.[23]

The western Pennsylvania home was in the wilderness. A desire to be nearer civilization and probably to provide more adequate education for his children led the elder Farny to make another move; this time down the Allegheny on a raft to the Ohio, and then down the Ohio to the metropolis of Cincinnati, long a center of business, publishing and art. Here Henry Farny's artistic bent was soon apparent, for by the time he was eighteen he had published a two-page spread of Cincinnati views in the celebrated *Harper's Weekly*,[24] and was serving an apprenticeship as a lithographer in one of the numerous Cincinnati firms preparing views of the Civil War for sale.

The following year (1866) he went abroad for art training, first to Rome and later to Düsseldorf. Here he was a fellow student with Munkacsy, who at that time was working on the painting, "The Last Day of the Condemned Man," which brought him wide fame. Farny is said to have posed as the central figure in the painting. Funds were scarce, however, and Farny was forced to resort to intermittent labor to secure his livelihood. He wandered from Düsseldorf to Vienna, from Vienna to Munich, interspersing his art training with odd jobs. Three and a half years were thus spent in various European art centers; then in 1870 he returned to Cincinnati. Times were hard, but occasional illustrations for *Harper's,* posters for John Robinson's circus, sketches and illustrations for Cincinnati publishing houses kept the wolf from the door.[25]

He again went to Vienna in 1873 for a period of further training but returned shortly to Cincinnati. His decision to make a specialty of Indian and Western pictures appears to have been reached by 1881. The surrender of Sitting Bull to United States authorities in the summer of that year again focused national attention on the Indian problem. Sitting Bull,

with a number of his followers, on the loose since 1876, the year of the Custer tragedy, had spent much of the time in intervening years across the Canadian border. Wearying of the constant pressure of the United States authorities for his return and greatly concerned about relatives, especially a daughter who was reportedly held in chains until his return, he gave up the unequal struggle and surrendered at Fort Buford, Dakota territory, on July 19, 1881.[26]

Every move made by Sitting Bull in this period was eagerly reported by the newspapers of the country. The additional tragedy of Spotted Tail in the same year and the agitation of Helen Hunt Jackson and her followers raised the Indian question to one of the major topics of the day.[27] It is not surprising, therefore, that Farny, after his boyhood experiences with the redskin, became interested in exploring the possibility of the Indian as an art theme. In the fall of 1881 he made a visit to the Sioux agency at Standing Rock, where Sitting Bull had been first "confined" after his surrender. He found that the famous Indian had been transferred to Fort Randall, but he discovered a wealth of material which he was soon to utilize. Not only were many drawings of the Sioux and of life at the agency secured for his sketchbook, but photographs and examples of Indian attire and equipment were brought back to his studio in Cincinnati in large quantity.[28] His enthusiasm for his new subject grew greater and greater as he began to put his experiences in permanent form. "The plains, the buttes, the whole country and its people," he ardently declared, "are fuller of material for the artist than any country in Europe." And a reporter, making the rounds of Cincinnati studios after Farny had returned, commented: "He draws Indians, he paints Indians, he sleeps with an Indian tomahawk near him, he lays greatest store by his Indian necklaces and Indian pipe, he talks Indian and he dreams of Indian warfare." [29]

The first finished work from Farny's brush resulting from the Western trip was "Toilers of the Plains," a painting which was sold almost immediately upon its completion. A reproduction in black and white appeared several years later as a full-page illustration in *Harper's Weekly*.[30] The picture depicted two squaws gathering firewood while their lord and master walked in unburdened dignity across the plain. The illustration is particularly striking in its play of light and shade across butte and valley, an effect which conveys successfully the feeling of a vast and lonesome land. At the same time, Farny completed a second painting for exhibition at the Paris salon on the same general theme, "The Sioux Women of the Burnt Plains," an effort that attracted the attention and favor of Oscar Wilde, who was lecturing on art in Cincinnati at the time.[31] The picture which

doubtless gave Farny the widest publicity of any made at this time was the bold and striking double-page illustration, "Ration Day at Standing Rock Agency," which appeared in 1883 in *Harper's Weekly*.[32]

Before any of these illustrations were nationally known, however, Farny had attracted wide attention by his Indian portraits and drawings which appeared in Frank H. Cushing's remarkable memoir on his (Cushing's) life among the Zuni of present New Mexico, published in *The Century Magazine*.[33]

Cushing lived for several years in the pueblo of Zuni, having been sent by the Smithsonian Institution to study the life of these Indians. During his stay he made extensive notes and rough sketches, and employed a photographer (John K. Hillers) to record their life in picture. When Cushing's story appeared in print, it was elaborately illustrated by Farny and by W. L. Metcalf.[34]

Metcalf had spent several years in the Southwest from 1881 to 1883, and had visited Cushing in Zuni; his illustrations, therefore, were based on direct observations of Indian life.

Farny, on the other hand, made no Southwestern trip, but visited Washington in 1882 where Cushing had induced some half-dozen Zuni headmen to come and pay their respects to the Great White Father.[35]

From the Hillers photographs, the Cushing notes and sketches, and from his personal observation of the visiting Zuni, Farny prepared his illustrations used in the Cushing articles.[36] The illustrations contributed by Farny are distinctly individualistic and are not only well drawn but are highly decorative, with the result that they attracted not only popular attention but the approval of critics as well. The "Chief Priest of the Bow", for example, was used by Pennell many years later as a model of excellence for pen-and-ink illustration. The manner in which the black-and-white illustration suggests color was noted particularly by Pennell, who also called attention to the strong character of the face. "The decorative manner in which the shield and bow are put in and balance each other," wrote Pennell, "is good and the whole drawing is very well put together." [37]

Farney's next actual contact with the West was on the Henry Villard excursion which left St. Paul early in September, 1883, over the Northern Pacific railway. The excursionists witnessed the ceremony of the completion of this new transcontinental line and the joining of the rails of its eastern and western divisions near Missoula, Mont., on September 8. Some three hundred and fifty members were in the party, personally conducted by President Villard, including many notables both from the United States and abroad.[38]

The railroad celebration and the cornerstone-laying of the territorial capitol at Bismarck, one of the stopping points for the excursionists, had attracted a large and gala crowd drawn from many miles about. Sitting Bull and many of his friends came up from the Standing Rock agency some sixty miles away, and the celebrated Indian was an object of overwhelming curiosity. Farny, who had missed the old chief on his previous trip to Dakota in 1881, made a special effort to meet him, and later introduced him to Villard and General Grant. Grant, the most famous American present, was also an object of curiosity to Sitting Bull, and the two eyed each other with respectful wonder. Both were called upon for speeches at the cornerstone-laying ceremony, Sitting Bull speaking through an interpreter.[39]

Grant and Farny had mutual interests, for Grant too was interested in the West and in painting. He was an excellent draftsman, for all West Point men received training in drawing in the early days, and he even had essayed painting in oils. The only painting to which he is reported to have affixed his signature was a frontier scene including several Indian figures.[40]

After Bismarck, no further stops were made until the excursionists reached Grey Cliff, Mont., on or near the Crow reservation. Here they witnessed a "grass" dance by one hundred warriors.[41] It continued well into the night and the weird spectacle of the dancing Crows, with the long trains of the excursionists brightly lighted in the distance, so impressed Farny that he made a sketch of the scene. The resulting illustration, "A Dance of Crow Indians," is one of Farny's most striking Westerns and appeared late in the year in *Harper's Weekly*.[42]

The *Weekly*, in describing the event in words for its readers, reported in part:

> . . . Never had the extremes and highest types of savage and civilized life been brought together as on this unique occasion, when the dandified habitues of Pall Mall and spectacled German "Philistine" elbowed the painted warriors of the plains. The lurid light of the camp fires, deafening drum-beat, jingling bells of the dancers, and weird monotonous chant of the singers were echoed by the whistle of the locomotives as the excursion trains successively drew up. Great was the desire to secure mementos of the event amongst the foreign guests, and the untutored children of the desert sold the brass ornaments and bracelets which the President of the railroad had given them in the afternoon at a handsome advance over the original cost of the same. As the transatlantic guests are probably ignorant to this day of the fact of their distribution, the desire for souvenirs was gratified, and the Crows retired to their tepees with many shining silver dollars in their pouches.[43]

The culmination of the trip where the ceremony of joining the rails was carried out resulted in a Farny illustration which appeared in *Leslie's Weekly*.[44]

The next year (1884) Farny was back in Montana in company with Eugene V. Smalley, both of whom were sent by *The Century Magazine* to secure material for a magazine article. Smalley was a frequent contributor to *Century* in this period, his articles covering a wide variety of topics, many dealing with various aspects of life in the West. They arrived in Helena on September 14 and were entertained by a group of notables, among whom was Gov. John S. Crosby of Montana territory. An expedition was arranged which included a voyage down the Missouri river in two boats from near Helena to the Great Falls of the Missouri, a portage around the Falls, and a brief extension of the down-river journey to historic Fort Benton, which was, in the days preceding the coming of the railroad, the head of steamboat navigation on the Missouri.

During the first day's voyage, although the swift current carried them many miles, only one ranch was passed. As evening came on and the shadows began to lengthen, the landscape became lonelier than ever.

> . . . Weird profiles and masks [wrote Smalley] looked down from the rocky walls. The talk and laughter, and the shouting for echoes, that had made the voyage a merry one so long as the sun shone, had ceased, and there came upon the wanderers a sense of loneliness and mystery, as though they had set out to penetrate an unknown wilderness. It was a relief to all to tie up to the bank at dark, to light a camp-fire, pitch the tents, and unload the boats; and the efforts of the party to eat supper on the ground, in darkness made visible by the flickering fire, were amusing enough to restore good humor all around.[45]

The second day's run took them through the Gate of the Mountains, those towering cliffs through which the river passes and which had so impressed Lewis and Clark, eighty years earlier, that they had bestowed the name that has clung to them ever since. On the fourth day part of the group, including Farny and Smalley, left their boat and journeyed by wagon across a wide bend in the river, spending that night at the ranch of R. B. Harrison, son of President Benjamin Harrison. Portage of the boats around the Great Falls was made the next day and the river trip continued for twenty-four miles to Fort Benton.

The glory of the famed post and military center had departed. In 1884 it was a town of fifteen hundred, "a queer conglomeration of handsome new brick structures and old cottonwood-log huts, with a few neat frame houses painted in the fashionable olives and browns." On the edge of the

town, Smalley and Farny visited a dozen lodges of the Piegans in one of which a young squaw lay hopelessly ill.

From Fort Benton, Smalley and Farny traveled overland by stage to the railroad at Billings, a journey of some two hundred miles.

The Smalley article in *The Century* contained a number of Farny's illustrations resulting from the trip. All are excellently engraved and all are interesting. Probably the most important are: "Great Falls of the Missouri," one of the best drawings of the Great Falls I've seen; "Piegan Camp on Teton River," and "Ruins of Fort Benton." Concerning the last of these views, Smalley wrote:

> The four towers at the corners of the quadrangle are in a good state of preservation, but portions of the connecting walls have fallen. The rooms where the trappers and traders used to count their profits and make merry are now a rookery of poor homeless people, and the court looks like the backyard of a block of New York tenement houses.

In the late fall of this year (1884) Farny attended the famous "Cattlemen's Convention" in St. Louis. The convention, the most extensive of its kind ever attempted, began on November 17 and lasted a week. Some twelve hundred delegates, "the most influential assemblage of men engaged in pastoral pursuits heretofore held in the world," included representatives from the rapidly expanding cattle industry—one association represented was reported to control a fifteen-million-acre range on the Great Plains. St. Louis made a gala occasion of the event. Farny sketched the convention, a parade and a part of the celebrated Dodge City cowboy band.[46]

It seems possible that two other *Harper's Weekly* illustrations appearing subsequent to Farny's Montana visits are to be attributed to the experiences of these years, although they do not depict actual scenes. The first of these, "The Prisoner," shows a white captive staked on the plain, a passive Indian guard by his side and the tepee village in the distance. This imaginative scene is excellently done; the original—a water-color painting—is now in the collections of the Cincinnati Art Museum.[47] If a realist were criticizing the painting he might observe that the prisoner, stripped of all clothes save his trousers, was treated with more consideration than was usually shown Indian captives. Farny, however, could not paint his captive in a state of complete nudity and expect to get the picture exhibited.

The second illustration was "Suspicious Guests," a double-page spread showing a group of hunters—one of whom is obviously an Englishman— cooking a meal in the shelter of a gully, snow covering the ground on a bleak and broken Western landscape. An Indian is approaching the party

and in the distance, *behind* the party, can be seen several mounted Indians.[48]

Another illustration of this period suggests that in the middle 1880's Farny made a trip to Indian territory, although I have no other information on such a trip. The locality of the illustration, "A Cheyenne Courtship," is identified in the accompanying text as in the "western part of the Indian Territory." [49]

That other Western trips by Farny were made in the late 1880's may be indicated by an illustration of San Francisco,[50] and an especially interesting group entitled, "Sketches on a Journey to California in the Overland Train," nine illustrations on two pages. Of these possibly "Nevada Stage Coach" and "Emigrant Camp, Omaha, Neb." are the most important; the last be-cause it shows that overland migration by horse and wagon was still a factor in the westward movement.[51]

After 1890, Farny's illustrations in the popular magazines of the period nearly ceased.[52] The disappearance of illustrations, however, but marked a change in his activities, for his efforts were directed chiefly toward painting imaginative Western scenes. The first of his more pretentious efforts in this direction was "The Last Vigil" which was reproduced in *Harper's Weekly* in 1891 under the title, "The Last Scene of the Last Act of the Sioux War." [53] The title in the *Weekly*, of course, referred to the Pine Ridge mas-sacre of 1890. The painting showed a squaw mourning beneath the body of a warrior which rested on the crude platform used by the Plains Indians to "bury" their dead.

It was this painting, together with his previous illustrations, which led to Farny's designation as an "Indian painter." In depicting the Indian he was sympathetic but realistic. In much of his work he seemed to take particular delight in portraying contrasts between civilizations. "A Dance of Crow Indians," for example, shows a ritual of the Indian against a background of Northern Pacific trains; "Ration Day at Standing Rock Agency" shows effective contrasts in costumes, as does "Suspicious Guests." Later in his career he painted "The Song of the Talking Wire," which shows an Indian with his ear intently placed against a telegraph pole listening to the hum of the wire.[54]

Farny was particularly successful in conveying the immensity and solitude of the country in which the Indians lived. Theodore Roosevelt, certainly as ardent a proponent of Western life as the East ever produced, saw Farny's pictures on several occasions. Among his favorites were "The Last Vigil," "The Captive" and "The Edge of the Desert." The last shows a sagebrush and cactus desert in the foreground on which there is a single

lonesome figure, with foothills in the middle distance and in the background the peaks of the Rockies. "That's great," said Roosevelt as he saw it in Cincinnati. "It is like going home to see that. I have seen exactly that landscape a hundred times. It is perfect. It is the real West. I am glad that I have seen it." [55] Roosevelt was as enthusiastic in his likes as in his dislikes, and although he cannot be taken as an authority on art, he knew the West intimately and he was well acquainted with the work of other Western artists.

How many Western paintings Farny produced in the last phase of his career, we do not know with certainty. In 1943 the Cincinnati Art Museum held an extensive exhibition of Farny's work which included thirty-nine oil paintings and one hundred and four water colors. Not all of these paintings were Westerns and it is difficult to decide from the printed catalogue which are Westerns and which are not. At least twenty-four of the oils belong to his Western group and seventy-one of the water colors.[56] Reference to Western paintings by Farny not listed in the 1943 catalogue have been occasionally encountered. It would appear, therefore, that the total number of his Western paintings is something in excess of one hundred.

Although the record of Farny's Western trips from 1890 until his death in 1916 is incomplete, some journeys were undoubtedly made in search of fresh material. Many of the subjects of his Apache paintings were probably secured on a trip to Indian territory in the fall of 1894. He was invited to accompany General Miles to Fort Sill, where portions of the Kiowa and Comanche Indians were on reservation, and where Geronimo and remnants of his Apache band had just been transferred. Farny made much of his opportunities on this trip, securing among his sketches a portrait of Geronimo which the famous Apache himself signed. A newspaper account stated that Farny also took photographs,[57] which were used as the basis of future work.

It is odd, indeed, that artists of Farny's calibre have been so completely overlooked by the art historians. Famed and acknowledged in their day— much of their work is of historic value and intensely interesting for the stories their pictures tell, many times with more than ordinary ability—they have been needlessly forgotten. Many of them have made far more than ordinary effort, as did Farny, to secure authentic material and to make certain, by observation and study, that their work was essentially true to the spirit and the fact of their times. Yet until 1950, Farny's fifty years of artistic labor are virtually unmentioned in the usual sources of information on art in America.[58]

Chapter Fifteen

The End of an Era

> *For we ourselves, and the life that we lead, will shortly pass away from the plains as completely as the red and white hunters who have vanished before our herds.—The broad and boundless prairies have already been bounded and will soon be made narrow. It is scarcely a figure of speech to say that the tide of white settlement during the last few years has risen over the west like a flood; and the cattle-men are but the spray from the crest of the wave, thrown far in advance, but soon to be overtaken.*
> —Theodore Roosevelt, *Hunting Trips of a Ranchman*, 1885.

By the end of 1899 the Trans-Mississippi West had established its boundaries pretty largely as we know them today. Only Oklahoma, Arizona and New Mexico remained as territories, and in the course of a dozen years or so all these became states. The century had thus seen the transformation of a huge realm, virtually unexplored and unknown, into an organized and populous section of the Union.[1]

During the last two decades of the century the volume of literature on the West, with accompanying illustrations, became greater and greater. Indeed, the number of illustrators increased so rapidly that it is difficult, if not impossible, to note them all. This period saw the rise of the best-known names in Western illustration, those of Remington, Russell and Schreyvogel. Remington achieved a great popularity as an illustrator between 1885 and 1900, but probably his greatest fame rests on his work done from 1900 until his death in 1909.[2]

CHARLES SCHREYVOGEL

Charles Schreyvogel began his career as an artist of the Western scene in the 1890's, but his greatest fame, too, was achieved after the turn of the

226

century. However, since there is no single source of information about him, as there is for both Remington and Russell, we shall here give a brief review of his work.

It should be pointed out that all three, Remington, Russell and Schreyvogel, were artists and sculptors. In addition, Remington was a most prolific illustrator and writer. Remington and Russell, although seldom depicting a specific scene, were imaginative artists portraying the life of the West as they knew it, or as they had known it. Both made occasional sorties into historical painting. On the other hand, Schreyvogel was primarily an historical artist, depicting events of an earlier day but depending upon study of the written record and of costume. However, his background and atmosphere were obtained by actual visits to the West. Many, probably most, of Schreyvogel's canvases deal with various aspects of the United States' soldier on the Western frontier, although occasional paintings have solely Indian themes.

Schreyvogel was born on the East Side of New York City in January, 1861. As a boy, he showed a talent for drawing and was apprenticed to an engraver. As a boy, too, he dreamed of the West, dreamed of cowboys, Indians and hard-riding soldiers, though his actual experience was delayed until relatively late in life. In 1887 he went abroad for training at Munich, where for three years he was a student of Marr and of Kirschbach. He returned in 1890 and for another three years made a precarious living supplying art work for advertising lithographers. He finally realized his ambition—a trip to the West—and in 1893 spent the summer of that year on the Ute reservation with its post office at Ignacio, in southwestern Colorado, making side excursions to other localities in Colorado and Arizona. His summer was spent in sketching, making models and photographs and in collecting Western firearms, Indian costumes and equipment, all of which he took back to his studio in Hoboken, N. J. He does not appear to have made another Western trip until 1900, when he spent the summer in the Dakotas.[3] His career between 1893 and 1900 seems to have been a continuation of his early work, but Western scenes were now his main interest.[4]

Schreyvogel's greatest fame was achieved with his painting "My Bunkie." Apparently after his return from Colorado in 1893 he still made his living furnishing art work for lithographers; that is, in producing copy for calendar pictures and other advertising. "My Bunkie," painted in 1899, was made for this purpose. Schreyvogel tried to dispose of the painting and was offered a small sum for it. The lithographer who made the offer, however, upon trying to reduce it to calendar size, found that the proportions weren't satisfactory. Schreyvogel then secured permission to hang the picture in an

East Side restaurant in the hope that it would attract the eye of a prospective purchaser. Some of his friends urged him to send it to the annual exhibition of the National Academy of Design. He had already sent at least one such painting to a previous Academy exhibit, and as it had won no special distinction he feared that any new effort was a waste of time.[5] It was finally sent and accepted, and Schreyvogel was astounded when it received the Thomas B. Clarke prize of three hundred dollars, one of the principal awards of the exhibit of 1900.[6] Schreyvogel, the unknown, had become famous overnight, and his days of comparative poverty were over.

"My Bunkie," according to Schreyvogel, depicted an incident that had been related to him by a trooper on his Western trip of 1893. A mounted soldier whose horse is in full gallop is shown swinging a dismounted trooper up into the saddle beside him, while other troopers hold the Indians at bay.[7] The painting is now owned by the Metropolitan Museum of Art. It undoubtedly was a principal factor in Schreyvogel's election as an associate of the National Academy of Design in 1901.[8]

Schreyvogel, as has been said, was primarily interested in the life of a West prior to his day. The difficulties and problems that beset the historical painter and his critics are well illustrated in the events following the first exhibition of another of Schreyvogel's paintings, "Custer's Demand," in 1902. Here Schreyvogel attempted to depict a parley of Custer and his staff with Plains Indians under Lone Wolf, Satanta and Kicking Bird in southwest Kansas during Custer's campaign in the fall and winter of 1869.[9]

The painting is dated 1902 and after its first exhibition at the Corcoran Art Gallery in Washington it was widely reproduced in newspapers and magazines. One reproduction was published in the New York *Sunday Herald* of April 19, 1903, and drew the attention of no less a person than Frederic Remington. Remington by 1903 was rapidly becoming "the most famous of all illustrators in this country" and regarded himself with some right as *the* illustrator of the West.[10] Whether he was jealous of the attention bestowed on Schreyvogel or whether egotism destroyed his sense of values, he took it upon himself to criticize the Schreyvogel painting gratuitously and at some length.

After making the comment that he had studied and ridden "in the waste places and had made many notes from older men's observations for twenty-three years" he went out on the limb and called Schreyvogel's effort "half baked stuff" on the following grounds:

1. The Indian on the left has a form of pistol holster which was evolved in Texas in the late 70's and was not generally worn until the 80's. (And his picture is in 1869.) The cartridge belt was invented by

buffalo hunters and soldiers about that time, and was hand made of canvas and not at all in general use for ten years afterward.

2. The Sioux war bonnet was almost unknown in the southern plains—though one might have have been there through trade. The white campaign hat was not worn at that period, and not until many years after. The hat was black. The boot Custer wears was adopted by the United States cavalry, March 14, 1887, and the officer's boot of 1867[9] was quite another affair. The Tapadero stirrup cover was oblong and not triangular as he paints it. The saddle bags in this picture were not known for years after 1869. . . .

Crosby wears leggings, which were not in general use until after 1890. The color of Colonel Crosby's pantaloons was not known until adopted in 1875. . . .

The officer's saddle cloth is wrong as to the yellow stripe. Now, the picture as a whole is very good for a man to do who knows only what Schreyvogel does know about such matters, but as for history—my comments will speak for themselves.[11]

Two days later the *Herald* published a letter from Mrs. Elizabeth B. Custer defending Schreyvogel.[12] Mrs. Custer, in a letter to Schreyvogel, stated, "I think the likeness excellent, the composition of the picture and harmony of color admirable." She also pointed out that on campaigns on the plains of the West great freedom in selection of uniform was allowed and that the "red necktie, buckskins and wide felt hat were the unvarying outfit of my husband on a campaign." The boots, she further stated, were made by a Philadelphia bootmaker "who shod so many distinguished feet in our service." She concluded by stating:

> I was impressed with the fidelity of the likeness and the costume of the Indians, with whom I was familiar especially with war bonnet and shield, for my husband had both presented to him by chiefs at that time. The whole picture is so free from sensationalism and yet so spirited, that I want to commend your skill.

Mrs. Custer's letter drew a response from Remington in the *Herald* that Schreyvogel's picture and the criticisms "lend themselves to interminable controversy" and accused Schreyvogel of hiding behind Mrs. Custer's skirts. Remington then went on to say that he was enclosing a check for $100 payable to any charity the *Herald* might select if Col. Schuyler Crosby (depicted in the painting and still living in 1903) would admit "that he ever saw a pair of trousers of the color depicted in Mr. Schreyvogel's picture in the year of 1869 in any connection with the regular United States army."

It was unfortunate for Remington that he drew Colonel Crosby into the argument, for in a letter to the *Herald* printed a few days later, Crosby

supported Schreyvogel with considerable vigor although he did admit his trousers "were not the shade of blue depicted in the picture; they were blue but not that shade of blue. Neither Mr. Schreyvogel nor Mr. Remington can enlighten me as to the exact shade, because they were not there and I have forgotten, but Mr. Remington is right." [13]

Crosby made additional comments on Remington's criticisms, pointing out that the leggings worn by Crosby were correct as shown by Schreyvogel and that he (Crosby) had worn them as early as 1863; that he saw many Indian war bonnets on the day depicted by Schreyvogel; that the hats worn by Col. Tom Custer and Crosby were grey or tan color and were purchased in Leavenworth, Kan., "a few days before we started on the campaign"; that the size and shape of stirrup leathers were often changed by the troop saddler to conform to the size of the officer's foot." He did admit, however, that Custer's boots as depicted by Schreyvogel were probably in error.

> Of course it must be very annoying to a conscientious artist [he further wrote] that we were not dressed as we should have been, but in those days our uniforms in the field were not according to regulations and were of the "catch as catch can" order, and were not changed regularly as Master Frederic Remington's probably were at that date. . . . Doubtless Mr. Remington could have made a better picture, but doubtless he never did.

The truth of the matter therefore appears to be that some of Remington's criticisms were justified but the major share of them were not, although it must be remembered that both Mrs. Custer and Colonel Crosby were testifying to events that had taken place over a third of a century before the discussion of 1903 arose.

All of Schreyvogel's paintings are of interest—they all tell a stirring story—but possibly those with greatest appeal show men, troopers usually, in violent action: the height of combat, the fierce charge, the strain of intense and deadly effort, are realistically portrayed. To get these effects, Schreyvogel made careful and extensive preparations. His Western trips were made to secure atmosphere and detail, and on these trips he made many sketches and photographs, collected firearms and Indian dress equipment.[14] All of this material was brought back to his studio in Hoboken. Here after his preliminary composition was thought out, he modeled his characters in clay. Painting was then done on the roof of his studio, with the Palisades as a background. "Their ruggedness," he is reported to have said, "is not unlike that of the Western mountains," and portions of these rocky cliffs appear in his paintings.[15]

Some of Schreyvogel's clay models were later cast in bronze; Tiffany's, for example, carried two of them, "The Last Drop" and "White Eagle," the bust of an Indian chief, as part of their luxurious wares for a number of years.[16]

Although Schreyvogel did little or no illustrating, reproductions of his paintings are quite numerous. His work became fairly well known in the first decade of the century through the medium of large photographs of his paintings. These photographs, platinum prints, can still be occasionally found, although a complete set of forty-eight is now very rare.[17]

Probably more important, however, in making Schreyvogel known to his day were the half-tone reproductions in black and white of thirty-six of his paintings published in book form in 1909. The collection appeared under the title *My Bunkie and Others*, the individual illustrations being of generous dimensions (about 9 x 13 inches) and the reproductions being excellently executed.[18]

If one may judge from the copyright dates of the paintings reproduced in this book, 1900 and 1901 were Schreyvogel's most productive years, as thirteen of the thirty-six paintings were made in those two years.

After Remington's death in 1909, Schreyvogel came to be regarded, in the East at least, as the leading exponent of the West in picture. Russell's reputation was growing but his fame was later achieved. In fact, shortly after Remington's death one of the country's leading magazines referred to Schreyvogel as "America's greatest living interpreter of the Old West." [19] Schreyvogel, however, was not destined to retain for long the mantle of Remington. An accident led to blood poisoning which cost him his life, and he died in Hoboken, on January 27, 1912.[20]

J. H. SMITH

Charles Russell, the third member of the triumvirate of Remington, Russell and Schreyvogel, also belongs to the Western story after 1900, rather than before, although his earliest illustrations in *Harper's Weekly* and *Frank Leslie's Weekly Newspaper* appeared in 1889. Russell, however, was not as prolific an illustrator as Remington and his fame rests largely on his many canvases done after 1900. They are still reproduced in color.[21]

Russell's first illustrations in *Leslie's*, however, bring us directly to one of the little-known Western artists about whom we can now furnish more information than has been previously available. These illustrations appeared in *Leslie's* for May 18, 1889, just six days after Russell's first illustration in *Harper's Weekly* which was apparently the first appearance of Russell in

print. The *Leslie* illustrations, seven in number, appear over the title "Ranch Life in the North-west—Bronco Ponies and Their Uses—How They Are Trained and Broken." Near the center of the page on which these illustrations appear are the signatures of C. M. Russell and J. H. Smith.

J. H. Smith was Jerome H. Smith, although his many illustrations usually appear under the signature, "J. H. Smith." Smith was born in Pleasant Valley, Ill., in 1861. As a boy he grew up on an Illinois farm and he there broke Western horses before he ever traveled beyond the Mississippi.[22] When eighteen, the lure of the West called him and he found his way to Leadville, Colo., where the silver-mining boom was under way. He drifted around the West and then returned to Chicago in 1884 where he attended a Chicago art school for a time. His first published illustrations appeared in *The Rambler,* a Chicago weekly, and were cartoons, a field in which he later became very prolific. *The Rambler* lasted only for a year or so and Smith went on to New York where he eventually landed a position on the art staff of *Judge,* for many years a well-known humorous weekly. Cartoons with his signature are particularly numerous in the period 1887–1891, and many of them have a decidedly Western background, particularly those published in 1889 and 1890. In 1889, he appears to have been sent on assignment to the Northwest by *Leslie's Weekly,* which at that time was also a *Judge* publication. The assignment may have arisen from the fact that these publications had been acquired in part by Russell B. Harrison, a son of President Benjamin Harrison.[23] Harrison had been publisher of the Helena (Mont.) *Daily Journal,* but in 1889 he and W. J. Arkell acquired *Judge* and *Leslie's Weekly,* and *Leslie's* soon announced that they were to have Montana pictures and a Montana issue.[24] The Montana issue never appeared, but a series of important Western illustrations, many with a Montana locale, begin at practically this same time and were the work of J. H. Smith. The group of illustrations already noted, the joint effort of Smith and Russell, was the first in the series. There then followed the illustrations signed only by Smith, listed below:

1. "Phases of Ranch-Life on the Plains—Capture of Horse-Thieves by a Sheriff's Posse" (full page).
2. "Phases of Chinese Camp-Life in Montana, A Quiet Game [Cards]" (full page).
3. "On the Western Plains—Friend or Foe?" (full page).
4. "Montana—Cattlemen Compelling Their Herd to Cross a River" (full page).
5. "An Indian Trader's Store on the Western Plains" (full page).
6. "The Highwaymen of the Plains—Perils of Stage-Coach Travel in the Far West" (five illustrations on one page).

7. "A Herd of Cattle Threatened by a Blizzard [Montana]" (one-third page).

8. "A Race-Day in a Frontier Town" (eight illustrations on one page).

9. "The Recent Indian Excitement in the Northwest" (four illustrations on one page).[25]

Many of these sketches are excellently drawn and, strangely enough, well reproduced; but, more important for our purpose, they are pictorial history of real worth. Possibly of the entire series, the last two, "A Race-Day in a Frontier Town" and "The Recent Indian Excitement in the Northwest," are the most important, because both sets are obviously on-the-spot records, the first depicting life in Montana sixty years ago, and the second including a sketch of the celebrated "Ghost Dance," of which there are few pictorial records.

After 1890, Smith's name gradually disappeared from the pages of both *Judge* and *Leslie's Weekly*. He was one of those individuals who had an itching foot, and the life of the West led him from Texas to British Columbia, from California to the Dakotas. He was a jack of all trades, for he tried mining, herding cattle, freighting and stagecoach driving. He sketched from time to time, and even made serious attempts to improve his art, for sometime after 1890 he spent two years in Paris. The wanderlust was ever too strong; too many years had passed by for him to profit by his training and to achieve the reputation he might have made. "You can't teach an old dog new tricks," was his trite summary of his art training in Paris. He finally settled down in British Columbia after he married a girl who was part Indian, and began painting in oils. His subjects were for the most part recollections of his earlier days in the West, although a few non-Western paintings appeared among his work. Occasionally he sold a painting or illustration, but his work attracted little attention. As late as 1934 an earlier illustration of his was reproduced in the *Saturday Evening Post*.[26]

In 1935, Fred T. Darvill reproduced twelve of Smith's paintings, including the Western, "The Frontier Trial", the remaining eleven being other aspects of legal life. Smith continued to paint a considerable number of oils for Darvill, most of which are still in his possession. These oils all depict various aspects of early Western life and vary in size from eight by ten inches to three by four feet.[27] Some of these paintings have also been reproduced in lithograph.

Smith lived until his eighty-first year, re-creating until the end the life he recalled in the West of an earlier day.[28]

DAN SMITH

An illustrator who was sometimes confused with J. H. Smith was Dan Smith, although the two, as far as I have been able to determine, were not related. Dan Smith, of Danish parentage, was born in Greenland in 1865, but came as a boy to this country. When fourteen he went to Copenhagen and studied at the Public Arts Institute. Upon returning to this country he received further training at the Philadelphia Academy of Fine Arts and joined the art staff of *Leslie's Weekly* about 1890.[29]

Dan Smith later in life "was known to millions of readers in the United States," as for over twenty years he drew the covers of the Sunday magazine section of the New York *World*. At the time of his death on December 10, 1934, he was an artist for King Features.[30] His place in this book, however, owes itself to a number of Western illustrations appearing in *Leslie's Weekly* from 1891 to 1897. These illustrations are bold and interesting drawings of Western scenes that were based on at least one, and probably several Western trips.[31]

His first Western illustrations appeared in *Leslie's Weekly* in the early part of 1891 and are pictorial records of the Indian troubles at the Pine Ridge agency (South Dakota) that resulted in the tragedy of the Wounded Knee "battle." Since one of this group of illustrations bears the legend, "From Sketches Made on the Spot," one would infer that Smith was an observer of the incidents depicted, although another illustration of the same group bears the credit line "after photo." [32]

The next group of Dan Smith illustrations were apparently based on a trip to New Mexico and the Southwest in 1891, or possibly they resulted from a continuation of his Western trip begun at the Pine Ridge agency. Most of them deal with various aspects of the cattle industry, and that never-failing topic of interest, "cow-boys." Included in the group are: "An Impromptu Affair—A Bull Fight on the Plains," "Freighting Salt in New Mexico," "Christmas in the Cow Boys' Cabin," "Giving the Mess Wagon a Lift," "Cattle Herding in New Mexico" and "Perilous Wagoning in New Mexico." [33]

Several sets of illustrations by Dan Smith picturing the opening of the Oklahoma country will also be found in *Leslie's Weekly*, but these are redrawn after photographs.[34] The last three of his Western illustrations to be mentioned are hunting illustrations. The first of these shows a trial between Siberian wolf-hounds and Scotch deer hounds in the Rockies. It is also redrawn after a photograph. "Bear Hunting in the Rockies" and "Gen. Nelson A. Miles' Recent Bear Hunt in New Mexico" may possibly be the result of direct observation.[35]

After 1897, Dan Smith's activities were directed into other channels. He was a pictorial reporter of the Spanish-American War and his subsequent efforts, which made him so well known, have already been mentioned.[36]

H. W. Hansen

Literary critics make much of the fact that James Fenimore Cooper was a forceful writer on the political and social scene of his day, and that he was a novelist of the sea, but surely his Leatherstocking tales have affected more lives than all the remainder of his work together. The breathless unrelenting chase in the forest wilderness of *The Last of the Mohicans;* the life of a frontier settlement depicted in *The Pioneers;* the sublime scenes of the raging prairies fire and of the wild and thunderous buffalo stampede in *The Prairie,* with the other volumes of the series, not only attracted a great audience in their day but moved many members of that audience to new pathways and careers. The Cooper theme of the American frontier and the continual movement of that frontier westward was a major factor in developing an attitude of mind toward the West—the West of the 1830's and 1840's—not only at home but abroad. To be sure, this attitude was one concerned with the romantic aspects of the frontier—the idealized Indian, the idealized pioneer, the idealized backwoodsman. Cooper, together with Catlin, created frontier and Indian types that were to survive in the national consciousness for long, long years. They served as models for other writers (a whole German school of writers followed Cooper); stirred the imagination and spurred the activities of many individuals.[37]

One of this last group was H. W. Hansen. Born in Dithmarschen, Germany, on June 22, 1854, he was a reader of Cooper from early boyhood, and to Cooper's influence may be attributed the impulse to wander and to see for himself wild Western scenes. He came to this country in 1877. His bent toward an artistic career had led to a thorough training at Hamburg under Simmonsen, a well-known painter of battle scenes. This training was supplemented in 1876 by a year's study in London. Upon arrival in the United States, Hansen supported himself by commercial art work, first in New York and later in Chicago. It was in Chicago that a commission for three paintings led directly to his career as a painter of Western scenes. Hansen himself, in 1908, recalled his first Western experience:

> I painted three pictures for the Chicago and Northwestern railroad in 1879; I think they used them for advertising purposes, showing the progress of transportation; one showed a canal boat towed by mules, the next a stage coach, and the last a train. Now the railroad had just penetrated the Dakotas, and had a fine locomotive, all decked out with

silver, at the extreme end of the line, and the company commissioned me to paint a picture of it.

They asked me if it wouldn't be best for me to go to Dakota to paint the engine, and I at once said "yes," although the proposition was absurd as they had plenty of good photographs, but I was young and anxious to see the western country. Once I got there, I stayed until I had made all the studies of Indians and buffalo I wanted at the time.[38]

Several years were spent in Chicago, where Hansen attended the Chicago Art Institute, but many other side excursions were made. On one of these trips, with a companion, he made an extensive walking tour and sketching trip through the length of the Blue Ridge mountains. In February, 1882, Hansen went to California to settle the estate of an older brother. He soon made the state his permanent home, married and, with brief absences, lived in and around San Francisco for the remainder of his life. Hansen was not an illustrator, and doubtless for that reason his work was not widely known for many years. He achieved some local reputation with the paintings "A Critical Moment" (1894), "The Round-Up" (1895), "Indian Gratitude" (1895), "A Surprise Party" (1898), "Mexican Vaqueros" (1899), but his larger reputation, like Schreyvogel's, was achieved after 1900 and he therefore more properly belongs to a later story than ours. But, like Schreyvogel again, no account of his work is readily available and we have therefore included him here.

It was Hansen's habit to make frequent and extended sketching tours. These were at first confined to the Southwest, Texas, New Mexico, Arizona, and to Mexico. He sought not only subjects, but incidents, stories, equipment of the Western horse and his riders, for Hansen early devoted many of his canvases to the horse. In fact, one authority on Hansen's work wrote in 1924:

It was the horse which formed the prime motif of his work. It may be that he some time painted a canvas which did not hold a horse; if he did I have not seen the picture. It was the horse that afforded him the real means of telling his story—what a short-coming that is in the minds of today's generation of painters, to tell a story—and it was usually his pleasure to tell a tale of some sort, dramatic, tragic or of the every day. . . .[39]

Hansen's first exhibition was held in San Francisco in 1901, and this exhibition together with the painting, "The Pony Express," completed in 1900, were Hansen's introduction to a wider audience. "The Pony Express" especially brought him considerable notice, since it was bought by a Chicago paper and reproduced in the pages of the newspaper in three

colors. That this picture was widely distributed is shown by a comment of
Frank Mayer, editor of the *Western Field*. Mayer, while riding the cow
ranges with a companion in northern Colorado, found the print nailed on the
wall of a dugout. Mayer's companion, a professional cowboy, surveyed the
print and was moved to comment, "The feller who drawed that savvey's
his business." [40]

A careful student, an excellent draftsman, an exacting taskmaster for
correct detail, Hansen won his Western audience. He continued his field
work, ranging over an ever-increasing area of the West. In 1903, he made
his first visit to Montana, spending part of the summer at the Crow agency
in the southeastern part of the state, where he was a guest of S. G. Reynolds,
the Indian agent on the reservation. Reynolds, popular with the Indians,
was able to secure many favors for Hansen, among them an invitation to
a series of Indian dances held to celebrate the Fourth of July. The Crows
were so patriotic that the celebration was held for three days rather than
one. In describing his attendance at some of the dances, Hansen wrote:

> We were given a most hearty reception and conducted to the center
> of the teepee where we were requested to be seated. Then some special
> dances were performed by the participants, of which there were hun-
> derds, whose nude bodies were painted in the most varied and original
> designs of brilliant red, blue, green and yellow, immense war bonnets
> on their heads, and otherwise decorated and ornamented with heavily
> beaded trimmings and feathers. This grotesque and weird-in-the-
> extreme looking lot of beings, bucks and squaws alike, danced to the
> accompaniment of the dismal tones of their tom-toms, until they fairly
> reeled and were completely exhausted.[41]

And then in the intermissions—shades of Fenimore Cooper and George
Catlin—the guests were served lemonade! Such incongruity, the contrast
between the barbaric dances and the hospitable gesture of a church
sociable, did not go unnoted among the guests; the lemonade, Hansen
noted, savored "too much of civilization."

The fine bead and leather work of the Crows also impressed Hansen,
"their designs being so artistic, and their combinations of colors so harmoni-
ous," he wrote, "that it seems almost incredible that it is the work of beings
still on the lowest rung of the ladder of civilization."

The continued practice of making these summer field trips, with the
wealth of incident and atmosphere gathered and eventually transformed
into pictured reality, finally brought Hansen well-deserved recognition and
a competence. Exhibitions of his work appeared in the East and he began
to make sales in considerable number. Adolphus Busch of St. Louis bought

six of Hansen's paintings in 1906 for $10,000 and European buyers in England, Germany and Russia left little of Hansen's work available for sale in California. The great earthquake of 1906 was a severe blow to Hansen, as a number of his paintings in his studio were destroyed. The greatest loss was the collection of Indian and Western arms, dress and equipment, as well as field notes and sketches.[42]

Hansen's work at present is chiefly in the hands of private owners. The notable exception is found in the Art Museum of the Eastman Memorial Foundation of Laurel, Miss., which owns six paintings. As Hansen was primarily a worker in water color, though to some extent in oil, reproduction of his work never had the wide distribution achieved by Remington, with whom his work has been frequently compared. A critic writing in 1910 pointed out that the subject matter of Hansen and Remington paintings were many times identical, but he added the pertinent comment that Hansen's work "lacks some of the crispness of out-line and the vividness of coloring seen in Remington's [but] he makes up for it in greater softness and finish." Neuhaus, the California art historian, also comments on his work.[43]

Remington, Russell and Schreyvogel, all contemporaries of Hansen, have left interesting records of their work in bronze. Hansen never attempted the art of sculpturing but unlike his contemporaries, he did enter the field of etching. In 1924, the year of his death, he took up this new art and several successful works followed.[44]

Chapter Sixteen

Connecting Links

" 'The yawnin' peril to this nation,' says Peets, as we're loiterin' over our drinks one Red Light evenin', 'is the ignorance of the East. Thar's folks back thar, speshully in Noo York, who with their oninstructed backs to the settin' sun, don't even know thar is a West. Likewise, they're proud as peacocks of their want of knowledge. They'd feel plenty ashamed to be caught knowin' anything on the Rocky Mountain side of the Hudson River.' "
—Alfred Henry Lewis, *The Wisdom of Doc Peets.*

As the century drew to a close, many artists and illustrators—other than those belonging to the Taos group whom we shall consider shortly—were beginning the practice of their profession. Most of this group achieved their greatest reputation after the turn of the century, but as they serve as a link between the older and the modern "schools"—as do the Taos group—the early careers of four of their number have been selected as illustrative of all. They are Fernand H. Lungren, Maynard Dixon, W. R. Leigh and H. W. Caylor.

Lungren, born in 1857, grew to young manhood in the Middle West. When he was nineteen he met Kenyon Cox, only a year older than Lungren. Cox had already entered on an artistic career and his example influenced Lungren toward the same profession. After some art training in Cincinnati, Lungren went to Philadelphia where he studied with Thomas Eakins. He began a professional career in New York as an illustrator for *Scribner's Magazine* in 1879. After several years in New York he went abroad for some years but returned to make his home in Cincinnati in 1892. Cincinnati at this time was an active art center, including among its artistic personnel Frank Duveneck, J. H. Sharp and Henry F. Farny. Farny by this time had begun painting imaginative Western scenes and Sharp was already interested in Indian portraiture; Lungren soon became intimate with both men.

239

When an opportunity was offered by the Santa Fe railroad to spend the summer of 1892 sketching in New Mexico for an advertising campaign, Lungren was eager to make the trip. The following summer he was in Arizona. From these two visits to the Southwest there soon appeared a number of magazine illustrations and paintings and eventually a career as a painter of Western desert scenes.[1]

Several illustrations in *St. Nicholas Magazine* in 1895, and January, 1896, mark Lungren's first appearance as a Western illustrator, but a painting reproduced shortly thereafter in *Harper's Weekly* created a sensation.[2] The painting was "Thirst" and is said to be based on a personal experience of Lungren on a desert trip. It depicts a dead horse on a desert waste with a man in desperate condition in the foreground, his eyes staring and extended. It was on display first at the 29th annual exhibition of the American Water-Color Society and was soon reproduced in *Harper's Weekly*. Owen Wister wrote that the painting was "appallingly natural to anyone who has ridden over that country" and that it was "too true for one's sitting room." John Berger, Lungren's biographer, and Stewart Edward White, an intimate friend of Lungren, confirmed Wister's comment many years later. Mr. Berger wrote me that "so many people were so horror-stricken with the painting that Lungren finally quit showing it." [3] The present location of the picture is unknown.

Other illustrations in *Harper's Weekly, Harper's Magazine* and the *Century Magazine* followed in considerable number. These for the most part were concerned with life on the mesa and desert of the Southwest.[4] In fact, it was not long until Lungren decided to devote his entire time to painting the Southwest desert, and his later reputation is based primarily on his desert pictures. He became a Californian in 1903 and settled permanently at Santa Barbara in 1908, where he devoted the remainder of his life to art instruction and to painting Death Valley and the Mojave Desert. At his death in 1932, many of Lungren's paintings were willed to Santa Barbara State College.[5]

Maynard Dixon was California's notable contribution to Western illustration and art. Born at Fresno in 1875, he spent his boyhood on the great interior plain of California, at a time when the gold rush days were still vivid memories to many a citizen of Fresno and of California. Dixon, before his untimely death in 1946, wrote a brief paragraph for this book on the beginning of his career:

Back in the late 80's [he wrote me in 1940] when Harpers, Century and Scribners were tops, Frederic Remington and Howard Pyle were

beginning their best work. I was living in a West that was real, '49ers were still our neighbors, even some "mountain men," Miller and Lux were going strong and the California vaquero was still king of the saddle. When I was 16 (1891) I quit school and sent Remington 2 sketchbooks. He wrote me a splendid letter and I have been on the job ever since. The West of Then and Now is still my subject, and at 65 I have yet another lap to go.

I did my first paid illustrating in 1895 for old Overland Monthly and S. F. Call, Jack London's "Men of Forty Mile," "Malemute Kid" and others. I think "Lo-To-Kah" was my first book. All these drawings were terrible. Looking back through old clippings of newspaper and magazine work it seems I did not begin to hit the ball until '98 or '99. Made my first "frontier" trip outside Calif. (Ariz. and New Mex.) in 1900. Did my last magazine illus. in 1922—and a little for Touring Topics (now Westways) 1930–31.[6]

Evidently, Dixon did some "free" illustrating for *Overland Monthly* before 1895, for the record shows that his first illustration appeared in that magazine in December, 1893—when he was but eighteen years old—and many others were to appear before the turn of the century.[7] The first of his book illustrations appeared in Verner Reed's *Lo-To-Kah*, published in 1897, which was illustrated by both Dixon and Charles Craig. Before his career in illustration was finished, Dixon pictures were to appear in over thirty books.[8] As Dixon's own account infers, a gradual change in his activities occurred about 1920. Painting from that time on became the center of his life. His career thereafter belongs to the modern period of Western art.[9]

William R. Leigh, like many another artist of the West, had cherished the desire since early boyhood to visit that fabulous country, the far West. Born on a West Virginia farm in 1866, he early began to draw animals. At the age of twelve he was given an award of one hundred dollars by W. W. Corcoran, the great art collector of Washington, after Corcoran had seen a drawing of a dog made by the youngster. Three years of training at the Maryland Institute of Art in Baltimore was followed by extensive training abroad, especially at Munich. One impression that he brought from Munich was the appearance of horses seen in many paintings abroad. To one who had begun his career in boyhood by drawing animals on his father's farm, realistic draftsmanship was the first criterion of animal representation. But the horses seen in Munich paintings, Leigh said a few years later, were "not only unlike any horses that I ever saw, but unlike any beast I had ever seen." [10] His reaction to these paintings may have set him on an exhaustive study of the depiction of the horse, which Leigh eventually

published in book form as *The Western Pony*.[11] By 1897, Leigh had achieved a considerable reputation as an illustrator of national magazines and in the summer of that year he was sent by *Scribner's Magazine* to North Dakota to make sketches of wheat farming. Sixteen illustrations resulting from this assignment were used that fall by *Scribner's* in an article by William Allen White, "The Business of a Wheat Farm." [12] Particularly notable among the illustrations were "Steam Threshers at Work" and "A Camp," the latter showing harvest hands about an evening campfire. These illustrations, Mr. Leigh wrote me in 1940, "were all made from life," and he continued:

> I went to North Dakota in 1897 to do some illustrations for Scribner's Magazine, but while I then had my first taste of the west, and was really inspired by it, I had no opportunity to do any studies independently for my own use.
> From the moment I returned from my studies in Europe, I had wanted to go to the west, which I had already determined was the really true America, and what I wanted to paint. I made many efforts to that end, but was always troubled by lack of funds and misinformation as to the cost and difficulties.[13]

These illustrations of wheat farming were followed shortly by a series of remarkable pictures which undoubtedly played their part in stirring the slowly awakening social conscience of the American people around the turn of the century. The illustrations were made for a series of articles by W. A. Wyckoff, "The Workers—The West," and show the life of the drifting worker, primarily in Chicago.[14] Included, however, is one illustration belonging to the farther West, a scene depicting an Indian and two cowboys in camp on the plains.

By 1906 Leigh decided to devote all his energies to the drawing and painting of Western scenes. Probably of all artists who have entered this field exclusively, Leigh's mastery of draftsmanship is the surest and most skillful. His later career belongs again to the modern period.[15]

H. W. Caylor is representative of a considerable group of men who, though known locally, never achieved a wide reputation. Born in 1867, he began as a boy to draw pictures of animals. He, like many another youngster, wanted to be a cowboy and was actually employed as such in Kansas for a few months when in his teens. Self-taught, he made most of his early living as an itinerant portrait painter. After his marriage in 1889, he acquired two sections of land near Big Spring, Tex., bought a few of the vanishing longhorn Texas cattle for models and devoted the rest of his life

to depicting ranch life and cattle and cowboy scenes. He fitted up a horse-drawn outfit which carried camping and painting equipment, and with his wife followed cattle drives and roundups. He became acquainted with a number of cattlemen who were interested in his work and who became his patrons. "The Trail Herd," "The Stampede," "The Passing of the Old West," "Going Up the Old Trail," "The Lucien Wells Ranch," "Prayer for Rain," "The Chuck Wagon," "Disputing the Trail," were among his better-known paintings. The titles show the nature of his work, which was done between 1891 and the time of his death in 1932.[16]

THE BEGINNING OF THE TAOS SCHOOL

The eighty years of Western illustration, beginning with the work of Samuel Seymour in 1819, had its logical conclusion in the Taos art colony of the modern day. The landscape of the great open spaces and of the Shining mountains (an early and appealing name given the Rockies), the activities of the memorable but past Western scene, including its Indian inhabitants, had so firm a hold on the life of America that it seems inevitable that collectively these aspects of our land and history would eventually lead to its artistic expression. That it culminated at Taos may be more or less accidental; that artists not connected with the Taos School have utilized the same themes is more or less irrelevant. The point of immediate concern is that there exists a considerable group of artists who carry on the Western tradition and spirit.

The attitude of the art historian toward this group is varied. In the recent *Art and Life in America* which purports to be written "for students of American civilization who wish to know what part the visual plastic arts have played in our society" no mention is made of Taos and modern Western painting and illustration, although the early Western landscape school is given brief comment.[17] Royal Cortissoz, in his addition to Samuel Isham's *History of American Painting*, at least makes recognition of the Taos group and its purpose. "In substance," he wrote, "the group has brought into American painting romantic motives studied against a notably vivid background." [18] Other art historians have in general ignored the Taos artists; the most notable exception to this group, as might be expected from the fact that he himself is a Westerner, has been Eugen Neuhaus. Neuhaus, writing with commendable understanding and judgment, stated:

> . . . the name of Taos has come to mean a definite achievement in American art, which promises to have a long and honorable career before its artistic possibilities are exhausted. A peculiar combination

of the great open country relatively easy of access and a long season of painting weather and clear sunlight, under which the landscape as well as human beings assume definite contrast of light and shadow, has made Taos a focal point in American art life. The Indian at Taos, furthermore, has survived without much loss of his original characteristics, and his genuine qualities are not the least element in attracting artists to the Southwest.[19]

If the later history of Taos artists is primarily part of another story than ours, its development as a logical extension of the field which we are here considering warrants the few words which we have devoted to its present significance.

The origin of Taos as an art colony in 1898, however, does manage to come within the more or less arbitrary time limits we have set for ourselves. A number of artists had visited Taos before 1898. Blanche C. Grant in her history of Taos, *When Old Trails Were New,* has listed a number of them, including Henry R. Poore, whose painting, "Pack Train Leaving Pueblo of Taos, New Mexico," has already been mentioned in this book.[20] This illustration is probably the first bearing the name of Taos to be reproduced. Poore was in Taos in 1890 but he had been preceded by one well-known Western artist in 1881. Charles Craig sketched and painted at Taos in the summer of that year, but later in the same year settled in Colorado Springs where he spent the next fifty years of his life. With Harvey B. Young, he was the first resident artist of the Springs and his depiction of Western scenes won him not only a local but an international clientele.[21]

For many years Craig had virtually a continuous one-man exhibit in the lobby of the famous Antlers Hotel of Colorado Springs and many of his buyers were visitors at the hotel. When the Antlers was destroyed by fire in 1898, many of Craig's canvases were lost.

Although neither Craig nor Poore was in any way responsible for the present art colony of Taos, Joseph H. Sharp, who visited Taos in 1893, can be more directly related to its origin.

Sharp, born in Ohio in 1859, began the study of art in Cincinnati when he was but fourteen years of age, and for many years was associated with the art life of Cincinnati. He had a studio in the same building as Henry F. Farny, at the time Farny began his career as a Western artist, and it was Farny's example that played an important part in determining Sharp's career. Sharp, in a letter written in 1939, pointed out that he was fascinated with the American Indian long before he met Farny. He wrote:

I was first interested in Indians before becoming an artist—the first group I ever saw was at the B. & O. depot near Wheeling, W. Va. They

would shoot at dimes and quarters placed in upright forked stick with bow and arrow—even the kids were expert. I was about six years old [then]. Later, living at Ironton, O., near Cincinnati, the town used to have summer parades and fiestas—simple floats, etc. Once, when I was 12–13 yrs. old, 4 other boys & myself were Indians on ponies, stripped to G-string & all painted up by local druggist with ochre . . . we got tired of the slowness [of forming the parade] and with yells and war whoops we broke loose, stole the show and went galloping & maurauding all over town. When I went to Cincinnati Art Academy & learned to draw and paint, I wanted to paint Indians—Farny was doing it then, & dissuaded me by telling of hardships, dangers and made me feel I didn't exactly have a right to paint Indians—after a couple of years or so when he saw I was determined to go west, he gave me books on Pueblo Indians & particularly the Penitentes of New Mexico & wanted me to take that up!

It was to the Southwest that Sharp finally went—first to Santa Fe in 1883, and later to Taos in 1893, and to other pueblos of New Mexico and Arizona in the following years. He retained a position on the Cincinnati Art Academy in the winter months, from 1892 until 1902, and then resigned to devote all his time to painting Indian themes in the Indian country. For a number of years, beginning in 1901, he had a summer studio on the Crow agency of Montana which was located at the foot of the Custer battlefield. He became a permanent resident of Taos in 1912, where he lives across from the home of the celebrated frontiersman, Kit Carson.[22]

After Sharp's sketching trip to Taos in the summer of 1893 he went abroad. There he met Bert G. Phillips and Ernest L. Blumenschein, both interested in painting the American Indian. They were students at the Academie Julien in Paris, and were particularly receptive to Sharp's glowing account of the Southwest and of the village of Taos in particular. Upon their return to this country in 1895, they set up a studio together and then in the winter of 1897 and 1898, Blumenschein, who was also a one-time student of Lungren, spent some time in Colorado and New Mexico. A number of illustrations appeared in *McClure's Magazine* as the result of this trip. In the fall of 1898, Blumenschein, with Phillips as his companion, was back in the West.

The two young artists started out from Denver for Mexico after buying a team and a light wagon for their artistic exploration of the Southwest. Neither of the two had handled horses before and their training in harnessing and driving was gained the hard way by the method of trial and error. After a series of vicissitudes, one of the rear wagon wheels collapsed when they were on a mountain road about thirty miles north of Taos. By drawing lots, it was decided that Blumenschein should take the wheel to Taos for

repairs, Phillips remaining behind to guard their belongings. After three days, Blumenschein was able to return with the repaired wheel, and the two traveled on to Taos where they arrived September 4, 1898. So entranced were both with Taos and its surroundings that they went no further, both resolving to make the wealth of beauty and picturesque life around them known to a far wider audience; "a wealth," as Mr. Phillips remarked, "that will continue to exist as long as this old world shall endure." It is not surprising that the modern Taos Art Colony has adopted the broken wagon wheel as its symbol.

Blumenschein stayed for a time with Phillips but he did not make Taos his permanent home until 1919, so that Phillips is to be regarded as the founder of this modern art colony in the Southwest.[23] The first of the pictures to be reproduced belonging to the modern Taos group, however, is to be credited to Blumenschein, for there appeared late in 1898, the illustration, "A Strange Mixture of Barbarism and Christianity—The Celebration of San Geronimo's Day Among the Pueblo Indians," and signed by Blumenschein, "Taos N. M. 1898." The next year there appeared two further illustrations, "The Advance of Civilization in New Mexico—the Merry-Go-Round Comes to Taos," and "Wards of the Nation—Their First Vacation From School [Navaho]." [24] The original drawing of "The Merry-Go-Round" illustration, according to Mr. Blumenschein, was done in black-and-white gouache, and its present whereabouts is unknown.[25] These illustrations were "very early work in my career," continued Mr. Blumenschein. "I afterward and until about 1912 was a successful illustrator at a period when illustration of magazines was in a much higher plane than today." The long and imposing list of awards made to Blumenschein since that day and his election to the National Academy in 1927, are sufficient achievements for his inclusion in any consideration of American art.[26]

For many of these artists and illustrators, as has been said, the Indian and the cowboy of the West were the boyhood magnets that drew them to their careers. Even mature men, with no previous acquaintance with the West, were not immune to the power of this attraction. One artist wrote on his initial trip to the West in 1893:

> We Easterners were worked up to a pitch of nervous excitement, until, at the close of the third day, we could descry from the car window signs of approaching desolation. Even the seemingly endless plains with bunches of cattle here and there were interesting to us. . . . Our ears tingled with new names and new expressions.[27]

The marvelous range of color, the brilliant sunlight, the early inhabitants—both red and white—the contrasts of plain and desert and mountain

captivated many artists as they have captivated a countless number of souls outside the profession. "It is a striking scene of gorgeous color," wrote one artist in viewing an Indian dance. "The brilliant sunlight illumines the gaudy trappings of the dancers." Another artist wrote after a trip across the San Juan valley:

> Sand, sage, and cactus, a true picture of the Southwest. The mountains in the distance, with their snowy tops, were beautiful in their softness of tone and grand proportions. . . . During the ages of erosion, towers of rock have been left standing in the plain, giving to the scene a weird and wondrous effect. The color in all is beautiful, the snuff-brown hue of the nearer towers and slopes losing itself in the blue and misty ones far away.

And still another artist, an ardent lover of solitude and remote mountain recesses, was to write of New Mexico and the beauty of

> . . . the skies of marvelous blue through which pass, in summer, regiments of stately clouds; the majesty of the mountains, those serrated, rugged peaks to the East and North, and the gentler tone of the remoter ranges low lying in the west. . . . Every turn unfolds a new wonderland of beauty. [And in fall] the timbered sides of the mountains capped in snow are now carpeted in the delicate pattern of the changes, aspens, gold and russet against the green of the pine. The heat of summer is gone. . . . Everywhere the sage, the adobes and the cottonwoods melt together in one harmonious symphony of greys and browns and violets of the choicest quality.[28]

All these marvels of western land and color remain to us today. All who will may look and see. But the life of an earlier day, portrayed against this colorful background of tremendous breadth and scope, has gone. To that group of artists who recorded the early life of our West we owe much, for they have left us the nearest approach to the past that we will ever know.

The passing of the old West was mourned by many, including these pictorial recorders who lived through its closing hours. One artist wrote:

> When I was last in Tucson there were four gambling houses running full blast night and day to every block. They were patronized by Indians, cowboys, sheepherder, niggars and Chinamen. Every man, whatever his color, wore a gun in sight, and I could walk up and down the main street of Tucson all day and every day of the week getting material for pictures, local color and new types. Now the town is killed from my point of view. I met a man here who had just come up from Arizona and he tells me they have shut down all the gambling houses

tight, and not a gun in sight! Why the place hasn't the pictorial value of a copper cent any longer.[29]

Even the best-known of all the recorders of the life of the West that was lamented its passing. Frederic Remington wrote:

> I knew the derby hat, the smoking chimneys, the cord-binder, and the thirty-day note were upon us in a resistless surge. I knew the wild riders and the vacant land were about to vanish forever, and the more I considered the subject the bigger the Forever loomed. . . . I saw the living, breathing end of three American centuries of smoke and dust and sweat, and I now see quite another thing where it all took place, but it does not appeal to me.[30]

The wheels of change and progress wait for no man, not even artists. Doubtless in the comments above, at least two were carried away by their own words. The fact remains that the years around the turn of the century mark with some finality the end of an important era in the life of the West and of the nation.

Sources and Notes

NOTES ON PREFACE

No one will question the importance of pictorial records, although professional historians in general have not often made them a matter of serious study. In fact, the most surprising circumstance is that many historians, professionals and amateurs alike, who are most meticulous about documenting their written manuscripts with source notes and arguments, use illustrations without the least attempt at documenting the source or the authenticity of the illustrations used. This practice is so common that it seems invidious to single out any one case for criticism.

Of the various types of illustrations available in modern times for the historian's use, the photograph is regarded by the author as the most important and I have treated it at length elsewhere. (*Photography and the American Scene*, New York, 1938; see especially pp. 314–321; see, also, the *Kansas Magazine*, Manhattan, Kansas, 1938, pp. 45–64.) This book deals with the work of the *artist*, i.e., the illustrator or painter, as he has left us a pictorial record of the past. The type of hand-executed picture with which we are concerned is that which is of interest to the social historian—realistic scenes from everyday life and usually called by the artistic profession "genre" drawings or paintings, as distinguished from purely portrait, still life, or landscape work.

It is particularly tempting to include some landscape artists of the West for the period under consideration; Thomas Moran (1837–1926), who is quoted below, and W. H. Holmes (1846–1933), for example. Fortunately both of these artists are being studied in some detail by Wallace Stegner in connection with a biography of John Wesley Powell which is shortly to be published. Professor Stegner has kindly allowed me to read the chapter dealing with his evaluation of these artists. If any of my readers are unfamiliar with the really marvelous illustrations of the Grand Canyon by Holmes (and Moran) in Clarence E. Dutton's *Tertiary History of the Grand Cañon District with Atlas*, a treat is in store for them. Stegner calls the Dutton work "the most beautiful book produced by any of the government surveys"; and of the Holmes illustrations in the *Atlas*, "to open . . . to any of its double-page panoramas is to step to the edge of forty miles of outdoors." The Dutton books will be found as 48 Cong., 2d Sess., H. R. Misc. Doc. #35, Washington, 1882 (serial nos. 2320 and 2321).

From the standpoint of merit pictures portraying the life and growth of the old West, may be divided into several groups according to the standard of evaluation used:

(1) Illustrations, sketches, drawings, paintings, made by eyewitnesses of a given scene; (2) illustrations that are imaginary but which have been made by contemporary artists who have observed and studied the environment, the characters, and the incidents depicted; (3) illustrations made by modern artists who have based their work on study of contemporary literature and pictures, either hand executed or photographic (this group lies largely outside the present study); (4) and lastly, illustrations made by contemporary artists which are purely imaginary with little

utilization of fact or study. All of these various types may have value but for present purposes they are ranked in importance in the order given. Of course, it should be realized that the artist, unlike the photographer, frequently selects, excludes, and introduces detail at his discretion for the purpose of giving unity and emphasis to the subject depicted. Such artists, chiefly those included in the second of the above groups, can produce pictorial records of very real value if they convey the impressions of the place and time that are the contemporary prevailing ones. Thomas Moran, well known for his landscapes of the West in the period we are considering, has discussed this point and it is worth repeating here:

> I place no value upon literal transcripts from Nature. My general scope is not realistic; all my tendencies are toward idealization. Of course, all art must come through Nature; I do not mean to depreciate Nature or naturalism; but I believe that a place, as a place, has no value in itself for the artist only so far as it furnishes the material from which to construct a picture. Topography in art is valueless. The motive or incentive of my *Grand Canyon of the Yellowstone* was the gorgeous display of color that impressed itself upon me. Probably no scenery in the world presents such a combination. The forms are extremely wonderful and pictorial, and, while I desired to tell truly of Nature, I did not wish to realize the scene literally but to preserve and to convey its true impression. Every form introduced into the picture is within view from a given point, but the relation of the separate parts to one another are not always preserved. For instance, the precipitous rocks on the right were really at my back when I stood at that point, yet in their present position they are strictly true to pictorial Nature; and so correct is the whole representation that every member of the expedition with which I was connected declared that he knew the exact spot which had been reproduced. My aim was to bring before the public the character of that region. The rocks in the foreground are so carefully drawn that a geologist could determine their precise nature. I treated them so in order to serve my purpose. (G. W. Sheldon, *American Painters*, New York, 1879, p. 125).

Moran's views of the Yellowstone are among the most noted of western illustrations; see *The Yellowstone National Park, and the Mountain Regions of Idaho, Nevada, Colorado and Utah*. Described by Professor F. V. Hayden. Boston: L. Prang and Co., 1876. Contains 15 plates, chromo-lithographic reproductions of Moran's water color sketches.

Or, to quote another artist, the philosophical Kurz, who spent several years in the frontier trading posts of the upper Missouri river during the early 1850's:

> The artist's task is to improve nature's forms, make perfect her imperfections, strive not only to emulate but to excel her in the creation of beauty. Nature achieves nothing in ideal perfection, but the artist's mind can conceive of ideal beauty and clothe his ideas with correspondingly lovely forms, i.e., idealize them. (*Journal of Rudolph Friederich Kurz* (Washington, 1937), p. 189.)

The psychological effect of the attitudes expressed by Moran and Kurz upon the historian interested in precision of fact is to produce skepticism of the pictorial record as a document of history. The work of such artists, however, does have value and frequently it is of higher artistic merit than that of the literal transcribers included in the first group. Possibly our judgment can best be expressed by stating that if the subject depicted is of an actual event, the historian prefers as literal a

transcript as the artist can render. For general impressions of behavior and of place the second group listed above does have important value. In either case it should be remembered that we are seeing, or attempting to see, past life through other skills and from a different viewpoint than that of the written record.

This discussion may have suggested to the reader that still another set of criteria should be employed in judging these pictures of the past. In any one class, differences between artists are to be observed and such questions, especially in the first class, as "Was the artist a careful and honest observer (or student)?" and "Was he a competent and satisfactory draftsman?" must be answered to our satisfaction. The knowedge necessary to answer the first question can be secured by seeking information concerning the artist, his training, his method of work (water color, pencil sketch, etc.—a water color, for example, cannot be expected to show the detail that is present in a carefully drawn pencil sketch), the judgment of his contemporaries, especially those who witnessed an original incident or scene, and were able to compare it with the artist's record of the event.

It is, of course, recognized that different artists in viewing the same scene will reproduce their impressions in different styles and manners. As Audubon philosophically (and resignedly) remarked on comparing George Catlin's paintings of the upper Missouri river with Audubon's own observations as he proceeded up the same river in 1843, "different travelers have different eyes." (Maria R. Audubon, *Audubon and His Journals*, London, 1898, v. 2, p. 10.)

In answering the second question, even the least artistically trained individual can distinguish between a crude drawing and a well-finished one and certainly the well-finished one is to be preferred to the cruder drawing. Even crude drawings, it should be pointed out, can, at times, be tremendously important, as witness the Bruff sketches. (Georgia W. Read and Ruth Gaines, eds., *Gold Rush*, New York, 1944.) These drawings, crudely done and with little sense of perspective, were executed with meticulous attention to detail and portray one pioneer's experience on the overland route to California in 1849. Their importance lies in the fact that they were drawn in detail and are among the few direct pictorial records extant of this most important and dramatic migration in American history.

Unfortunately, seldom is there available all the information which we would desire in forming a complete and competent judgment on any artist's work so far as its value to the social historian goes. The same comment, of course, can be made on the written record upon which our present histories are based. The same procedures, therefore, in passing judgment on the pictorial record must then be employed as is employed in the examination of the written record, namely, to utilize the information that is available to the best of our ability and intelligence.

The question of passing final judgment in the case of pictorial records, too, is complicated by the fact that many times the *original* work of the artist is not available. The only record of the artist may be a reproduction in the form of a lithograph, a woodcut print, or an engraving. These and other forms of reproduction necessitated the hand of at least one intermediary (and usually more) who reproduced the original drawing (or painting) on stone, wood, or metal, and the faithfulness to the original must often be weighed. Our problem is, therefore, a complex one and we can only make an attempt to open up the field and leave to future historians a more complete judgment as additional data and sources of information are added to our store of knowledge.

We should again keep clearly in mind that our chief concern is not with the artistic merit of any picture in which we are interested but rather with its value as an authentic record of our past life. As Isham has so pertinently pointed out in connection with his discussion of artists of the old West: "The subject is more [important] . . . than the purely artistic qualities displayed in its representation.'

(Samuel Isham, *The History of American Painting*, New York, 1927, p. 501.) In fact, many of the artists we shall consider are so obscure and their work so poor (from an artistic point of view) that modern artists and art historians daintily hold their nose by thumb and forefinger when these "artists" are mentioned or their work examined. (It may be that the views of the art historian are undergoing change. In a fairly recent issue of the *College Art Journal*, Menasha, Wis., May, 1945, p. 192, Frederick A. Sweet calls attention to the need of study of the artists of the Western expansion.)

In setting a beginning date (in our case 1850), there is always the troublesome question of how consistently one should adhere to the beginning limit. Some artists, contemporary with a given period, have a habit of living past any chosen date and we are confronted with the choice of inclusion or exclusion. The choice here made is largely arbitrary, and it excludes from the story of western picture such names as Paul Kane, William T. Ranney, George Bingham, and Seth Eastman. Eastman is at least referred to late in our story but the other three may be briefly cited here. Paul Kane (1810–1871?) was a Canadian whose western wanderings on which his paintings were based, were made in the years 1845–1848. A number of his paintings are now in the Royal Ontario Museum; see Albert H. Robson, *Canadian Landscape Painters*, Toronto, 1932, Chapter I (which also discusses other early Canadian artists and illustrators) and especially Paul Kane, *Wanderings of An Artist Among the Indians of North America*, Toronto, 1924 (with introduction and notes by L. J. Burpee).

An account of Kane's work at considerable length also appears in the *Manitoba Free Press*, Jan. 5, 1907, pp. 21, 24, and 25. Several hundred Kane oil and water color paintings were (in 1952) on the market at a reported asking price of a quarter-of-a-million dollars.

For William T. Ranney (1813–1857), see *Dictionary of American Biography* (N. Y., 1946), v. 15, pp. 377–378. A grandson, C. J. Ranney of Philadelphia, owned (in 1940) a number of the Ranney paintings. Mr. Ranney also kindly furnished me a number of other items of information concerning his grandfather as well as photographic copies of several paintings. As far as I have been able to determine, Ranney's western experiences were confined to those of his trip to the Southwest during the Mexican War of 1846–47.

George Bingham (1811–1879), one of the most important indigenous early artists of the Western scene, is noted especially for his Missouri River scenes (*Fur Traders Descending the Missouri*, for example) and his portrayal of contemporary Missouri political life. His Missouri River pictures were for the most part completed by 1850. In any case, there are available for the interested reader two biographies: *George C. Bingham, the Missouri Artist*, by Fern Helen Rusk, Jefferson City, Mo., 1917 (a well-documented source) and *George Caleb Bingham of Missouri* by Albert Christ-Janer, N. Y., 1940.

CHAPTER I

1. *The Cong. Globe*, Washington, 1850, vol. 22, Part 2, pp. 94–138, First Sess., 31st Congress. The election of the Speaker occurred on Dec. 22; see p. 66 of above reference.
2. *The Cong. Globe*, vol. 22, 1850, Part 2, p. 97, and pp. 166–171 where the boundaries of the state of Jacinto are defined.
3. *Cong. Globe*, vol. 22, 1850, Part 2, p. 195.

3a. The great overland migration to California beginning in 1849, continued through the 50's. One searches almost in vain for authentic pictorial records of the overland trail. There are a few, however. The work of Joseph G. Bruff cited in the notes to the *Preface*, I regard as the most important. The original Bruff sketches are now in the Huntington Library, San Marino, California. In addition to Bruff (1804–1889) there may be mentioned the work of William H. Tappan, a number of whose over-

land route sketches of 1849 are owned by the State Historical Society of Wisconsin and some have been reproduced in *California Letters of Lucius Fairchild*, edited by Joseph Schafer (State Historical Society of Wisconsin, 1931). The identification of Tappan is made by Raymond W. Settle in *March of the Mounted Riflemen*, Glendale, California, 1940 (see also *Wisconsin Magazine of History*, September, 1928, v. 12, pp. 97–108). I am indebted to Miss Alice E. Smith of the State Historical Society of Wisconsin for calling my attention to the Tappan sketches.

Artists of the California scene in gold rush days include Alburtis D. O. Browere (1814–1887). The most reliable (but brief) account of Browere with which I am familiar is given by his great-great-grandson, Everett L. Millard, in the New York *Sun*, February 10, 1940, p. 9. The work of other California artists of the period may be found in such reference works as Eugen Neuhaus *The History and Ideals of American Art* (Stanford University, 1931).

Another type of significant pictorial recording of the gold rush, but one presumably lost to us now, were the western panoramas designed for exhibition in the East and abroad. For instance, the New York *Tribune* (June 18, 1850, p. 5, c. 4; see also July 27, 1850, p. 1, c. 3) advertises a 40,000-foot canvas "Overland Route to the Pacific" from St. Joseph, Mo., to the California shore based on the work of one Minard Lewis who made the overland trip in 1849. Another panorama depicted the voyage to California via the Horn and scenes in the diggings based on sketches by Wm. H. Myers "late of the U. S. Navy" (New York *Tribune*, Sept. 21, 1849, p. 3, c. 6; Sept. 24, 1849, p. 2, c. 4, and Oct. 3, 1849, p. 2, c. 6). Myers was the sailor, a number of whose sketches the late President F. D. Roosevelt reproduced in *Naval Sketches of the War in California*, New York, 1939.

4. Admittedly the census figures of 1850 are none too reliable but they are, in fact, all the data that are available to us. The figures on population above were secured by adding those of the trans-Mississippi states and territories as reported in *Seventh Census of the United States: 1850*, J. D. B. de Bow, Washington, 1853, p. XXXIII, as follows: Arkansas, 209,897; California, 92,-597; Iowa, 192,214; Louisiana, 517,762; Minn. Territory, 6077; Missouri, 682,044; New Mexico Territory, 61,547; Oregon

Territory, 13,294; Texas, 212,592; Utah Territory, 11,380; Total, 1,999,404. The California population was undoubtedly shifting and changing too rapidly to enable anything approaching an accurate count. *The National Intelligencer*, Jan. 14, 1851, p. 3, c. 1, points out that California claimed a population of 200,000, but there were "actually only about 117,000 reported."

In Henry V. Poor, *Manual of the Railroads of the United States for 1868–69* (N. Y. 1868) there is a table "Progress of Railroads in the United States" (pp. 20–21) which indicates that the only state west of the Mississippi that had any railroads in 1849–50 was Louisiana, which is credited with 80 miles of track in both 1849 and in 1850. Although I have not determined with certainty the company which owned this trackage, it was probably the New Orleans, Jackson and Great Northern Railroad, a company which resulted from the consolidation of two roads, one of which was incorporated in 1841 and the other in 1848 (see Edward Vernon, *American Railroad Manual for the United States and the Dominion*. N. Y. 1873, vol. 1, p. 367). Further, however, this road ran north from New Orleans on the east side of the Mississippi and was therefore not in the trans-Mississippi West (see map in Vernon, cited above, "Railroad Map of the States of Arkansas, Louisiana and Mississippi").

Poor, cited above, pp. 20, 21, gives the total railroad mileage in the United States and therefore east of the Mississippi, as 7365 miles in 1849 and 9021 miles in 1850.

5. *A Congressional History of Railways in the United States to 1850.* Lewis Henry Haney, Madison, Wisconsin, 1908, p. 406 (Bull. Univ. Wis. #211).

6. The quotations in the order given in the text are from the *North American Review*, vol. 70, p. 167, Jan. 1850, and 32d Cong., 2d Sess., Senate Misc. Doc. #5 (1852).

7. Memorial of a committee appointed at a Railroad Convention held at Little Rock, Ark., on July 4, 1852, 32d Cong., 2d Sess., Senate Misc. Doc. #5.

8. *National Intelligencer*, Jan. 1, 1850, p. 1. *Hunts Merchants Magazine* (N. Y.) vol. 24, p. 784, 1851, reported that the Clipper Ship *Surprise* made the trip from New York to the Golden Gate (around the Horn) in 96 days, "The quickest trip between New York and San Francisco."

9. *National Intelligencer*, Jan. 1, 1850, p. 3, c. 5.

10. Lewis Henry Haney, *op. cit.*, pp. 415, 416, 420, and Robert R. Russel, *Improvement of Communication with the Pacific Coast as an Issue in American Politics, 1783–1864*, Cedar Rapids, 1948, Chaps. I–III.
11. Russell, *op. cit.*, Chap. VII, discusses the work of this session of Congress (the 32d Cong., 2d Sess.) on the Pacific railroad problem in some detail.

Probably there were few topics in Congress that were discussed in more detail and at greater length during the middle of the 19th century than that of a railroad to the Pacific. Beginning in the 1840's and extending up to 1864 when Federal legislation was finally enacted that made possible the beginning of Pacific railway construction, there are literally hundreds upon hundreds of references in the indices of *The Congressional Globe* to discussions in the halls of Congress upon this subject. When one realizes that each such reference may reveal a speech of considerable length, these references mean hundreds of pages of

actual discussion. For example, Senator Jefferson Davis of Mississippi has a speech running to ten pages (Appendix to *The Congressional Globe*, 35th Cong., 2d Sess., pp. 277–286, Jan. 20, 1859) on the subject. As each page of the *Globe* contains in the neighborhood of 3,000 words, the total volume of words upon the Pacific railroad in the *Globe* would constitute an extensive encyclopedia in itself.
12. For the ambush of Gunnison and Kern see p. 261, note 17.
13. The *Reports*, whose title in full has been given in the text and which will be subsequently cited simply as *Reports*, have an involved bibliographic record. For this reason it seems necessary to describe the set in some detail. Copies were published for the use of both Senate and House, and in several cases in more than one printing. As a result there are variations, especially in illustrations, as will be mentioned later in the text. The date given below is the date of publication as it appeared on the title page of each volume.

Volume	Date	Description	Illustrations	Congressional Document		Serial No.
1	1855	General consideration of routes	None	33d Cong., 2d Sess.	Senate Ex. Doc. 78 House Ex. Doc. 91	758 791
2	1855	Reports of Beckwith, Pope, Parke, and others (central Route, Calif., etc.)	By Kern, Stanley, and Egloffstein	33d Cong., 2d Sess.	Senate Ex. Doc. 78 House Ex. Doc. 91	759 792
3	1856	Report of Whipple, 35th Parallel	By Möllhausen, Tidball, Campbell	33d Cong., 2d Sess.	Senate Ex. Doc. 78 House Ex. Doc. 91	760 793
4	1856	Whipple's Route, botany, zool.	Botanical only	33d Cong., 2d Sess.	Senate Ex. Doc. 78 House Ex. Doc. 91	761 794
5	1856	Report of Williamson on Calif. route	By Charles Koppel and W. P. Blake	33d Cong., 2d Sess.	Senate Ex. Doc. 78 House Ex. Doc. 91	762 795
6	1857	Report of Abbot and Williamson on Calif. to Oregon route	By John Young	33d Cong., 2d Sess.	Senate Ex. Doc. 78 House Ex. Doc. 91	763 796

Volume	Date	Description	Illustrations	Congressional Document		Serial No.
7	1857	Report of Parke on routes in west Calif. and Rio Grande	By A. H. Campbell	33d Cong., 2d Sess.	Senate Ex. Doc. 78 House Ex. Doc. 91	764 797
8	1857	General report of zoology	Scientific only	33d Cong., 2d Sess.	Senate Ex. Doc. 78 House Ex. Doc. 91	765 798
9	1858	Zoology report contd.	None	33d Cong., 2d Sess.	Senate Ex. Doc. 78 House Ex. Doc. 91	766 799
10	1859	Zoology report contd., reptiles, fish, birds	Scientific only [1]	33d Cong., 2d Sess.	Senate Ex. Doc. 78 House Ex. Doc. 91	767 800
11[2]	1859	Warren's Review of Western Explo. 1800 – 1857, maps, profiles	By Egloffstein	33d Cong., 2d Sess.	Senate Ex. Doc. 78 House Ex. Doc. 91	768-1 768-2 791
12 Books 1 & 2	1860	Stevens Report of Northern Route	By Stanley, Sohon, and Cooper	36th Cong., 1st Sess.	Senate Ex. Doc.[3] House Ex. Doc. 56	1054 1055
(12)[4]	1859	"	"	35th Cong., 2d Sess.	Senate Ex. Doc. 46	992

[1] Contains a number of excellent hand-colored bird plates.

[2] Also published as 36th Cong., 2d Sess., Senate Ex. Doc.—(not in Serial Set and therefore possessing no serial number), Washington, 1861. The maps in the Senate Serial Set (768[1] and 768[2]) of volume 11 are mounted on linen (rather than paper) requiring 2 books (parts 1 and 2) to contain them. It should be observed that in the 1859 printings of volume 11, the date given on the title page is 1855 which was either intentionally or accidentally an error. Warren's report included in this volume is dated 1859 and Senator Jefferson Davis of Mississippi speaking in the Senate early in 1859 was sharply critical of the fact that the volume of the *Report* containing maps (i.e., volume 11) had not yet appeared (*Appendix to Cong. Globe*, 35th Cong., 2d Sess., p. 284).

[3] Not in the Serial (Congressional) Set and therefore possessing no serial number.

[4] This volume (Serial No. 992) duplicated in a single book the material in Serial Nos. 1054 and 1055 but is designated on the title page as "Supplement to Volume 1."

It should be observed that I continue to run across variations in printings of the above set and I also find contemporary discussions which lead me to believe that there are still other variations and discrepancies in dating and printing. My observations are therefore based on three sets I have studied in the University of Kansas Library and two sets in the Kansas State Historical Library plus a few miscellaneous volumes of duplication. It should also be observed that there is a preliminary report of these surveys un-illustrated which is sometimes confused with the large set of 12 volumes listed above. The preliminary reports will be found in 33 Cong., 1st Sess., Senate Ex. Doc. 52, Serial No. 698, and 33 Cong., 1st Sess., House Ex Doc. 129, Serial Nos. 736–739.

Nearly all volumes that contain illustrations (views) have a "List of Illustrations" at the beginning of the section containing each group of views. These lists sometimes specify the artists and give the page numbers where the plates may be found. The plates, however, are not always inserted as indicated and some even may be lacking from a given volume. In one volume exam-

ined, only seven of fourteen illustrations listed were present and there was no indication that the plates had been removed as no breaks in the back strip or torn stubs were apparent. Printed as they were on a large scale for their day, errors in assembling and binding produced variations in the pagination of the plates. It is true that occasionally one will come across a volume of these reports at the present day from which the plates have been removed but such a removal can usually be detected by a careful examination of the back strip and the specified page of insertion of an individual plate.

One further variation in connection with the plates may be noted. The titles of plates both in the lists of illustrations and the legends on individual plates will be found at times to differ in spelling, especially if the legend contains an unusual word. As a result of these variations one becomes cautious about making too definite statements concerning the illustrations in general; such observations are therefore of necessity confined to specific illustrations examined in a real copy.

I have also tried to estimate the number of each of the twelve volumes printed, a matter of some interest to the bibliographer and collector. On the back of most title pages in the individual volumes is quoted congressional action on the number to be printed. It is on these statements that the estimate below is based. Here again, however, I have found contemporary discussion that would suggest that a greater number were printed than is indicated by the table below.

Volume	No. Printed (to nearest thousand)
1–10 inclusive	21,000 each
11	32,000
12	53,000

The number of volumes of the 1859 Senate printing of volume 12 (i.e., "Supplement to vol. 1") is not specified. I have assumed a printing of 11,000 volumes. As a result of the large number printed, a number of these reports can still be obtained at moderate cost, especially volume 12 which is the most profusely illustrated of any of the set.

Russel, *op. cit.*, Chap. XI, gives a brief review of the surveys and it is his estimate on the cost of the surveys that I have used. The estimate on cost of illustrations is based on a comment of Senator Harlan (see note 16) which included only the first nine vol-

umes. It seems reasonable to assume that the last three volumes would average at least $100,000 each (considering the large number of volumes 11 and 12 printed) which would bring the cost of printing up to $1,200,000 approximately.

A detailed review of the surveys will be found in George Leslie Albright, *Official Explorations for Pacific Railroads*, Berkeley, Calif., 1921, 187 pp.

14. The complete review from which the two quotations in the text are taken may be found in the *North American Review*, vol. 82, pp. 211–236, Jan. 1856. It is based not on the final report, but the preliminary one, i.e., serial numbers 736–739.

15. For incidents of the completion of the railroad see Chapter VI.

16. *The Congressional Globe*, Jan. 6, 1859, p. 240. Senator Harlan stated that the first nine volumes cost nearly $900,000.

17. Tidball, Cooper, and Blake are represented by relatively few illustrations and their work needs only brief comment. Tidball (1825–1906) was an army officer who, like many of the profession of his day, had some training in sketching. As far as I know he is represented by no other illustrations save those included in the *Reports*. He later achieved a considerable reputation during the Civil War; see *Dictionary of American Biography*, vol. 18, p. 529, N. Y., 1946. Cooper (1830–1902), too, has no other illustrations save the two credited to him in the *Report*. Although a practicing physician he achieved his reputation as an amateur naturalist; see *Dictionary of American Biography*, vol. 4, p. 406, N. Y., 1946. Blake (1825–1910), achieved his reputation, too, as a naturalist and at one time was professor of mineralogy and geology in the College of California (later the University of California) and still later he became director of the School of Mines of the University of Arizona. He has no other illustrations, as far as I know, save these published in the *Report*. For his career, see *Dictionary of American Biography*, vol. 2, p. 345, N. Y. 1946.

Tidball is clearly credited with three illustrations in the third volume of the official *Reports* and may be the original artist of a fourth. Lt. Tidball was a member of Lt. Whipple's survey along the 35th parallel and Tidball's illustrations depict a camp of the party on Jan. 28 (1854) in present Arizona; the "Valley of Bill Williams' Fork" in present Arizona, the most

interesting of the Tidball drawings, and the "Valley of the Mojave" in California. The last of these illustrations is a woodcut in the text of the report; the remainder are full page lithographs. A fourth illustration depicting still another camp site of the party is credited in some printings of the report to Tidball and in others to Möllhausen. In the copies I have examined, "Bivouac, Jan. 28" will be found in volume III of the *Reports,* opposite page 97. In some printings, the lithography is credited to Sarony, Major and Knapp (of New York) and in others is uncredited; the "Valley of Bill Williams' Fork" was found opposite p. 102 in all copies of volume III examined, the lithography credited to either Sarony, Major and Knapp or to Sarony and Co.; the "Valley of the Mojave" was found in all copies on page 53 of the "Report on the Geology of the Route"; the lithograph sometimes credited to Tidball and sometimes to Möllhausen; "Bivouac, Jan. 26" was found opposite page 95 in all copies. The lithography in all cases was by T. Sinclair (Philadelphia).

Four of Tidball's original sketches on sheets 9″ x 6½″ made on the Whipple survey have recently come to light and are now in the Oklahoma Historical Society; see note 29, Chapter Two.

Dr. Cooper is represented by not more than two views, both sketched in the Northwest on the Stevens survey. "Puget Sound and Mt. Rainier from Whitby's Island" is credited to Cooper in one printing of the report but in a second printing it is credited to J. M. Stanley. "Mount Rainier Viewed from near Steilacoom" is credited in all printings that I have seen to Stanley "From sketch by Dr. Cooper." (In the Stevens report issued as "Supplement to Volume I" (Serial No. 992, 1859) the lithography of all plates was by J. Bien and in this volume (opp. p. 263) is found the first illustration mentioned above and credited to "Dr. Cooper del." In the 1860 printing (vol. 12, Book I, Serial No. 1054) it is credited to Stanley, opp. p. 289, the lithography by Sarony, Major and Knapp. The second illustration described above will be found opp. p. 265 in the 1859 printing and opp. p. 290 in the 1860 printing.)

William P. Blake was the geologist on Lt. Williamson's survey of two possible routes in southern California. Operations were begun in July, 1853, at Benicia, about 25 miles above San Francisco and the northernmost point of the survey. Much

of the work of the survey was spent in the deserts of California and in the Sierra Nevada Mountains. Charles Koppel was the official artist of the expedition and a number of his illustrations appear in Lt. Williamson's report (volume 5 of the official *Reports*). Blake, however, had an extensive report in this volume on the geology of the country explored and his report is as extensively illustrated as is Williamson's and included thirteen full page lithographs (Views) and over 80 woodcut engravings in the text of the report. (In the index of "Illustrations" (pp. XIV–XVI of the official *Reports,* vol. 5) fourteen full page plates are listed, three credited to Blake, one credited to Koppel after Blake, and the rest to Koppel. In all the volume 5's I have examined, however, Plate XIII of the list is missing and the plate that is numbered XIV in the list appears on the illustration itself as "Plate XIII.") All illustrations, of course, were meant to have special geologic significance but a number of both lithographs and woodcuts are of general interest as views. Of the full page plates, three were drawn by Blake, and one was re-drawn by Koppel from an original sketch by Blake. The most interesting of the Blake sketches reproduced as lithographs are "Sierra Nevada, from the Four Creeks" (Plate IV) and especially "Mirage on the Colorado Desert" (Plate XII).

A number of the woodcuts, too, are of interest and over seventy of them were drawn by Blake. The better drawn ones, however, were done by Koppel. Most of the woodcut illustrations, of course, are geological sections and the few of general interest drawn by Blake were outline sketches. Possibly of these Blake sketches the most interesting are "Mission of San Gabriel" (p. 78) and "San Diego from the Bay" (p. 129). (Blake also re-drew a number of geological cross-sections from original sketches by Jules Marcou in Volume III of the official *Reports.*)

That the surveys were made with real hazards, in addition to those of travel in a mapless territory, is best illustrated by the tragic fate of one of its artists, Richard H. Kern. Kern, Capt. Gunnison, in charge of the survey on the central route, J. Creutzfeldt, the botanist of the expedition, and five other members of the survey while detached from the main party were surprised by Paiute Indians on Oct. 27, 1853, and all were slain. (*Reports,* vol. II, part I, pp. 9–10 and 72–74. News of the massacre was

received in the East with more than usual dispatch. It was first reported in the *National Intelligencer* (Washington) on Dec. 3, 1853, p. 1, and in more detail on Dec. 10, 1853, p. 3; also the issue of Feb. 21, 1854, p. 3 c. 5.).

Kern was one of three brothers from Philadelphia who were active in explorations in the West in the middle eighteen hundreds and all of whom had sketching ability. Two were killed by Indians and the third died at an early age, possibly as the result of extreme hardships suffered on at least one western expedition. Dr. Benjamin Jordan Kern was the eldest of the brothers (born Aug. 3, 1818). He was a member of Fremont's ill-fated fourth expedition that left Westport on the Missouri River—Westport is now part of modern Kansas City—in the fall of 1848. The expedition attempted the crossing of the Colorado Rockies in the dead of winter, encountered such toil and starvation that eleven of thirty-two members of the expedition perished and the rest were barely able to make their way back to Taos in northeastern New Mexico. All three Kerns were members of the expedition and after returning to Taos, Dr. Kern and the celebrated Bill Williams, Fremont's guide, returned to the mountains to secure notes, collections and equipment cached after their tragic retreat. They reached their cache but were treacherously slain on March 14, 1849, as they conversed with a party of Utes who had been defeated a few days earlier by U. S. troops. (Alpheus H. Favour, *Old Bill Williams—Mountain Man*, Chapel Hill, North Carolina, 1936, Chap. 14, 15 and 16.)

Edward Kern (born Oct. 26, 1823), another member of the family, had been the artist on Fremont's third expedition that left St. Louis in the summer of 1845, crossed the Plains and Rockies to Salt Lake City and then went on to California. Here he served as lieutenant in the U. S. Army from July, 1846 to April, 1847 under Lt. Col. Fremont. In addition to the Fremont fourth expedition, both Richard and Edward were members of a military expedition that left Santa Fe for the Navajo country in the summer of 1849. In the reports of this expedition 72 lithographed plates (a number were colored) of Indians and scenery appear, and are credited to R. H. and E. M. Kern. The report, generally referred to as the Simpson report, was published as 31st Cong. 1st Sess., Sen.

Ex. Doc. 64 (Serial No. 562) Washington, 1850. Most of the illustrations are credited to R. H. Kern, the lithography was by P. S. Duval, Philadelphia and Ackerman, New York. Simpson (p. 56) expresses appreciation to the Kerns for their efforts on the illustrations and specifically points out that most of the views were made by R. H. Kern. The last plate of the set is numbered 74 but plates 2, 21, and 39 are lacking from the several copies of this report I have examined. Further, of the 71 plates thus actually present, a number are illustrations of designs on fragments of Indian pottery, Indian hieroglyphics, and ground plans of several pueblos, invaluable for the archeologist, but not of immediate concern in the present study. About forty of the total are "Views" of Indians and Indian activities. A number are in color which in addition to the fact itself, is of interest as they were "printed in colour" a fact recorded on some of the individual plates. Although I have not made the matter a point of special study, these colored plates must be among the earliest in government reports reproduced by multiple impressions; see note 32 in Chap. II. The report was also published privately as James H. Simpson, *Journal of a military reconnaissance, from Santa Fe, New Mexico, to the Navajo Country in 1849*, Philadelphia, 1852. The plates here are credited to R. H. Kern, but some are recorded as being after sketches by E. M. Kern. All plates are not identical with those in the 1850 government report and 34 are colored; the lithography in the 1852 printing was also by Duval.

Edward M. Kern was also a member of Commander C. Ringgold's North Pacific Exploring Expedition of 1854. The Huntington Library of San Marino, Calif., has a number of western diaries and letters of the Kern brothers as well as some biographical material and photographs supplied by Helen Wolfe. It is from this source that I have secured the birth dates of the three Kerns given here in the notes. An obituary of E. M. Kern appears in the *Philadelphia Public Ledger*, Nov. 28, 1863. Kern County and Kern River of California are named after him (H. A. Spindt, *Kern County Historical Society, Fifth Annual Publication*, Nov. 1939.)

The Huntington Library also has a diary of Edward M. Kern containing entries from Aug. 6, to Sept. 6, 1851 that indicate that Kern accompanied a military reconnaissance under Lt. John Pope. Included

in the diary are a few field sketches by Kern. Considerable biographic material on the Kern brothers written by "A friend" appears in the *Nat. Int.*, Jan. 24, 1854, p. 2, c. 4.

Richard Kern (b. 1821) was artist on Capt. Sitgrave's expedition in the southwest in the summer and fall of 1851 and in the report of the expedition he is represented by 23 plates of scenery and Indians. (32d Cong., 2d Sess., Sen. Ex. Doc. 59, Serial No. 668, Washington, 1853. The expedition left Zuni (New Mexico) Sept. 24, 1851, and arrived at Fort Yuma (Arizona), Nov. 30, 1851. The plates were lithographed by Ackerman and are numbered but all after number thirteen should apparently be decreased by one in number. Kern also drew a number of zoological plates for this report.)

Probably the illustration for which R. H. Kern is best known, however, is "View of Santa Fe and Vicinity from the East [1849]." This view appears in J. H. Simpson's *Report of Exploration and Survey of Route from Ft. Smith, Arkansas, to Santa Fe, New Mexico, made in 1849*, (31 Cong., 1st Sess., House Ex. Doc. 45, serial no. 577. The report contains only one other plate, also after Kern, a zoological record). Probably a better known view of Santa Fe is the one appearing in Josiah Gregg's *Commerce of the Prairies* (N.Y. 1844), "The Arrival of the Caravan at Santa Fe." I have puzzled over the original source of this illustration many times. At present, my conjecture is that it was based on a daguerreotype made by Gregg himself.

Richard Kern then had extensive experience in western travel and field sketching before he joined Capt. J. W. Gunnison's command in St. Louis in early June, 1853, for the survey of the central route. The engineering and scientific party arrived at Westport on June 15, where Kern was left to select a fitting-out camp, while Capt. Gunnison and Lt. Beckwith, the second in command, went on to Fort Leavenworth to secure the military escort. They returned in a few days. "Our encampment," reported Lt. Beckwith, "was some five miles from Westport, and the western line of the State of Missouri, selected by Mr. Kern in a fine grove near a spring, and surrounded by fine grass and an open prairie, and in the midst of the various Shawnee Missions, which appeared well." (*Reports*, vol. 2, p. 11 [Beckwith's first report]. Beckwith re-

ports Kern's official title as "topographer and artist.")

Some days were then spent in buying and breaking mules and employing teamsters and camp helpers, but by June 23rd the party made "its first marching essay" and despite soft roads caused by heavy rains made eight miles on their first day of travel. The route followed was in general that of the Santa Fe Trail (through modern Kansas) although side excursions of small parties were made from time to time in search of possible alternate railroad routes. Capt. Gunnison and Kern, for example, with an escort left the main party on the Trail near present Lawrence, Kansas, and traveled northwest along the Kansas River (while the main command went southwest). Gunnison and Kern passed the frontier town of Uniontown which had "a street of a dozen houses," and on up the Kansas river valley until they came to a "new" fort, Fort Riley. (Notice that June of 1853 would be a year before Kansas Territory was organized and open to settlement. Fort Riley at the junction of the Republican and Smoky Hill Rivers (forming the Kansas River) was established the same year that it was visited by Gunnison and Kern; see Hunt, *History of Fort Leavenworth*, p. 93; W. F. Pride, *The History of Fort Riley* (1926), p. 61.)

After some observations on the Smoky Hill and the Republican Rivers, the party turned southward and again joined the main command on the Trail. The Arkansas River was crossed on July 20, "old" Fort Bent reached on July 29 and the mountains on August 5. Although observations and records were made on the crossing of the plains, the route was already so well-known that all felt the real work of survey would commence when the Rockies were reached. Although the diary of the expedition from Westport to the mountains is intensely interesting, the general attitude of the report is itself reflected in Kern's illustrations, for the first to appear is a view of the Spanish Peaks (in present southeastern Colorado) where the mountains were reached. Probably Kern made sketches, which would be priceless at present of some, if not all, of the points suggested in the above brief review of the crossing of the Plains. They seem to be no longer extant. (All of Kern's illustrations in volume 2 of the *Reports*, were re-drawn by John M. Stanley, a fact made necessary by Kern's death. Stanley re-drew them from Kern's field sketch-

books but what has happened to these original sketch-books, and those of all other illustrators of the *Reports* with two exceptions (see notes of Chap. II) I have been unable to ascertain. The National Archives now has many of the original manuscript reports and letters of the surveys, but the sketch books of the artists on the surveys are not among them as I have ascertained by correspondence with the Archives and by a personal visit in the summer of 1949. I shall have occasion to refer to this matter at one or two points in the subsequent discussion in the text.

The route of the party from the mountains westward is clearly indicated by the remaining Kern illustrations which include:

"Sangre de Cristo Pass Looking Toward San Luis Valley." The first crossing of the mountains was made through this pass (about four miles north of modern La Veta Pass) and the westward descent led into the San Luis Valley of southern Colorado.

"Fort Massachusetts, At the Foot of the Sierra Blanca, Valley of San Luis." This post was near the present site of Fort Garland (Colorado) which was at one time commanded by Kit Carson; see M. L. Crimmins, "Fort Massachusetts, First U.S. Military Post in Colorado," *Colorado Magazine*, vol. XIV, pp. 128–135 (1937).

"Coo-Che-To-Pa Pass, View looking up Sahwatch Creek, Sept. 1st." This pass (modern spelling Cochetopa) on the western side of the San Luis Valley (northwestern Saguach County, Colorado) received Beckwith's comment: "No mountain pass ever opened more favorably for a railroad than this. The grouse at camp are abundant and fine, as are also the trouts in the creek, several having been caught this evening [Aug. 31st] weighing each two pounds." (Beckwith's first report, p. 45, *Reports*, vol. 2) Gunnison's party determined the elevation at the summit of the pass to be 10,032 feet. It appears on modern maps with exactly the same figure. Kern's view of the pass has been made the basis of an interesting color illustration "Old Bill Williams at Cochetopa Pass" painted by Marjorie Thomas in Favour's book cited above.

"Summit of the Nearest Ridge South of Grand River Traversed in passing around lateral Canones, 12 o'clock, Sept. 12."

The illustration shows that the country through which the proposed railroad was to pass was becoming exceedingly rugged, for the party now was not far from the present Black Canyon of the Gunnison; for the Grand River of the Beckwith-Gunnison report is now appropriately called the Gunnison River. An excerpt from Beckwith's journal, a few days before this illustration was sketched, gives a vivid glimpse of the difficulties encountered by the survey.

"This morning (Sept. 9th) [wrote Beckwith] . . . large working parties of soldiers and employes started forward, under their respective commanders, to prepare the crossing of the creek [a tributary of the Gunnison]; and at 2 o'clock p.m. we received orders to move on with the train. Ascending from the ravine on which we had encamped, we were forced high up on the mesas, to avoid numerous deep ravines, which we succeeded in turning successfully, when a short, steep ascent around the rocky wall of the table to our left, brought us, four miles from our morning camp, to the top of the difficult passage—a rapid descent of 4,055 feet in length, and 935 in perpendicular height above the stream, covered with stones of all sizes, from pebbles to tons in weight, with small ledges of rock cropping out at various points. Some of the stones had been removed in the proposed roads; but the wagons, with locked wheels, thumped, jarred, and grated over the greater portion, especially those too large and deeply imbedded in the soil to be removed, until their noise quite equalled that of the foaming torrent creek below. At one point, as they passed obliquely over a ridge, it was necessary to attach ropes to the wagons, and employ a number of men to prevent their overturning. Two hours were thus employed in descending our eighteen wagons, and in twice crossing the creek, in the bed of which we had to descend for a quarter of a mile, before we could gain a permanent footing on the west side. The creek is sixty feet wide by from one to two deep, with an impetuous current falling with a loud noise over a bed of rocks and large stones. Just above its mouth two fine streams half a mile apart, enter Grand [Gunnison] river from the Elk Mountains. Day's march five miles, through a heavy growth of sage." (Beckwith's first report, p. 52, *Reports*, vol. 2; Albright, *op. cit.* p. 91, discusses the modern geographical nomenclature of the Gunnison and other streams as they appear in the Beckwith report. A brief account of Gunnison's and Beckwith's explorations in Colorado and Utah by L. H. Creer will be

found in the *Colorado Magazine*, vol. VI, pp. 184–192 (1929).)

"View of the Roan or Book Mountains At the Spanish Trail Ford of Green River, Oct. 1st."

The survey was near the present Colorado-Utah border when Kern made the sketch upon which this illustration is based and two days before had come upon the well-known Spanish Trail that led from Santa Fe to the Pacific Coast at Los Angeles. The trail at this point was almost in constant use by the Green River Utahs, whom Beckwith characterized as "—The merriest of their race I have ever seen, except the Yumas—constantly laughing and talking, and appearing grateful for the trifling presents they receive." (Beckwith, first report, p. 62, *Reports*, vol. 2.)

For the next two weeks the survey continued north and westward (they were now well within present Utah) and eventually reached the great Sevier Valley of central Utah. Their arrival here marked, in more ways than one, the end of a definite stage of the survey. Gunnison, himself, remarked that "a stage is attained which I have so long desired to accomplish: the great mountains have been passed and a new wagon road open across the continent —a work which was almost unanimously pronounced impossible by the men who know the mountains and this route over them.—That a road for nearly seven hundred miles should have been made over an untrodden track,—through a wilderness all the way, and across five mountain ranges, (the Sierra Blanca, San Juan, Uncompahgra, Sandstone, and Wahsatch) and a dry desert of seventy miles between Grand [Gunnison] and Green Rivers, without deserting one of our nineteen wagons, and leaving but one animal from sickness and one from straying, and this in two and a half months, must be my excuse for speaking highly of all the assistants on this survey." (Gunnison was quoted by Beckwith; Beckwith's first report, p. 70, *Reports*, vol. 2.)

On Oct. 25, Capt. Gunnison, Richard Kern, Creutzfeldt the botanist, Potter the guide, and an escort of eight men left the main party to explore the vicinity of Sevier Lake (in west central Utah). Noon of the next day a survivor of Gunnison's party, weak and exhausted, reeled into the main camp, with the tragic news that Gunnison's party had been ambushed. Four of the soldiers escaped but the remaining eight of the party were killed. "The sun had not yet risen," wrote Beckwith in describing the tragedy, "most of the party being at breakfast, when the surrounding quietness and silence of this vast plain was broken by the discharge of a volley of rifles and a shower of arrows through that devoted camp, mingled with the savage yells of a large band of Pah-Utah Indians almost in the midst of the camp, for, under cover of the thick bushes, they had approached undiscovered to within twenty-five yards of the campfires. The surprise was complete. At the first discharge, the call to 'seize your arms' had little effect. All was confusion. Captain Gunnison, stepping from his tent, called to his savage murderers that he was their friend; but this had no effect." (Beckwith's first report, p. 74, *Reports*, vol. 2.) Gunnison's cry did have the effect of drawing the attention of the Indians, for he fell, his body pierced with fifteen arrows.

As soon as the news was received by the main camp, relief was dispatched in the hope that other survivors could be rescued but only the eight bodies mutilated by Indians and wolves were found.

The command of the survey now devolved on Lt. Beckwith who continued the survey northward toward Salt Lake City until Nov. 8. Efforts to regain instruments, field notes and Kern's sketch book which had been taken by the Indians were urged upon the Mormon settlements and eventually "all the notes, most of the instruments, and several of the arms lost" were delivered to Beckwith in Salt Lake City, where the survivors of the survey spent the winter of 1853–54. (Beckwith's first narrative, p. 75, *Reports*, vol. 2. An interesting account by one of the Indian participants in this massacre (as told in 1894) is given by J. F. Gibbs in the *Utah Historical Quarterly*, vol. 1, pp. 67–75 (1928). In addition to the six Kern illustrations described in the text above, there were six additional illustrations: "View of Sangre de Cristo Pass looking northeast from camp north of Summit, Aug. 11"; "Sangre de Cristo Pass" (looking down Gunnison Creek); "Peaks of the Sierra Blanca"; "Head of first Canon of Grand River"; "View of ordinary Lateral Ravines on Grand River"; and "Rock Hills between Green and White Rivers." Crediting and page insertion of these plates are very irregular and there is no "List of Illustrations." In some copies, as many as three of the plates are credited to Kern alone; in others all are credited "J. M. Stanley

from sketch by R. H. Kern." In addition to the twelve Kern sketches there is a thirteenth plate "View showing the formation of the Canon of the Grand River." In some copies this is credited to F. W. Egloffstein; in others to "J. M. Stanley from sketch by F. W. Egloffstein."

The officers spent their time through the winter working up reports and attempting to replace some of the personnel who had fallen victim to the Indians. On March first, two travel-worn men reached Salt Lake City, one of whom made almost immediate contact with Lt. Beckwith. Beckwith invited the two men, S. N. Carvalho and F. W. Egloffstein, to join his mess at "E. T. Benson's, one of the Mormon apostles." Carvalho and Egloffstein had been members of another—and the last—of Col. Fremont's expeditions across the Rockies. Fremont and his father-in-law, Senator Benton of Missouri, were intensely interested in proving that the central route to the Pacific was the most feasible and to prove this point Fremont, despite his terrible experiences in the Rockies of 1848–49, set out to show that the central route could be followed to the Pacific coast *in winter*. To carry out his project, he organized an expedition at his own expense which assembled at Westport, Gunnison's starting point, late in September, 1853. Carvalho was officially the "artist and daguerreotypist of the expedition" and Egloffstein, the "topographical engineer." (Most of our knowledge of this expedition comes from S. N. Carvalho, *Incidents of Travel and Adventure in the Far West*, N. Y., 1859. There are several printings and editions of this book). Fremont's account has never been published although there are three contemporary letters (the first two to Senator Benton) available; one dated "Big Timber on Upper Arkansas, Nov. 26" in *Nat. Int.* (Washington), March 18, 1854, p. 3; a second dated "Parawan, Iron County, Utah Territory, February 9, 1854," in *Nat. Int.*, April 13, 1854, p. 1; and a third to the editors of the *Nat. Int.* describing the general results of the expedition, June 15, 1854, p. 4 (later reprinted as 33d Cong., 1st Sess., Senate Misc. Doc. 67, Wash., 1854). Carvalho's experiences as a daguerreotypist I have reviewed in *Photography and the American Scene*, N. Y. 1938, pp. 262–266.)

Fremont's party, which included ten Delawares, were under way westward on Sept. 24. Their route in general followed that of Gunnison who had started from Westport three months earlier, and in fact, when Fremont and his party got into the mountains they actually followed the trail left by Gunnison's wagons. (Carvalho, *op. cit.* pp. 81, 82.)

As the party crossed successive ranges of the Rockies in the dead of winter, the rigors of travel increased alarmingly, food gave out even after their horses were eaten, one man died from exhaustion and the remainder were in a perilous state when they arrived at the Mormon settlement of Parawan (southern Utah) on Feb. 8, 1854. Fremont's brief comment, an obvious understatement when compared to Carvalho's account of the party's sufferings, at least gives some idea of the state of affairs: "The Delawares all came in sound but the whites of my party were all exhausted and broken up and more or less frostbitten. I lost one [man]" . . . (Fremont's second letter, previously cited. A letter from Parawan published in the *Nat. Int.*, May 18, 1854, p. 1, c. 2, stated that Fremont arrived in that town on Feb. 7.)

Both Carvalho and Egloffstein were so exhausted upon their arrival at Parawan that they could go no further. Fremont and the rest of the party, after resting for a few days, went on to California. The two men left behind, when they had gained sufficient strength, started slowly north for Salt Lake City which they reached on March first, as already described. Beckwith immediately offered both men employment on the railroad survey which was soon to take the field again and complete the survey to the coast. Carvalho declined but Egloffstein accepted and took Kern's place. (Carvalho, *op. cit.*, p. 140. Incidentally, Carvalho (1815–1899) should be added to our list of western artists. He several times mentions sketching or painting on the way west in his book (pp. 140, 141, 180, 192, 211) and upon his return to New York City painted western scenes based on his experiences. For a brief biographical sketch, see Taft, *op. cit.*, p. 490.)

Beckwith's party began their work in the spring by a survey of a route northeast from Salt Lake City to Fort Bridger, a possible connection with any line coming east through South Pass (in present Wyoming) but the real work of the party got under way on May 5, 1854. The survey passed south of Great Salt Lake and then turned west, traversed the desolate country through (present) northern Nevada,

coming eventually to the Sierra Nevadas. Here a number of passes were explored that might effect a railroad crossing of the mountains into the Sacramento Valley.

The party completed its work at Fort Reading (present Redding, Shasta County) in northern California on July 26. (Beckwith's second report, pp. 20 and 58.)

The character of the country traversed, especially through the Sierra Nevadas, is represented in illustration by a series of five folding panoramic views and eight full-page ones, all steel engravings, and based on sketches by Egloffstein. Probably in none of the 12 volumes of this monumental work are the illustrations more specifically directed to the immediate purpose of the report, that of depicting the country through which a railroad would have to pass, than in these thirteen illustrations by Egloffstein. To enhance their value for this specific purpose, important landmarks are identified in the illustrations and these in turn keyed into the map that accompanied the report. Although Beckwith's reports are contained in volume two of the set, only one Egloffstein illustration occurred in this volume. This view is a lithographic representation of the canyons of the Grand [Gunnison] River and was made when Egloffstein was still with Fremont (see p. 262). The thirteen steel engravings are found in volume 11 of the reports where they were undoubtedly placed in order to be with the maps.

The list of these Egloffstein engravings (all dates cited below should include the year 1854) is given in full as the illustrations and their titles tell in brief and concise fashion the story of this part of the survey. The meticulous care exercised by Egloffstein in dating, even to the hour, and specifying the observation point, is a revealing fact of the man himself.

FULL PAGE PLATES

(the first four, as can be seen from the dates, are of country north of Salt Lake City).

1. "Weber Lower Canon April 5th at 2 p.m. From an Island in Weber River, Valley of Great Salt Lake."
2. "Second or Sheeprock Canon of Weber River April 6th at 1 p.m. View Looking East."
3. "Porcupine Terraces Uintah Mountains in the Distance."

4. "Round Prairie from Head of Same April 21st at 10 a.m."
5. "Humboldt Pass May 22d at 12 a.m. from High Peak East of Pass."
6. "Franklin Valley May 24th at 10 a.m. from a Spur of the Humboldt Mountains."
7. "West End of Madelin Pass June 26 at 8 a.m. from a Peak overlooking Madelin Creek."
8. "Portion of Main Mountain Passage of the Upper Sacramento on Pitt River July 20 at 1 p.m. 25 miles south of Mt. Shasta."

FOLDING PANORAMIC VIEWS

1. "Gooshoot Passage showing 65 miles of the proposed line of Railroad from the Desert West of Great Salt Lake to the Humboldt Mountains May 20th at 2 p.m. from a Peak Near Antelope Butte."
2. "Valley of the Humboldt River at Lassen's Meadows showing 50 miles of the Projected Line of Railroad June 29th at 3 p.m. from a Peak on the Western Humboldt River Range."
3. "Valley of the Mud Lakes Showing Eighty two miles of the Projected Railroad Line June 14th at 9 a.m. from Mud Lake Peak."
4. "Madelin Pass showing 70 miles of the Projected Line of Railroad June 19th at 2 p.m. view Taken from a Mount Observation."
5. "Northern Slopes of the Sierra Nevada June 30th at 9 a.m. View towards the West." (This view shows Mount Shasta at a distance of 50 miles). (All thirteen engravings are credited to "C. Schurman from F. W. Egloffstein." Schurman was doubtless an artist employed by the firm of Selmar Siebert's Engraving and Printing Establishment (Washington) who printed these illustrations. Plates numbers 2 and 3 of the full page group also have the engraver designated, R. Henshelwood and S. V. Hunt, respectively. There is a brief discussion of the significance of Egloffstein's engravings in appendix B of Volume II (see especially p. 126) of the *Reports*.

There is no list of illustrations of these 13 views (in volume 11) that I have ever seen but I have never found more than 13 in a set although I have found copies of volume 11 in which one or more of the engravings were lacking; not a surprising fact when one considers that there were at least three printings of this volume (see note 13).

Egloffstein was not only a member of Fremont's and Beckwith's surveys in 1853 and 1854 but he was also on the Ives survey of the Colorado River in 1858. He is represented in the Ives report also by a group of notable steel engravings. (See Chapter II, pp. 33 and 34). That he was an artist of considerable merit and a most skillful map-maker there is no doubt. Egloffstein, during the Civil War, became colonel of the 103d Regiment of New York Volunteers, was seriously wounded and breveted out of service as a brigadier-general. Still later he became actively engaged in developing a half-tone process based upon a patent he secured in 1865. By one authority he has been called "the inventor of half-tone." He died in London in 1898. See Beckwith's comments in Volume 2 (first report) of the *Reports*, p. 88 ("my very able assistant,") and p. 127 ("I cannot speak too highly of the fidelity, zeal and ability with which Mr. Egloffstein performed these onerous duties") and Lt. Ives (*Report Upon the Colorado River of the West*, 36th Cong., 1st Sess., House Ex. Doc. 90, Washington, 1861), p. 6 ("The privation and exposure to which Mr. Egloffstein freely subjected himself, in order to acquire topographical information, has resulted in an accurate delineation of every portion of the region traversed.") For Beckwith's comment on Egloffstein as a map maker, see volume 2 of the *Reports*, appendix B of his first report, p. 125. Ives also mentions Egloffstein's skill in drawing maps; see Appendix D in Ives report. For Egloffstein's patent, see U. S. Letters Patent #51103, Nov. 21, 1865; and for his efforts to develop the patent see S. H. Horgan, "General Von Egloffstein, the Inventor of Half-Tone," *Int. Annual of Anthony's Bulletin*, vol. 9, pp. 201–204 (1897).

Von Egloffstein was the author of a *New Style of Topographical Drawing*, Washington, 1857, and was the editor of *Contributions to the Geology and the Physical Geography of Mexico*, New York, 1864. He was listed as a resident of New York City in directories extending from 1864 to 1873. According to Col. Wm. J. Mangine of the Adjutant General's office (Albany, New York), records in that office state he was mustered in as colonel of the 103d Regiment of Infantry (N. Y.) on Feb. 20, 1862; "Age at entry, 38 years; born, Prussia; eyes, blue; hair, light; height 5 ft. 7 inches. Brigadier general by brevet, for gallant and meritorious services, to date from March 13, 1865"; see also Frederick Phisterer, *New York in the War of the Rebellion, 1861–65*, 3d ed., IV, 3201–2 and 3217, Albany, 1912.

A grandson, C. L. Von Egloffstein, is now (1951) a resident of New York City. Mr. Von Egloffstein wrote me on March 25, 1951, that to the best of his recollection his grandfather died in London in 1898, although he was not sufficiently interested to look the matter up. If this last date is correct, it would put von Egloffstein's life span at 1824–1898.

Egloffstein's name appears in the literature in at least four forms: Egloffstein; v. Egloffstein; van Egloffstein; and von Egloffstein; probably the last is the correct form. In a number of reports by Egloffstein in *Official Records of Union and Confederate Armies* (Series 1, volume 9), Egloffstein signed himself as "Baron Egloffstein" and in several drawings in the Ives report, they are credited to "Frh. F. W. V. Egloffstein", the German equivalent of Baron Egloffstein.

Albert H. Campbell, to consider still another illustrator of the *Reports*, was a civil engineer with considerable ability in sketching. He is represented by a number of illustrations in two volumes of the *Reports*, volumes 3 and 7. Campbell was "Engineer and Surveyor" for Lt. Whipple's exploration along the 35th parallel. The survey began at Fort Smith, Arkansas, on July 14, 1853, traveled nearly due west through (present) Oklahoma, New Mexico, and Arizona, and arrived at Los Angeles on March 21, 1854. Möllhausen was the official artist of the expedition and we have described the survey in more detail in Chapter II of this book. Several of the illustrations in this report, however, are credited to Campbell, the most important of which are views of the crossing of the Colorado River. The expedition crossed the river, on the Arizona-California boundary (at or near where U. S. Highway 66 now crosses it) on Feb. 27, 1854. The crossing was watched with great interest by a huge group of Mojaves, friendly but virtually uncivilized. After the River was crossed Whipple recorded in his diary: "Every day these Indians have passed with us has been like a holiday fair, and never did people seem to enjoy such occasions more than the Mojaves have done. They have been gay and joyous, singing, laughing, talking, and learning English words, which

they readily and perfectly pronounce. Everything that seems new or curious they examine with undisguised delight. This evening a greater number than usual remained in camp. Placing confidence in our good intentions and kindness, all reserve was laid aside. Tawny forms could be seen flitting from one campfire to another, or seated around a blaze of light, their bright eyes and pearly teeth glistening with emotions of pleasure." (Whipple's report, *Reports*, Vol. III, p. 119).

Evidently the crossing of the river interested those responsible for selecting the illustrations for Whipple's report, as well as the Mojaves, for there are four views of the Mojave villages and the crossing. Three of these are credited to Campbell and the fourth to Möllhausen. (The four views in Vol. III of the *Reports* are: "Rio Colorado near the Mojave Villages, View #1 from the left bank looking W. N. W. J. J. Young from a sketch by A. H. Campbell" (frontispiece of *Itinerary*); "Camp Scene in the Mojave Valley of Rio Colorado" (credited to Campbell in same printings, uncredited in others—opp. p. 113 in the *Itinerary*); "Rio Colorado near the Mojave Villages View No. 2 from an Island looking North" (front. to *Report on Topographical Features*), J. J. Young after H. B. Möllhausen; "Rio Colorado near the Mojave Villages View No. III from the right bank, looking East," J. J. Young after Campbell (front. to *Report Upon the Indian Tribes*).

All four views show the Mojaves in various activities and it can be readily seen why Whipple noticed the tawny forms about the camp-fire, as evidently men and women alike wore little more for the evening's festivities than they did the day they were born.

One other illustration, a woodcut, credited to Campbell in Volume III of the *Reports* should be noted as it depicts "Albuquerque and the Sandia Mountains." (This illustration will be found in the *Report on the Geology of the Route*, p. 30. There is still another full page lithograph credited to "E. Stout after sketch by A. H. Campbell" in the topographic section of the *Report*, Vol. III, opp. p. 33 in the copies I have examined. The list of illustrations in this section does not carry the view which has the title "View of the Black Forest Mount Hope and Sierra Prieta.")

In the fall of 1854, Campbell joined Lt. Parke who had been directed to survey possible railroad routes in California between San Francisco and Los Angeles as the first part of his task. Upon the completion of this task he was to study a portion of the route on the 32d parallel, principally from Fort Yuma in extreme south-western Arizona across (present) southern Arizona and New Mexico to the Rio Grande, thus making a connecting link with Lt. Pope's survey along the 32d parallel through Texas.

Campbell began active work on the Parke survey at San Jose, Calif., on Nov. 24, 1854, and worked south to San Diego which was reached on May 7, 1855, completing the first part of the survey. The second part was begun almost immediately for the survey was at Fort Yuma on June 9 and pushed east, traveling many times at night in crossing the desert stretches, and completed their work at Fort Fillmore, New Mexico, on the Rio Grande on August 21. (Campbell's itinerary can be minutely followed in Appendix E, *Reports*, vol. 7, which is a table of distances, etc., kept by Campbell himself.)

The eight full page lithographic views which appeared in Parke's report are all credited to Campbell. Of the eight, three depict scenes in California, the remaining five in southern Arizona. Three of the plates have greater interest than the rest and include "Guadalupe Largo and San Luis Harbor" (Guadalupe Largo, a plain of about 80 square miles extending from the coast inland in the neighborhood of San Luis Obispo. San Luis Harbor is near modern Pismo Beach); "Warner's Pass from San Felipe" (Warner's Pass was on the wagon road between San Diego and Fort Yuma. It crossed the mountains immediately to the west of the Colorado Desert); and "Mission Church of San Xavier Del Bac" (some 8 or 10 miles south of Tucson, Ariz.). (The illustrations are credited to original sketches of A. H. Campbell in the "List of Illustrations", p. 23 *Reports*, vol. VII. The remaining illustrations include "South End of Santa Inez mountains, and San Buenaventura Valley" (California); "View on the Gila below the Great Bend" (Arizona); "Valley of the Gila and Sierra de las Estrellas, from the Maricopa Wells" (Arizona); "Valley of Aravaypa from Bear Springs" (Arizona); "Porphyritic Statue, Peloncillo range" (Arizona.)

Campbell, as far as I have been able

to ascertain, made no other published illustrations. From 1857 to 1860 he was "Superintendent of Pacific Wagon Roads," charged with surveys of wagon roads in many far western states and territories but with his office in Washington. At the outbreak of the Civil War, Campbell followed the lead of his native state, Virginia, and became Major A. H. Campbell, Chief of Topographic Bureau, C.S.A. His maps played an important part in southern military tactics. After the war, he settled in West Virginia and for the remainder of his life was chief engineer of a number of railroads. He died in Ravenswood, W. Va. on Feb. 23, 1899. Campbell, born in Charleston (W. Va.) on October 23, 1826, was a graduate of Brown University in the class of 1847. For a brief biographical sketch, see *Historical Catalogue of Brown University, 1764–1904*, Providence, R. I., 1914. I am indebted to Clifford K. Shipton, Custodian of Harvard University Archives, for finding this sketch of Campbell's life. For mention of Campbell in the Civil War, see Douglas S. Freeman, *R. E. Lee*, N. Y., 1935, vol. 3; and *Lee's Lieutenants*, N. Y., 1946, vols. 2 and 3. A long biographical sketch of Campbell's life may be found in the Charleston (W. Va.) *Gazette*, March 4, 1899. I have not been able to locate a file of this newspaper including this date in any of the leading libraries of the country. However, Campbell's obituary clipped from the *Gazette* is in the files of the Alumni Office, Brown University, Providence, R. I. I am indebted to Miss Ruth E. Partridge of the Alumni Office, who provided me a typed transcript of the clipping.

Of all the illustrators for these famous reports, least is known about Charles Koppel and John Young. Koppel sailed from New York City on May 20, 1853, with Lt. R. S. Williamson and other members of a survey party, bound for California. San Francisco was reached exactly one month later and the party went immediately to near-by Benicia where there was an army post and where the survey began its work. Koppel had the official title of "assistant civil engineer and artist." Nearly the only comment on his work was Williamson's statement: "The sketches which accompany this report were made by Charles Koppel, assistant civil engineer, and they will serve as aids in forming a correct idea of the nature of the country." (Koppel's official designation will be found

in Part I (*Reports,* vol. V), p. 7; Williamson's comment on Koppel in a letter to Secretary of War Jefferson dated Dec. 31, 1854, appearing in the above volume immediately after the second title page.)

Lt. Williamson on this survey was charged with exploration of possible routes that would connect the east-west surveys along the 32d and 35th parallels in California and was instructed to examine especially the passes of the Sierra Nevada, that formidable barrier to any railroad from the East, "leading from the San Joaquin and Tulare Valleys". As a result, Williamson's efforts were made chiefly in central and eastern California from Benicia southward. The work of the party began on July 10 and was completed at San Diego on Dec. 19.

The illustrations for Williamson's report are therefore confined solely to California and most of them are the work of Koppel who is credited with twenty-one full page lithographs and twenty-six woodcuts. (The illustrations are specifically credited by the line "From original sketches in the field by Mr. Charles Koppel" in the list of "Illustrations" for Part I; they include 12 lithographic plates and 12 woodcuts in text. For Part II (the geological report) the list of "Illustrations" specifically credits either Koppel or Blake. Nine lithographic views and 14 woodcuts are credited to Koppel. In addition one lithograph is credited to Koppel "from a sketch by W. P. B. [Blake].")

Of all the illustrations by Koppel the one which is of the greatest interest is his view of Los Angeles, which was probably sketched on Nov. 1, 1853. "This place," the report reads, "is celebrated for its delightful climate and fertile soil. Large quantities of grapes are exported to San Francisco, and considerable wine was formerly produced. The accompanying view was taken from a hill near the city." (*Reports,* vol. V, Part I, p. 35.) The view of Los Angeles in all copies I have seen is opposite this page. The date when the sketch was made is based on the fact that Smith (the civil engineer of the party) took a small detachment through San Fernando Pass to Los Angeles, the party leaving base camp for the lateral survey on Oct. 21 (Part I, pp. 34 and 35). The New York *Tribune* for Dec. 13, 1853, p. 5, c. 6, reprints an item from the Los Angeles *Star* of Nov. 5 which states that the party of which Koppel was a member arrived

in Los Angeles on Oct. 31 and left on Nov. 2. For other early views of Los Angeles see H. M. T. Powell *Santa Fe Trail to California* edited by Douglas S. Watson, San Francisco, 1931, which contains a view of Los Angeles made by Powell in 1850; and the Huntington Library (San Marino, California) possesses a collection of contemporary pencil drawings and water colors done by W. R. Hutton which includes views of Los Angeles in 1847 and in 1852.)

Other full-page Koppel illustrations which are of interest include "View of Benicia from the West," "U. S. Military Post, Benicia," "Mission and Plain of San Fernando", "Mission of San Diego", and two desert views, "Colorado Desert and Signal Mountain" and "Valley in the Slope of the Great Basin." The last view looks east from the Tejon Pass (northwest Los Angeles County) into the desert "with its peculiar vegetation." (The brief quotation is from *Reports,* vol. V, Part II (geology), p. 215. The illustration appears opposite this page. The other illustrations, in the order listed above, will be found in *Reports,* vol. V: frontispiece, Part I; opp. p. 4, Part II; opp. p. 74, Part II; following p. 40, Part I as does "Colorado Desert and Signal Mountain". A number of Koppel's woodcut illustrations are also of considerable interest; see especially "Straits of Carquines and Martinez, as seen from Benicia" (p. 9) and "Tejon Indians" (p. 20), both in Part I, *Reports,* vol. V.)

The only other illustration by Koppel of which I have found mention is a bust portrait, nearly life size, of Jefferson Davis reproduced lithographically in 1865; see Harry T. Peters *America on Stone,* Doubleday, Doran and Company, 1931, p. 255. Peters' only comment on Koppel is "unknown". I have written all the southern historical societies, and many other places, but have found no record of Koppel.

In 1855, Lt. Williamson was back again in California. He left New York City with Lt. H. L. Abbot and five civilian assistants, among whom was John Young, "draughtsman", on May 5, 1855 and arrived at San Francisco on May 30. Benicia was again made the outfitting headquarters for a survey this time directed northward to determine "the practicability or otherwise, of connecting the Sacramento Valley, in California, with the Columbia River, Oregon Territory, by a railroad." (Secretary of War Jefferson Davis instructions to

Lt. Williamson, *Reports,* vol. VI, "Introduction", p. 9, dates are from Part I of this volume, p. 56.)

The survey got under way July 10, 1855, and was completed by Nov. 15th of the same year. More or less independent and lateral and alternate surveys were made by Lt. Williamson and by Lt. Abbot, some accomplished with great difficulty and considerable danger because of an uprising among the northern Indians. Williamson became seriously ill before his report was made and as a result the final report was prepared by Abbot (*Reports,* vol. VI).

The survey was made through northern California and Oregon, a country that was in many respects an almost unknown region. "The great importance of the Williamson-Abbot exploration," writes one modern student of the surveys, "lay in the thorough examination made of the Cascade Range. Their observations of distances, practicability of river valleys and passes, and adaptability of the soil to cultivation were an invaluable contribution to the existing knowledge of Oregon Territory." (Albright, *op. cit.,* p. 152. Mr. Albright's extensive studies on the surveys and their reports are invaluable and timesaving in studying the *Reports* themselves.)

The general report of the survey contains 12 full-plate lithographic views and two wood cuts which are credited "From original sketches made by Mr. John Young, artist of the Expedition". The geology section of the report also contains a single full page view which, although uncredited, is doubtless the work of Young. (The credit line appears in the "List of Illustrations", p. 24 of Part I, *Reports,* Vol. VI. Abbot himself infers that all views are to be credited to Young (p. 3 of Part I) in the statement "The masterly sketches of views upon the route, and the characteristic style of the topography upon the accompanying maps, testify to the professional skill of Mr. Young.")

One of the unusual features of Abbot's complete report, however, is the inclusion of ten colored full-page lithographs of trees characteristic of the country passed over by the survey. In some respects, these plates are as interesting as any in the report, for they not only represent striking flora, but the plates have been drawn in their natural habitat with the inclusion, many times, of rugged and distant backgrounds. Five of the ten plates are credited to Young and there is reason to believe

that all ten were his work. (The botanical section of Vol. VI is comprised in Part III of the complete report and was written by Dr. J. S. Newberry. Newberry complains on p. 52 of Part III that Young failed to make a sketch of one particular tree which would infer that Young had made the others. From the fact that the five uncredited, Plates I to V inclusive, were drawn in the same manner i.e., with extensive backgrounds, as are Plates VI to X and which are credited on each plate to "J. Young del.", would indicate that Young was responsible for all ten.)

Young's views, although interesting, are for the most part illustrative of the rugged and mountainous country traversed. Possibly of greatest interest are "Lassen's Butte from Vicinity of Camp 18" (Lassen Peak in present Shasta County, northern California); "Mount Hood from Tysch Prairie" (present Hood River County, northern Oregon); and "Diamond Peak and Ravine of Middle Fork of Willamette River, from Camp 48 W" (present Lane County, west central Oregon). (Plates I, IX, and VII respectively of Part I, *Reports*, vol. VI.)

Additional information concerning Young beyond that given in Abbott's report is indeed meager. J. J. Young, as already pointed out (see p. 265), re-drew two of A. H. Campbell's sketches and probably J. J. Young is the John Young of the Williamson-Abbott survey. A number of the illustrations of the Ives expedition of 1858 were also re-drawn by J. J. Young after sketches of Möllhausen and Egloffstein.

The name of J. J. Young also appears on eleven very beautiful lithographs in color to be found in a report made by Capt. J. N. Macomb. Macomb explored the country from Santa Fe to the junction of the Grand and Green Rivers (Colorado) in 1859 which Dr. J. S. Newberry accompanied as a geologist. Newberry made a number of sketches of scenery along the way and they were made into a group of water-colors by Young for re-production. Newberry himself is represented by three black-and-white illustrations in the report. (For the Young credit of illustrations in the Ives report see the notes of Chap. II.) The Macomb report will be found in J. N. Macomb, *Report of The Exploring Expedition from Santa Fe, New Mexico, to the Junction of the Grand and Green Rivers of the great Colorado of the West*,

in 1859, Washington, 1876. The report, completed in 1861, was delayed in publication by the Civil War. Macomb mentions "eleven water-color sketches" in the "Letter of Transmittal" in this volume but apparently from the context they had been done by 1861. The lithography, judging from its excellence, was done at the time of publication by T. Sinclair and Son, Philadelphia; for J. S. Newberry, see *Dictionary of American Biography*, v. 13, pp. 445, 446.) A number of water colors by J. J. Young to illustrate Capt. J. H. Simpson's journal of an exploration in the Great Basin of Utah in 1859 are to be found in the National Archives. Four of the Young water colors (after sketches by H. V. A. Von Beckh) are listed in *Centennial of the Settlement of Utah Exhibition*, Washington, 1947, pp. 27–28.

Although exact identification has not been made, John J. Young probably spent his remaining years in Washington after his return from the survey as there is an individual of this name listed in Washington city directories from 1860 until 1879. He is sometimes identified as draftsman for the War Department, as topographical engineer and as an engraver. He died in Washington on Oct. 13, 1879 at the age of 49. (George M. Hall of the Library of Congress has examined Washington city directories in the period 1855–1880 for me and in many of the directories for this period the name of John J. Young occurs. Death notice of Young will be found in the Washington *Evening Star*, Oct. 14, 1879, p. 3, c. 7. As the name J. Young appears in Harry T. Peters, *America on Stone*, confusion with John J. Young who signed himself occasionally as "J. Young" may result. The J. Young of Peters was John T. Young of Rochester, New York, who died in that city on Sept. 7, 1842, at the age of 28 (see Rochester *Daily Democrat*, Sept. 8, 1842, p. 3, c. 4). I am indebted to Miss Emma Swift of the Rochester Public Library for information on John T. Young.)

The survey of the 32d parallel under Captain John Pope completed the survey on this route begun by Lt. Parke from Fort Yuma to Fort Fillmore. Capt. Pope began his survey near the latter place on Feb. 12, 1854 and traveled eastward across much country that was unknown. The survey was completed at Preston, Texas (near present Denison) on May 15, 1854, (*Reports*, vol. II). As can be seen by an

inspection of a map, most of Pope's route lay through Texas. No illustrations accompany Pope's report but a contemporary report by a private concern covered a somewhat similar survey of a route through Texas and west and the report is accompanied by 32 interesting illustrations; see A. B. Gray *Survey of a route for the Southern Pacific R. R. on the 32d parallel for the Texas Western R. R. Company,* Cincinnati, 1856. The plates are by Carl Schuchard. Schuchard, a German, was born in 1827 and was a mining engineer who joined the '49 rush to California. Later he became a surveyor, settled in Texas where he lived for a number of years, but spent much of his later life in Mexico where he died on May 4, 1883. Schuchard's original sketches for the report cited above were destroyed in a fire in the Smithsonian Institution, apparently the same fire that destroyed a number of Stanley paintings (see Note 38). I am indebted to Miss Llerena Friend of the Barker Texas History Center, University of Texas, for information concerning Schuchard.

18. The information on Stanley thus far given in the text is based on an account given by Stanley's son, L. C. Stanley, and published by David I. Bushnell, Jr., in "John Mix Stanley, Artist-Explorer" *Annual Report Smithsonian Inst.,* 1925, pp. 507–12. Subsequent reference to this biographic material is indicated by *L. C. S.* Stanley's manuscript account of his father is said to be in the Burton Historical Collections, Detroit.

The advertisement of Fay and Stanley appeared in *The Independent* (Washington) on March 15, 1842, p. 3, c. 7, and in many subsequent issues between this date and May 31, 1842. The same advertisement with minor variations, also appeared in the *National Intelligencer* (Washington) (see, for example, the issue of March 29, 1842, p. 3, c. 4). The *Independent* of March 18, 1842 p. 3, c. 4, has a brief comment on the firm of Fay and Stanley and identifies Fay as one who had a "long and respectable connection with the Press of South Carolina" but makes no direct comment on Stanley. Mention is made of "a competent artist" in the account which may or may not mean Stanley. Further circumstantial evidence that it was John M. Stanley who was concerned is borne out by the fact that the firm of Fay and Stanley became Fay and Reed in the

advertisement of the firm for June 3, 1842, in the *Independent* (p. 4, c. 5). As will be pointed out shortly, Stanley was in the southwest in the year of 1842 and the change in the firm may have arisen from Stanley's withdrawal for this trip. Comment and letters in *Diary and Letters of Josiah Gregg,* M. G. Fulton, editor, Norman, Okla., 1941, pp. 181–188, vol. 1, also suggests that Stanley, a friend of Gregg's, had a knowledge of daguerreotypy in 1846; Stanley's subsequent use of the daguerreotype in 1853 will be discussed in the text which follows. For the introduction of daguerreotypy in the United States, see Robert Taft, *Photography and the American Scene,* N. Y., 1938, Chap. 1.

19. *L. C. S.* identified Dickerman only by the two words "of Troy." W. Vernon Kinietz, *John Mix Stanley and His Indian Paintings,* Ann Arbor, 1942, p. 17 (note 3), states that Stanley's will assigned Dickerman a one-fourth interest in Stanley's Indian Gallery to be described in the text. Dickerman was born in 1819. He is listed as a resident of Troy in the city directories from 1836 to 1843. He was a Civil War veteran and lived in Maryland for some years after the war. He returned to Troy in 1881 where he died on July 21, 1882; see Troy *Daily Times,* July 22, 1882. I am indebted to Miss Fanny C. Howe, Librarian, Troy Public Library, for this information. I have also corresponded with Miss Kate L. Dickerman of Troy, who wrote me on March 21, 1951, that Sumner Dickerman was her uncle and that she remembered her uncle relating stories of his adventures in the Indian country with Stanley. Miss Dickerman, the last of her family, also wrote me that Stanley painted portraits of her aunt and other members of the family which hung for many years in the Dickerman home. She stated that no records of Stanley and Dickerman in the Indian country were available in the family.

20. *Catalogue of Pictures in Stanley and Dickerman's North American Indian Portrait Gallery; J. M. Stanley, Artist,* Cincinnati, 1846, pp. 21 and 22.

21. *Arkansas Intelligencer* (Van Buren), June 24, 1843, p. 2, c. 3 and 4. Van Buren, located only some half-dozen miles from Fort Smith, which in turn was only some 50 miles below Fort Gibson on the Arkansas River, was thus an important post near the early southwestern frontier; its newspaper is an invaluable source of in-

formation on the early history of this region.

Mention is made of the presence of Stanley and Dickerman in the Indian country in the *Arkansas Intelligencer* a number of times, including issues of July 15, 1843, p. 2, c. 2; Sept. 23, 1843, p. 2, c. 2 (which stated that Stanley had just returned from the Creek Busk which was painted by Stanley, the painting being listed in the Stanley Catalogue); and Oct. 28, 1843, p. 2, c. 2, and other issues specifically cited later.

The observer of the Council stated that when his account was written (June 1) the number of persons present were estimated at "two to five thousand." In Stanley's catalogue *Portraits of North American Indians* published by the Smithsonian Institution, December 1852, (usually found as part of *Smithsonian Miscellaneous Collections,* vol. II, 1862, p. 18), the number present at the Council is estimated at 10,000. I have seen other estimates as high as 20,000. In this catalogue Stanley has dated the painting of most of his pictures. It is apparent from these dates he was busy with the painting of the Council and with portraits of visitors to the Council during June, July, August, and September of 1843. On page 18 of this source, Stanley states that the Council was in session for four weeks during June, 1843. Stanley's painting, "International Indian Council," is now in the National Museum. Reproductions may be found in the Bushnell article cited in note 18 and in the Kinietz book cited in note 19.

22. Bushnell, *loc. cit.*, p. 511.

23. In the "Preface" to a proposed Indian portfolio by Stanley now in the Museum of the American Indian, Heye Foundation New York City (for a discussion of this portfolio see F. W. Hodge, *Indian Notes,* vol. VI, No. 4, Museum of the American Indian, Heye Foundation, New York, October, 1929), the statement is made that Stanley accompanied Butler on two expeditions to the prairie tribes of Texas. The first was probably made in the early spring of 1843 as brief mention is made on Butler's return from this council in the *Nat. Int.,* Apr. 27, 1843, p. 3, c. 5 (reprinted from the Shreveport *Red River Gazette* of April 12). The second trip of Stanley with Butler to the head-waters of the Red River is identified in the same "Preface" as taking place in the winter of 1843–1844, for Butler was reported as preparing to meet the Prairie Indians on the Red River on Nov. 25, 1843 in the *Nat. Int.,* Nov. 18, 1843, p. 3, c. 5, and later his return from the council is reported in the *Arkansas Intelligencer* Dec. 30, 1843, p. 2, c. 2 and Jan. 6, 1844, p. 1, c. 1, 2, 3. In both of these accounts mention is made of Stanley's presence at the council. In fact, Stanley made badges, at the suggestion of Butler, to designate each of the tribes present, a courtesy which greatly pleased the Indians. One Comanche woman thought so much of Stanley that she gave him her prized riding whip. Additional information on this council will also be found in *Niles Register* (Baltimore), Jan. 13, 1844, p. 306, c. 2 and Jan. 27, 1844, p. 339. Stanley's paintings (in his catalogue of 1852) of the Comanche Indians which were undoubtedly secured on this expedition are dated "1844" which must mean that Stanley completed them at Fort Gibson after his return from the last expedition in December, 1843.

The council was actually held on Cache Creek (*Arkansas Intelligencer,* December 30, 1843, cited above) probably near Warren's Trading Post; this post, according to W. H. Clift in *Chronicles of Oklahoma,* vol. 2, pp. 129–140 (1924) was located some 31 miles south and 7 miles east of (present) Lawton, Oklahoma. The post was 400 yards back from Cache Creek, a tributary of the Red River.

P. M. Butler received his title of governor from the fact that he was governor of South Carolina from 1836 until 1838. He was agent to the Cherokees from 1838 to 1846 and was killed in battle in the Mexican War in 1847; see *Dictionary of American Biography,* vol. 3, pp. 365–366.

24. The departure of Stanley and Dickerman from the Indian country of the southwest is reported in the *Arkansas Int.,* May 3, 1845, p. 2, c. 2 and the *Arkansas Banner* (Little Rock), May 21, 1845, p. 3, c. 7. In the first of these reports it is stated that the partners were leaving for "The mouth of the Yellowstone on the Upper Missouri, where they were to continue their painting of Indian portraits and scenes." I have found no evidence that this contemplated plan was carried out. In fact, the reference which follows, if correct, would seem to be good evidence against such a possibility.

The Cincinnati *Gazette,* Jan. 21, 1846, reports "Messrs Stanley and Dickerman, the proprietors of these pictures, are already most favorably known to many of our

citizens, by a residence of some months in our city, during which time they have been elaborating these pictures from the numerous sketches and *material* gathered during their three years residence and travel among the tribes of the 'far West'." I am indebted to Professor Dwight L. Smith of the department of history, Ohio State University, Columbus, who searched the *Gazette* and *Cists' Western General Advertiser* for January and February, 1846, seeking items concerning the first exhibition of Stanley paintings. The Cincinnati catalogue cited in note 20 was used in connection with this exhibition and lists 100 paintings and 34 sketches. One of the paintings was "John M. Stanley, the artist, painted by Mooney." The copy of the catalogue I have used (in the New York Public Library) bears evidence that the last two pages were inserted after the original publication in 1846. Several of the paintings, for example, are of incidents in the Northwest in 1847, and the last two pages are unnumbered, while the remaining pages (34) are numbered. The first 34 pages catalogued 83 paintings and an advertisement in the Cincinnati *Gazette*, Jan. 26, 1846, stated there were 83 paintings in the gallery. It is obvious then that the New York Public Library copy of this catalogue was one used for exhibition *after* 1846.

25. Cincinnati *Gazette*, Jan. 20, 1846; Feb. 14, 1846; Jan. 26, 1846. The *Cherokee Advocate* (Tahlequah) of March 12, 1846, p. 3, c. 2 noted the various comments in the Cincinnati papers on the Stanley and Dickerman Gallery and was moved to make its own comment: "We perceive from Cincinnati papers that Messrs. Stanley and Dickerman have been exhibiting recently in that city their extensive collection of Indian portraits and it will afford pleasure to their numerous friends in this country, to learn that they are receiving the meed of praise from an intelligent public, which their merit as artists and gentlemen so richly deserves."

26. *Cist's Western General Advertiser* (Cincinnati), Jan. 28, 1846, stated that Stanley "proposes in April next to resume his interesting employment in other and yet unexplored fields of labor" and in *Diary and Letters of Josiah Gregg*, edited by M. G. Fulton, Norman, Okla., 1941, vol. 1, p. 188, is a letter of Gregg's dated April 17, 1846, which mentions Stanley and indicates that Gregg was expecting Stanley to be in St. Louis at or before

the time Gregg's letter was written. An editorial note (p. 188) states that Gregg and Stanley were fellow-residents of Independence, Missouri. If Stanley was a resident of Independence it could not have been for a matter of more than a few months.

27. *Down the Santa Fe Trail and into Mexico—The Diary of Susan Shelby Magoffin*, edited by Stella M. Drumm, New Haven, 1926, p. 19. For Gregg's departure with Owen's train, see *Diary and Letters of Josiah Gregg* (previously cited) vol. 1, p. 192 (footnote), p. 197 and p. 202 (footnote 7).

28. Stanley's catalogue of 1852, pp. 35–40.

29. *Nat. Int.*, Nov. 14, 1846, p. 3, c. 6, reported that Kearny left Santa Fe for California on September 25, and that the scientific staff of the expedition included "Mr. Stanley employed at Santa Fe as the artist of the expedition." W. H. Emory's official report of the Kearny expedition (30th Cong., 1st Sess., H. Ex. Doc. #41, serial no. 517, p. 45) stated that the party as organized at Santa Fe included "J. M. Stanly, draughtsman."

30. Twenty-three plates of scenery and Indian portraits in black and white, three of natural history and Indian hieroglyphics, and fourteen botanical plates appear in the official report. Apparently all were after sketches by Stanley although nowhere is there direct statement of this fact save in the case of the fourteen botanical plates. On page 79 of either report listed below, there is a statement crediting one specific view as a sketch by Stanley. Both Senate and House printings of the report exist: W. H. Emory *Notes of a Military Reconnaissance, from Fort Leavenworth, Missouri to San Diego, California*, Washington, 1848, 30th Cong., 1st Sess., Senate Ex. Doc. No. 7 (serial number 505) and 30th Cong., 1st Sess., House Ex. Doc. #41 (serial number 517). The lithography of the plates in both printings I have examined was by C. B. Graham, although Charles L. Camp in *Wagner's The Plains and the Rockies*, San Francisco, 1937, p. 112, reports that in the Senate edition he examined the plates of scenery were lithographed by E. Weber and Co.; a point which illustrates the fact made previously that general conclusions on plates cannot be based on the examination of single volumes of such early reports. There is, of course, the possibility that some of the views in the Emory report were not based

on Stanley's original sketches. Ross Calvin in *Lieutenant Emory Reports*, Albuquerque, 1951, states (pp. 3 & 4) that some of the illustrations "are so inaccurate as to make it clear that the draughtsman never beheld the scenes he was attempting to depict" but does not explain the discrepancy further. Calvin's statement still does not preclude the possibility that all the original drawings were made by Stanley as it has already been observed in the text that the plates reproduced in this report were extremely crude. The lithographer may well have been responsible for the inaccuracies.

31. Edwin Bryant *What I Saw in California*, N. Y. 4th ed., 1849, pp. 435–436. Bryant had ample opportunity to observe "the desert and wilderness" for he made the overland crossing himself and was made alcalde of San Francisco in the spring of 1847 by Gen. Kearny. Bryant's book is one of the most interestingly written of all the early accounts of overland travel. Bryant (1805–1869) lived in California for some time but spent his last years in Kentucky. For an obituary, see San Francisco *Bulletin*, Jan. 3, 1870, p. 2, c. 2.

32. The "Indian Telegraph" was either repainted or painted for the first time in 1860 (Kinietz, *op. cit.*, p. 33) and therefore was not one of the paintings seen by Bryant. It is now owned by the Detroit Institute of Arts. "Black Knife" was among the original paintings of 1846 and was one of those that escaped the disastrous fire of 1865. It is owned by the National Museum. Both of these paintings are reproduced in black and white in the Kinietz book. The information concerning the discovery of the Stanley paintings of 1846 was kindly given me by Mrs. Acheson. At the present writing, nine of these extremely important American historical paintings are in the possession of Edward Eberstadt and Sons, New York City, the well-known specialists in Americana, who kindly supplied me with photographs. The remaining five paintings are still in the possession of Mrs. Acheson and her family.

33. For an extended account of Stanley in the Northwest see Nellie B. Pipes "John Mix Stanley, Indian Painter", *The Oregon Historical Quarterly*, vol. 33, pp. 250–258, September, 1932.

34. Judging from the Stanley catalogue of 1852, Stanley was still in Oregon in the spring of 1848. In *The Polynesian* (Hono-

lulu) August 19, 1848, p. 55, there is record of the arrival of the American brig *Eveline* at the port of Honolulu "13 days from Columbia River"; *George* M. Stanley was listed as one of the passengers. I believe that this is a record of *John* M. Stanley's arrival in Honolulu, for *The Polynesian*, in the next year after this date, has several notices of John M. Stanley's artistic labors in the Islands. Accounts will be found of Stanley's work in *The Polynesian* for September 16, 1848, p. 70, c. 3; in the *Sandwich Island News*, August 21, 1848, p. 187, c. 1; in *The Polynesian*, April 14, 1849, p. 190, c. 6. In the first of these accounts, there is the corroborative statement that Stanley "recently arrived from Oregon."

Stanley left the Islands for the United States on November 17, 1849, for a letter by one Charles Jordan Hopkins of King Kamehameha's retinue written November 16, 1849, stated that Stanley was to sail the following day and directed that Stanley be paid $500 for his portraits of the King and Queen. The letter bears the receipt from Stanley of this sum. A copy of a letter in the Hawaiian Archives dated February 4, 1850, is directed to Stanley in Boston, expressing the hope he had a pleasant return voyage. I am indebted to Mrs. Dean Acheson of Washington, D.C., Stanley's granddaughter, for copies of these letters.

Kinietz, *op. cit.*, p. 7, is the authority for the fact that the portraits made in the Islands were of Kamehameha III and his queen and for the present location of these paintings.

35. In the New York *Tribune*, Nov. 28, 1850, p. 1, c. 6, there appeared for the first time the advertisement:

"Indians—Will be opened at the Alhambra Rooms, 557½ Broadway, on Thursday evening, Nov. 28, *Stanley's North American Indian Gallery*, containing 134 Oil Paintings, consisting of Portraits, life size of the principal chiefs and Warriors of fifty different tribes roving upon our Western and South-wessern (sic) Prairies, New Mexico, California and Oregon, together with landscape views, Games, Dances, Buffalo Hunts and Domestic Scenes, all of which have been painted in their own country during eight years travel among them, forming one of the most interesting and instructive exhibitions illustrative of Indian life and customs ever presented to the public.

"Descriptive lectures may be expected at 3 P.M. on Wednesday and Saturday, also each evening at 7½ o'clock. Open at 9 A.M. to 10 P.M. Single tickets 25 cents. Season tickets $1. Can be obtained at the Principal Hotels and at the door. Stanley and Dickerman, Proprietors."

This advertisement ran for a week but comment and other small advertisements indicated that the Gallery was on exhibit in New York for at least two months and probably longer; see N. Y. *Tribune*, Jan. 21, 1851, p. 5, c. 2; Jan. 23, 1851, p. 5, c. 3; Jan. 24, 1851, p. 1, c. 1.

36. The first notice I have found of Stanley's Gallery in Washington occurs in the *Nat. Int.*, Feb. 24, 1852, p. 1, c. 4, which stated that the gallery had been "recently brought to this city." Henry reported to the Board of the Smithsonian on March 22, 1852, that Stanley had deposited his gallery of Indian portraits in the Institution and that they "had attracted many visitors" (32d Cong., 1st Sess., Senate Misc. Doc. #108, p. 108, Serial no. 629; see also Henry's comment on Stanley's gallery in 32d Cong., 2d Sess., Sen. Misc. Doc. #53, p. 27). Henry stated here that there were 152 paintings in the collection, which is the number listed in the catalogue of 1852; note the comment of Senator Weller, however, as given in note 37. *L. C. S.* mentions the display of the gallery in eastern cities during 1850 and 1851.

37. For Eastman's comment, see letter of Eastman's dated Jan. 28, 1852, and quoted by Kinietz, *op. cit.*, p. 17. For Eastman (1808–1875) as a painter of the American Indian, see David I. Bushnell, Jr., "Seth Eastman, Master Painter of the North American Indian," *Smithsonian Misc. Collections*, vol. 87, No. 3, April, 1932, 18 pages.

Senator Weller of California introduced the matter of the purchase of the Stanley Gallery to the Senate on Dec. 28, 1852, where the matter was referred to the Committee on Indian Affairs (*The Cong. Globe*, 32d Cong., 2d Sess. 1852–53, p. 158). Weller stated that there were 154 paintings in the collection "139 in substantial gilded frames." The committee to whom the matter was referred examined the exhibit and were very favorably impressed but they failed to arouse enough enthusiasm among the rest of the senators when the matter came to a final vote on March 3, 1853 (*Cong. Globe* as above, p. 1084). Senator Weller apparently quoted Stanley when he

reported Stanley's investment as $12,000 "in addition to time and labor."

The *National Intelligencer* item cited in note 36 stated Stanley's hope when it reported that the Gallery "may become the foundation of the great national gallery."

38. The annual reports of the Smithsonian Institution from 1852 to 1866 contain frequent mention of the Stanley Gallery and the facts stated above come from this source. That Stanley was hard pressed financially is all too evident in his request of the Institution for an allowance of $100 a year to pay the interest on money that Stanley had borrowed so that he would not have to sell the Gallery privately (*Annual Report of the Smithsonian Inst. for 1859*, Washington, 1860, p. 113). The destruction by fire and the fact that the Gallery had grown to 200 paintings is reported in the *Annual Report of the Smithsonian Inst. for 1864* (Washington, 1872), p. 119.

39. In the discussion in the text I have followed Hazard Stevens *Life of General Isaac I. Stevens*, Boston, 1900, vol. 1, Chap. XV. For his appointment as survey head, see vol. 12 of the *Reports*, p. 31. For a "Bibliography of Isaac I. Stevens" by Rose M. Boening, see *Washington Historical Quarterly*, vol. 9, pp. 174–196 (1918).

40. New York *Tribune*, June 3, 1853, p. 5, c. 6.

41. *Reports*, vol. 12, p. 36.

42. N. Y. *Tribune*, June 3, 1853, p. 5, c. 6. This account lists Stanley and Strobel as artists and although in the quotation above the plural "artists" is employed, it must apply to Strobel's work as it was written before Stanley reached St. Paul.

43. N. Y. *Tribune*, Aug. 3, 1853, p. 5, c. 2. Strobel was not the only one who turned back as a result of Stevens' drive and insistence upon his way of doing things. This same account stated that there were over twenty-five who had returned and Stevens' official account also described his difference of opinion with members of the survey resulting in withdrawal from the expedition. Stevens mentions Strobel's discharge because he was "inefficient," *Reports*, vol. 12, p. 55.

44. For the comment on Strobel see N. Y. *Tribune*, Aug. 3, 1853, p. 5, c. 2; for a reproduction of Strobel's view of St. Paul, see I. N. Phelps Stokes and Daniel C. Haskell, *American Historical Prints*, N. Y., 1933, Plate 85a with comment on page 111; for Strobel with Fremont see S. N.

Carvalho, (cited in note 17), p. 29. The Minnesota region had been visited by an artist in the 1850's even before the coming of Strobel and Stanley; see Bertha L. Heilbron *With Pen and Pencil on the Frontier in 1851*, St. Paul, 1932. Miss Heilbron reproduces a number of western sketches of the artist Frank B. Mayer (1827–1899), as well as Mayer's diary while in Minnesota Territory in 1851.
45. Actually Stevens instructed one group of his expedition to ascend the Missouri from St. Louis to Fort Union and to make meteorological, astronomical and topographical observations above St. Joseph, Missouri. Nine of the survey made the river trip, see *Reports*, vol. 12, pp. 79–82. The general course of the Stevens party through present North Dakota was such, as one of the party stated, "to turn the great Bend of the Missouri and to cross its tributaries where the least water was to be found" (N. Y. *Tribune*, Sept. 13, 1853, p. 5, c. 4). Roughly it would correspond to a route that would follow north of U. S. 52 from Fargo to Minot and then U. S. 2 westward. Jessie Lake (Griggs County), for example, which is mentioned later in the text, was on the Stevens route, as was the Butte de Morale, of which Stanley made a sketch reproduced in the *Reports*. The Butte de Morale is some seven miles from Harvey, N. D., almost in the center of the state.
46. The first quotation on the buffalo is from *Stanley's Western Wilds* (see note 61), p. 8; Stevens' comment from *Reports*, vol. 12, p. 59.
47. The date was July 16, 1853; Stevens in *Reports*, vol. 12, pp. 65, 66.
48. The St. Paul correspondent of the N. Y. *Tribune* reported the arrival of 133 carts of the Hunters in that frontier town on July 20; see N. Y. *Tribune*, Aug. 3, 1853, p. 5, c. 2. Mention is made of their meeting with the Stevens party. An excellent description of the Pembina carts and of the Red River colonists may be found in a letter to the N. Y. *Tribune* July 27, 1857, p. 5, c. 2.
49. Stevens, *Reports*, vol. 12, pp. 73–76. Included in the panorama of *Stanley's Western Wilds* (see note 61), p. 10, was a painting of the Assiniboine council; the illustration in the text depicts the distribution of goods. Another member of Stevens' party also wrote an interesting account of the Assiniboine council; see N. Y. *Tribune*, Sept. 13, 1853, p. 5, c. 4.

50. New York *Tribune*, Sept. 13, 1853, p. 5, c. 4. Stevens, *Reports*, vol. 12, p. 78, also makes brief comment on the entry to Fort Union. The writer of this letter undoubtedly was Elwood Evans, as he was a native of Philadelphia and accompanied Stevens' expedition; see Bancroft's *Works*, vol. 31, p. 54.
51. *Reports*, vol. 12, p. 87. Another comment on Stanley's use of the daguerreotype will be found in this same volume, p. 103.
52. Letter of Stevens dated "Fort Benton, Upper Missouri, Sept. 17, 1853" and published originally in Washington *Union* for Nov. 23; see also New York *Tribune*, Nov. 24, 1853, p. 6, c. 2.
53. *Reports*, vol. 1 (in Stevens report), pp. 447–449. The portion quoted has been condensed somewhat. Stevens also described Stanley's excursion, see *Reports*, vol. 12, p. 107; pp. 114–115. The location of the Piegan camp given by Stanley would indicate that he went well north of the U. S.-Canadian border into present Alberta.
54. In *Reports*, vol. 12. Evidently this sketch was also used in the Stanley panorama (*Stanley's Western Wilds*, p. 15) and Stanley planned to use it in his projected portfolio (letter press of portfolio p. 8; see note 23). Other views included in the panorama which belong to the same group of sketches were a view of Fort Benton, "Cutting up a Buffalo," and "A Traveling Party [of Blackfeet]."

Stevens, in a letter dated "Sept. 16, 1853, Fort Benton, Upper Missouri" (reprinted from the Boston *Post* in the *Nat. Int.*, Nov. 26, 1853, p. 2, c. 4) wrote a friend that Stanley was at the time of writing in the midst of the Blackfeet and went on to say "We have traversed the region of the terrible Blackfeet, have met them in the war parties and their camps, and have received nothing but kindness and hospitality." Stanley, too, reported concerning the Blackfeet "During my sojourn among them I was treated with the greatest kindness and hospitality, my property guarded with vigilance, so that I did not lose the most trifling article" (*Reports*, vol. 1, p. 449). Evidently Stevens' employment of Culbertson and his Blackfoot wife was a master stroke, for the Blackfeet usually gave trouble to whites entering their territory. The liberal distribution of goods and presents, in one case amounting to a value of $600.00, to Indians encountered was also

no doubt a contributing factor to amicable relations.

55. The site of the Coeur d'Alene Mission was established by Father De Smet about 1845; it was designed and built by Father Anthony Ravelli, S. J. and opened for services in 1852 or 1853; its use was discontinued in 1877 but the Old Mission was restored in 1928. It is known locally at present as the Cataldo Mission; see *History of the Coeur D'Alene Mission*, Rev. E. R. Cody, Caldwell, Idaho, 1930. I am also indebted to the Public Library of Coeur D'Alene, Idaho, for information about the Mission.

56. The number varies depending upon whether one is using the 1859 or 1860 printing of the final Stevens report. Some of the differences to be noted are: (1) the lithography in the 1859 printing (Supplement to vol. 1) was by Julius Bien of New York in the two copies I have seen. In the 1860 printing (vol. 12, Book I), the lithography was by Sarony, Major and Knapp; (2) the plate numbers and page insertions of the plates are different, in general, in the two printings; (3) "Crossing the Hell Gate River Jan. 6, 1854" is credited to Stanley in the 1859 printing; to Sohon (as it should be) in the 1860 printing; (4) "Main Chain of the Rocky Mountains as seen from the East . . ." is credited to Stanley in the 1859 printing; to "Stanley after Sohon" in the 1860 printing; (5) "Source of the Palouse" is uncredited in the 1859 printing; "Source of the Pelluse" is credited to "Stanley after Sohon" in the 1860 printing; (6) "Big Blackfoot Valley" is credited to Stanley in the 1859 printing; to Sohon in the 1860 printing.

As is to be expected since the plates for the Stevens report were lithographed by two firms, the same title will show illustrations differing more or less in detail. In the copies I have seen the coloring is superior in the Sarony, Major, and Knapp printings but even lithographs from the same house will differ in brilliance of color depending upon how much the stones were used and inked.

57. Stanley's arrival in New York is given in the N. Y. *Tribune*, Jan. 9, 1854, p. 5, where an "M. Stanley" is listed among the passengers on the "Star of the West" and in the next column under "Oregon Views" it specifically states that J. M. Stanley, the artist of the Stevens survey, arrived on the "Star of the West." Stanley was back in Washington by Jan. 19, 1854 as Stanley's report of his visit to the Piegans is dated "Washington City, January 19, 1854" (see note 53).

58. For the remainder of Stanley's life see Kinietz, *op. cit.*, and obituaries in the Detroit *Free Press*, April 11, 1872, p. 1, c. 3 and the Detroit *Advertiser and Tribune*, April 10, 1872, p. 4, c. 4.

Some idea of Stanley's method in the field can be gathered from a memorandum which he prepared for Stevens on plans for the work of the artists of the surveys (see *Reports*, vol. 1, Stevens report, pp. 7 and 8). Stanley stated in part: "Sketches of Indians should be made and colored from life, with care to fidelity in complexion as well as features. In their games and ceremonies, it is only necessary to give their characteristic attitudes, with drawings of the implements and weapons used, and notes in detail of each ceremony represented. It is desirable that drawings of their lodges, with their historical devises, carving and etc., be made with care."

That Stevens was more than satisfied with his selection of Stanley is indicated in a letter of Oct. 29, 1853, after Stanley's part in the survey was virtually complete. The letter reads in part: "The chief of the exploration would do injustice to his own feelings if he omitted to express his admiration for the various labors of Mr. Stanley, the artist of the exploration. Besides occupying his professional field with an ability above any commendation we can bestow, Mr. Stanley has surveyed two routes—from Fort Benton to the Cypress Mountain, and from St. Mary's valley to Fort Colville near the Bitter Root Range of mountains—to the furtherance of our geographical information, and the ascertaining of important points in the question of a railroad; and he has also rendered effectual services to both cases and throughout his services with the exploration, in intercourse with the Indians."—*Reports*, vol. 1, Stevens report, p. 67.

59. The National Archives (Washington) in their file of material on the Pacific Railroad Surveys contains a letter by Stanley dated April 3, 1855, to Lt. G. K. Warren, who with Capt. A. A. Humphreys was in charge of the preparation of the reports for publication by the War Department, stating that it would take Stanley 5½ months to complete the necessary illustrations, and containing a list of 57 proposed illustrations. In this list are a number of those which finally appeared in the report.

Apparently Stanley had a few illustrations ready at the time the letter was written for he so states. Stevens in a letter to Capt. A. A. Humphreys of the War Dept. dated Sept. 26, 1854 (also in the National Archives) directed that Stanley be paid $125 a month for his work of preparation "a small compensation however in view of his ability and experience." Apparently, too, this rate of pay was Stanley's compensation while on the actual survey; see Hazard Stevens, *op. cit.*, vol. 1, p. 306. This sum was probably the standard rate of pay for many on the surveys, for Charles Koppel also received $125 a month while on Lt. Williamson's survey; see 33d Cong., 1st Sess., Sen. Ex. Doc. 29 (serial No. 695), p. 113.

60. *Daily Evening Star* (Washington), Aug. 9, 1854, p. 3, c. 1.

61. Many comments and advertisements on "Stanley's Western Wilds" appear in the Washington *Star* from Aug. 9, 1854 to Jan. 18, 1855. A copy of the handbook of *Stanley's Western Wilds* is in the collections of the Library of Congress. According to the Washington *Star* of Dec. 14, 1854, p. 3, c. 1, it was written by Thomas S. Donaho.

62. The last of the Pacific Railroad Survey artists we can mention but briefly. He was Gustav Sohon, one of the enlisted men who brought supplies from the Pacific coast to the Indian village of St. Marys, west of the Rockies for the Stevens party proper in the summer of 1853. Later he accompanied Lt. Mullan, who under Stevens' orders, surveyed the mountains on the northern route for possible passes in the winter of 1853–54 and from this time until 1862 he was frequently associated with Mullan in the Northwest. Some ten or a dozen of his sketches are included in the final Stevens report but by far the most interesting of Sohon's work now available was reproduced in a report by Mullan published in 1863. Included among these illustrations were "Walla-Walla, W.T. in 1862"; "Fort Benton" (not dated but probably 1860–1862), the most satisfying illustration I have seen of this famous frontier post and the head of steamboat navigation on the Missouri; "Coeur D'Alene Mission in the Rocky Mountains," a different view than Stanley's illustration of 1853, and "Mode of Crossing Rivers by the Flathead and other Indians" showing the use of hide "bull-boats." A number of Sohon's original Indian sketches are now in the United States National Museum. They are stated to be "the most extensive and authoritative pictorial series on the Indian of the Northwest Plateau in pre-reservation days." For Sohon (1825–1903) see John C. Ewers "Gustavus Sohon's portraits of Flathead and Pend D'oreille Indians, 1854," *Smithsonian Miscellaneous Collections*, vol. 110, No. 7, Nov. 1948, 68 pp. The above quotation is from this source. For Mullan's report see Capt. John Mullan, *Report on the Construction of a Military Road from Fort Walla-Walla to Fort Benton*, Washington, 1863; some additional information on Mullan will be found in "Captain John Mullan and the Engineers Frontier" by S. F. Bemis in the *Washington Historical Quarterly*, vol. 14, pp. 201–205 (1923), and "Captain John Mullan" by Addison Howard in the *Washington Historical Quarterly*, vol. 25, pp. 185–207 (1934). The excellent lithography in the Mullan book was by Bowen and Co.

No trace of the original Stanley and Sohon sketches for the Stevens report has been found. They are not in the National Archives, although a letter in the Archives from Stevens to Capt. A. A. Humphreys, dated March 11, 1858, requested that all of the sketches of Stanley and Lt. Mullan (presumably those of Sohon) to be used in the report be sent to Stevens. Humphreys has a notation dated March 12, 1858, on the Stevens letter stating that the sketches requested had been sent Stevens. What happened to them subsequently I have been unable to determine.

The only other government report for this period that can approach the Pacific Railway Report from the standpoint of western illustration is the Emory account of the United States-Mexico boundary survey and to conclude this chapter of our story brief comment on the illustrations will be made. The survey began initially in the spring of 1849 but as a result of a series of obstacles was not completed until the fall of 1855.

The report, in three volumes, was published in 1857–59. The first volume includes the general account and details of the survey and the last two volumes deal with the botany and zoology of the region traversed. These two volumes are illustrated with many wonderful plates including a number of hand-colored plates of birds.

Part one of the first volume includes the

illustrations of most general interest, and here will be found 76 steel engravings, 12 lithographs (a number colored) and 20 woodcuts. These elaborate illustrations are primarily the work of two artists who accompanied the survey, Arthur Schott and John E. Weyss.

The survey in its final stages worked in two parties, one traveling west and the second, starting from Fort Yuma (Arizona), traveling eastward. Weyss accompanied the first party which was under the immediate command of Emory, and Schott, under Lt. Nathaniel Michler, was with the second. The official title of the report— *United States and Mexican Boundary Survey Report of William H. Emory*, 34th Cong., 1st Sess., H. R. Ex. Doc. 135, Washington 1857, vols. 1, 2,[1] 2.[2] Mention of Weyss (sometimes spelled Weiss in the report) and of Schott as members of the survey and of their responsibility as illustrators is made on pages 15, 24, 96, and 124. The engravings on steel were by James Smillie, James D. Smillie and W. H. Dougal; the lithography by Sarony, Major and Knapp. The list of illustrations on pp. X and XI calls for 74 steel engravings but in the copy I examined there were two number 32's and 33's of different titles (two not included in the list) making a total of 76 engravings.) W. H. Dougal (1822–1894?), the engraver for some of the plates in the Emory report, should be included in our list of Western artists, for he visited California in 1849 and 1850 and made a number of sketches which have been reproduced with a brief biographical account of Dougal's life in *Off for California* (Letters, Log and Sketches of William H. Dougal), edited by Frank M. Stanger, Biobooks, Oakland, California, 1949.

Among the most interesting of the illustrations in this volume are "Military Plaza —San Antonio, Texas" (by Schott), "Brownsville, Texas" (by Weyss) and "The Plaza and Church of El Paso" by A. de Vaudricourt who was with the survey in 1851.

Schott was a resident of Washington for many years after his return from the survey. He was an ardent naturalist and his name appears frequently in the reports of the Smithsonian Institution in the 1860's and 1870's. His death occurred in 1875 at the age of 62. (For mention of Schott, see *Annual Report of Smithsonian Institution for 1866*, p. 27; for 1867, p. 48; for 1871, p. 423; for 1873, p. 390; for 1877, p. 44;

see also 39th Cong., 2d Sess., Senate Misc. Doc. #21, vol. 1, Jan. 16, 1867, pp. 7–11. Schott appears in Washington city directories from 1858 until his death in 1875. He must have been a remarkable man for he is listed at various times as naturalist, engineer, physician, and referred to as a well-known professor of German and music. His death, at the age of 62, occurred in Washington (Georgetown) D. C. on July 26, 1875; see *National Republican* (Washington), July 28, 1875, p. 2, c. 5 and Georgetown *Courier*, July 31, 1875, p. 3, c. 1. S. W. Geiser, *Naturalists of the Frontier*, Dallas, 1948, p. 281, gives a very brief sketch of Schott.)

Weyss later became Major Weyss during the Civil War, serving as a member of the staff of engineers of the Army of the Potomac. (See *Official Records of the Union and Confederate Armies*, Series I, vol. 36:1, p. 294 for Weiss (note change of spelling) in the Civil War, where it is stated that Weyss was commissioned by "the governor of the State of Kentucky.")

After the war, Weyss again turned to employment in Western surveys and according to Wheeler (George M. Wheeler, *Report upon United States Geographic Surveys West of the One Hundredth Meridian*, Washington, 1889, v. 1, p. 52) was "for many years connected with Western explorations and surveys under the War Department." Several plates in the Wheeler report cited above are by Weyss. Weyss died in Washington, D.C., on June 24, 1903 at the age of 83. I am indebted to Meredith B. Colket, Jr., of the Columbia Historical Society of Washington for aid in locating information on the death date of Weyss. A death notice of Weyss will be found in *The Evening Star* (Washington) June 24, 1903, p. 5, c. 7.

There is little biographic data available on A. de Vaudricourt. The *San Antonio Ledger* of Oct. 10, 1850, described him as an "accomplished and gentlemanly draughtsman and interpreter who has made a number of beautiful sketches of the most striking parts of our country—." He was connected with the survey for less than a year and he then disappears from view. (The quotation concerning Vaudricourt is reprinted in the *Nat. Int.*, for Nov. 2, 1850, p. 3, c. 2. The *Nat. Int.*, Sept. 24, 1850, p. 4, c. 2 reported that Vaudricourt was head of the topographic party of the survey that was to work from Indianola (Texas) to El Paso and the same news-

paper, July 22, 1851, p. 1, c. 6, reported that Vaudricourt had severed his connection with the survey. Bartlett (see below), vol. 2, p. 541, also made mention of Vaudricourt and stated that Vaudricourt left the survey soon after they reached El Paso. Harry C. Peters, *op. cit.*, p. 392, lists an A. de Vaudricourt who made lithographic illustrations for Bouve and Sharp of Boston in 1844-45).

Actually there were at least two other artists on these Mexican boundary surveys, John R. Bartlett and H. C. Pratt. Some of their work is reproduced in Bartlett's account of the survey. Bartlett, who was U. S. Commissioner for the survey for several years, was an amateur artist but Pratt, who accompanied him, was a professional and is reported to have made "hundreds" of sketches and some oil portraits of Indians. Bartlett, however, in his report employed his own sketches very nearly to the exclusion of those of Pratt. As a probable result, the illustrations (15 lithographs and 94 woodcuts), with two exceptions, are of no great interest. The exceptions are a double page lithograph of Fort Yuma, Arizona (by Pratt), and of Tucson, Arizona, and surrounding desert by Bartlett. (For Bartlett (1805-1886) see *Dictionary of American Biography*, vol. 2, pp. 7-8 and his report *Personal Narrative of Explorations and Incidents in Texas, New Mexico, California, Sonora, and Chihuahua, Connected with the United States and Mexico Boundary Commission During the Years 1850, '51, '52, '53*, New York, 1854, two volumes. Bartlett, Emory and others became involved in a serious contretemps and their differences required many written words of discussion, explanation and recrimination. Bartlett, in his own report, makes mention of his own and Pratt's sketches in vol. 1, p. 357 and vol. 2, pp. 541, 545, and 596. Pratt (1803-1880) is listed by D. T. Mallett (*Mallett's Index of Artists*, N. Y., 1935, p. 352) as a landscape painter. Contemporary mention of Pratt's Indian portraits made on the survey will be found in the San Diego *Herald*, Feb. 14, 1852 (reprinted in the *Nat. Int.*, March 20, 1852, p. 3, c. 3.)

CHAPTER II

Heinrich Balduin Möllhausen

1. The publications of many of the individuals mentioned in the text are listed in

Henry R. Wagner's *The Plains and the Rockies*, rev. and ext. by Charles L. Camp (San Francisco, 1937). For Kurz (1818-1871), see "Journal of Rudolph Friederich Kurz," Myrtis Jarrell, tr., and J. N. B. Hewitt, ed., in Smithsonian Institution, Bureau of American Ethnology, *Bulletin 115* (Washington, 1937); for Gerstäcker (1816-1872), see *Der Grosse Brockhaus* (Leipzig, 1930), v. 7, p. 230, and for Strubberg, see *The Life and Works of Friedrich Armand Strubberg*, by Preston A. Barba (Philadelphia, 1913).

2. The closest approach to such a study with which the writer is familiar will be found in the introductory chapter, "America in German Fiction," of Preston A. Barba's *Balduin Möllhausen, the German Cooper* (Philadelphia, 1914), cited hereafter as Barba.

Some estimate of the influence on American life—but only incidentally on literature —made by the refugees of the German Revolution of 1848 will be found in Adolf E. Zucker *The Forty-eighters*, N. Y., 1950. Zucker lists brief biographical sketches of over 300 Germans, a considerable number of whom settled in the trans-Mississippi West. The Forty-eighters constituted, of course, but a small proportion of the total German immigration to the United States. (The *North American Review* for Jan. 1856, p. 260, reported that German arrivals in the United States averaged 100,000 annually between 1846 and 1855.) Doubtless the Germans who settled in Texas lived the frontier life to a greater extent than any other German group with the possible exception of those settling at New Ulm, Minn., and who underwent the Sioux massacres of 1862. For Germans on the Texas frontier, see R. L. Biesele, *The History of the German Settlements in Texas 1831-1861*, Austin, Texas, 1930. A series of articles in *The American-German Review* for 1941 and 1942 also adds to our knowledge of Germans in Texas. Samuel Wood Geiser, *Naturalists of the Frontier*, Dallas, 1948, has reviewed some of the scientific contributions made by Germans on the Texas frontier.

3. In addition to Möllhausen, I am referring to Kurz (*see* his journal, cited in note 1, which contains reproductions of a number of his Western sketches), and to the work of Charles (or Karl) Bodmer who accompanied Maximilian. A discussion of Bodmer has been recently made by Bernard DeVoto; see his *Across the Wide*

Missouri (Boston, 1947), "The First Illustrators of the West," pp. 391–415.

4. Barba, *op. cit.*, discusses Möllhausen's literary career at some length. How much Möllhausen's purely literary efforts (as contrasted to his own personal narratives of his Western experiences) would contribute to the history of the West is problematic. Barba is quite obviously unfamiliar with Western history, and the literary work of Möllhausen is difficult to secure in this country. It should be studied, however. There are, for example, several short stories and novels with territorial Kansas as a background written by Möllhausen during his long career: *Whip-poor-Will* (novelette, 1865); "Die Tochter des Squatters" (short story, 1881); "Der Ritt ums Leben" (short story, 1896); *Der Vaquero* (novel, 1905). These all may be based in part on personal experiences. In the same category is the short story, "Die Gräber in der Steppe" (1863), a description of farm life in the early 1850's near St. Charles, Mo.

5. Barba, *op. cit.*, p. 37.

6. This date is given in a brief biographical sketch of Möllhausen by his friend Alexander von Humboldt, the celebrated geographer, in a preface to Möllhausen's book, *Diary of a Journey From the Mississippi to the Coasts of the Pacific*, Mrs. Percy Sinnett, tr. (London, 1858), v. 1, p. xxi; cited hereafter as *Diary*.

7. Barba, *op. cit.*, p. 38.

8. Möllhausen makes this statement in the *Diary*, v. 1, p. 119, although the expedition of Prince Paul is not specifically mentioned. A fragmentary account of Prince Paul's expedition of 1851 by Prince Paul himself appears in the *New Mexico Historical Review*, Santa Fe, v. 17 (1942), pp. 181–225, 294–344, and is edited by Louis C. Butscher. Supposedly this account is a translation of an original manuscript by Prince Paul which was preserved in the Royal State Library of Stuttgart although nowhere in the published version is such a claim specifically made. The account is interspersed by Möllhausen's (spelled Moellhausen in the Butscher article) story of the 1851 expedition. Parts of the Möllhausen tale appear to be but variations in translation from Möllhausen's own story in the *Diary* cited in note 6 (see especially pp. 323–344 of the Butscher account and pp. 119–130, 142–152 of the *Diary*). It is regrettable that the Butscher article was printed with so little documentation.

In the Butscher account, Prince Paul states that it "was near the middle of August, 1851" when he and Möllhausen set out from St. Louis on their Western expedition (Butscher, *loc. cit.*, p. 193).

9. Möllhausen, *Diary*, v. 1, p. 120. The location of the camp would place it probably in present Jefferson county, Nebraska. There is no Sandy Hill creek listed in modern gazetteers, although both a Sandy Creek and a Big Sandy are listed.

Whether Möllhausen and Prince Paul went much farther west than Fort Laramie is uncertain. According to Prince Paul (Butscher, *loc. cit.*, p. 209), Fort Laramie was reached on October 5 and a few pages later (p. 213) Prince Paul states that he concluded his westward journey "about the beginning of October"; one of the reasons being Möllhausen's ill health, a fact that Möllhausen does not state. Prince Paul expressed concern in several places for Möllhausen's health but his concern was apparently not so deep as to prevent him from abandoning Möllhausen at the camp on Sandy Hill creek.

Möllhausen (*Diary*, v. 1, p. 120; v. 2, p. 37) states that he "crossed the Rocky Mountains" in 1851. Possibly a side trip of a few days was made from Fort Laramie beyond the Front Range but if Prince Paul's account can be relied upon, the two travelers certainly couldn't have been much farther west than Fort Laramie.

10. Möllhausen described his harrowing experiences on the plains at some length as campfire and travel tales in an account of a subsequent expedition. See his *Diary*, v. 1, pp. 119–130, 142–152, 171–181, 198–212, 243–258, 287–304, for the complete account. He also made reference to his Nebraska trip in the *Reisen in die Felsenge-Birge Nord-Amerikas* (1861) cited in note 45. Möllhausen's experiences on the return trip are also a part of the Butscher account cited in note 8. Stories of some of these experiences are for the most part, as has already been stated, a variation in wordage of those appearing in the *Diary*. There are included in the Butscher account, however, two additional stories attributed to Möllhausen that do not appear in the *Diary*—an encounter with the Cheyennes on the South Platte (Butscher, *loc. cit.*, pp. 220–225) and one with the Sioux a few days later (*ibid.*, pp. 296–302). Contemporary mention of Möllhausen's experiences during the fall of 1851 are made in the "Journal" of Friederich Kurz (*see* note 1) under date of May 11, 1852. Kurz writes.

"Not long since, I am told, some Oto found, on the Platte, a Prussian named Mullhausen [sic] in a hopeless situation, having with him a wagon but no team. He is said to be an attendant of Duke Paul of Wurttemberg who was banished from court, and, so they say, he was protecting his Grace's silverware(?). Meantime where was the Duke?" The arrival of the Duke in Independence, Mo., is reported in *The Frontier Guardian*, Council Bluffs, January 9, 1852, p. 4. The item is dated "Independence, Dec. 5," and reads "Paul William, Prince of Würtemberg was picked [up] by Salt Lake stage about 235 miles from here. Four of his mules were frozen to death a few days before the stage came along." The item also reports heavy snows on the plains. Dr. Charles L. Camp of the University of California is preparing an account of Prince Paul and doubtless will include Prince Paul's diary of this trip which is cited in Henry R. Wagner's *The Plains and the Rockies* (p. 49) as having been published in the *Allgemeine Zeitung*, of Stuttgart, on February 20–22, 24, 1852; whether this account of the expedition of 1851 is different from that given in the Butscher account (note 8) remains to be seen. *See also* the letter of Prince Paul to Möllhausen dated "New Orleans, March 10, 1852" and published in Barba, *op. cit.*, p. 158.

11. Bethlehem was on the Iowa side of the Missouri river. The Bellevue *Nebraska Palladium*, October 25, 1854, in an item about Otoe City just established three miles below the mouth of the Platte river, added further "it is ten miles south of this place [Bellevue] opposite Bethlehem, Iowa." I am indebted to Supt. James C. Olson of the Nebraska State Historical Society for this information. Mr. Olson also called my attention to a statement in the *Iowa Journal of History and Politics*, Iowa City, v. 38, p. 212, which reads: "Morgan Parr founded Bethlehem, Iowa, in 1852. . . ." If the *Iowa Journal* statement is correct, Möllhausen was almost in on the birth of the settlement, for, according to his account, he was in Bethlehem in February, 1852.

12. Möllhausen, *Diary*, v. 1, p. 211.

13. Belle Vue, or more exactly Bellevue, is now a village in Sarpy county, Nebraska, about ten miles south of present Omaha. It was established as a fur-trading post about 1823. The Indian agency at this location was officially entitled "Council Bluffs at

Bellevue."—R. G. Thwaites, *Early Western Travels* (Cleveland, 1906), v. 22, p. 267.

14. Sarpy, called "Colonel Peter," was Pierre Labbadie Sarpy (1805–1865) who ruled autocratically at the American Fur Company post at Bellevue for many years. For a brief biographical sketch *see ibid.*, v. 29, p. 372.

15. Möllhausen, *Diary*, v. 1, pp. 301–303.

16. Letter to the writer from the director of the American department of the museum, Prof. Dr. W. Krickeberg, dated April 29, 1939. The Möllhausen collection included landscapes, animal pictures, Indian types and scenes, and records of frontier life. The water-colors were for the most part 25 x 30 cm. to 25 x 35 cm. in size.

17. Letter from the director of Staatliches Museum, Dr. Walter Krickeberg, dated September 23, 1946, to the writer. Six of the Möllhausen paintings escaped destruction as they were hung separately in a museum room spared by the fire. The paintings remaining in the museum are:

1. Buffaloes, signed 1851.
2. Grizzly bears, 1859.
3. Earth lodge of the Mohave with Indians playing ring-and-pin game (Plate *facing* p. 396 of Möllhausen's *Tagebuch einer Reise*, etc., 1854).
4. Group of Mohave, 1857–1858.
5. Group of Navaho, 1853.
6. Group of Walapai, 1857–1858.

18. The titles of the U. S. Museum collection include:

1. A cougar. Signed, "Möllhausen." (No date or location given.)
2. Indian woman with dog travois. Entitled, "Sioux Squaw," in Möllhausen's handwriting. Signed, "Möllhausen." (No date or location given.)
3. Indian woman with horse drawing tipi poles. Unsigned. (No date, tribe or location given.)
4. Pictographic designs painted by Indians on a buffalo hide. Unsigned. (No tribe, date or location given.)
5. Mounted Indians fighting. Signed, "B. Möllhausen." (2 Indians shown, no tribe, date or location given.)
6. Five Indians, one scalping a fallen enemy, the remainder brandishing weapons. Unsigned. (No tribe, date or location given.)
7. Three bears. Signed, "B. Möllhausen." (No date or location given.)
8. Indians and white man. Unsigned. (No date, tribe or location.)
9. Two Indians, one with Catlinite pipe,

other with long-barrel flintlock. Signed, "Möllhausen." (No tribe, date or location.)

Information from Dr. F. M. Setzler, head curator, Department of Anthropology, U. S. National Museum, Washington.

19. The titles are:

1. "San Felipe on the Rio Grande," 1853.
2. "Walapai Indians, Diamond Creek." Colorado Expedition, 1857–1858.
3. "Buffalo Hunt on the Prairie," 1851. (Indian and white hunters.)
4. "Antelope," 1851. (Closeup of 5 animals.)
5. "Zuni Pueblo," 1853. (Distant view.)
6. "Corero, New Mexico," 1853.
7. "The Grey Bear," 1859. (Three bears.)
8. "Wolves Fighting Buffalo," 1852.
9. "Sioux Indians," 1851. (Group on prairie, skinning deer, using fire, etc.)
10. "Kioway," 1853. (Village with painted lodge in foreground.)
11. "Comanche," 1853. (One mounted, three standing males, one female.)
12. "Inhabitants of New Mexico (Albuquerque)," 1853. (Mexican costume.)
13. "Waco, Delaware and Shawnee," 1853. (Four men, full length.)
14. "Oto Chiefs in Trading Post, Council Bluffs," 1852. (Indians and traders.)
15. "Fort Roubideaux, 1851, Western Slope of Rocky Mountains." (Panoramic view.)
16. "Ruins on Pecos River, N. M." Colorado Expedition, 1857–1858.
17. "Mohave Indians." Colorado Expedition, 1857–1858.
18. "Apache, Chimehuevi, Mohave, Haulpi Indians." Colorado Expedition, 1857–1858.
19. "Ojibway Indians of the Upper Mississippi," 1850.
20. "Pawnee Indians," 1851–1852. (One male mounted; three males, one female standing.)
21. "Buffalo Crossing the Platte River," 1851.
22. "Dancing Warriors, Omaha Indians," 1852. (Good for dance costume and equipment.)
23. "Navaho Indians," 1853. (Good costume.)
24. "Wild Game of Colorado Region." Colorado Expedition, 1857–1858.
25. "Hunters—Oto Warriors," 1851. (In winter costume.)
26. "The Wild Buffalo." (No date.)

27. "Apache, Moqui, Navaho." Colorado Expedition, 1857–1858.
28. "Mohave Indians near Colorado River," 1854. (House in background; men and boys playing hoop-and-pole game in foreground.)
29. "Choctaws, Chickasaws and Cherokees (Arkansas)," 1853. (Shows varied costume worn by these Indians at that period.)
30. "Interior of Oto Tipi," 1851.
31. "Zuni and Moqui Indians," 1853. (Good for costume.)
32. "Crossing of the Colorado by the Expedition," 1854. (Distant view.)

This information also comes from Dr. Setzler.

20. Titles as given by the Staatliches Museum für Völkerkunde in letter accompanying photographs, August 5, 1939.

21. Dr. Camp wrote me that these Möllhausen sketches were in the Länderbibliotek in Stuttgart among Prince Paul's papers. Whether this material escaped destruction in the conquest of Germany by the Allies, Dr. Camp did not know at the time of writing me (Oct., 1948).

22. The conclusion that these items are work resulting from Möllhausen's first trip is based on the dates included on the sketches and the character of the subjects of the sketches as compared to Möllhausen's personal narrative of his travels. Note that sketch No. 19 of the Hudson list suggests that Möllhausen had traveled to the region of the upper Mississippi before his experiences on the plains.

23. The titles of these lithographs in the *Diary* include:

1. "Wa-ki-ta-mo-ne and Hunting Party of Ottoe Warriors," v. 1, frontispiece.
2. "Chiefs of the Ottoe Tribe," v. 1, *facing* p. 248. These chromolithographs (and others in the *Diary*), 4⅝ in. x 7⅛ in. by "Hanhart," and signed "Möllhausen, Del," are not particularly well done. The same two illustrations appear in the German edition of the Möllhausen diary *Tagebuch Einer Reise vom Mississippi Nach den Küsten der Südsee* (Leipzig, 1858). Unlike the English translation, it was published as a single volume. The chromolithography was usually by Storch and Kramer of Berlin and is not superior to that of Hanhart. The illustrations in color measure approximately 6 by 9 inches. The first illustration listed above is also used as a frontispiece for the German edition; the second illustration appears *facing*

p. 158. Barba, *op. cit.*, p. 153, lists a second German edition of this book which appeared under the title *Wanderungen durch die Prairien und Wüsten des westlichen Nordamerika vom Mississippi nach den Küsten der Südsee im Gefolge der von der Regierung der Vereinigten Staaten unter Lieutenant Whipple ausgesandten Expedition* (Leipzig, 1860). This edition, according to Barba, has one lithograph.

24. Barba, *op. cit.*, pp. 44, 45; von Humboldt "Preface" in Möllhausen's *Diary,* pp. xxii and xxiii.

25. *Ibid.*, p. vii.

26. *Ibid.*, p. ix; *Reports of Explorations and Surveys, To Ascertain the Most Practicable and Economical Route for a Railroad from the Mississippi River To the Pacific Ocean* (Washington, 1856, 33 Cong., 2 Sess., Sen. Ex Doc. 78, v. 3, Part 1, p. 3. This, the official report, lists H. B. Möllhausen as "topographer and artist." The official report is hereafter cited as Whipple. Whipple's diary of the 1853–1854 expedition was reprinted recently as *A Pathfinder in the Southwest* (Norman, Okla., 1941); it is edited and annotated by Grant Foreman. Mr. Foreman includes in this version of the Whipple expedition an original photograph of Möllhausen (*facing* p. 16) and about which Mr. Foreman wrote me that he could not remember "to save my life where I got the picture." As Mr. Foreman had worked in the National Archives, it is possible that the Möllhausen photograph was among the Pacific railroad survey materials in the archives. Although Möllhausen's pose in Mr. Foreman's photograph is different from that in the photograph reproduced by Barba, *facing* p. 37, the frontier costume worn by Möllhausen is apparently the same in both photographs. Barba dates his photograph, "1854."

A portion of Whipple's original field journal of 1853 was recently published in the *Chronicle of Oklahoma*, vol. XXVIII, pp. 235–283 (1950). This portion of the journal was edited by Muriel H. Wright and George H. Shirk.

27. Whipple, *op. cit.*, pp. 5–135.

28. Lt. Joseph C. Ives, *Report Upon the Colorado River of the West* (Washington, 1861), 36 Cong., 1 Sess., House Ex. Doc. 90, p. 21. Hereafter referred to as *Ives*.

29. The list of original Möllhausen paintings and drawings, which for some years had been in the possession of Whipple's descendants, will be found in the *Chronicles of Oklahoma*, vol. XXVIII, p. 233

(1950). Four original Tidball sketches, as already noted, are included in the collection. In the *Diary* the following full-page lithographic illustrations (in color) will be found:

	Vol.	Facing p.
1. "Sandstone Formation in the Prairie Northwest of Texas"	1	136
2. "Camp of the Kioway Indians"	1	212
3. "Sandstone Formation at Pueblo de Santo Domingo"	1	276
4. "Church in the Pueblo of Santo Domingo"	1	336
5. "The Petrified Forest in the Valley of the Rio Seco"	2	front.
6. "Zuni, New Mexico"	2	98
7. "San Francisco Mountains (Extinct Volcanoes)"	2	156
8. "Mohave Indians, Valley of the Rio Colorado of the West"	2	250
9. "Dwellings of the Natives of the Rio Colorado of the West"	2	262

Note that, in addition to these lithographs, there were two others in the *Diary*, those already listed in note 23. In addition to the lithographs, there are 12 woodcut illustrations, chiefly of Indian utensils and drawings, although the following full-page woodcuts possibly should be noted:

	Vol.	Facing p.
1. "Cereus Giganteus"	2	219
2. "The Colorado River"	2	239
3. "Sequoia Gigantea"	2	364

The illustrations in the German edition (first) of the *Diary* (see note 23) were much the same as those listed above, although slightly larger than those in Mrs. Sinnett's translation.

30. The index of illustrations in Part III of Whipple, "Report Upon the Indian Tribes," lists 42 illustrations and then states: "The above named views, portraits, and inscriptions, are careful representations of the originals. They were drawn by H. B. Möllhausen, artist to the expedition."

31. In fact, in two of the four copies of the Whipple report that I have examined it is credited to "H. E. Möllahusen del."

32. The colored plates are by multiple impressions as can be clearly seen on a number of the plates; the color was not

washed in on a black and white lithograph as some authorities suggest. A number of the plates are two color; one a black impression and the other a brown one. On a few plates, a third impression of blue has been made. That chromolithography, printing from different color plates in register, was practiced in this country by the time the Whipple report was published is evident from the following note published in *Sartains Union Magazine,* Philadelphia, v. 6 (1850), p. 100: "Two specimens of chromolithography by Mr. Ackerman of New York [are published?] in our present issue. The print (The serenade) in our number for August last Mr. Devereaux claims as the first successful attempt in this country to obtain a finished effect in color by means of successive printings from a series of engraved blocks; but in Europe this art (although rude enough until the last ten years) is ancient." In the June, 1849, issue of the *Bulletin of the American Art-Union,* p. 27, the claim is made that J. Duval of Philadelphia was using the process and that Childs and the firm of Leslie and Traver were just beginning printing from tinted wood blocks to produce illustrations in color.

33. These instances are in addition to those found elsewhere in Whipple, such as that given in note 31.

34. Whipple, *op. cit.,* Part I, p. 42.

35. *Ibid.,* November 13, 1853, p. 59.

36. *Ibid.,* February 15, 1854, pp. 106, 107. The inscriptions were probably those described in Part III, p. 42, as "Plate 35" but "Plate 35" is missing from copies of the official report which I have examined.

37. *Ibid.,* February 27, 1854, p. 117.

38. Möllhausen, *Diary,* v. 2, p. 271.

39. Whipple, *op. cit.,* Part I, p. 127. Möllhausen also describes the murder of the Mexican in his *Diary,* v. 2, p. 300 *ff.*

40. *Ibid.,* chs. 19 and 20, from which both the brief quotations given in the text were taken.

41. *Ibid.,* ch. 21.

42. Barba, *op. cit.,* pp. 50, 51.

43. Möllhausen, *Diary,* v. 2, p. 389; Barba *op. cit.,* p. 52.

44. Lt. Joseph C. Ives, *Report Upon the Colorado River of the West,* pp. 5, 19 and 21.

45. Ives, *op. cit.,* pp. 21, 22; Möllhausen, *Reisen in die Felsengebirge Nord-Amerikas bis zum Hoch-Plateau von Neu-Mexico, unternommen als Mitglied der im Auftrage der Regierung der Vereinigten Staaten Ausgesandten Colorado-Expedition* (Leipzig, Herman Costenoble, pub., 1861), v. 1, pp. 9–20. This two-volume work, unlike the *Diary* of Möllhausen, has never been translated. Prof. J. A. Burzle of the department of German, University of Kansas, however, has become interested and is now in the process of translating this important item of Western Americana; the translation of the portion of Möllhausen's account dealing with the return journey over the Santa Fe Trail through present Kansas has been published in the *Kansas Historical Quarterly,* vol. XVI, pp. 357–380 (1948). The translation is by Professor Burzle; the introduction and the notes by the author of the present volume.

Dr. J. S. Newberry was physician, geologist and in charge of natural history collections on the expedition; for a biographical sketch concerning him *see Dictionary of American Biography,* v. 13, pp. 445, 446. For Egloffstein see Chapter I, note 17.

46. Ives, *op. cit.,* pp. 25–45. A pack train left Fort Yuma going by an overland route to resupply the party upstream.

47. *See ibid.,* Appendix B and Map No. 1.

48. *Ibid.,* p. 106.

49. Fort Defiance, a frontier military post, about 190 miles west of Albuquerque (and a little north); *see* A. B. Bender, "Frontier Defense in the Territory of New Mexico," *New Mexico Historical Review,* v. 9 (July, 1934), p. 266.

50. Ives, *op. cit.,* p. 116.

51. Möllhausen, *Reisen,* v. 2, chs. 29 and 30; Ives, *op. cit.,* pp. 116, 117, 130, 131.

52. Möllhausen, *Reisen,* pp. 263, 286; Barba, *op. cit.,* p. 55.

53. Möllhausen, *Reisen,* pp. 390, 392; Barba, *op. cit.,* p. 56.

54. The illustrations in the *Reisen* include:

Volume I

1. "Ruinen von Pecos" Frontispiece
 "Ruins on the Pecos"
2. "Vegetation der Kiesebene und des Colorado-Thales" facing p. 112
 "Vegetation of the Rocky Desert and the Colorado Valley"
3. "Schornsteinfelsen oder Chimney Peak" facing p. 174
 "Chimney Rock or Chimney Peak"

4. "Felsformation in der
Nähe der Mundung von
Bill Williams Fork" *facing* p. 238
"Rock Formation at the
Mouth of Bill Williams
Fork"
5. "Die Nadelfelsen oder
Needles (von Norden
Gesehen)" *facing* p. 238
"The Needle Rocks or
Needles (Seen From the
North)"
6. "Ende der Schiffbarkeit
des Rio Colorado—
Aussicht aus dem Black-
Canyon" *facing* p. 374
"End of Navigation on the
Colorado River—Seen from
the Black Canyon"
 Volume II
1. "Eingeborene des Nord-
lichen Neu-Mexiko" Frontispiece
Moquis Navahoes Zunis
Wallpoys
"Natives of Northern New
Mexico" Moqui Navaho
Zuni Walapai
2. "Eingeborene in Thales
des Colorado" p. 1
Wallpoys Mohaves Uma
Chimehuebes Apache
"Natives of the Colorado
Valley" Walapai Mohave
Yuma Chemehuevi Apache
(Listed in the index as the frontispiece
to v. I)
3. "Der Diamant-Bach
(Diamond Creek)" *facing* p. 48
"Diamond Back (Dia-
mond Creek)"
4. "Der Rio Colorado, Nahe
der Mundung des
Diamant-Baches" *facing* p. 54
"Colorado River, Near the
Mouth of Diamond Creek"
5. "Schluchten in Hoch
Plateau und Aussicht auf
das Colorado-Canon" *facing* p. 100
"Gorge in the High
Plateau and View of the
Colorado Canyon"
6. "Vegetation des Hoch-
Plateaus" *facing* p. 222
"Vegetation of the High
Plateau"

55. In Ives, *op. cit.*, Part I, p. 18, is an
index of the woodcuts. A note states that
they were "Drawn by Mr. J. J. Young
from sketches by Messrs. Möllhausen and

Egloffstein." The 28 woodcuts of Part III
are not, however, similarly credited in the
"List of Illustrations" on p. 8 of Part III.
Presumably, however, the same credit as
given in Part I applies.

Mention should also be made of Möll-
hausen's contribution to the botanical re-
ports of the expedition.—Whipple, *op. cit.*,
(33 Cong., 2 Sess., *Senate Ex. Doc.* 78), v.
4, Part V. On p. 58 of this report it states:
"The drawings made on the spot by Mr.
H. B. Möllhausen, the artist of the ex-
pedition, greatly aided the work and were
made use of, and even partly copied,
especially in the plates exhibiting Cylindric
Opuntiae."

Comments on Möllhausen in the official
Ives report will be found in Part I on p. 6
(statement that Möllhausen "prepared the
greater portion of the views and illustra-
tions taken during the trip"); p. 21 (ap-
pointment of Möllhausen as artist and
collector in natural history); pp. 43, 52, 62
(Möllhausen's activities in natural history
collections); pp. 82, 91, 98 (incidental
references); p. 100 (Möllhausen takes
sketch of canyon at Diamond river—which
may be uncredited woodcut, Fig. 31 on p.
99). On p. 5 of Part V, Möllhausen is
spoken of as the "zoölogist of the expedi-
tion," the zoological collections being
principally birds.

56. A letter received from H. C. Bryant,
superintendent of the Grand Canyon Na-
tional Park (February 10, 1947), states
that the earliest pictorial records of the
Grand Canyon known to them are those of
von Egloffstein of the 1857–1858 Ives
expedition and I have not encountered in
my studies any other records than those of
von Egloffstein and Möllhausen. It is diffi-
cult to believe, however, that there are not
extant earlier views of the Grand Canyon
than those made by these two men in the
spring of 1858.

57. Barba, *op. cit.*, pp. 135, 136. Another
group of western sketches of this period
that should be mentioned are those of
Joseph Heger. Heger (1835–?), with the
U. S. army in Utah in 1858–1860 sketched,
among other subjects, a number of Utah
towns, including Manti, Ephraim, Nephi,
and Goshen. Some 16 of his sketches are
reproduced in *Campaigns in the West
1856–1861*, edited by George P. Ham-
mond and published by the Arizona
Pioneers Historical Society, Tucson, 1949
(Grabhorn Press). Heger's original sketches
are to be found in the Coe Collection

(Yale University) and the W. J. Halliday Collection.

A contemporary volume of the same period containing many beautifully engraved illustrations, *Route from Liverpool to Great Salt Lake Valley*, was edited by James Linforth, and published in Liverpool in 1855. The engravings were based on sketches by Frederick Piercy who actually made the trip indicated by the title. The book, therefore, is one of the basic sources of illustrated western Americana of the period. The Wagner-Camp comment on the book (*The Plains and the Rockies*, San Francisco, 1937, p. 172) should be of interest to collectors: "For some reason or other, it is of considerable rarity." Some of Piercy's original sketches are now reportedly held by the Missouri Historical Society, St. Louis (see *Bulletin Missouri Historical Society*, vol. 5, Oct. 1948, pp. 34–39).

Piercy was born in Portsmouth, England, on January 27, 1830, according to the records of the church historian, Church of Jesus Christ of Latter Day Saints, Salt Lake City. He was active as an artist in London from 1848 until 1880 (see Algernon Graves, *Royal Academy Exhibitions, 1769–1904*, vol. VI). The last ten years of his life he was a sufferer from paralysis. He died in London on June 10, 1891. (These last items of information were furnished me on certificate DA093867 of the General Register Office, Somerset House, London).

CHAPTER III
William Jacob Hays and W. M. Cary

1. Henry T. Tuckerman, *Book of the Artists* (New York, 1867), pp. 495, 496.
2. London *Weekly Times*, June 18, 1865.
3. The *Art Journal*, New York, n. s., v. 1 (1875), p. 127.
4. S. G. W. Benjamin, *Art in America* (New York, 1880), p. 85.
5. *Dictionary of American Biography* (New York, 1932), v. 8, pp. 463, 464—W. H. Downes was the author of the sketch; *see, also, Appletons' Cyclopedia* of American Biography (New York, 1887), v. 3, p. 147.
6. It is a curious fact that Downes (*see* note 5) reports that Hays visited Colorado, Wyoming, and the Rocky Mountains in 1860. Downes was apparently basing this statement on the obituary of Hays in the *Art Journal* for 1875 (note 3). Thus are errors propagated. A student looks up a

previous account and without verification repeats the earlier statement; a type of error which we all are prone to make. Hays was never in Colorado, Wyoming or within several hundred miles of the Rockies, for his 1860 trip up the Missouri river was his only Western trip. Although the Missouri does eventually reach the Rockies, there is no evidence that Hays went any farther west than Fort Stewart on the Missouri (*see* page 40) which was still many hundreds of miles from the Rockies proper.

7. New York *Tribune*, March 16, 1875, p. 7, col. 6; *Art Journal* citation in note 3 and *Dictionary of American Biography* cited in note 5.
8. Tuckerman, *op. cit.*, p. 495.
9. For much of the material in this paragraph, I am indebted to Dr. Annie Heloise Abel's "Historical Introduction" in *Chardon's Journal at Fort Clark, 1834–1839* (Pierre, S. D., 1932), pp. xv–xlvi. (Dr. Abel's work, it should be remarked, is one of the most exhaustive and scholarly studies of original sources in the literature bearing on the early history of the West.) The closing quotation above is from H. M. Chittenden's *The American Fur Trade of the Far West*, hereinafter cited as *American Fur Trade* (New York, 1935), v. 1, p. 385.
10. My comment in the text "of the most extraordinary spectacles of the past American scene" should not be taken to mean "the most romantic spectacle," although the discussion in the text, I grant, might make such inference correct. Life in the upper Missouri country also had its extraordinary spectacles of exploitation, of unbridled rivalry, of debauchery, of viciousness, and of corruption. The white invaders of the Indian country (traders, trappers and engagés), as Dr. Abel remarks in the conclusion to her "Historical Introduction," relapsed into barbarism rather than making any attempts to assist the red man to emerge from that state.
11. Some six publications of Father De Smet published before 1865 are listed in the bibliography, Henry R. Wagner's *The Plains and the Rockies*, rev. and ext. by Charles L. Camp (San Francisco, 1937). The most extended account of "Blackrobe's" life will be found in H. M. Chittenden and A. T. Richardson, *Life, Letters and Travels of Father Pierre-Jean De Smet, S. J.* (New York, 1905), 4 vols. Some measure of the magnitude of the extraor-

dinary journeys of Father De Smet is given in his own words in summarizing his travels (upon his return to St. Louis) for a single year, 1842: "From the beginning of April I had traveled 5,000 miles. I had descended and ascended the dangerous Columbia river. I had seen five of my companions perish in one of those life-destroying whirlpools, so justly dreaded by those who navigate that stream. I had traversed the Willamette, crossed the Rocky Mountains, passed through the country of the Blackfeet, the desert of the Yellowstone, and descended the Missouri; and in all these journeys I had not received the slightest injury."—*Ibid.*, v. 1, p. 402.

12. Catlin states that the book was based on eight years' travel among the Indians of North America (1832–1839), which may be correct. However, half of the work (sometimes in two volumes, sometimes in one) was devoted to his 1832 trip in the upper Missouri country.

13. Thomas Donaldson, "The George Catlin Indian Gallery in the U. S. National Museum"—Part V of "Annual Report of the Board of Regents of the Smithsonian Institution, . . . To July, 1885" in *House Miscellaneous Documents*, 49 Cong., 1 Sess. (Washington, 1886), pp. 786–793. It should not be inferred that there were no other editions of Catlin published. There are many subsequent to 1860. In fact, one was published in Edinburgh (cited later in this chapter) as late as 1926. For a biography of Catlin see Loyd Haberly, *Pursuit of the Horizon*, N. Y., 1948. I have expressed my opinion of Haberly's biography in the *New York Historical Society Quarterly*, October, 1949, p. 276.

14. There are at least three editions and probably more. Public exhibitions of Catlin's work at home and abroad was a third publicity factor not mentioned above.

15. I have made some effort to identify this Terry. Hays speaks of him in one of the letters published later in the text and the St. Louis correspondent of the *Crayon*, New York, v. 7 (July, 1860), p. 206, reports: "Hays and Terry, artists of your city, passed through here on their way to the Yellowstone River. They will have a splendid trip, as several tribes will show up for the first time. . . ." Terry possibly may have been W. E. Terry, a wealthy amateur animal painter who lived for a time, at least, in Hartford, Conn.—H. W. French, *Art and Artists in Connecticut* (Boston and New York, 1879), p. 163. Recent inquiry directed to the Hartford Public Library gave me no further information than that given by French.

16. The *Tri-Weekly Missouri Republican*, St. Louis, reports in the column, "Port of St. Louis," in its issue of May 5, 1860, p. 1, col. 10, that the *Chippewa, Key West* and *Spread Eagle*, upper Missouri boats, left St. Louis Saturday morning, which would presumably mean that the three steamships left before May 5. The same newspaper for July 28, 1860, reports under "River News," p. 1, col. 10, the return to St. Louis of the *Key West* and states, "She left this port (on the upriver journey) with the *Spread Eagle* and *Chippewa* on the 3d of May"; *see, also*, notes 23 and 54. I am indebted to William S. Wight of the University of Missouri Library, Columbia, who made the search of the *Republican* for me.

17. Major Blake and the soldiers mentioned in Hays' letter of June 20, without doubt, were a group of 300 U. S. recruits sent by steamboat up the Missouri river to Fort Benton (the first time troops had been thus transported), and then overland to Fort Walla-Walla in the Military Department of the Pacific.—*Senate Executive Documents*, 36 Cong., 2 Sess.—Special Session (Washington, 1861), v. 4, No. 2, p. 3. For an account of the river and overland journey of Major Blake and his command, see "From Missouri to Oregon in 1860", Martin F. Schmitt, *Pacific Northwest Quarterly*, vol. 37, July, 1946, pp. 193–230.

18. The four Hays letters and the sketches discussed or reproduced in the present chapter were obtained from H. R. Hays of New York City, grandson of W. J. Hays. Mr. Hays kindly placed at my disposal a considerable fund of information and was most helpful in many other ways in collecting material for this chapter.

19. The position of Fort Randall is given in Frederick T. Wilson's "Old Fort Pierre and Its Neighbors," in *South Dakota Historical Collections* (Aberdeen, S. D., 1902), v. 1, pp. 291, 292, and by Elliott Coues, ed., *Forty Years a Fur Trader on the Upper Missouri; the Personal Narrative of Charles Larpenteur* (New York, 1898), v. 2, p. 355, note 1 (written by Coues); *see, also*, note 51.

20. Charles DeLand's "Editorial Notes on Old Fort Pierre and Its Neighbors," in *South Dakota Historical Collections*, v. 1, p. 351.

21. Chittenden, *American Fur Trade,* v. 2, p. 956.

22. Coues, *op. cit.,* v. 2, pp. 355, 359, 360. Larpenteur's trip was slow, however, as his boat was delayed by unusually low water and was held up for three days at Fort Sully because of Indian troubles.

23. Although Hays' Fort Pierre letter is apparently no longer extant, some extremely interesting side lights, additional information, and corroboration of the information in the Hays letters, will be found in an extensive account published in the *Tri-Weekly Missouri Republican,* Thursday morning, July 12, 1860, p. 1, col. 9, on the return of the *Spread Eagle* to St. Louis. The account reads:

"The steamer, Spread Eagle, Captain Bob Wright, arrived yesterday morning about 7 o'clock, from the mouth of the Milk River. She was the 'flag-ship' of the fleet of mountain boats which left here on the 3d of May, in charge of Commodore Chouteau, of the American Fur Company. The fleet had a most trying time in reaching Fort Randall in consequence of the extreme low water, and an unusual large number of passengers and amount of freight. At Fort Randall the fleet met the mountain rise, and from there up had comparatively smooth sailing.

"From Mr. Jacob Linder, mate, and Mr. Joseph Mayhood, carpenter, of the Spread Eagle, we gather some news in regard to the upper country, and the up-trip of the fleet. Forts Clark and Kip on the Missouri and Fort Sarpy on the Yellow Stone have been abandoned by the Fur Company. The various tribes of Indians along the entire upper river are reported to be engaged in a war of extermination. Everyday almost, war parties were seen on the bank of the river. Bleeding scalps were seen dangling from sticks at the door of the lodges of the chiefs and big men. Murmuring out complaints were the burden of the speeches at every council held. They complain of the government of the Indian Agents and of one another. The probabilities are that they will allow no peace to each other till a strong military post is established at some point in their country, as the Agents feel that until this is done their influence has but little force in controlling the turbulent spirit of the young and ambitious warriors.

"A difficulty occurred on the Key West on her upward trip, between Lieutenant G. W. Carr and Henry Dix, pilot of the boat. It appears, from the statements of the gentlemen who were present, that Lieut. Carr, or some one of his soldiers, was desirous of shooting an elk which was seen upon the bank. The boat was approaching the bluffs above Fort Pierre, and it was desired to give notice of her approach to persons on the shore, so as not to delay the boat more than possible. To effect this, Mr. Dix blew the whistle, and at the same moment the soldier was going to shoot the elk. The elk was startled by the noise, and ran off. Lieut. Carr then took a squad of soldiers, and went up to the pilot house to attack Mr. Dix. He fired his Sharp's rifle at him but missed him, when Mr. Dix drew his revolver and commenced firing upon Lieut. Carr. He fired four shots (the fifth one missing fire) only one of which took effect upon Carr, very seriously wounding him in the shoulder. The soldiers then rushed into the pilot house, knocked Mr. Dix down, thrust at him with their bayonets, (one going through his hand) and finally tied him, and locking him in a stateroom, placed a guard over him.

"During all this time the boat was under way, with no one at the wheel. When anyone tried to reach the roof of the boat, the soldiers would force them back, and when some remonstrated with Carr, and told him that there was danger of sinking the boat, his reply was, 'Let her sink, and be d--d.' Captain Wright finally, when he found he could not reach the pilot-house to manage the boat, went below and had the engines stopped until the other boats came up. Major Blake promptly released Mr. Dix, and Lieut. Carr was court martialled, but their verdict was not determined upon when the Spread Eagle left on her return trip.

"Buffalo, elk, deer, bear, and big-horn were reported more plentiful along the river than they have been known before for many years. Fresh meat was therefore had in abundance on the entire trip. From the hearty looks of our friend James A. Hull, and others, we should judge a trip up the Missouri very conducive to health. They all look as hearty as if they had been training for a prize mill. No sickness is reported on any of the boats, and this, in a company of some six hundred men, is remarkable.

"Below we give memoranda of the down trip furnished us by the clerk, Mr. James A. Hull: The mountain fleet arrived at the

mouth of the Milk River, Friday, June 22d, fifty days out from St. Louis, and as the river had commenced falling, it was thought advisable to send the 'flag-ship,' Spread Eagle back. Accordingly we transferred the balance of our freight to the Chippewa and Key West. Com. Chouteau then proposed that the Spread Eagle should make a pleasure trip above the point reached by the El Paso some years since. With the army officers, and most of the officers of the fleet, on board, she ran some fifteen miles above El Paso Point, and Captain La Barge has now the honor of having taken the Spread Eagle higher up the Missouri river than was ever reached by any other side-wheel boat. On our arrival at this point two guns were fired, a basket of champagne drank by the officers and guests, and one bottle buried, which I have no doubt anyone will be welcome to who will take the trouble to go back after it. The Spread Eagle could easily have gone higher; indeed, at one time it was thought she would reach Fort Benton, but when the river commenced falling, though still only a matter of doubt, Com. Chouteau did not wish to risk so much only for glory. The river above the mouth of the Yellow Stone was some eight feet higher than it had been known for several years, and the little boats anticipated no trouble in reaching Fort Benton. They are probably now on their return, and may be looked for here in about two weeks.

"After we got through our pleasure trip we returned to where the little boats lay. Here Com. Chouteau, Captain La Barge, and our other friends left us; Captain La Barge transferring the command of the Spread Eagle to Captain Bob Wright. After bidding adieu, and firing a parting salute, the Chippewa and Key West left on their upward voyage and the Spread Eagle down the river homeward bound." (There then followed the log of the down-river trip.)

24. It is so listed by Chittenden-Richardson, *op. cit.*, v. 2, frontispiece. Chittenden's *American Fur Trade*, v. 1, ch. 22, carries the history of the American Fur Company to 1843 only; *see, also,* note 25.

25. The most extensively quoted source of information on Fort Union is the one given in 1843 by Edwin T. Denig who lived for some years at Fort Union, and which was published in Maria R. Audubon, *Audubon and His Journals* (London,

1898), v. 2, pp. 180–188. A briefer description of Fort Union more nearly contemporary (1863) with Hays' visit will be found in Henry A. Boller's *Among the Indians* (Philadelphia, 1868), pp. 370–373. "The great distributing Post for the Northwest" as Boller calls it, was planned about 1829 (Abel, *op. cit.*, p. 201, note 12); it was torn down beginning August 7, 1867 (Coues, *op. cit.*, v. 2, p. 389, Footnote 9). "This ended," writes Coues, "what may be regarded as on the whole the most historic structure that had ever existed on the upper Missouri, excepting of course Fort Mandan of Lewis and Clark." Still another description of the fort in 1853 is given by Isaac Stevens (*see* note 31).

26. Coues, *op. cit.*, v. 1, *opposite* p. 68. In the "Journal of Rudolph Friederich Kurz," in Smithsonian Institution, *Bureau of American Ethnology, Bulletin* 115 (Washington, 1937), Plate 13, there will be found a Kurz sketch credited with some doubt as "Fort Union?," the date 1852. The sketch shows a portion of the main headquarters building. Comparison with the sketch in Coues leaves little doubt that the Kurz sketch was that of Fort Union. The main difference in detail between the two sketches is a tall flagpole in front of the building in the Kurz sketch which is not seen in the one published by Coues. The difference in dates (1852 and 1864) might readily account for the change.

27. Catlin's painting of Fort Union (painted June, 1832) is reproduced lithographically in Catlin's *North American Indians* (Edinburgh, 1926), v. 1, *opposite* p. 14, Plate No. 3. Coues, *op. cit.*, v. 1, p. 69, criticizes the illustration because Catlin showed the fort with more than two "Bastions." Presumably the original painting from which the illustration is reproduced is now in the United States National Museum. I have a photograph of this painting and the fort is so far distant as to be scarcely discernible, the painting being a panorama of a vast stretch of country. The painting is catalogued as No. 388 in "The George Catlin Indian Gallery."—Donaldson, *op. cit.*, p. 274. This exhaustive treatise on Catlin is Part V of the *Annual Report* of the Smithsonian Institution.

28. The view by Karl Bodmer in R. G. Thwaites' *Early Western Travels, 1748–1846*, v. 25 (atlas), Plate 61, bears the subtitle "Assiniboins Breaking Up Their Camp." Bodmer accompanied Maximilian, prince of Wied, on his travels up the Mis-

souri river, and the artist's sketches of the journey were first published in an atlas with Maximilian's *Reise in das Innere Nord-Amerika in den Jahren 1832 bis 1834* (Coblentz, 1839–1841). Thwaites' four volumes concerning Maximilian's Missouri river journey are based on the original English edition published by Ackermann and Co. (London, 1843). I have a tinted folio plate the same in form as Plate 61 mentioned above. My plate bears the legend "Fort Union on the Missouri" in English, French and German. The publisher's legend on this separate sheet is "London, published by Ackermann and Company, 90, Strand, 1st March, 1841" with the artist's legend "Karl Bodmer, pinx, ad nat." I mention these two plates of Fort Union for the reason that in the *Forty-Sixth Annual Report of the Bureau of American Ethnology*, Smithsonian Institution (Washington, 1930), *opposite* page 394, there is an illustration "Fort Union As It Appeared in 1833"; a plate on the lower part of the illustration reads "Fort Union, 1833, Ackermann & Co., London (Publ)." This illustration is the same as the above two, save for a difference of a few figures in the right foreground and middle distance. Evidently this last illustration is either another version of the Bodmer illustration or possibly it was made by a copier of Bodmer's work, not credited.

29. W. R. Hodges, *Carl Wimar* (Galveston, 1908), *opposite* p. 32. Wimar (1828–1862) apparently made several excursions up the Missouri but Hodges quotes at considerable length a letter of Wimar's written in 1858 describing his experiences on the upper Missouri and the forts he visited. The six forts sketched by Wimar appear on a single page, the legend for the page being forts of "P[ierre] Chouteau, Jr., Fur Company." The six forts included were Fort Berthold, Fort Union, Fort Clark, Fort Pierre Chouteau, Fort Benton, and Fort Kipp. The same plate is reproduced as the frontispiece in v. 2 of Chittenden-Richardson, *op. cit.*

Wimar (1828?–1862) really deserves a larger place in this chronicle than we give him. Additional material on his career will be found in a manuscript biography written in 1864 by William T. Helmuth and now in the Missouri Historical Society, St. Louis. The Hodges biography cited above is an extension of an article written by Hodges in the *American Art Review*, vol.

2, part 2, pp. 175–182 (1881). W. B. Napton in a book of reminiscences published in 1905, *Over the Santa Fe Trail in 1857*, described also some of his experiences while going up the Missouri River in 1858 and makes (p. 76 and pp. 79–82) comment on Wimar who was a fellow passenger on the river boat. The Wimar sketch books on the Missouri River trip of 1858 are described by J. B. Musick in the *Bulletin of the City Art Museum* (St. Louis), Vol. 27, May–June, 1942. *The Crayon*, vol. 5, p. 353, 1858, in a letter from St. Louis dated Nov., 1858, noted that Wimar had just returned to St. Louis from the Missouri River trip. A translation of a most interesting letter by Wimar written in 1858, the original of which was said to have been published in the Düsseldorf *Art Journal* for 1858, appeared at some length in the St. Louis *Daily Globe-Democrat*, Nov. 20, 1887, p. 26. The original publication containing the letter, in which Wimar related a number of his experiences on the Missouri River trip, was in the possession of his widow, Mrs. Charles W. Schleifforth of St. Louis. From her account, indirectly told, Wimar made two Missouri River trips in "consecutive summers."

30. Maria R. Audubon, *op. cit.*, v. 2, pp. 77, 78, 82, 84, 86.

31. Isaac I. Stevens, *Reports of Explorations and Surveys, . . . For a Railroad From the Mississippi River To the Pacific Ocean*, v. 12, Book 1 (Washington, 1860), Plate 16, *opposite* p. 85. The original illustration was drawn on August 7, 1853.

32. The foreground shows the annual government distribution of goods to the Assiniboins which took place on the visit of Stevens and Stanley to Fort Union.

33. Fort Stewart was established as a fur-trading post in 1854 and was destroyed by fire in 1860. (All the more reason that the Hays crude sketches are important.) It was about 57 channel-miles above Fort Union on the Missouri, although the land distance was about 35 miles. Its site was in present Dawson county, Montana. Larpenteur (whose journals Coues edited) was in charge of Fort Stewart during the winter of 1859–1860, but probably had left by the time Hays and Terry reached there.—Coues, *op. cit.*, v. 2, pp. 306–308, and map *opposite* p. 316.

34. *Ibid.*, p. 316. Coues says that Larpenteur arrived in the neighborhood of Fort Stewart and Fort Kipp on November 9, 1860, and found that both "forts" had

been burned by Indians. Traveling west up the Missouri in Hays' day had its adventures, as both this incident and the Hays letters show. Hays' sketch of Fort Kipp is again a crude one. A few buildings, part of a stockade, and four Indian tepees in the foreground are shown. Wimar (note 29) also sketched Fort Kipp in 1858 and his sketch shows it to be a somewhat larger establishment than is indicated by Hays.

35. Two sentences are here omitted as they deal with a death in the family which occurred while Hays was in the upper Missouri country.

36. Coues, *op. cit.*, v. 1, p. 227. According to Coues, Fort Primeau was built at this location "in the fifties or later." Charles E. DeLand, *loc. cit.*, v. 1, p. 378, states that a detailed description of Fort Primeau "is not at hand; but it was built and occupied by Chas. Primeau early in the sixties and probably before 1862." From the uncertainty of Coues and DeLand, the Hays sketch serves to give some idea of its appearance and shows that it was in existence on July 14, 1860. The Hays sketch of Fort Primeau is the only one in existence as far as I know.

37. Chittenden, *American Fur Trade*, v. 2, p. 932. For the early history of Fort Clark, see Abel, *op. cit.* Curiously enough, Dr. Abel has no illustration of Fort Clark in her book, probably because the only one available to her was the very small sketch by Carl Wimar (see note 29) which would be unsuitable for reproduction; the Hays sketch was unknown to her, of course.

38. *Travels in the Interior of North America*, R. G. Thwaites, editor, volume 25 (Atlas), plate 13.

39. Wilson, *loc. cit.*, v. 1, p. 296.

40. The quotation is from editorial notes on "Old Fort Pierre" by Charles E. DeLand in *South Dakota Historical Collections*, v. 1, p. 344, as is the information prior to the quotation in the text.

41. Wilson, *loc. cit.*, v. 1, p. 295.

42. *Ibid.*, pp. 278, 279, 290.

43. *Senate Executive Documents*, 40 Cong., 2 Sess. (Washington, 1868), No. 77, p. 121. The quotation is from Captain Raynolds' journal of the 1859–1860 Yellowstone expedition.

44. Wilson, *loc. cit.*, p. 296.

45. Catlin, *op. cit.*, v. 1, Plate 57, *opposite* p. 234. Catlin's original painting of Fort Pierre in the United States National Museum is No. 384—Donaldson, *loc. cit.*, p. 274.

46. Bodmer's sketch is published as Plate 43 of the atlas which comprises v. 25 of Thwaites' *Early Western Travels*, and is the fourth part of Thwaites' series subtitled, "Maximilian, Prince of Wied's, Travels in the Interior of North America, 1832–1834." Thwaites' reprint of Maximilian's travels is from the original English edition translated from Maximilian's work.

47. Kurz, *loc. cit.*, Plate 42.

48. Hodges, *op. cit.*, pp. 17–19, and Chittenden-Richardson, *op. cit.*, v. 2, frontispiece.

49. DeLand's picture of "old" Fort Pierre was one prepared under the direction of one of the Chouteaus of St. Louis from recollections of employees of the American Fur Company, from steamboat pilots and others. It was, therefore, not drawn by a "pinx. ad nat." DeLand refers to it in one place as a pen drawing (p. 344) and on another page as a painting (*between* pp. 256, 257) where it is reproduced in halftone.—DeLand, *loc. cit.*

50. *Ibid.*, p. 366.

51. Fort Randall was laid out in 1856 by Gen. W. S. Harney and was named for Daniel Randall, one-time deputy paymaster general of the United States army. It was abandoned on July 22, 1884.—*South Dakota Historical Collections*, v. 1, pp. 288, 292, 365, 428; Coues, *op. cit.*, v. 2, p. 355. (*See* note 19 for the location of Fort Randall.) Coues wintered there in 1872–1873. At the time of Hays' visit, Fort Randall was garrisoned by over 300 troops of the Fourth artillery under Capt. J. P. McCown. Fort Randall was the only military establishment above Fort Leavenworth on the Missouri in the Military Department of the West.—*Senate Executive Documents*, 36th Cong., 2d Sess. (Washington, 1861), v. 2, p. 216.

52. Coues, *op. cit.*, v. 1, p. 22, Footnote 10. Sioux City was platted in 1854.—*Encyclopedia Britannica*, v. 20 (1945), p. 717.

53. St. Joseph, or St. Joe, was one of the earlier upriver Missouri towns, being platted in 1843.—*Dictionary of American History* (New York, 1940), v. 5, p. 10. An engraving, probably based on a daguerreotype of St. Joseph in the early 1850's, much better finished than the hurriedly-drawn sketch by Hays, will be found in Charles A. Dana, ed., *The United States Illustrated* (Herrmann J. Meyer, New York, n. d.), West, v. 2, *opposite* p. 140. Although this work is not dated, it was re-

viewed in *Putnam's Monthly Magazine*, v 3 (June, 1854), p. 675. This two-volume work, judging from the review, was first published serially.

54. *Tri-Weekly Missouri Republican*, St. Louis, Saturday morning, July 28, · 1860, p. 1, col. 10 (River News). The note also records the fact that the *Chippewa* and the *Key West* made the run directly to Fort Benton, the head of navigation on the Missouri (some 300 or 400 miles above Fort Union) and were the first steamboats that ever landed at the fort (Benton). The three boats, *Key West*, *Spread Eagle* (Hays' upriver ship) and *Chippewa*, left St. Louis May 3 as already noted. The *Key West* and the *Chippewa* reached Fort Benton on July 2. The two ships left Fort Benton on July 5 and the *Key West* reached St. Louis July 27 as mentioned above. The *Chippewa* reached St. Louis a few days after the *Key West*. H. M. Chittenden, *History of Steamboat Navigation on the Missouri River* (New York, 1903), v. 1, p. 219, mentions that the *Chippewa* and *Key West*, in 1860, were the first steamboats to complete the journey to Fort Benton but he gave no further details.

55. R. G. Thwaites, *op. cit.*, v. 25 (atlas), Plate 39.

56. Coues, *op. cit.*, v. 2, p. 324. Coues also reports the fate of the *Spread Eagle* mentioned above in the text.

57. New York *Daily Tribune*, October 6, 1860, p. 4, col. 4.

58. The description is from an exhibition catalog published in the early 1860's. It was furnished me by H. R. Hays. Tuckerman, *op. cit.*, p. 495, copied the same description in 1867.

59. New York *Times*, June 14, 1862, under "Fine Arts." The *Times* account refers to the painting as "Stampede of the Bisons."

60. The source of this description is the same as that indicated for the description of "The Herd on the Move." Tuckerman also reprints it.

61. The New York *Evening Post*, September 25, 1863, in its column, "Fine Arts," reports the lithograph, "Herd on the Move." H. R. Hays writes me that he has seen a number of the lithographs but I have never had that good fortune. Goupil and Company was a branch of the celebrated Parisian firm of lithographers founded by Adolphe Goupil. — *The Art Journal*, London, v. 45 (1893), pp. 31, 32; *see, also* Harry T. Peters' *America on Stone* (New York, 1931), p. 197. Peters does not

include Hays in his list of artists and does not reproduce "Herd on the Move."

62. *The American Art Journal*, v. 6 (1866), p. 149, reports: "Hays has at his studio the large picture of a Bison at Bay which, although painted some few years since, has never been exhibited in this country, having been sent to England, almost as soon as finished. . . . The picture may be set down as an unqualified success." The London *Weekly Times*, June 18, 1865, cited in note 2, refers to the exhibition of this picture in London. A crude woodcut reproduction of the painting appears in *Frank Leslie's Illustrated Newspaper*, December 22, 1866, p. 216. *The National Cyclopedia of American Biography* (New York, 1897), v. 4, p. 186, dates the picture 1865.

63. *Turf, Field, and Farm*, New York, v. 2 (March 31, 1866), p. 202. The criticism occupies nearly a column of a three-column page. This curious periodical although devoted chiefly to turf news, had in its issues nearly a page devoted to art, all signed "By Rembrandt," and another page on theater news and criticism. I am indebted to the library of the Ohio State University, Columbus, for the privilege of examining volumes 2 and 3 of *Turf, Field, and Farm*.

64. *Ibid.*, v. 2 (April 28, 1866), p. 266.

65. Hays, from the standpoint of the historian, made an error here. The author has often wondered (as I suppose have many other readers of Western literature) about the appearance of the famed buffalo chip, the fuel of travelers on the Great Plains.

66. For S. D. Bruce, *see National Cyclopedia of American Biography* (New York, 1896), v. 6, pp. 321, 322.

67. Hart and Beard were well-known contemporaries of Hays (*see* Tuckerman, *op. cit.*, pp. 498–501, 547, 549). Warren was an extensive explorer of the upper Missouri and mapped this country. He was in that country in 1859, if not 1860.—*See Dictionary of American Biography* (New York, 1936), v. 19, p. 473, and the Wagner-Camp bibliography, *The Plains and The Rockies*. Dr. Flint was probably Dr. Austin Flint, professor of physiology at Long Island College Hospital, 1865–1868.—*Dictionary of American Biography* (New York, 1931), v. 6, p. 472. Dr. Rimmer was probably Dr. William Rimmer, a physician turned artist, and lecturer on art anatomy at Harvard, the Lowell Institute and other schools.—*See Appletons' Cyclopedia of American Biography* (New York, 1888),

v. 5, p. 256. Richardson was the author of *Fauna Boreali Americana* according to "Rembrandt."

68. Letter of Hays to S. D. Bruce, May 10, 1866, which specifically states that "the critic [Rembrandt] has backed out of his agreement." Another indirect reference to the matter is made in *Turf, Field, and Farm*, May 26, 1866, p. 330, where an inquirer writes to "Rembrandt" inquiring if the omission "of the vulgar and unsightly white splotches in the 'Buffalo picture' " wasn't permissible from the standpoint of art. To which "Rembrandt" made a classic reply: ". . . the characteristic 'white-splotched' appearance of a great American Buffalo prairie is suggestive of 'truths' too important to the wearied traveler or ambitious hunter, to justify an artist in rejecting them on account of their *vulgarity* when painting a great historical picture of the 'Home of the Buffalo'; for not only are their presence suggestive of the near consummation of the hopes and pursuits of the hunter, but the *contemplative* mind is filled with *grateful feelings* to the Divine Giver of All Good for providing 'unsightly white blotches,' the *only kind* of 'fuel in the wilderness' for cooking his hard-earned food, and ministering to the comfort of the half-frozen traveler while wending his wearied way for hundreds of miles across it." "Rembrandt" was riding hard the one admission that Hays had made to his criticism.

69. The papers were "The Mule Deer," in *American Naturalist*, Salem, Mass., v. 3 (June, 1869), pp. 180, 181, one plate; "Notes on the Range of Some of the Animals in America at the Time of the Arrival of the White Men," in *ibid.*, v. 5 (September, 1871), pp. 387–392; "Description of a species of Cervus [Deer]," in *Annals of the Lyceum of Natural History* (New York, 1872), v. 10, pp. 218, 219, one plate.

70. In the possession of H. R. Hays.

71. These titles were compiled from a published auction list of Hays' paintings sold after his death. The list is dated by the sales date, December 17, 1875, the sale taking place at the Kurtz gallery. The dates of two of the above paintings are taken from the biographical sketch of Hays appearing in *The National Cyclopedia of American Biography* (New York, 1897), v. 4, p. 186. This account states correctly the nature of Hays' Western trip in 1860.

72. Samuel Isham, *The History of American Painting* (New York, 1927), p. 349.

73. *Dictionary of American Biography*, v. 8, p. 464.

74. A number of these paintings are included in the auction list cited in note 71.

75. New York *Tribune*, March 15, 1875, p. 7, col. 6; March 16, p. 7, col. 2.

76. The account of this trip was told over thirty years later by W. H. Schiefflin, "Crossing the Plains in '61," *Recreation* (N. Y.), June (pp. 395–399), July (pp. 14–21), Aug. (pp. 53–56), and Sept. (pp. 115–118), 1895. The article is accompanied by many illustrations drawn by Cary.

77. For Cary's western trip of 1874 see contemporary mention of his presence in Helena, Montana, in the Helena *Weekly Herald*, Aug. 27, 1874, p. 7, c. 3 and September 3, 1874, p. 8, c. 1; see also G. B. Grinnell "Recollections of the Old West" *American Museum Journal*, vol. 17, pp. 332–340 (1917). Grinnell's article is illustrated by nine black and white reproductions of Cary paintings. The Historical Society of Montana also possesses a letter from Cary dated July 9, 1916, in which Cary specifically stated that he was in the west in 1861 and again in 1874, but makes no mention of other western trips.

78. The pictures above will be found in the order listed, in *Leslie's Weekly*, May 30, 1868, p. 169; *Harper's Weekly*, vol. 12, p. 329 (1868); *Scribner's Magazine*, vol. 3, pp. 143–149, Dec., 1871; *Harper's Weekly*, vol. 18, p. 420 (1874); *Leslie's Weekly*, Feb. 27, 1875, p. 413; *Harper's Weekly*, vol. 19, p. 904 (1875); *Harper's Weekly*, vol. 22, p. 96 (1878). Many other Cary illustrations appeared in *Harper's Weekly* especially in the decade 1868–1878 but to show how extensive were his western illustrations mention can be made of a Cary illustration found in a small country newspaper as late as 1897 (see *The Cash Merchant* (Glasco, Kansas) Sept. 1, 1897, p. 3).

Just when Cary began his career after his return from the West in 1861 seems uncertain. The first notice I have found of his artistic activities is given in *Watson's Weekly Art Journal*, vol. 4, p. 308, 1866, where he is reported preparing prairie scenes and animal pieces for exhibition. Cary (1840–1922) died in Brookline, Mass. in his 81st year on Jan. 7, 1922; see Brookline *Chronicle*, Jan. 14, 1922. I am indebted to the Brookline Public Library for the death date.

Another Western illustrator of the fifties and sixties was the versatile J. Ross

Browne (1821–1875) who drew sketches, many humorous, for his articles in *Harper's Monthly*, and for his books. A brief biography will be found in Francis J. Rock's *J. Ross Browne*, Washington, 1929, 80 pp.; see also, Duncan Emrich, *Comstock Bonanza*, N.Y., 1950.

CHAPTER IV

Theodore R. Davis and Alfred R. Waud

1. By May, 1865, the Union Pacific railroad had made no progress save that of organization and planning, the first spike being driven at Omaha on July 10, 1865. The 100th meridian, 247 miles west of Omaha, was not reached until October 5, 1866, and the celebrated junction with the Central Pacific railroad at Promontory Point, Utah, was not effected until May 10, 1869. See Paul Rigdon, *The Union Pacific Railroad* (Omaha, 1936), pp. 71–73. The less well-known Union Pacific railroad, Eastern division, began westward construction at Wyandotte, Kan., on April 14, 1864, and by December, 1865, had reached a point between Lawrence and Topeka. Service to Denver, however, did not begin until August, 1870. *See* John D. Cruise, "Early Days on the Union Pacific," *Kansas Historical Collections*, Topeka, v. 11 (1909–1910), pp. 536, 540 (Footnote 28). For the growth of the Far West during the 1860's *see* Dan E. Clark, "The Movement to the Far West During the Decade of the Sixties," *The Washington Historical Quarterly*, Seattle, v. 17 (April, 1926), pp. 105–113.
2. *Kansas Weekly Tribune*, October 12, 1865.
3. A. T. Andreas and W. G. Cutler, *History of the State of Kansas* (Chicago, 1883), p. 306. The population increase in Nebraska during the same decade was from about 30,000 to a figure something better than four times this number.—A. T. Andreas, *History of the State of Nebraska* (Chicago, 1882), p. 328. The contemporary newspapers of the period also record the immigration at the close of the Civil War. *See*, particularly, accounts in the Leavenworth *Daily Conservative*, March 25, 1865 ("The tide of immigration into our State this Spring is immense; . . ."); *Kansas Weekly Tribune*, Lawrence, March 15, 1866 ("The ingress of immigrants is becoming large, and increasing from day

to day."); *Weekly Leader*, Topeka, May 31, 1866 ("Immigration continues unabated. Hundreds of strange faces show themselves daily in our streets. . . ."). Similar comment will be found in Nebraska papers. For example, the Omaha *Weekly Republican*, July 6, 1866, reports: "Large numbers of pilgrim wagons have been crossing the river and passing up our streets today. Their white covers dot the river banks and green prairies in all directions. They move along into the interior. There is yet no let up to the stream of emigration."

Even during the winter of 1865–1866, the flow of travelers across the plains continued in large numbers as was reported in a letter dated February 25, 1866, and written by Gen. John Pope (39th Cong., 1st Sess., *House Ex. Doc. No. 76* [Washington, 1866], p. 3): "People, in incredible numbers, continue to throng across the great plains to these rich mining territories, undeterred by the seasons, by hardships and privation, or by the constant and relentless hostility of the Indian tribes. . . . For several hundred miles along the routes to New Mexico, Colorado, and Montana, the hospitals of the military posts are filled with frost-bitten teamsters and emigrants, whose animals have been frozen to death, and whose trains, loaded with supplies, stand buried in the snow on the great plains. Notwithstanding these bitter and discouraging experiences, and the imminent danger of like if not worse results, trains of wagons still continue to move out from the Missouri river, and to pursue the overland routes to the mining regions."
4. Bayard Taylor, *Colorado: A Summer Trip* (New York, 1867), based on a series of letters to the New York *Tribune*, June–December, 1866; Henry M. Stanley, letters to the *Missouri Republican*, St. Louis, republished in *My Early Travels and Adventures . . .* (London, 1895), v. 1; Samuel Bowles, *Our New West* (Hartford, 1869), based on Western travels in 1865 and 1868; Albert D. Richardson, *Our New States and Territories* (New York, 1866), based on a series of letters to the New York *Tribune*, 1865–1866. The last letter in the series, No. 36, appears in the *Tribune*, May 16, 1866. This book of Richardson's is not to be confused with his better-known *Beyond the Mississippi* (New York, 1867). Richardson was an old hand at Western travel. Descriptive letters in the New York *Tribune* from Colorado territory appeared in 1860;

see, for example, *Tribune*, September 8, November 9 and 13, 1860.

5. Davis and Waud were the earliest arrivals in the West after the close of the War. The arrival of Theodore R. Davis (1840–1894) in Denver is reported in *The Rocky Mountain News*, Denver, December 1, 1865. The beginning of Alfred R. Waud's (1828–1891) Southwestern trip is described in *Harper's Weekly*, New York, v. 10 (1866), pp. 225, 228, 257, 286. He was in Cincinnati on his way west and south on March 23, 1866.

6. Eight woodcut illustrations on one page. —*Ibid.*, p. 644. *The Daily Rocky Mountain News*, October 19, 1866, not impressed with Gookins' view of Denver, commented: "Gookins, the artist, recently here from Chicago, has furnished *Harper's Weekly* with some sketches of this country. Some of the smaller views are correct enough, but his picture of Denver is a most miserable caricature, and were it not for the name of the city printed at the bottom of the engraving, there is no one here who would ever suppose the picture referred to this city. Either the artist or the engraver were sadly at fault in their work." One always must take such criticism with a grain of salt. If city views did not present a most pleasing aspect, the booster spirit was sure to find fault.

7. *Harper's Weekly*, v. 10 (October 13, 1866), p. 654. Bayard Taylor, *Colorado: A Summer Trip*, p. 146, reports that he met "Mr. Ford, the artist of Chicago and his wife, and Messrs. Gookins and Elkins also Chicago artists. They had made the entire trip from the Missouri in their wagon and were on their way to the Parks for the summer." Mention of the Ford, Gookins and Elkins party is also made in *The Daily Rocky Mountain News*, September 3, 8, 22 and 27, 1866.

8. *Ibid.*, April 8, 1867. This item also lists paintings by Ford and Elkins. James F. Gookins was born in Terre Haute, Ind., in 1840 and died while on a visit to New York City on May 23, 1904. He was a member of Gen. Lew Wallace's staff and is said to have studied art in Italy and France. Most of his adult life was lived in Chicago.—*See* Chicago *Tribune*, May 24, 1904, and Chicago *Daily News*, May 24, 1904. I am indebted to the Chicago Historical Society for these two obituaries. Three of his Civil War illustrations appeared in *Harper's Weekly*—v. 5 (1861), pp. 388, 423, and v. 6 (May 31, 1862), p.

348. A two-page spread of Indian scenes by Gookins will be found in *ibid.*, v. 11 (November 2, 1867), pp. 696, 697.

9. Henry Chapman Ford, *Etchings of the Franciscan Missions of California* (New York, 1883). *The Daily Rocky Mountain News*, April 8, 1867, mentions a Western painting by Ford, "The Garden of the Gods."

Ford was born at Livonia, N. Y., in 1828 and died at Santa Barbara, Cal., on February 27, 1894. He went abroad in 1857 to study and spent nearly three years in Paris and Florence. At the outbreak of the Civil War he enlisted and served for a year, receiving a discharge for physical disability. He is said to have furnished war sketches for the illustrated press. After his discharge from the army, he opened a studio in Chicago and was the first professional landscape painter in that city. He took an active part in the inauguration of the Chicago Academy of Design and was its president in 1873. He made several trips to Colorado, the one recorded above in 1866 and another in 1869 (*Daily Rocky Mountain News*, September 20, 1869), and possibly others. He moved to Santa Barbara in 1875 where he spent the rest of his life.—*See* Mrs. Yda (Addis) Storke, *A Memorial and Biographical History of the Counties of Santa Barbara, San Luis Obispo and Ventura* (Chicago, 1891), pp. 485, 486; San Francisco *Call*, February 28, 1894, and Santa Barbara *Weekly Independent*, March 3, 1894. Thanks for aid in securing the above biographical information concerning Ford is due the California State Library, The Southwest Museum (Los Angeles), the Chicago Historical Society and The Newberry Library (Chicago).

10. Henry Arthur Elkins was a widely known artist of Chicago, Bloomington, Ill., and Kansas City. He was born in Vermont on May 30, 1847, and died in Georgetown, Colo., in July, 1884. He lived in Chicago from 1856 until 1873 when he moved to Bloomington and later to Kansas City. Among his better-known paintings were "Elk Park, Colorado," "The Thirty-Eighth Star," "The New Eldorado," "The Crown of the Continent," "Mount Shasta," and "The Storm on Mount Shasta." Obituaries of Elkins, provided through the courtesy of the Chicago Historical Society, will be found in the Chicago *Tribune* for July 25, 26 and August 1, 1884. Mention of his work in Kansas City will be found in the

Kansas City (Mo.) *Times*, April 14, June 2 and July 1, 1884.

For some years the Denver papers remarked on Elkins' work, many times reprinting accounts from Chicago papers. Among the more important of these comments are those found in the *Rocky Mountain News*, September 4, 1869; May 18, 1870 (reprinted from the Chicago *Post*); June 18, 1870 (also from the Chicago *Post*); December 29, 1872; September 2 and 28, 1873; December 19, 1874; March 16, 1875 (extended account of Elkins); January 4, 1877 (extended account of Elkins' painting, "The Thirty-Eighth Star," reprinted from the Chicago *Evening Journal*); September 23 and October 2, 1883. These extensive bibliographies on Elkins and on several other artists listed in these notes are given because there is nowhere else available biographical data concerning them, for they are not listed in the usual biographical directories and in encyclopedias of American artists.

11. A biographical sketch of Whittredge (1820–1910) will be found in the *Dictionary of American Biography* (New York, 1936), v. 20, p. 177. Also there is an autobiographical account of Whittredge's life in the *Brooklyn Museum Journal*, v. 1 (1942), pp. 1-66, edited by John I. H. Baur. In this autobiographical account Whittredge states "We left Fort Leavenworth on the first of June, 1865." As the Pope expedition which Whittredge accompanied was on the plains in 1866 and not 1865 (*see* report of Gen. John Pope cited below) a query was sent Mr. Baur, editor of the Whittredge autobiography. Mr. Baur wrote me on April 6, 1949, that an examination of the original Whittredge manuscript showed that an error of transcription had occurred in preparing the material for publication and the date should read "June, 1866" and not "June, 1865."

Gookins, as we have already pointed out, mentions Whittredge in his 1866 account (*see* p. 57) and Bayard Taylor, *Colorado: A Summer Trip*, p. 146, states: "Mr. Whittredge, who crossed the Plains with General Pope, was at the time [June, 1866] in the neighborhood of Pike's Peak." Henry T. Tuckerman, *Book of the Artists* (New York, 1867), p. 517, also reports that Whittredge accompanied General Pope on his journey of inspection. Gen. John Pope, in his official report for 1866 (*House Ex. Doc.* No. 1, 39th Cong., 2d Sess. [1866], v. 3, pp. 29–30) makes no mention of Whittredge. *The American Art Journal*, New York, v. 5 (1866), p. 244, states, however, "Whittredge we hear is at Denver City," and later in the year (*ibid.*, v. 6 [1866], p. 37), "Whittredge having spent the summer amid the Rocky Mountains brings back many fine sketches." Somewhat later the same journal (v. 6 [1867], p. 326) reports that Whittredge was at work on a "view of the Prairie near Denver," probably the Platte river painting mentioned in the text. This painting was reproduced in *Leslie's Weekly*, January 9, 1869, p. 268, under the title "Plains at the Base of Rocky Mountains." The *Dictionary of American Biography* states that Whittredge was accompanied on his Western tour of 1866 by John F. Kensett and Sanford R. Gifford. This statement is in error as the trip by these three artists was made in 1870 and not in 1866; *see* his autobiography mentioned above and the list by John F. Weir, *Catalogue of Paintings of Sanford R. Gifford* (New York, 1881), p. 8. Several of the Western sketches of Gifford in this list are also dated "1870"; *see*, *also*, New York *Tribune*, August 30, 1880, p. 5. Kensett had had Western experiences before he made the 1870 trip for he was on the headwaters of the upper Missouri river in 1856.—*See, The Crayon*, New York, v. 3 (1856), p. 30; v. 4 (1857), pp. 252, 377.

12. Beard (1824–1900) appears in the *Dictionary of American Biography*, v. 2 (1929), pp. 95, 96, but no mention of his Western experiences is made. Beard's later representation of animals acting like human beings so overshadowed all his other work that the rest has been lost sight of. Beard is mentioned several times in the local press during his stay in Denver: *Rocky Mountain News*, June 6 and 20, 1866.

In 1940, the late Michael J. de Sherbinin sent me copies of nine letters written by W. H. Beard to his wife while in the West. From these letters it is possible to trace Beard's journeyings with ease. He was in Atchison, Kansas, on June 8, 1866, preparatory to starting the overland stage journey to Denver. He stopped in Leavenworth and Topeka, being delayed by flooded streams. He reached Denver June 22 and wrote (in part): "Here I am safe at Denver at last thank God! From the stories I heard of Indians before starting from Atchison I did not feel at all sure that I should ever reach here, but the

farther I came the more groundless the stories appeared. . . . I only saw a few Buffalo on the plains but enough to study them, and ascertain that they are not very available for pictures. But I saw splendid effects of light and shade—storms, etc. and thousands or less of Antelopes and wolves. But perhaps the most interesting animals I saw were Maine dogs living in dog towns as the natives call them."

Beard, with Taylor, visited Central City, Colorado Gulch, Empire, Breckenridge, Buckskin Joe, and South Park for several weeks but he was back in Denver by July 9, and on July 20 was in Omaha on his way east. Beard sums up his trip by the statement (upon his return to Denver): "I think I shall go back to the States and make some sketches of different things much more useful to me than anything I can get here. The fact is I am disappointed in the Rocky Mountains somewhat. Still I am very glad I came. I have seen some grand things and I would not take anything for my experience, but I would not *like to go through with it again*".

13. "Our Artists During the War," *Harper's Weekly*, New York, v. 9 (1865), June 3, p. 339. This account listed a number of artists who had "gone through all the long and stirring campaigns of this war." In the opening year of the war (1861) the *Weekly* did not credit by name its staff artists, usually crediting them to "our staff artist," or "our special artist," so that it is not often possible to identify the illustrator. However, several accounts of T. R. Davis were printed during the year which enable some of his illustrations to be attributed; see the *Weekly*, v. 5 (1861), June 1, p. 341, and June 22, p. 397. *Harper's Weekly* (see the citations just listed) claimed that Davis accompanied W. H. Russell, the well-known English war correspondent, on a tour of the South which started just before the beginning of hostilities. According to Russell, however, there was no formal agreement with Davis about this trip. In fact, Russell presented a story that is almost a direct contradiction to the *Weekly's* claim; see William Howard Russell, *My Diary North and South* (London, 1863), v. 1, pp. 67, 90, 114, 115, 137, 286, 335, 336, 339. Russell in describing his experiences with Davis does not even mention him by name; see, also, the counterclaim of *Harper's Weekly* in the issue of July 20, 1861, p. 450.

Beginning in 1862, the *Weekly* credited the illustrator in most cases. Davis, it becomes apparent from his illustrations, traveled more extensively than Waud, and was present in the campaigns of the south and west (*see, also*, p. 70); Waud's illustrations, on the other hand, were pretty largely restricted to the operations of the Army of the Potomac and to Washington scenes.

14. The Library of Congress received these sketches by gift in 1919 from the late J. Pierpont Morgan. The Waud material also includes six letters and two photographs. With the exception of J. G. Randall, in *The Civil War and Reconstruction* (New York, 1937), this treasure trove of pictorial material has been scarcely used by historians. William Waud contributed extensively to the war illustrations in *Frank Leslie's Illustrated Newspaper*, New York, in the first two years of the war but toward the end, his illustrations began appearing in *Harper's Weekly*. In addition to William Waud, Edwin Forbes, F. H. Schell, Henri Lovie and W. T. Crane were important Civil War illustrators for *Leslie's*.

Biographical data on William Waud is meager. There is a very brief sketch of his life in *Harper's Weekly*, v. 22 (1878), November 30, p. 947, which noted his death in Jersey City on November 10, 1878, and stated that Waud was not only an excellent artist but was a gifted writer and architect as well. Inquiry directed to the Jersey City Public Library brought the reply that no obituary of William Waud could be found in three Jersey City papers for the period November 11–16, 1878.

15. George Augustus Sala, *My Diary in America in the Midst of War* (London, 1865, 2d. ed.), v. 1, pp. 302, 303. Sala does not mention Waud by name but the identity is proved from the description. This description of Waud is also used in an account of Waud and his work appearing in *American Art and American Art Collections* (Boston, 1889), Walter Montgomery, editor, v. 2, p. 836.

16. *Harper's Weekly*, v. 10 (1866), April 28, p. 259.

17. *Ibid.*, May 5, p. 286.

18. The illustrations noted above will be found in *ibid.*, May 26, p. 328; May 19, p. 308; November 10, p. 705. The notes by Waud on his illustrations of this trip appeared in *ibid.*, for the following dates: May 12, p. 289; May 19, p. 318; May 26, p. 327; June 2, pp. 345, 346; June 23, p.

398; June 30, pp. 411, 412; July 14, p. 442; July 21, p. 449; August 4, pp. 485, 486; August 11, pp. 508, 509; August 18, p. 526; September 8, p. 566; September 15, p. 581; October 13, p. 654; October 20, p. 670, and November 10, p. 706. There are, of course, Waud illustrations in all of the issues listed.

19. *Ibid.,* v. 11 (1867), October 19, p. 665. The Acadian illustration will be found in the *Weekly,* October 20, 1866, p. 657; *see, also,* the issue of December 8, 1866, pp. 769, 781. There is also an illustration specifically titled, "A Storm on the Prairies —A Scene in Western Louisiana," *ibid.,* October 6, 1866, p. 636.

20. Waud was back in New York by October 25, 1866, at least, for there is an illustration depicting an event of that date in Brooklyn in *ibid.,* v. 10 (1866), November 10, p. 713. Waud's Southern and Southwestern illustrations appeared, however, for several years after his return.

21. This illustration of Waud's and one of James E. Taylor, "Branding Cattle on the Prairies of Texas," in *Frank Leslie's Illustrated Newspaper,* June 29, 1867, p. 232, which appeared shortly before Waud's, are the first of the illustrations on the Western cattle industry to be printed in the national illustrated press. Taylor doubtless deserves more than mention in a footnote in this book and I hope that enough material will be accumulated about him to make a more extended account possible. The chief source of information concerning him is an obituary in the New York *Tribune,* June 23, 1901, p. 9, which stated that he was born in Cincinnati on December 12, 1839, graduated from the University of Notre Dame at 16, painted a Revolutionary War panorama by the age of 18, and enlisted in the Union army at the age of 21. He became a war correspondent and artist for *Leslie's* in 1863 and in 1867 went to the plains with the Indian Peace Commission. Some of his illustrations of the Medicine Lodge council (of the Peace Commission) appeared in *Leslie's* for November 16, 1867, p. 133, and November 23, 1867, p. 153. He must have painted many Indian pictures, probably in water color, for, according to the *American Art Annual,* v. 4 (1903), p. 145, he became known as "the Indian artist." He severed his connection with *Leslie's* in 1883 and became a free-lance illustrator. His death occurred in New York City on June 22, 1901.

22. *Harper's Weekly,* v. 11 (1867), October 19, p. 666.

23. *Ibid.,* v. 12 (1868), November 21, p. 741. The note accompanying the illustration is on p. 742.

24. Although I have examined several Texas maps that are nearly contemporary with this Waud illustration, I have not found the Sakatcho mountains. A letter directed to the State Geological Survey at Austin brought the reply that they were unfamiliar with Texas mountains of this name. If we may judge from Waud's travels, the "mountains" would have to be located in eastern Texas.

25. Waud made several illustrations of steamboating on the Mississippi which at least should be mentioned. One of the best of these was "A Mississippi Steamboat Making a Landing at Night," *Harper's Weekly,* v. 10 (1866), December 22, p. 801. Mention should also be made of his Texas illustration depicting a view across the Rio Grande river from the American side at Brownsville (*ibid.,* November 17, p. 732). The note accompanying this illustration is not by Waud and it seems doubtful if he ever got as far west as Brownsville. Not many issues after this sketch appeared, another illustration of the same general character, credited to a photograph, appeared in the *Weekly* and it may be that Waud used a similar photograph in preparing his illustration; *see ibid.,* v. 11 (1867), January 5, p. 12.

26. *Ibid.,* v. 15 (1871), December 23, p. 1200.

27. The Davis illustration will be found in *ibid.,* v. 13 (1869), June 12, p. 377.

28. *Beyond the Mississippi* (Hartford, Conn.) was published first in 1867; it was republished in many subsequent editions or printings. I have seen a printing as late as 1875 but the one I have used is dated 1869, "New Edition Written Down to Summer of 1869." The Waud illustration referred to above appears *facing* p. 567. This book is profusely illustrated and strangely enough for that day, each illustration is credited in the index to both artist and wood engraver. The list of illustrations reads like a roll call of the field artists of the Civil War: A. R. Waud, Wm. Waud, Edwin Forbes, F. H. Schell, J. Becker, J. R. Chapin, Thomas Nast and others. Forty of the 216 illustrations were by A. R. Waud. It is doubtful if any of the illustrations in the book were original (in the sense that they were sketched by

the artist on the spot) but were redrawn from photographs or earlier illustrations appearing in the illustrated press. The topics included in the illustrations (all, of course, Western) range in time from 1857 to 1869 and from the Mississippi river to the Pacific coast.

The same illustration, "Building the Union Pacific Railroad in Nebraska," is reproduced in a collection of A. D. Richardson's writings by his wife, *Garnered Sheaves* . . . (Hartford, Conn., 1871), *facing* p. 393, under the incorrect title, "Building the Mississippi Valley Railroad in Kansas." It was "borrowed" by the publishers solely because Richardson was describing railroad construction of a line in eastern Kansas running south from Kansas City. The background is obviously not that of eastern Kansas.

29. For discussion and reproduction of some of the Carbutt photographs of 1866, *see* Robert Taft, *Photography and the American Scene* (New York, 1938), ch. 15.

30. *Harper's Weekly*, v. 19 (1875), July 17, p. 577. A note discussing the illustration will be found on p. 579.

31. *Picturesque America;* . . . (New York, v. 1, 1872, and v. 2, p. 2, 1874). Among the artists who contributed to this interesting work, in addition to Waud, were Harry Fenn, R. Swain Gifford, James D. Smillie, Thomas Moran, F. O. C. Darley and Worthington Whittredge. Smillie is the only one of the group whose written description of his work appeared in this publication. He spent several weeks in Yosemite sometime between 1869 and 1872. Most of the illustrations—principally of scenery—are reproduced as wood engravings; a few are steel engravings.

32. *American Art and American Art Collections*, Walter Montgomery, ed., v. 2, p. 836.

33. *Harper's Magazine*, v. 60 (1880), March, pp. 529–535, May, p. 805; E. V. Smalley, *History of the Northern Pacific Railroad* (New York, 1883), and "Out on a Prairie in a Blizzard," *Harper's Weekly*, v. 25 (1881), January 29, p. 77.

34. Obituaries and biographical notes at Waud's death will be found in *ibid.*, v. 35 (1891), April 18, p. 279; Marietta (Ga.) *Journal*, April 9, 1891; Atlanta (Ga.) *Constitution*, April 8, 1891, p. 7; Orange (N. J.) *Chronicle*, April 11, 1891, and others. The biographical material given in these accounts varies considerably. One

stated that he had no survivors; another that he had three daughters; several said that Waud was buried at South Orange, N. J., others in Marietta. A headstone in the Episcopal cemetery in Marietta settles the question, however, for it is marked, "Alfred R. Waud, Oct. 2, 1828–Apr. 6, 1891." The *Harper's Weekly* account stated that Waud was born in London and came to this country when 30 years of age. The first of his illustrations in the *Weekly* that I have been able to identify with certainty is in the issue of July 3, 1858, p. 429. Frank Weitenkampf in his *American Graphic Arts* (New York, 1912), mentioned Waud and his brother, William, and stated that A. R. Waud also illustrated for Demorest's New York *Illustrated News* during its life (1859–1864). A brief biographical account of Waud is also given in *The Cyclopedia of American Biographies* (Boston, 1903), v. 7, p. 520.

35. T. R. Davis, "A Stage Ride to Colorado," *Harper's Magazine*, v. 35 (1867), July, pp. 137–150. Davis says that the party left at sunrise on November 17, 1865, and *The Daily Free Press*, Atchison, November 18, 1865, recorded the fact that the B. O. D. coach "left yesterday morning at 8 o'clock, for Central City [Colorado territory], with the following passengers: L. Hasbrouck, T. R. Davis, Gen. W. R. Brewster, Wm. M. Calhoun." The coach with these passengers reached Junction City at four o'clock the next morning, thus making about 120 miles in 20 hours, according to the Junction City *Union*, November 25, 1865, which identified Brewster as the vice-president of the B. O. D. The Butterfield service to Denver and Central City (in the heart of the mining district) had been under way scarcely two months when Davis made his trip, for the first coach had left Atchison on September 11 and had reached Denver September 22, being 12 days en route over approximately 600 miles; *see* Atchison *Daily Press*, September 25, 1865.

36. The identification of Brewster is made in note 35; of Hasbrouck in the *Rocky Mountain News*, Denver, December 1, 1865, and the Central City (Colo.) *Daily Miners' Register*, December 15, 1865; Calhoun was back in Atchison by December 5, *see* Atchison *Daily Press*, December 5, 1865.

37. Atchison *Daily Press*, November 15, 1865. The identification of Perrin (also spelled Perine and Perrine) as the corre-

spondent of the *Times* is made through *Harper's Weekly*, v. 10 (1866), January 27, p. 58, which quoted from Perrin's account of the fight (described later in the text) in the *Times*.

38. The locality of the fight was at Downer station, one of the 59 stations of the B. O. D. between Atchison and Denver, which was in present Trego county, Kansas. A table of stations and distances west of Junction City on the B. O. D. will be found in the Leavenworth *Daily Conservative*, September 22, 1865. The Atchison *Daily Press*, July 22, 1865, gave the first six stations west of Junction City. Frank A. Root and William E. Connelley, *The Overland Stage to California* (Topeka, 1901), p. 398, also listed the B. O. D. stations west of Junction City, varying somewhat from those given in the Leavenworth *Conservative*. In the discussion which followed their table, Root and Connelley became inconsistent. As these sources seem to be all that are available upon the subject, the exact distances and stations are uncertain. The total distance from the Missouri river to Denver is given as 588 miles in one account and 592 in the other. Accounts of Merwin's death will be found in the Atchison *Daily Press*, November 30, 1865, and in Davis' own story in *Harper's Magazine*, July, 1867.

39. The *Weekly Rocky Mountain News*, December 6, 1865. This account, only a small part of which is reprinted above, is dated "Denver, Dec. 2, 1865," and is the continuation of a description of the early part of the trip by the occupants of the coach which Davis had described for the *Daily Rocky Mountain News* but is reprinted in the same issue of the *Weekly* as above. This earlier part is headed "HEADQUARTERS IN A 'DOBE' (*Indians on every side*), SMOKY HILL SPRINGS, Nov. 25, '65." Both accounts are signed "D." Davis also has a story of the fight in *Harper's Magazine*, July, 1867, and Perrin apparently wrote his own account (which is in agreement with the Davis accounts) for the New York *Times* which *Harper's Weekly* reprinted in part in its issue of January 27, 1866, p. 58.

The Smoky Hill station, the scene of this fight, was in present Logan county, Kansas.

40. The arrival of the party "this morning" is reported in the *Rocky Mountain News*, December 1, 1865.

41. Fifteen illustrations resulting from this

ride across the plains will be found in *Harper's Magazine*, July, 1867, pp. 137–150, a few of which are duplicates of those which had already appeared in *Harper's Weekly*. The *Weekly* illustrations will be found in the issue of January 27, 1866, p. 56, " 'Council of War' on the Plains" (duplicated in part one of the *Harper's Magazine* illustrations); "On the Plains—Indians Attacking Butterfield's Overland Dispatch Coach" (duplicating one in the *Harper's Magazine* account although in the *Weekly* it was a full-page illustration), April 21, 1866, p. 248; "Exterior of the Adobe Fortification at Smoky Hill Station—Fighting the Fire," *ibid.*, p. 249, and "Interior of the Adobe Fortification at Smoky Hill Station," *ibid.*

42. In 1940 I secured from Mrs. Cullen W. Parmelee of Urbana, Ill., a daughter of Theodore R. Davis, a collection of letters, notes, photographs, etc., bearing on the Western trips of Davis. Reference to this material is hereafter made by the notation "Parmelee collection." I am indebted to Mrs. Parmelee and her sister, Mrs. W. D. Pennypacker of Madison, Wis., not only for the privilege of examining this material but for personal recollections and other information concerning their father.

The sketch noted above is the only original Western drawing of Davis that I have so far found. The sketch appeared on adjacent sides of a notebook carried by Davis on his first Western trip; the notebook measured approximately 2 x 4 inches.

43. Comments on Davis' character will be found in *Harper's Weekly*, v. 38 (1894), November 24, p. 1114; *Rocky Mountain News*, January 17, 1866, and December 1, 1865; Central City *Daily Miners' Register*, December 19, 1865.

44. "Banking-House, Denver City, Colorado—Miners Bringing in Gold Dust" and "The Overland Coach Office, Denver City, Colorado [Blake Street]," in *Harper's Weekly*, v. 10 (1866), January 27, p. 57; "Central City, Colorado" and "A Gambling Scene in Denver City, Colorado," February 17, p. 97 (cover page); "Street View in Santa Fe, New Mexico," April 21, p. 249; "Indian Squaws Weaving a Blanket," September 15, p. 580. Probably the "Overland Mail-Coach," *ibid.*, v. 12 (1868), February 8, p. 88, also belongs to this period as a note on p. 87 of this issue identified the locality as Guy's gulch, "about thirty miles west of Denver." Davis made but two other Western trips (those of 1866 and

1867) and on neither of these is there any evidence that he reached Denver.

45. Davis' return to Atchison is noted in the Atchison *Daily Champion*, February 24, 1866, which reported that he arrived in Atchison on the 23d. He left Denver on the 18th (*Rocky Mountain News*, February 19, 1866). Other mentions of Davis made in the Colorado papers and not already cited will be found in the *Rocky Mountain News*, December 12, 1865; January 18, 1866; February 3, 1866 (comment on the first Davis illustrations on the Smoky Hill route to appear in *Harper's Weekly*); February 13, 1866 (notes Davis' return from Santa Fe the evening before; he had left for Santa Fe on January 17); Davis, in an account signed "Russell"—his middle name —described some of his New Mexico experiences in the *Weekly Rocky Mountain News*, February 21, 1866; Central City *Daily Miners' Register*, December 13, 15, 16 and 19, 1865.

46. The first of these Southern illustrations to appear will be found in *Harper's Weekly*, v. 10 (1866), May 5, p. 285, and June 2, p. 345, and dealt with Virginia. Succeeding issues also contained other Southern illustrations. New Orleans sketches by Davis in considerable number appeared in the issue for August 25, pp. 536, 537, and then in the issue of September 1, p. 556, was a note from Davis in New Orleans.

47. The views of Houston and of Galveston (four in number) appeared in *ibid.*, October 27, p. 684. A descriptive note by Davis appeared on p. 686. The Galveston and Houston railroad view will be found in the issue of October 6, p. 637, with descriptive comment on p. 631.

48. The quotations are from Davis' article, "A Summer on the Plains," *Harper's Magazine*, v. 36 (1868), February, pp. 292–307. Actually there must have been some previous discussion and correspondence on the subject for in the Parmelee collection is a letter of General Hancock's dated: "Headquarters Department of the Missouri, Fort Leavenworth, Kansas March 10, 1867," to Davis advising him that he was "only waiting for a proper condition of the roads to enable me to transport my supplies to the proper points, before starting on a tour of a month or six weeks in the Indian Country.

"I propose going in the direction of the Arkansas and Smoky Hill, with 1200 men —possibly a few hundred more. I had in-

tended to redress some outrages but the late action of Congress has been such that I shall now go for the purpose simply of displaying some *sufficient* force. To show the Indians that we are now ready for peace or war.—Leaving to the Indian Bureau the duty of investigating the facts and indicating the course to be pursued in reference to outrages of past date. Our visit may prevent an outbreak. If one is intended, it may precipitate it. The Indians threaten to stop travel over the Overland and Pacific R. R. We *will* demand peaceful dispositions and also will punish aggressions or hostile acts coming under our notice. . . .

"I expect to be absent six weeks. You will best know whether it will afford you sufficient interest to accompany us. You will have time to join me by rail and overland at Fort Harker (Fort Ellsworth) after you see in the papers that I have started from here."

Davis' reference to Fletcher Harper is made as "the Commander-in-chief of Harper's"; as is well-known, Fletcher Harper was the directing officer of *Harper's Weekly; see Dictionary of American Biography*, v. 8, p. 281; *Harper's Weekly*, v. 51 (1907), January 5, p. 11, Henry Mills Alden, "Recollections of an Early Editor." Alden stated: "The man who originated the *Weekly* [Fletcher Harper] really conducted it as long as he lived. Every Monday morning he brought me the scheme of the illustrated pages of the next number of the paper, leaving to me the supply and adjustment of the text for all the other pages, except the portion occupied by Mr. Curtis's [George William Curtis] editorials."

49. The quotation is from the Topeka *Weekly Leader*, June 27, 1867. A correspondent in the *Leader* a few months earlier (September 20, 1866), however, had written, "The Smoky Hill valleys [of central and western Kansas] were the Indians paradise, and to yield this great and glorious hunting grounds up to the pale faces without a struggle would be asking too much of the poor red men."

How *lo*, an interjection, came to be used as a proper noun, a synonym for *Indian* (as it is in the text) has always intrigued me. Dictionaries ascribe it to Pope's famous lines in his *Essay on Man* with the sentence beginning

"Lo, the poor Indian! whose un-
tutor'd mind

Sees God in clouds, or hears him
in the wind!"
I have no fault to find with this ascription for it is undoubtedly correct, but who first started using Pope's introductory *Lo for Indian* is entirely a different matter and for some years I have been jotting down notes when I found *Lo* used in this manner. Horace Greeley was apparently one of the first to suggest its use in this manner in the United States as far as my researches on this molehill in the path of history go. In the New York *Weekly Tribune*, December 30, 1843, p. 2, is a column devoted to the discussion of Indian affairs headed, "Lo! The Poor Indian!"; and a number of times in the *Tribune* between this date and the early 1860's I have found it thus used, including a heading for one of Greeley's own letters (*Daily Tribune*, July 19, 1859, p. 6).

On the frontier itself it seems to have appeared in the press about 1865 in the shortened form, *Lo*. Possibly the casual reference of Edwin C. Manning in his paper, "The Kansas State Senate of 1865 and 1866" (*Kansas Historical Collections*, v. 9 [1905–1906], p. 363), to D. W. Houston, a member of the senate in 1865, may explain it. Manning wrote of Houston's fame by stating, as if it were common knowledge, that Houston made a famous paraphrase of Pope's lines in the state senate (presumably in 1865) which read

"Lo, the poor Indian, whose untutored mind

Clothes him before and leaves him bare behind."

Undoubtedly such a statement would tickle the risibilities of a generation well versed in the ordinary dress of the Indian and this circumstance may well have given the impetus to the very common usage of *Lo* for *Indian* in the frontier press. D. W. Wilder, however, in his *Annals of Kansas* (Topeka, 1886), p. 628, under date of December 31, 1873, stated "The word *Lo*, meaning an Indian, and in general use, Prof. Dunbar learns originated with Sol. Miller [editor of the *Kansas Chief*, of White Cloud and Troy]."

50. For Hancock's letter to Davis, see note 48. For an extended account of frontier Indian troubles of 1864–1867 in Kansas, *see* Marvin H. Garfield, *The Kansas Historical Quarterly*, v. 1 (1931–1932), pp. 140–152, 326–344.

51. In this resume of the Indian campaign of 1867 I have followed Davis' own account which, in general, is in agreement with the standard accounts (such as that given by Garfield, cited in note 50). It will be found as "A Summer on the Plains," *Harper's Magazine*, v. 36 (1868), February, pp. 292–307. Davis also had several earlier notes in *Harper's Weekly* written from the field during the campaign. They will be found in the *Weekly*, v. 11 (1867), May 11, pp. 301, 302; May 25, pp. 328, 329; June 29, pp. 405, 406; July 6, p. 426; September 7, p. 564. In the last citation there is quoted in part a letter from Davis written at Fort Harker, August 3 (1867). The Union Pacific Railway, Eastern division, was opened as far as Ellsworth and Fort Harker by July 15, 1867, according to "Report of the Condition and Progress of the Union Pacific Railway, E[astern]. D[ivision]., for the Year Ending September 30, 1867 . . . ," in *Speeches of Senator Yates . . . , on the Pacific Rail Road Question*, p. 72, and the Topeka *Weekly Leader*, November 7, 1867 (adv.).

For the location of army posts, I have used Garfield, "The Military Post as a Factor in the Frontier Defense of Kansas, 1865–1869," in *The Kansas Historical Quarterly*, v. 1 (1931–1932), pp. 50–62. A useful map of army posts in the West will be found in *Harper's Weekly*, June 15, 1867, p. 372. The Pacific railroad lines on this map, however, mark only the *proposed* routes. Additional light on the Hancock campaign is also furnished by the letters of H. M. Stanley in the *Missouri Democrat*, St. Louis, and reprinted in his *My Early Travels and Adventures . . .* (London, 1895), v. 1.

52. Junction City *Weekly Union*, August 17, 1867. Frontier towns and Western transportation companies, of course, were expecting far too much of the army as General Sherman harassedly pointed out under date of July 1, 1867: "Were I or the department commanders to send guards to every point where they are clamored for, we would need alone on the plains a hundred thousand men, mostly of cavalry. Each spot of every road, and each little settlement along our five thousand miles of frontier, wants its regiment of cavalry or infantry to protect it against the combined power of all the Indians, . . ."—*Report of the Secretary of War. House Ex. Doc. No. 1, 40th Cong., 2d Sess.* (1867–1868), pp. 65–68.

53. Junction City *Weekly Union*, July 13, 1867.

54. These illustrations and many others not listed will be found in *Harper's Magazine*, February, 1868 (15 illustrations, although in general not as interesting as those which appeared in the *Weekly*); *Harper's Weekly*, v. 11 (1867), May 11, p. 301 (three illustrations), May 25, pp. 328, 329 (six illustrations including two of Fort Dodge), June 8, p. 357 (four illustrations, two possibly are after photographs), June 29, p. 405 (two illustrations), July 6, pp. 424, 425 (nine illustrations of buffalo hunting), August 3, p. 484 (four illustrations), August 17, p. 513 (two illustrations) and p. 516 (three illustrations), September 7, p. 564 (four illustrations).

It should also be pointed out that illustrations by other artists than Davis were published concerning the Indian war of 1867 in *Harper's Weekly*. Chief among these were several illustrations by Philip D. Fisher. They will be found in the *Weekly*, v. 11 (1867), April 27, p. 268 (shows the Hancock expedition encamped at Fort Harker on April 2, 1867, before Davis reached it); July 27, p. 468 (two illustrations). Fisher also had four illustrations of scenes along the newly-constructed Union Pacific, Eastern division (through Kansas), in the issue for June 15, p. 373. Fisher was a civil engineer employed by the railroad and his name occurs frequently in Kansas newspapers of the late 1860's. He was apparently a Civil War veteran and a native of Ohio; *see* mention in Topeka *Leader*, April 25, 1867; Junction City *Weekly Union*, July 27 and August 3, 1867.

The illustrations of J. D. Howland at the Indian peace treaty at Medicine Lodge in the fall of 1867 should likewise be included in the pictorial record of Indian wars. They will be found in *Harper's Weekly*, vol. 11, pp. 629 and 724 (1867). Howland (1843–1914) was one of the earliest artists in the West, crossing the Plains to Colorado in 1857, although his artistic career did not begin until after the Civil War. A number of his very well executed buffalo paintings will be found in the Colorado Historical Society, Denver. Considerable biographic material on Howland's life will be found in the *Colorado Magazine*, vol. 8, pp. 60–63 (1931). He deserves more space than he is given in this book but his daughter, Mrs. Kate Charles of Denver, is at work on a full-length biography of Howland.

The illustrations of James E. Taylor of the Indian War of 1867 have already been mentioned in note 21, above.

Three illustrations after photographs and sketches of A. R. Calhoun and William A. Bell of the Indian war appeared in *Harper's Weekly*, July 27, 1867, p. 468. Calhoun and Bell were members of a surveying party of the Union Pacific. Calhoun was said to be an artist and correspondent for the Philadelphia *Press*; for Bell, *see* his book, *New Tracks in North America* (London, 1869). Mrs. Custer's reference to the Davis sketches at Fort Hays will be found in her book, *Tenting on the Plains* (New York, 1889), p. 610.

55. In the order listed above these will be found in *Harper's Weekly*, v. 11 (1867), August 10, p. 500, December 14, p. 792, December 21, p. 805; v. 12 (1868), March 28, p. 196, May 9, p. 292. Davis also had an extremely interesting plowing illustration (locality identified as Illinois, however) in the *Weekly* for September 23, 1871, pp. 900, 901. The illustration depicting the buffalo shooting from the trains was atrociously engraved, in fact, the engraving in general of all of Davis' illustrations was poor; as a result, this illustration (buffalo shooting) does not possess the interest that is in a similar scene I have attributed to Henry Worrall and which appeared in *Frank Leslie's Illustrated Newspaper*, June 3, 1871, p. 193. (See p. 123 of text.)

56. The first will be found in *Harper's Magazine*, v. 38 (1869), January, pp. 147–163, and the second, v. 39 (1869), June, pp. 22–34. The first contained 15 illustrations and the second 11.

57. The illustrations referred to above will be found in *Harper's Weekly*, v. 12 (1868), December 26, p. 825; v. 13 (1869), January 16, p. 41, and March 27, p. 204. In the *Weekly* for December 12, 1868, p. 788, is an illustration of a Philadelphia locality which is identified as the scene of a murder occurring on November 22, 1868. Davis made the illustration and made it after November 22 and before (several days to a week before) December 12. As the battle of the Washita occurred on November 27, 1868, I believe that the Philadelphia illustration rules out any possibility that Davis was on the Custer campaign. Still better evidence on this point is the lack of any positive statement that Davis was present. If he had been, the *Weekly* would have stated it. I take some time to labor this point as these illustra-

tions have been used in "histories" of the Custer campaign as actual scenes in the campaign.

58. *Harper's Magazine*, v. 35 (1867), July, p. 138. The illustration, "Pilgrims on the Plains," will be found in *Harper's Weekly*, v. 13 (1869), June 12, p. 377.

59. *Harper's Weekly*, v. 16 (1872), February 24, p. 164. There were a few Davis Western illustrations even after this date. For example, "Young Bucks on the War-Path," and "Young Bucks Returning With Spoils" in *ibid.*, v. 17 (1873), May 17, p. 413. Both of these were redrawn by Sol Eytinge, Jr.

60. Manuscript material in the Parmelee collection included two unfinished and unrevised pieces by Davis. These have been published in *The Westerners Brand Book 1945–1946* (Chicago, 1947), as "Henry M. Stanley's Indian Campaign in 1867," pp. 101–114, and "With Generals in Their Camp Homes: General George A. Custer," pp. 115–130. As is evident from their content both were written late in life; in the first he referred to the disappearance of Editor S. S. Conant (of *Harper's Weekly*). Conant disappeared in 1885 (New York *Tribune*, January 29, 1885, p. 1; February 9, 1885, p. 1) and therefore the article was written probably in the late 1880's. In the second article he specifically dated it in the text as "1890." It is well to remember therefore that both of these articles were recollections colored by the lapse of time and by the happenings of the years intervening between their writing and the occurrence of the events described by Davis.

61. *Harper's Weekly*, v. 11 (1867), September 7, p. 564.

62. James Walker's connection with Davis was called to my attention by Mrs. Pennypacker, a daughter of Mr. Davis, now deceased. Information on Walker (1819–1889) has been secured from obituaries following Walker's death on August 29, 1889, and which appeared in the Watsonville (Cal.) *Pajaronian*, September 5, 1889, and the San Francisco *Call*, August 30 and September 4, 1889. I am indebted to the Watsonville Public Library and the California State Library for these accounts. A brief sketch of Walker will also be found in *Appleton's Annual Encyclopedia*, 1889, p. 651.

63. Davis died in Asbury Park, N. J., on November 10, 1894. The biographical notes given in the concluding paragraphs come from obituaries in the New York *Tribune*, November 11, 1894, p. 7, and a clipping from the Asbury Park (N.J.) *Shore Press*, November 10, 1894, furnished by Mr. Davis' daughter. Some biographical data is also given in *The White House Porcelain Service* (New York, 1879). (Davis designed this service in the spring and summer of 1879). Letters from Davis also appeared in *Harper's Weekly* during the war and extend somewhat our knowledge of his life (*see* especially the *Weekly*, June 22, 1861, p. 397; June 20, 1863, p. 395; September 26, 1863, pp. 621, 622.) He is also mentioned early in his career in the New York *Tribune*, July 21, 1861, p. 4.

The Civil War panorama Davis described in an article in the magazine *St. Nicholas*, New York, v. 15 (1886), December, pp. 99–112.

CHAPTER V

Alfred E. Mathews

1. In 1905, Charles H. Mathews, a brother of Alfred E. Mathews, prepared a manuscript biography, including letters, etc., of the latter for the Denver Public Library. In addition, Miss Ina T. Aulls of the Denver Public Library secured some biographical data, letters, etc., from a niece of Mathews, Mrs. Priscilla Gibbs of Denver. All biographical data concerning A. E. Mathews not otherwise credited in the following notes are to be attributed to this collection now in the possession of the Denver Public Library. For example, in this material is included a transcript from a family record giving the exact hour, place and date of birth of each of the seven Mathews children.

Miss Isadora E. Mathews of New Philadelphia, Ohio, a grandniece of Alfred E. Mathews, has also kindly furnished me biographical data concerning the Mathews family.

William T. Mathews, a brother of Alfred, also achieved considerable reputation, at least locally, as an artist and became known as "the painter of presidents," for he portrayed Lincoln, Hayes, Garfield, Harrison and McKinley. William T. Mathews was born in Bristol, England, May 7, 1821, and died in Washington, D. C., January 11, 1905. *Harper's Weekly*, v. 8 (December 24, 1864), p. 829, has two illustrations credited to W. D. Matthews, who may have been this W. T. Mathews.

2. Capt. Charles S. Cotter, Battery A, 1st Ohio artillery.—Francis B. Heitman, *Historical Register and Dictionary of the United States Army, . . .* (Washington, 1903), v. 2, p. 166.

Mathews published an account of his arduous and difficult "escape" from the South, a journey fraught with considerable danger in the days when all sections of the country were aflame. In a pamphlet of 28 pages of text, *Interesting Narrative; Being a Journal of the Flight of Alfred E. Mathews of Stark County, Ohio* (July, 1861), Mathews describes his circuitous route from northern Alabama to Chicago. He went from Alabama to Texas as he thought Texas would not secede, but when it did, he began his northern trek through Louisiana, Arkansas and Missouri. In the opening sentence, Mathews states that he had been residing "for more than one year previous to the close of the year 1860" in northern Alabama.

3. Lithography was by Middleton, Strobridge and Company; by Ehrgott, Forbriger & Company, and by Donaldson and Elmes, all of Cincinnati, Ohio. The lithographs are of various sizes ranging from 11 by 7 inches to 24 by 16 inches.

The combined list of titles of the Mathews lithographs held by the Library of Congress and by the Denver Public Library include:

Lithographs by Middleton, Strobridge and Company, Sketched by A. E. Mathews—

"Battle of Jackson, Mississippi."

"The Battle of Logan's Cross Roads, Fought on the 19th of January, 1862."

"Battle of Perryville, the Extreme Left, Starkweather's Brigade."

"Battle of Shiloh, the Gunboats, Tylor and Lexington Supporting the National Troops."

"The Battle of Stone River or Murfreesboro."

"The Battle of Stone River or Murfreesboro [another view]."

"The Battle of Stone River or Murfreesboro [another view]."

"The Battle of Stone River or Murfreesboro, Charge of Gen. Negley's Division Across Stone River."

"The Battle of Wild Cat, Oct. 21, 1861."

"The Battle of Wild Cat, Oct. 21, 1861 [smaller view with text]," dated 1861.

"Camp Ready, Hamburg, Tennessee, Composed of Companies C, I and E of the 80th Reg't O. V. I."

"Charge of the First Brigade, Commanded by Col. M. B. Walker, on the Friday Evening of the Battle of Stone River."

"Encampment of Gen. Pope's Army Before Corinth, May, 1862. View From the Camp of the 43rd Ohio Reg't."

"Farmington, Mississippi, May, 1862."

"Female Seminary, Nashville, Tenn. Barracks of the 51st Reg't O. V."

"The First Union Dress Parade in Nashville."

"Fort Anderson, Paducah, Kentucky, and the Camp of the 6th Illinois Cavalry, April, 1862."

"Fort Mitchell."

"On the March From Hamburg to Camp Before Corinth."

"The 103rd Reg't O. V. in Line of Battle at Fort Mitchell."

"Pittsburg Landing."

"The 121st Reg't Ohio Volunteers, Crossing the Pontoon Bridge at Cincinnati, Friday, Sept. 19, 1862," dated 1862.

"Rev. L. F. Drake, Chaplain 31st Ohio Volunteers, Preaching at Camp Dick Robinson, Ky., November 10, 1861."

"Siege of Vicksburg."

"Siege of Vicksburg [another view]."

"Siege of Vicksburg [another view]."

"The Siege of Vicksburg, the Fight in the Crater of Fort Hill After the Explosion, June 25, 1863."

"The 10th Reg't Iowa Volunteers on the March from Hamburg to Camp Before Corinth, Apr. 28th, 1862."

"The 31st Reg't Ohio Vol., (Col. M. B. Walker) Building Breastworks and Embrasures Before Corinth, Miss., May, 1862."

"The 21st Reg't Wisconsin Vol., Crossing the Pontoon Bridge, at Cincinnati, Sept. 13, 1862."

"Union Forces Crossing Fishing Creek."

Lithographs by Ehrgott, Forbriger & Company, sketched by A. E. Mathews—

"The Battle of Shiloh."

"Hospital Varian, Hamburg, Tenn."

"Shiloh Church."

"Shiloh Spring."

Lithographs by Donaldson and Elmes—

"Lookout Mountain, Near Chattanooga, Tenn." (This shows Field Hospital, Encampment Pioneer Brigade, Nashville & Chattanooga Rail Road. Dated 1864.)

"The Army of the Cumberland in Front of Chattanooga. Maj. Gen. W. S. Rosecrans, Commanding. Representing the Position of Gen. Brannan's Division, Gen. Negley's Division and Gen. Rousseau's Division, of Maj. Gen. Geo. H. Thomas' Army Corps."

"Chattanooga And the Battle Ground. Scene of the Brilliant Operations of Major General Geo. H. Thomas' Army of Major General U. S. Grant's Military Command. (The Eagle's Nest.)"

Mathews also had two illustrations of this period published in *Harper's Weekly*, v. 5 (November 23, 1861), p. 743, illustrating "The War in Kentucky."

4. I am indebted to James C. Olson, superintendent of the Nebraska State Historical Society, for photographic prints of each of the above lithographs and also for additional information concerning them. No. 3 above was reproduced in *Nebraska History*, Lincoln, for September, 1948, *facing* p. 212. The lithography of the first print above is not credited, although the original lithograph bears the initials "J. G."; the remaining three were lithographed by Donaldson and Elmes, Cincinnati.

It is a curious fact that the imprint of Mathews' name on these Nebraska views shows the spelling "Matthews." In all his subsequent work, but one *t* appears. Further confirmation of the date of the Nebraska City sketches is furnished by the item from *The Rocky Mountain News* for November 13, 1865, reprinted in the text.

The print size of the four Nebraska City lithographs is 16 by 10 inches; they were apparently printed in two colors, brown and black.

5. *Nebraska History Magazine*, Lincoln, v. 13 (1932), pp. 137–159.

6. A number of the leading libraries of the country have been queried in the hope that some original Mathews sketches could be located, but without success. Miss Isadora E. Mathews of New Philadelphia, Ohio, grandniece of A. E. Mathews, reports that none of the original Mathews sketches are in the possession of the family.

7. It is interesting to compare Mathews' views of Main street, Nebraska City, with the reproduction of a photograph of Main street which must have been made at about the same time as the sketches. It will be found in J. Sterling Morton's *Illustrated History of Nebraska* (Lincoln, 1905), v. 1, *facing* p. 107. The photograph, too, shows that Main street was a busy place in freighting days.

Of importance in the first of the Mathews lithographs listed above (the river view) is the fact that three large river boats can be seen: *Post Boy, Sioux* and one whose name is not distinct. *Post Boy* was a real river craft, for it is included in Phil

E. Chappell's list of "Missouri River Steamboats," *Kansas Historical Collections*, Topeka, v. 9 (1905–1906), p. 309. Chappell does not list a *Sioux* although he does list a *Sioux City* (No. 1) and *Sioux City* (No. 2), p. 310, and still another *Sioux City* (No. 2) on p. 316. There evidently is some confusion in Chappell's list and Mathews' *Sioux* may be the key to the solution of this confusion.

8. *The Daily Rocky Mountain News*, November 13, 1865.

9. *Daily Miners' Register*, Central City, Colo., December 1, 2, 1865.

10. *Rocky Mountain News*, March 5, 1866. These well-known views of Denver were originally sketched, as can be inferred from the above comment, sometime between the date of Mathews' arrival in Denver in November, 1865, and early February, 1866, for mention of "the lamented Dr. McLain" apparently limits the later date. Dr. L. B. McLain died February 2, 1866.—*Ibid.*, February 2, 1866.

11. *Daily Rocky Mountain News*, March 19, 1866.

12. *Rocky Mountain News*, October 19, 1866.

13. The titles include (titles bracketed together indicate that lithographs appear together on a single page):

1. "Snowy Range of the Rocky Mountains; From Bald Mountain, Near Nevada" (full page, frontispiece).
2. "Denver, City of the Plains" (full page).
3. "F Street, Denver" (full page).
4. "Blake Street, Denver, Colorado" (full page).
5. "Laramie Street, Denver" (full page).
6. "Golden City" (full page).
7. "Black Hawk, Looking Up Gregory and Chase's Gulches" (full page).
8. "Central City; From the Side of Mammoth Hill Looking Up Gregory and Eureka Gulches" (full page).
9. "Central City; Looking Up Spring Gulch" (full page).
10. "Nevada, Colorado" (full page).
11. "Russell Gulch, Gilpin County" (half page).
12. "The Chief, Squaw and Papoose, as Seen from Idaho" (half page).
13. "Idaho, Clear Creek County" (half page).
14. "Fall River, Clear Creek County" (half page).

15. "The Old Mountaineer, Fall River" (half page).
16. "Profile Rock, Fall River" (half page).
17. "Empire City, Clear Creek County. From Near the Foot of Silver Mountain, Looking Towards Elizabethtown" (half page).
18. "Elizabethtown, Clear Creek County. From the Griffith Tunnel" (half page).
19. "South Park" (full page).
20. "Mount Lincoln. The Town Montgomery Is Seen at Its Base" (full page).
21. "Twin Lakes" (full page).
22. "Pike's Peak and Colorado City" (full page).
23. "Garden of the Gods" (full page).
24. "Monuments, Near Monument Creek" (full page).
25. "Gulch Mining.—Colorado Gulch" (fourth page).
26. "Spanish Arastra—On Clear Creek" (fourth page).
27. "The Stamp Process.—Mr. Sensenderfer's Mill" (fourth page).
28. "Shaft or Lode Mining.—Interior of No. 1, On the Gregory, the Black Hawk Co.'s Mine" (fourth page).
29. "The Ore Breaking Room.—Blake's Ore Breaker" (fourth page).
30. "The Furnace" (fourth page).
31. "The Ore Pit, or Drying Room" (fourth page).
32. "Amalgamating Room" (fourth page).

The four lithographs last mentioned appear above the general page title, "The Keith Process. Hope Gold Company's Works."

33. "Ore Dressing Room—The Buddle and Jiggs" (fourth page).
34. "Reverberatory Furnace" (fourth page).
35. "Cupel Furnace" (fourth page).
36. "Scotch Hearths" (fourth page).

The four lithographs last mentioned appear above the general page title, "The Smelting Process. James E. Lyon & Co.'s Smelting Works."

Pencil Sketches of Colorado will be found in various bibliographic lists under place and date: sometimes as "(Denver, 1866)" and sometimes as "New York, 1866." These differences arise from the fact that following the title page is the entry, "Entered according to Act of Congress, in the year 1866, by A. E. Mathews, In the Clerk's Office of the District Court of the United States for the Southern District of New York," whereas at the conclusion of the single page "Preface" there is the entry, "Denver, May, 1866."

14. The original price is given in *Rocky Mountain News*, October 19, 1866. The current retail price was kindly furnished by Norman L. Dodge of Goodspeed's Book Shop, Boston. Edward Eberstadt's *Catalogue No. 106* (1937), p. 23, lists a copy of *Pencil Sketches of Colorado* at $275.

15. *Daily Rocky Mountain News*, March 19, 1866, reports that Mathews left "today" for the Pike's Peak region; the same newspaper, May 7, 1866, states that he returned "Saturday" from the south. Probably the views of Pike's Peak and Colorado City and of the Garden of the Gods included in *Pencil Sketches of Colorado* were obtained on this trip.

16. *Daily Rocky Mountain News*, May 7, August 10, 1866.

17. *The Rocky Mountain News*, October 30, 1866, advertises "Mathews Colorado views bound and unbound for sale at the Denver Art Emporium." The Denver Public Library possesses some of the unbound lithographs; one, in color, is of Long's Peak and measures about 16½ by 27 centimeters. It was lithographed by Major & Knapp Eng. Mfg. and Lith. Co.

The Daily Miners' Register, Central City, July 20, 1867, reports that Mathews called on the editor of the *Register* "yesterday" and then went on to say that the earlier Colorado lithographs (presumably those in the *Pencil Sketches of Colorado*) "were sent on to a lithographing house in New York, which so botched the work as to leave little trace of the original design. The work was coarse, badly colored and altogether 'dutchy.' Notwithstanding these serious defects, they were sold. Subsequently Mr. Mathews made pictures of the most prominent points and went on himself to supervise their execution. We now have as pretty a series as could be wished. There are two of Long's and Pike's Peak [possibly one of these was the one referred to above in this note], one of each colored in 'chromo' style, the others plain, but very skillfully engraved. The third is an elegant view of a point of rock at Fall River, known as the 'Old Mountaineer,' which is the most picturesque and interesting of all. Specimens may be seen at the bookstores and various other places in town. . . ." "The Old Mountaineer," located in Clear

Creek county "near the mouth of Fall River," and mentioned above, was a discovery of Mathews, according to The *Rocky Mountain News*, December 24, 1866. Doubtless Mathews' early experience with the Eastern "great Stone Face" may have sharpened his eye for such natural curiosities. Mention of the new style Mathews "chromos" was also made by the weekly *News*, May 29, July 5, 1867.

18. *See* note 17; in addition, *The Rocky Mountain News*, December 24, 1866, stated that Mathews was leaving "in a few days" for Europe to supervise the lithography of sketches. There is no other evidence that he made the European trip and the fact that I have found no lithographs of European origin would also tend to support the New York trip rather than the European one.

19. *Weekly Rocky Mountain News*, May 29, 1867.

20. *Daily Miners' Register*, Central City, July 20, 1867, states that Mathews was sketching in Colorado and would soon start for the Great Salt Lake valley. *The Daily Rocky Mountain News*, July 20, 1867, states that Mathews had just returned from a trip to the Snake river country (possibly in Wyoming). *The Montana Post*, Virginia City, October 19, 1867, reports his presence in Virginia City after a tour of several weeks through Montana. *The Daily Rocky Mountain News*, November 21, 1867, reports his return to Denver from Montana by way of Salt Lake City.

21. *The Montana Post*, Virginia City, October 19, 1867. I am indebted to Mrs. Anne McDonnell of the Montana Historical Society for this item and others listed in notes 28 and 31 (relating to Tofft).

22. *Daily Rocky Mountain News*, November 21, 1867; *The Montana Post*, October 19, 1867.

23. In fact, the Central City *Daily Miners' Register*, July 25, 1868, states: "The sketches [for the panorama] were all made by Mr. Mathews, but the painting is by artists in New York."

24. *The Weekly Republican*, Omaha, Neb., June 24, 1868. According to the *Republican*, the panorama was to be exhibited June 27 and 29, 1868, with Mathews giving an explanatory lecture. The notice states that the panorama was endorsed by Gen. G. M. Dodge, "who says they [the scenes depicted] are very accurate."

25. Notices of its appearance are given in *The Rocky Mountain News*, July 10, 14,

1868; *Daily Miners' Register*, Central City, July 21, 22, 24–26, 1868; *The Montana Post*, Helena, November 13, 1868. It had been exhibited "along the Missouri river" prior to its arrival in Colorado according to The *Daily Miners' Register*, July 21, 1868; possibly this statement means that other exhibitions than the one in Omaha had been made.

26. *Rocky Mountain News*, July 14, 1868.

27. *Daily Miners' Register*, July 22, 1868.

28. *The Montana Post*, Helena, November 13, 1868.

29. Many of the reports cited in notes 25 and 30 state this fact.

30. *Rocky Mountain News*, July 15, October 20, 1869; *Colorado Miner*, Georgetown, August 12, 13, 18, 1869; *Colorado Transcript*, Golden, November 10, 1869. *The Rocky Mountain News*, August 24, 1869, states that Mathews was starting on a tour with his panorama which would include exhibitions at Breckenridge, Fairplay, Canon City, Pueblo and Colorado City.

The sale of the panorama to Dr. J. E. Wharton was announced in the *News*, November 20, 1869. Wharton in turn exhibited it, for there is notice that he was in Junction City, Kan., with it in January, 1870; *see* Junction City *Weekly Union*, January 15, 1870. Apparently Wharton re-sold the panorama by the start of 1871 to a Mr. Smart of Denver, who exhibited it with additions by Stobie, another Western artist; *see Daily Rocky Mountain News*, January 4, 1871.

Charles S. Stobie, "Mountain Charlie," possibly should have been included in the list of artists who crossed the plains to the Rocky Mountains at the close of the Civil War. In J. W. Leonard's *Book of Chicagoans* (Chicago, 1905), p. 551, the statement is made that Stobie "crossed the Plains to Denver in 1865." Stobie's earliest Western experiences seem to have been that of a plainsman rather than as an artist. Many years later he described his experiences on his first trip to Colorado but made no mention of artistic labors; *see* his reminiscences, "Crossing the Plains To Colorado in 1865," *The Colorado Magazine*, Denver, v. 10 (1933), pp. 201–212. He subsequently achieved considerable reputation locally as an artist of the Western scene. Born in 1845, he died in 1931; *see* obituary in the Chicago *Daily Tribune*, August 19, 1931, p. 8.

31. Peter Tofft (also spelled Toft, Toffts,

as well as Tufts) was born in 1825 and died in 1901 according to C. F. Bricka, *Dansk Biografisk Lexikon* . . . , v. 17 (1903?), p. 428. Tofft was a native of Denmark but traveled extensively. He became well known in the 1860's and 1870's in the Far West, especially the Northwest. He is probably best known for the illustrations accompanying the article by Col. Cornelius O'Keefe (Thomas Francis Meagher), "Rides Through Montana," which appeared in *Harper's Magazine*, v. 35 (1867), pp. 568–585. The incidents depicted by Tofft were made on a journey accompanying O'Keefe in 1866. O'Keefe (Meagher) was drowned at Fort Benton on July 1, 1867.

32. *Rocky Mountain News*, July 10, 1868.

33. *Daily Miners' Register*, Central City, July 21, 1868.

34. The list of plates found in *Pencil Sketches of Montana* is:

Plate
XXIV "Great Falls of the Missouri frontis., large folding."
Plate I "Beaver-Head Rock."
II "In the Stinking Water Valley."
III "Virginia City [large folding]."
IV "Union City."
V "Bald Mountain."
VI "In the Madison Valley."
VII "Exit of the Yellowstone From the Mountains."
VIII "In the Yellowstone Valley."
IX "Spring Canyon."
X "In the Gallatin Valley."
XI "The Three Forks. Head Waters of the Missouri [large folding]."
XII "Head Waters of the Missouri."
XIII "Helena [large folding]."
XIV "The Hangmans Tree."
XV "Unionville."
XVI "New York Gulch."
XVII "The Gate of the Mountains."
XVIII "Gate of the Mountains."
XIX "Bear Tooth Mountain."
XX "Prickley Pear Canyon."
XXI "Prickley Pear Canyon." "Bird-Tail Mountain [plate number not printed]."
XXIII "Falls of the Missouri."
XXV "Fort Benton."
XXVI "The Palisades."
XXVII "Citadel Rock."
XXVIII "The Church, Castle, and Fortress."
XXIX "Fort Pegan."
XXX "Fort Cook."
XXXI "Deer Lodge Valley."
The plate numbers and titles are those

appearing in the Denver Public Library copy.

Edward Eberstadt's *Catalogue No. 106* (1937) reports the record price and lists a copy at $225. For the current price I am again indebted to Norman L. Dodge of Goodspeed's Book Shop.

35. *Putnam's Magazine*, N. S., v. 4 (August, 1869), pp. 257, 258. The *Rocky Mountain News*, June 29, 1869, in noting *Gems of Rocky Mountain Scenery*, states that it was published by Mathews from 1227 Broadway, New York City, which must have been Mathews' studio address for the winter of 1868–1869.

36. *Rocky Mountain News*, July 26, 1869.

37. The current price was furnished by Norman L. Dodge, Goodspeed's Book Shop. The Eberstadt *Catalogue No. 106* of 1937, lists a copy at $85. The contemporary prices ($15 and $10) are given in *Putnam's Magazine*, N. S., v. 4 (September, 1869), p. 391, and *Rocky Mountain News*, July 5, 1869.

38. The "Introductory" page of *Gems of Rocky Mountain Scenery*. The plates in the order of their appearance in the book were: Colorado–"The Eastern Slope, Near Denver," "Bear Canyon," "The Sierra Madre Range," "Clear Creek Canyon," "The Chief, Squaw and Papoose" mountains, "Chicago Lakes," "The Old Mountaineer" cliff, "Gray's Peak," "Buffalo Mountain," "Turkey Creek Canyon," "Exit of the South Platte From the Mountains," "Natural Monuments"; Idaho–"A Mirage on the Plains," "The Three Tetons"; Montana–"Exit of the Yellowstone From the Mountains," "Citadel Rock"; Utah–"Church Buttes [shows Wells, Fargo & Co. coach]," "Echo Canyon," "Weber Canyon [looking down]," "Weber Canyon [looking up]."

39. *Rocky Mountain News*, October 14, December 23, 1869; May 23, 1870.

40. *Ibid.*, May 23, 1870. Eberstadt's *Catalogue No. 106* (1937), p. 23, lists a copy of this work at $275 with the comment, "We have never seen nor heard of another copy of this work, nor are we able to trace the existence of another in the records." Goodspeed's Book Shop lists a current retail price of $250 with a question mark. The only copy I have seen is in the Denver Public Library. The book bears the imprint, "New York: Published by authority of the Citizens of Fremont County, Colorado, 1870."

41. *Rocky Mountain News*, August 16,

1870; March 14, December 9, 1871. The biographical material prepared by Charles H. Mathews for A. E. Mathews and described in note 1, above, includes copies of two letters, one of which was addressed to A. E. Mathews at Bristol, England, and dated July 18, 1871. It was from R. K. Scott, governor of South Carolina, and commended Mathews' zeal in furthering the colonization project. The second letter dated "Cummenglen, Massachusetts, Aug. 4, 1871," was from William Cullen Bryant and addressed to Wm. T. Mathews. It also commends A. E. Mathews' zeal in "making arrangements for settling some part of the territory of Colorado with emigrants from the Old World."

42. One William Gibbs recalled Mathews' trip to England in 1871 and some of the subsequent history of the colonization scheme and its lack of success in "Reminiscences of the Early Days." According to the State Historical Society of Colorado this account was published in a Canon City paper dated February 17, 1927.

43. *Rocky Mountain News*, May 7, 1873.

44. In a letter written to one of his brothers on May 28, 1874, Mathews makes the comment: "I have been getting up pictures in charcoal, and having them photographed, but they do not print them well; but I think it can be done, and a few pictures of some points in California will sell well there." Probably these views were never made, for Mathews died a few months after the above letter was written.

I am indebted to Carey S. Bliss of the Huntington Library, San Marino, Cal., for calling my attention to the two Mathews lithographs listed in the Peters book.

45. *Rocky Mountain News*, October 15, 1872; September 7, 1873; January 24, 25, 1874. The last item gives an extensive description of the map.

46. *Ibid.*, March 5, 1874.

47. Details of his death are reported in a letter of W. M. Large, an associate of Mathews, to the family. The letter is dated "Longmont, Col. Nov. 22d, 1874" and was addressed to Wm. T. Mathews, a brother of A. E. Mathews. The *Boulder County News*, Boulder, November 6, 1874, reports the death with a record of the date and also states that Mathews' ranch was 22 miles northwest of Longmont on Big Thompson creek. According to Large, Mathews was buried on his ranch, and Charles H. Mathews reports that his grave was marked by the "authorities at Wash-

ington" about 20 years after his death, with a marble slab "such as is placed over the grave of all soldiers."

48. *Rocky Mountain News*, November 4, 1874.

CHAPTER VI

The Joining of the Rails

1. The nation-wide interest in the event is recorded in the extended and frequent accounts in the newspapers of the day. The New York *Tribune*, for example, devoted to the event over three columns on page one in the issue of May 8, 1869; four columns on page one in the issue of May 10, including a poem for the occasion by George W. Bungay, "Rivet the Last Pacific Rail"; two columns on page one of the issue of May 11, which described the telegraphic report of events at Promontory Point and gave news of the celebration in other cities. In Omaha, practically the entire first page of the Omaha *Weekly Republican*, May 19, 1869, was devoted to accounts of the local celebration and those occurring elsewhere. The quotations in the text (concerning Omaha) are from this source. The plans and celebration in San Francisco are reported in the *Daily Alta California*, San Francisco, May 6, p. 1, May 8, p. 1, May 9, p. 1, May 12, p. 1, 1869. The *Alta* in the issue of May 9 published a poem by W. H. Rhodes, written for the occasion. The *Alta* in the issue of May 20, 1869, p. 1, reprinted an account from the Chicago *Tribune* of May 11, describing the celebration in Chicago. The accounts in the Sacramento *Daily Union* also published a poem for the occasion by L. E. Crane (May 10, 1869, p. 8). Since we have taken the trouble to mention poems resulting from this historic occasion we should not, of course, leave out the best known of all, "What the Engines Said," by Bret Harte. This poem appeared originally in *The Overland Monthly*, San Francisco, v. 2 (1869), June, p. 577. Still another poem dealing with the completion of the Pacific railroad, and probably the longest, is "America or the Hope of Mankind," W. E. F. Krause, San Francisco, 1869, 20 pp.

2. New York *Tribune*, May 10, 1869, p. 4.

"The crowning triumph" was viewed by many representatives of the press, but curiously enough, the two leading pictorial papers of the day, *Harper's Weekly* and

Leslie's, had no "artists on the spot" so that the pictorial records of the event upon which we are dependent today are the well-known photographs of C. R. Savage and the lesser-known ones of A. J. Russell.

Not until the issue of May 29, 1869, did *Harper's Weekly* take recognition of the completion of the railroad. A double-page spread of wholly imaginative and decorative pictures (pp. 344, 345) pay their respects to the event (with descriptive note on p. 341).

Leslie's was still later in recording the event. In the issue of June 5, 1869, there are reproduced several of the A. J. Russell photographs of the event. For information on the Savage and Russell photographs, *see* Robert Taft, *Photography and the American Scene* (New York, 1938), pp. 272, 280, 293. The California *Alta,* May 12, 1869, p. 1, stated that A. A. Hart of Sacramento also photographed the ceremony of May 10, 1869.

Doubtless the best-known picture of the ceremony of the joining of the rails is Thomas Hill's "The Last Spike" (currently called "The Driving of the Last Spike"). This huge oil painting (eight feet, two inches by eleven feet, six inches) was begun by Hill about 1877 and is based on photographs of the event and of the celebrities who participated. One account has it that the painting was commissioned by Leland Stanford who never paid for or acquired it. It was finally bought in the late 1890's by Paul Tietzen, who presented it to the state of California in 1937. It now hangs at the end of the north corridor of the first floor in the California state Capitol, Sacramento. Hill first exhibited the painting in San Francisco on January 28, 1881, according to an account in the San Francisco *Alta California,* January 29, 1881, p. 1. This account states that the painting was "the consummation of nearly four years of arduous labor" and continued:

"In painting his picture, Mr. Hill selected the moment of the most serious feeling, when the officiating clergyman, Rev. Dr. Todd, of Pittsfield, Massachusetts, has just concluded his invocation to the Almighty and the electricians were about connecting the golden spike, presented by Mr. David Hewes, with the Transcontinental telegraph line, that was to ring out the glad tidings of 'the last spike driven' on the bell of the Capitol at Washington, and the cannon that woke the echoes of the Golden Gate. The view is eastward, along the track of the Union Pacific Railroad, toward the horizon, bounded by the snowy summit of the Wahsatch Mountains. The commanding figure of Governor Stanford, leaning on the silver hammer, arrests the eye, which, after a moment's pause, glances beyond to the locomotive, half hidden by figures, and then on to the plains dotted with sagebrush and suffused with the genial rays of the sun, upon an almost cloudless afternoon. There are some four hundred figures on the canvas, seventy of which are portraits in rich diversified and harmonious colors, with flowing grace of outline and freedom of individual treatment. The characteristics of the men, many of whose names are familiar on both hemispheres, are as well shown in pose and outline as in feature, presenting a rare combination of strong faces and manly forms. There are also introduced some well-known characters of the plains, and several incidents contrasting the old life and the incoming civilization. To the left is presented an old-fashioned stagecoach, while beyond is a wagon train that had left the Missouri months before; and a race is in progress between mustangs, to whose drivers gambling was paramount to matters of national concern.

"Other features are a strap-game, poker-playing on a barrel-head, a couple of saloons improvised for the occasion, a few Indians in their native attire, a few itinerant vendors, and a company of soldiers that chanced to be present, all of which give variety of detail and relieve the more formal groupings. At the feet of Governor Stanford, adjusting the wire leading off through the crowd to the telegraph pole on the right, is F. L. Vandenburg, the chief electrician of the occasion. To the left is J. H. Strowbridge, General Superintendent of the work of construction. The leading lights of the Central Pacific Railroad—C. P. Huntington, Mark Hopkins, E. B. Crocker, Charles Crocker, and T. D. Judah—are represented in characteristic attitudes, with features accurately portrayed. Near Governor Stanford are the President and Directors of the Union Pacific—Oakes Ames, Sidney Dillon, Dr. Durant and John Duff. The wives of the officers commanding the troops in the vicinity, who were present, add to the canvas a picturesque quality. The Wahsatch Mountains, five or six miles distant, trend away to the north, diminishing in

height until they become a low range of blue hills bounding the grayish-green expanse of plains, while the foreground is bathed with warm light, lending to the pile of ties, the kegs of spikes, the grading implements, and even the fresh earth, a mellow radiance that invests them with a portion of the interest attached to the scene. Although Mr. Hill dealt with four hundred figures in almost perfect rest, and the landscape in which they stand, except for a lovely quality in the atmosphere and a certain enhancement of distance, is without extraordinary features, the thankless material yielded to the skillful hand of the artist, and the picture is complete."

I am indebted to Miss Beora Snow, information clerk at the California State Capitol and to Miss Caroline Wenzel of the California State Library, Sacramento, for the above information. Hill's famous painting was reproduced in color in *Fortune*, February, 1940, and in *Life*, July 4, 1949.

Thomas Hill (1829–1908) is one of the best-known of California painters of mountain scenery. For a biographical sketch *see Dictionary of American Biography*, v. 9, pp. 46, 47. Eugen Neuhaus, *History and Ideals of American Art* (Stanford Univ., 1931), pp. 86, 87, has an undocumented account of his work. Thad Welch, another California painter, characterized Hill as "an amiable Englishman, who said he painted the Yosemite, not as it is, but as it ought to be."—*Overland*, v. 82 (1924), April, p. 181.

3. The articles (eight in number) appeared under the general heading "Through to the Pacific" and will be found in the New York *Tribune* of 1869 as follows: May 29, pp. 1, 2 (this first one is dated "Chicago, May 21"); June 5, p. 1; June 22, p. 2; June 25, pp. 1, 2; June 26, p. 14; July 12, pp. 1, 2; July 19, p. 1; July 28, pp. 1, 2. The series was concluded by a column headed "Back From the Pacific" (describing Richardson's experiences as far east as Omaha and Atchison) in the issue of August 2, 1869, pp. 1, 2. All nine articles are signed with Richardson's initials "A. D. R." This series was reprinted in a greatly condensed version in a compilation of Richardson's writings prepared by his wife, Mrs. A. D. Richardson, *Garnered Sheaves* . . . (Hartford, 1871), pp. 258–322. Other contemporary accounts of travel over the trans-continental railroad in the first few months of use will be

found in W. L. Humason's *From the Atlantic Surf to the Golden Gate* (Hartford, 1869), a very poor and inadequate description as far as actual travel experiences go; a more satisfactory account will be found in W. F. Rae's *Westward By Rail* (New York, 1871), 2d ed. Rae made the trip across the continent in September, 1869. Still another account of overland travel by rail in 1869, although not as satisfactory as either Richardson or Rae, is given by Harvey Rice, "A Trip to California in 1869," *Magazine of Western History*, v. 7, pp. 675–679, 1887–1888; v. 8, pp. 1–7, 1888.

4. Richardson gives a nine-day time table from New York to San Francisco in the New York *Tribune*, June 26, 1869, p. 14. There is an item in the *Tribune*, July 26, 1869, p. 3, reporting that the first through car from Sacramento arrived in New York City on July 24. It had left Sacramento on July 17 and made the trip in "a trifle over six days."

5. *Ibid.*, June 5, 1869, p. 1.

6. *Ibid.*, June 26, 1869, p. 14.

7. Omaha *Weekly Republican*, October 27, 1869, p. 3, reprinted from the Elko (Nev.) *Independent* of October 18.

8. Richardson, New York *Tribune*, July 12, 1869, pp. 1, 2.

9. *Ibid.*, June 25, 1869, pp. 1, 2.

10. Samuel Bowles, *The Atlantic Monthly*, Boston, v. 23 (1869), April, p. 496. Bowles published a series of three articles in the *Atlantic* under the general title "The Pacific Railroad-Open" (all in v. 23, pp. 493–502, pp. 617–625, pp. 753–762, 1869) which were later published in book form (with slight revisions) under the same title *The Pacific Railroad-Open*, Boston, 1869, 122 pp. Essentially this publication is a travelers' guide and not an account of personal experience. Bowles (1826–1878) was a frequent visitor and writer on the trans-Mississippi West; see *Dictionary of American Biography*, v. 2, pp. 514–518.

11. New York *Tribune*, June 22, 1869, p. 2.

12. Richardson reported (*ibid.*) that "within thirty days" many artists and writers were going west. Already he had met Ed. F. Waters of the Boston *Advertisers*, Gov. Bross of the Chicago *Tribune*, J. W. Simonton of the Associated Press, and Wm. Swinton of the New York *Times*, but he did not mention by name any of the artists. I have found no other illustrator until Becker's work is reported,

although the photographers mentioned in note 2 should not be overlooked.

13. The biographical data on Becker given above comes from reminiscences of Becker published in *Leslie's Weekly*, v. 101 (1905), December 14, p. 570, and from an obituary published after his death on January 27, 1910, in the New York *Tribune*, January 29, 1910, p. 7. For a biographical sketch of Frank Leslie see the notes of Chapter X.

14. *Alta California*, October 22, 1869, p. 1.

15. The arrival of the first Pullman special from the East is reported in *ibid.*, October 23, 1869, p. 1, in an article which included a resolution signed by a number of the passengers. Included in the list of names is that of "Joseph Becker, New York City." The article stated that the train left Omaha "at a quarter past nine o'clock in the morning on Tuesday last." Tuesday of that week was October 19. A group of travelers on a special train from New York City which left New York October 16 was supposed to have made the trip west from Omaha on the same special train; owing to storms they failed to make connections (the above citation and the Omaha *Weekly Republican*, October 20, 1869, p. 3). This fact would establish that Becker left New York City prior to October 16.

In the Becker reminiscences of 1905 (*loc. cit.*), he stated that the Western trip was made in 1872; an obvious slip of memory for not only did the name of Becker appear in the *Alta California* of 1869 (cited above) but there are no Western illustrations of Becker in *Leslie's* for 1872 or 1873, whereas there are such illustrations for 1869 and 1870.

16. *Frank Leslie's Illustrated Newspaper*, v. 29 (1869), November 13, p. 145 (full page).

17. The record of Becker's Western trip as given in the *Alta California* reference (see notes 14 and 15, above) and the subject matter of the Western illustrations as listed in note 20 which follows, is good evidence for crediting Becker with the series of illustrations. But there is more positive evidence. In the issue of *Frank Leslie's Illustrated Newspaper* for February 5, 1870, p. 346 (v. 29), there is editorial comment on a two-page illustration (one of the series "Across the Continent") issued as supplement, "The Snow Sheds on the Central Pacific Railroad, in the Sierra Nevada Mountains." The editorial

goes on to state: "The numbers of *Frank Leslie's Illustrated Newspaper* since the commencement of the publication in its pages of scenes and incidents met with by *our artist* [italics are by the writer] in his journey to San Francisco, are especially valuable, and should be purchased and carefully filed for future reference by all who have an intelligent idea of the future of this continent." The illustration referred to in this issue bears the legend, "From a Sketch by Joseph Becker." The identification of *our artist* with Joseph Becker and with the series "Across the Continent" completes the proof.

18. Becker's illustrations of Chinese life in California appeared in *ibid.*, beginning with the issue of May 7, 1870, where (p. 114) editorial comment is made on them and there is included as a supplement to the issue a large two-page illustration, "Scene in the Principal Chinese Theatre, San Francisco, California, During the Performance of a Great Historical Play" with the legend "From a Sketch by Joseph Becker." Other Chinese illustrations appeared in the issues of May 14, 21, 28, June 4, 11, 18, 25, July 2, 16, 23, 30, 1870. In the issue of July 30 (p. 316) is the statement that "with this number we close the interesting series of engravings illustrating the Chinese as they are seen today in our chief maritime city on the Pacific coast." Curiously enough, Becker in his reminiscences (see note 13, above) stated that the chief object of his Western trip was to depict the Chinese and that he "spent six weeks among the Celestials."

Other contemporary comment on the Chinese question will be found in the report on a national discussion of the Chinese labor question held at Memphis, Tenn., in 1869 (New York *Tribune*, July 15, 1869, p. 5) and in A. D. Richardson's lengthy discussion of the Chinese problem in "John," *The Atlantic Monthly*, v. 24 (1869), December, pp. 740–751.

19. That the trip to Salt Lake City was made on the return from California is so stated by Becker in his reminiscences (see note 13); in fact, even without his comment it would appear obvious that Salt Lake City would have to be visited on the return trip as the outbound trip from Omaha to San Francisco in 81 hours would preclude any side trips.

The possibility of a Becker visit to Denver is suggested by an illustration in *Frank Leslie's Illustrated Newspaper*, v. 30

(1870), April 2, p. 44, "Monuments on Monument Creek, Colorado, Near the Line of the Pacific Railroad," credited to the general series of illustrations and to "our artist"; the text (p. 29) identified the locality as "south of Denver."

20. The illustrations have the following titles (starred items have the series title, "Across the Continent"):

1. "Sunday in the Rocky Mountains" (full page).
2. "On the Plains—A Station Scene on the Union Pacific Railway" (full page).
*3. "Dining Saloon of the Hotel Express Train" (about full page).
*4. "Drawing-Room of the Hotel Express Train" (Nos. 4, 5, 6, 7 on two pages).
*5. "Kitchen of the Express Train."
*6. "Gamblers and Gambling-Table in the Street at Promontory Point."
*7. "Gambling-House at Promontory Point."
*8. "Passing Through the Great Salt Lake Valley" (double page).
*9. "Salt Lake Branch Railroad in Course of Construction" (full page).
*10. "Scene in Salt Lake Valley—Fortified House on the Plains" (Nos. 10, 11, 12 on one page).
*11. "Utah—Transporting Railway Ties Across Salt Lake."
*12. "Utah—Mormons Hauling Wood From the Mountains."
*13. "Hotel Life on the Plains" (six illustrations on one page).
*14. "A Prairie Dog City Near the Pacific Railroad" (Nos. 14 and 15 on one page).
*15. "Brigham City, and Old Water-Marks, as Seen From Corinne, on the Line of the Pacific Railroad."
*16. "Mormon Converts on Their Way to Salt Lake City—The Halt on the Road at a Watering Place" (full page).
*17. "A Mormon Farmer and His Family in the Streets of Salt Lake City" (Nos. 17, 18, 19, on one page).
*18. "Street Scene in Salt Lake City."
*19. "The Fish Market, Salt Lake City—Members of Brigham Young's Family Buying Fish."
*20. "View of Echo City, and Entrance to Echo Canon, Looking East" (full page and contains the signature, lower left, "J. B.").
*21. "A View in Echo Canon" (Nos. 21 and 22 on one page).
*22. "A Mormon Farmer and Family Returning From Salt Lake City."
*23. "Snow Sheds on the Central Pacific Railroad, in the Sierra Nevada Mountains" (double page).
*24. "Salt Lake City—The Reserved Circle in the Mormon Theatre for the children of Brigham Young" (Nos. 24 and 25 on one page).
*25. "Salt Lake City—The Interior of the Great Mormon Temple."
*26. "Salt Lake City—The Reserved Circle for the Wives of Brigham Young in the Mormon Theatre" (Nos. 26 and 27 on one page).
*27. "Salt Lake City—Mormon Leader with His Last 'Seal' in the Mormon Theatre."
*28. "Entrance to the Great American Desert" (Nos. 28 and 29 on one page).
*29. "The Weber Canon."
*30. "Wood Shoots in the Sierra Nevada —Pacific Railroad" (about ½ page).
*31. "Hauling Lumber in the Sierra Nevada" (Nos. 31 and 32 on one page).
*32. "Humboldt River and Canon."
*33. "The Post-Office at Promontory Point" (small).
*34. "In the Sierra Nevada, on the Line of the Pacific Railroad" (about ½ page).
*35. "Scene on the Road to Salt Lake City—A Mormon Adobe Dwelling" (about ½ page).
36. "View on Truckee River in Sierra Nevada" (about ½ page).
*37. "Laborers on a Hand-Car of the Pacific Railroad, Attacked by Indians—Running Fight, and Repulse of the Assailants" (full page).
38. "Monuments on Monument Creek, Colorado, Near the Line of the Pacific Railroad" (about ½ page).
39. "On the Plains—Early Morning at Fort Laramie" (about ½ page).
40. "An Exciting Race Between a Locomotive and a Herd of Deer on the Line of the Pacific Railroad, West of Omaha" (about ½ page).

These illustrations appeared in *ibid.*, as follows: In v. 29 (1869), No. 1, December 4, p. 193; No. 2, December 11, pp. 208, 209. In v. 29 (1870), No. 3, January 15, p. 297; Nos. 4, 5, 6, 7, January 15, pp. 304, 305; No. 8, January 15, supplement;

No. 9, January 22, p. 321; Nos. 10, 11, 12, January 22, p. 324; No. 13, January 22, p. 325; Nos. 14, 15, January 29, p. 336; No. 16, January 29, p. 337; Nos. 17, 18, 19, February 5, p. 349; No. 20, February 5, p. 352; Nos. 21, 22, February 5, p. 353; No. 23, February 5, supplement; Nos. 24, 25, February 12, p. 372; Nos. 26, 27, February 12, p. 373; Nos. 28, 29, February 19, p. 389; No. 30, February 26, p. 401; Nos. 31, 32, February 26, p. 404; No. 33, March 5, p. 409; No. 34, March 5, p. 417; No. 35, March 12, p. 436. In v. 30 (1870), No. 36, March 19, p. 12; No. 37, March 26, p. 25; No. 38, April 2, p. 44; No. 39, April 30, p. 108; No. 40, May 28, p. 173.
21. The White Pine silver mines of Nevada were probably attracting the most interest at the time of Becker's trip. The New York *Tribune* in August and September of 1869 ran a series of five long articles on these mines (No. 1 in the series appeared on August 16, 1869, pp. 1, 2, and No. 3, August 24, 1869, pp. 1, 2) the railroad station for which was Elko, Nev. I have examined the Omaha papers of the period (in the Byron Reed collection of the Omaha Public Library), i.e., the summer and fall of 1869, and both the Omaha *Weekly Republican* and the Omaha *Weekly Herald* devoted many columns to mining news, not only of the White Pine region but to regions in Montana (the freight station for the Montana mines on the line of the railroad was Corinne, Utah— Omaha *Weekly Herald,* November 24, 1869, p. 4), Wyoming and Colorado.
It will be noted that this illustration (i.e., "A Station Scene") bears, lower left, a signature which appears to be a composite of several, but the initials "J" "B" and "D" are discernible. "D" probably is the signature of J. P. Davis the wood engraver, as his signature appeared on at least one other of Becker's illustrations, *Leslie's,* v. 30 (1870), May 7, supplement.
22. In Becker reminiscences (see note 13.)
23. For the exhibition of the Becker painting in 1939, see *Life in America* (Metropolitan Museum of Art, N. Y., 1939), pp. 157, 158. More recently this painting has been acquired by the Thomas Gilcrease Foundation where it apparently has been given the title (still incorrect) "The First Train on the Central Pacific Railroad, 1869" (see *American Processional,* Washington, 1950, p. 197).
24. The only other Western illustrations that I have found credited to Becker are

two appearing in *Leslie's* many years after his trip of 1869. In the issue of August 17, 1889, p. 21, is the Becker illustration "Forest Fires in Montana" and in the issue of March 21, 1891, p. 121, is the Becker illustration "The Invasion of the Cherokee Strip." As no information in the text appears concerning these illustrations, I presume that Becker redrew them from photographs or from the sketches of other artists.
Reproduced with Becker's reminiscences (note 13) was a photograph of a group of Leslie artists of the early 1870's. Included in the group, in addition to Becker, are a number of individuals whose names appear in this book, including Albert Berghaus, James E. Taylor, T. de Thulstrup and Walter Yeager.

CHAPTER VII

Western Excursions

1. For additional pictorial excursions, see the pictures of T. Willis Champney (1843–1903) in *Scribner's Magazine* in the series by Edward King, "The Great South." Those in the series that belong to the trans-Mississippi West include *Scribner's Monthly,* v. 6 (1873), July, pp. 257–288 (Missouri, Kansas, Indian Territory, Texas); v. 7 (1874), January, pp. 302–330; February, pp. 401–431 (Texas); v. 8 (1874), July, pp. 257–284 (Missouri); October, pp. 641–669 (Arkansas). A few of the illustrations are signed by Champney but a number bear the initials of Thomas Moran and W. L. Snyder. However, in v. 6, pp. 279, 280, 286, are illustrations bearing the signature "W. L. S. after Champney" and in the table of contents of v. 7 (p. iv) there is the credit line for six of the King articles appearing in that volume, "Illustrated from sketches by Champney." Occasionally, too, one will encounter in the series an illustration "C-WLS," so that it is apparent that Moran and Snyder (and others) redrew many of the Champney sketches. That Champney was the artist sent by *Scribner's* is verified by the fact that he was in the Southwest in 1873; see Topeka *Commonwealth,* January 28, 1873, p. 2. For a short biographical sketch of Champney, see *American Art Annual,* New York, v. 4 (1903), p. 138.
Other picture series will be found in the *Illustrated London News* of William Simpson in various issues of 1873 and later (see comment on Simpson in the *News,*

Jan. 4, 1873, p. 11, c. 3) and by Valentine W. Bromley (1848–1877) in 1876 and 1877 (for a brief biographical sketch of Bromley, see the *News,* May 19, 1877, p. 469).

2. *Harper's Weekly,* v. 17 (November 8, 1873), pp. 961, 994. As this notice appeared after some of the sketches had already appeared in the *Weekly* (see note 14) and as the artists were in Wichita on October 6, 1873, it is quite probable they left New York in early September or possibly in August.

3. The biographical data are from obituaries in the San Francisco *Morning Call,* June 11, 1889, p. 3, col. 2, and the New York *Tribune,* June 10, 1889, p. 5, col. 5; see, also, recollections of Amadee Jouillin, a well-known California artist and pupil and friend of Tavernier, in San Francisco *Sunday Call,* April 16, 1911, p. 5.

4. Tavernier's first illustration for *Harper's,* a full-page one, "The Christmas Dream," appeared in the issue for December 30, 1871, p. 1233.

5. The Division of Fine Arts, Library of Congress; the New York Public Library; the Museum of the City of New York; the Frick Art Reference Library; the New York Historical Society; the Metropolitan Museum of Art; La Bibliothèque Nationale of Paris; the California State Library; the Bohemian Club of San Francisco; and D. T. Mallett, author of *Mallett's Index of Artists,* were all consulted in 1940 and information concerning Frenzeny from these sources was meager. Examination of the *Art Index* to October, 1945, gives no entry under "Frenzeny." My friend, the late William H. Jackson, of pioneer photography fame, was acquainted with Frenzeny but could tell me little about Frenzeny's personal history or the date of his death; see, also, notes 87–92.

Deejay Mackart (see note 9) stated that Frenzeny was an excellent horseman, had been in the French cavalry and had served with Bazaine in Mexico. The illustration cited in note 6 is supporting evidence for Frenzeny's Mexican venture.

6. *Harper's Weekly,* v. 12 (1868). pp. 200, 733, 828. The first of these sketches "Las Cumbres Railroad, Mexico—Scene in the Pass de la Mula" and the text accompanying it indicate that Frenzeny had been in Mexico before 1868.

7. *Ibid.,* v. 13 (1869), pp. 4, 108, 116; v. 14 (1870), pp. 616, 744; v. 15 (1871), p. 360; v. 16 (1872), pp. 161, 660, 661,

669, 836, 876, 908; v. 17 (1873), pp. 145, 148, 156, 157, 468, 744, 745.

8. *Ibid.,* v. 17 (1873), pp. 296, 297, 865.

9. Deejay Mackart, a friend of both Tavernier and Frenzeny, wrote that Frenzeny "was infinitely more clever with the point than the brush."—San Francisco *Call,* July 10, 1892, p. 13, cols. 7, 8. Paintings were also in the portfolio of Western sketches made by the two artists. See notes 53 and 54.

10. The *Rocky Mountain News,* February 28, 1874, p. 4. Frenzeny and Tavernier spent the winter of 1873–1874 in and around Denver. See p. 108.

11. In their sketches appearing in *Harper's Weekly* for 1874, I have counted 21 letters reversed.

12. San Francisco *Call,* July 10, 1892, p. 13, cols. 7, 8.

13. Some of these observations will become apparent as we list or discuss the individual illustrations. For the Bohemian character of the two (chiefly concerned with Tavernier) see San Francisco *Call,* July 10, 1892, p. 13, cols. 7, 8; August 12, 1909, p. 6, cols. 6, 7; the *Sunday Call,* April 16, 1911, p. 5; San Francisco *Examiner,* March 3, 1925, p. 7, col. 1, and R. H. Fletcher, ed., *Annals of the Bohemian Club* (1872–1880), 2d ed. (San Francisco, 1900), v. 1, p. 191.

14. *Harper's Weekly,* v. 17 (October 18, 1873), pp. 920, 921, 940.

15. *Ibid.,* v. 17 (November 1, 1873), pp. 964, 965, three illustrations; on p. 993 (November 8, 1873), one illustration of eight views.

16. *Ibid.,* v. 18 (January 31, 1874), p. 105, single page in size. The men depicted were said to be members of the famed "Molly M'Guire Secret Society."

17. The evidence for this route will be presented in the text which follows.

18. *Harper's Weekly,* v. 18 (January 24, 1874), p. 76; the comment will be found on p. 78.

19. For the early history of the M. K. & T. see *The Great South-West* (a monthly house organ of the M. K. & T.), Sedalia, Mo., June, 1874, and subsequent issues; Sylvan R. Wood, *Locomotives of the Katy* (Boston, 1944), pp. 8–19; also *Report of the Commissioners of the M. K. and T. Railway Co.* (New York, 1888), pp. 2, 3; map in *Missouri, Kansas and Texas Railway Company, Report To Stockholders, 1903* (*Evening Post* Job Print, New York); A. T. Andreas-W. G. Cutler, *History of*

the State of Kansas (Chicago, 1883), pp. 250, 251.

From *The Great South-West*, we obtain some of our information on Frenzeny's and Tavernier's itinerary as it contains a number of illustrations signed by these artists and which appear in this publication as follows: Views in Hannibal and Sedalia, Mo., issue of July, 1874; depot in Parsons, Kan., November, 1874; Denison, Tex., August, 1874; Arkansas river valley (near Fort Gibson, I. T.), June, 1874; Neosho valley, July, 1874; interior of passenger car, M. K. & T., November, 1874. Several of these illustrations were used a number of times in different issues of the *The Great South-West*. I have assumed, as seems reasonable, that these illustrations were made on the trip beginning in the fall of 1873, for there is record of only one trip through the West by these two artists.

20. In addition to the illustrations themselves, and those listed in note 19, we may add as further proof of the artists' actual appearance in Texas, the following item from the *Rocky Mountain News*, Denver, November 6, 1873, p. 4, the day after their arrival in Denver: "Messrs. Frenzeni and Tavernier, artists for Harper's Weekly, . . . have made an extensive tour of Texas, Indian Territory, and southern Colorado, where they have made a large number of interesting sketches of frontier life."

20a. The illustrations will be found in *Harper's Weekly* as follows: 1, vol. 18 (March 21, 1874), p. 267; 2, vol. 19 (May 15, 1875), p. 396, not signed but credited on p. 406; 3, vol. 18 (April 11, 1874), p. 326; 4 (March 21, 1874), p. 249; 5 (April 4, 1874), p. 306; 6 (April 25, 1874), p. 361; 7 (April 25, 1874), p. 361; 8 (April 4, 1874), p. 307; 9 (February 28, 1874), pp. 206, 207; 10 (July 25, 1874), p. 613; 11 (March 28, 1874), p. 272; 12 (March 28, 1874), p. 272.

21. See note 19 and map of the West showing army posts and Indian reservations, *Harper's Weekly*, v. 18 (1874), p. 691.

22. *The Denison* [Tex.] *Guide*, American Guide Series (Denison, 1939), pp. 11–15.

23. *Ibid.*, p. 13.

23a. The illustrations will be found in *Harper's Weekly* as follows: 1, vol. 18 (May 2, 1874), pp. 386, 387; 2 (July 11, 1874), p. 573; 3 (February 28, 1874), p. 192; 4 (May 30, 1874), p. 460; 5 (September 12, 1874), p. 760; 6 (February 28, 1874), p. 192; 7 (April 4, 1874), p. 307;

8 (December 12, 1874), p. 1013; 9 (April 4, 1874), p. 306.

24. The Wichita sketch was recently reproduced, although incorrectly dated, as illustration No. 33 in *Wichita 1866–1883— Cradle Days of a Midwestern City* (Wichita, 1945), edited by R. M. "Dick" Long.

25. The *Fourth Annual Report* (1875) of the Kansas State Board of Agriculture (Topeka, 1875), p. 120, mentions an extensive manufactory in operation at Fort Scott. On the other hand mention of production of lime and limestone at Florence will be found in a pamphlet edited by Stephen C. Marcou, *A Description of Marion County, Kansas* (Marion Centre, 1874), pp. 8, 11; in *Kansas in 1875* (Topeka, 1875), p. 15, the statement is made "3,000 carloads [of stone] were shipped" from Florence in 1874; and in *The Kansas Handbook*, J. S. Boughton, publisher (Lawrence, 1878), the statement is made on page 14 that the most extensive lime kilns and stone quarries in the state were in Florence. It will be noted that Boughton's comment is made some four or five years after the *Fourth Annual Report* (which makes no specific mention of lime kilns or quarries at Florence) and an examination of the data given in Andreas-Cutler, *op. cit.*, pp. 1264, 1265, indicates that extensive quarrying did not begin in Florence until 1873, the year the artists were through Florence on the A. T. and S. F. railroad. Since Fort Scott was on the M. K. & T. it seems more probable the illustration was made there on their original and southward trip through Kansas.

26. *Rocky Mountain News*, November 6, 1873, p. 4.

27. A short branch of the Santa Fe ran north from Wichita to the main line at Newton.

28. Las Animas (Colo.) *Leader*, November 8, 1873, p. 3, col. 2, has this entry under "West Las Animas Items": "The following were the arrivals at the American House this week, as furnished us by the affable Geo. D. Williamson, Clerk: Patrick Shanley, Kit Carson, Col.; . . . P. Frenzeny, New York City; Jules Tavernier, do. . . ."

29. Glenn Danford Bradley, *The Story of the Santa Fe* (Boston, 1920), pp. 140, 141.

30. Andreas-Cutler, *op. cit.*, pp. 762, 763, 769.

31. Bradley, *op. cit.*, p. 85.

32. E. Douglas Branch, *The Hunting of the Buffalo* (New York, 1929), p. 158.

33. R. I. Dodge, *The Plains of the Great West* (New York, 1877), p. 133.

34. *Harper's Weekly*, v. 18 (December 12, 1874), pp. 1013, 1023. For the feeble efforts made by the Kansas legislature to control the indiscriminate slaughter of the buffalo, see E. O. Stene, "The Development of Kansas Wildlife Conservation Policies," *Transactions of the Kansas Academy of Science*, v. 47 (1945), p. 291. In 1874, the Topeka correspondent of the New York *Tribune* described the use to which buffalo bones, hides and meat—2,000,000 pounds of it—were put; see "The Buffalo and His Bones," the *Tribune*, November 27, 1874, p. 3, col. 2 (nearly a column).

Mention of the growing importance of the bone trade almost coincident with Tavernier's and Frenzeny's trip to Kansas will be found in the Topeka *Commonwealth*, March 14, 1873, p. 2, c. 3 ("ten cars of buffalo bones will probably be shipped this week from Great Bend"); the *Commonwealth*, April 2, 1873, p. 2, c. 4 ("the bone trade becoming quite an item of commerce —large piles all along the railroad [the Santa Fe]"); see also recollections of M. I. McCreight *Buffalo Bone Days*, privately printed by McCreight in 1939, 40 pp; and note 43, chapter XII.

35. For an excellent illustration of an individual dugout, see Edwin White's sketch in Andreas-Cutler, *op. cit.*, p. 253, or Henry Worrall's sketch in W. E. Webb's *Buffalo Land* (Cincinnati and Chicago, 1872), p. 329.

36. Pleasant Hill (Mo.) *Leader*, November 22, 1872, p. 2, col. 3. The quotation is from a letter dated "Wallace, Kas., Nov. 15, 1872." Wallace was on the Kansas Pacific north of the Santa Fe line and the traveler reported that at Wallace some of the habitations were dugouts.

37. Fort Aubrey was about eight miles west of the present town of Kendall, Kan. —*Kansas, A Guide to the Sunflower State* (New York, 1939), p. 390.

38. Pleasant Hill (Mo.) *Leader*, January 3, 1873, p. 2. An illustration of one of these way stations on the Santa Fe appears as a wood engraving in Frank Fossett's *Colorado* (Denver, 1877), p. 446. The account in the *Leader* cited in this note also gives some description of the town of Dodge City.

Some interesting recollections of southwest Kansas along the Santa Fe in 1872–1875 but told some ten years later will be found in *The Globe Live Stock Journal* (Dodge City) July 17, 1885.

39. In the North Topeka *Times*, December 20, 1878, are the recollections of a traveler of 1873. "During the year 1873 we 'roughed it' in the West," he writes. "Our first stopping place was the famous Dodge City, at the time a perfect paradise for gamblers, cutthroats and 'girls.' On our first visit the buildings in the town were not buildings, with one or two exceptions, but tents and dug-outs. Every one in the town, nearly, sold whisky, or kept restaurant, perhaps, both. The A., T. and S. F. R. R. was just then working its way up the low-banked Arkansas, and Dodge was the frontier town." "The unsightly dugouts" of early Kendall are mentioned in the Syracuse *Journal*, June 11, 1886, p. 3, col. 3. The same issue of the *Journal* (p. 2, col. 1) mentions "the inevitable tank . . . a store in a sort of cellar" at Lakin. The dugout store was still there in 1879, when A. A. Hayes, Jr., and W. A. Rogers went through Lakin on the Santa Fe, for Rogers drew a sketch of it; see A. A. Hayes, Jr., *New Colorado and The Santa Fe Trail* (New York, 1880), p. 151.

40. *Annual Report of the Board of Directors of the Atchison, Topeka & Santa Fe Railroad Co.*, for the year ending December 31, 1874 (Boston, 1875), p. 35. Other stops between Dodge City and Granada were Cimarron, Pierceville, Sherlock, Lakin, and Aubrey. These possessed windmills and water towers only.—*Ibid.*, p. 37.

41. Note that no comment is made on the construction of the "buildings," however.

42. *The Daily Chieftain*, Pueblo, Colo., August 26, 1873, p. 2, col. 2. Another contemporary written description, which offers no further clues, will be found in the Las Animas (Colo.) *Leader*, July 4, 1873, p. 2. It was written two days before the Santa Fe reached Granada.

43. A brief description of the town of Sargent appears in *The Daily Chieftain*, Pueblo, Colo., February 19, 1873, p. 2, but it is of little value in identifying the illustration; see also Topeka *Commonwealth*, May 30, 1873, p. 2, c. 2. Sargent was almost on the Kansas-Colorado line. The Santa Fe was constructed to this point by December 28, 1872; Bradley, *op. cit.*, p. 85. J. H. Conrad of Coolidge, long a resident of western Kansas, has been interested in the history of Hamilton county. As Hamilton county contains the towns Coolidge (formerly Sargent), Syracuse and Kendall, all on the line of the Santa Fe, I wrote him in 1946 describing the illustration "An Un-

der-Ground Village." Mr. Conrad replied that he had talked with J. M. Ward, of Coolidge, who lived in the town in the early days of the Santa Fe. Mr. Ward told him that the picture would fit any of the three towns, Dodge City, Sargent (now Coolidge) or Granada, C. T. "That is about the way all the towns near here started." Some of the results of Mr. Conrad's research on the history of Hamilton county from 1873 to 1887 will be found in the Syracuse *Journal,* November 3 and 10, 1944.

43a. The illustrations will be found in *Harper's Weekly* as follows: 1, vol. 18 (July 4, 1874), p. 556; 2 (May 30, 1874), pp. 456, 457; 3 (July 18, 1874), p. 597; 4, vol. 19 (May 1, 1875), pp. 360, 361; 5, vol. 18 (June 20, 1874), p. 509; 6 (July 4, 1874), p. 565; 7, vol. 20 (January 15, 1876), p. 45; 8, vol. 19 (May 29, 1875), p. 444; 9 (May 29, 1875), p. 441; 10, vol. 18 (July 18, 1874), p. 604.

44. Bradley, *op. cit.,* p. 141, gives the rail distance as 133 miles and the stage route was undoubtedly longer.

45. Pueblo *Chieftain,* November 5, 1873, p. 4, col. 1.

46. Bradley, *op. cit.,* p. 151.

47. *Rocky Mountain News,* Denver, November 6, 1873, p. 4. The Denver Public Library recently (1951) has acquired a water color sketch by Tavernier "Habitations Mexicaines, Las Animas. Col." which is different from any of the illustrations reproduced in *Harper's Weekly.*

48. Mention of Frenzeny and Tavernier has been found in the following Denver papers: *Rocky Mountain News,* November 6, 1873, p. 4; *Daily Times,* February 16, 1874; *Rocky Mountain News,* February 17, 1874, p. 4; *ibid.,* February 28, 1874, p. 4; *Daily Times,* March 5, 1874; *ibid.,* March 20, 1874. The reference to their studio is made in *ibid.,* March 5, 1874.

49. *Harper's Weekly,* v. 18 (May 30, 1874), p. 461.

50. *Ibid.,* v. 19 (May 1, 1875), p. 362.

51. Another illustration should probably be assigned to the Colorado group. It is, however, signed by Frenzeny alone and appeared in *ibid.* (October 13, 1877), v. 21, p. 808. As the text of the *Weekly,* in describing the picture, refers to the incident depicted, "Sheep Raid in Colorado," as occurring "some time ago" it was probably drawn during Frenzeny's stay in Colorado, 1873–1874.

52. *Rocky Mountain News,* February 28,

1874, p. 4. Note that the last item would indicate a stop or a special side trip to Colorado Springs.

53. *Ibid.,* February 17, 1874, p. 4.

54. Denver *Times,* February 16, 1874. As the historian must at least attempt to be honest we must record the comment of still another Denver paper a few days later: "Everybody who examines that painting of Denver, in Richards and Co's windows, comes at once to the conclusion that the artist must have been cross-eyed to have located the city between the Platte river and the mountains, and near sighted to have the foot hills appear to be immediately joining the suburbs, when they are fully ten miles distant."—*Rocky Mountain Herald,* February 28, 1874, p. 3, col. 1. We can't be sure, of course, that the *Herald* reporter was referring to Frenzeny and Tavernier's painting, as the word "artist" only is specified. We might conclude from the opinion of the other two Denver papers that the *Herald* reporter was a grouch and unduly hypercritical, if the painting he was discussing belonged to Frenzeny and Tavernier. It should be pointed out also that there was a considerable number of resident artists in Denver in the 1870's.

54a. The illustrations will be found in *Harper's Weekly* as follows: 1. vol. 18 (April 11, 1874), p. 321; 2. vol. 19 (November 13, 1875), p. 924; 3. (January 2, 1875), pp. 8, 9.

55. An account of the Indian troubles mentioned above may be found in George E. Hyde, *Red Cloud's Folk* (Norman, Okla., 1937), pp. 210–215; see, also, letter by Col. John E. Smith dated "February 12, 1874, Fort Laramie," New York *Semi-Weekly Tribune,* February 24, 1874, p. 5, col. 2; other mention of the troubles is given in *ibid.,* February 17, 1874, p. 5, col. 4; February 20, 1874, p. 5, col. 3. Troops under Colonel Smith left Fort Laramie on March 2 and arrived at the Red Cloud Agency on March 5 effectively quieting the Indians for the moment.—*Ibid.,* March 10, 1874, p. 5, col. 5.

56. The record of the first distance will be found in *Report of the Special U. S. Commission Appointed To Investigate the Affairs of the Red Cloud Indian Agency, July, 1875* (hereinafter cited as *Report of the Special Commission, 1875*), (Washington, 1875), p. 195; the second is from Hyde, *op. cit.,* p. 206.

Apparently Tavernier only witnessed the Sun Dance. The Cheyenne *Leader,* June

10, 1874 has the item: "Mr. Jules Tavernier, an accomplished artist from Paris, now engaged on Harper's Weekly, accompanied Major Stanton, U. S. Paymaster, on his last trip to Forts Laramie and Fetterman, and to the Red Cloud and Spotted Tail Agencies. Mr. T. made a great many sketches of the country, and of persons and things at the military posts, which will appear in Harper's in due season. He will return in a few days from his interesting trip." The Nebraska Historical Society has a typewritten manuscript "Sketch of Fort Robinson, Nebraska" by Maj. Gen. Wm. H. Carter, U. S. Army retired. The manuscript includes reminiscences of Carter in 1874, who was stationed in the West and was at the Red Cloud Agency in the spring of 1874. Carter says (p. 13) he secured "with considerably difficulty" permission for Tavernier to see the Sun Dance. The Carter manuscript also contains photographs, laid in, made in 1874 at the agency. Carter identifies the individuals in two of the photographs, an identification which includes himself and Tavernier. Carter also *published* an account *The History of Fort Robinson* (Crawford, Nebraska, 1942) which makes much the same comment (p. 10) as above. Where Frenzeny stayed during the Red Cloud Agency episode is unknown, possibly at Cheyenne.

57. *Report of the Special Commission, 1875* (note 56), p. 496, and note 58. Catlin described the Sun Dance of the Sioux in 1832 but did not paint it although many Indian dances were portrayed by this early artist. He arrived in Sioux country a few days after the ceremonial had taken place. The dance took place, he reports, under "an awning of immense size—in the center of which was a pole."—George Catlin, *North American Indians* (Edinburgh, 1926), v. 1, p. 262.

58. *Harper's Weekly*, v. 19 (January 2, 1875), p. 10; F. W. Hodge, ed., *Handbook of American Indians* (Washington, 1910), Pt. 2, p. 650; Leslie Spier, "The Sun Dance of the Plains Indians," *Anthropological Papers of the American Museum of Natural History* (1921), v. 16, pp. 451–529.

59. The Indian population of the Red Cloud Agency for the year ending June 30, 1874, is listed as 9,177—*Executive Document 6*, House of Representatives, 43 Cong., 2 Sess. (Washington, 1874); see, also, *Report of the Special Commission, 1875*, pp. 435, 821.

60. Schwatka's description may be found in the *Century Magazine*, v. 39 (March, 1890), pp. 753–759. The 1875 dance also took place in June, the locality being between the Spotted Tail Agency and "another agency 40 miles to the west." The second agency was the Red Cloud Agency (*Report of the Special Commission, 1875*, pp. 804, 807, 820). It is of interest to note that Remington illustrated the Schwatka article but he did not attempt to depict the Sun Dance itself. In fact, Remington did not see an Indian Sun Dance (Blackfoot) until July, 1890, after the illustrations of the Schwatka article were drawn.—*Harper's Weekly*, v. 34 (December 13, 1890), p. 976, and my own exhaustive study of Remington. Oddly enough, Remington did not produce a picture of a complete view of the Sun Dance until the last year of his life. Evidently, however, the scene witnessed in 1890 made so profound an impression on him that he wrote in his diary (now in the Remington Art Memorial, Ogdensburg, N. Y.) under day of February 28, 1909: "Am starting 'Sun Dance' for the love of Record of Great Themes but I'll never sell it—it will give everybody the Horrors. It is in my system and its got to come out."

61. San Francisco *Call*, July 10, 1892, p. 13, col. 7. Mackart stated that the sketch was published in the *Illustrated London News* as well as in *Harper's Weekly*. I have made some effort to find it in the *News* but so far without success.

62. Another half-page illustration, "Red Cloud Agency—Distributing Goods," is found in the *Weekly*, v. 20 (May 13, 1876), p. 393, and is signed by I. P. Pranishnikopf. My study of Pranishnikopf is not yet complete but he had occasional Western illustrations appearing in various periodicals for many years. In some of these, the illustrations, although signed by Pranishnikopf, also had the added credit line "redrawn after a sketch by" so and so. It is possible that the illustration, "An Indian Agency—Distributing Rations," in the *Weekly* for November 13, 1875, p. 924, was based on observation by Pranishnikopf but on the above basis, I think it is unlikely. I have also considered the possibility that Pranishnikopf redrew a Frenzeny-Tavernier sketch for the illustration of May 13, 1876, but this possibility seems ruled out by the fact that in Pranishnikopf's illustration of the Red Cloud Agency the legend "F. D. Yates Trading Co." appears on one of the buildings; but F. D. Yates

did not begin business at the Red Cloud Agency until April 16, 1875, nearly a year after Frenzeny and Tavernier were there.— *Report of the Special Commission, 1875*, p. 330. The Pranishnikopf illustration may have been redrawn from a photograph. It should be pointed out, however, that Pranishnikopf had what apparently was a Denver scene in *Harper's Weekly*, v. 20 (October 14, 1876), p. 836.

63. In addition to the references already noted are the vague recollections of Joullin (San Francisco *Call*, April 16, 1911, p. 5) and a reference to the artist's experiences in 1874 with General Smith, Spotted Tail and Red Cloud that will be found in *California Art Research*, First Series (San Francisco, 1937), v. 4, p. 3. The General Smith is undoubtedly the Colonel Smith mentioned in note 55.

Dr. G. R. Gaeddert, formerly of the staff of the Kansas State Historical Society but now of Washington, kindly searched the records in the National Archives for me. He reports that no mention of Frenzeny and Tavernier occurs in the period March 20 to July 1, 1874, in the "Fort Laramie Letter Books and the Red Cloud Agency Letters." These materials, however, are confined almost exclusively to military and agency affairs. Unfortunately no log books of daily happenings and register of visitors at Fort Laramie, which I had hoped to find, are among the collections of the Interior and War branches of the National Archives.

64. This painting, on display in San Francisco in 1919, is probably the most authentic evidence that the artists were at Fort Laramie. It was painted on the lid of a cigar box, dated 1874, with the legend on the store "J. S. Collins."—San Francisco *Chronicle*, April 20, 1919, p. 25, col. 5. The Wyoming State Library informs me that Gilbert Collins, a brother of J. S. Collins, was actually in charge of the post-trader's store in 1874.

65. San Francisco *Alta California*, October 22, 1878, p. 1, col. 3. The vicinity of the scene depicted was near Chimney Rock, western Nebraska. The locality would be between Fort Laramie and the Red Cloud Agency. The painting is now owned by the Bohemian Club, San Francisco.

66. *Ibid.*, January 27, 1879, p. 1, col. 3. The account of the painting states "It recently sold for $2,000."

67. Information from the California State Library, Sacramento. This item, together with other data on Tavernier, was compiled in 1907. The painting was reported then as owned by "H. Belloc, Paris."

68. *California Art Research*, First Series, v. 4, p. 25. Reported as painted about 1880–1882.

68a. The illustrations will be found in *Harper's Weekly* as follows: 1. vol. 18 (September 26, 1874), p. 793; 2 (September 26, 1874), p. 793; 3. (December 12, 1874), p. 1024; 4. vol. 19 (January 30, 1875), p. 97; 5. (February 6, 1875), p. 109; 6. (July 3, 1875), p. 537; 7. vol. 18 (October 24, 1874), p. 880; 8. vol. 19 (March 20, 1875), p. 240; 9. (May 22, 1875), p. 421; 10. (May 29, 1875), p. 440.

69. See map, *Harper's Weekly*, v. 18 (August 22, 1874), p. 691.

70. Contemporary notice in the San Francisco papers has been found for only one of the above sketches. The San Francisco *Bulletin*, May 20, 1875, p. 3, col. 6, makes the brief comment, "*Harper's Weekly*, just at hand, is embellished with a number of graphic views in the Chinese quarter, San Francisco, by the artists Frenzeny and Tavernier."

71. Records of the Bohemian Club, San Francisco.

72. San Francisco *News Letter*, May 1, 1875, p. 12; May 15, 1875, p. 5; San Francisco *Bulletin*, May 22, 1875, p. 2, c. 2; San Francisco *Daily Post*, May 22, 1875, p. 1, col. 3.

73. *Harper's Weekly*, v. 18 (March 14, 1874), p. 246.

74. *Ibid.*, v. 19 (May 22, 1875), pp. 420, 426.

75. Among the paintings of Tavernier listed in *California Art Research*, First Series, v. 4, p. 25, is "A Scene in New Mexico" which was dated 1880–1882. This painting may be based on a trip to the New Mexico country in 1873–1874 or later, or it may be based on photographs as suggested later in the text.

76. San Francisco *Alta California*, April 2, 1879, p. 1, col. 3. In 1892, a painting "Montezuma Landscape," by Tavernier, was reported in the possession of one Irving M. Scott.—*The Wave*, San Francisco, v. 8 (January 16, 1892), p. 7, col. 3. Whether this was the painting, "Waiting For Montezuma," or an additional one, is uncertain. It is possible that all three references to the Montezuma titles refer to but one painting.

77. San Francisco *Call*, May 28, 1893, p. 26, col. 1.

78. *Ibid.*, December 16, 1884, p. 7, col. 6.

79. See note 3.

80. The quotations are from *Annals of the Bohemian Club*, v. 1, p. 191. Other sources of information on Tavernier's later life are found in *California Art Research*, First Series, v. 4, pp. 1–26, a very inadequate and poorly documented account. Among the newspaper references utilized may be mentioned the following (many others are available at the California State Library, Sacramento): San Francisco *Alta California*, July 13, 1877, p. 1, col. 9; January 27, 1879, p. 1, col. 3; San Francisco *Morning Call*, March 10, 1886, p. 4, col. 2; *The Wave*, San Francisco, January 16, 1892, v. 8, p. 7, col. 3; San Francisco *Call*, July 10, 1892, p. 13, cols. 7, 8, which credits Tavernier with the founding of the Monterey art colony; San Francisco *Call*, August 12, 1909, p. 6, cols. 6, 7; the *Sunday Call*, April 16, 1911, p. 5; *San Francisco Examiner*, March 3, 1925, p. 7, cols. 1–3; and obituaries listed in note 3.

81. Tavernier also had an illustration appearing under his own signature in *Harper's Weekly* (July 26, 1879), v. 23, p. 588, "'Jeanette' Leaving the Harbor of San Francisco" (full page).

82. Depicts a sick or dying pioneer in rude cabin. For an amusing contemporary criticism of this piece see the San Francisco *Argonaut*, November 24, 1877, p. 3, col. 4. The original painting is now in the possession of The Society of California Pioneers, San Francisco.

83. "Taken From Life" in an underground sweat house of the California Digger Indians near Clear Lake.—San Francisco *Alta California*, June 12, 1878, p. 1, col. 4.

84. *California Art Research*. First Series, v. 4, p. 25.

85. According to *ibid.*, p. 19, Tavernier went to the Pacific Northwest on a hunting trip with Sir Thomas Hesketh and sketches of the Northwest Indians were obtained. No other record of the sketches or paintings resulting from the trip seems to be available.

86. *Ibid.*, p. 25.

87. *Annals of the Bohemian Club*, v. 1, pp. 19, 26, 43, 107, 191. At the end of volume 1, Frenzeny is listed as a member of the board of directors of the club for 1876–1877.

88. Deejay Mackart.—See note 9.

89. Frenzeny's illustrations in *Harper's Weekly* for 1876–1878 are: "The Indian War—Buying Cavalry Horses," near San Francisco (full page), v. 20 (November 11, 1876), p. 924; "Chinese Immigrants at the San Francisco Custom-House" (title page), v. 21 (February 3, 1877), p. 81; "Sunday Sports in Southern California" (full page), v. 21 (March 3, 1877), p. 164; "Chinese Lantern Feast" (⅛ page), v. 21 (April 25, 1877), p. 332; "Charcoal Burning in Nevada" (⅛ page), v. 21 (May 26, 1877), p. 405; "Chinese Reception in San Francisco" (double page), v. 21 (June 9, 1877), pp. 444, 445; "A Whaling Station on the California Coast" (title page), v. 21 (June 23, 1877), pp. 477; "Camel Train in Nevada" (⅛ page), v. 21 (June 30, 1877), p. 501; "Nevada Silver Mine—Changing the Shift" (title page), v. 21 (August 25, 1877), p. 657; "Sheep Raid in Colorado" (⅛ page), v. 21 (October 13, 1877), p. 808; "Mission Indians of Southern California . . ." (⅛ page), v. 21 (October 20, 1877), p. 821; "The Vintage in California" (double page), v. 22 (October 5, 1878), pp. 792, 793; "On the Way To the Yosemite Valley" (full page), p. 952. For the camel experiment of 1856, see Dan E. Clark, *The West in American History* (New York, 1937), pp. 520, 521.

90. *Harper's Weekly*, v. 23 (August 23, 1879), p. 664; v. 24 (1880), pp. 152, 556, 812.

91. "The Brighton Beach Fair Grounds, Coney Island" (full page), *ibid.*, v. 23 (August 30, 1879), p. 684.

91a. The illustrations will be found in *Harper's Weekly* as follows: 1. vol. 24 (July 24, 1880), p. 476; 2, vol. 26 (February 11, 1882), p. 89; 3 (June 10, 1882), p. 365; 4. (November 18, 1882), p. 733; 5. (November 25, 1882), pp. 744, 745; 6. vol. 28 (July 26, 1884), pp. 480, 481; 7. vol. 30 (August 28, 1886), p. 556; 8. (September 4, 1886), p. 565.

92. The book was published by June of 1889 as there is a brief description of it in the *Publisher's Weekly*, v. 35 (June 29, 1889), p. 833. Recently (1951) I have seen advertised a French translation of this book, Harrington O'Reilly *Cinquante ans chez Les Indiens*, Paris, 1889; the translation and a preface were furnished by Hector France. The Frenzeny illustrations in *Leslie's* will be found in issues of Jan. 14, 1882, p. 348; June 16, 1883, p. 272; Feb. 13, 1886, p. 428; June 19, 1886, p. 280; Aug. 13, 1887, p. 424.

93. An artist whose active western period was nearly coincident with that of Frenzeny and Tavernier was Vincent Colyer (1825–1888). A student of J. R. Smith, he was elected an associate of the National Academy in 1849. Colyer was best known in his day as a public servant, first as a member of the Christian Commission during the Civil War (see *Harper's Weekly* v. 9, p. 461, 1865) and later as a special U. S. Indian Commissioner during the late sixties and early seventies. In the latter capacity he traveled extensively and made many notable sketches, drawings, and water colors in the southwest and in Alaska. Recently (1952), Edward Eberstadt and Sons of New York City acquired several hundred of these original sketches. Included among them are such valuable southwestern pictorial records as "Fort Gibson, March 11, 1869"; "Old Fort Arbuckle, 1868"; "Camp Prescott, Ariz. Terr., 1871."

A few Colyer sketches have been reproduced: see 41 Cong., 2d. Sess., Senate Ex. Doc. 68 (serial no. 1406), five Alaskan illustrations; *Harper's Weekly* v. 14, p. 124 (1870), Alaskan; v. 21, p. 641 (1877), the Nez Percés campaign. Brief biographical sketches of Colyer will be found in the N. Y. *Tribune*, July 13, 1888, p. 5, c. 5, and *Cyclopedia of American Biographies* (Boston, 1900), v. 2, p. 135.

CHAPTER VIII

Indigenous Artists: Henry Worrall

1. For a number of the states of the trans-Mississippi West, some attempts have been made to review the art (i.e., painting and drawing) of the states. These reviews, either in periodical or book form, vary greatly in quality and quantity. The following bibliography, although incomplete, is, as far as I know, the only one available. It was secured either through actual use in the course of the study preceding this book or in those cases where none was used, inquiries were sent (July, 1951) to the directors of the state historical societies requesting such information. The bibliography arranged in the geographic order of the western states follows:

1. Louisiana
ART & ARTISTS IN NEW OR-LEANS DURING THE LAST CEN-

TURY, by Isaac Monroe Cline, published in New Orleans by the Louisiana State Museum, 1922.

NEW ORLEANS ARTISTS, compiled by the New Orleans Museum Project of the W.P.A.

"The former publication is very small, and we consider it drastically incomplete, out-of-date, and inaccurate. The latter is not actually a publication, but is a typescript of which there are three copies: one in the Delgado Museum Library, one in the Howard Tilton Library of Tulane University, New Orleans, and one in the Library of Congress in Washington. When I arrived two and one-half years ago, I found this material tied up in bundles, and pretty useless. It is now bound into thirteen sizeable volumes, the material arranged in chronological order, accessible through an alphabetical cross-file current index. This material is amazingly extensive and intensive, and comprises all references to art or artists in New Orleans in all newspaper files, city directories, tax lists, court proceedings, and postal notices. In many sections it is rather repetitious. The card index is broken down into art categories, such as, painter, portrait painters, sculptors, architects, printers and engravers, and the like. New material is being constantly added as it turns up. Eventually the Delgado Museum will publish a history of the artists of Louisiana of the 19th Century, being a distillation of this material."

The above information was supplied by Mr. Alonzo Lansford, director of the Isaac Delgado Museum of Art, New Orleans, and is quoted directly from a letter by Mr. Lansford to the author.

2. Arkansas
No reply.
3. Missouri
Mr. Floyd C. Shoemaker, secretary of the State Historical Society of Missouri, Columbia, writes me as follows on a bibliography of Missouri art:

"There are a few rather brief accounts of special phases of the subject, however, which may come within your classification, as, for instance, Chapter 69 entitled 'Art and the Artists,' in Volume II (pp. 747–760) of my own work, *Missouri and Missourians, Land of Contrasts and People of Achievements* (Chicago: The Lewis Publishing Co., 1943), and the chapter on 'Arts and the Crafts'

in the state guidebook compiled by the Writers' Program of the WPA and published in 1941 with the title, *Missouri, A Guide to the 'Show Me' State.*

"An article by Edmund H. Wuerpel on 'Art Development in St. Louis' appears in the old *Encyclopedia of the History of St. Louis,* edited by Wm. Hyde and Howard L. Conard (New York, Louisville, St. Louis: The Southern History Company, 1899), Volume I, pp. 43–52.

"I might say, too, that a brief bibliography of 'Art in Missouri' was published in our *Review* for July, 1933 (Vol. 27, No. 4, p. 348). Articles that have appeared in our *Review* from time to time which might possibly be of interest to you are: Penn, Dorothy, 'George Caleb Bingham's "Order No. 11," ' in Vol. 40 No. 3 (Apr. 1946), pp. 349–357; Windell, Marie George, 'As Benton Sees the War,' in Vol. 39 No. 4 (July, 1945), pp. 460–467; Roth, James, 'Special Acquisitions of the Society: Augustus G. Beller's *A View of Weston, Missouri,*' in Vol. 44 No. 2 (Jan. 1950), pp. 109–112; Mahan, George A., 'Carroll Beckwith,' in Vol. 17, No. 2 (Jan. 1923), pp. 218–220; McReynolds, Allen, 'Special Acquisitions of the Society: George Caleb Bingham's *Thomas Jefferson,*' Vol. 44 No. 2 (Jan. 1950), pp. 105–109; and 'Art Speaks in Contemporary History: The Fitzpatrick Cartoons,' Vol. 39 No. 4 (July, 1945), pp. 550–551.

"The 'Letters of George Caleb Bingham to James S. Rollins' were published in issues of our *Review* from that for October, 1937, through that of July, 1939."

4. Iowa

Iowa Artists of the First Hundred Years, Zenobia B. Ness and Louise Orwig, Wallace-Homstead Co., Des Moines, 1939.

5. Minnesota

No review published although the article "Frontier Artists" by Bertha L. Heilbron, *American Heritage,* Winter, 1950, reviews briefly frontier art in Minnesota.

6. North Dakota

No published review.

7. South Dakota

No report.

8. Nebraska

Nebraska Art and Artists, Clara Bucklin, Lincoln, Neb., 1932. An account of early Nebraska artists by Martha Turner will be found on pp. 7–22.

9. Kansas

"Kansas Art and Artists," Edna Reinbach, *Collections of the Kansas Historical Society,* v. 17, pp. 571–585 (1928).

10. Oklahoma

No published review.

11. Texas

Art and Artists of Texas, Esse Forrester O'Brien, Dallas, 1935, 408 pp. Of particular interest from the standpoint of this book is the work of Herman Lungkwitz (1813–1891) on pp. 21–22 and H. A. McArdle (1836–1908) on pp. 26–29.

12. New Mexico

No published review although some account of early art in New Mexico is furnished by this book.

13. Colorado

No review available but again material in this book bears on the subject; see, for example, in the index the names of Charles Craig, Frank Sauerwen, Charles S. Stobie, J. D. Howland, Harvey Young, John Harrison Mills, Henry A. Elkins, and others.

14. Wyoming

"Artists of Wyoming," Olive Wills, *Annals of Wyoming,* v. 9, pp. 689–704 (1932–35); "Autobiography of Elling William Gollings, the Cow-Boy Artist," *Annals of Wyoming,* v. 9, pp. 704–714 (1932–35). Gollings (1878–1932) was a friend of Remington and Russel.

15. Montana

No report.

16. Idaho

No review published.

17. Utah

Devotees and Their Shrines—A Handbook of Utah Art, Alice Merrill Horne, Salt Lake City, 1914. Heber G. Richards has a short review, "George M. Ottinger, Pioneer Artist of Utah," in *Western Humanities Review,* v. 3, pp. 209–218, 1949. Ottinger (1833–1917) was not only a pioneer artist but a member of the celebrated firm of Savage and Ottinger, pioneer photographers.

18. Nevada

No review published.

19. Arizona

No review published.

20. California

I have received no report on books or reviews of the history of art in California other than the PWA project *California*

Art Research, some of which are listed in the notes to a number of chapters, but Eugen Neuhaus, *The History and Ideals of American Art* (Stanford University, 1931), reviews the work of many California artists although this book suffers, as do most so-called histories of art, from a lack of an adequate and reliable bibliography. Biographical sketches (again with no statement of the source of information) of a number of early California artists will also be found in the catalog *California Centennials Exhibition of Art,* Los Angeles, 1949.

21. Oregon
 No report.
22. Washington
 No report.

2. There were other Kansans who contributed scenes of Kansas events to the illustrated press in the early years of the state, but the work of such artists is usually difficult to identify. For instance, Lawrence during the Quantrill raid of 1863 was depicted in *Harper's Weekly,* v. 7 (September 5, 1863), p. 564 (full page). The illustration is not signed nor does the legend or the text in the *Weekly* make any attempt to identify the artist; it is quite probable that the illustration was purely imaginary. In the issue of the *Weekly* for September 19, 1863, p. 604, however, there appears the full-page illustration, "The Ruins of Lawrence, Kansas.—Sketched by a Correspondent."

In 1940, Harry Still of Lawrence claimed that his grandfather, Henry Still, made the sketch in the *Weekly* for September 5, 1863; see Lawrence (Kansas) *Journal World,* March 21, 1940. Henry Still, according to his grandson, lived in Tonganoxie, some 15 miles from Lawrence, and he visited Lawrence the day of the raid and made drawings. Sketching was Still's hobby, according to the younger Still, and after making the drawings they were sent to the *Weekly.* Harry Still refers only to the sketch in the issue of the *Weekly* for September 5, 1863, but it seems more probable, from the legends of the two drawings stated above, that the second drawing may have been an attempt at factual depiction of Lawrence after the raid by Still. Still may have drawn the first illustration but the action it portrayed was undoubtedly imaginary.

While on the topic of early Kansas sketches, several very interesting ones of Atchison appear in *Harper's Weekly* for 1866: "Eastern Terminus of Butterfield's Overland Route, Atchison, Kansas," "Driving the First Spike on the Atchison and Pike's Peak Railroad," and "Butterfield's Overland Mail-Coach Starting Out From Atchison, Kansas," in the issue of January 27, 1866, v. 10, p. 56, and "Commercial Street, Atchison, Kansas," in the issue of July 28, 1866, p. 476. All four sketches are credited to "William M. Merrick." William Marshall Merrick was undoubtedly a citizen of Kansas when the sketches were made, for according to George Byron Merrick, *Genealogy of the Merrick-Mirick-Myrick Family of Massachusetts* (Madison, Wis., 1902), p. 360, a daughter of William was born in Atchison on March 11, 1866, and another in Lawrence on September 29, 1868. Merrick himself was born in 1833 in Wilbraham, Mass., and at the time the above *Genealogy* was published in 1902, he was "a draughtsman by profession, with his office in Chicago." No subsequent data on Merrick has been found.

This note might very well be extended into some pages if all the minor (minor in number, but not in interest) illustrators of Kansas were considered. Note, of course, that we are restricting ourselves for the moment to Kansas illustrations by citizens of Kansas. Traveling artists, such as Frenzeny and Tavernier, considered in a previous chapter, have left important pictorial records of Kansas. Again, we cannot make a complete survey of such artists at present but the first sketch—at least it is the first sketch in my records—made in Kansas may be noted here. It was "War Dance in the Interior of a Konza Lodge" and was drawn by the artist Samuel Seymour on August 24, 1819, near the site of Manhattan.—See Edwin James' *Account of an Expedition From Pittsburgh to the Rocky Mountains,* first published in Philadelphia, 1823. A reprint of this account (after an English edition) appears as volumes 14–17 in R. G. Thwaites, ed., *Early Western Travels* (Cleveland, 1905). The citation to the Seymour illustration will be found in v. 14 of the Thwaites edition, p. 209, and the illustration on the opposite page.

3. Part of the biographical information on Worrall stated above and in the text which follows will be found in obituary notices in the Topeka *Capital,* June 21, 1902, p. 6, col. 4; Topeka *Herald,* June 21, 1902, p. 1, col. 3; Topeka *State Journal,* June 21, 1902, p. 5, cols. 1, 2. J. W. Valentine (see

note 5), who was for many years an intimate friend of Worrall, wrote me on January 5, 1946, that Worrall was so despondent as a youth in Cincinnati that he twice attempted to commit suicide.

4. *Kansas Historical Collections*, v. 3 (1883–1885), p. 459. The speech, by Noble Prentis, was made, along with many other speeches, in Topeka on January 29, 1886.

5. Worrall's early musical activities in Topeka are recorded in the Topeka *State Record*, January 17, 1869, p. 4, col. 2; April 28, 1869, p. 2, col. 1; Topeka *Commonwealth*, October 13, 1869, p. 3, col. 3; his artistic activities in *ibid.*, August 4, 1869, p. 3, col. 1; November 23, 1869, p. 3, col. 1; *State Record*, April 2, 1870, p. 4, col. 3; his grape culture in *ibid.*, October 28, 1870, p. 4, col. 1; *Commonwealth*, March 31, 1875, p. 4, col. 1. The *State Record* for July 1, 1870, p. 4, col. 1, reports Prof. Henry "Worrell [sic] makes one of his characteristic speeches tonight at the Congregational [raspberry] Festival, and plays on his wood and straw piano." The *Valley Republican,* Kinsley, reported on February 23, 1878, p. 3, col. 2: "Our Kansas artist, who has a reputation almost national, Prof. Worrall, entertained a Kinsley audience last Saturday evening with one of his interesting crayon and musical programmes. The verdict of rich, rare, and racy was voted unanimously. Prof. Worrall is a genius and a gentleman, and he can always secure a full house here. Come again." The Topeka *State Record*, August 23, 1870, p. 4, col. 2, states Henry Worrall perpetrated a "sell" on George W. Crane.

Worrall's musical activities in Cincinnati were described by J. W. Valentine of Kansas City, Mo., in letters to the author dated January 4 and 5, 1946. Worrall apparently was a teacher in a conservatory of music in Cincinnati. He played not only the guitar, on which he was a real expert, but the violin, the viola, the flute, the double bass and other instruments. For a time he traveled with a celebrated violinist, Tasso by name, as accompanist. Mr. Worrall met his wife, according to Mr. Valentine, at the Cincinnati conservatory where he gave her guitar lessons.

6. These caricatures began to appear early in his Topeka career. The Topeka *Commonwealth*, August 4, 1869, p. 3, col. 1, states: "Worrall, the prince of artists and musicians, has concocted and executed a most admirable burlesque on the picture of the infantile groupe of the Commonwealth proprietors, recently taken by Capt. Knight [a well-known Topeka photographer]. A peep at Worrall's carricature is worth more than a physician's prescription for the worst case of biliousness. Knight has taken photographic copies of the carricature"; and on May 11, 1871, p. 4, col. 2, the *Commonwealth*, "At McMeekin's is a fine engraving, executed by Topeka's celebrated artist and caricaturist, Prof. [Henry] Worrall, of Wild Bill [Hickok, the famed marshal of Abilene] 'toting' on his shoulder the refractory and absconding councilman of Abilene. Knight has photographed it. . . ."

7. Mr. Valentine, then in his eighties, so wrote me on January 4, 1946.

8. Worrall's illustrations, when signed, have signatures in various forms. Probably "H. Worrall" was used the most frequently but in addition "Worrall," "H. W.," "W" and occasionally an "H" superimposed over a "W" are employed.

9. The illustrations will be found in *Harper's Weekly* as follows: 1, vol. 21 (September 15, 1877), p. 720; 2 (September 22, 1877), p. 748; 3, vol. 23 (February 8, 1879), p. 105; 4 (July 5, 1879), p. 532; 7 (September 13, 1879), p. 733; 9, vol. 28 (April 5, 1884), p. 224; 10, vol. 30 (February 27, 1886), p. 132 (redrawn by Charles Graham); 11, vol. 37 (March 4, 1893), p. 200 (redrawn by W. P. Snyder from sketches by Worrall and photographs), p. 210; 12, vol. 37 (September 30, 1893), p. 928; 13, vol. 38 (September 29, 1894), p. 920. In *Leslie's Weekly*, there will be found 5, vol. 49 (August 9, 1879); 6 (August 23, 1879), p. 417; 8, vol. 50 (April 17, 1880), p. 105.

Other Worrall illustrations in *Leslie's Weekly* will be found in the issues of Oct. 18, 1879, pp. 105, 108; March 12, 1885, p. 97; Apr. 4, 1885, pp. 105, 113.

The New Mexico illustrations listed here and above in the text were secured in part at least in a visit to New Mexico in 1886, for under the title "Seeking Subjects" the Santa Fe *Daily New Mexican,* Jan. 19, 1886, p. 4, c. 4, reports the visit of three artists, Worrall of Topeka, C. T. Webber of Cincinnati, and Henry Mosler "of France." Mosler was reported as having two commissions for Indian paintings that were to pay him $25,000 each. The party were to tour New Mexico for six weeks. Worrall, the same account stated, had been in Santa Fe "three years ago"; the other

two were making their first visit to Santa Fe and New Mexico. Henry Mosler (1841–1920) was an American who lived abroad for many years; see *Dictionary of American Biography*, v. 13, p. 279.

10. Glenn Danford Bradley, *The Story of the Santa Fe* (Boston, 1920), pp. 151, 152. The Denver and Rio Grande narrow gauge from Pueblo had crossed the mountains (through Veta pass) and had reached Fort Garland in the San Luis valley in 1877.

11. A glowing account of the trip over the pass appears in the New York *Semi-Weekly Tribune*, January 29, 1878, p. 5, col. 1, and Helen Hunt (Jackson) had likewise described its wonders in "A New Anvil Chorus," *Scribner's Magazine*, v. 15 (January, 1878), pp. 386–395. The article is credited in the index of *Scribner's* to "H. H."

12. According to Bradley, *op. cit.*, p. 204, the New Mexico & Southern Railroad Company reached Las Vegas on July 4, 1879.

13. *Harper's Weekly*, v. 21 (September 22, 1877), p. 748. For a modern review of this famous border battle see James C. Malin, *John Brown And the Legend of Fifty-Six* (Philadelphia, 1942), pp. 619–628.

14. For the significance of the John Brown monument as a part of the John Brown legend, see *ibid.*, ch. 14.

15. *Harper's Weekly*, v. 23 (February 8, 1879), pp. 105, 106; see, also, Topeka *Commonwealth*, January 14, 1879, p. 3, cols. 2–4.

16. *Kansas*, American Guide Series (New York, 1939), p. 329. For studies of the Negro colonization in Kansas during the 1870's, see Nell Blythe Waldron, "The Colonies Organized by the Negro Race," in "Colonization in Kansas From 1861 to 1890," doctor's dissertation, Northwestern University, Evanston, Ill., 1923, pp. 121–131; also Lee Ella Blake, "The Great Exodus of 1879 and 1880 to Kansas," master's thesis, Kansas State College, Manhattan, 1942. The Blake study includes a letter of Gov. John P. St. John, dated January 16, 1880, which states "that since last April, 15,000 to 20,000 colored refugees have arrived in Kansas." The statement of Senator Ingalls given in the text will be found in *Harper's Weekly*, v. 23 (July 5, 1879), p. 534; see, also, *ibid.* (May 17, 1879), pp. 384, 386.

17. That outside aid was very real is shown by the fact that the Kansas Central Relief Committee received donations from outside the state of nearly $75,000 in cash, $75,000 in army rations, and 265 carloads of supplies, among other contributions.—*Kansas Central Relief Committee, Report of the Executive Board* (Topeka, 1875), pp. 3–7.

18. *Harper's Weekly*, v. 28 (April 5, 1884), pp. 223, 224.

19. Hermann Hagedorn, *Roosevelt in the Bad Lands* (Boston, 1930), appendix, p. 482.

20. For a review of the Kansas political troubles of 1893, see *Kansas Historical Collections*, v. 16 (1923–1925), pp. 425–431.

21. For contemporary newspaper accounts of the opening of the Cherokee strip see the Arkansas City *Daily Traveler*, September 12–19, 1893. The issue of the *Traveler* for September 16, 1893, p. 1, has five illustrations depicting various aspects of the opening of the strip, all of which are signed "D. Gibson." As one of them depicts an incident that took place on September 16 the illustration must represent an imaginary event. It is my guess that Gibson was an illustrator for a metropolitan newspaper sent to cover the event. For photographs of the opening of the strip, see *Leslie's Weekly*, September 28, 1893, p. 208 (the photographs are credited to "Rogers, Wichita"); and in more recent times "Strip" photographs can be found in George Rainey, *The Cherokee Strip* (Guthrie, Okla., 1933).

22. The *Reports* of the Kansas State Board of Agriculture indicate that suggestions and attempts for irrigation were solutions often sought in the relief of arid western Kansas, especially after the large influx of immigrants to the region in the early 1880's followed by the disastrous drought of 1887; see, for example, "Irrigation for Homesteaders in Western Kansas," *Seventh Biennial Report of the State Board of Agriculture* (1889–1890), Pt. II, pp. 219–223, and *Ninth Biennial Report* (1894–1895), pp. 324–379; see, also, James C. Malin, *Winter Wheat in the Golden Belt of Kansas* (Lawrence, 1944), pp. 90, 91, for earlier suggestion on irrigation. Worrall, himself, had a signed review of irrigation in western Kansas in the issue of *Harper's Weekly* that contained his illustrations (September 29, 1894, p. 931).

23. Full page, p. 624.

24. Topeka *Commonwealth*, August 4, 1872, p. 4, col. 4.

25. Topeka *Daily Commonwealth*, September 23, 1869, p. 3, col. 3; D. W. Wilder, *Annals of Kansas* (Topeka, 1886), pp. 509, 510, states that the cartoon was published in the *Kansas Farmer*, November, 1869. This issue, however, is lacking from the file of the *Farmer* available in the State Historical Society.

26. For Capt. J. Lee Knight, see Robert Taft, "A Photographic History of Early Kansas," *Kansas Historical Quarterly*, v. 3 (1934), pp. 3–14.

27. For the great drought of 1860 see the discussion by James C. Malin, "Dust Storms," in *ibid.*, v. 14 (May, 1946), pp. 137–144.

28. For "Drouthy Kansas," see Topeka *Commonwealth*, September 23, 1869, p. 3, col. 3; March 31, 1875, p. 4, col. 1. The sketch is reproduced (full page) on p. 41 of Hutchinson's *Resources of Kansas* (Topeka, 1871). The State Historical Society possesses one of the advertising broadsides of the *Kansas Farmer* as well as a duplicate in oil of the sketch. The original sketch was a charcoal drawing according to some of the above contemporary accounts. The *Report of the State Board of Agriculture . . . 1873* (Topeka, 1873), reported (p. 47) that "Prof. Henry Worrall exhibited the original sketch of 'Drouthy Kansas' so widely copied and well known" at the exhibition of the State Agricultural Society in September, 1870.

29. Topeka *Commonwealth*, March 31, 1875, p. 4, col. 3.

30. The *Kansas Daily Commonwealth* (Topeka), July 31, 1873, p. 4, c. 3, has the item: "Prof. Henry Worrall, of Topeka, is in Denver and vicinity taking views of the different scenes along the cattle trails and of the live stock business generally. These views are to be incorporated in a book shortly to be issued, entitled: 'The Cattle Trade of the West and Southwest; what it has been and is and what it will be in the near future.' The book is to be issued by J. G. McCoy, the pioneer western cattle shipper, and senior member of the well-known live stock firm of J. G. McCoy & Co., of Kansas City."

According to Ralph P. Bieber, who edited a reprint of McCoy's book, *Southwest Historical Series*, v. 8 (Glendale, Cal., 1940), pp. 65, 66, the McCoy book appeared originally as a series of joint articles by McCoy and J. Parker Mitchner in *The Cattle Trail*, a weekly Kansas City paper. McCoy collected and enlarged the series and published it under the title given above in the text. A facsimile reprint of McCoy's book was also published by The Rare Book Shop, Washington, D. C., in 1932. The latter is an admirable supplement to Bieber's exhaustive and painstaking work, for it gives the student an exact copy of McCoy's original book (now a collector's item and very scarce), while the Glendale reprint makes no attempt to render the McCoy book in facsimile and omits many of the cruder illustrations and the very interesting and useful advertisements appearing in McCoy's original edition. Incidentally there must be at least two binding or printings of McCoy's original work, for the reprint of 1932 contains two pages of advertisements between pages 22 and 23 which do not occur in 1874 editions (University of Kansas and State Historical Society copies) which I have examined.

31. The first comment is that of James C. Malin, "Notes on Historical Literature of the Range Cattle Industry," *Kansas Historical Quarterly*, v. 1 (1931–1932), p. 74, and the second is by E. E. Dale, *The Range Cattle Industry* (Norman, Okla., 1930), p. 204.

32. For example, on p. 25 of McCoy there appears the illustration, "Mobbing Dougherty in Southwest Missouri," which is supposed to depict a scene in 1866 before Worrall came West; in the same category is "Abilene in 1867" on p. 45.

33. Joseph G. McCoy, "Historic and Biographic Sketch," *Kansas Magazine*, Wichita, v. 2, December, 1909, pp. 45–55.

34. See Chap. VII, p. 101.

35. The McCoy book was out by May 28, 1874, as notice of it appeared in the Wichita *Eagle* for that date (cited by Bieber, *op. cit.*, p. 66); the Frenzeny and Tavernier illustration appeared in *Harper's Weekly*, v. 18 (May 2, 1874), p. 386.

36. For a more satisfactory depiction of the longhorns see the advertisements of Hunter, Evans & Co. or of White, Allen & Co., in the advertising pages of McCoy, *op. cit.* The artist who has spent the greatest study and care in depicting the longhorn is Henry W. Caylor of Texas. His work will be discussed in more detail in Chapter XVI.

37. McCoy, *op. cit.*, p. 394.

38. McCoy in *Kansas Magazine*, December, 1909, p. 47.

39. The copy I have used is W. E. Webb, *Buffalo Land* (Cincinnati and Chicago: E. Hannaford & Company. San Francisco:

F. Dewing & Co., 1872). I have seen a Library of Congress card for the book cited as above and another Library of Congress card reading the same as above save that the name of the San Francisco publisher was omitted. *The American Catalogue* (New York, 1880), p. 791, lists the same title with the publisher, Maclean, Philadelphia, 1872, and Henry Fairfield Osborn, *Cope: Master Naturalist* (Princeton, N. J., 1931), p. 703, cites still another publisher for Webb, "Hubbard Bros., Philadelphia, 1872." The *American Catalogue,* p. 16, states of Maclean, "now ceased publication." The *British Museum Catalogue of Printed Books* (London, 1884), v. 55, lists an edition of *Buffalo Land* for "Philadelphia, 1873."

The subtitle of *Buffalo Land* reads, "An Authentic Account of the Discoveries, Adventures, and Mishaps of a Scientific and Sporting Party in the Wild West. . . . Replete with Information, Wit, and Humor." The illustrations are credited on the title page, "From actual photographs, and original drawings by Henry Worrall."

40. *Buffalo Land,* p. 76.

41. I have made some effort to determine if Webb's account is that of a real expedition or not. The expedition which Webb reports, seems to have taken place in the fall of 1868. On page 366 of his book Webb speaks of the death of Dr. Moore (J. H. Mooers) and Lieutenant Beecher as a recent event. Both of these men were killed on September 17, 1868, at the Battle of Beecher's Island on the Arickaree in eastern Colorado. The frontispiece by Worrall bears the date "69." Webb also quotes at long length from a report by the naturalist, E. D. Cope (pp. 339–365 of *Buffalo Land*). Cope's full-length report from which the above-mentioned excerpt is taken appears in Survey of Montana, *Fifth Annual Report of Progress* (Washington, 1872), Pt. III, pp. 318–349. Cope, in the full-length report, speaks several times of Webb (pp. 319, 325, 336, and on p. 327 Cope refers to "my friend Dr. Wm. E. Webb of Topeka"). Henry Fairfield Osborn, *Cope: Master Naturalist,* discusses Cope's trips to Kansas in search of paleontological material but Cope's first Western trip was not made until 1871. Cope (Osborn, *op. cit.,* p. 161), in a letter dated Topeka, September 7, 1871, stated that he was planning a special expedition in November, 1871, "with Webb to combine fossils and land business. Such an opportunity is very fine with a man who knows the ground." No subsequent letters of Cope appear in Osborn that would indicate whether the trip was made or not and Dr. Edwin H. Colbert of the American Museum of Natural History, who is preparing a biography of Cope, writes me that he has been unable to find any letters of Cope (or field notes) that would indicate whether the Webb-Cope expedition was made.

This extensive note is made as there is the possibility that Webb's character "Professor Paleozoic" was Cope, but it now appears unlikely. Prof. O. C. Marsh was another pioneer paleontological collector in western Kansas but an examination of Charles Schuchert's and Clara Mae Le-Vene's *O. C. Marsh* (New Haven, 1940), makes it appear unlikely that Marsh had any connection with Webb. Still another possibility, if Webb's character "Professor Paleozoic" had an actual prototype, is Prof. B. F. Mudge, for many years geologist of the Kansas State Board of Agriculture. Mudge was a collector for Marsh (see *O. C. Marsh* cited above) and is known to have made many collecting expeditions; see letters by a member of Mudge's party in Leavenworth *Conservative,* November 2, 4, 10, 12, 1869 (each letter is printed on page 2).

Still another possibility is that Webb conducted a party through western Kansas consisting of Louis Agassiz (the well-known naturalist of Harvard University), Sen. Roscoe Conkling of New York, Samuel Hooper of Boston, J. P. Usher, Secretary of the Interior in Lincoln's cabinet, and others. Agassiz and the party were in Leavenworth in August, 1868 (Leavenworth *Conservative,* August 28, 1868, p. 1, cols. 1, 2) and went to the end of the rail on the Kansas Pacific and then overland to Denver, returning east by way of the Union Pacific through Nebraska.—Elizabeth Cary Agassiz, *Louis Agassiz* (Boston, 1886), v. 2, p. 661. Some connection with the National Land Company (of which Webb was manager) and Agassiz is indicated by a paragraph in the Topeka *State Record,* November 4, 1868, p. 2, col. 2, and by a statement in *Buffalo Land* (p. 326) in discussing the fossil remains of a huge reptile discovered by the party near Sheridan, Kan. "It" (the fossil), writes Webb, "now rests in the museum at Cambridge, Massachusetts."

There is, of course, the possibility that the Webb expedition was a composite of several expeditions. The *Kansas Magazine*, Topeka, v. 2 (July, 1872), p. 100, states that *Buffalo Land* "embraces the results of extensive personal experiences and observations within the last three years." The *Kansas Daily Commonwealth*, March 9, 1872, p. 2, c. 1, however, in commenting on Webb's *Buffalo Land* "soon to be published" stated that it was based upon "incidents of the trip of an eastern scientific and sporting party, last summer, through western Kansas."

I am unable to reconcile these various conflicting statements; at present, my opinion is that the Webb experiences as told in *Buffalo Land* are a composite of several expeditions.

Webb was "a gentleman well known throughout the State in connection with land and immigration affairs."—*The Kansas Magazine*, v. 1 (April, 1872), p. 383. The title page of *Buffalo Land* cites him as "W. E. Webb of Topeka, Kansas," and Andreas-Cutler, *History of the State of Kansas*, p. 1291, states that in 1866 a party from St. Louis, including W. E. Webb, selected lands for colonization in the vicinity of present Hays. F. E. Haas, register of deeds of Ellis county, wrote me under date of April 15, 1946, that William E. Webb acquired title to the SW¼ of 33-13S-18W from the Union Pacific Railway company by warranty deed dated October 26, 1868; this quarter section is now part of the townsite of Hays. Webb's name can occasionally be found in the Topeka papers for the period under discussion. For example, the *Commonwealth*, August 4, 1869, p. 3, col. 2, describes preparations for a Western trip over the K. P. R. W. by a party including "Dr. Webb and wife, of the National Land Company," and the *State Record* on January 20, 1869, p. 4, col. 1, reports the marriage of "Dr. W. E. Webb, the Manager of the National Land Company."

Webb was also the author of two articles entitled, "Way Down South Among the Cotton," published in *The Kansas Magazine*, v. 1 (May, 1872), pp. 406–415; (June, 1872), pp. 518–522, and "Neb, the Devil's Own," v. 2 (August, 1872), pp. 128–133. The latter article recites presumably some of Webb's experiences at Sheridan, Kan., "four years ago." To this Webb bibliography should be added his article

"Air Towns and Their Inhabitants" in *Harper's Magazine*, v. 51, pp. 828–835, November, 1875. The article is based on Webb's recollections of the frontier western Kansas towns of Coyote and Sheridan and is illustrated by three cartoons, uncredited, which may well have been the original work of Worrall.

The *Kansas Historical Collections*, v. 10 (1907–1908), has a brief biographical sketch of Webb stating that he represented Ellis county in the state legislature of 1868 and that he platted Hays City (present Hays) in 1867, concluding with the statement, "He died in Chicago." Mr. Stanley Pargellis of the Newberry Library, Chicago, recently wrote me that their genealogical department had no information on Webb and that the Chicago Historical Society and the Chicago Bureau of Vital Statistics could furnish no information on Webb. Webb moved to Chicago late in 1872 (*Kansas Daily Commonwealth*, Topeka, Oct. 5, 1872, p. 4, c. 1; Oct. 21, 1872, p. 4, c. 1; Jan. 10, 1873, p. 4, c. 1). Miss Elizabeth Baughman of the Chicago Historical Society has searched Chicago city directories for me and reports that a William E. Webb, who is without doubt the Webb of *Buffalo Land*, is listed in Chicago directories for the period 1873–1879 inclusive. Although I have made many attempts to trace him from there, the results have so far been fruitless.

42. *The Kansas Magazine*, v. 1 (April, 1872), pp. 383, 384. Worrall may not have been on any western excursion with Webb himself but he had been on several extensive sight-seeing and buffalo hunting excursions himself. Extensive accounts of at least one of these appear in the Topeka *Commonwealth*, October 19, 1873, p. 4, c. 2; October 28, p. 4, c. 2, 3. Another such excursion was made in 1871 for the Kansas State Historical Society possesses photographs of a number of Worrall sketches made on a buffalo hunt dated "November 1, 2 and 3, 1871."

43. *Ibid.*, v. 2 (July, 1872), p. 100. The books of Greeley and Richardson referred to are, of course, Horace Greeley, *An Overland Journey* (New York, 1860), and Albert T. Richardson, *Beyond the Mississippi* (Hartford, Conn., 1867), and subsequent editions.

44. *Kansas Historical Collections*, v. 9 (1905–1906), p. 505.

45. Topeka *Herald*, June 21, 1902, p. 1.

CHAPTER IX

Custer's Last Stand

1. Note that portraits have not been included in the list. If such pictures were included, mention should be made of Whistler's "Mother" and Gilbert Stuart's "Washington." The story of Willard's "Spirit of '76" will be found in an interesting privately printed item of Americana by Henry Kelsey Devereux, *The Spirit of '76* (Cleveland, 1926). I mention this fact because "The Spirit of '76" is probably the closest competitor for the author's candidates of popular favor, yet it is not mentioned in such histories of American art as Samuel Isham's *The History of American Painting* (New York, 1927), nor in Eugen Neuhaus, *The History & Ideals of American Art* (Stanford University, 1931). Neuhaus, however, does point out (p. 143) that when Hovenden's "Breaking Home Ties" was exhibited at the great Chicago Fair of 1893 "the carpet in front of it had to be replaced many times; it was easily the most popular picture of that period." Many years later the same picture was exhibited in San Francisco and St. Louis and was apparently as popular as ever.

The "September Morn" of Chabas attracted· tremendous attention, partly because of the activities of Anthony Comstock, when it was first exhibited in this country in 1913, as can be seen by examining the *New York Times Index for 1913*. The widespread attention was but temporary, however, for "September Morn" is remembered now only by oldsters who were impressionable youths at the time of its first appearance. The other paintings listed above are such well-known favorites that further comment seems unnecessary.

2. To the writer's mind, the most satisfactory biography of Custer is Frederic F. Van de Water's *Glory-Hunter* (Indianapolis, 1934). No sooner had it appeared, however, than it was the subject of violent and bitter criticism. No less a person than Gen. Hugh Johnson, of N.R.A. fame, despite a very obvious lack of knowledge, launched an attack on the book.—"General Johnson Rides to the Defense," *Today*, December 29, 1934, p. 16; *see, also,* the New York *Times*, December 27, 1934, p. 19, col. 6; December 28, 1934, p. 20, col. 4 (editorial); January 4, 1935, p. 20, col. 6. That the subject of Custer and the battle of the Little Big Horn is one of perennial

interest is shown by the fact that in the last 25 years the index of the New York *Times* reveals that discussions, notices, letters, articles, etc., have appeared over 40 times. The most extensive bibliography of Custer material will be found as an appendix to Fred Dustin's *The Custer Tragedy* (Ann Arbor, Mich., 1939, 251 pp.). Mr. Dustin lists nearly 300 items in his bibliography which scarcely touch the truly voluminous mass of newspaper material on Custer which has accumulated since 1876. *The Custer Tragedy* bears evidence of painstaking and exhaustive work and is one of the most valuable sources of information on the battle of the Little Big Horn available to the student. Other Custer items that have come to the writer's attention since the publication of the Dustin book are: Charles J. Brill, *Conquest of the Southern Plains* (Oklahoma City, 1938), a severe criticism of Custer's Washita campaign; Edward S. Luce, *Keogh, Comanche and Custer* (St. Louis, 1939); Katherine Gibson Fougera, *With Custer's Cavalry* (Caldwell, Idaho, 1940); Charles Kuhlman, *Gen. George A. Custer*—also called *Custer and the Gall Saga* (Billings, Mont., 1940), by a real student of Custer's career; F. W. Benteen, *The Custer Fight* (Hollywood, Cal., 1940), published by E. A. Brininstool, another Custer student; William Alexander Graham, *The Story of the Little Big Horn* (sec. ed., Harrisburg, Pa., 1942), a standard work the first edition of which was published in 1926; Albert Britt, "Custer's Last Fight," *Pacific Historical Review*, Berkeley and Los Angeles, Cal., v. 13 (March, 1944), pp. 12–20, undocumented; Fred Dustin, "George Armstrong Custer," *Michigan History Magazine*, Lansing, v. 30 (April–June, 1946), pp. 227–254, a biographical review. Recently (1950) Col. W. A. Graham (retired) of Pacific Palisades, Calif., has published at his own expense the *Official Record of the Court of Inquiry* that investigated in 1879 Major Reno's conduct at the battle of the Little Big Horn three years earlier. Col. Graham has made all students of the Custer battle his debtors in the publication of this extensive record. The most recent publication at the time this book goes to press is Charles Kuhlman's *Legend into History* (Harrisburg, 1951).

3. See the classification of pictures suggested in the notes to the Preface. Pictures of the Custer battle would be classed in the second and fourth groups there given.

4. It is worth a few moments of anyone's time to listen to the critical comments and the discussion of detail not immediately apparent, which result as groups of observers, both young and old, cluster around Adams' and Becker's "Custer's Last Rally."

5. For those who wish, examination of the battlefield itself would be in order. According to Dustin, *The Custer Tragedy* p. xi, some changes in the course of the Little Big Horn river have occurred since 1876 but the general features of the landscape, of course, remain the same.

6. *Ibid.,* p. xiv. Reprinted through the courtesy of Mr. Dustin.

7. *The Tepee Book* (Sheridan, Wyo., June, 1916), p. 50.

8. New York *Times,* June 19, 1927, p. 13, col. 2.

9. The absurd pictorial climax of the Warner Brothers picture of 1941, *They Died With Their Boots On,* shows Custer, the final survivor, surrounded by a group of prostrate soldiers arrayed in new and scarcely wrinkled uniforms; see *Life,* December 8, 1941, pp. 75–78.

10. Dustin, *The Custer Tragedy,* p. 185; *see, also,* p. 184. The monument mentioned by Dustin above is one erected on the summit of the ridge overlooking the valley of the Little Big Horn river and is part of the Custer Battlefield National Cemetery, Crow Agency, Montana. On the monument are inscribed the names of those who fell during the battle. For the topography of the battle site, see the reproduction of the Morrow photograph of 1877 opposite p. 376. in *The Kansas Historical Quarterly,* Nov., 1946. This photograph, by S. J. Morrow of Yankton, Dakota territory, is one of a group of 12 photographs made by Morrow, at the interment of the Custer soldiers in June and July, 1877.—*See* Robert Taft, *Photography and the American Scene* (New York, 1938), p. 307. The burial party which Morrow accompanied consisted of Company I of the 7th cavalry under the command of Capt. H. J. Nowlan. Captain Nowlan's command reached the military cantonment on the Tongue river on the way to the Custer battlefield on June 20, 1877, and after completing the burial returned to the cantonment on July 13, 1877.—*House Executive Documents,* 45 Cong. 2 Sess. *Doc. No. 1,* Part 2 (Washington, 1877), v. 1, pp. 540, 544, 545. Further description of the burial party of 1877 will be found in Joseph Mills Hanson,

The Conquest of the Missouri (Chicago, 1909), Ch. 44.

11. Thomas B. Marquis, *A Warrior Who Fought Custer* (Minneapolis, 1931). Dr. Marquis has made a contribution of first rate importance to Custer literature in recording in simple language the story of Wooden Leg. Chapters VIII, IX, and X are devoted to the battle of the Little Big Horn.

12. *Ibid.,* p. 245. Reprinted by permission of the copyright owners, The Caxton Printers, Caldwell, Idaho.

13. *Ibid.,* p. 219.

14. *Ibid.,* pp. 224, 230, 243.

15. *Ibid.,* pp. 229–231.

16. *Ibid.,* p. 274. Marquis also attributed the low losses among the Indians to extensive suicide among the troops.

17. Dustin, *The Custer Tragedy,* p. 184.

18. Hamlin Garland, "General Custer's Last Fight As Seen by Two Moon," *McClure's Magazine,* New York City, v. 11 (September, 1898), pp. 443–448.

19. *Ibid.,* p. 448.

20. Dustin, *The Custer Tragedy,* p. 225.

21. Charles A. Eastman, "Rain-in-the-Face, The Story of a Sioux Warrior," *The Outlook,* New York, v. 84 (October 27, 1906), pp. 507–512. Rain-in-the-Face also stated that Custer fought with "a big knife saber." Two Moon (Garland, *loc. cit.*) reported a trooper (possibly a scout) who "fought hard with a big knife." These statements, as against the statement of Dustin that no sabers were used, are difficult to reconcile and indicate some of the difficulties in obtaining specific facts with certainty at this late date. It should, of course, be noted, that the statements of Two Moon and Rain-in-the-Face are recollections made many years after the battle of 1876.

For other important recollections of Custer and the Custer battlefield *see* "After the Custer Battle," edited by Albert J. Partoll, in the historical section *Frontier and Midland* (Missoula, Mont.) v. 19, no. 4, 1939.

22. Dustin, *The Custer Tragedy,* p. 188; Marquis, *op. cit.,* Chapter X; Eastman, *loc. cit.*

23. For the reader who wishes to review briefly the main features of the battle of the Little Big Horn the following summary may be useful:

During the summer of 1876, a vigorous and three-pronged campaign was planned by the U. S. Army in an attempt to force the Plains Indians back to their reserva-

tions. One prong, led by Gen. A. H. Terry, came into present Montana from the east and reached the mouth of the Tongue river, where it empties into the Yellowstone river, early in June, 1876. Here, after some delay, the 7th cavalry under Lieutenant Colonel Custer (Col. S. D. Sturgis, the commanding officer of the 7th, was on detached duty) was sent south by Terry to locate any concentrations of hostile tribes supposed to be in the open country of southeastern Montana. It was this move that led to the fateful engagement.

About 12 or 15 miles from the scene of battle General Custer divided his command, the 7th cavalry, into four battalions, two of which were commanded by Custer personally, another was commanded by Major Reno and the fourth by Captain Benteen. At the time the division was made, the 7th cavalry was on a small tributary of the Little Big Horn. Captain Benteen's battalion was detached and ordered to move to the left and to scout and engage any hostiles encountered. Custer's and Reno's battalions proceeded down the tributary toward the Little Big Horn but on its opposite sides. Upon nearing the Little Big Horn, Reno received orders from Custer to advance across that stream and attack the Indians who were now believed to be close at hand in force. Custer turned to the right before reaching the Little Big Horn and soon found himself cut off from Reno and Benteen and overwhelmed by the Indians in the hills overlooking the river.

Reno, meanwhile, had encountered, after making contact with the Indians, such stiff resistance that he fell back to the river and was finally forced to re-ford it, taking refuge in the high bluffs above the river where he was joined by Benteen's command. Here the combined battalions were able to hold the Indians at bay for two days until relieved by General Terry and the infantry under his command. Reno's and Benteen's losses amounted to nearly 50 killed and a somewhat larger number wounded. "The defense of the position on the hill [by Reno and Benteen]," reads the official report of the court of inquiry, "was a heroic one against fearful odds."

This brief outline of the action of the 7th cavalry on June 25–27, 1876, is based on "General Orders No. 17," March 11, 1879, a report of the court of inquiry requested by Major Reno. It will be found quoted in Dustin, *The Custer Tragedy*,

p. 210. Casualties of the 7th cavalry during the above days will be found in Appendixes II and III of *ibid.*, pp. 225–230. The dead of Custer's immediate command totaled 220.–*Ibid.*, p. 184.

Despite Reno's and Benteen's *successful* defensive stand against the overwhelming numbers of the Indians, the heroic action "against fearful odds" has scarcely attracted the attention of any artist.

24. This information on Mulvany's early life comes from obituaries in the New York *Sun*, May 23, 1906, p. 3, col. 1; New York *Times*, May 23, 1906, p. 9; New York *Tribune*, May 23, 1906, p. 6, col. 6, and the *American Art Annual*, 1907–1908, v. 6, p. 112. The last account states that he was born about 1842 but does not state the source of its information. None of the above accounts specifically states that Mulvany was *born* in Ireland but in an eight-page pamphlet, *Press Comments on John Mulvany's Painting of Custer's Last Rally* (no date, but published about 1882), there is a brief biographical sketch which doubtless was prepared by Mulvany himself and which states that he was "an Irishman by birth."

25. Chicago *Times*, August 13, 1882, supplement, p. 8, col. 8, and the *Art Journal*, v. 2 (1876), p. 159. The *Times* account above states that "The Trial of a Horse Thief" was "now the property of a Boston Gentleman." For reference to Mulvany in St. Louis, *see* note 41. The Cincinnati *Daily Gazette*, July 1, 1881, p. 8, c. 2, stated that Mulvany was a one-time resident of Cincinnati.

26. Kansas City (Mo.) *Daily Journal*, March 2, 1881, p. 5, col. 1. This account is a lengthy description of Mulvany's newly-completed painting as well as an interview with the artist. It is of major importance in any estimate of Mulvany's career.

27. Kansas City (Mo.) *Times*, March 17, 1881, p. 8, col. 3; March 19, 1881, p. 5, col. 3. Note that the Kansas City *Journal* account had appeared before the reporters as a group viewed the painting. Evidently it was the *Journal* description that whetted their appetites for they addressed a public letter to Mulvany requesting the privilege of seeing the painting.

28. Kansas City *Journal*, *loc. cit.*

29. *Ibid.*

30. Boston *Evening Transcript*, June 20, 1881, p. 6, cols. 3, 4. Part of the same account was reprinted (but credited to the

Boston *Advertiser*) in the Kansas City *Sunday Times*, June 26, 1881, p. 5, col. 2. I am indebted to the reference department of the Boston Public Library for verifying the location of the Boston *Transcript* account. The account is given in the Mulvany pamphlet mentioned in note 24, where it is credited to the *Transcript* of "June 21st, 1881." The pamphlet credits the account to "Ed. Clements."

31. New York *Tribune*, August 15, 1881, p. 5, col. 5. Whitman reprinted this account in his *Specimen Days*, first published in 1883; *see* Walt Whitman, *Complete Prose Works* (Philadelphia, 1897), p. 186.

32. Quoted in the Mulvany pamphlet cited in note 24 and credited to "Mr. Allison." The pamphlet dates the account "December 18, 1882." Miss Edna J. Grauman of the reference department, Louisville Free Public Library, has very kindly made an examination of the Louisville newspapers of the above date but could find no reference to the Mulvany picture. An examination of the Louisville *Commercial* for December 18, 1881, p. 2, described the painting and the Louisville *Courier-Journal* for December 18, 1881, p. 4, also had mention of the painting as follows:

CUSTER'S LAST RALLY

"This grand work of art is drawing crowds daily to the Polytechnic Society. At the special request of nearly all who see it season tickets have been issued at fifty cents each, entitling the holder to admission at all times, visitors on entering the room stand in awe and admiration for hours in some instances. It is truly the most thrilling and realistic picture ever brought to this city. The exhibition room adjoins the Polytechnic Library, entrance on the north side."

Miss Grauman also identified "Mr. Allison" as Young E. Allison, prominent Louisville writer and editor.

33. Mention and extensive discussion appear in the Chicago *Times*, August 6, 1882, supplement, p. 5, col. 8; August 13, 1882, supplement, p. 8, col. 8; August 20, 1882, p. 5, col. 8; August 27, 1882, supplement, p. 6, col. 8, and Chicago *Tribune*, August 13, 1882, p. 7, col. 7. I am greatly indebted to Miss Frances Gazda of the Newberry Library, Chicago, for the above extensive array of information. Miss Gazda writes me that the last mention of display of the painting is reported on September 9, 1882. In addition to the newspaper mention of the painting given above, the Mulvany pamphlet (*see* note 24) quotes from the Chicago *Weekly Magazine*, the Chicago *Citizen*, and still another account (not located) from the Chicago *Times*.

34. Chicago *Inter Ocean*, November 24, 1895, p. 35, col. 3, a six-paragraph account of Mulvany and his work.

35. Chicago *Times*, August 27, 1882, supplement, p. 6, col. 8. The *Times* for August 13, 1882, supplement, p. 8, col. 8, mentions a painting "On the Alert," but whether it is a Western picture is uncertain.

36. *Ibid.*, August 27, 1882, supplement, p. 6, col. 8, reports that "it will be returned to New York and then go to Paris for reproduction in photogravure"; *see, also,* Whitman's comment on p. 139. Mention of the exhibition of the painting in Chicago in 1890 is found in the concluding paragraph of the following account from the Denver *Republican*, September 23, 1890, p. 8, col. 2, which is reprinted in full as it gives considerable additional information on Mulvany's celebrity as an artist. I am indebted to Miss Ina T. Aulls, of the Western History department, Denver Public Library, for the account:

"Mr. John Mulvaney [*sic*], the artist who painted the celebrated picture of Custer's rally in the fatal fight of the Big Horn, is in Denver with friends. He arrived last Saturday night. For several weeks past he has been visiting his brother in Salida. He has been sketching all through the mountains during the past summer—up the Shavano range, along the line of the Colorado Midland and in the beautiful stretch of country about Marshall pass. His sketches, most of them, were done in colors, and many of them are paintings in themselves. From these rough and sketchy studies he proposes soon to give to the public some oil-paintings on an elaborate scale, of the picturesque scenery of the Rockies.

"He has with him a new painting which he has just finished. It is entitled 'McPherson and Revenge.' It is an incident from the battles about Atlanta. The most prominent figure in it is General John A. Logan. He is riding down the front of the rifle-pits and the improvised breastworks. He is materializing out of a white cloud of smoke that the guns of both sides have sent rolling across the field of battle. His horse is as black as night; as black as his own tossed hair. He seems a genius or a demon of battle. The soldiers have sprung out [of] the breastworks. They are waving

their hats in the air, shouting and yelling their enthusiasm for that splendid leader, who is sweeping down their hue. The picture is full of color; full of action, and the portrait of Logan is a telling likeness. The painting is 12 x 6 feet in dimensions, and is framed in an elegant gilt frame, twelve inches broad. The picture was only finished recently. It was never exhibited before in its finished form. It was on exhibition at the national convention which nominated Harrison for president. Some of the speakers of that memorable convention referred to it. It was only an earnest then of what it would be.

"Mr. Mulvaney still has 'Custer's Last Rally' in his possession. It made his fame. The picture is now in Chicago on exhibition. It has made a small fortune for its painter."

37. New York *Times*, May 23, 1906, p. 9.
38. Information to the writer from A. L. Schiel, secretary to Howard Heinz, president, in letters dated September 20, September 30, and October 17, 1940. In his last letter Mr. Schiel wrote that the painting was in storage but it was brought out and measured for me. The exact dimensions given by Mr. Schiel were 236 inches by 131 inches.
39. This fact is mentioned in the obituaries of Mulvany appearing both in the New York *Times* and in the New York *Sun.—see*, note 24.
40. Confer note 24. Since no other adequate biographical sketch of Mulvany has apparently been attempted, a listing of his paintings as they have been found in my newspaper search seems to be in order. Mulvany's paintings of Western interest have already been described in the text and will not be repeated here. The other titles found include "Love's Mirror" or "Venus at the Bath," "The Old Professor" (Kansas City *Times*, March 19, 1881, p. 5, col. 3; March 31, 1884, p. 8, col. 4; March 1, 1885, p. 2, cols. 1, 2; November 16, 1885, p. 5, col. 2; evidently the latter was quite a remarkable picture for I have seen other favorable comments on it); "A Discussion of the Tariff Question" (Chicago *Times*, August 27, 1882, supplement, p. 6, col. 8, two Southerners and a Negro servant in the living room of one of the heated debaters); "Sheridan's Ride from Winchester," "Sunrise on Killarney," "Sunrise on the Rocky Mountains" (Chicago *Inter Ocean*, November 24, 1895, p. 35, col. 3); "The Striker" (coal miner), "The Anarchist" (a

group of a half dozen men cutting cards to see who would commit murder), "An Incident of the Boer War," "Major Dunne of Chicago" (portrait), "Henry Watterson of Louisville" (portrait), "John C. Breckenridge" (portrait), paid for by Kentucky legislature (New York *Times*, May 23, 1906, p. 9); "The Battle of Aughrin," "The Battle of Atlanta" (New York *Sun*, May 23, 1906, p. 3, col. 1). There were probably many others. The New York *Times* cited above states, "He painted many other Western pictures which he sold for trifling sums."
41. Samuel Isham, *The History of American Painting* (New York, 1927), pp. 382, 383; Katherine Metcalf Roof, *The Life and Letters of William Merritt Chase* (New York, 1917), p. 25. It is apparent that Isham and Roof knew little about Mulvany. Roof even spells the name "Mulvaney" and Isham repeats the error. It should be pointed out out that the work of Mulvany seen by Chase did not include "Custer's Last Rally." According to Roof, Chase saw Mulvany's work in St. Louis about 1871 or 1872. If this date is correct, it would suggest that Mulvany lived in St. Louis for a time. Mulvany was evidently a restless spirit, never satisfied for long in one place. The account of Clements in the Boston *Transcript* of 1881 (*see* note 30) also states that not only was Mulvany responsible for Chase's trip to Munich but that he also furnished the incentive that sent Frank Duveneck, another important leader in American art, to Munich.
42. Kansas City *Star*, May 3, 1925, magazine section, p. 16.
43. The proprietor of the St. James Hotel of Kansas City brought suit in 1884 against Mulvany to recover judgment for $450, allegedly due "in the shape of borrowed money and an unpaid board bill of four years' standing," Mulvany was reported as being "now in Detroit."—Kansas City *Times*, March 31, 1884, p. 8, col. 4. Several of Mulvany's paintings were seized in the court action and sold by the sheriff under the execution to satisfy the judgment obtained by the hotel proprietor.—*Ibid.*, March 1, 1885, p. 2, cols. 1, 2.
44. This biographical information was obtained from Mrs. C. C. Adams of Washington, D. C., and William Apthorp Adams of Hammersley's Fork, Pa., a son of Cassilly Adams. Mrs. Adams wrote me that Cassilly Adams' birth date and Civil War record were obtained from the files of the

pension office in Washington. Cassilly Adams served as ensign on the U. S. S. *Osage* and was wounded at the battle of Vicksburg.

45. Adams is listed in the St. Louis city directories from 1879 to 1884 at various addresses: sometimes as an artist and sometimes as an engraver. W. A. Adams wrote me that his father lived in St. Louis from 1878 to 1885 and then moved to Cincinnati. Cassilly Adams died at Trader's Point (near Indianapolis), Ind., on May 8, 1921. (*See* death notices of Adams in Indianapolis *News*, May 9, 1921, p. 24, col. 1, and Indianapolis *Star*, May 9, 1921, p. 13, col. 8. I am indebted to the reference department of the Indianapolis Public Library for locating these notices.) Francis O. Healey, a retired art dealer of St. Louis, wrote me under date of October 15, 1940, that Adams and Hastings had a studio together.

46. Letters to the writer, August, 1946.

47. Letter to the writer, August 12, 1946. Cassilly Adams, according to his son, also painted many other Western pictures including Indians, buffalo hunting, and other game-shooting scenes. The illustrations for Col. Frank Triplett's *Conquering the Wilderness* (New York and St. Louis, 1883), were drawn in part *on wood* by Cassilly Adams according to W. A. Adams, although they are not so credited in the book itself. The title page of this book credits the *original* illustrations to "Nast, Darley and other eminent artists." As a matter of fact many of the illustrations have been borrowed from other books without the least attempt on the publishers' part to give due credit.

48. Kansas City *Gazette*, August 11, 1903, p. 2, col. 1. In a letter to the writer dated October 3, 1940, Maj. E. C. Johnston, then adjutant of the 7th cavalry, also stated (from the records of the 7th cavalry) that the painting was acquired by a saloon-keeper. The owner of the saloon was identified as one John Ferber but examination of the city directories of St. Louis for the years 1885–1892 failed to show any listing of Ferber's name. However, in the St. Louis city directories for the years 1885 through 1888, the entry "Furber, John G., saloon, 724 [or] 726 Olive" was found for me by the reference department of the St. Louis Public Library. A more positive connection between Furber and the Adams painting is found by the fact that the Library of Congress possesses a four-page

pamphlet *Custer's Last Fight* which bears a copyright stamp dated "Apr. 26, 1886," the copyright being issued to John G. Furber, St. Louis. Apparently the pamphlet was published by Furber to accompany copyright of the painting and to use in exhibitions of the painting. The subtitle of the pamphlet reads "Painted by Cassilly Adams—Representing the Last Grand Indian battle that will be fought on this Continent. 12 feet high by 32 feet long, valued at $50,000." The pamphlet is essentially a description of the Custer battle and has little to say about the painting itself.

49. The statement concerning the supposed "cost" of the painting occurs frequently in newspaper comments on the Adams painting (sometimes it is given as $35,000; sometimes as $30,000). The most recent newspaper statement to this effect with which the author is familiar will be found in the Kansas City *Times*, June 14, 1946, p. 1, col. 2. Note that the account cited above in the Kansas City *Gazette*, August 11, 1903, p. 2, col. 1, states "it [the painting] was valued at $10,000," and in the pamphlet cited in note 48 the claim "valued at $50,000."

In the *Journal of U. S. Cavalry Assoc.*, vol. 8, p. 69 (1895) it is stated that the painting *originally* cost $8,000; just what *originally* means, however, is uncertain.

50. Information from Maj. E. C. Johnston, Fort Bliss, Tex., in a letter dated October 3, 1940. Major Johnston measured the painting for me. *See* note 48 for the size of the original painting and panels.

51. Information from W. A. Adams. The end panels are also mentioned by the reporter in the account of the Kansas City *Gazette*, August 11, 1903, p. 2, col. 1, and are briefly described in the pamphlet *Custer's Last Fight* cited in note 48.

52. A letter from the corresponding secretary of the Anheuser-Busch Brewing Association dated Feb. 13, 1895, offering the painting to the Seventh Cavalry is reprinted in the *Journal of U. S. Cavalry Assoc.*, vol. 8, pp. 69–70 (1895). The formal ceremony of presentation at Fort Riley is reported in the Junction City *Republican*, April 5, 1895, p. 7, c. 4 and the Junction City *Sentinel*, March 30, 1895, p. 2, c. 4.

53. Junction City *Union*, April 27, 1895, p. 2, col. 2, and May 25, 1895, p. 3, col. 4.

54. Kansas City *Star*, June 22, 1930, p. 16A, col. 3; Harold Evans, "Custer's Last

Fight," *Kansas Magazine*, 1938, pp. 72–74, gives a somewhat different version.

55. Information from Supt. E. S. Luce, Custer Battlefield National Monument, Crow Agency, Montana, in a letter to the writer dated July 17, 1946.

56. Information from Maj. E. C. Johnston, the adjutant of the 7th cavalry, in a letter to the writer dated October 3, 1940, and from Superintendent Luce (*see* note 55). Superintendent Luce believes that it cost the W. P. A. some $4,200 to restore the painting.

57. Kansas City *Times*, June 14, 1946, p. 1, col. 2.

58. In an article in the St. Louis *Globe-Democrat*, November 26, 1942, it is reported that in a recent letter of Adams' son written to Anheuser-Busch, Inc., the painting was exhibited, after its completion, "all over the United States." This reference is probably that already described on p. 143. From the fact that the promoters gave up their venture as there described, the Adams painting never achieved the national recognition given to Mulvany.

59. E. A. Brininstool of Hollywood, Cal., long a student of Western history and of Custer in particular, writes me. "The lay of the land [in the lithograph] is perfect—I have been over it many times, and can vouch for that part. . . ."

60. See comment about saber on p. 132, and note 21.

61. Copies of the original lithograph, one of which was published as early as 1896, are owned by the Kansas State Historical Society and are those upon which the subsequent remarks in the text are based. Modern printings of the lithograph show the halftone screen very distinctly; the early copies show no screen marks at all.

62. Letter from the reference department of the Milwaukee Public Library dated July 25, 1946. I am indebted to Miss Mamie E. Rehnquist of the Milwaukee Public Library for this information.

63. Miss Becker wrote me under dates of August 9 and 14, 1946. I am greatly indebted to her for her kindness and help in supplying the information concerning her father given above and described subsequently in the text.

64. Information from a letter to the writer by F. W. Webber, of Anheuser-Busch, Inc., July 29, 1946.

65. Otto Becker was born on January 28, 1854, in Dresden, Germany, and as a young man studied in the Royal Academy of Arts in Dresden. He came to New York in 1873 and worked as artist and lithographer in that city as well as in Boston, Philadelphia and St. Louis. In 1880, he went to Milwaukee and was associated with the Milwaukee Lithographic and Engraving Company for 35 years. In oil and water color, he painted copy for many of the publications of that firm and supervised the work of preparing the copy on stone. On his own account he painted many Western pictures of Indians, cowboys, and portraits of Indian chiefs "after the manner of Remington." Later in life, he supported himself by making city views, religious paintings, marines, and Dutch interior views. Oddly enough, the prolific work of Becker has found no record in one of the most important regional studies of Western art, Porter Butts, *Art in Wisconsin* (Madison, Wis., 1936). Mr. Becker died in Milwaukee on November 12, 1945, in his 92nd year. This biographical information is, of course, from Miss Blanche Becker.

66. Recall that the painting's whereabouts was practically unknown from at least 1903 to 1934; *see* page 144, and note 54.

67. Statement from the reference department of the Library of Congress to the author under date of Jan. 28, 1947. I have also made personal examination of the photograph in the Library of Congress and I am not completely satisfied that the photograph in their files is a photograph of 1886. It is obvious in any case that differences in the background, especially in the contour of the hill, are different in the two photographs described in the text.

68. St. Louis *Globe-Democrat*, November 26, 1942, and letter to the writer from F. W. Webber of the advertising department of Anheuser-Busch, Inc., July 18, 1946.

69. The red tie may have been suggested to Becker by Mrs. Custer who wrote, in a letter dated January 25, 1889, a description of the flowing red merino cravat that Custer wore when with the Third cavalry division of the Army of the Potomac.— See *Cyclorama of Custer's Last Battle* (Boston, 1889), pp. 13–17.

70. The legend below the print identifies by name a number of the individuals: "Sioux Warrior Who Killed Custer"; "Rain in the Face"; "Autie Reed, Custer's Nephew"; "Capt. T. W. Custer"; "General Custer"; "Lieut. A. E. Smith"; "Lieut. Cook"; "Lieut. W. Van W. Reilly"; "Capt.

G. W. Yates"; "Courier From Sitting Bull," etc. It may be noted here that there are at least three printings of the lithograph known to the writer. In the original printing, the print itself measures 24¼" by 38½". A modern version on paper, a gift from Anheuser-Busch, Inc., in 1940, shows screen marks (as stated in note 61) and the print measures 23⅞" by 37¼". The colors are brighter than the original lithograph but considerable detail has been lost. There apparently is still another printing for E. A. Brininstool wrotes me that he has a copy printed on *canvas*.

71. Topeka *State Journal*, January 9, 1904, p. 5, col. 1. Miss Boies' attack on the Custer lithograph has been interestingly described by Harold C. Evans in the *Kansas Magazine*, 1938, pp. 72–74. Much information on the history of the lithograph will be found in this article. I am also indebted to Mr. Evans for supplying me with additional leads concerning the lithograph.

72. A listing of a number of other artists of the Custer battle scene can be found in "Custer's Last Stand" by the author, *Kansas Historical Quarterly*, v. 14, pp. 385–390 (1946) and Don Russell "Sixty Years in Bar Rooms" in *Westerner's Brand Book* (Chicago) v. 3, pp. 61–68 (1946). In addition, Mr. Gerhard D. Zeller of Nazareth, Pennsylvania, recently (1951) wrote me that he has collected some 42 reproductions of different Custer battle scenes.

73. For Leigh, see Chapter XVI and notes.

CHAPTER X

The Leslie Excursion of 1887

1. Doubtless there were many other illustrators in the decades of the 1860's and 1870's. For example, the Southwestern illustrations of T. Willis Champney made for *Scribner's Magazine* in 1873 mentioned in note 1, Chap. VII. But illustrators sent by newspapers and the lesser-known magazines must have made the transcontinental tour in considerable number, though their work today is not readily accessible. Much of it, I hope, will through the continued work of myself and others, eventually come to light.

Local and state historical societies should find a particularly fertile and interesting field in stimulating the study of types and sources of pictorial materials that record the history of their individual regions along the lines suggested by the point of view developed in this book.

2. For the Leslies, see *Dictionary of American Biography*, v. 11, pp. 186–188; *National Cyclopedia of American Biography*, v. 3, p. 370; v. 25, pp. 237, 238; the most satisfactory account of Mrs. Leslie as yet available is Madeleine B. Stern's "Mrs. Frank Leslie: New York's Last Bohemian" in *New York History*, Cooperstown, January, 1948. Miss Stern is now at work on a full-length biography of Mrs. Leslie.

The circulation of *Frank Leslie's Illustrated Newspaper* estimated from data supplied by the *American Newspaper Directory* for the period 1870–1900 is considerably less than the figures given in the text above and in general less than its chief competitor, *Harper's Weekly*, whose maximum circulation was 100,000 in the period stated. Nevertheless, on special occasions the circulation of *Leslie's* jumped to astonishingly large figures. After the Chicago fire, the two succeeding issues of *Leslie's* were reported as having a circulation of 327,000 and of 470,000 (*Frank Leslie's Illustrated Newspaper*, v. 33 [1871], November 4, p. 114; November 11, p. 130). Incidentally, many of the Chicago fire illustrations in *Leslie's* were sketched by Joseph Becker.

3. *Frank Leslie's Illustrated Newspaper*, v. 44 (1877), April 28, pp. 140, 141. Mrs. Frank Leslie, *California—A Pleasure Trip From Gotham to the Golden Gate* (New York, 1877), pp. 17–20, also described the departure. The last account is subsequently cited as *Mrs. Leslie*.

4. The identification of the Leslie party is based on accounts of the Leslie trip appearing in the Chicago *Times*, April 13, 1877, p. 6; the Chicago *Daily Tribune*, April 14, 1877, p. 8; the Omaha *Daily Bee*, April 17, 1877, p. 4; the *Wyoming Daily Leader*, Cheyenne, April 19, 1877; *Rocky Mountain News*, Denver, April 20, 1877, p. 4; San Francisco *Chronicle*, April 26, 1877, p. 3; April 27, 1877, p. 3. I am indebted to the Chicago Historical Society, the Nebraska State Historical Society, the Wyoming State Library and Historical Department, the Western History Department of the Denver Public Library and Miss Madeleine Stern of New York City for these accounts.

5. Credit is variously given for the illustrations. In the issue of July 7, p. 301, are several small sketches credited to "Harry Ogden and W. Yeager"; in the same issue, p. 304, is one credited to "Harry Ogden";

in the issue of July 14, 1871, p. 321, are several illustrations credited to "Harry Ogden and W. Yeager"; in the issue of September 15, 1877, p. 17, an illustration is credited to "Harry Ogden"; in the issues of September 24, 1878, pp. 420–421, and September 7, 1878, p. 5, are a number of illustrations, "Walter Yeager and H. Ogden"; in the issue of November 30, 1878, p. 220, is one credited to "Walter Yeager"; the remainder are credited either "to our special artist" or "to our special artists," with a very considerably larger proportion credited in the latter manner. In a few cases the credit lines "From photos and sketches by our special artists"; in still fewer cases the credit is given "from a photograph." It seems probable, therefore, that most of the illustrations were the joint work of Ogden and Yeager.

The San Francisco *Chronicle*, April 27, 1877, p. 3, makes specific mention of *two* illustrators and their method of work.

"He [Frank Leslie] has a photographer and two promising young artists whose nimble fingers have been constantly employed since their departure from New York. At places like Chicago, the sketching and photographing of objects of interest was a comparatively easy task, there being plenty of time. Where a briefer pause was made, there was a good deal of difficulty. The railroads were very accommodating, especially overland roads, and delayed the trains at any desired point long enough for the artists to outline their sketches, and the photographer, who had his plates in readiness, to obtain his negatives. The easy motion of the fine Pullman hotel car, which was taken instead of the Wagner at Chicago, allowed the sketchers to do considerable work between stations. An immense amount of unfinished sketches and negatives have been accumulated, which have to be finished up before anything further can be done.

THE ARTISTS

were yesterday busily occupied in elaborating their outlines, and the photographer was printing from his negatives at one of the city photographic establishments. Mr. Curly, the historian of the expedition, was busy with his notes of the trip, and Mr. Hemyng was absorbed in a new lot of boys . . . who will figure in a coming tale of 'Jack Harkaway in California,'" . . .

Mrs. Leslie is of very little help in crediting illustrations. On p. 22, a comment was made on *our* artist and Mrs. Leslie continued: "I say *our* artist, for, although several are with us, H—— [presumably Harry Ogden, 20 years old at the time] is ours, *par excellence,* not only because he has grown up beneath the eye of our Chief [Frank Leslie], but from his thoroughly sympathetic nature, combining the ability of a man with the winning qualities of a boy; the *enfant gâté* of our office—the *enfant terrible,* occasionally, of our party." *Mrs. Leslie,* too, confirmed the fact that the Nevada mining illustrations (to be discussed later in the text) were made by only one of the artists (pp. 282, 283) but she did not indicate which one. The credit lines on these illustrations, too, are among the relatively few credited "to our special artist." It would be my guess that the artist was Yeager, for if it had been Ogden, a favorite of Mrs. Leslie, she would have so stated it. She does not mention Yeager anywhere by name.

Although Miss G. A. Davis, an illustrator, was a member of the party, no reference is made by Mrs. Leslie or by *Leslie's Weekly* to the possibility that Miss Davis contributed any illustrations of the excursion. Davis illustrations in *Leslie's Weekly* do not appear in any number until considerably after 1877. Miss Davis is listed as a member of the art staff of *Leslie's* in *Leslie's Weekly,* Jan. 31, 1880, p. 403.

6. *Ibid.,* pp. 27–33. Illustrations of their Chicago visit appeared in *Frank Leslie's Illustrated Newspaper,* July 21, July 28, and August 4, 1877.

7. *Ibid.,* September 8, 1877, p. 9.

I thought for some time that the accounts of the excursion appearing in *Leslie's Weekly* were the work of Bracebridge Hemyng [Jack Harkaway] but now I am no longer certain. Harkaway was a skillful and prolific writer and it has even been inferred that Dickens borrowed from him (*Frank Leslie's Ladys Magazine 34,* p. 118, Feb., 1874). The San Francisco *Chronicle,* however, of April 26 and 27, 1877, both comment on the fact that Curley, who was an English "literary gentleman," was describing the trip presumably for publication.

The only biographical comment on Curley that I have found is a brief mention in *A Supplement to Allibones Dictionary of . . . Authors,* Philadelphia, 1896, p. 432. This account states that Curley was the author of *Nebraska, Its Advantages, Resources and Drawbacks,* London, 1875, and

had been sent by *The Field* "to the emigrant fields of North America" and had resided for "many" years in Nebraska before the publication of the book cited above. An examination of the book itself shows that Curley also was an excellent writer. Examination of *The Field* (London) for 1873 and 1874 shows many letters from Curley written from Kansas, Nebraska, Wyoming, and elsewhere. Curley was also the author of *Glittering Gold* (Chicago, 1876), an account of the Black Hills gold fields. For a brief biographical sketch of Hemyng (1841–1901), *see* Albert Johannsen, *The House of Beadle and Adams*, Norman, Oklahoma, 1950, vol. 2, p. 138.

8. Mrs. Leslie had some very outspoken comments as a result of the visit of the Leslie party to the mining town of Virginia City, Nev. She not only called it "dreary, desolate, homeless, uncomfortable, and wicked . . . and Godforsaken" (*Mrs. Leslie,* p. 277), but she made the additional unfortunate comment, "The population is largely masculine, very few women, except of the worse class, and as few children." (*Mrs. Leslie,* p. 278.) The descriptive phrase, tacked onto all the women of Virginia City, so aroused the ire of the celebrated editor, R. M. Daggett, of the *Daily Territorial Enterprise,* Virginia City, that he hired a New York correspondent to investigate the past life of both Mrs. Leslie and of her husband. The correspondent, an admitted enemy of the Leslies, made an exhaustive inquiry into the love affairs of both Leslies and especially of Mrs. Leslie's first marriage with one David C. Peacock which had some of the aspects of a shotgun wedding. All of the Leslies' conduct was interpreted by this critic in the worst possible light. He made some errors of fundamental facts and may have made others. His detailed account of the Leslies' past lives, Daggett published in a Sunday edition of the *Daily Territorial Enterprise* on July 14, 1878, occupying all of the front page.

9. *Mrs. Leslie,* pp. 222–229.

10. Illustrations connected with the trip from Omaha west will be found in *Frank Leslie's Illustrated Newspaper* for every weekly issue from August 4, 1877, through August 3, 1878, *except* the issues of August 11, 1877, and of June 1, 8, 22, July 13, 20, 27, 1878. In addition illustrations will be found in the issues of August 24, 1878, and November 30, 1878. The illustrations in *Mrs. Leslie* include some of those appearing in the *Newspaper* (of smaller size) and several which obviously are reproduced from photographs and are of far less interest than those that appeared in the *Newspaper.*

11. The sole illustration was the "Mississippi River Bridge at Clinton Iowa" in the issue of *ibid.* for August 4, 1877, p. 369.

12. "Arrival at Council Bluffs" will be found in *ibid.,* August 4, 1877, p. 369. For the completion of the Missouri river bridge and Council Bluffs as a junction point, *see* Paul Rigdon, *The Union Pacific Railroad* (Omaha, 1936), p. 78.

13. *Mrs. Leslie,* pp. 39, 40. The illustration will be found in *Frank Leslie's Illustrated Newspaper,* August 18, 1877, pp. 404, 405.

14. The two illustrations, in the order listed above, will be found in *ibid.,* September 29, 1877, p. 53, and October 6, 1877, pp. 72, 73. Actually the Leslie party stopped at Sydney on the return trip.—Cf. *Mrs. Leslie,* p. 285. A poorly reproduced illustration, "A Street of 'Dug-Outs,' on the Hillside in Sydney," appeared in *Frank Leslie's Illustrated Newspaper,* September 22, 1877, p. 37. The Omaha newspapers, of course, were filled with Black Hills news at that time. The Omaha *Weekly Bee,* April 25, 1877, p. 3, had a good account of Sydney and the Black Hills trade and a still better one was given in the Omaha *Daily Herald,* July 6, 1877, p. 2. *See* G. Thomas Ingham, *Digging Gold Among the Rockies* (Edgewood Publishing Co., 1882), Ch. 5, for an account of the mining development in the Black Hills from 1875 to 1880. Contemporary information on the early stages of the Black Hills gold rush will also be found in *Report on the Mineral Wealth, Climate, and Rain-Fall and Natural Resources of the Black Hills of Dakota* (Washington, 1876), Walter P. Tenney. A review of the history of this interesting period is Harold E. Briggs' "The Black Hills Gold Rush," *North Dakota Historical Quarterly,* Bismarck, v. 5 (1931), January, pp. 71–99. Briggs stated that the peak of the gold rush occurred in the spring of 1877, so it was practically coincident with the arrival of the Leslie party.

15. *Mrs. Leslie,* p. 45.

16. *Frank Leslie's Illustrated Newspaper,* October 13, 1877, p. 85. The arrival of the Leslie party in Cheyenne "last evening" was reported in the *Wyoming Daily Leader,* Cheyenne, April 19, 1877.

17. The illustrations will be found in *Frank Leslie's Illustrated Newspaper,* October 13, 1877, p. 85 (the theatre), and November 3, 1877, p. 133, title page; with an interesting comment on p. 139.

18. The illustration appeared in *ibid.,* October 6, 1877, p. 73. Information concerning the Inter-Ocean and Plains Hotels comes from Mr. Howard A. Hanson, present manager of the Plains Hotel. According to Agnes Wright Spring, *The Cheyenne and Black Hills Stage and Express Routes* (Glendale, Cal., 1949), pp. 50, 78 and 79, the Inter-Ocean Hotel was under construction in 1875 and was in operation by early 1876.

19. The arrival of the Leslie party in Denver, the Denver reception and the visit to Colorado Springs are reported in the Denver *Daily Times,* April 19, 1877, p. 4 (which stated that the party arrived "this morning in a special car from Cheyenne"); *Rocky Mountain News,* Denver, April 20, 1877, p. 4.

20. *Frank Leslie's Illustrated Newspaper,* July 7, 1877, p. 303. The illustration will be found in the same issue, p. 297. A. A. Hayes and W. A. Rogers were in Colorado Springs two years later and Rogers drew a somewhat similar sketch of the procedure for obtaining a refreshing draft when in the city; *see* A. A. Hayes, Jr., *New Colorado and the Santa Fe Trail* (New York, 1880), p. 56.

21. This illustration, along with sketches of Church Buttes, Pedmont and Aspen appeared in *Frank Leslie's Illustrated Newspaper,* November 10, 1877, p. 160. The emigrant camp was apparently sketched on the return trip. Illustrations of other Wyoming towns will be found in the issues of *ibid.* for October 13, 20, 27, November 3, 17, 24, and December 1, 1877.

22. Utah illustrations will be found in the issues of *ibid.* for December 1, 8, 15 (including that of Ogden Junction), 22, and 29, 1877.

23. *Mrs. Leslie,* pp. 97–102. No illustrations of the interview appeared in the *Newspaper,* but one is published in *Mrs. Leslie,* facing p. 102.

24. Mrs. Leslie's quotation will be found in *ibid.,* p. 71; the interview with Frank Leslie was secured on the return trip and is reported in the Omaha *Daily Herald,* June 3, 1877, p. 4.

25. *Mrs. Leslie,* p. 108.

26. It was Frank Leslie's interest in the silver mines which undoubtedly was responsible for the relatively large number of such illustrations in *Leslie's,* every issue, beginning with that of March 2, 1878, through the issue of April 27, 1878 (nine issues), contained pictorial records of various aspects of mining in Virginia City; one of the issues (March 2, 1878) contained a four-page supplement, "Panorama of Virginia City," based on photographs by Watkins of San Francisco. From Mrs. Leslie's account, Virginia City was visited on the return.—*Mrs. Leslie,* Ch. 32. The Indian illustrations in *Leslie's,* mentioned above, included: "Indian Lodges Near Corlin, on the C. P. R. R." (January 5, 1878, p. 305), and "Winnemucca, Chief of the Piute Indians Engaged in an Annual Rabbit Drive" (January 26, 1878, p. 353). Some of the Nevada town illustrations included: Elko (January 5, 1878, p. 305), Battle Mountain (January 12, 1878, p. 321), Humboldt (January 19, 1878, p. 337), Carson City (February 16, 1878, p. 405) and a particularly good "View of the Main Street in Virginia City" (March 2, 1878, p. 445).

27. *Ibid.,* February 2, 1878, p. 373. According to the text accompanying the illustration, the first one was an imaginary sketch based on the story of the Leslie party conductor.

28. *Mrs. Leslie,* p. 284. The day coach is pictured and also described in *Frank Leslie's Illustrated Newspaper,* February 9, 1878, pp. 389, 390, where will also be found the armory illustration. It was observed on the return trip as was the Nebraska editorial excursion; *see ibid.,* February 16, 1878, p. 405.

29. The illustration will be found in *ibid.,* April 27, 1878, pp. 128, 129. Among the more interesting illustrations of this part of the trip are "Snow Sheds at Summit Station" (same issue as above, p. 132); "A Street Scene in Sacramento" and "The Grand Hotel in Sacramento" (May 4, 1878, p. 141); "The Wharf at Oakland, The Terminal of the Central Pacific Railroad, Opposite the City of San Francisco," and "Crossing the Bay on the Ferry Boat from Oakland" (May 11, 1878, p. 165); "The Western Terminal of the Central Pacific Railroad" and "View of Market Street San Francisco, Looking Toward the Palace Hotel" (May 18, 1878, p. 181), and "A View of Montgomery Street, San Francisco" (June 15, 1878, p. 249).

30. *Mrs. Leslie,* pp. 109, 110.

31. *Ibid.*, pp. 115–117. *The Overland Monthly*, v. 15 (1875), September, pp. 298, 299, has an account of the Palace Hotel upon its completion, which contains the statement, "We have seven big world-wonders now; the Bay of San Francisco, the Central Pacific Railroad, the Big Trees, the Bonanza, Yosemite, the Geysers, the Palace Hotel—and Assessor Rosenor." I hope some native son will write me explaining "Assessor Rosenor" and his inclusion as an eighth wonder.

Illustrations of the Palace Hotel appeared in *Frank Leslie's Illustrated Newspaper* for May 25, 1878, p. 197 ("The Main Entrance"), and June 29, 1878, p. 281 ("The Grand Court of the Palace Hotel," credited to "our photographer"). Five illustrations of Baldwin's Hotel, also newly completed, and, according to *Mrs. Leslie*, p. 192, visited by the party, appeared in *ibid.*, July 6, 1878, p. 301.

32. *Ibid.*, Chs. 11–21, 29, 30.

For other accounts of the Leslie party in California, *see* the San Francisco *Chronicle* of April 26 and 27, 1877 (previously cited) and the *Chronicle* for April 28, 1877, p. 3, April 30, 1877, p. 3, May 9, 1877, p. 3, May 25, 1877, p. 3; the San Francisco *Alta*, April 26, 1877, p. 1; *The Argonaut* (San Francisco), May 26, 1877, p. 3, June 2, 1877, p. 3; and the Sacramento *Union*, May 28, 1877, p. 3. I am indebted to Miss Madeleine Stern for copies of the above items.

33. Six Chinese illustrations, credited to Yeager and Ogden, appeared in *Frank Leslie's Illustrated Newspaper*, August 24, 1878, pp. 420, 421; September 7, 1878, p. 5. In *Mrs. Leslie*, California illustrations appeared *facing* p. 125 (Belmont); p. 128, "Salmon Fishing, Sacramento River"; p. 136 (Chinese theater); p. 142 (Chinese gambler); *facing* p. 145 ("Chinese Joss House"); p. 154 ("Chinese Barber"); *facing* p. 169 ("A Chinese Goldsmith"); *facing* p. 179 ("The Cliff House"); *facing* p. 180 ("Seal Rocks"); *facing* p. 205 ("The Witches Cauldron [geyser]"); p. 212 ("A Drive With Fosse of Fosseville"); p. 217 ("On the Road to The 'Big Trees'"); *facing* p. 227 ("Making a Night of It"); p. 231 ("En Route for the Yosemite"); *facing* p. 232 (Chinese cobbler); *facing* p. 244 ("Ascending the 'Fallen Monarch'"); p. 246 ("Cutting Down One of the Big Trees"); p. 276 ("Cutting Bark and Cones as Mementoes of the Mariposa Grove").

34. The return of the party to Omaha in the Palace car "Cataract" was reported in the Omaha *Daily Herald*, June 3, 1877, p. 4. Senator Connoyer of Florida was reported to be a member of the party on the return trip. It should be pointed out again that the side-trip to Virginia City, Nev., was made on the return trip.

35. I am indebted to Mrs. Mary Yeager Poole of Havertown, Pa., for the information concerning her father, Walter Rush Yeager, who was born in Philadelphia in April, 1852. Mrs. Poole wrote me that her father illustrated for *Harper's Magazine, Ladies Home Queen* and a number of religious publications in Mr. Yeager's freelance days. He is listed in the Philadelphia city directories as artist or designer from 1885 until 1896. The Library of Congress has a volume, *Art Studies in the Bible*, designed by W. R. Yeager, and published in Philadelphia in 1896. It was this volume that furnished the clue in tracing down the source of biographical information concerning Yeager as the art historians and lists again furnished me no biographical information. A brief death notice of Walter R. Yeager will be found in the Philadelphia *Public Ledger*, April 18, 1896, p. 8.

Yeager illustrations for an article on the Bahamas by Mrs. Leslie appeared in *Leslie's*, June 21, 1879, pp. 268, 269. California illustrations by Yeager continued to appear for some time after those cited in note 34. They were based on Yeager's trip with the Leslies in 1877; *see ibid.*, May 17, 1879, p. 166; May 24, 1879, p. 192; May 31, 1879, p. 201; June 7, 1879, p. 229; June 14, 1879, p. 248 (credited to both Yeager and Ogden); June 28, 1879, p. 281; July 19, 1879, p. 329; August 23, 1879, p. 416. *Leslie's*, January 31, 1880, p. 403, lists Becker, Yeager, Ogden, Berghaus and others as members of the art staff on that date.

36. For information on Ogden see *Who's Who in America*, v. 18 (1934–1935), p. 1801, and an obituary in the New York *Times*, June 16, 1936, p. 25. Ogden's labors as a painter of military costumes are given a thorough appraisal in the *Military Collector and Historian*, Washington, v. 1 (1949), April, pp. 4, 5, by George C. Groce. Ogden had other Western illustrations (Texas) in *Leslie's*, May 22, 1880, p. 196. He was also a member of a commercial expedition sent out by *Leslie's* to Mexico in 1879, and sketches on this trip appeared February 1, 1879, and succeeding issues through April 19.

CHAPTER XI

William Allen Rogers and
Mary Hallock Foote

1. Joseph Pennell, *Modern Illustration*
(London and New York, 1895), p. 114. So
frail, however, are human memories that
no adequate account of Parson's life and
work has ever been made. His name isn't
even listed in the *Dictionary of American
Biography* nor in any of the usual listings
and biographical directories of American
artists.

Accounts of the art department of Har-
per's by various members of its staff when
Parsons was in charge all refer to the es-
teem and affection in which Parsons was
held; *see* the Rogers autobiography and
Abbey biography cited in note 2 and *How-
ard Pyle* (Charles D. Abbott, New York,
1925), pp. 50 and 77. J. Henry Harper in
The House of Harper (New York and Lon-
don, 1912), pp. 204, 205, also pays real
tribute to Parsons.

Parsons, born in England in 1821, came
to this country at the age of nine. By the
time he was fourteen he was an appren-
ticed lithographer and from this time until
the early 60's when he joined Harper and
Brothers, he did considerable original
work, as well as lithography, for the cele-
brated firm of Currier and Ives. Among the
best known work of this period was a large
group of marines (see Harry T. Peters,
*Currier and Ives Printmakers to the Amer-
ican People,* Garden City, 1942, p. 30). In
1851 he was listed in the *Exhibition Rec-
ords* of the National Academy of Design
(to which he was elected an associate in
1862) as an exhibitor in the latter year
with a New York address. According to
Henry Mills Alden (*Harper's Weekly,* v.
54 [1910], November 19, p. 21), Parsons
joined *Harper's* staff in 1861 and left it in
1889. After his retirement in 1889 and until
his death in 1910 Parsons free-lanced in oil
and watercolor, painting some westerns.
His death occurred at his home in Brook-
lyn on November 9, 1910.—*See* death notice
in the New York *Daily Tribune,* November
10, 1910, p. 7. I am indebted to the secre-
tary of the National Academy of Design
(New York) and to Charles Baker of the
New York Historical Society for informa-
tion concerning Parsons.

2. For the preparation of the illustration
of the 1870's and 1880's *see* W. A. Rogers'
book, *A World Worth While* (New York,

1922), p. 13 *et seq.,* and for information on
the subject contemporary to the period un-
der discussion *see Harper's New Monthly
Magazine,* v. 75 (1887), July, pp. 181–
187.

Rogers' book has recollections of many
aspects of American illustration from 1874
until the early 1900's. It is to be empha-
sized that they are recollections, for in
detail, the Rogers account does not tally
exactly with the information given by an
examination of contemporary periodicals to
which Rogers refers. Still another account
of the art department of *Harper's* in the
1870's is given in E. V. Lucas' *Edwin Aus-
tin Abbey* (London and New York, 1921),
v. 1, Chs. 4 and 5.

3. This biographical material will be
found in Rogers, *op. cit.,* Chs. 1 and 4, and
is supplemented with the Rogers sketch in
Who's Who in America, v. 10, p. 2322, and
a brief biographical sketch in *Harper's
Weekly,* v. 38 (1894), December 22, pp.
1210, 1211.

4. *Report of the Secretary of War,* House
Ex. Doc. No. 1, pt. 2, 45 Cong., 3 sess.
(1878–1879), pp. 65–72. Rogers' illustra-
tions of these fairs will be found in *Har-
per's Weekly,* v. 22 (1878), September 28,
p. 777, and October 5, p. 788. The group
of illustrations included in the first refer-
ence contained a view of Dr. Carver, the
celebrated rifle shot of the West, as he ap-
peared at the Minnesota State Fair. Rogers
also had a most interesting group of illus-
trations in *Harper's Weekly,* October 5,
1878, p. 789, depicting field trial of dogs
(pointers and setters) near Sauk Centre,
Minn., and held on September 10–12 of
that year. The illustration is accompanied
by a note from Rogers on p. 788.

5. *Harper's Weekly,* v. 51 (1907), January
5, pp. 21–23. The account given in the
Weekly is reprinted in part in Rogers' book,
pp. 66–69.

6. The first Northern Pacific locomotive
crossed the Missouri river at Bismarck on
February 12, 1879, and the rails were being
laid on the first 100 miles west of Bismarck
at that time—*Harper's Weekly,* v. 23
(1879), March 15, pp. 205 and 207.

7. *Harper's Weekly,* v. 22 (1878), Decem-
ber 14, p. 990. Rogers also described some
of his experiences at Bismarck in his book,
p. 69, in a letter he wrote to Parsons at the
time. Illustrations of Bismarck appeared in
the above issue of the *Weekly,* p. 988, and
included: "Selling Buffalo Robes," "The
Telegraph Repair Car," "The Opera

House," "Bottled Groceries," and "Black Hills Freight Train."

8. In the order listed these appeared in *Harper's Weekly*, v. 23 (1879), February 22, pp. 148, 149; April 19, p. 304; July 19, p. 564, and March 15, p. 205. One other illustration in this group, "Standing Rock, the Sacred Stone of the Sioux," in *Harper's* January 25, p. 73, is of interest only because it shows the "Standing Rock" for which the agency was named. Rogers gave some of the recollections of his visit at Fort Yates in his book, pp. 72–95.

9. The two illustrations will be found in *Harper's Weekly*, v. 25 (1881), August 27, p. 588, and v. 22 (1878), December 7, p. 973. His experiences at Fargo, Rogers records in his book, pp. 96–101. Strictly speaking the last illustration above belongs on the down-river trip to Fort Garry.

10. Rogers, *op. cit.*, p. 102.

11. The *Harper's Magazine* illustrations, 14 in number, will be found in v. 59 (1879), June, pp. 18–32; the *Weekly* illustrations in v. 23 (1879), January 25, p. 73.

12. Rogers, *op. cit.*, pp. 110, 111; *Harper's Weekly*, v. 51 (1907), January 5, p. 23.

13. Rogers, *op. cit.*, Ch. 13; A. A. Hayes Jr., *New Colorado and the Santa Fe Trail* (New York, 1880). Of the 15 chapters in this book, ten are reprinted from articles appearing originally in *Harper's Magazine* and are the chapters that contain Rogers' illustrations as they appeared in the *Magazine*. The *Magazine* articles appeared as follows: v. 59 (1879), November, pp. 877–895 (chapters 2 and 3 of Hayes' book); v. 60 (1880), January, pp. 193–210 (chapters 4 and 5); February, pp. 380–397 (chapters 6 and 7); March, pp. 542–557 (chapters 8 and 9); July, 1880, pp. 185–196 (chapters 10 and 11). (The last chapter contained several additional pages of text not in the *Magazine* version but contained the same Rogers illustrations.) Hayes was a popular writer of his day contributing frequently to both *Harper's Magazine* and *Harper's Weekly*. In addition to *New Colorado and the Santa Fe Trail* he wrote a novel, *The Jesuits Ring*. His death was announced in *Harper's Weekly*, v. 36 (1892), April 30, p. 411.

14. Rogers, *op. cit.*, pp. 189–196.

15. The illustrations, 14 in number, will be found in *Harper's Magazine*, v. 59 (1879), November, pp. 877–895.

16. The second set of illustrations, 14 in number, will be found in *ibid.*, v. 60 (1880), January, pp. 193–210.

17. *Ibid.*, February, pp. 380–397; Hayes, *op. cit.*, pp. 94–108; 12 illustrations by Rogers. An extensive account of silver and gold mining in Colorado at a time nearly contemporary with the Hayes-Rogers trip will be found in G. Thomas Ingham's *Digging Gold Among the Rockies* (Edgewood Publishing Company, 1882). A considerable part of this account is based on personal experience in 1881 (and possibly earlier) in the Black Hills as well as in Colorado. The book contains a number of illustrations, most of which are not credited, although three bearing the characteristic signature of Thomas Moran are readily recognizable.

A contemporary account of Leadville with information on its history, mines, methods of reaching the town, which on the whole is realistic, will be found in a 20-page pamphlet, *A Complete Illustrated Guide to Leadville* by C. W. Waite, Chicago, 1879. The illustrations are chiefly copied after photographs by D. D. Burnham of Leadville.

18. Edward Jump in *Frank Leslie's Illustrated Newspaper* had a number of contemporary Leadville illustrations of considerably greater interest than those of Rogers. They will be found in *Leslie's* for 1879 as follows: February 8, p. 416; April 12, pp. 81, 89; April 26, p. 120; May 3, p. 140; May 17, p. 169 (two illustrations); May 24, pp. 181, 187, 188; May 31, pp. 205, 213; June 7, pp. 217, 235; June 14, p. 255; June 21, p. 261. Not all of these are credited to Jump, several being credited to "our special artist." As they form an obvious series I believe that Jump was responsible for all. Several were redrawn by Albert Berghaus. Jump is credited with several illustrations in A. D. Richardson's *Beyond the Mississippi* which was published in 1867, and Joseph Becker, for many years head of the art department of the Leslie publications, listed E. Jump as a one-time leading staff artist of *Leslie's—Leslie's Weekly*, v. 101 (1905), December 14, p. 570. Jump also had a California sketch in *Leslie's*, October 10, 1874, p. 77; the last illustration I have found credited to him is a St. Louis scene in *Leslie's Newspaper*, October 14, 1882, p. 117.

The *Rocky Mountain News* (Denver) reported Jump's visit to Leadville in its issue of April 13, 1879, p. 4, c. 6. Jump (1838?– 1883) had at the time of his death a considerable reputation as a caricaturist. He probably was of French origin and during

his brief life span had knocked around half the world, living in Europe, Australia, and the United States. In this country he lived in New York, Montreal, Cincinnati, St. Louis and Chicago. His death occurred, following suicide, on April 21, 1883 in Chicago; see the Chicago *Tribune*, April 21, 1883, p. 6, c. 7; the St. Louis *Republican*, April 21, 1883, p. 6, and recollections of Jump by a fellow artist, Frank Bellew, in the New York *Daily Tribune*, May 14, 1883, p. 2, c. 4.

19. *Harper's Magazine*, v. 60 (1880), March, pp. 542–557; 11 illustrations.

20. *Ibid.*, v. 61 (1880), July, pp. 185–196; 9 illustrations.

21. The full-page illustration will be found in *Harper's Weekly*, v. 24 (1880), September 11, p. 581.

22. The full-page illustration will be found in *ibid.*, October 2, p. 636, and the accompanying note on p. 637.

23. The first illustration appeared in *Harper's Weekly*, v. 26 (1882), November 18, p. 729. The note accompanying it does not identify the locality other than "along the railways in the far west and southwest." The second of these full-page illustrations appeared in *Harper's* November 27, 1880, p. 756, with the accompanying note by A. A. Hayes, Rogers' friend, on p. 759; the third illustration in the *Weekly*, October 9, 1883; p. 636, with the note on p. 638. Another Western illustration of Rogers, probably imaginary, had also appeared in *Harper's*, January 20, 1883, p. 44, "Emigrants in Midwinter—Making Camp for the Night," half-page.

24. The redrawn illustration was in *ibid.*, v. 26 (1882), February 25, p. 120. Rogers' version of the redrawing of the sketch will be found in his book, p. 245. Mention is also made of this Remington sketch in Chapter XIII.

25. *Harper's Weekly*, v. 27 (1883), November 10, p. 717.

26. The illustration (full page) will be found in *Harper's Weekly*, December 13, 1890, p. 973, with an accompanying note on p. 975, giving a brief review of wheat developments in Dakota in the 15 years preceding.

There is a remote possibility that this illustration of Rogers was based on his 1878 trip and on photographs taken subsequent to 1878. The great Dakota wheat boom occurred between the years 1879–1886, according to Harold E. Briggs (*North Dakota Historical Quarterly*, Bismarck, v.

4 [1930], January, pp. 78–108). Land taken by settlers rose from 213,000 acres in 1877 to a record 11,000,000 acres in 1883. The Casselton project, however, was begun in the spring of 1874 (James B. Power, *Collections of the State Historical Society of North Dakota*, Bismarck, v. 3 (1910), pp. 337–349), and the famous Dalrymple wheat farm began its operations in the summer of 1875 although the first wheat crop was not planted until the following year (John Lee Coulter, *ibid.*, pp. 569–582). A letter from a Minnesota correspondent to the New York *Daily Tribune* (November 16, 1878, p. 2) called attention to the rising tide of wheat farms and estimated the Red River valley wheat crop of that year (1878) at four million bushels. This correspondent further stated that the first furrow for a wheat field in the Red River valley was turned in 1871. Still another contemporary account of the beginnings of the wheat industry in "the Northwest" was written by W. G. Moody who visited Minnesota and Dakota in the summer of 1879, "The Bonanza Farms of the West," *The Atlantic Monthly*, Boston, v. 45 (1880), January, pp. 33–44.

27. The illustrations were "In the Colorado Gold Fields," five illustrations on one page, *Harper's Weekly*, v. 27 (1893), December 23, p. 1224; the "Lobby of the Palace Hotel," full page, is in the *Weekly*, v. 38 (1894), January 6, p. 17. The note accompanying the full group of illustrations stated that the gold camp at Cripple Creek was "a trifle over a year old," p. 1231. Also made on the same trip was the full-page illustration, "Open-Air Bathing at Glenwood Springs, Colorado, in Mid-Winter," *ibid.*, March 17, p. 253. The note accompanying the illustration, p. 254, called Glenwood Springs "a new rendezvous in the heart of the Rockies" and described the huge swimming pool fed by hot springs.

28. *Ibid.*, v. 40 (1896), February 29, p. 201; the note is on p. 207.

29. In 1848, the only states west of the Mississippi were Texas, Louisiana, Arkansas, Missouri and Iowa. Among the states added by 1898 were: Colorado, Kansas, Nebraska, Wyoming, Montana, North and South Dakota, and Minnesota.—See *Atlas of the Historical Geography of the United States*, Charles O. Paullin (New York and Washington, 1932), plates 64 and 65.

30. *Harper's Weekly*, v. 42 (1898), October 8, p. 992 (full page). Other Rogers

illustrations of the exposition will be found in the same issue of the *Weekly*, pp. 985, 988 and 989. A full page of descriptive text by Rogers will be found on p. 987 of this issue.

James Mooney, the Indian expert, stated that the Indian congress at Omaha was "the most successful ever held in this country from the Centennial down, not even excepting the World's Fair [of 1893]."— *American Anthropologist*, New York, N. S. v. 1 (1899), pp. 126–149. Mooney reported that 400 to 550 Indians, representing about 20 tribes, were present during the congress.

31. These will be found (all full page) in the order listed above in *Harper's Weekly*, v. 43 (1899), June 17, p. 594; June 24, p. 618; v. 44 (1900), Supplement, March 17, *facing* p. 258. Identifying notes by Rogers will be found in each of the respective issues on p. 609, and p. 633, 1899. Still other notes that served to verify the outlines of Rogers' extensive Western trip given in the text above will be found in *Harper's*, March 4, 1899, pp. 221 and 225. There were some three or four of his California illustrations in the *Weekly* for 1899 as well. These as well as many other Rogers illustrations and writings will be found listed in *19th Century Readers' Guide to Periodical Literature, 1890–99* (New York, 1944), v. 2, pp. 860–862.

32. *American Art Annual*, Washington, v. 28 (1932), p. 416.

33. Rogers, *op. cit.*, p. 188. Both quoted lines above are from this source.

34. The biographical facts concerning Mrs. Foote come from *Who's Who in America*, vols. 15 and 21; from Helena DeKay Gilder's "Mary Hallock Foote," *Bookbuyer*, New York, v. 11 (1894–1895), pp. 338–342; from Arthur B. Foote, a son, and from the public library of Grass Valley, Cal., where Mrs. Foote lived for many years.

35. "A California Mining Camp," *Scribner's Monthly*, v. 15 (1878), February, pp. 480–493 (14 illustrations); "A Sea-Port on the Pacific," *ibid.*, v. 16 (1878), August, pp. 449–460 (10 illustrations). In the first of these articles, as Mrs. Foote made mention of personal experiences of the four seasons, her California life undoubtedly began with the spring of 1877. Her experiences in Mexico mentioned above were described in a series of three articles in *The Century Magazine*, N. S. v. 1 (1881–1882), November, pp. 1–14; January, pp. 321–333; March, pp. 643–655.

36. In 1922, Mrs. Foote described her Leadville experiences briefly in two letters to Thomas F. Dawson, curator of the State Historical Society of Colorado. These letters were published by L. J. Davidson, "Letters From Authors," in *The Colorado Magazine*, Denver, v. 19 (1942), July, pp. 122–125.

37. *Scribner's Monthly*, v. 18 (1879), October, pp. 801–824.

38. Mills' presence in Leadville in connection with the Ingersoll article is noted in the Leadville *Daily Chronicle*, May 29, 1879, p. 1. Mills probably warrants a more extended discussion as a Western artist than the mere mention we have given him in the text above. He achieved a considerable reputation during his lifetime not only as an artist, but as a poet and sculptor as well. Nowhere have I found an adequate account of his life, but through the courtesy of Mrs. Carl E. Krebs of the reference department of the Buffalo (N. Y.) Public Library, there has been secured a brief autobiographical account of Mills' life which he wrote several years before his death but which was published posthumously in the Buffalo *Express*, November 5, 1916. Since it is not readily accessible and little other biographical information on Mills is available, I have included it in this note. Mills' autobiography reads:

"John Harrison Mills, No. 494 Elmwood avenue, Buffalo, painter, sculptor, engraver, illustrator, writer. Born on a farm near Buffalo, on January 11, 1842.

"Began study of art in that city under John Jamison, banknote engraver, in 1857. In summer of 1858, to relieve eye strain from over-application, changed to modeling and marble work under William Lautz, and continued experiments in color begun at home in childhood.

"Painted first portraits in Buffalo and Lockport in 1859, under influence and encouragement of L. G. Sellstedt and William H. Beard, attempting also landscape and animals in 1860.

"Enlisted in April, 1861, upon Lincoln's first call, in 21st regiment, New York State Volunteer infantry. Portrait of Captain E. L. Hayward, painted in camp at Upton's Hill after first Bull Run, is in hall of Hayward post, G. A. R., in Buffalo.

"Wounded at second Bull Run, returned to Buffalo on crutches in 1863. Morgenroth, a sunrise on a yesterday's battlefield, bought by Dr. Rochester first night of its exhibition at the Buffalo Fine Arts Acad-

emy, winter of 1864, still in possession of that family.

"Bronze medal of New York State Agricultural society for best animal painting in oil by American artist awarded in 1864 for picture of Hotspur, a Durham short-horn bull, and a heifer, Lucille, owned by Ezra Cornell of Ithaca.

"Bust of Abraham Lincoln from studies before and during the war and while guarding the body during the stay in Buffalo, exhibited at Academy, winter of 1865, and copies in plaster widely published in the following summer.

"While publishing Chronicles of the 21st Regiment, a history with illustration of the campaigns of 1861–2 in Virginia, became regular contributor to the columns of *The Buffalo Morning Express*; made the first illustrations for Mark Twain's Sketches, engraving them upon wood in 1869.

"Removed to Denver and Middle Park, Col., in 1872, doing portrait, mountain, hunting, animal and figure subjects; also magazine articles with illustrations on wood; among these, 'Hunting the Mule Deer,' in *Scribner's* for October, 1878. Taught in Colorado Academy of Fine Arts; president of same in 1881–2; same year collected and managed first art exhibition in Colorado for the Mining and Industrial exposition, bringing a large number of pictures from New York and Philadelphia.

"Returned east to New York city in 1883. In 1888 elected secretary and manager of the New York Art guild, an association organized in 1865 for the protection of artists in their relations with exhibition throughout America, it having happened that often through financial failure, pictures had to be recovered with trouble and expense. Inaugurated and conducted a system of circuit exhibitions; active in same until 1898, but finding time to continue painting and modelling, being one of the 67 sculptors having work accepted and exhibited at the World's Columbian exhibition, Chicago, 1893.

"Received the award of prize for eight stanzas on the Battle of Gettysburg, published with full page colored illustration in the New York Sunday Herald, on July 8, 1902, the judges being Edward Eggleston, Edwin Markham and Daniel E. Sickles, of nearly 1,000 poems submitted.

"Member American Federation of Arts, Washington, D. C., New York Water Color club, Buffalo Society of Artists, Buffalo Guild of Allied Arts and honorary membership of Denver Art club, conferred for services to art in the early days of Denver.

"Works in many private collections, the Albright gallery and Guild of Allied Arts, Buffalo, Panama-Pacific, San Francisco, memorial in bronze to 21st regiment; Hutchinson, memorial in bronze with portraits in medallion, Central High school; portraits in City Hall, Historical Museum with Academy of Fine Arts, Buffalo."

A somewhat more detailed account of his Colorado life is available in a 16-page letter written in March, 1916, and now in the State Historical Society of Colorado, Denver (Accession No. 10,184). Mills died in Buffalo on October 23, 1916. Obituaries are given in the Buffalo *Commercial*, October 24, 1916, and Buffalo *Express* and Buffalo *Courier* of the same date.

Additional information bearing on his work as a Western artist will be found in *Frank Leslie's Illustrated Newspaper*, October 25, 1873, p. 101, where a Mills illustration "Buying Outfits for the Mountains and Mines at Denver" is reproduced. Mills also wrote and illustrated the article "Hunting the Mule-Deer in Colorado," *Scribner's Monthly*, v. 16 (1878), September, pp. 610–622. Another article, by Ernest Ingersoll, "The Heart of Colorado," *Cosmopolitan*, v. 5 (1888), September, pp. 417–435, October, pp. 471–488, was also illustrated in part by Mills. Possibly his most important Western painting (his later reputation was achieved largely as a landscape artist) was "A Frontier Justice of the Peace," which is described in some detail in the *Rocky Mountain News*, Denver, August 27, 1882, p. 3.

Thomas Allen (1849–1924) belongs also to the group of little-known Western artists for the 1870's. Allen first went West to Colorado in the summer of 1869 with a group of art students from Washington University but apparently there are no sketches or paintings extant of this period. He then went abroad for some years and upon returning to this country spent the winter of 1878–79 in and around San Antonio. There resulted from the winter's work a number of excellent paintings including "*Toilers of the Plains*," "*The Covered Wagon*," "*Portal of San José Mission*," "*Ford at the San Pedro River*," and "*Market Place at San Antonio*." Allen's latter reputation was based on other than Western paintings. I am indebted to Miss Eleanor W. Allen, of Boston, Massachusetts, a daughter, for the above information. A brief sketch of Allen will be found

in the *American Art Annual,* vol. 21 (1924), p. 282.

39. *The Led-Horse Claim,* appeared in five installments in *The Century,* N. S. v. 3 (1882–1883). Her other novels of Colorado were *John Bodewin's Testimony* (*The Century,* N. S. v. 9 [1885–1886], six installments) and *The Last Assembly Ball* (*The Century,* N. S. v. 15 [1888–1889], two installments, and N. S. v. 16 [1889], two installments).

40. *See* Mrs. Foote's letters referred to in note 36. *Literary History of the United States* (New York, 1948), v. 2, p. 869, mentioned Mrs. Foote in the chapter "Western Record and Romance" and indicated that although there are fine passages and fine single stories by Mrs. Foote, her reputation as a writer is more likely to dwindle with the passage of time than to revive.

For contemporary comment on Mrs. Foote's popularity as a writer, *see* Charles F. Lummis' "The New League for Literature and the West," *The Land of Sunshine,* Los Angeles, v. 8 (1898), April.

41. The movements of the Footes can be followed with some precision by examining the biographical record of Arthur DeWint Foote and Mary Hallock Foote in *Who's Who in America,* v. 15 (1928–1929), p. 788.

42. *Coeur D'Alene,* as the name suggests, had an Idaho background. It appeared serially in *The Century,* N. S. v. 25 (1893–1894), three installments, and N. S. v. 26 (1894), one installment. All of the novels of Mrs. Foote mentioned in the text were published in book form after the serial publication. An extensive list of her novels will be found in the *Who's Who in America* reference given in note 41.

43. The illustrations appeared in *The Century,* N. S. v. 15 (1888–1889); N. S. v. 16 (1889); N. S. v. 17 (1889–1890).

44. An extensive bibliography of Mrs. Foote's illustrations and writings during the 1890's will be found in *19th Century Readers' Guide to Periodical Literature, 1890–99,* v. 1, p. 962. It should also be pointed out that Mrs. Foote's illustrations were not all confined to the Western scene, for during the 1870's, 1880's and 1890's, illustrations of a considerable number of other subjects by Mrs. Foote appeared in the periodical literature. For example, another group of subjects of which she had firsthand knowledge are depicted in John Burroughs' article "Picturesque Aspects of

Farm Life in New York," *Scribner's Monthly,* v. 17 (1878), November, pp. 41–54.

45. *The Century,* N. S. v. 21 (1891), December, p. 201.

46. Arthur B. Foote to the writer, September 6, 1940. That Mrs. Foote was an accomplished artist on the wood block is borne out by the comment of that severe critic W. J. Linton who called her "the best of our designers on the wood"; *see American Art,* Walter Montgomery (Boston, 1889), v. 1, p. 464.

47. Information from Jane Whelan, librarian of Grass Valley (Cal.) Free Public Library, in a letter to the writer August 23, 1940.

CHAPTER XII

Charles Graham and Rufus F. Zogbaum

1. See the introductory paragraphs of Chapter XIII.

2. Remington's first illustration in *Harper's Weekly,* as already pointed out, appeared in v. 26 (1882), February 25, p. 120. It was redrawn by W. A. Rogers. Russell's first illustration ("Caught in the Act") to appear in the *Weekly* will be found in v. 32 (1888), May 12, p. 340.

In 1880 four out of the some 900 illustrations in *Harper's Weekly* were Westerns. This number was undoubtedly low, for Western illustrations in considerable number had appeared in the 1870's. Even for 1881, however, the Western illustrations in the *Weekly* numbered only some eight out of nearly 1,300. By 1889, however, nearly 125 out of over 1,600 illustrations were Westerns.

3. In *Harper's Weekly* in the decade, 1880–1889, inclusive, Graham had some 120 Western illustrations; Remington had a few over 100, practically all in the four years 1886, 1887, 1888 and 1889; Zogbaum over 30; Farny nearly 30; and Rogers about a dozen. Rogers' contribution to Western illustration was made chiefly in the late 1870's and early 1880's. There were other Western illustrators working in this decade, also. Paul Frenzeny, whose work was described in Chapter 7 of this book continued to publish a few Westerns during the 1880's, and some very excellent Western mining illustrations by Alfred Mitchell appeared in the *Weekly.* Mitchell's illustrations, probably Colorado scenes, will

be found in v. 31 (1887), April 30, p. 317; v. 32 (1888), September 29, p. 737, December 15, p. 976 (a note on p. 959 identifies the locality as "a certain Colorado town"); v. 33 (1889), July 13, p. 561, and August 3, p. 621. Although I have made considerable search, so far I have uncovered no information about Mitchell at all other than the record of the above illustrations. A. F. Harmer had a number of sketches of the Indian war in the Southwest; John Durkin of lumbering operations; William Gilbert Gaul of California scenes and Thomas Moran of Rocky Mountain scenery. Western illustrations from photographs also appeared more frequently as the decade advanced. Of the illustrators listed above, A. F. Harmer and Gilbert Gaul were probably the most important from the standpoint developed in this book. For information concerning Gaul, see Chapter XIV.

Harmer is not well known as his name does not appear in any of the lists, indices, or biographical sources of information on artists. Dr. Arthur Woodward of the Los Angeles County Museum is collecting material for a biography of Harmer and has generously placed some of his notes at my disposal. I am indebted to him for most of the information which follows:

Alexander F. Harmer was born in Newark, N. J., on August 21, 1856, and died in Santa Barbara, Cal., January 8, 1925. He enlisted in the U. S. army in 1872 and again in 1881, and saw service in the West. Even as a youngster he was interested in sketching, an interest which led eventually to a life profession. He had several years' training in the late 1870's in the Philadelphia Academy of Fine Arts. In 1881 he decided to become a painter of Western scenes. Illustrations by Harmer of the Apache war appear in *Harper's Weekly*, v. 27 (1883), June 2, p. 340, July 7, p. 417, August 4, p. 484. Illustrations by Harmer also appear in John G. Bourke's *The Snake-Dance of the Moquis of Arizona* . . . (New York, 1884), and *An Apache Campaign in the Sierra Madre* (New York, 1886), many of which were made "on the spot" as Harmer saw service in the army during these years. Sketches and notes of his experiences during this period were later transcribed into oils and water colors. After 1890 he turned sympathetic eyes on the fast vanishing life of the old California families and of the missions and Mission Indians of California and his later career

was devoted almost entirely to the reproduction in picture of these themes.

4. My information concerning Graham's part in the survey came originally from his daughter, Mrs. Elizabeth Graham Hurlbert of Hartsdale, N. Y. Mrs. Hurlbert stated that Graham was a member of the Northern Pacific railroad survey under Gen. T. L. Rosser in 1874, but correspondence with Mr. J. H. Poore, vice-president of the Northern Pacific, seems to establish conclusively that no surveys were made by the Northern Pacific in 1874 or 1875, as no reports of these years are on file in the company records. The failure of Jay Cooke & Co., the financial agents of the Northern Pacific, in 1873 resulted in the suspension of all construction work on the railroad after 1873 and until 1876. Rosser, according to company records, joined the Northern Pacific in 1871. (The *Dictionary of American Biography*, v. 16, p. 181, gives the date as 1872.) Reference to army protection in the N. P. survey of 1873 will be found in "Report of Lieut. Gen. Sheridan," in *Report of the Secretary of War* . . ., *House Ex. Doc. No. 1, Pt. 2,* 43 Cong., 1 Sess. (1873), pp. 40, 41. Some mention of the survey will be found in the *Annual Report of the Board of Regents of the Smithsonian Institution, . . . for the Year 1873* (Washington, 1874), p. 41. For the part of Jay Cooke & Co. in the history of the Northern Pacific, *see* Eugene V. Smalley, *History of the Northern Pacific Railroad* (New York, 1883). Smalley's history is particularly inadequate, however, on the survey and construction of the road.

Some information and confirmation of Graham's part in the N. P. survey will be found in the Minneapolis (Minn.) *Journal*, January 11, 1906, "Builders of N. P. Meet After 30 Years." This account described a reunion of early workers on the N. P., but the date of Graham's experience cannot be established from this account. Graham is referred to by name and by the description, "A young man, very short of stature and inclined to corpulency, who waddled along with a surveying party in Montana and Idaho, making their topographical maps . . . " The title of this account would place the original date as 1876; but the text states that the reunion was one of workers on the N. P. "prior to 1873." The survey in 1873, however, was made in Montana, from the accounts cited earlier in this note, and it therefore seems more probable that Graham was with it that year.

5. A brief biographical note in *Harper's Weekly*, v. 31 (1887), September 10, p. 643, states that Graham joined the Harper's Brothers staff "eleven years ago. . . ." Mrs. Hurlbert writes me that he joined Harper's staff in 1878. Graham's name first appeared in the *Weekly*, v. 21 (1877), June 2, pp. 428, 429.

W. A. Rogers was an intimate friend of Graham's in their early years on *Harper's Weekly* and in Rogers' book, *A World Worth While* (New York, 1922), he several times makes mention of "little Charley Graham" (pp. 15 and 247). Rogers confirmed the fact that Graham was a scenic aritist before he joined Harper's staff. One of Graham's early illustrations (*Harper's Weekly*, v. 22 [1878], November 30, p. 953) depicted scene painters at work preparing stage backgrounds and drops.

6. Most of this information comes from Mrs. Hurlbert, who also wrote me that Graham was an official artist for the Columbian Exposition in Chicago in 1893. It seems probable that Graham was a resident of California in the middle 1890's. According to John F. Connolly, secretary, Graham was a member of the Bohemian Club of San Francisco from 1893 to 1896. He was not listed in New York city directories from 1892 to 1897 although he was for all other years from 1883 to 1906. The New York Public Library has informed me that the illustrated catalogues of the American Water Color Society show that Graham was entered in their annual exhibition in 1879, 1881, 1883, 1884, 1885, 1890 and 1891. Of these water colors, two are apparently Westerns: "Indian Camp" and "Nomads of the Wild West." The New York Public Library also stated that Graham contributed illustrations to the Chicago *Tribune*, in addition to the publications stated above.

A brief obituary of Graham will be found in the New York *Herald*, August 10, 1911.

7. *Harper's Weekly*, v. 32 (1888), January 7, pp. 4, 11.

An incident related by the illustrator Howard Pyle emphasizes with still greater clarity both the point made above and the one which follows in the text. In a letter dated August 4, 1885, Pyle related (*Howard Pyle* [Charles D. Abbott, New York, 1925], p. 100) that he went to New York City to see Charles Parsons, the art editor of the Harper publications. Parsons showed Pyle the engravings of illustrations of a Broadway procession that *had not yet occurred*, drawn from important viewpoints. Pyle dryly commented that "It struck me that this was a trifle previous and I asked Mr. Parsons what they would do if it rained." Parsons pointed out that the sky in the engravings was not dead white so that the engravings could readily and rapidly be made to show either a clear day or a driving rain.

8. *Ibid.*, v. 22 (1878), May 4, pp. 352, 355.

Graham also had an illustration "The Burial of the Wagon Master" in *Leslie's Weekly*, Feb. 13, 1896, p. 104, which was also probably based on his first Western trip, as the text of a note on the illustration refers to an incident that occurred in an early railroad survey in "The Black Hills."

9. Among these illustrations in *Harper's Weekly* were: "Winter Railroad Travel in the Northwest [possibly Minnesota or Dakota]," v. 27 (1883), January 27, p. 57; "A Snow-Slide in the Rocky Mountains," February 17, p. 105, and sketches in and around Santa Fe, July 14, p. 445. Although not Western in the sense that we have defined the West, Graham had sketches of the northern shore of Lake Superior in *ibid.*, January 6, p. 8. The Wisconsin and Lake Superior region must have been visited on several occasions by Graham as he illustrated this country in both its summer and winter aspects a number of times; *see ibid.*, v. 29 (1885), January 17, pp. 41 and 45, March 28, p. 196, August 22, pp. 552, 553, September 5, p. 589; v. 30 (1886), February 6, p. 81, June 5, pp. 360, 361; v. 33 (1889), August 31, p. 700, and September 28, p. 780. Graham also had an illustration of an Indian village, which may have been based on his experiences of 1873, in *Harper's Magazine*, New York, v. 60 (1880), March, p. 496. Probably in the same class is the excellent illustration, "Indian Warfare—The Village," *Harper's Weekly*, v. 29 (1885), October 3, p. 652.

10. Helena (Mont.) *Daily Herald*, September 7, 1883; *Harper's Weekly*, v. 27 (1883), September 15, p. 589, September 22, pp. 596, 601, September 29, p. 617, November 17, p. 728, November 24, p. 749; v. 28 (1884), January 19, p. 40, February 9, p. 96, June 14, p. 384, and August 2, p. 496. The last two illustrations are dated on the print " '83." A note in the *Weekly* for November 17, 1883, p. 731, also

specifically states that Graham was in the Pacific Northwest.

11. *Ibid.*, v. 30 (1886), January 16, p. 37.

12. In the order listed above the illustrations appeared in *Harper's Weekly* as follows: v. 30 (1886), October 30, pp. 700, 701; v. 31 (1887), April 30, p. 313; v. 28 (1884), February 2, p. 72; v. 30 (1886), February 13, pp. 104, 105, November 20, pp. 741 and 753. The return trip as suggested above is purely a conjecture. Graham may have made an independent trip to Colorado in the interval between the fall of 1883 and 1886, or the illustrations may have been drawn from photographs. Usually in the latter case, the *Weekly* specifically made the statement "after photographs." The fact that "A Snow-Slide in the Rocky Mountains" is identified as a real locality is fairly good evidence that Graham had at least visited Colorado; *see ibid.*, February 13, 1886, p. 110.

The Denver *Tribune-Republican* Nov. 26, 1886, p. 4, commends Graham "an artist of exceptional ability" for the Colorado illustrations of this period.

13. In *Harper's Weekly*, v. 31 (1887), April 9, p. 249 (cover page), is the illustration credited to Graham, "The Yellowstone in Winter—A Surprise." On pp. 256, 257, are reproductions of a number of the Haynes photographs in Yellowstone, one of which is entitled "Our Artist." It shows an individual heavily dressed, on snowshoes, with a sketch book in hand. On p. 259 is a description of this trip which in a number of places mentioned "our artist."

14. In the order as listed above the illustrations appeared in *Harper's Weekly* as follows: v. 31 (1887), April 23, pp. 296, 297 (the Denver views), July 23, p. 524, July 30, p. 540; v. 32 (1888), April 14, p. 272, October 27, p. 816, September 1, pp. 652, 653, and February 4, p. 85. The Denver Public Library has an original wash drawing of Graham's dated 1887 which is called "Eastern Slope Marshall Pass—The Great Loop on the D. & R. G. RR." Miss Ina T. Aulls of the Western History department informs me that it is the same view as shown in the last of the illustrations listed above and it is therefore probably the original from which the wood engraving was made.

In the late fall of 1886 Graham and a party of Harper's correspondents made an extensive tour of the South and between December, 1886, and August, 1887, Graham had a large number of illustrations of Southern cities. For comment on the tour see *Harper's Weekly*, v. 30 (1886), November 20, p. 743. J. Henry Harper (*The House of Harper* [New York and London, 1912], pp. 550–552) described this trip of Harper correspondents in some detail. In addition to Graham, Horace Bradley and John Durkin accompanied the Harper party as artists. In the early fall of 1887 the *Weekly* announced that Graham was leaving on an extended tour of "the great West and Northwest."—*Ibid.*, September 10, 1887, p. 643.

15. *Ibid.*, April 23, 1887, p. 299.

16. Graham was abroad in 1889. There is a group of English scenes, one of which is signed and dated by Graham, "Liverpool '89."—*Ibid.*, v. 33 (1889), December 28, p. 1041. Mrs. Hurlbert wrote me that her father was abroad several times.

17. The illustrations in the order given above appeared in *Harper's Weekly*, v. 34 (1890), March 8, p. 173, April 19, p. 293, July 19, p. 561 (Santa Fe), June 28, p. 496 (Las Vegas Hot Springs), July 5, p. 520 (Harvey's ranch), and August 2, p. 592. Some of the others included: "Sketches in New Mexico, Near Las Vegas," v. 34 (1890), July 12, p. 544; "Sketches at Santa Barbara, Southern California," August 23, p. 652; sketches at Spokane Falls and the Northwestern Exposition, September 6, pp. 690, 691; "Salmon-Fishing on the Frazer River, British Columbia," September 20, p. 729; "Golden Gate Park, San Francisco," September 20, p. 732; "Pueblo Farmers Watching Their Crops," October 4, p. 765; "The City of Los Angeles, California," October 18, pp. 808, 809, and probably belonging to the same group, "Sketches in Albuquerque, New Mexico, and Vicinity," v. 35 (1891), August 1, p. 576. This last group is of additional value in that the sketches were reproduced in half-tone and not by woodcut and therefore give a record of Graham's very real skill as a draftsman.

The illustrations dated included one of the Harvey ranch group, "N. M., June 1st, 1890"; one in the group near Las Vegas, "N. M., May 13, 90"; one in the Santa Fe group, "Santa Fe, May 16, 90"; one of the Santa Barbara group, "Santa Barbara, June 4, 90," and one of the Los Angeles group, "Los Angeles, June 1st." Evidently Graham had a slip of memory in the first sketch which should probably be "May 1st." One of the San Francisco

sketches also bears the letters "S. F." with his signature.

It seems quite probable that Graham's illustration of the "Church at Acoma" was based upon a photograph of W. H. Cobb of Albuquerque. The Bureau of American Ethnology, Smithsonian Institution, Washington, D. C., has such a photograph dated "1890" which in many respects is similar to the Graham illustration; a fact which further illustrates the discussion made at the beginning of this chapter.

18. *Ibid.*, v. 35 (1891), January 17, p. 39.

19. Some of Graham's drawings and paintings of the fair were published by the Winters Art Lithographing Company of Chicago; *see Harper's Weekly*, September 19, 1891, pp. 707, 708.

20. *Harper's Weekly*, v. 38 (1894), September 22, p. 897. Other California illustrations of this period by Graham in the *Weekly* included: "Santa Cruz, California," July 28, 1894, p. 708; "A Model Lemon Ranch in California," August 4, p. 728; "The Great Soda Lake, in Inyo County, California . . .," September 8, p. 849, and "The Sutro Baths, San Francisco, California," p. 856; "Around San Francisco Bay," September 15, p. 872; "Asphalt Industry in Southern California," October 6, p. 945; "The Water-Supply of San Francisco," October 20, p. 992; "A Steam-Wagon Hauling Lumber in the Sierras," October 27, p. 1028; "Mining for Gold in California," v. 39 (1895), January 19, p. 56; "Scenes In and About San Jose," February 16, p. 153, and "Crater Lake and Cove, Cascade Mountains," v. 40 (1896), September 19, p. 932.

21. The illustrations in the order listed above appeared in *Harper's Weekly*, v. 34 (1890), August 30, pp. 680, 681; v. 35 (1891), July 18, p. 540, September 19, a double-page supplement; v. 37 (1893), November 25, p. 1125, and v. 40 (1896), October 10, p. 996. The last picture is almost the final illustration of Graham's to appear in *Harper's Weekly*, the last ones being several Cuban illustrations which were published in the *Weekly* of 1898. Although most of Graham's Western illustrations have been listed in text or notes, there have been some omissions. Note, too, that there are probably Western illustrations of Graham's in other periodicals or newspapers than the *Weekly* that have not been caught. A more complete list of Graham's illustrations of all types than is given here for the decade 1890–1899 will

be found in *19th Century Readers' Guide to Periodical Literature, 1890–99* (New York, 1944), v. 1, pp. 1108, 1109.

22. The information on Graham's work after 1900 comes from his daughter, Mrs. Elizabeth Graham Hurlbert. For the reference to Pennell, *see* Joseph Pennell, *Pen Drawing and Pen Draughtsmen*, 3rd ed. (London and New York, 1897), pp. 223, 270, 271. Pennell also makes brief mention of Graham in his *Modern Illustration* (London and New York, 1895), p. 127.

The source of the Rogers quotation is cited in note 5.

23. These biographical facts concerning Zogbaum came from Appleton's *Cyclopaedia of American Biography* (New York, 1889), v. 6, p. 662, and an interview (the quoted material above) by P. G. H., Jr., in an article "Rufus S. [*sic*] Zogbaum," *The Bookbuyer*, New York, v. 12 (1895), April, pp. 132–135. P. G. H., Jr., was probably Philip G. Hubert, Jr., a frequent contributor to *The Bookbuyer*. It should be noted that Zogbaum had already contributed a military illustration to the pictorial press before his Paris trip. "Artillery School for Militiamen at Fort Hamilton" by Zogbaum had appeared in *Harper's Weekly*, v. 23 (1879), November 15, p. 904. The small item of information on Bonnat comes from Champlin's *Cyclopedia of Painters and Paintings*, v. 1, p. 179.

24. In the order as stated these will be found in *Harper's Magazine*, v. 71 (1885), July, pp. 188–193; *Harper's Weekly*, v. 29 (1885), August 29, p. 571; *Harper's Magazine*, v. 71 (1885), September, pp. 605–610; *ibid.*, v. 72 (1886), May, pp. 849–860. The last two articles, with additional illustrations and text, were later reprinted in Zogbaum's book, *Horse, Foot, and Dragoons* (New York, 1888).

25. The first article appeared in July, 1885, and the illustrations are dated '84 (Zogbaum, fortunately for the historian, dated nearly all his illustrations) and none of his Western sketches bear any earlier date. An incident to which Zogbaum refers in the fourth article listed above can definitely be dated as occurring in 1884; *see* note 31.

26. "A Night on a Montana Stage-Coach," *Harper's Weekly*, v. 29 (1885), August 29, p. 571.

27. *Ibid.*, August 8, 1885, pp. 520 and 528. The Sheridan picture was supposed to show the general in Oklahoma but Zogbaum supplied him with a Montana background, for it is almost the same as

Zogbaum used in the illustration, "The Herd," for his article, "Across Country With a Cavalry Column" (*see* note 24).

28. "Report of Brigadier-General Terry," in *Report of the Secretary of War, House Ex. Doc. No. 1, 48 Cong., 2 Sess.* (1884–1885), p. 112. The report of the Secretary of War for 1883 has also been examined and the troop movement described fits the facts as described by Zogbaum the most closely of any for the two years. As Zogbaum's account indicated, the expedition was of considerable size. The official report stated that Hatch's troops consisted of headquarters, field, staff, band, and Troops F, G, H, I, and L (joined by Troop E at Billings and B at Helena). The description of the route as given by Zogbaum would coincide with Hatch's movements. Further, since the second in command is referred to by Zogbaum as "the senior major" would require an officer of still higher grade as the leader. Zogbaum refers to "our chief" as an officer of great service, "the snows of forty years of active service in field and garrison crowning his head. . . ." Hatch, according to the *Dictionary of American Biography*, v. 8, pp. 392, 393, retired in 1886 as the commanding officer of the Second cavalry. He was graduated from the military academy at West Point in 1845 and had seen service in the Mexican war, the Civil War and had had 20 years of the life of a professional soldier on the plains after the Civil War. Further, Zogbaum quoted the cook of the officers' mess as addressing his commanding officer as "Sheneral." Hatch had been breveted both as a brigadier general and major general for service in the Civil War.

The second in command of the Second cavalry would, of course, be the lieutenant colonel, who in 1884 was Andrew J. Alexander. In fact the *Official Army Register for January, 1884* (p. 53) gives the ranking officers of the Second cavalry as John P. Hatch, colonel; Andrew J. Alexander, lieutenant colonel; James S. Brisbin, Eugene M. Baker and David S. Gordon, majors ranked in the order given. An examination, however, of the *Army & Navy Journal*, New York, for 1883 and 1884 shows that Colonel Alexander was almost continually on sick leave and on December 31, 1883, was granted a six-months' sick leave (*ibid.*, January 5, 1884, p. 454) which in July, 1884, was extended for another six months (*ibid.*, July 19, 1884, p. 1037). This absence of Colonel Alexander

in 1884 would leave Major Brisbin as "the second in command." Brisbin, however, was on detached duty at the time of the overland trip in 1884, for he left Fort Ellis, Montana, for Pocatello, Idaho, with Troop D of the Second cavalry on May 26, 1884 ("Report of Brigadier-General Terry," *loc. cit.*), which would leave Major Baker as the second in command on the overland trip from Fort Custer to Missoula.

Further, and this point is the clincher, Zogbaum described the second in command as "a brave and unassuming soldier, whose bloody encounters with the savage foe of the pioneer form part of the history of the great Northwest. . . . He will be long and kindly remembered by his comrades. He has made his report to the Great Captain since then, and has joined the grand army of the dead." As Zogbaum's article was published in September, 1885, the second in command had died between the summer of 1884 and September, 1885. According to the *Army & Navy Journal* (December 27, 1884, p. 421), Maj. E. M. Baker, Second cavalry, died at Fort Walla Walla on December 19, 1884. This account further stated that Baker was breveted colonel on December 1, 1868, "for zeal and energy while in command of troops operating against hostile Indians in 1866, 1867, and 1868, . . . since the Civil War his record was one of arduous service on the frontier." I consider that the review of the facts given here establishes the identity and date of the expedition that Zogbaum accompanied with certainty.

In Zogbaum's book, *op. cit.* (p. 133), there is an added paragraph not present in the original *Harper's Magazine* version which stated that Zogbaum took leave of the Second cavalry "on the edge of a forest in northern Idaho" and inferred that the locality was on the line of the newly-finished Northern Pacific. Evidently Zogbaum entrained with the troops at Missoula (some 40 miles from the Montana-Idaho border) and rode with them some distance westward.

29. Zogbaum, *op. cit.*, p. 116. That Zogbaum's comment on "our little army" was certainly true is shown by the fact that on November 1, 1884, the U. S. army totaled 2,147 officers and 24,236 enlisted men.—"Report of the Lieutenant-General of the Army," in *Report of the Secretary of War, House Ex. Doc. No. 1, Pt. 2, 48 Cong., 2 Sess.* (1884–1885), p. 45.

30. Many years later Zogbaum stated that

he had visited Poplar River (*Scribner's Magazine*, New York, v. 57 [1915], January, p. 16) but contemporary evidence is furnished by a Zogbaum sketch belonging to his daughter, Mrs. Linzboth (*see* note 33), which bears the inscription, "The Captured Cayuse—Camp Poplar River M. T. 1884." Mrs. Linzboth writes, "The cayuse is anything but sleek or well groomed."

In the summer of 1884 some companies of the 15th U. S. infantry were stationed at Camp Poplar River.—*Report of the Secretary of War, loc. cit.*, pp. 62, 113. The identification of Fort Maginnis above is largely a guess; Zogbaum mentioned Fort Maginnis in one of his articles and it appears to be the only army post "forty miles back of us [from the Missouri] over the prairie."

31. Zogbaum's comment on the vigilantes is additional evidence on the date of the trip, for, according to Granville Stuart in *Forty Years on the Frontier* (Cleveland, 1925), the vigilantes were at work in July, 1884. Zogbaum mentioned the night before the river boat on which he was a passenger reached a small camp, one "Billy D—" had been taken by the vigilantes and hanged. Stuart, v. 2, p. 206, stated that Billy Downs was hanged by the vigilantes on the night of July 4, 1884. Zogbaum mentioned the still burning ruins of "the Jones boys' ranch." Stuart (pp. 207–209) described the destruction of the *James* family (father and two sons) and their allies. Zogbaum further mentioned the fact that the vigilantes hailed the river boat which stopped for them and their leader, "a tall, handsome, blond-bearded man, flannel-shirted, high-booted, with crimson silk kerchief tied loosely, sailor fashion, around his sunburnt neck . . .," who asked for upriver news. "Many on board recognize him," wrote Zogbaum, "for a man of wealth and education well known in the Territory. . . ."

32. The second illustration does not appear in the original article in *Harper's Magazine* but does in *Horse, Foot, and Dragoons*, p. 157.

33. I have been in correspondence with Mr. Harry St. Clair Zogbaum and Mrs. Kate Zogbaum Linzboth, children of R. F. Zogbaum, who supplied me with personal recollections of their father and of his Western experiences. Both have examples of their father's water-color sketches of the period under discussion and I am indebted to both for their kindness and courtesy in supplying such information as they possess. Neither Mr. Zogbaum nor Mrs. Linzboth, however, could supply me with information concerning the number of Montana trips made by their father.

Mrs. Anne McDonnell of the Historical Society of Montana has spent considerable time searching Montana newspapers of this period to see if contemporary mention of Zogbaum would throw more light on the number of his Montana trips, but so far she has met with little success. Mrs. McDonnell has, however, contributed greatly to my knowledge of the history and geography of Montana territory, a contribution which has been a very real aid in my study of Zogbaum and other Montana artists. I acknowledge her aid with sincere thanks.

34. To complete the bibliography of Zogbaum's Western writings up to 1890, we should cite: "An Evening Among the 'Chickens' in Montana," *Harper's Weekly*, v. 29 (1885), October 10, p. 670; "A Day's Trout-Fishing in Montana" (the locality is identified as Fort Missoula), *ibid.*, v. 30 (1886), July 10, p. 443; "On the Modern 'Ship of the Plains'," *ibid.*, November 13, p. 731; "How the Sergeant Shot the Bear," *ibid.*, v. 33 (1889), January 5, p. 7.

35. In the order listed above these appeared in *Harper's Weekly*, as follows: v. 29 (1885), September 19, p. 613, October 10, p. 668; v. 30 (1886), July 10, p. 445, October 16, pp. 668, 669, November 13, p. 728; v. 31 (1887), January 15, p. 36, March 12, pp. 184, 185, April 23, p. 289, July 30, p. 541, December 24, p. 944; v. 32 (1888), January 28, pp. 64, 65, August 11, p. 585; v. 33 (1889), January 5, p. 1.

36. The Remington illustration, also a double-page feature, will be found in *ibid.*, v. 33 (1889), December 21, pp. 1016, 1017. The original sketch, "Painting the Town Red," is now in the possession of Mrs. Linzboth. It measures 15¼ x 13½ inches.

37. His first, if we except the sporadic illustration published in 1882 in *Harper's Weekly* (and previously mentioned) which was redrawn by W. A. Rogers. It is in style and manner a Rogers illustration and not a typical Remington.

38. *Harper's Weekly*, v. 30 (1886), October 9, p. 645. Probably Remington's first illustration of cowboys at "play" was his "A Quarrel Over Cards—A Sketch From a New Mexican Ranch," *ibid.*, v. 31 (1887), April 23, p. 301.

It should, of course, be pointed out that the earlier cowboy illustrations mentioned above in the text were the cowboys of Texas, Kansas and Colorado. Cowboys of Montana were unknown in 1880, according to Granville Stuart (*Forty Years on the Frontier*, v. 2, p. 188), who also gives a good word picture of cowboy life in Montana as he witnessed it in the 1880's (*ibid.*, pp. 175–188).

The article that accompanied "Painting the Town Red," written by G. O. Shields, did nothing to change the conception of the cowboy prevalent in the middle 1880's and which, of course, is still prevalent in the movies and "slick" fiction. The cowboy, according to these sources, was a rough and ready customer, the possessor of a crude wit and an individual who was always ready to draw and shoot on the slightest provocation. Shields attempted to defend and change the popular opinion and started out his defense by stating that cowboys "as a class are brimful and running over with wit, merriment, good-humor," but he goes on to recount that cowboys once boarded a train and forced Theodore Thomas and his orchestra, who were passengers, to give an impromptu concert on the plains. With similar yarns Shields actually built up the contemporary conception and even an account of a "gentlemanly" cowboy, the celebrated Howard Eaton, did little to change this conception. There were serious contemporary accounts of the changing character of the cowboy, however, as witness the article by Joseph Nimmo, Jr., in *Harper's Magazine*, v. 73 (1886), November, pp. 880–884.

39. *Art Interchange*, New York, v. 16 (1886), p. 212. Of similar significance, possibly, was the publication of six of Huffman's photographs of a Montana roundup in *Harper's Weekly*, v. 30 (1886), May 15, p. 316.

40. Lloyd Goodrich, *Thomas Eakins* (New York, 1933), p. 102.

41. *Harper's Weekly*, v. 30 (1886), November 13, p. 731. The illustration was on p. 728 as already noted. It may be recalled that Frenzeny and Tavernier, some dozen year earlier, had attempted the same theme. Their illustration, "In the Emigrant Train," *ibid.*, v. 18 (1874), January 24, p. 76, is small and not as successful in treatment as is Zogbaum's.

42. Robert Louis Stevenson made his overland trip in the summer of 1879, on the Union Pacific rather than the Northern Pacific. *See* his essay, "Across the Plains," in *The Travels and Essays of Robert Louis Stevenson* (New York, 1918), v. 15, pp. 99–148 (the essay first appeared in *Longman's Magazine*, London, July and August, 1883) and v. 23, pp. 169, 170. It should, of course, be pointed out that Stevenson's account was influenced by the fact that he was ill and desperately fatigued by the overland journey.

43. In the note accompanying this Zogbaum illustration (*Harper's Weekly*, v. 31 [1887], January 15, p. 39) the statement is made that in the season 1883–1884 the Northern Pacific shipped nearly 8,000 tons or 800 cars of buffalo bones. The bones were converted to bone black, used in sugar refineries and other industries. Col. Henry Inman in *The Old Santa Fe Trail* (Topeka, 1899), p. 203, stated on the basis of freight reports of Kansas railroads, that some 300,000 tons of buffalo bones, which he estimated represented 31,000,000 animals, were shipped from Kansas alone in the decades when bone gathering formed a means of livelihood or a welcome supplement to a livelihood on the plains; *see* also note 34, Chap. VII.

44. For a review of these affairs, *see* R. N. Richardson and C. C. Rister, *The Greater Southwest* (Glendale, Cal., 1934), ch. 23, "Oklahoma Boomers and Eighty-niners." A more extended account of the "Boomer" movement is given in C. C. Rister's *Land Hunger: David L. Payne and the Oklahoma Boomers* (Norman, Okla., 1942).

45. Six illustrations on one page, *Harper's Weekly*, v. 33 (1889), April 13, p. 280. These sketches are not dated, as was the usual practice of Zogbaum. All the remaining Zogbaum illustrations of the period described in the text are dated "89."

The date of Zogbaum's Indian territory trip is had from a letter in Mrs. Linzboth's possession which Zogbaum addressed to his wife. It is headed, "In camp, 5th Cav. Ind. Terr. Oct. 10, 1888."

46. In the order listed these appeared in *Harper's Weekly* as follows: v. 33 (1889), May 25, p. 405, July 6, p. 544, August 3, p. 613; v. 34 (1890), January 4, pp. 8–11 (Nos. 4–8); v. 40 (1896), December 5, p. 1185. The last illustration listed above is dated "96" and may represent the result of another trip to the Indian country but as there are no companion pieces for 1896 I scarcely think there was an 1896 trip. Moreover, Zogbaum had an illustration in

ibid., v. 33 (1889), April 6, p. 257, "Hunting Wild Turkey by Moonlight," which was probably based on his trip to the Indian territory in 1888; his experiences on this trip doubtless gave rise to the latter illustration (that of 1896).

It is interesting to note that Remington had an illustration, "Cheyenne Scouts Patrolling the Big Timber of the North Canadian, Oklahoma," in *ibid.*, April 6, pp. 264, 265, over a month before Zogbaum's illustration, "Cheyenne Scouts at Drill," listed above. There is no similarity, however, in the two illustrations. Remington also had an illustration somewhat similar to Zogbaum's "A Beef Issue in the Indian Territory," in *ibid.*, v. 36 (1892), May 14, p. 461, "The Beef Issue at Anadarko." The locality of the two were not the same, however, as Zogbaum's was made near Fort Reno. The beef issue at an Indian agency, however, was depicted by other artists in addition to these two.

47. The phrase quoted is from *ibid.*, v. 33 (1889), May 25, p. 411.

Harper's Weekly, Nov. 14, 1891, p. 887, particularly emphasizes the accuracy which Zogbaum always insisted upon in his military pictures.

48. *Ibid.*, v. 34 (1890), January 4, pp. 8–11.

49. In the order listed these appeared in *Harper's Weekly*, v. 33 (1889), September 28, pp. 776, 777, November 16, pp. 916, 917; v. 34 (1890), March 29, pp. 240, 241, June 7, p. 449; v. 36 (1892), December 17, p. 1216.

50. An extensive bibliography of Zogbaum's illustrations and his own writings in the decade 1890–1899 will be found in the *19th Century Readers' Guide to Periodical Literature, 1890–99*, v. 2, pp. 1553, 1554. Three additional Zogbaum illustrations of the 1880's may be found in *Harper's Bazar:* "Montana Horse Band" (dated '85), *Bazar*, November 20, 1886, p. 766; "A Citizen Outfit on the Move" (dated '85) with a brief article "An Hour's Drive Through an Idaho Forest" signed by Zogbaum, *Bazar*, April 28, 1888, p. 280; "Army Life on the Frontier—Visit to the Rifle Range" (dated '87), *Bazar*, October 20, 1888, p. 689.

51. The illustration and accompanying article will be found in *Scribner's Magazine*, v. 30 (1901), November, pp. 593–613.

52. *Harper's Weekly*, v. 36 (1892), April 23, p. 387. The New York Public Library

has also a *Catalogue of Original Drawings and Water Colors by Rufus Fairchild Zogbaum*, being a list of his pictures on sale at the American Art Galleries, New York City, January 22, 1897. The *Catalogue* included some Westerns, three of which were scenes connected with the Wounded Knee Indian "Campaign" of 1890. Whether these were drawn from direct observation I have not been able to determine.

53. *The Outlook*, New York, v. 61 (1899), February 4, p. 284.

54. A biographical sketch of Zogbaum appears in the *Dictionary of American Biography*, v. 20, pp. 658, 659. The sketch makes no mention of Zogbaum's contribution to Western illustration.

CHAPTER XIII

Remington in Kansas

1. The Buckman article, quoted at the heading of the chapter, "Ranches and Ranchers of the Far West," *Lippincott's Magazine*, Philadelphia, v. 29 (1882), p. 435, begins by commenting on the Western exodus of young collegians and professional men from the overcrowded East. The fundamental origin and the economic causes of the migration and the organization and conduct of the huge cattle companies have been satisfactorily dealt with by Ernest S. Osgood, *The Day of the Cattleman* (Minneapolis, 1929), especially in the chapter "The Cattle Boom." W. P. Webb, *The Great Plains* (Boston, 1931), pp. 233–239, and Louis Pelzer, *The Cattleman's Frontier* (Glendale, Cal., 1936), are other sources of information on these topics. The social aspects of the migration in all their interesting features, however, still lack a chronicler. In this connection, the three books of Theodore Roosevelt (*Hunting Trips of a Ranchman*, N. Y., 1885; *Ranch Life and the Hunting-trail*, N. Y., 1888; *The Wilderness Hunter*, N. Y., 1893) are among the most important of contemporary accounts of ranching in the eighties; not only because Roosevelt was an actual participant in the Western scene of this period but because of his historical perspective in writing his accounts and his keen interests as an amateur naturalist. The additional contemporary literature listed in notes 10 and 11 (far from complete, but somewhat more extensive than is available elsewhere) may serve as a starting point for such a study; and, inci-

dentally, this book itself contributes, I trust, to this interesting subject.

2. Roosevelt's enthusiastic comment on ranch life will be found in his *Hunting Trips of a Ranchman* (Medora edition, p. 19). The Medora edition of Roosevelt's book (1885) is a choice item for any collector of Western Americana. Beautifully printed in limited edition (500 copies) it contains 4 notable etchings (india-proof impressions) by R. Swain Gifford, 7 animal heads (Japan-proof impressions by J. C. Beard, the well-known animal artist), and 20 full-page illustrations by Henry Sandham, Fannie E. Gifford, R. Swain Gifford, A. B. Frost, and J. C. Beard with the engravers specified on each page of illustration. Of the above illustrators, R. Swain Gifford, Henry Sandham, and A. B. Frost, deserve brief comment in our account. Gifford (1840–1905) had other western illustrations; in *Picturesque America* (2 vol. 1872–74), for which he made a western trip for the purpose of collecting his picture material: in "Ladies Day at the Ranch" by Alice W. Rollins, *Harper's Magazine* v. 71, p. 3 (1885) and in *Century Magazine* n.s., v. 8, p. 220 (1885) (Big Horn Mountains). A brief sketch of his life will be found in *Dictionary of American Biography*, v. 7, pp. 263–264, N. Y., 1946.

Henry Sandham (1842–1910), Canadian born, traveled extensively both in this country and abroad, and a considerable number of his illustrations deal with the western scene (*see Art Amateur,* v. 12, p. 111, 1885, and *Century Magazine,* 1883). A brief biographical sketch appears in *Dictionary of American Biography,* v. 16, pp. 339–340, N. Y., 1946.

A. B. Frost (1851–1928) also has many scattered western illustrations but the standard biographic sources on his life are of little value in describing any of his western experiences. (*A. B. Frost*, Henry W. Lanier, N. Y., 1933, and *Dictionary of American Biography*, v. 7, pp. 41–42, N. Y., 1946.) Especially notable from our standpoint are his illustrations in Octave Thanet's *Stories of a Western Town,* N. Y., 1893. The "Western Town" was in Iowa.

The standard sources of information on the Western experiences of Roosevelt are his own accounts cited in note 1 and Hermann Hagedorn, *Roosevelt in the Bad Lands* (Boston and New York, 1921); *see also,* Ray H. Mattison, "Roosevelt and the Stockmen's Association," in *North Dakota History,* v. 17, April and July, 1950. The ranching experiences of Roosevelt as only one of the chapters of his life are described in many biographies; for example, Henry F. Pringle, *Theodore Roosevelt* (New York, 1931). It is not argued in the text, of course, that Roosevelt would not have been President save for his ranch experience, but the route, which began with the Dakota ranch, and then led through the Rough Riders and the Spanish war to the governorship of New York, to the Vice-presidency and then to the White House, got him there more quickly than if his Dakota experiences had not occurred. After I had written the lines in the text concerning Roosevelt, and the effect of Western life on his career, I chanced across John Burroughs' *Camping and Tramping With Roosevelt* (Boston and New York, 1907). On pp. 14 and 15 Burroughs made a statement credited to Roosevelt himself that is practically the same as my summary.

3. There is no satisfactory biography of Emerson Hough. His original Western venture, not dated with certainty, is briefly described by Lee Alexander Stone, *Emerson Hough: His Place in American Letters* (Chicago, 1925), p. 16. *The Covered Wagon* was called "the one great American epic that the screen has produced" by Robert E. Sherwood, ed., *The Best Moving Pictures of 1922–23* (Boston, 1923), p. 72. Lewis Jacobs in *The Rise of the American Film* (New York, 1939), gives a more reasonable judgment of the film but even he called *The Covered Wagon* "forthright, impressive, and vigorous."

4. For Owen Wister's initial experience in the West and his early contacts with Theodore Roosevelt *see* Wister's *Roosevelt—The Story of a Friendship* (New York, 1930). On page 28, Wister writes "Early in July, 1885, I went there [Wyoming]. This accidental sight of the cattle-country settled my career." For a brief biography of Wister, *see* New York *Times,* July 22, 1938, p. 17. *The Virginian,* when it first appeared in 1902, was an overnight best seller.—*The Publishers' Weekly,* New York, v. 135 (February 18, 1939), p. 835.

5. Finley P. Dunne, *Observations by Mr. Dooley* (New York, 1902), p. 227; *see also* the comment by Theodore Roosevelt (cited in note 11) on his classmates at Harvard who were ranchers.

6. Hagedorn, *op. cit.,* p. 101.

7. *The Spectator,* London, March 17, 1877, p. 341. The report of the Royal Commis-

sion referred to is *Report on American Agriculture, With an Appendix* (1880), which is part of the report of the Royal Commission on Agriculture (depressed condition), 1879. Buckman, *loc. cit.*, also states in connection with this Western migration, "The English first sought out the new land."

Even before the date of the *Spectator* reference cited above, English periodicals were sending representatives to Western America to inquire into the possibilities of emigration abroad. Edwin A. Curley, for example, was sent by *The Field* (London) as a special representative to the "Emigrant Fields of North America." Curley published many letters in *The Field* for 1873 and 1874 written from Kansas, Nebraska, Wyoming and elsewhere, describing in considerable detail agricultural conditions in the West as he found them, with his estimates of the chance for success by emigrants from England.

8. Emerson Hough, "Texas Transformed," *Putnam's Magazine*, New York, v. 7 (1909-1910), p. 200.

9. Remington's autobiography, *Collier's Weekly*, New York, March 18, 1905.

10. Richard I. Dodge, *The Plains of the Great West* (New York, 1877), or its English edition, *The Hunting Grounds of the Great West* (London, 1876), was one of the best-known books of its kind and doubtless was the incentive that drew many to the West. Many years after its publication, Theodore Roosevelt and George Bird Grinnell called it "The best book upon the plains country."—*See* their *American Big-Game Hunting* (New York, 1901), p. 323.

The other books mentioned in the text were published as follows:

J. S. Campion, *On the Frontier* (London, 1878). Experiences of some years in the West, ranching, hunting and traveling.

A. Pendarves Vivian, *Wanderings in the Western Land* (London, 1879). Experiences in the West on a hunting trip in 1877.

William A. Baillie-Grohman, *Camps in the Rockies* (New York, 1882). A London edition appeared the same year; a second English edition in 1883, and a second American edition in 1884. The book, based on four trips to America, was essentially a sporting book but it contains a chapter on ranching and an appendix which estimates the probable profits to be gained from cattle ranching. Other books bearing on the same general period are numerous.

A few are listed below. Altogether their influence, quite apart from any real merits the books may or may not have possessed, must have been considerable. The interested reader will note how many are of English origin or had English editions. A continuation of Wagner's *The Plains and the Rockies* from 1865 until 1890 or 1900 would be a most welcome addition to the tools of the worker in Western history. Although far from complete I have listed some additional titles below which have been of use to me in the period 1876-1886. These include:

William Blackmore, ed., *Colorado, Its Resources, Parks and Prospects* (London, 1869). Although lying outside the dates specified above, it is given as an illustration of an elaborate emigrant brochure.

Earl of Dunraven, *The Great Divide: Travels in the Upper Yellowstone* (New York, and London, 1876).

Frank Whittaker, George A. Custer (New York, 1876).

Edward L. Wheeler, *Deadwood Dick Library* (Cleveland, 1878-1889). Over fifty published in this period. All were Westerns.

James B. Fry, *Army Sacrifices* (New York, 1879). Western Indian war.

Harry Castlemon, *George in Camp or Life on the Plains* (Philadelphia, 1879). A book for boys.

William F. Cody, *Life of William F. Cody* (Hartford, 1879).

John Mortimer Murphy, *Sporting Adventures in the Far West* (New York and London, 1879).

Rossiter W. Raymond, *Camp and Cabin: Sketches of Life and Travel in the West* (New York, 1880). Nevada, California and the Yellowstone country.

Stephen R. Riggs, *Mary and I: Forty Years With the Sioux* (Chicago, 1880). Missionary life from 1837 to 1877.

Samuel Nugent Townshend, *Our Indian Summer in the Far West* (London, 1880). Description of a tour of Kansas, Colorado and the Southwest.

Benjamin F. Taylor, *Summer-Savory Gleaned From Rural Nooks in Pleasant Weather* (Chicago, 1880). Colorado and Utah.

J. W. Buel, *Heroes of the Plains* (St. Louis, 1881).

James A. Little, *Jacob Hamblin* (Salt Lake City, 1881). Frontiersman in Utah and Arizona.

Gen. James S. Brisbin, *The Beef Bo-*

nanza, or How To Get Rich on the Plains
(Philadelphia, 1881; also an English edition with the same imprint). Here's a daisy! There was no curb on General Brisbin's enthusiasm. By five years, according to Brisbin's estimate, the annual income from a cattle ranch would be bigger than the original investment. "After the fifth year the profits will be enormous." Sheep ranching also was boosted and the prospective sheep rancher was told that he could "clear on herd and ranch worth $12,000 in three years." To prove his points for skeptical readers Brisbin has the expenses and profits all carefully tabulated for a five-year period.

R. P. Spice, *The Wanderings of the Hermit of Westminster Between New York and San Francisco* (London, 1881).

Caroline H. Dall, *My First Holiday or Letters Home from Colorado, Utah and California* (Boston, 1881).

G. Manville Fenn, *The Silver Canon: a Tale of the Western Plains* (N. Y., 1884).

Captain D. C. Poole, *Among the Sioux of Dakota: 18 months experience as an Indian Agent* (N. Y., 1881).

G. Thomas Ingham, *Digging Gold Among the Rockies* (Philadelphia, 1882).

William H. Russell, *Hespereothen: Notes From the West* (London and New York, 1882), 2 vols. By the well-known English correspondent of the Civil War. Described a trip of 1880–1881 through Minnesota, Kansas, Colorado, New Mexico and California.

Richard I. Dodge, *Our Wild Indians* (Hartford and Chicago, 1882). The Indians were Western Indians, and Dodge, an army officer, wrote with the authority of a good many years' experience on the plains as this book and *The Hunting Grounds of the Great West* show.

George R. Price, *Across the Continent With the 5th Cavalry* (New York, 1883).

George O. Shields, *Hunting in the Great West* (Chicago and New York, 1883). Mainly Montana and Wyoming.

E. S. Topping, *The Chronicles of the Yellowstone* (St. Paul, 1883). Historical and promotional.

Gen. George A. Custer, *Wild Life on the Plains and Horrors of Indian Warfare* (St. Louis, 1883). Reprints of General Custer's *Galaxy* articles plus additional material. Presumably published for large circulation (cheap paper and extremely crude illustrations), it went through many editions. Intermediate between the more conservative books listed above and the still cheaper dime novels. Incidentally, dime novels by 1884 were being severely criticized on the grounds that the pernicious influence which they exerted was causing youngsters to commit crimes (robberies and holdups) so that they could "go West and be cowboys"; a criticism certainly pertinent in any discussion of the effect of literature on the Western migration.—*See* the New York *Semi-Weekly Tribune,* March 11, 1884. In Albert Johannsen's notable contribution to Americana *The House of Beadle and Adams* (Norman, Okla., 1950, two volumes) is found a listing of a vast number of dime novels. Although it is not always possible to tell the locale of the story in each of these dime novels from the listed title, it is all too apparent that the Western theme contributed to a very considerable number of the total list. In "Beadles Dime Novels" (listed in vol. 1 of Johannsen) published between 1860 and 1874 there are listed 321 titles; of these I count 112 with a distinctly trans-Mississippi locale. In "Beadles New Dime Novels" (also listed in vol. 1) published between 1874 and 1885, 125 of 311 titles are clearly of stories occurring beyond the Mississippi.

Reginald Aldridge, *Life on a Ranch* (New York, 1884); in England as *Ranch Notes* (London, 1884). Aldridge, an Englishman, out of work in the depression of the 1870's, came to the United States after reading the letters from Kansas and Colorado already used in the English periodical *The Field.* The book reviews his cattle-ranching experience in Kansas, Indian territory and Texas from 1877 to 1883.

William Shepherd, *Prairie Experiences in Handling Cattle and Sheep* (London, 1884, and New York, 1885).

Profits of Sheep and Cattle Raising in Southwest Kansas (Topeka, 1884). This pamphlet is cited as illustrative of still another type of literature which had marked influence in the Western migration of the 1880's. It is a promotional bulletin published by the Santa Fe railroad. That these bulletins did have a considerable effect—although not always the desired one—is attested by a Kansas correspondent in a letter to *The Nation,* New York, August 6, 1885, p. 113.

Elizabeth Custer, *Boots and Saddles* (New York and London, 1885). Although the life of the Custers on the Dakota plains in the 1870's is the topic, the book

again focused Eastern attention on the West. *Harper's Weekly* commented (July 4, 1885, p. 423) "By common consent one of the pleasantest, as it is one of the most popular, books of the year is Mrs. Custer's *Boots and Saddles* . . . a valuable contribution to the literature of military and frontier life. . . ."

Walter, Baron von Richthofen, *Cattle Raising on the Plains of North America* (New York, 1885). The author states that he had lived in Colorado and was for many years engaged in the stock business. He gives a brief account of the extent of cattle ranching by 1885 with estimates of costs and profits. Chapter 9 deals with the great ranches of the West and gives some idea of the magnitude of ranching as a big business. I have read that Baron Richthofen was the father of the celebrated aviator Richthofen of World War I and that the aerial tactics of the "flying circus" introduced by Richthofen were suggested by tales told by the elder Richthofen of the circling tactics used by the Plains Indians in the warfare against the whites. I have been unable to verify the relationship between the two Richthofens.

John H. Sullivan, *Life and Adventures of a Cow-Boy or Valuable Hints on Raising Stock* (New York, ca. 1885).

De B. Randolph Keim, *Sheridan's Troopers on the Border* (Philadelphia, 1885).

Ernest Ingersoll, *The Crest of the Continent* (Chicago, 1885).

Percy G. Ebutt, *Emigrant Life in Kansas* (London, 1886). Cattle ranching in Kansas in the 1870's.

E. Marston, *Frank's Ranche or My Holiday in the Rockies* (London and New York, 1886), "What We Are To Do With Our Boys."

11. Among my notes on articles in the periodical literature dealing specifically with various aspects of ranching (not already cited) are those listed below. It should be kept in mind that articles dealing with Western Indians, the West, etc., should also be included in any complete bibliography of Western literature, for in the late 1870's and early 1880's all such material served to instruct and attract its readers in the West.

W. A. Baillie-Grohman, "Cattle Ranches in the Far West," *Fortnightly Review*, London, v. 34 (October, 1880), p. 438. This article forms the basis of Chapter 12 in his book *Camps in the Rockies*.

Alfred Terry Bacon, "Ranch Cure," *Lippincott's Magazine*, Philadelphia, v. 28 (1881), p. 90. The title suggests one cause of Western migration. Bacon continued the above article in a second one, "Colorado Round-Up," *ibid.*, p. 622.

"Ranche Life in the Far West" (uncredited), *Macmillan's Magazine*, London, v. 48 (1883), p. 293. Reprinted in *Living Age*, Boston, v. 158 (1883), p. 596. A word of caution to those enthusiasts of little knowledge who were considering ranch life (sheep raising) on the plains. Many of the difficulties and hardships are pointed out.

Arthur H. Paterson, "Camp Life on the Prairies," *Macmillan's Magazine*, London, v. 49 (1884), p. 171. An Englishman's experience.

"A Wyoming Cowboy on Cattle Raising," one-half column in the *New York Semi-Weekly Tribune*, February 29, 1884, p. 3. This item is cited as illustrative of much of the fugitive contemporary literature, which altogether must have totaled hundreds of accounts. This story, for example, was reprinted in the *Tribune* from the Pittsburgh *Dispatch*. It is a hearty recommendation of ranch life with its great profits, plus an amusing tall story of Western justice.

Alice W. Rollins, "Ladies' Day at the Ranch," *Harper's Magazine*, New York, v. 71 (June, 1885), pp. 3–17. Still another aspect of life on a western Kansas ranch.

Rufus F. Zogbaum, "A Day's 'Drive' With Montana Cow-Boys," *ibid.* (July, 1885), pp. 188–193.

The Nation, New York, v. 41 (July 2, 1885), pp. 15–17, has a long review and discussion of the well-known *Report in Regard To the Range and Ranch Cattle Business in the United States*, by Joseph Nimmo, Jr., another important item in any Western bibliography. How extensive the interest was in this report and in the West can be judged by the letters to this publication which the review initiated. Letters to *The Nation*—some of them of considerable length—on the same general topic (most of them are from Westerners) will be found in v. 41 as follows: (July 16, 1885) pp. 50, 51, (August 6) pp. 113, 114, (August 27) pp. 172–174, (September 17) pp. 237, 238, (October 29) pp. 360, 361.

Frank Wilkeson, "Cattle-Raising on the Plains," *Harper's Magazine*, New York, v.

72 (April, 1886), pp. 788–795. Another first-hand account by one who had tried it out. Theodore Roosevelt's "Who Should Go West?" (*Harper's Weekly,* Jan. 2, 1886, p. 7) is itself important evidence for a number of the points made in the text. To be fit for Western emigration, according to T. R., a "Man must be made of fairly stern stuff. . . . For such men of bold, free spirit, yet with balance and self-control, the West is the place of all others. . . . Several of my classmates in Harvard are now successful ranch-men and first class cow hands. . . ."

12. The quotation from Robert E. Strahorn will be found in his *Hand-Book of Wyoming* (Cheyenne, 1877), p. 105. For a biographical sketch of Strahorn, see *The National Cyclopaedia of American Biography,* v. C (1930), pp. 445, 446.

That Eastern newspapers really gave many items of Western news can be seen from the number of entries found in the *Index To the New York Daily Tribune* under the heads "Indians," "West," "Cowboys," "Ranching," "Plains," for the years 1868–1885 inclusive, a period in which large migrations to the West took place.

13. *See* Chapter IX for the Custer episode in more detail.

14. For Russell, *see* note 2, Chap. XII; note 21, Chap. XV.

15. Remington left Canton, N. Y., in August, 1881, for Montana, according to the *St. Lawrence Plaindealer,* Canton, N. Y., August 10, 1881, p. 3. I am indebted to Editor Atwood Manley of the *Plaindealer* for the courtesy of examining the files of the *Plaindealer* in his office. Remington several times referred in later years to this early trip to Montana.—*See* the autobiography cited in note 9 and his book *Pony Tracks* (New York, 1895), p. 7.

16. The sketch will be found in *Harper's Weekly,* New York, v. 26 (February 25, 1882), p. 120. It was re-drawn by W. A. Rogers who mentions the fact in his autobiography *A World Worth While* (New York, 1922), p. 246. Rogers' experiences as a Western artist have been recorded in Chapter XI.

The length of Remington's Montana visit has not been established with certainty. He was back in Albany, N. Y., by October 18, 1881, as I have a copy of a letter written by Remington on that date in which he states that an interview with George William Curtis, editor of *Harper's Weekly,* had been arranged for him so

that Curtis could be shown some of Remington's sketches.

17. Remington was enrolled at Yale for the school years beginning in 1878 and 1879 (Yale University *Catalogues* for these years). He left school during the Christmas holidays of 1879 and did not return because of the ill health of his father who died on February 10, 1880.—Ogdensburg (N. Y.) *Journal,* February 19, 1880. I have studied in some detail Remington's life at Yale as well as his life in Albany, N. Y. He held some five or six jobs in Albany from 1880 until he moved to Kansas in 1883. I hope to publish these studies subsequently.

18. Roosevelt's investment in the Bad Lands ranch will be found in Hagedorn, *op. cit.,* appendix, p. 482. Mr. Hagedorn estimates that Roosevelt lost over fifty thousand dollars in Dakota, a considerable share of the loss being caused by the terrible winter of 1886–1887.

19. My information on Robert Camp and Remington is based on personal interviews with Robert Camp in 1943, who was then over eighty and living in Milwaukee. I am indebted to Wilbur I. Barth of the First Wisconsin Trust Company, Milwaukee, who interviewed Mr. Camp for me on three different occasions, asking him my many questions and returning the replies. Mention of "Bob" Camp's activities in Kansas will be found in the Peabody *Gazette* for the period under discussion as follows: August 24, 1882, p. 5, mentions the presence of Bob Camp, and the issue of September 7, p. 5, in its Plum Grove notes, mentions that Mr. Camp moved onto his place "some two weeks ago"; also mention of the Camp venture on October 19, p. 5, November 30, p. 5, and December 28, p. 4. The last item states that Camp owned 900 sheep and "thinks sheep raising the boss business." The location of his ranch is also given as Sec. 25, T. 23, R. 3. It is thus seen that his ranch was in the same section as Remington's (*see* note 20). The issue of June 21, 1883, p. 4, states that Camp "clipped between six and eight thousand pounds of wool this spring." Camp lived in the Peabody neighborhood for some years. The last reference that I have found to Camp in the *Gazette* is in the issue of September 9, 1886, p. 5.

20. An item in the *St. Lawrence Plaindealer,* Canton, N. Y., February 28, 1883, states that Fred Remington had resigned

his position in Albany and was in Canton and would leave for the West "in a few days."

An examination of records in the office of the register of deeds of Butler county (at El Dorado) was made for me by Mrs. Corah Mooney Bullock of El Dorado, to whom I am indebted for other valuable aid as well. Mrs. Bullock's examination shows that Frederic Remington bought from Johann and Maria Janzen the southwest quarter of Sec. 25, T. 23, R. 3 (Fairmount township, Butler county), on April 2, 1883, for the consideration of $3,400. On May 31, 1883, Remington purchased the southeast quarter of Sec. 26, T. 23, R. 3, from Charles W. and Sara Potwin for $1,250. These figures enable us to make a fair estimate of Remington's resources. To the $4,650 spent for land, there should be added $2,000. A letter to Horace D. Sackrider from Frederic Remington dated Peabody, May 16, 1883, stated that Remington was that day making a draft against the St. Lawrence County Bank for $1,000. "My sheep sheds are going up and I want the money." The letter is in the H. M. Sackrider collection. The other thousand dollars Remington drew from the Canton bank in the fall of 1883. The basis for this last thousand is found in a telegram dated "Sept. 5, 1883, Peabody, Kansas" that Remington sent his uncle, Horace D. Sackrider (H. M. Sackrider collection). The total investment in the Kansas ranch, then, as exactly as can now be determined, was $6,650. It is doubtful if Remington's patrimony was as large as this. It is probable that part of the money was borrowed from his mother, for in a letter to H. D. Sackrider, which from its context was written in the fall of 1889, Remington writes of paying interest on money borrowed from his mother. (The last cited letter is also in the H. M. Sackrider collection.)

Information from the Butler county clerk shows that both quarters were sold by Remington to David W. Greene on May 31, 1884.

21. For the history of Butler county I have consulted Vol. P. Mooney, *History of Butler County* (Lawrence, 1916), p. 186; Jessie Perry Stratford, *Butler County's Eighty Years* (El Dorado, 1934), p. 45. The A. T. Andreas and W. G. Cutler, *History of the State of Kansas* (Chicago, 1883), p. 1430 *ff*, is especially useful for my purpose as it is almost contemporary with Remington's

stay in Butler county. For the agricultural history of Butler county in Remington's day I have used the *Second Biennial Report of the State Board of Agriculture* (1879–1880), pp. 229, 265, 266; *Third Biennial Report* (1881–1882), pp. 152–157, and *Fourth Biennial Report* (1883–1884), pp. 44–50. "Agricultural Resources of Kansas," in *Kansas State College Bulletin*, Manhattan, October 15, 1937, pp. 24–26, also has given useful information on the characteristics and topography of Butler county.

22. By Remington's day, the cowboy capital had shifted to Dodge City, over 150 miles west of Newton.

23. A very valuable source of information on Remington's life in Kansas is found in an article by Remington, "Coursing Rabbits on the Plains," *Outing*, New York, v. 10 (May, 1887), pp. 111–121. Appearing only three years after Remington's residence in Kansas it is especially useful as it gives names, geographic localities and incidents which, in many cases, can be actually verified. Mrs. Myra Lockwood Brown of Rosalia (also in Butler county) has been especially active in collecting Remington material relating to his Kansas residence. In the past fifteen years she has interviewed many of the older residents of Butler county who had personal recollections of Remington in Kansas, including Judge R. A. Scott and J. H. Sandifer of El Dorado, Rolla Joseph of Potwin, and others. She was able to verify all the geographic locations mentioned by Remington in his article and has visited the Remington "ranch." As a result of the efforts of Mrs. Brown and the writer, a brief illustrated review of Remington's activities in Kansas appeared in the *Country Gentleman*, September, 1947, p. 16 *ff*. Reference to material collected by Mrs. Brown is referred to hereafter as "M. L. Brown."

24. From the *Outing* article. See note 23.

25. The copy of the letter given in the text (to William A. Poste) was kindly lent to me by Mrs. Alice Poste Gunnison of Canton, N. Y., a daughter of William A. Poste.

26. Mrs. M. L. Brown interviewed Rolla Joseph of Potwin (*see* note 23) some years ago and he described the Remington house, barns and corrals for her before either of them had seen the sketches reproduced in this book. Writing January 5, 1948, after having viewed the drawings, Mrs. Brown said: "In regard to the house as Reming-

ton knew it, this is what I know: Rolla Joseph of Potwin described to me the house in detail—the barns, corrals, etc., the shape of the house and roof, the number of rooms and what they were used for, the color of the house, etc., and the way it faced.

"Everything is just as Remington sketched it, according to Mr. Joseph. The one-story room on the north with a gable roof, not shed roof, was the kitchen where Remington prepared meals, including pancakes and beef steak, for the ranch hands, the men that were constantly coming in, and for the little boys he had out there to ride his horses and watch whatever fun, such as wild steer riding, boxing, or just planning something, might be under way. Mr. Joseph told me that Remington was always, to use his phrase, 'mixing in' with the smaller boys, particularly those at a disadvantage in any way.

"The other room downstairs, besides the kitchen, would now probably be called a living room. I think that Remington and his fellows often ate there. At any rate, it was in this room that the small diary, black and about the size of an ordinary pocket loose-leaf notebook, was one day discovered, opened. Mr. Joseph told me about the book. One of the two Lathrop men, one a Peabody banker, the other a Wichita oil man, which I do not at the moment recall, told me of what he read there. At that time the Lathrops were neighbors of Remington. Remington had been attempting to do something for a problem son sent west by his father for Remington to make a man of him. The words inscribed were: 'You can't make a man out of mud.' The book lay on a table.

"The half-story room upstairs was sleeping quarters. Billy Kehr stayed at the ranch most of the time. There were other guests. The door, in the sketch, in which a man appears standing, is on the east.

"This is right for the lay of the land and the road as I saw it. I do not believe any of the former buildings could be recognized from present structures, which are modern in every respect. According to what Clifford Lathrop told me, one of the last of the old buildings to be razed was the one of the barns which held inside— not on the door, as some reports have it— the sketch of the cowboy roping a steer, which Remington had cut there with his knife. That sketch was a neighborhood

pride. This barn also served as a sort of gymnasium, as did the yard near it."

27. The Peabody *Gazette* items cited in note 31 reveal some of these facts: others come from the *Outing* article. Kehr appears in the *Outing* article as Carr.— M. L. Brown.

28. The *Outing* article. For the story of the unwashed potatoes I am indebted to Miss Jennie Owen of the Kansas State Historical Society, Topeka. Miss Owen worked for some years on the staff of an El Dorado (Kansas) newspaper and her neighbor while living in that town was a middle-aged lady who as a young girl was a neighbor of Remington's and the one who took him the freshly baked bread mentioned in the story.

29. Quotation from the *Outing* article.

30. M. L. Brown.

31. I have made extensive examinations of the Peabody and El Dorado newspapers of the period and have found occasional contemporary mention of Remington in these sources. In the Plum Grove notes of the Peabody *Gazette*, June 21, 1883, p. 4, is the item "Mr. Remington, on the 'Johnson place,' is building a large sheep barn." The issue of July 5, p. 5, mentions a prospecting trip of Remington and George Shepherd to "the southern part of the State." The *Gazette*, October 18, p. 5, reports that "Fred Remington's father started for his home in the East, last Monday morning." "Father" is obviously in error and should read "uncle," for Mrs. Ella Remington Mills and Pierre Remington both wrote me that Lamartine Remington, an uncle of Frederic Remington, visited the Kansas ranch and caught a cold that developed into tuberculosis.

Mention is made of a trip that Remington and Robert Camp made to El Dorado in *ibid.*, December 13, 1883, p. 5, and the El Dorado *Republican*, December 7, p. 3.

From the interviews of M. L. Brown, it seems certain that preliminary sketches that Remington afterward worked into his more mature productions were made during his Kansas stay. Included among these were "The Last Stand" and "The Bronco Buster."

In addition to a small album of original Kansas sketches (approximately quarto in size) in the Remington Art Memorial at Ogdensburg, N. Y., reproductions of sketches of direct Kansas interest appear in the *Outing* article (note 23), and in *Harper's Weekly*, v. 32 (April 28, 1888),

p. 300, a half-page illustration "Texan Cattle in a Kansas Corn Corral."

32. *See* reference to Peabody *Gazette* and Lamartine Remington in note 31.

33. The description of the race and the quotations are from the *Outing* article.

34. *Walnut Valley Times*, El Dorado, January 11, 1884. The item was discovered by Mrs. Bullock of El Dorado.

35. The affair at the Plum Grove schoolhouse was recalled by Rolla Joseph (mentioned above), who stated that "it never would have happened if the boys hadn't been drinking," and by the justice of the peace in the case, Charles Lobdell. Lobdell, later a member of the state legislature and still later the editor of the Kansas City (Kan.) *Tribune*, gave his recollections of the affair in the *Tribune*, October 29, 1897. Still another version of the story appears in the recollections of H. A. J. Coppins, a resident of the Plum Grove community in Remington's day. The Coppins recollections, a valuable contribution as they contain several interesting sidelights, appeared in the El Dorado *Times*, November 24, 1943. I am indebted to Mrs. Bullock, who became so much interested in this Remington affair that she attempted to trace the records in the justice court of El Dorado but found, as the result of her search, that some cleanly and God-fearing former mayor of the town had, in a burst of zeal for cleaning up things, thrown away all old reports, the accumulation of years. Probably it is just as well that they were destroyed for many a sinning soul will rest easier in his grave since the records of his misdeeds are thus forever hidden from the eye of man.

36. From the interviews of W. I. Barth (1943).—*See* note 19.

37. The difficulties of sheep farming in Remington's period are feelingly described in the recollections of a Kansan, William M. Wells, in *The Desert's Hidden Wealth* (1934), pp. 177, 178. In this category of recollections, another item having some bearing on ranching in the Flint Hills is Frank Harris' *My Reminiscences As a Cowboy* (New York, 1930). Harris, later a literary light, was a partner in a cattle ranch at Eureka in the 1870's. The book is cited as evidence to show the close contiguity of cattle and sheep ranching in the Flint Hills area. In all of the contemporary accounts of sheep and cattle raising before 1885, I have never found any indication that there was marked rivalry or hostility

between the two. Indeed in Aldridge, *op. cit.* (note 10), mention is made of a cattle ranch and sheep ranch which were adjacent to each other. My colleague, Prof. James C. Malin of the University of Kansas, tells me that in his studies of agricultural history on the plains, there is no evidence that there was marked rivalry between sheep and cattle raisers in this period. Some ranchers, indeed, raised both sheep and cattle; others were in some years cattle ranchers and in other years sheep ranchers, depending upon the fluctuations of economics and weather.

38. *See* note 20. It is probable that Remington left before May. The Peabody *Gazette*, January 24, 1884, p. 5, has a reference of the sale of the Remington place to "D. M. Greene." According to this item Greene planned to move to the Remington place "about March 1st," a usual date for moving on the farm.

Chapter XIV

Artists of Indian Life: Henry F. Farny

1. *The Crayon*, New York, v. 3 (1856), January, p. 28. For an interesting discussion of the ethnographical value of Indian paintings by white men, *see* Herman ten Kate, *Anthropos*, v. VI, pp. 521–545 (1911), "On Paintings of North American Indians and their Ethnographical Value."

2. For mention of Kensett's Western experience *see* note 11, Chap. IV; for Johnson's Western trips of 1856–1857, *see* Bertha L. Heilbron; "A Pioneer Artist on Lake Superior," *Minnesota History*, St. Paul, v. 21 (1940), June, pp. 149–157; John I. H. Baur, *Eastman Johnson* (Brooklyn, 1940), pp. 15, 16. Johnson made two trips to the Northwest of his day in the region around Superior, Wis. The first trip was made in the summer and fall of 1856, the second in the summer of 1857. Kensett's trip up the Missouri river was reported in 1856.

3. New York *Daily Tribune*, March 31, 1860, p. 4.

4. Sadakichi Hartmann, *A History of American Art* (London, 1903), v. 1, p. 78. Hartmann spoke about the *decline* of the Rocky Mountain school in 1860 as exemplified in the work of Bierstadt, Thomas Moran, William Keith and Thomas Hill. The important work of these men was all done *after* 1860. For Bierstadt's Western experiences on the trip of 1859 *see* his

letter dated, "Rocky Mountains, July 10, 1859," *The Crayon*, v. 6 (1859), September, p. 287.

5. In 1939 I had considerable correspondence with De Cost Smith who wrote me that his decision to become an Indian artist was made after seeing some of Brush's pictures in the early 1880's. In 1884 Smith visited the Rosebud, Lower Brule and Standing Rock Indian agencies in Dakota territory—his first Western experiences—and spent the winter at Standing Rock and Fort Yates. After that time he made many Western trips. Some of Smith's life in the West is described in his posthumously published volume, *Indian Experiences* (Caldwell, Idaho, 1943). Mr. Smith died on December 7, 1939, at the age of 75.

Deming's first Western experiences after his professional training as an artist occurred in 1887 when he visited the reservations of the Apaches and Pueblos in the Southwest and the Umatillas in Oregon. His paintings of Indians first appeared in 1891. For a brief account of his career, *see E. W. Deming. His Work*, Therese O. Deming, privately printed, 1925. Mr. Deming died on October 15, 1942, at the age of 82.

A series of three articles in *Outing*, New York, "Sketching Among the Sioux," v. 23 (1893), October, pp. 3–13; "Sketching Among the Crow Indians," v. 24 (1894), May, pp. 83–91, and "With Gun and Palette Among the Red Skins," v. 25 (1895), February, pp. 355–363, are almost contemporary accounts of the experiences of De Cost Smith and Deming among the Indians, as they traveled together for a time. The first two of the above article are credited to "Man-Afraid-of-His-Name," but Mr. Deming wrote me in 1940 that he and Smith were responsible both for the illustrations of these two articles and for the text. The third of the above articles is credited to Smith and Deming in the text but curiously enough the illustrations are by Frederic Remington.

The same consideration, with respect to time, applies also to the noted painter of Indian portraits, Elbridge Ayer Burbank (1858–1949). Burbank began his exhibition of American Indian paintings in 1897 (*Who's Who in America*, v. 13 [1924–1925], p. 579 and *Brush and Pencil* cited below) but his reputation was achieved largely after the turn of the century. Some of Burbank's experiences in the West are recounted in *Burbank Among the Indians* (Caldwell, Idaho, 1944), ed. by Frank J. Taylor. According to the New York *Times*, March 22, 1949, p. 25, Burbank died in San Francisco on March 21, 1949.

Burbank was encouraged to devote his attention to the Indian by his uncle E. E. Ayer, the founder of the famous Ayer Indian collection now in the Newberry Library, Chicago. Burbank went West in search of material about 1895 or 1896 and had his first exhibition of Indian portraits in Philadelphia; *see Brush and Pencil*, October 1898, vol. 3, pp. 16–35, "Elbridge Ayer Burbank" by Charles Francis Browne. This account includes some of Burbank's western experiences in his own words and ten reproductions of Burbank's work, one in color. In other issues of volumes 3 and 4 of *Brush and Pencil*, there appear a considerable number of Burbank's Indian portraits in color. Burbank also has an article on Indian art and the Indian as an artist in *Brush and Pencil*, vol. 7, pp. 75–91, November, 1900.

Henry H. Cross (1837–1918) should also be mentioned with the group of artists we are here considering. Cross, however, was chiefly a portrait painter, many of whose canvases were Indian subjects. Several examples of his work are to be found in the T. B. Walker collection, now on loan to the State Historical Society of Wisconsin, and in the Chicago Historical Society. Brief accounts of Cross' life will be found in the article "In Memoriam—H. H. Cross," *Horse Review*, Chicago, April 10, 1918; in a death notice in the Chicago *Tribune*, April 4, 1918, and in R. H. Adams' *Illustrated Catalogue of Indian Portraits* (n. p., 1927). A revision of this catalogue, with reproduction of a number of the Cross paintings in color, was published in 1948 by the State Historical Society of Wisconsin.

6. The biographical data on Brush given in the text above comes from *The Century Magazine*, New York, N. S. v. 21 (1892), February, p. 638; the quotation from the short article by Brush, "An Artist Among the Indians," *ibid.*, v. 8 (1885), May, pp. 54–57.

7. Information on Brush's Western travels is meager. The brief article by Brush mentioned in note 6 referred to the Crows and the Mandans. A note in *Harper's Weekly*, New York, v. 30 (1886), November 20, p. 743, stated that Brush had returned "after four years' work among the Indians of Canada and the far West." Thomas Donaldson in his memoir on Catlin mentioned

that Brush worked among the Sioux and "obtained material from their every-day life," *House Misc. Doc. No. 15*, Pt. 5, 49 Cong., 1 Sess. (1885–1886), p. 807. An article by Lula Merrick, "Brush's Indian Pictures," *International Studio*, New York, v. 76 (1922), December, pp. 187–193, stated, without any evidence of the source, that Brush visited Wyoming and Montana in 1884.

Recently I have had correspondence with Mrs. Nancy Douglas Bowditch of Brookline, Mass., a daughter of Brush, who has been working on a biography of her father. Mrs. Bowditch wrote me that Mr. Brush kept no diary and "practically none" of his early letters were known to her and that she "was obliged to write much of his early life with the Indians from the memories of stories he told us." Mrs. Bowditch further wrote:

"My father went to live among the Indians after his return from his studies in Paris. It was in about 1881. He lived with several tribes and became familiar with their habits and customs. He was at Fort Washeka [Washakie], in Wyoming, where the Arapahoes and the Shoshones were camped together. He spent a winter at the Crow Agency, which was, I believe, about fifty miles from Billings, Montana. At that time the town had just been started and the drug store was in a tent. The Indians were still hunting for their meat.

"He never could forget his early impressions of the Indians, of whom he was very fond, and later in life he would occasionally paint an Indian picture. He witnessed the religious ceremony of the Sun Dance, which was the festival to the sun."

8. Reproductions of these oils in black and white (with one exception) will be found in the order listed above, as follows: *The Century*, N. S. v. 8 (1885), May, p. 54; *International Studio*, v. 34 (1908), Supplement, April, p. LIV; Hartmann, *op. cit.*, p. 263; *Harper's Weekly*, v. 30 (1886), November 27, p. 760; *The Century*, N. S. v. 22 (1892), June, p. 274; "The Aztec Sculptor" (in color), "The Weaver," "Dawn" and "Evening" in *International Studio*, v. 76 (1922), December, pp. 187–193; *The Century*, N. S. v. 21 (1892), February, p. 600, and *ibid.*, v. 8 (1885), May, p. 56.

Although Brush's Indian paintings have been praised and admired for their skillful and beautiful execution and for the highly imaginative faculty displayed by Brush, they have been on occasion criticized for their details of composition. Thus the art critic of the New York *Tribune*, April 22, 1888, p. 14, in commenting on Brush's "Aztec Sculptor" (the critic appears confused and was more probably referring to Brush's "The King and the Sculptor") stated: ". . . it is a little confusing to find Central American sculpture a Navajo Blanket, a Pompeian oil or grain jar, Italian marble, one figure Oriental in color if not in face, and another a North American Indian in face and very large in costume, all combined in one picture. . . ."

9. His return to Paris is reported in *The Century*, N. S. v. 21 (1892), February, p. 638, and his change of style in *ibid.*, v. 29 (1896), April, p. 954. For accounts of his work subsequent to 1896 *see* Hartmann, *op. cit.*, pp. 262–271; Minna C. Smith, "George de Forest Brush," *International Studio*, v. 34 (1908), Supplement, April, pp. XLVII–LVI. Eugen Neuhaus' appraisal will be found in his book, *The History and Ideals of American Art* (Stanford University, 1931), p. 209.

10. The reference to the statement of the census bureau and the end of the frontier is, of course, the statement made famous by Turner; *see* Frederick Jackson Turner, *The Frontier in American History* (New York, 1921), p. 39. That the suggestion of sending artists among the Indians in connection with the 11th U. S. census (1890) came from Donaldson is so stated in *Harper's Weekly*, v. 36 (1892), October 8, p. 975. This account mentions *six* artists rather than the five I have enumerated in the text. Possibly the *Harper's Weekly* account, however, included George F. Kunz, a gem expert who is reported to have made investigations among the Indians for the 11th census.

11. The complete title reads, *Report on Indians Taxed and Not Taxed in the United States (Except Alaska) at the Eleventh Census: 1890* (Washington, 1894).

12. *Indians Taxed and Indians Not Taxed*, pp. 186–198, 440–446 (Scott); pp. 424–440 (Poore); pp. 360–363 (Shirlaw); pp. 519–526, 584–588 (Gaul); pp. 629–634 (Moran). A letter addressed to the bureau of census recently brought a reply to the writer from David S. Phillips, chief of the administrative service division, dated March 29, 1949. Mr. Phillips stated that the census bureau had no knowledge of the paintings made for the bureau in 1890 and 1891 and that the correspondence with the

special agents "was destroyed years ago."

A number of the illustrations in this census volume plus some additional ones also appeared in Thomas Donaldson's *Moqui Pueblo Indians of Arizona and Pueblo Indians of New Mexico, Extra Census Bulletin, Eleventh Census of the United States* (Washington, 1893). This account contains more detailed accounts of the Western experiences of Scott, Poore, and Moran than does the larger volume.

13. A mention of Shirlaw's 1869 trip is made in the *American Art Review*, Boston, v. 2 (1881), p. 98; Poore had a Western mining illustration, "From Mine to Mill," in *Harper's Weekly*, v. 22 (1878), September 14, pp. 732, 733; Moran was apparently in the West before 1880 as the New York *Tribune*, January 26, 1880, p. 5, reported the sale of a painting, "Bannack Indians Breaking a Pony," for $400. The *American Art Review*, v. 2 (1881), Pt. 1, p. 163, and Pt. 2, p. 200, listed three (of four) Western paintings and the first of these references stated, "Moran will have left for New Mexico again by the time these lines are in print." *Indians Taxed and Not Taxed*, p. 195, stated that Moran and Capt. John G. Bourke witnessed "the snake dance at Walpi in August, 1883." There may be some confusion of dates here, and the Bourke-Moran trip of 1881 as described in the text is meant; *see* note 14.

14. New York, 1884.

15. The quotation above will be found on p. 297 of Bourke's book. Bourke credited the illustrations (31 plates, lithographs, some in color) to Harmer in the "Preface" of his book. One of Harmer's illustrations is of the Snake Dance and is dated "August 12, 1881."

Biographical data on Moran is very meager. He was one of the famous Moran family of artists; *see* Frances M. Benson, "The Moran Family," *The Quarterly Illustrator*, New York, v. 1 (1892), pp. 67–84, which makes only brief reference to Peter Moran. Moran was born in 1841 and died in Philadelphia on November 9, 1914; *see American Art Annual*, Washington, v. 12 (1916), p. 260; an obituary will be found in the Philadelphia *Public Ledger*, November 11, 1914, p. 16.

Mention of Harmer is made in note 3, Chapter XII.

16. Jeannette L. Gilder, "A Painter of Soldiers," *The Outlook*, New York, v. 59 (1898), July 2, pp. 570–573. A biographical sketch of Gaul (1855–1919) is included

in the *Dictionary of American Biography*, v. 7, p. 193. This account stated that Gaul spent "much time in the Far West" and was noted not only for his battle and military paintings but for his cowboy and Indian pictures as well. I have seen relatively few of the latter. Edward Eberstadt and Sons of New York City, have kindly supplied me with a photograph of a Gaul painting "The Sentinel" (see their catalog #127, item 436). Some of Gaul's western illustrations, in addition to those cited in the text, will be found in *Harper's Weekly*, v. 32 (1888) Oct. 27, pp. 812, 813; v. 33 (1889) March 23, p. 228 (illustration in western fiction); in *The Century Magazine*, n.s., v. 20, 21 (1891, 1892), which are chiefly redrawn from earlier sketches; and in *The Cosmopolitan*, v. 4 (1887–1888), pp. 86, 91, 92, 231.

17. Hartmann, *op. cit.*, p. 259.

18. Smith, *op. cit.*, p. 23.

19. Walter Shirlaw, "Artists' Adventures: The Rush to Death," *The Century*, N. S. v. 25 (1893), November, pp. 41–45. The article is accompanied by several illustrations which are apparently portions of the larger painting, "A Rush to Death," which was reproduced in *Harper's Weekly*, v. 34 (1890), October 18, p. 812. Theodore Roosevelt also told, at second-hand, the incident witnessed by Shirlaw in "The Rush to Death"; see Theodore Roosevelt *The Wilderness Hunter* (N. Y., 1893), p. 439 (Presidential Edition). Shirlaw died in Madrid, Spain, on December 26, 1909; *see Dictionary of American Biography*, v. 17, pp. 119, 120, for a brief sketch of his career.

Brief accounts of the life of Julian Scott and of Henry R. Poore, the remaining two artists of the 1890 census, will be found in the New York *Tribune*, July 5, 1901, p. 2, Scott (1846–1901), and New York *Times*, August 16, 1940, p. 15, Poore (1859–1940).

Scott also illustrated in color Edna Dean Proctor's remarkable poem *The Song of the Ancient People* (Boston and New York, 1893). Scott's illustrations consist of 11 aquatints interpretative of Moqui-Zuni thought. The University of Pennsylvania Museum of Art possesses Indian portraits by Scott made on his western travels of the early 90's some of which are the originals of those reproduced in *Indians Taxed and Not Taxed*. In addition, the Division of Ethnology, Smithsonian Institution, possesses a portrait (#362,137) by Scott of

Sitting Bull painted in October, 1890, two months before Sitting Bull's death.

20. Joseph Pennell, *Pen Drawing and Pen Draughtsmen*, 3rd ed. (London and New York, 1897), pp. 226 and 231.

21. *Harper's Weekly*, v. 33 (1889), August 31, p. 699. Farny received a third medal, Remington was awarded a second medal at the same exhibition, and Gilbert Gaul also a third medal. In 1885 Farny had been awarded one of four prizes of $250 each at the American Art Association by exhibiting an Indian subject.—*Ibid.*, v. 29 (1885), November 28, p. 771.

22. Biographical data on Farny in the text unless credited to other sources is from the *American Art Review*, v. 2 (1881), Pt. 2, pp. 1 and 2 (reprinted in *American Art and American Art Collections* [Boston, 1889], Walter Montgomery, ed., v. 1, pp. 145, 146); and a long article probably by Edward F. Flynn, "The Paintings of H. F. Farny—Something About the Career of the Eminent Cincinnati Artist," Cincinnati *Commercial Gazette*, March 14, 1893, p. 9. The last item mentioned the illustration of the McGuffey readers as do many other Cincinnati newspaper items in my possession. One from the Cincinnati *Times-Star*, September 12, 1889, p. 8, stated: ". . . the artist Farny prides himself not a little on the fact that he introduced to school book publishers a new and decent kind of school book illustration. In the old days school book pictures never bore any relation to real life. There were impossible boys and impossible girls and impossible houses and trees that no botanist could recognize. Farny changed this. In illustrating the publications of Van Antwerp, Bragg and Co. [publishers of the McGuffey readers] he made sketches from life of real boys and girls, real houses and natural trees. The result was soon apparent and the other publishers followed suit."

As far as I know there has been no study made of the illustrations in the McGuffey readers. Harvey C. Minnich in *William Holmes McGuffey and the Peerless Pioneer McGuffey Readers* (Miami University, Oxford, Ohio, 1928) had a brief paragraph on "Pictures" (pp. 45–47) but said nothing about their origin. Van Antwerp, Bragg and Company, according to Minnich (p. 87), were the parent publishing firm from 1877 to 1890, the present American Book Company of Cincinnati succeeding them. The annual production of McGuffey readers, also according to Minnich (pp. 40 and

71), reached its high mark of 1,700,000 in 1880 after the appearance of revised editions in 1879, presumably the ones illustrated by Farny.

The claim of Farny as a McGuffey illustrator for the 1879 editions, however, seems established, as Minnich later published *William Holmes McGuffey and His Readers* (American Book Company, 1936), in which on p. 118 there is reproduced an illustration from McGuffey's Second Reader, 1879, bearing Farny's initials and on p. 141 an illustration from the Fifth Reader, 1879, which also shows Farny's initials on the illustration.

Charles F. Goss, in his *Cincinnati, the Queen City* (Chicago and Cincinnati, 1912), v. 2, p. 449, had a brief discussion of Farny, pointing out that Farny was "one of the most notable figures in Cincinnati," and he went on to say "the children of Cincinnati soon came to know him in person and hailed him on the streets, to his delight, as the man who made the pictures for their school books. Perhaps he never enjoyed quite as thoroughly his great fame as a painter of pictures that are to be seen in public and private galleries as he did his reputation among children."

23. "In Farny's Studio," Cincinnati *Tribune*, October 6, 1895, p. 22. Farny's recollections of his boyhood experiences with Indians are also told in considerable detail in the Cincinnati *Enquirer*, June 24, 1900, p. 17, "Artist Farny."

24. Volume 9 (1865), September 30, pp. 620, 621.

25. Illustrations of Cincinnati, Louisville and the Midwest by Farny are of occasional occurrence in *Harper's Weekly* during the period 1870–1890. His other sources of income are stated in the Flynn article cited in note 22.

26. For Sitting Bull's reasons, *see* his statement, given to an interpreter, in the New York *Tribune*, September 6, 1881, p. 5. His surrender is reported in *ibid.*, July 21, 1881, p. 5, which also stated Sitting Bull's concern over his daughter.

27. *See* the large number of entries, for example, under the heading "Indians" in the *Index To the New York Daily Tribune, 1881.* The death of Spotted Tail was reported in the New York *Tribune* for August 7, 1881, p. 2, and August 13, 1881, p. 1. Mrs. Jackson's most celebrated thesis on the Indian question, *A Century of Dishonor*, was published in this year of 1881; she was also agitating the case of the In-

dian by letters to the papers; *see* her letter in the New York *Tribune*, May 28, 1881, p. 5.

28. Farny's trip to the Standing Rock agency (Fort Yates) was reported in some detail in the Cincinnati *Daily Gazette*, November 8, 1881, p. 8, "Mr. Farny Among the Sioux," which stated that Farny returned from his trip "on Saturday," and in the Cincinnati *Enquirer*, November 8, p. 8, "Lo! the Poor Indian," which stated that Farny did not see Sitting Bull as he had been taken to Fort Randall, a fact that had already been reported in the New York *Tribune*, September 12, 1881, p. 1. The *American Art Review*, v. 2 (1881), p. 2, in a brief review of Farny, commented: "Mr. Farny's studio in Cincinnati is a place rich in Indian trappings from the far West."

29. The quotation ascribed to Farny above was in the Cincinnati *Gazette* reference given in note 28; the reporter's comment in the Cincinnati *Commercial*, December 1, 1881, p. 4.

30. The original display of the picture and report of its sale to one James McDonald was given in the Cincinnati *Daily Gazette*, January 28, 1882, p. 6. The *Harper's Weekly* illustration was in v. 28 (1884), June 21, p. 393.

31. Cincinnati *Daily Gazette*, May 6, 1882, p. 6; May 13, 1882, p. 4.

32. *Harper's Weekly*, v. 27 (1883), July 28, pp. 472, 473.

33. Frank H. Cushing, "My Adventures in Zuni," *The Century Magazine*, N. S. v. 3 (1882, 1883), pp. 191–207, 500–511; v. 4 (1883), pp. 28–47.

34. Willard Leroy Metcalf (1858–1925) according to the *Dictionary of American Biography*, v. 12, pp. 582, 583, spent two years in New Mexico and Arizona presumably in the very early 1880's. This account made no mention of any Western illustrations or paintings by Metcalf, but stated: "His paintings were mostly of New England scenes. . . ." There are, however, a number of illustrations in Sylvester Baxter's "The Father of the Pueblos," *Harper's Magazine*, v. 65 (1882), June, pp. 72–91, by Metcalf dated "Zuni, 81," and the article itself stated that Baxter and Metcalf, in company with Cushing, visited at the Zuni pueblo (one of the illustrations was a portrait of Cushing in Indian costume). Baxter also had an article, "Along the Rio Grande," *ibid.*, v. 70 (1885), April, pp. 687–700, which contained Metcalf illustra-

tions of New Mexico and Texas dated 1882, one of which was signed "W. L. Metcalf, El Paso."

More positive information of Metcalf's presence in the Southwest is given in the diary of John G. Bourke (edited by Lansing B. Bloom) appearing in the *New Mexico Historical Review*, v. 11, pp. 242 and 246 (1936). Bourke met Metcalf in Wingate (N. M.) and Santa Fe in the early summer of 1881 and commented on Metcalf's many "successful" sketches of the Southwest in oil, water-color, and crayon. The *Semi-Weekly Inter-Ocean* (Chicago), June 14, 1883, p. 9, c. 3, 4, also commented on the fact that Metcalf had passed through Chicago "yesterday" after having spent several months sketching in Zuni and devoted several columns to Metcalf and his opinions and experiences in the Southwest.

35. The visit of the Zuni to Washington and other Eastern cities was reported in the New York *Tribune*, March 6, 1882, p. 1; March 8, 1882, p. 4, and March 29, 1882, p. 1.

36. The Cincinnati *Daily Gazette*, July 29, 1882, p. 7, contained the item: "Mr. Farny has returned from Washington having made a pronounced success of his Zuni sketches. One of the Zuni men has adopted Farny as his son, and bestowed upon him the name of Cohok-Wah, White Medicine Bead."

37. Pennell, *op. cit.*, p. 231. Dr. F. W. Hodge, director of the Southwest Museum, Los Angeles, wrote me (April 17, 1950) in more detail concerning Farny's acquaintance with the Zuni in Washington. Dr. Hodge's letter, in part, reads:

"Farny's personal acquaintance with Zuni Indians was gained when Cushing conducted the four Zunis and one Hopi to the East in 1882. In Washington Farny volunteered to show the Indians some of the sights of the Capital, an experience with which Pahlowahtiwa (Cushing's brother by adoption) regaled his fellow tribesmen on many an occasion after his return.

"One of the company whom Cushing took to the East was Nai-u-chi, 'Chief Priest of the Bow,' whose portrait you reproduce from Pennell. The shield partly seen in the background was that of Cushing, adapted from the colored illustration (pl. xi) in the Second Annual Report of the Bureau of Ethnology. This shield may be in the Brooklyn Institute Museum. The

symbol above the portrait is the Zuni brand; while presumably the eagle and snakes were substituted for the 'great white bear' fetish for esthetic effect."

38. The excursion was extensively reported in the New York *Tribune; see* especially the issues of September 1, p. 5, September 2, p. 1, September 9, p. 1, and September 10, 1883, p. 5, and the citations given in the notes immediately following this one.

39. New York *Tribune,* September 6, 1883, p. 5. Farny recalled his part in the Bismarck celebration in the Cincinnati *Commercial Gazette,* December 18, 1890, p. 12, shortly after the death of Sitting Bull. "I was exceedingly amused," Farny was quoted as saying, "at his [Sitting Bull's] first meeting with General Grant. It was on an afternoon in the town of Bismarck. I was talking with the great chief when Henry Villard and Grant drove up in a carriage. Mr. Villard, pointing to the Indians, asked me who they were, and when I told him that Sitting Bull was among them he asked me to bring him over to the carriage. Sitting Bull walked over to the party in a swaggering and indifferent way.

"When I introduced him to General Grant he turned to me and asked, 'Is that the great father?' I told him that it was and he instantly straightened up and assumed a dignified and important bearing, eyeing the great soldier from the crown of his hat to the soles of his shoes. General Grant also appeared to be interested in the Indian chief, for he scrutinized him pretty closely."

40. *Harper's Weekly,* v. 31 (1887), January 1, p. 3. This account stated that Grant gave the painting to A. E. Borie, Secretary of the Navy in Grant's cabinet and noted for his art collection. From Borie it passed to his nephew who gave it to Mrs. Grant after Grant's death in 1885. At the time the note was published the account stated: "It is the only specimen of her husband's art work in her possession." In 1950, Elmo Scott Watson of the University of Denver wrote me that he had seen the Grant drawing or painting at West Point "several years ago." The Grant picture was on display in a classroom at West Point among other drawings and paintings made by former West Point cadets. The Grant picture—dated by Grant "1841"—was given by Grant's children to West Point in 1902 after it had been

given back to the Grant family by Mr. Borie.

41. New York *Tribune,* September 8, 1883, p. 1. The dispatch from Grey Cliff was dated September 6.

42. *Harper's Weekly,* v. 27 (1883), December 15, p. 800 (full page).

43. *Ibid.,* p. 799.

44. "The Completion of the Northern Pacific Railway.—Driving the Last Spike at the Point of Junction of the Eastern and Western Sections, Sixty Miles West of Helena, Sept. 8th," a full-page illustration in *Leslie's Weekly,* New York, September 22, 1883, p. 73, with text on pp. 70 and 71.

Charles Graham was also a member of this excursion party, *see* Chap. XII.

The Helena (Mont.) *Daily Herald,* September 7, 1883, p. 1, "Villard's Guests," listed "H. F. Farney, Esq., artist, *Century Magazine.*" I am indebted to Mrs. Anne McDonnell of the Montana Historical Society for this last item.

45. Eugene V. Smalley, "The Upper Missouri and the Great Falls," *The Century Magazine,* N. S. v. 13 (1888), January, pp. 408–418. Although this article did not appear until 1888, the trip was made in the fall of 1884 as has been established by Mrs. Anne McDonnell of the Montana Historical Society. Mrs. McDonnell has found newspaper references and accounts of the "expedition" in the Helena *Daily Independent,* September 16, p. 5, September 23, p. 5, and September 30, 1884, p. 5. This last was a rather long account of the trip which agreed with Smalley's account of 1888 and furnished additional details.

46. *Harper's Weekly,* v. 28 (1884), December 6, p. 798, four illustrations on one page. A description of the convention will be found on p. 805 of the above issue.

47. The illustration appeared in *ibid.,* v. 30 (1886), February 13, p. 109. It is dated "'85." The painting in the Cincinnati Art Museum is titled "The Captive," and according to the exhibition catalogue, *Henry F. Farny and the American Indian* (Cincinnati, 1943), it is dated '05. Either an error of transcription in the date ("05" in place of "85") has been made, or Farny repainted the picture in 1905.

48. *Harper's Weekly,* v. 31 (1887), February 5, pp. 96, 97.

49. *Ibid.,* v. 30 (1886), July 24, p. 465 (full page).

50. A double-page San Francisco illustration of a Chinese opium den will be found

in *ibid.*, v. 32 (1888), October 13, pp. 776, 777. Farny's illustration, "The Snake Dance of the Moqui Indians," appeared in *ibid.*, v. 33 (1889), November 2, pp. 872, 873, but was drawn from photographs. Possibly, too, the seven illustrations, "The Great Salt Lake of Dakota," *ibid.*, March 9, p. 192, credited to Farny, were redrawn from photographs, as the author of the article accompanying the illustrations, Dwight W. Huntington, mentioned that he carried a camera.

51. *Ibid.*, v. 34 (1890), March 22, pp. 220, 221.

52. A bibliography of a half-dozen or so illustrations of Farny's appearing in the leading periodicals of the 1890's will be found in *19th Century Readers' Guide to Periodical Literature, 1890-99* (New York, 1944), v. 1, p. 905. The bibliography includes illustrations of all kinds, Westerns as well as others.

53. *Harper's Weekly,* v. 35 (1891), February 14, p. 120 (full page). In 1940 the original of the painting was in the possession of Mr. George A. Rentschler of Hamilton, Ohio. Farny's change from illustrator to painter was described in the Cincinnati *Tribune,* October 6, 1895, p. 22, which stated that "for the last ten years he has done very little illustrating." Examination of the illustrated press, however, would put the date about five years later than that given by this report. Both the account cited above, however, and one in the Cincinnati *Commercial Gazette,* March 8, 1896, p. 25, were in agreement that Farny's "first pretentious" painting was "The Last Vigil."

54. "The Song of the Talking Wire" apparently was painted in 1904, and in 1915 was reported as owned by Mr. and Mrs. Charles P. Taft of Cincinnati; it now belongs to the Taft Museum in Cincinnati.

55. Cincinnati *Times-Star,* September 12, 1910, p. 4. This account contained a photograph of Roosevelt and Farny. Roosevelt had also seen Farny's paintings while President. His visit and comments on this occasion were reported in the Cincinnati *Commercial Tribune,* September 21, 1902, p. 2.

56. *Henry F. Farny and the American Indian* (Cincinnati Art Museum), March 2 through April 4, 1943. This catalogue contains a woefully inaccurate and inadequate biography of Farny. In addition to the 39 oils and 104 water-colors, there was exhibited an oil portrait of Farny by Frank Duveneck and four Farny drawings. It would appear from two of the drawings that Farny might have been in Cuba in 1898. The catalogue does not give the dimensions of the paintings shown, but it does give the owner of each painting at the time of the exhibition, Farny's signature and the date of the painting when these facts are shown on the painting.

57. The visit is reported in the Cincinnati *Tribune,* October 28, 1894, p. 15, and the Cincinnati *Commercial Gazette,* October 28, 1894, p. 22. This last account contained a reproduction of a sketch of Geronimo dated, "Fort Sill, October 14/94."

According to the *Report of the Secretary of War, House Ex. Doc. 1,* Pt. 2, 53 Cong., 3 Sess. (1894–1895), pp. 26, 27, and *ibid., House Doc. 2,* v. 1, 54 Cong., 1 Sess. (1895–1896), p. 130, the Apaches after being imprisoned since their capture in 1886 at Fort Pickens and Fort Marion, were transferred to Fort Sill and arrived at the latter place on October 4, 1894. The Kiowa, Comanche and Wichita agency in 1894 had its headquarters at Anadarko, some 30 miles from Fort Sill.

An earlier trip to the Southwest and previous (to 1894) acquaintance with the Apache is suggested by the fact that one of Farny's best-known pictures, "The Renegade Apaches," had been completed by 1892, for it was on display in June of that year. — Cincinnati *Commercial Gazette,* June 19, 1892, p. 17. (This account carried a reproduction of the painting.)

58. For example, Farny is not mentioned in Samuel Isham's *The History of American Painting,* supplemented by Royal Cortissoz (New York, 1927), nor in Eugen Neuhaus' *History and Ideals of American Art,* although Neuhaus is practically the only art historian to devote any consideration to the painters of Indian and frontier life. Even S. Hartmann, in his *History of American Art,* published while Farny was still well-known, had no comment on his work save a listing (v. 1, p. 260) of his name along with a number of other artists.

In 1950, I published much of the present chapter on Farny in the *Kansas Historical Quarterly* and in the same year, Virgil Barker in *American Painting* (N. Y., 1950), p. 560, devoted part of one sentence to Farny. Barker cited no source of information on Farny in his bibliography, one of the poorest features of this comprehensive work. When I first saw the Barker volume advertised I thought to myself:

"Here is what I have needed. Here will be the answers to my many biographical and bibliographic problems." I was sadly disappointed for it solved none of my problems. In fact, I believe that Barker might well have used to good advantage, some of my studies published previous to the issuance of Barker's volume. He is either not familiar with these studies—which seems incredible for one undertaking a *comprehensive* study of American art—or he couldn't condescend to the use of an amateur historian's work.

Farny's death on December 23, 1916, is reported briefly in the *American Art Annual*, v. 14, p. 322. An obituary of greater length will be found, however, in the Cincinnati *Enquirer*, December 25, 1916. I am indebted to the Ohio State Archaeological and Historical Society, Columbus, for a copy of this obituary. Attention should also be directed to the fact that the Ohio society possesses an excellent file of Cincinati newspapers which I used in securing the newspaper references contained in this chapter.

CHAPTER XV

The End of an Era

1. In round numbers the growth in the population of the trans-Mississippi West is given in the brief table which follows:

1850	2,000,000
1860	4,500,000
1870	7,400,000
1880	11,300,000
1890	16,500,000
1900	20,600,000

These figures have been obtained from *Statistical Abstract of the United States, 1900* (Washington, 1901), pp. 6–9, by adding the figures for the 22 Western states or territories for each of the decades shown above. Strictly speaking, not all these 22 states are in the trans-Mississippi West, as there are small portions of Minnesota and Louisiana that lie east of the Mississippi river. These deviations, however, cannot greatly affect the above figures. More detailed analysis of the tabulated figures shows that the *rate* of growth became progressively greater from 1850 to 1890, with the greatest growth occurring in the decade 1880–1890.

The population figures before 1850 mean little as far as the trans-Mississippi West

goes. For much of the fifty year period from 1800 to 1850 Missouri and Louisiana contributed chiefly to the total population of the West, as Texas and California, for example, were not part of the Union until after 1840. As cited in the same *Statistical Abstract* given above, however, the population figures for the trans-Mississippi West (in round numbers) as actually recorded run

1800	—
1810	100,000
1820	235,000
1830	400,000
1840	900,000

None of these figures include the small but important number of white inhabitants in the great Indian country of 1800–1850 and of what later became known as New Mexico Territory, nor of the Indian tribes of the West.

2. The only attempt at Remington biography is *Frederic Remington, Artist of the Old West* (Philadelphia and New York, 1947), Harold McCracken. This book has its greatest value in the extensive, although not complete, bibliographic list of Remington illustrations from 1882 on. My opinion of this book I have expressed at some length in *Nebraska History*, Lincoln, v. 29 (1948), September, pp. 278–282.

For collectors of Western prints, colored reproductions of some of Remington's paintings are still available from the Museum of Fine Arts of Houston, Houston 5, Tex., and from Artext Prints, Inc., Westport, Conn.

3. The information given above on Schreyvogel's career is based largely on two contemporary accounts, both apparently the result of direct interviews with Schreyvogel in 1900 and 1901: "A Painter of Western Realism," by Gustav Boehm, *The Junior Munsey*, New York, v. 8 (1900), June, pp. 432–438, which contains reproductions of five Schreyvogel paintings; and "A Painter of the Western Frontier," by Gustav Kobbé, *The Cosmopolitan*, Irvington, N. Y., v. 31, (1901), October, pp. 563–573, which contains 12 reproductions of Schreyvogel's work. Kobbé also had an earlier and briefer account of Schreyvogel, "A Painter of Life on the Frontier," in the New York *Herald*, December 23, 1900, Sec. 5, p. 8 (six illustrations).

Some additional biographical data with reproductions of many of Schreyvogel's earlier paintings will be found in *Souvenir*

Album of Paintings of Charles Schreyvogel, published by Charles F. Kaegebehn, Hoboken, N. J., in 1907. This booklet contains reproductions of 28 Schreyvogel paintings copyrighted between 1899 and 1906.
4. In a brief account of Schreyvogel given in the *National Cyclopaedia of American Biography* (New York, 1906), v. 13, p. 411, there are listed the following Western paintings (with dates) made before 1900: "Ration Day" (1893), "Standing Them Off" (1894), "On Enemies' Grounds" (1895), "The Stage Coach" (1896), "The Despatch Bearer" (1898), "Defending the Stockade" (1898), "The Skirmish Line" (1899), "My Bunkie" (1899).
5. *Harper's Weekly,* New York, v. 41 (1897), April 17, p. 380, reproduced one of Schreyvogel's paintings, "Over a Dangerous Pass," from the academy exhibit of 1897. It received no prize and the art critic of the New York *Tribune* (April 4, 1897, p. 7) made no mention of it. It was simply one of over 400 paintings on exhibit and the only attention it drew apparently was its selection for inclusion in a number of paintings reproduced in the above-cited issue of *Harper's Weekly.* Schreyvogel also exhibited at the National Academy of Design subsequent to 1900. Reproductions of three of his paintings appear in the exhibition catalogues of the academy for the 77th, the 79th, and the 80th annual exhibits: "Going for Reinforcements" (1902), "Dead Sure" (1904), "Attack at Dawn" (1905); *see Index to Reproductions of American Paintings* (New York, 1948), Isabel S. Monro and Kate M. Monro, p. 563. Schreyvogel may, of course, have appeared in other annual exhibitions of the academy without reproduction of his exhibits.
6. I have followed Gustav Kobbé, a writer for the New York *Herald,* in describing the circumstances of the award; *see The Cosmopolitan* article listed in note 3. Kobbé's account is supported by mention of the Clarke award in *Brush and Pencil,* Chicago, v. 5 (1900), February, p. 218. "The winner of the Clarke prize this year," it reported, "which is given for the best figure picture by an American, was won by a man utterly unknown. When the name was announced, all the exhibitors were asking each other where he came from, with whom he had studied, and what he had shown before. There were no answers to these queries. It was finally learned that he was Charles Schreyvogel,

of Hoboken, N. J., that he had studied in Munich, and that he had made a trip out West, where he obtained the material for this composition, which he called 'My Bunkie,' and which represents some United States soldiers dashing across the plains, while one of them has caught up a wounded comrade and draws him on his horse. The work recalls that of Frederic Remington, as all such themes must; but it is drawn better, painted better, and has some notion of color, a quality not often claimed for the better known illustrator. It furthermore seems that Mr. Schreyvogel had been doubtful of sending his picture until the last moment."
7. Not all critics were in agreement with the award committee of the academy and with the *Brush and Pencil* account cited in note 6.
 C. H. Caffin writing in *Harper's Weekly,* v. 44 (1900), January 13, p. 31, stated: "The Thomas B. Clarke prize has been awarded to 'My Bunkie' by Charles Schreyvogel. Exactly why, it is a little hard to conjecture. The coloring is bright and attractive, and fairly permeated with light, and the conception of the subject is stirring, but not very convincing. This kind of subject has been better treated before by others; for, when you examine this picture carefully, you will find many defects of drawing and a considerable flabbiness in details."
8. *American Art Annual,* New York, v. 10 (1913), p. 80. This account, an obituary, states that Schreyvogel was awarded a bronze medal at the Paris exhibition of 1900, a bronze medal at the Pan-American exposition of 1901, and a bronze medal at the St. Louis exposition of 1904. The Metropolitan Museum of Art wrote me under date of November 9, 1950, that "My Bunkie" was given to the museum in 1912 by a group of friends of the artist. The picture, dated "1899," is painted in oil on canvas and is 25″ x 34″ in size. At the time the letter was written the museum had the painting on loan to the Bronx Veterans' Hospital, Kingsbridge Road, New York City.
 I have a reproduction in full color of "My Bunkie" which measures 19¾ inches (width) by 14⅜ inches. The only identification of the publisher on the print is the copyright notice "c 1914 LWS."
9. Information of this painting will be found in the *Souvenir Album of Paintings of Charles Schreyvogel; see* note 3. As this

booklet was doubtless published under the direction or with the knowledge of Schreyvogel, it seems reasonable to assume that his intent is correctly given, as is the information concerning the painting. According to this account the painting was first exhibited at the Corcoran Art Gallery in Washington for several months where it attracted the attention of President Theodore Roosevelt. Later it was exhibited at the St. Louis exposition and was finally purchased and presented to the Pittsfield (Mass.) museum by Fred Love. It is now owned by the Gilcrease Foundation, Tulsa, Oklahoma. The date of the incident depicted is December 17, 1869, and the reproduction of the painting in the booklet identified Custer, Col. Tom Custer, General Sheridan, Col. J. S. Crosby, Scout Grover, Satanta, Kicking Bird, Lone Wolf and Little Heart.

10. *Cosmopolitan Magazine*, v. 40 (1905), December, p. 244.

11. New York *Herald*, April 28, 1903, p. 3. Remington's contempt of Schreyvogel is in marked contrast with Schreyvogel's comment on Remington, "I think he [Remington] is the greatest of us all."—Boehm, *loc. cit.*

12. New York *Herald*, April 30, 1903, p. 17.

13. *Ibid.*, May 2, 1903, p. 7. The letter is signed "John Schuyler Crosby, Charleston, W. Va., May 1, 1903."

14. In 1940, I had correspondence with Mrs. Louise F. Feldmann, widow of Charles Schreyvogel, who subsequently remarried. I am indebted to Mrs. Feldmann for much information and illustrative material concerning Schreyvogel. Mrs. Feldmann wrote me that in addition to the trips to southwestern Colorado and Dakota already mentioned in the text, other summers were spent at Fort Robinson in Nebraska and on a Blackfoot reservation in Montana.

15. Information from Kobbé, *loc, cit.*, Boehm, *loc. cit.*, and in *Harper's Weekly*, v. 46 (1902), November 15, pp. 1668, 1669.

16. Information from Mrs. Feldmann; *see* note 14.

17. These platinum prints are mentioned in *The Mentor*, New York, v. 3 (1915), No. 9, Ser. No. 85, in connection with Arthur Hoeber's review, "Painters of Western Life." Mrs. Feldmann wrote me that there were 48 photographs in the set. I have seen a dozen or so of these prints and

although they vary in size, they average about 20″ x 14″.

I have acquired sometime during my studies an advertising leaflet of six pages, published by Moffat, Yard and Co., N. Y. Someone, probably the original owner of the leaflet, has stamped "Received Feb. 18, 1907" on it, which serves to date the publication approximately. The leaflet advertises these platinum prints as "done under his [Mr. Schreyvogel's] personal supervision" and reports that the sale of prints "has now grown into a business of large proportions." The prints were advertised at $6.00 each and "now number twenty-eight active sellers." The leaflet also reported that a few of the prints had "been done in a smaller size, about 10 x 12 inches, and are sold at $3.00 each." The large size prints are described as measuring "about 15 x 19½ inches, varying slightly on account of their differing proportions."

18. *My Bunkie and Others* (New York, 1909), by Charles Schreyvogel. The publication also contained a two-page account of Schreyvogel and his work. The individual paintings with the exception of "My Bunkie" (1899) were all copyrighted between 1900 and 1909; the count of these copyright dates runs, one in 1899, six in 1900, seven in 1901, two in 1902, three in 1903, four in 1904, three in 1905, two in 1906, five in 1907, one in 1908 and one in 1909.

19. "The Romance of a Famous Painter," by Clarence R. Lidner, *Leslie's Illustrated Weekly*, New York, v. 111 (1910), August 4, pp. 111–113 (11 reproductions of Schreyvogel's paintings).

20. *Hudson Observer*, Hoboken, N. J., January 29, 1912. I am indebted to the Free Public Library of Hoboken, N. J., for a transcript of Schreyvogel's obituary which appeared in the *Observer*.

21. Biographic and bibliographic accounts of Russell will be found in *Charles M. Russell, the Cowboy Artist, a Biography* (Pasadena, 1948), Ramon F. Adams and Homer E. Britzman, and *Charles M. Russell, the Cowboy Artist, a Bibliography* (Pasadena, 1948), Karl Yost. Anyone interested in Russell prints should write the Dick Jones Co., 3127 Walnut Ave., Huntington Park, Cal., for a list and prices; these publishers have in stock some 111 colored reproductions of Russell's work as well as 19 black-and-white prints.

22. Much of my biographical information

concerning J. H. Smith has been supplied by Fred T. Darvill of Bellingham, Wash., who knew Smith well for many years. I am greatly indebted to Mr. Darvill for his aid. A brief obituary of Smith will be found in the Vancouver (B. C.) *Daily Province,* March 10, 1941. The obituary refers to Smith as "Josiah Howard Smith" but Mr. Darvill wrote me that Smith had told him that his first name was "Jerome." In all the Smith illustrations that I have seen, his name is signed as "J. Smith," "J. H. Smith," or "J. S." Mr. Darvill has a group of seven large "letters" measuring about 18″ x 24″ which were written by Smith, probably in the 1930's, and were illustrated with water colors by Smith. These letters are essentially recollections of Smith's early life—much of it dealing with his Western experiences. In one of these letters he recalled breaking Western horses on the Illinois farm, a fact which greatly interested me, as on a trip to northern New York in 1943 I encountered similar references. Several of the old-timers that I interviewed in Canton, N. Y., the boyhood home of Frederic Remington, told me that Western ponies in considerable number were imported into northern New York in the 1880's. Remington during his summer stays in Canton in the late 1880's used such ponies as models for some of his paintings.
23. For a biographical sketch of Harrison *see National Cyclopaedia of American Biography,* v. 27, p. 365.
24. The announcement of the ownership of *Leslie's* by Arkell and Harrison appeared in *Leslie's Weekly,* May 11, 1889, p. 222; the statement concerning the Montana issue on June 8, 1889, p. 304.
25. These illustrations will be found in *ibid.,* in the order listed in the text as follows: October 5, 1889, p. 148; October 19, p. 193; November 2, p. 225; November 16, p. 260; January 18, 1890, p. 429; January 25, p. 444; February 8, p. 12; June 28, p. 444; December 13, p. 354. In addition to these Smith illustrations, another group, "Sketches in the Chinese Quarter, San Francisco," eight illustrations on one page, were published in *ibid.,* July 5, 1890, p. 470.
26. *Saturday Evening Post,* Philadelphia, February 17, 1934, p. 15. The illustration was reproduced from *Leslie's Weekly,* January 25, 1890.
27. Information from Mr. Darvill who sent me a list of Smith paintings owned in 1950. Some 140 titles appear in the list of

the Darvill collection. For any one interested in reproductions of *The Frontier Trial* and other westerns, some in color, by Smith, address Darvill's Picture and Gift Shop, 1305 Pacific Highway, Bellingham, Wash.
28. A death notice of Smith will be found in the Vancouver (B. C.) *Daily Province,* March 8, 1941, where the date of his death is given as March 7, 1941 (in Vancouver).
29. New York *Times,* December 12, 1934, p. 23 (an obituary). He is listed as a member of *Leslie's* art staff in *Leslie's Weekly,* February 22, 1894, pp. 129–136. As will appear in the text, Dan Smith's illustrations began appearing in *Leslie's Weekly* by early 1891.
30. New York *Times,* December 12, 1934.
31. In 1940, I had correspondence with William Smith of New York City, a brother of Dan Smith. Mr. Smith wrote me that Dan Smith's Western illustrations were based on real life sketches made at the ranch of "Mr. Stevens of Albuquerque." Whether there were one or a number of such visits to the Stevens ranch, William Smith could not recall.
32. This series of illustrations in *Leslie's Weekly* in 1891 included: "The Sioux Ghost Dance," January 10, p. 437 (full page); "The Indian Troubles—A Body of Nineteen Teamsters Repel an Attack on a Wagon-Train Near Wounded Knee Creek, South Dakota," January 17, p. 461 (full page); "The Relief Corps Searching for the Dead and Wounded After the Fight with the Hostile Sioux at Wounded Knee—Discovery of a Live Papoose," January 31, p. 493 (title page); "The Recent Indian Troubles—The Military Guard, Searching the Field After the Fight at Wounded Knee, Discover the Body of Big Foot's Chief Medicine-Man," February 7, p. 13 (full page and "after photo"); "Running Down a Sioux Horse-Thief," March 21, p. 117 (full page). The second of the above illustrations is credited in the legend to J. H. Smith but is signed "D. Smith 90," which suggests the possibility that these illustrations were made originally by J. H. Smith, who was in the West at this time, and then were redrawn by Dan Smith. None of the remaining illustrations in this group, however, make any reference to J. H. Smith. As J. H. Smith's illustrations with credit were appearing in *Lesie's Weekly* at this time, I think that the more likely explanation of the matter is a confusion of names.

There were many newspaper correspondents and illustrators present for the Indian troubles of 1890–1891, including Frederic Remington (*see Harper's Weekly*, v. 34 [1891], January 24, 31, and February 7). Elmo Scott Watson of the department of journalism, University of Denver, made the reporting of the Wounded Knee troubles a matter of considerable study and he wrote me that he had found the names of neither J. H. Smith nor Dan Smith listed in any of the contemporary newspaper accounts with which he was familiar.

33. These and other Smith illustrations appeared in *Leslie's Weekly* as follows: "An Impromptu Affair—A Bull Fight on the Plains," April 4, 1891, p. 153 (full page); "The Cattle Industry on the Western Plains," July 4, 1891, p. 379 (three drawings on one page); "Devastating Prairie Fires in Dakota," September 19, 1891, p. 101 (three illustrations on one page); "Arrest and Trial of Horse Thieves [on Mexican Border]," November 7, 1891, p. 223 (full page); "Freighting Salt in New Mexico," November 28, 1891, p. 269 (full page); "Christmas in the Cow Boys' Cabin," December 5, 1891 (in this issue the pages were not numbered; a half-page illustration); "Giving the Mess Wagon a Lift," January 2, 1892, p. 383; "The Race on the Plains," January 9, 1892 (title page in color); "Cowboys Struggling With a Horse Maddened by the Plant [Mexican Crazy Weed]," January 23, 1892 (title page); "Sheep Herding in New Mexico," March 17, 1892, p. 117 (three illustrations on one page); "Cattle Herding in New Mexico," September 28, 1893, pp. 204, 205 (double page); "The Cowboy's Vision," December 14, 1893, p. 23 (one-half page); "Perilous Wagoning in New Mexico," April 12, 1894, p. 245; "On the Range" (roping), March 22, 1894, p. 191 (one-third page); "A Bull Fight on the Western Plains," November 26, 1896, p. 352.

34. *Ibid.*, May 19, 1892, p. 263 (four illustrations on one page); September 28, 1893, p. 208.

35. *Ibid.*, September 29, 1892, p. 229; January 18, 1894, p. 44; December 20, 1894, p. 413.

36. Smith had several Indian illustrations for a fictional article in *ibid.*, December 12, 1895, p. 6, and in the issue of August 12, 1897, pp. 104, 105, he was credited with a number of Alaskan pictures. There is no evidence, however, that these illustrations were the result of his direct observation.

Allen C. Redwood, among many others, should be added to the list of Western illustrators of the 1890's for there are a number of his illustrations of the West in *Leslie's Weekly, Harper's Weekly, Harper's Magazine* and *The Century Magazine* for this period. Redwood was a Confederate war veteran and was noted both for his war drawings and for his writings on the Civil War. He made an extended trip in 1882 going as far as Idaho and Washington and possibly may have made other western trips. He was born in 1844 and died in 1922. I am greatly indebted to a niece of Redwood, Mrs. Robert Pollard of Biltmore, North Carolina, who wrote at some length concerning her uncle's work. I have found Redwood's first name spelled *Allan* as well as *Allen*. Mrs. Pollard wrote me that the correct spelling was *Allen*. An obituary of Mr. Redwood will be found in the Asheville (N. C.) *Citizen*, December 26, 1922. I am indebted to the North Carolina State Library, Raleigh, for a copy of the obituary.

37. For Cooper's contributions as the main originator of the frontier hero and the place of the American West in literature *see* Henry Nash Smith, *Virgin Land* (Cambridge, 1950), chs. 6 and 7; for the school of German writers following Cooper, *see* P. A. Barba, "Cooper in Germany," *German American Annals*, N. S. v. 12 (1914), pp. 3–6, and the chapter "America in German Fiction" in Barba's book, *Balduin Möllhausen, the German Cooper* (Philadelphia, 1914); further information bearing on the general subject can be found in Barba's "The American Indian in German Fiction," *German American Annals*, N. S. v. 11 (1913), pp. 143–174.

38. Santa Barbara *Morning Press*, June 30, 1908, p. 5. It seems probable that Hansen's memory was defective in regard to the railroad that employed him in 1879. The chief railroad in Dakota in 1879 was the Northern Pacific. The Chicago and Northwestern had two subsidiary lines in the Dakotas, the Dakota Central of 24.6 miles length and the Winona and St. Peter R. R., 38.4 miles long. *See* Henry V. Poor's *Manual of the Railroads of the United States for 1880* (New York, 1880), p. 838. The biographic material upon which the above discussion is based comes from manuscript notes furnished me by Mrs. H. W. Hansen in 1939. Mrs. Hansen

not only sent me these notes, but also furnished me a number of newspaper clippings concerning her husband's work and several photographs of Mr. Hansen and of his paintings. After Mrs. Hansen's death in 1940, further biographic material concerning Mr. Hansen was sent me by his daughter, Miss Beatrice Hansen of San Francisco. I wish to express my sincere thanks to both Mrs. Hansen and Miss Beatrice Hansen for their very kind cooperation.

Additional biographic sources of information on Mr. Hansen will be found in *California Art Research*, San Francisco, First Series, v. 9 (1937), pp. 89–104 (mimeograph). I am indebted to Miss Caroline Wenzel of the California State Library, Sacramento, for making a copy of this work available to me. Obituaries of Hansen will be found in the San Francisco *Chronicle*, Sunday, April 13, 1924, and in the Oakland (Cal.) *Tribune* of the same date. Mr. Hansen's death occurred on April 2, 1924. A biographical sketch of Hansen also appeared under the title of "Etching in California," by Harry Noyes Pratt, in the *Overland Monthly*, San Francisco, v. 82 (1924), May, pp. 220, 237.

39. Pratt cited in note 38.

40. *Western Field*, San Francisco, v. 6 (1905), June. Hansen's first exhibition is described in the San Francisco *Call*, October 27, 1901. Mrs. Hansen wrote me that "The Pony Express" was reproduced in the Chicago *Tribune* sometime during 1900 but I have not found it.

41. Hansen described his Montana visit at some length in a letter to the Alameda (Cal.) *Daily Argus*, Saturday supplement, September 5, 1903. The quotation above is from this source as well as the information in the text.

42. An extensive exhibit of the work of California artists, most of which was Hansen's work, was held in Denver in the fall of 1905. A newspaper account of the exhibit stated that Hansen's ". . . Western pictures . . . are just now something of a sensation in the East."—Denver *Republican*, September 24, 1905, p. 24. The exhibit before its departure for the East was described in the San Francisco *Call*, September 10, 1905. The sale of the Hansen paintings to Busch was reported in an unidentified newspaper clipping supplied by Mrs. Hansen and dated (in pencil) "1906." Mrs. Hansen in 1939 sent me a list of purchasers of some of Hansen's paintings. Included among these buyers were three Russians, two Britons, and a German.

43. The quotation in the text is from an unidentified clipping sent me by Mrs. Hansen in 1939; the comment of Neuhaus will be found in his book *The History and Ideals of American Art* (Stanford Univ., 1931), p. 324. A brief comparison of Hansen's work with that of Russell and of Maynard Dixon, by H. N. Pratt, will be found in the San Francisco *Chronicle*, Sunday, August 26, 1923.

In 1939, Mrs. Hansen furnished me a list of the 31 paintings that she considered to be Hansen's most important canvases. The titles of these paintings follow:

1. "Geronimo Returning from a Raid."
2. "Pony Express."
3. "A Dash for the Relay Station."
4. "Renegade Apaches."
5. "Custer's Battle Field on the Little Big Horn."
6. "Stampede."
7. "Pony Express Relay."
8. "At the Water Hole."
9. "Out for a Lark."
10. "Before the Railroad Came."
11. "Winter."
12. "Lonesome."
13. "The Scalp."
14. "His Postoffice."
15. "Breaking an Outlaw."
16. "A Risky Catch."
17. "Waiting for the Rush."
18. "Calling His Bluff."
19. "A Surprise Party."
20. "Indian Gratitude."
21. "A Dangerous Party."
22. "Apache Scouts."
23. "In a Tight Place."
24. "The Return of the Vigilantes."
25. "A Rocky Trail."
26. "A Narrow Escape."
27. "The Outlaw."
28. "A Critical Moment."
29. "A Race for Dinner."
30. "Scenting Danger."
31. "Mexican Horse Thieves."

Even as late as fifteen years ago, the Chicago *Tribune* (March 8, 1936) reproduced in color two of Hansen's paintings, "Apache Scouts Trailing" and "Outcasts" (Dog Soldiers).

44. *See* Pratt, note 38, for a reproduction of one of Hansen's etchings.

CHAPTER XVI

Connecting Links

1. My information on Lungren comes from the comprehensive biography, *Fernand Lungren* (Santa Barbara, 1936), by John A. Berger; and from correspondence with Mr. Berger. All information concerning Lungren given in the text is from Mr. Berger's biography unless other citations are made. I should like to take this opportunity to thank Mr. Berger for his kind co-operation and aid in supplying information. Apparently resulting from Lungren's Western trip of 1892 were 38 paintings under the general title "Among the Pueblos" (Nos. 292–329 inclusive) listed in the *Catalogue of the Art Collection of the St. Louis Exposition and Music Hall Association Tenth Annual Exhibition, 1893.* This same catalogue lists two paintings (Nos. 276 and 277) by Charles Craig, "A Cold Day for the Indian" and "Indian Lookouts," and three by the Texas artist Frank Reaugh (Nos. 338–340 inclusive). For a brief sketch of Reaugh and his work (1861–1945), *see* his autobiography *Biographical* (December, 1936), 6 pp., and *Paintings of the Southwest by Frank Reaugh,* n. d., 45 pp. A number of paintings are reproduced in this booklet in black and white and Reaugh has made many notes on the original paintings. The Reaugh collection is now housed in the Barker Texas History Center, University of Texas, Austin.

2. The illustrations in *St. Nicholas*, New York, will be found as follows: "The Bronco's Best Race," by Cromwell Galpin, three illustrations by Lungren, Apache and Southwest locale, v. 22 (1895), August, pp. 795–803; "The Magic Turquoise," by Lungren himself, two full-page illustrations, one dated 1894, v. 23 (1896), January, pp. 216–222, and "Hemmed in With the Chief," by Frank W. Calkins, one full-page illustration by Lungren (Indian and buffalo), v. 23 (1896), February, pp. 290–293. "Thirst" was reproduced in *Harper's Weekly* as a full-page illustration on February 8, 1896, p. 128, with comment on p. 126 by Owen Wister.

3. Mr. Berger wrote on May 6, 1940, after talking with Stewart Edward White, who "studioed" with Lungren in Santa Barbara in 1906.

4. *Harper's Weekly*, v. 40 (1896), August 15, has four Lungren illustrations of the Moki (Moqui) Indians on pp. 801, 803, 806 and 807, and on pp. 804, 805, a double-page illustration "Among the Moki Indians—The Snake Dance," which is dated 1895; *ibid.*, October 3, 1896, p. 977, "Stalking Antelope [in the desert Southwest]," full page and credited to a painting; *ibid.*, v. 43 (1899), April 15, p. 359, "An Incident in Rocky Mountain Sheep-Hunting," full page and title page, credited to a drawing. In *Harper's Magazine*, New York, Lungren illustrated "An Elder Brother to the Cliff-Dweller's," by T. M. Prudden, v. 95 (1897), June, pp. 55–67, the most important of the illustrations being the full-page "A Sand-Storm on the Mojave Desert"; and Prudden's article "Under the Spell of the Grand Canyon," v. 97 (1898), August, pp. 377–392, four illustrations by Lungren, one in color, "On the Painted Desert." In this last article Prudden described a trip of several weeks in the Grand Canyon country, but it is obvious from the context that Lungren was not a member of the party. In *The Century Magazine*, New York, Lungren illustrated F. W. Hodge's account of the famous "Ascent of the Enchanted Mesa," N. S. v. 34 (1898), May, pp. 15–25, but again Lungren may not have been a member of the party that ascended the mesa; that Lungren was a serious student of mesa life, however, is attested by an article written and illustrated by himself, "Notes on Old Mesa Life," *ibid.*, pp. 26–31. For other Lungren illustrations in this period (not Western), see *19th Century Readers' Guide to Periodical Literature, 1890–99* (New York, 1944), v. 2, p. 140.

5. Berger, *op. cit.*

6. Letter from Mr. Dixon to the writer, October 3, 1940. I carried on an extended correspondence with Mr. Dixon from 1939 until his death on November 13, 1946, and although I never met him personally I felt that he was a real friend. He always answered my inquiries cheerfully and at length, when I am sure he must have marveled at my ignorance of art. He even went to the trouble of drawing outline sketches on thin paper to be placed over photographs of his paintings, to illustrate some elemental principle of art.

7. For a list see *19th Century Readers' Guide to Periodical Literature, 1890–99*, p. 739. Dixon's illustrations did not appear in Eastern periodicals until 1900. Some of

the earliest of this group include (all are full page): *Harper's Weekly*, v. 46 (1902), March 22 (title page), "The Trials of a 'Bronco-Buster'," dated "Oregon 1901"; April 19 (title page), "Stay With Him! Stay With Him!" (bronco buster); May 17, p. 621, "Wild Range-Horses in the Corral," dated "P Ranch Oregon 1901"; October 11, p. 1449, "Freighting in the Desert" (California); December 6, p. 15, "Christmas in the Arizona Desert."

8. My friend J. C. Dykes of College Park, Md., has been compiling a list of Dixon illustrations, particularly book illustrations, and in a list sent me several years ago, Dykes included 39 titles of books containing such illustrations. In *Lo-To-Kah* the earliest Dixon illustration bears the date 1894; Reed's book, *Tales of the Sun-Land*, was also published in 1897 and contained 20 full illustrations by Dixon and other drawings. Jack London's *The Son of the Wolf* (1900) is the third book on Mr. Dykes' list.

9. For biographical material on Dixon, consult *Who's Who in America* (Chicago, 1946), v. 24 (1946–1947), p. 621; U. S. W. P. A., *California Art Research*, v. 8; *Maynard Dixon* (San Francisco, 1937, mimeographed); *Arizona Highways*, Phoenix, v. 18 (1942), February, pp. 16–19—this material includes an account by Dixon himself—"Arizona in 1900"; Arthur Miller, *Maynard Dixon Painter of the West* (Tucson, 1945). This beautiful booklet contains reproductions of many Dixon paintings (a number in color), a list of his exhibitions, a list of his mural decorations and a list of his works in collections, 1915–1945.

10. James B. Carrington, "W. R. Leigh," *Book Buyer*, New York, v. 17 (1898), pp. 596–599; and "William R. Leigh," *The Mentor*, New York, v. 3 (1915), No. 9, Serial No. 85.

11. *The Western Pony* (New York, 1933), 116 pp., with illustrations in black and white by Leigh. Leigh discusses at some length in this book his feeling toward the West, his judgment of Remington and of Russell as depictors of horses, and his philosophy of art, as well as a discussion of the methods employed by the artist in showing movement in animals.

12. *Scribner's Magazine*, New York, v. 22 (1897), November, pp. 531–548. For an index to Leigh's illustrations of the 1890's see *19th Century Readers' Guide to Periodical Literature, 1890–99*, v. 2, p. 59.

Leigh also illustrated a Midwest political story for William Allen White's "Victory for the People," *Scribner's Magazine*, v. 25 (1899), pp. 717–728.

13. Letter to the writer, August 21, 1940.

14. *Scribner's Magazine*, vols. 23, 24; the articles appearing in all nine issues from March through November, 1898, except August.

15. For Leigh's later career see *Who's Who in America*, v. 26 (1950–1951), p. 1597, and *The Western Pony*, cited in note 11. In 1945 Leigh published (mimeograph) "Reproductions of William R. Leigh's Paintings in Color and Black and White Appearing in the Following Publications Since 1910." The list includes some 150 titles, a number of which are duplicates and also included are a number of African illustrations resulting from his trips to Africa in 1926 and 1928. Neuhaus, *op. cit.*, p. 324, wrote concerning Leigh: "His pictures have the sophistication and finesse of the schooled painter, but they lack the freshness and vigor of Remington's or Russell's work."

A colored reproduction of Leigh's "An Argument With the Sheriff" is available from the Dick Jones Picture Co., 3127 Walnut St., Huntington Park, Cal.

16. Material for the above brief description of Caylor came from his widow, Mrs. H. W. Caylor of Big Spring, Tex., by correspondence in 1940; from an obituary in the Big Spring *Daily Herald*, December 25, 1932, p. 1, kindly supplied by N. A. Cleveland, Jr., librarian, newspaper collection, University of Texas; and from an article by J. Frank Dobie, "Texas Art and a Wagon Sheet," in the Dallas *Morning News*, March 11, 1940, p. 9. More recently H. C. Duff, Box 292, Bremerton, Wash., has reproduced for sale the Caylor painting "The Passing of the Old West," the original sketches for which were made by Caylor in 1891 or 1892.

In addition to Caylor, Reaugh (*see* note 1) has depicted Texas cattle and ranch scenes. Still another artist made at least one excellent Texas cattle scene, "A Stampede," reproduced in color as the frontispiece in *Historical and Biographical Record of the Cattle Industry and the Cattlemen of Texas . . .* (St. Louis, 1895). The artist of this illustration is identified as Gean Smith of New York City. In addition to this illustration, there will be found the reproduction in black and white of a number of Smith paintings of famous

race horses in *Outing,* New York, v. 22 (1893), pp. 82, 83, 162, 193, 195, 269, 270, 271, 377–379; v. 26 (1895), pp. 182, 184, 185, 188.

Gean Smith (1851–1928) had a national reputation as a painter of horses, spending most of his active career in New York City. He retired in 1923 and made his home with relatives in Galveston, Tex., for the last five years of his life. An obituary will be found in the Galveston *Tribune,* December 8, 1928. I am indebted to Miss Llerena Friend of the Barker Texas History Center for locating the obituary for me.

17. The quotation is from Oliver W. Larkin, *Art and Life in America* (New York, 1949), p. vii.

Samuel Seymour was the artist with Stephen H. Long's expedition which crossed the Plains to the Front Range of the Rockies in 1819–1820 and was the first artist to my knowledge in the trans-Mississippi West. Some of his paintings are said to be in the Coe collection at Yale University; a few were reproduced in Edwin James' account of the Long expedition published both in Philadelphia and in London in 1823. A modern reprinting with reproduction of a few of Seymour's views (after the London edition) will be found in R. G. Thwaites *Early Western Travels,* Vol. 14–17 (Cleveland, 1905).

Seymour is one of the most elusive characters with whom I have had to deal and I probably have spent more time—without success—in trying to unravel even the simpler facts of his life. Although later references than 1823 have been made to him in the published literature, upon careful examination none have proved of value. The last positive information I have concerning him is that he was alive in New York City in the fall of 1823.

A brief discussion of Seymour's importance as a western artist will be found in Bernard DeVoto's *Across the Wide Missouri* (Boston, 1947) in the Appendix "The First Illustrators of the West."

What little is known—or thought to be known—about Seymour will be found in a recent review by J. F. McDermott in the *Annual Report of the Smithsonian Institution 1950,* Washington, 1951, pp. 497–509.

18. Samuel Isham, *The History of American Painting,* new edition (New York, 1927), p. 575.

19. Neuhaus, *op. cit.,* pp. 322 and 323. The attraction of light and color and of

Indian and Mexican life for the artist is attested by one member of the Taos group himself; *see* W. Herbert Dunton "Painters of Taos," *American Magazine of Art,* v. 13 (1922), August, p. 247. Rilla C. Jackson in *American Arts* (Chicago, 1928) is another art historian who, like Neuhaus, makes some consideration of Taos. In her discussion, "The Taos Artists" (pp. 266–274), she included not only the Taos group as such but Western artists in general, including Remington and his contemporaries. Art historians who make no mention of the Taos artists are Homer Saint-Gaudens, *The American Artist and His Times* (New York, 1941), and Suzanne La Follette, *Art in America* (New York, 1929). Miss La Follette has so little understanding of American history that she makes (p. 110) the well-nigh incredible statement "on the contrary, it [westward expansion] is one of the most depressing chapters in American life . . . it promoted deterioration in the quality of life." Miss La Follette is not alone in expressing such an attitude, but such critics have seized on fraud, land exploitation, corruption in public office and other ills that accompanied the development of the West, while totally overlooking the facts of similar irregularities of Eastern life and the more favorable aspects of Western life. Bernard De Voto's *Mark Twain's America* (Boston, 1932) is in part an answer to such critics.

20. Blanche C. Grant, *When Old Trails Were New* (New York, 1934), p. 254. For the previous mention of Poore, *see* Chap. XIV. Poore visited Taos in the summer of 1890; see *Report on Indians Taxed and Indians Not Taxed . . . Eleventh Census: 1890* (Washington, 1894), p. 424.

21. Craig (1846–1931) is another artist who really deserves fuller notice in this chronicle than we have given him. Examples of his work are so widely scattered that it is difficult if not impossible to secure photographs of them, as I have been trying to do for the last ten or dozen years. Craig was one of the illustrators for Verner L. Reed's *Lo-To-Kah* (New York, 1897) and others of Reed's publications. Born in Ohio in 1846, he made his first Western trip in 1865—up the Missouri river. He was a student in the Philadelphia Academy of Fine Arts in 1872 and 1873 and after he settled in Colorado Springs he took an active part in the art life of Colorado as a productive artist, a teacher of art, and as manager of a number of early art exhibi-

tions in Denver and Pueblo, as well as Colorado Springs. Biographic material will be found in obituaries in the Colorado Springs *Telegraph*, October 2, 1931, p. 1, and the Denver *Post*, October 20, 1931. Other materials bearing on his work include accounts in the Colorado Springs *Evening Telegraph*, February 4, 1920, p. 9; the Colorado Springs Sunday *Gazette and Telegraph*, November 11, 1923, Sec. 1, p. 4; in *Brush and Pencil in Early Colorado Springs* by Gilbert McClurg, also in Colorado Springs *Gazette and Telegraph*, November 30, 1924, Sec. 2, and in *Who's Who in America*, v. 13 (1924), p. 832.

Harvey B. Young (1841–1901), a landscape artist, had his first Western experiences in California in 1859. He received art training abroad and made his home in Manitou, Colo., in 1879, and later in Aspen and Denver. He deserted art for a time in the 1880's when he made and lost a fortune in mining. His reputation as an artist was based on landscape paintings of the Rockies and of Brittany and Fontainebleau. For biographical information *see* Gilbert McClurg, *op. cit.*, Colorado Springs *Gazette and Telegraph*, November 23, 1924, Sec. 2, pp. 1, 3, and an obituary in the Denver *Republican*, May 14, 1901.

Another friend of Craig's was Frank P. Sauerwen, who was also a visitor to Taos in 1898, but who was claimed as a Denver artist. Sauerwen was born in 1871 in New Jersey, and moved to Denver about 1891. He moved to California in 1905 and died in Stamford, Conn., on June 13, 1910. He had a large local reputation as an artist but was scarcely known outside of the mountain West. Fred Harvey was one of his patrons as was Judge J. D. Hamlin of Farewell, Tex. Judge Hamlin wrote me in 1940 that he owned some 40 canvases done by Sauerwen. I have seen but two reproductions of Sauerwen's work, "First Santa Fe Train," reproduced in color by the Fred Harvey System in post-card form and "The Arrow," probably his best-known picture, which was reproduced in black and white in *Brush and Pencil*, Chicago, v. 4 (1899), May, p. 83.

I am indebted to Judge Hamlin, to the Denver Public Library, and especially to Alfred W. Scott, art dealer of Denver, for biographic information concerning Sauerwen. Newspaper material on Sauerwen will be found in the Denver *Republican*, November 22, 1898; *Rocky Mountain News*, Denver, November 22, 1898; Denver *Weekly Church Press*, December 10, 1898; Denver *Republican*, April 9, 1899; *Rocky Mountain News*, April 9, 1899; Denver *Republican*, April 15, 1900, and April 13, 1903.

22. I have carried on a correspondence with Mr. Sharp since 1939, the material quoted above being from a letter dated "April, 1939." For published information on Sharp's career, see *National Cyclopaedia of American Biography*, v. 18, p. 188; *Who's Who in America 1950–1951*, v. 26 (1950), p. 2483. Sharp illustrations resulting from his visit to New Mexico in 1893 may be found in *Harper's Weekly*, v. 37 (1893), October 14, p. 981, "The Harvest Dance of the Pueblo Indians of New Mexico" (full page), dated "93" with a description by Sharp himself on pp. 982 and 983; *ibid.*, v. 38 (1894), June 9, p. 549, "The Pueblo Turquoise Driller" (small), with brief description by Sharp on the same page; *Brush and Pencil*, v. 4 (1899), April, pp. 1–7, "An Artist Among the Indians," by Sharp, with reproductions of 11 of his paintings, one (full page) in color, "The Mesa, from Kit Carson's Tomb, Taos, New Mexico." Several others of these reproductions indicate Taos as the locale. A full-page reproduction in color of Sharp's "The Evening Chant" (Pueblo Indians) appeared in *ibid.*, v. 5 (1900), March, opp. p. 241, with a brief comment by Sharp on p. 284; in the same periodical, v. 7 (1901), April, p. 61, is a full-page black and white reproduction of his painting, "Mourning Her Brave," which on p. 64 is credited "from life." *An Exhibition of Oil Paintings by Joseph Henry Sharp* (Tulsa, 1949) lists 204 of his paintings, many of which are dated; one, "Zuni Pueblo," bears the legend, "Painted 1898"; altogether some 16 were painted before 1900. The Sharp exhibition at Tulsa was opened on his 90th birthday!

23. In this statement of the founding of the art colony at Taos, I am following the account of E. L. Blumenschein which appeared in the Santa Fe *New Mexican*, June 26, 1940, "Artists and Writers Edition," the biographic sketch of J. H. Sharp which also appeared in the same issue of the *New Mexican* and an address by Phillips on "The Broken Wagon Wheel or How Art Came to New Mexico," delivered by Phillips in 1948 on the 50th anniversary of the founding of the Taos Art Colony.

Blanche C. Grant, *op. cit.*, ch. 35, was another who described the founding of the art colony at Taos and gave biographic sketches of a number of the artists in the colony at the time of writing (1934). Miss Grant also included an interesting group photograph of ten of the Taos artists. According to the Blumenschein account, some 50 artists were making Taos their permanent home in 1940. Blumenschein's illustrations appeared in *McClure's Magazine*, New York, as follows: v. 10 (1898), January, p. 252; v. 12 (1899), January, p. 241, February, pp. 298–304; v. 14 (1899), November, pp. 88, 90–93, 95. For Bert G. Phillips (born 1868), see *Who's Who in America*, v. 26 (1950–1951), p. 2163.

Santa Fe itself, as well as Taos, is now a very considerable center of art and has been for many years. Although no attempt will be made to outline the history of Santa Fe as a center of art it can be pointed out that the Santa Fe *New Mexican* has many items bearing on such a history previous to 1900. For example, the *New Mexican* for September 9, 1886, p. 4, described the work of a Mr. and Mrs. Elderkin, art teachers, who were established in Santa Fe.

Somewhat later, Warren E. Rollins was active during the first decade of the nineteen hundreds and had a showing of his paintings in Santa Fe about 1909. Some of his paintings of this period include "The Toiler," "The Burden Bearer," "The Medicine Man" and "Song of the Kieva." An account of his work by W. T. LeViness will be found in the Kansas City *Times*, August 14, 1951, p. 20. I am also indebted to Mr. Rollins' daughter, Mrs. Ruth Stieff of Baltimore, for information concerning her father's work who is still active at the age of ninety. The present colony at Santa Fe has a still more modern origin. Dr. Reginald Fisher of the Museum of New Mexico wrote me recently as follows concerning the modern period: "Roughly speaking, the years 1918 and 1919 might

be given for the founding of the Santa Fe art colony. It was during this time that the original group of artists established permanent homes here. Among these were Gustave Baumann, Randell Davey, Fremont Ellis, John Sloan, and within a year or two following were Will Shuster, Jozef Bakos, Theodore Van Soelen (who settled first at Albuquerque in 1916 then at Santa Fe in 1922) and Albert Schmidt. These are all leading names today among Santa Fe artists."

24. These illustrations appeared in *Harper's Weekly*, v. 42 (1898), December 10, pp. 1204, 1205; v. 43 (1899), June 17, p. 587, October 28, p. 1100. J. H. Sharp's painting reproduced in *Brush and Pencil*, "The Mesa, from Kit Carson's Tomb, Taos, New Mexico," cited in note 22, should not be overlooked in considering the early illustrations from Taos.

25. Letter of E. L. Blumenschein to the writer, March 16, 1940.

26. For Mr. Blumenschein's career see *Who's Who in America*, v. 26 (1950–1951), p. 253. Mr. Blumenschein is still active at the age of 76 (1952).

27. Remington W. Lane, "An Artist in the San Juan Country," *Harper's Weekly*, v. 37 (1893), December 9, p. 1174. Seven of Lane's pictures of southwestern Colorado and Utah will be found on p. 1168. Lane was a member of Warren K. Moorehead's archaeological party that traveled overland from Durango, Colo., to Bluff City, Utah. I have found no other data concerning Lane.

28. The first quotation given above was written by J. H. Sharp, *Harper's Weekly*, v. 37 (1893), October 14, p. 982; the second was Remington W. Lane in *ibid.*, December 9, p. 1174; the third by W. Herbert Dunton, in *American Magazine of Art*, v. 13 (1922), August, p. 247.

29. H. W. Hansen in the Santa Barbara *Morning Press*, June 30, 1908, p. 5.

30. *Collier's Weekly*, New York, v. 34 (1905), March 18, p. 16.

Artists and Illustrators

of the

OLD WEST

1850-1900

Examples from the Work of

JOHN MIX STANLEY	JOHN MULVANY
CHARLES KOPPEL	CASSILLY ADAMS
GUSTAV SOHON	HARRY OGDEN
JOHN E. WEYSS	WALTER YEAGER
ARTHUR SCHOTT	WILLIAM A. ROGERS
H. B. MÖLLHAUSEN	MARY H. FOOTE
W. J. HAYS	CHARLES GRAHAM
W. M. CARY	RUFUS F. ZOGBAUM
A. R. WAUD	FREDERIC REMINGTON
T. R. DAVIS	HENRY F. FARNY
ALFRED E. MATHEWS	CHARLES SCHREYVOGEL
JOSEPH BECKER	DAN SMITH
PAUL FRENZENY	J. H. SMITH
JULES TAVERNIER	H. W. HANSEN
HENRY WORRALL	J. H. SHARP
VINCENT COLYER	H. W. CAYLOR
OTTO BECKER	ERNEST L. BLUMENSCHEIN
WILLIAM R. LEIGH	

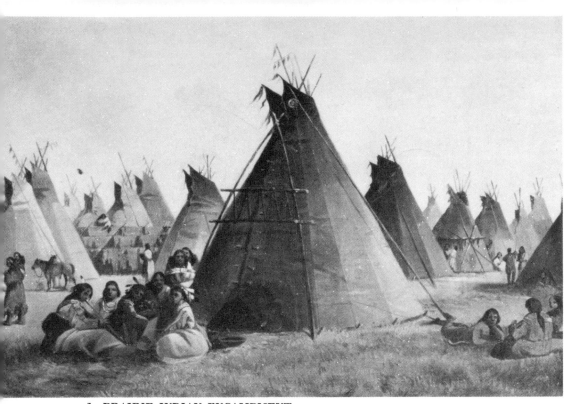

1. PRAIRIE INDIAN ENCAMPMENT

JOHN MIX STANLEY *Courtesy*, THE DETROIT INSTITUTE OF ARTS

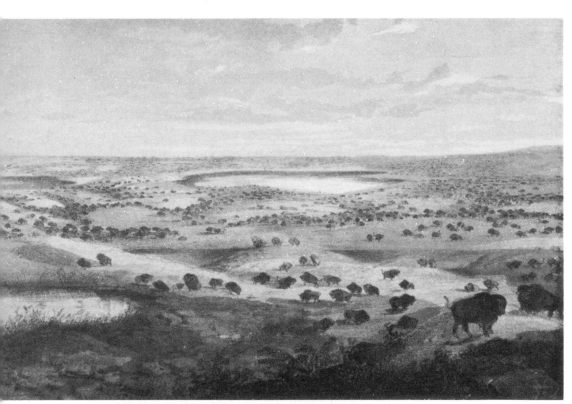

2. HERD OF BISON, NEAR LAKE JESSIE (1853)

JOHN MIX STANLEY *From* PACIFIC RAILROAD REPORTS

3. FORT UNION, AND DISTRIBUTION OF GOODS TO THE ASSINNIBOINES (1853)

JOHN MIX STANLEY *From* PACIFIC RAILROAD REPORTS

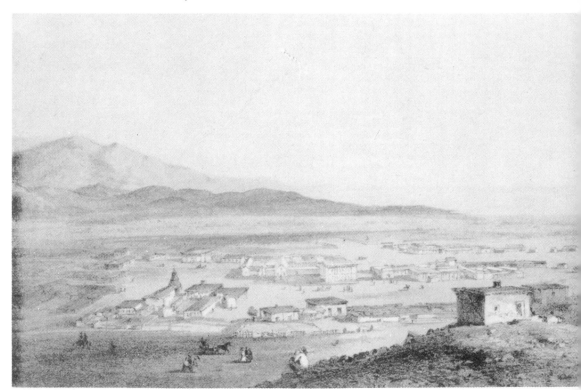

4. LOS ANGELES, C. 1853

CHARLES KOPPEL *From* PACIFIC RAILROAD REPORTS

5. COEUR D'ALENE MISSION, ST. IGNATIUS RIVER, 1853

JOHN MIX STANLEY *From* PACIFIC RAILROAD REPORTS

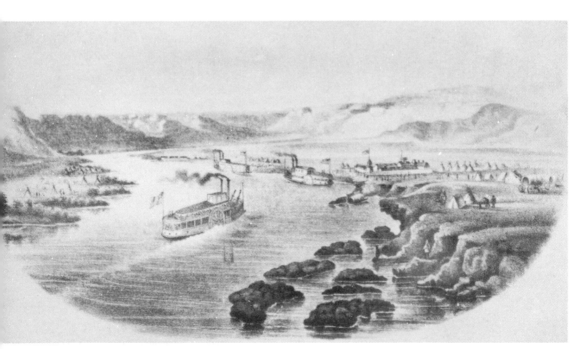

6. FORT BENTON—HEAD OF STEAM NAVIGATION ON THE MISSOURI RIVER (1860–1862)

GUSTAV SOHON *From* MULLAN'S REPORT

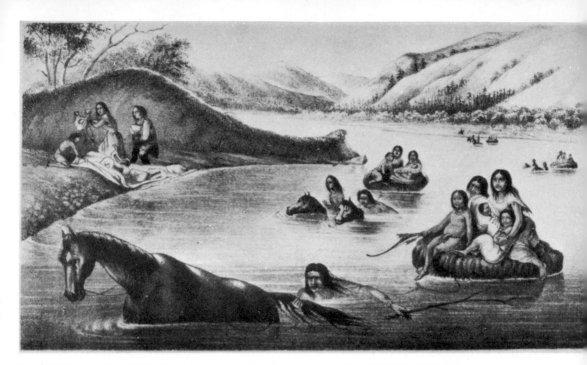

7. MODE OF CROSSING RIVERS BY THE FLATHEAD AND OTHER INDIANS
(1860–1862)

GUSTAV SOHON *From* MULLAN'S REPORT

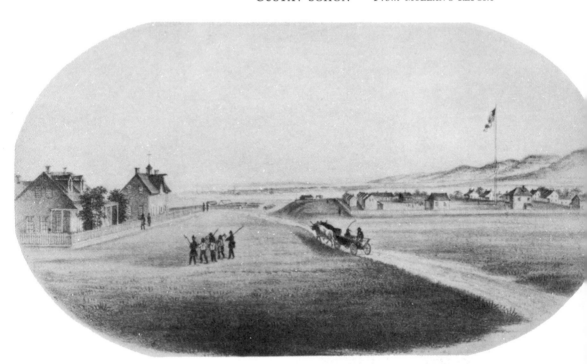

8. WALLA-WALLA, WASHINGTON TERRITORY, 1862

GUSTAV SOHON *From* MULLAN'S REPORT

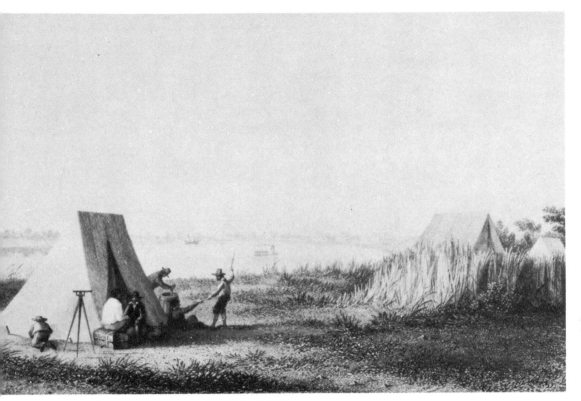

9. BROWNSVILLE, TEXAS (1853)

JOHN E. WEYSS *From* EMORY'S BOUNDARY SURVEY REPORT

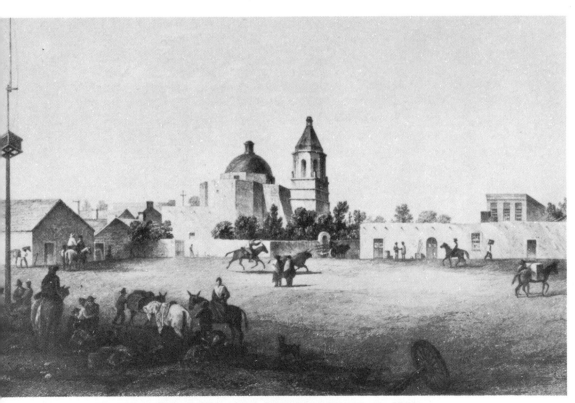

10. MILITARY PLAZA—SAN ANTONIO, TEXAS (C. 1853)

ARTHUR SCHOTT *From* EMORY'S BOUNDARY SURVEY REPORT

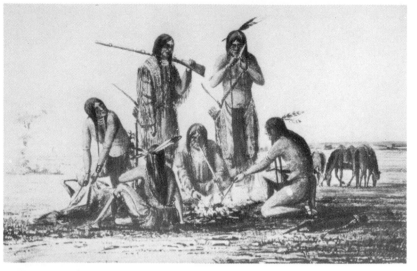

11. A GROUP
OF SIOUX, 1851
H. B. MÖLLHAUSEN

Courtesy,
STAATLICHES MUSEUM
FÜR VOLKERKUNDE, BER

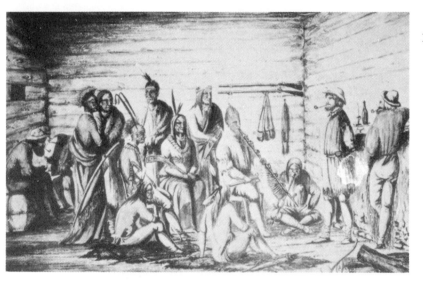

12. BELLE VUE,
NEBRASKA,
TRADING POST, 185
H. B. MÖLLHAUSEN

*The German title of thi
drawing makes it almos
certainly a view in the
American Fur Compan
trading post at Belle V
Possibly the white man
shown smoking a pipe
the right, facing the Ind
ans, is Möllhausen, and
man leaning against the
wall is Pierre Sarpy.*

Courtesy,
STAATLICHES MUSEUM
FÜR VOLKERKUNDE, BER

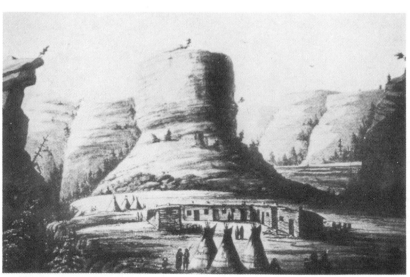

13. ROBIDOU
TRADING POST,
SCOTT'S BLUFFS, 18
H. B. MÖLLHAUSEN

Courtesy,
STAATLICHES MUSEUM
FÜR VOLKERKUNDE, BER

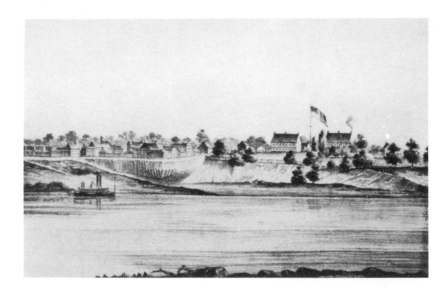

FORT SMITH,
ARKANSAS (C. 1853)
H. B. MÖLLHAUSEN

From WHIPPLE'S REPORT

THE GRAND CANYON
OF THE COLORADO

H. B. MÖLLHAUSEN

From REISEN IN DIE
FELSENGEBIRGE
NORD-AMERIKAS, 1861

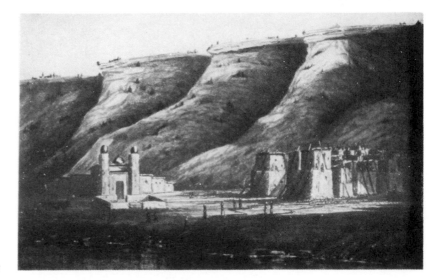

SAN FELIPE,
NEW MEXICO, 1853

H. B. MÖLLHAUSEN

Courtesy,
STAATLICHES MUSEUM
FÜR VOLKERKUNDE, BERLIN

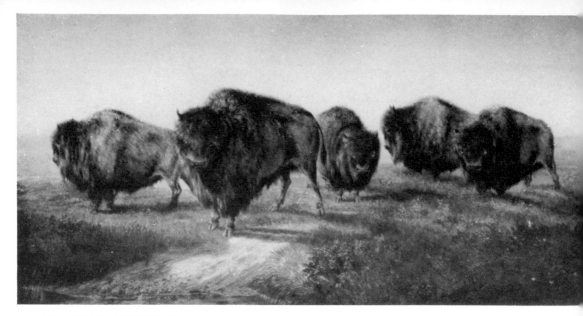

17. GROUP OF BUFFALO

W. J. HAYS *Courtesy,* AMERICAN MUSEUM OF NATURAL HISTORY, NEW YORK CITY

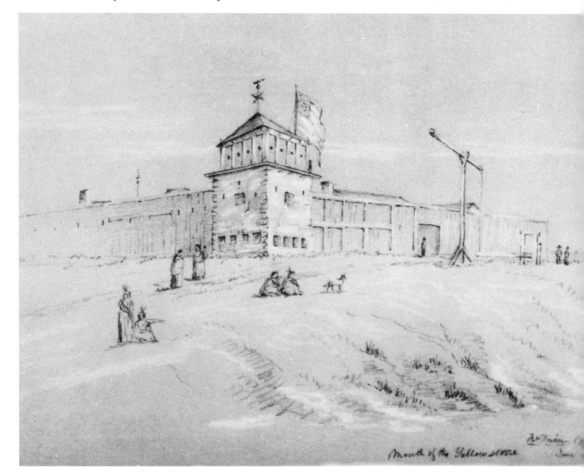

18. MOUTH OF THE YELLOWSTONE, FORT UNION, UPPER MISSOURI,
JUNE 16, 1860

W. J. HAYS *From* the Hays portfolio of field sketches

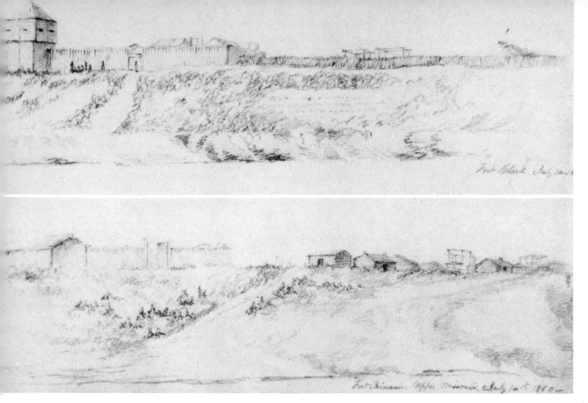

19. *Upper sketch,* **FORT CLARK, JULY 14, 1860**
Lower, **FORT PRIMEAU, JULY 14, 1860**

W. J. HAYS *From* the Hays portfolio, *courtesy of* MR. H. R. HAYS

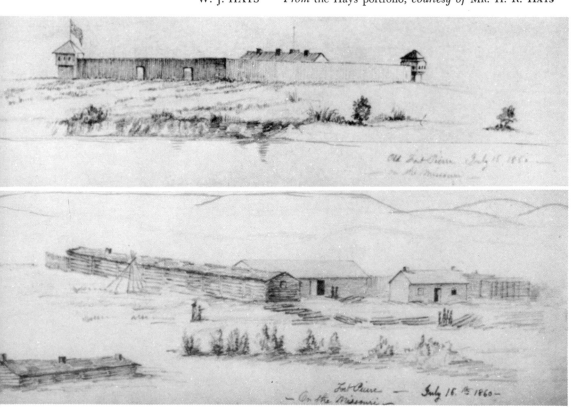

20. *Upper sketch,* **OLD FORT PIERRE, JULY 18, 1860**
Lower, **FORT PIERRE, JULY 18, 1860**

W. J. HAYS *From* the Hays portfolio, *courtesy of* MR. H. R. HAYS

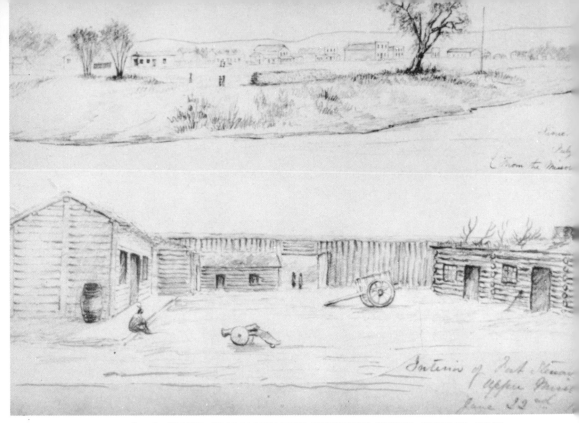

21. *Upper sketch,* **SIOUX CITY FROM THE MISSOURI RIVER, JULY 20, 1860**
Lower, **INTERIOR OF FORT STEWART, UPPER MISSOURI, JUNE 22, 1860**

W. J. HAYS *From* the Hays portfolio, *courtesy of* Mr. H. R. Hays

22. WAGON TRAINS AT HELENA, MONTANA

W. M. CARY *From* Harper's Weekly, 1878

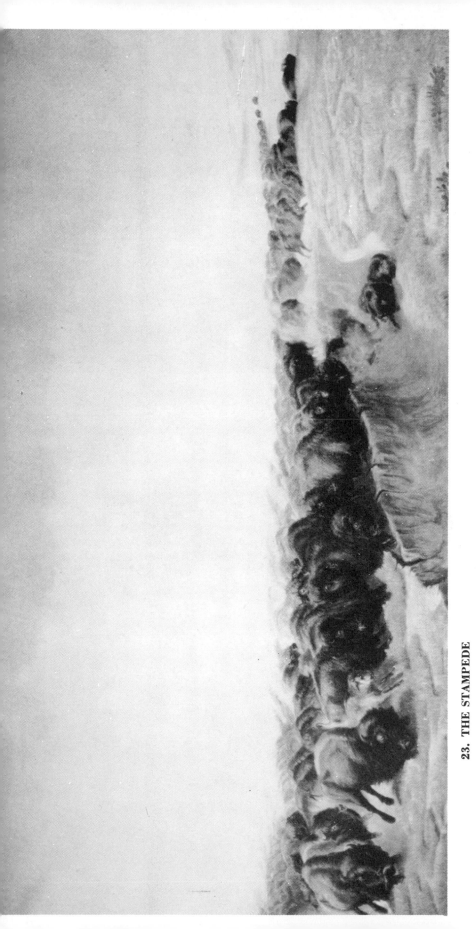

23. THE STAMPEDE

W. J. HAYS *Courtesy,* AMERICAN MUSEUM OF NATURAL HISTORY, NEW YORK CITY

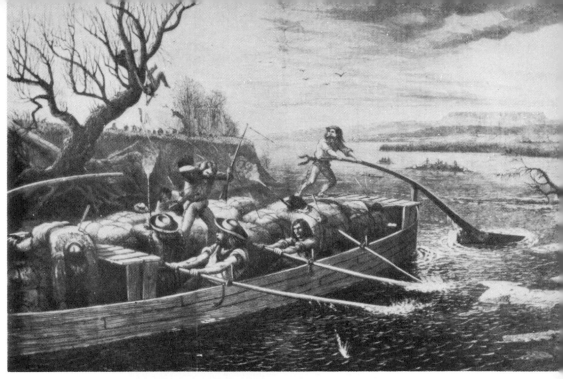

24. FUR TRADERS ON THE MISSOURI ATTACKED BY INDIANS

W. M. CARY *From* HARPER'S WEEKLY, 1868

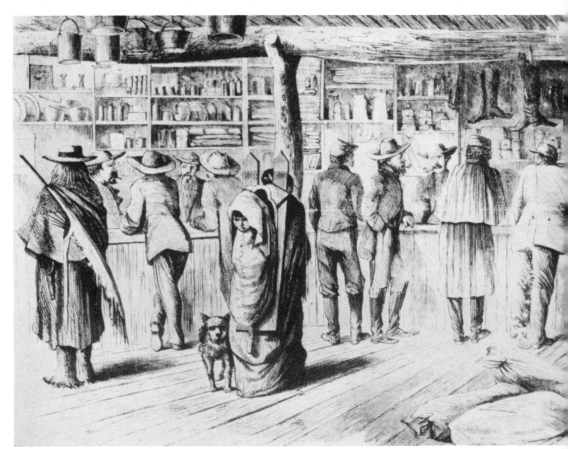

25. SUTLER'S STORE AT FORT DODGE, KANSAS

T. R. DAVIS *From* HARPER'S WEEKLY, 1867

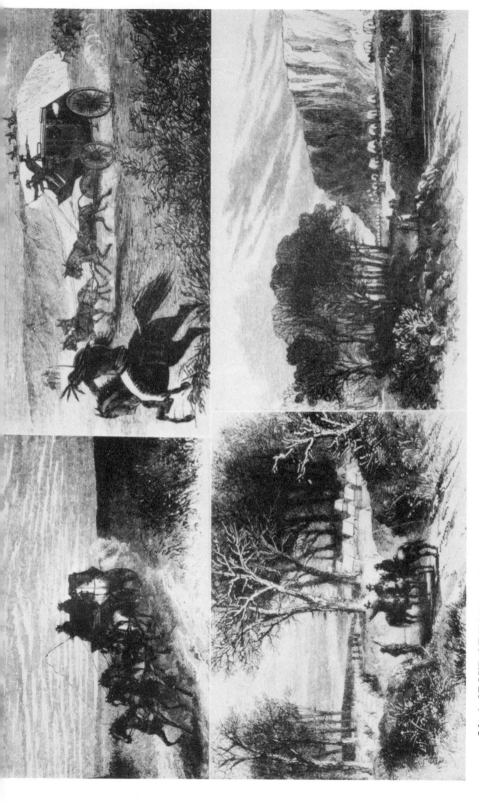

26. A GROUP OF KANSAS SCENES:

Upper left, DEPARTURE FROM ATCHISON; *Upper right,* HERE THEY COME (Logan County);

Lower left, FORT FLETCHER (Ellis County); *Lower right,* POND CREEK (Wallace County)

T. R. DAVIS *From* HARPER'S MONTHLY, JULY, 1867

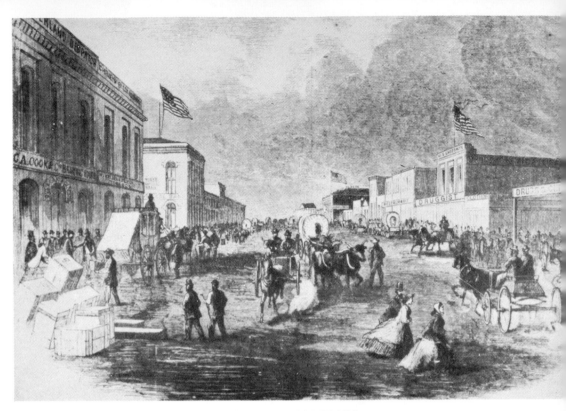

27. THE OVERLAND COACH OFFICE, DENVER, COLORADO

T. R. DAVIS *From* HARPER'S WEEKLY, 1866

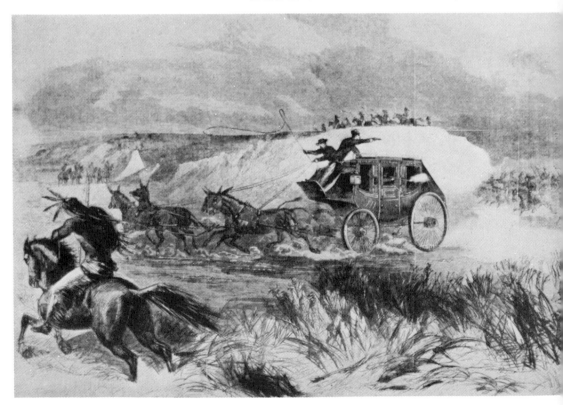

28. INDIANS ATTACKING BUTTERFIELD'S OVERLAND DISPATCH COACH

T. R. DAVIS *From* HARPER'S WEEKLY,

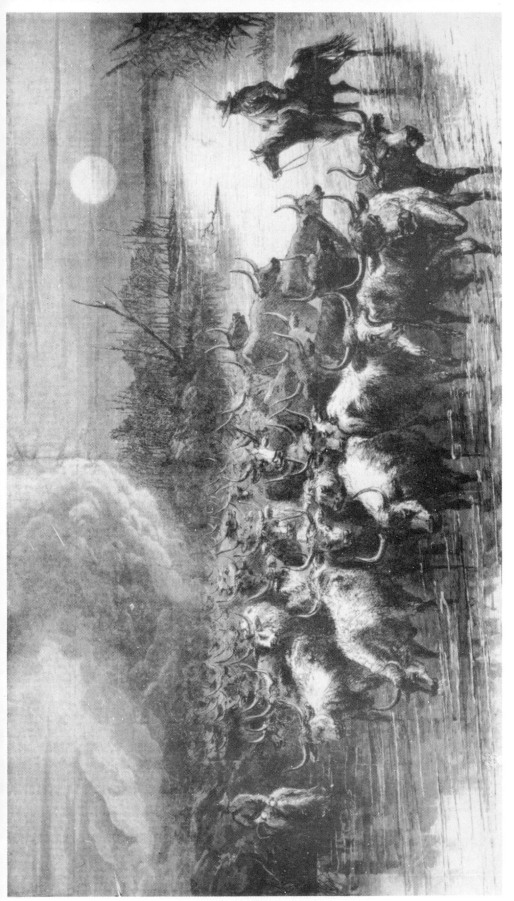

29. A DROVE OF TEXAS CATTLE CROSSING A STREAM

A. R. WAUD *From* HARPER'S WEEKLY, 1867

30. BUILDING THE UNION PACIFIC RAILROAD IN NEBRASKA

A. R. WAUD *From* A. D. RICHARDSON, *Beyond the Mississippi*, 1867

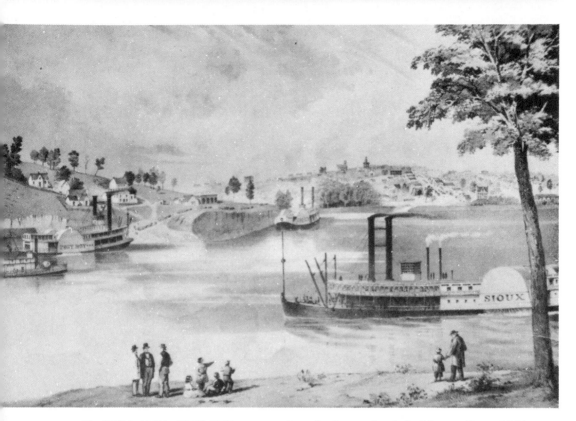

31. NEBRASKA CITY, NEB., *as seen from the Iowa side of the Missouri River,* 1865

ALFRED E. MATHEWS *Courtesy,* NEBRASKA STATE HISTORICAL SOCIETY, LINCOLN

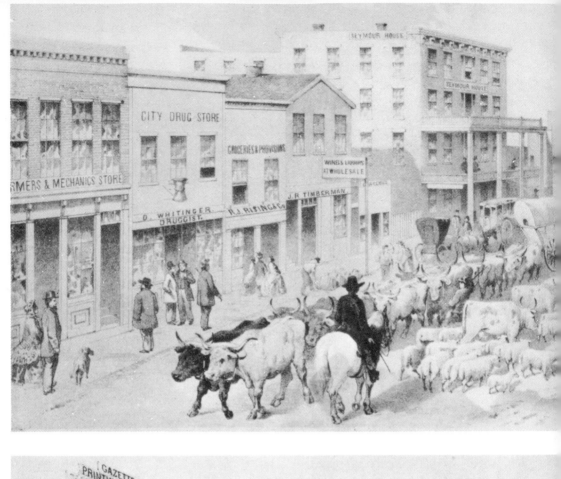

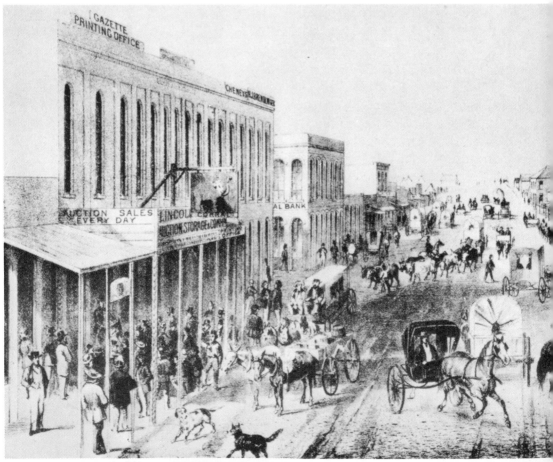

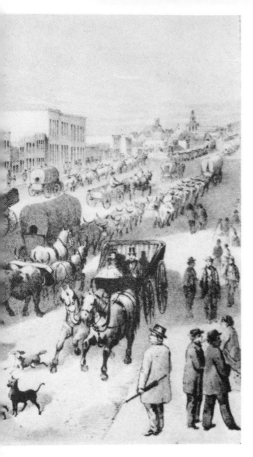

32. NEBRASKA CITY, NEB., MAIN STREET, LOOKING WEST (1865)

ALFRED E. MATHEWS

Courtesy,
NEBRASKA STATE HISTORICAL SOCIETY, LINCOLN

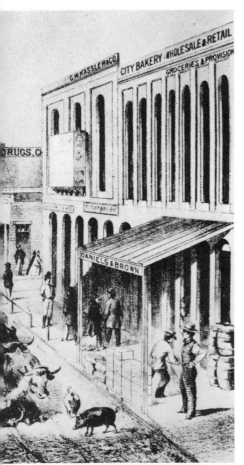

33. BLAKE STREET, DENVER, COLORADO

ALFRED E. MATHEWS

From PENCIL SKETCHES
OF COLORADO, 1866 (Plates 33 to 38 are by

courtesy, WESTERN HISTORY DEPARTMENT,
DENVER PUBLIC LIBRARY)

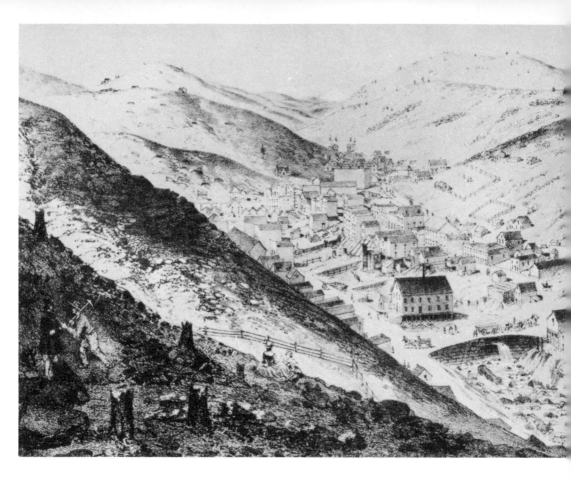

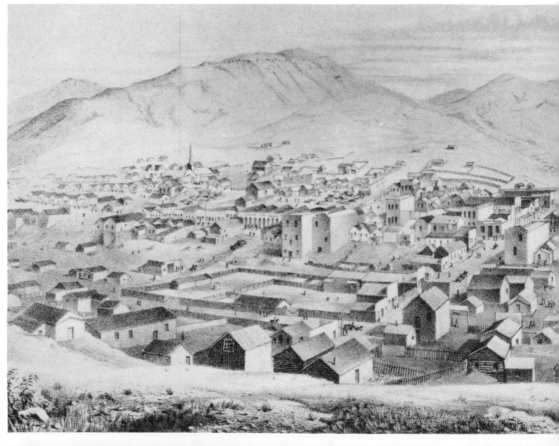

**34. CENTRAL CITY
FROM MAMMOTH HILL,
LOOKING UP GREGORY AND EUREKA
GULCHES**
ALFRED E. MATHEWS

From PENCIL SKETCHES
OF COLORADO, 1866

35. VIRGINIA CITY
ALFRED E. MATHEWS

From PENCIL SKETCHES
OF MONTANA, 1868

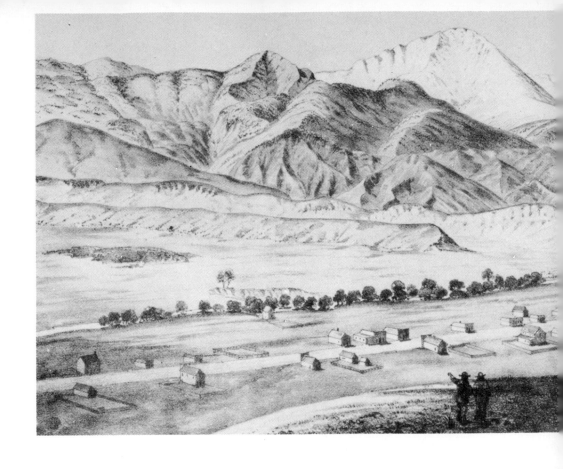

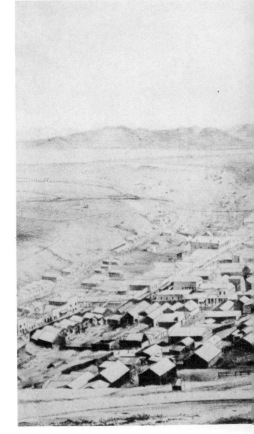

37. HELENA

ALFRED E. MATHEWS

From PENCIL SKETCHES
OF MONTANA, 1868

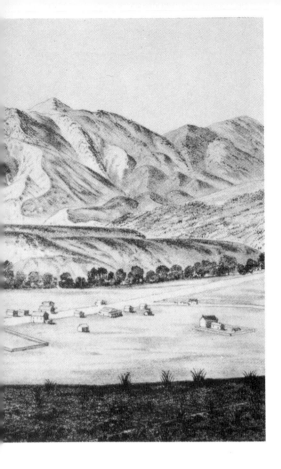

36. PIKE'S PEAK AND COLORADO CITY
ALFRED E. MATHEWS

From PENCIL SKETCHES
OF COLORADO, 1866

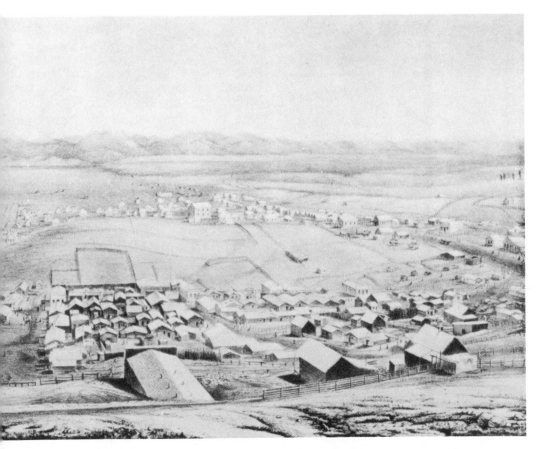

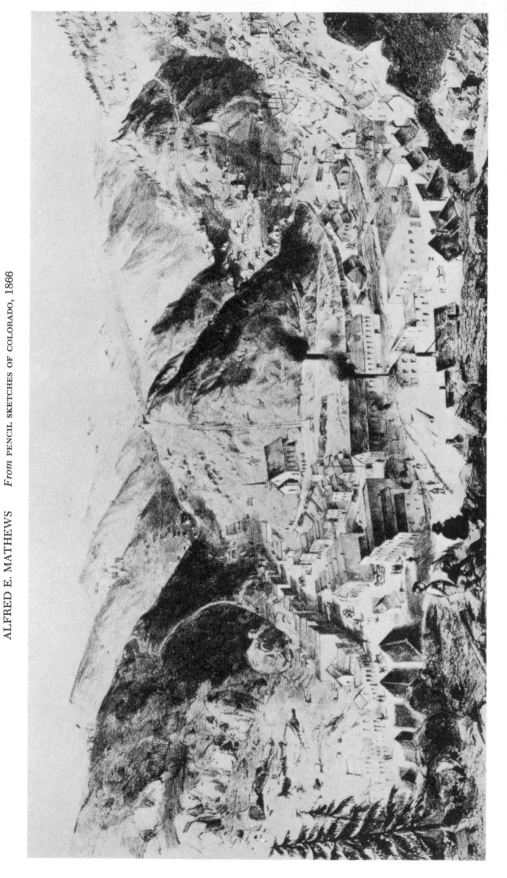

38. BLACK HAWK, LOOKING UP GREGORY AND CHASE'S GULCHES
ALFRED E. MATHEWS *From* PENCIL SKETCHES OF COLORADO, 1866

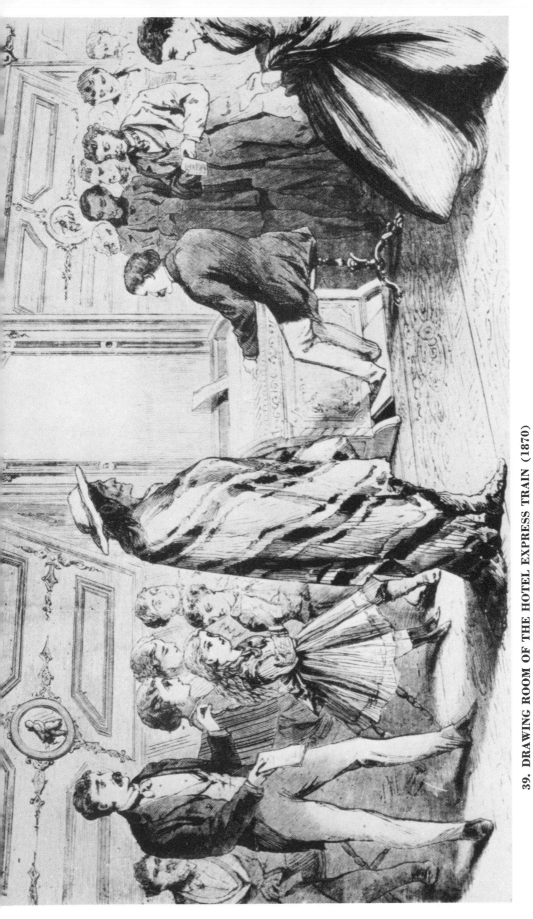

39. DRAWING ROOM OF THE HOTEL EXPRESS TRAIN (1870) *From* FRANK LESLIE'S ILLUSTRATED NEWSPAPER

JOSEPH BECKER

40. STATION SCENE ON THE UNION PACIFIC RAILWAY (1869)

JOSEPH BECKER *From* FRANK LESLIE'S ILLUSTRATED NEWSPAPER

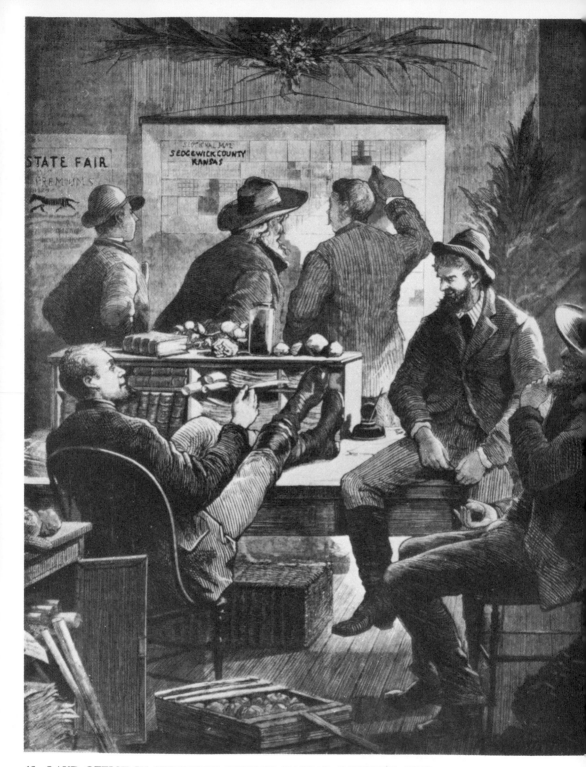

41. LAND OFFICE IN SEDGWICK COUNTY, KANSAS, OCTOBER, 1873

FRENZENY-TAVERNIER *From* HARPER'S WEEKLY

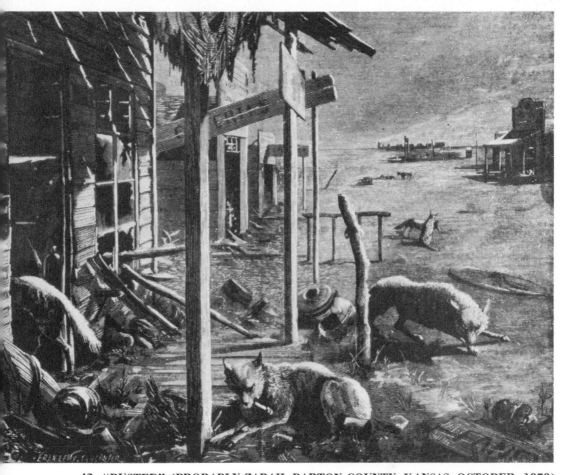

42. "BUSTED" (PROBABLY ZARAH, BARTON COUNTY, KANSAS, OCTOBER, 1873)

FRENZENY-TAVERNIER　　*From* HARPER'S WEEKLY

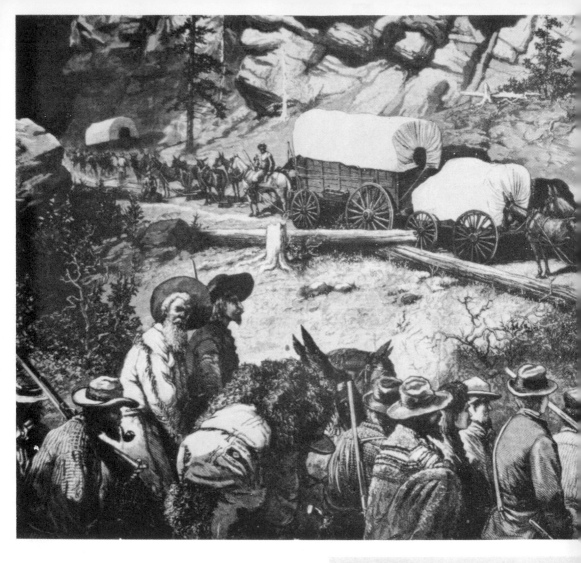

**44. ATTACK BY INDIANS
NEAR CHIMNEY ROCK, NEBRASKA**
JULES TAVERNIER

Courtesy, THE BOHEMIAN CLUB, SAN FRANCISCO

**43. A ROUGH MOUNTAIN ROAD
ON THE WAY TO THE MINES:
COLORADO, 1874**
FRENZENY-TAVERNIER

From HARPER'S WEEKLY

45. SUPPLY TRAIN ON THE PLAINS IN WINTER

PAUL FRENZENY From HARPER'S WEEKLY, 1882

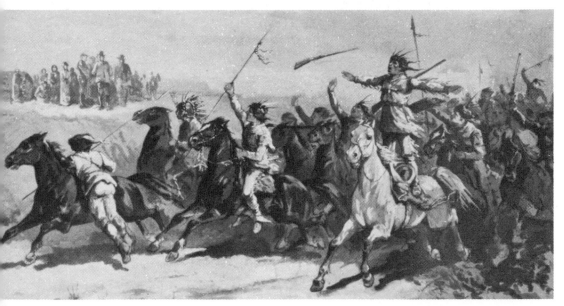

46. MUSTER DAY AT THE AGENCY

PAUL FRENZENY *Courtesy*, EDWARD EBERSTADT AND SONS, NEW YORK CITY

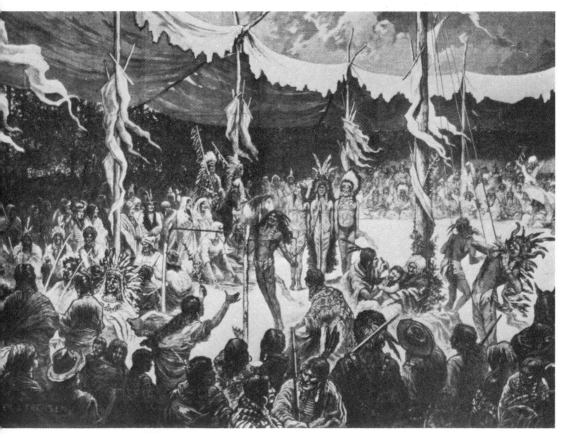

47. SUN DANCE

FRENZENY-TAVERNIER *From* HARPER'S WEEKLY, 1875

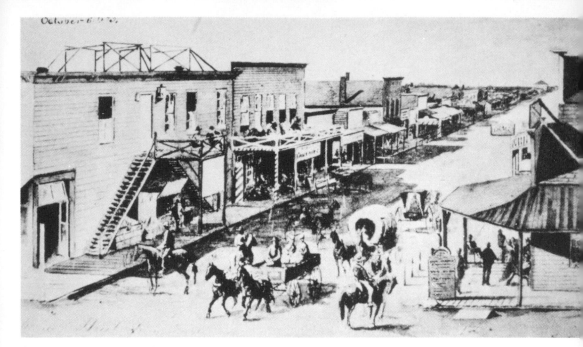

48. WICHITA, KANSAS. MAIN STREET FROM EAGLE BLOCK, OCTOBER 6, 1873

JULES TAVERNIER *Courtesy,* WICHITA PUBLIC MUSEUM, WICHITA, KANSAS

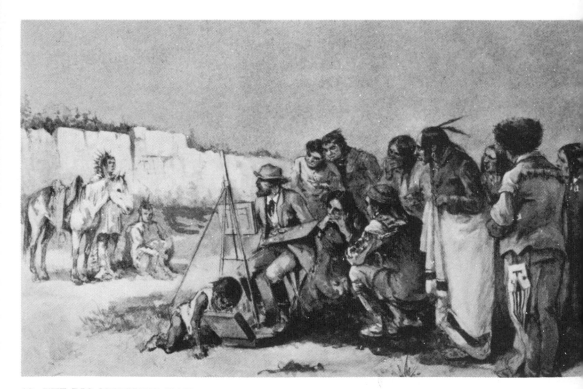

49. THE BIG MEDICINE MAN

PAUL FRENZENY *Courtesy,* EDWARD EBERSTADT AND SONS, NEW YORK CITY

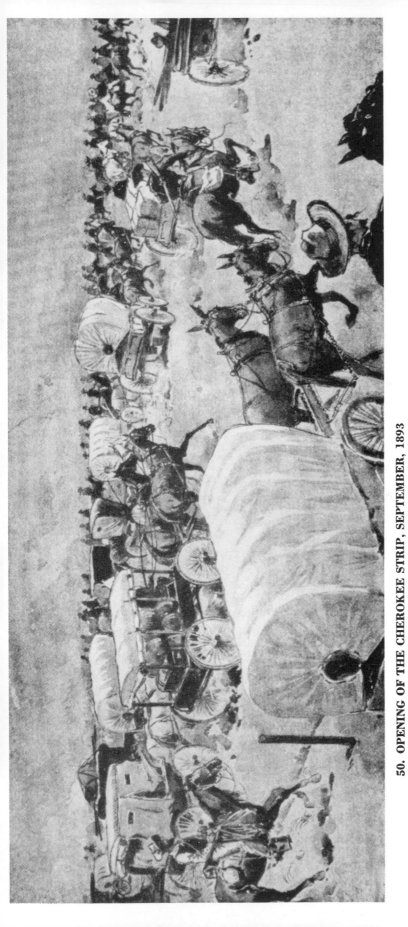

50. OPENING OF THE CHEROKEE STRIP, SEPTEMBER, 1893

HENRY WORRALL *From* HARPER'S WEEKLY

51. THE COLORED EXODUS—TOPEKA, KANSAS, 1879
HENRY WORRALL *From* HARPER'S WEEKLY

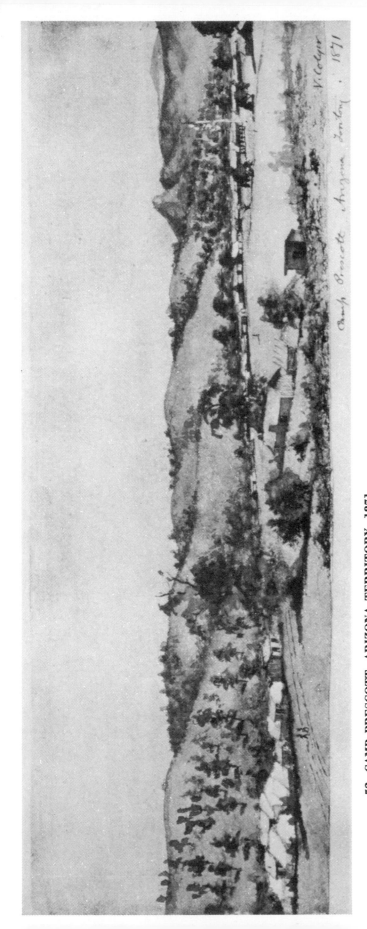

52. CAMP PRESCOTT, ARIZONA TERRITORY, 1871

VINCENT COLYER *Courtesy*, EDWARD EBERSTADT AND SONS, NEW YORK CITY

53. HENRY WORRALL *From* W. E. WEBB, *Buffalo Land,* 1872

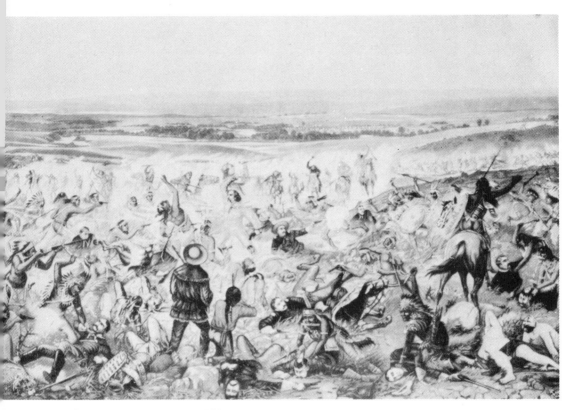

54. CUSTER'S LAST FIGHT

OTTO BECKER'S LITHOGRAPH, after the Painting by CASSILLY ADAMS

Courtesy, ANHEUSER-BUSCH, INCORPORATED, ST. LOUIS

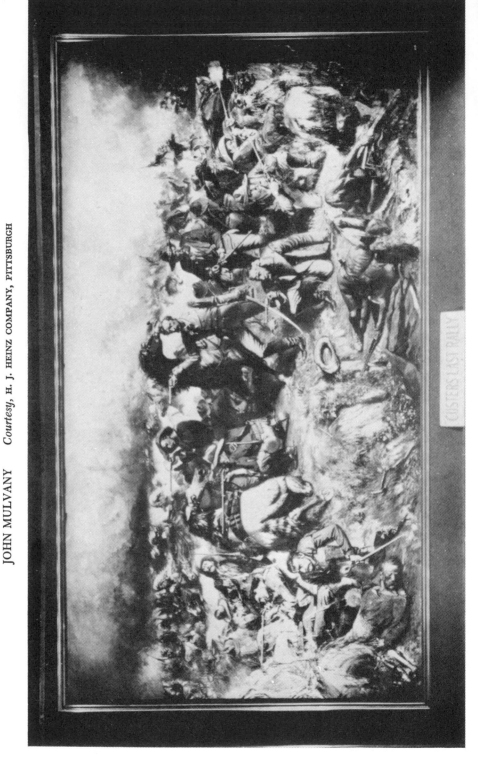

55. CUSTER'S LAST RALLY

JOHN MULVANY *Courtesy*, H. J. HEINZ COMPANY, PITTSBURGH

56. CUSTER'S LAST FIGHT

CASSILLY ADAMS

The Painting after Restoration in 1938

Courtesy, MAJOR E. C. JOHNSTON, 7TH CAVALRY, FORT BLISS, TEXAS

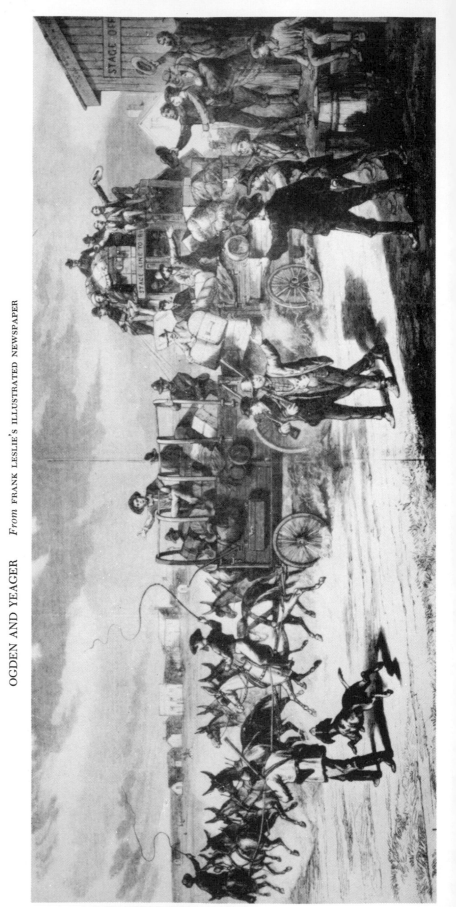

57. GOLD MINERS STARTING FOR THE BLACK HILLS: CHEYENNE, 1877 *From* FRANK LESLIE'S ILLUSTRATED NEWSPAPER

OGDEN AND YEAGER

58. WAITING ROOM, UNION PACIFIC RAILROAD DEPOT, OMAHA, 1877

OGDEN AND YEAGER *From* FRANK LESLIE'S ILLUSTRATED NEWSPAPER

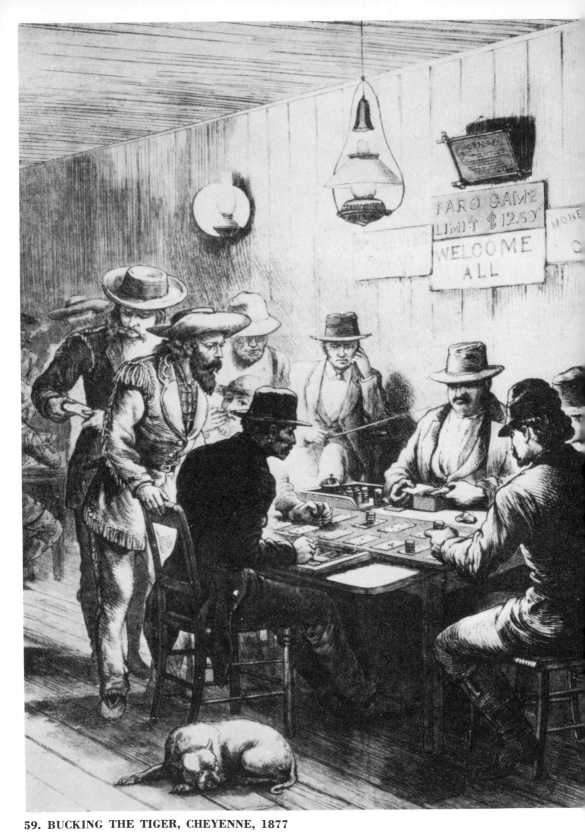

59. BUCKING THE TIGER, CHEYENNE, 1877

OGDEN AND YEAGER *From* FRANK LESLIE'S ILLUSTRATED NEWSPAPER

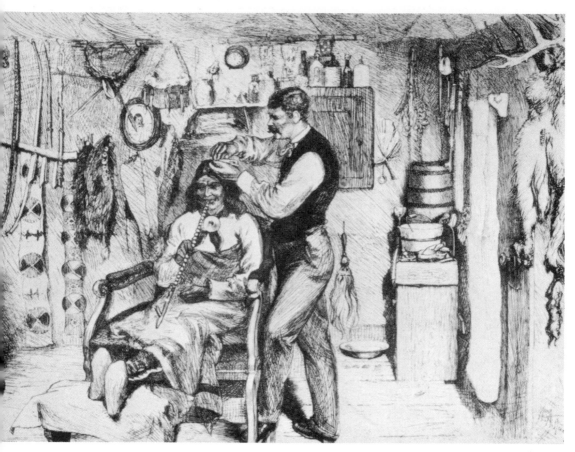

60. BARBER SHOP, STANDING ROCK, DAKOTA TERRITORY (1878)

WILLIAM A. ROGERS *From* HARPER'S WEEKLY

61. FARGO, DAKOTA—HEAD OF STEAMBOAT NAVIGATION ON THE
RED RIVER (1881)

WILLIAM A. ROGERS *From* HARPER'S WEEKLY

62. HARVEST HANDS ON THEIR WAY TO THE WHEAT FIELDS OF THE NORTHWEST (1890)

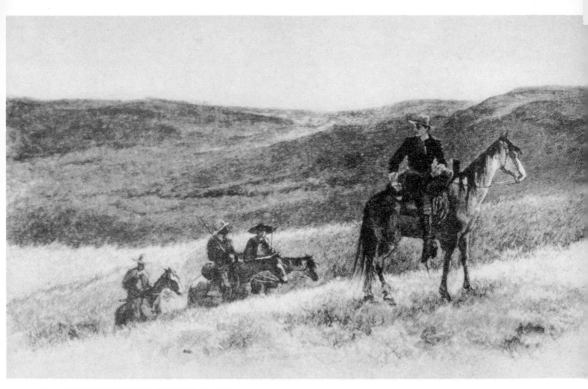

63. THE SHERIFF'S POSSE (1889)

MARY H. FOOTE *From* THE CENTURY MAGAZINE

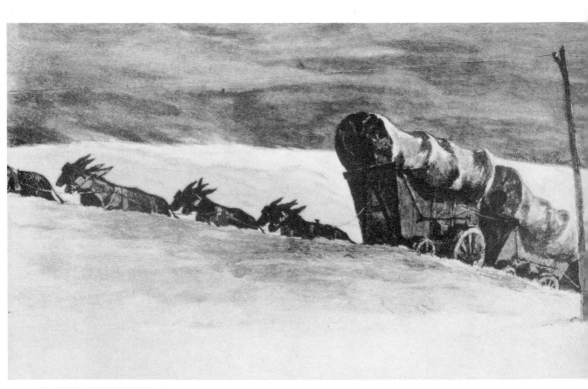

64. THE LAST TRIP IN (1889)

MARY H. FOOTE *From* THE CENTURY MAGAZINE

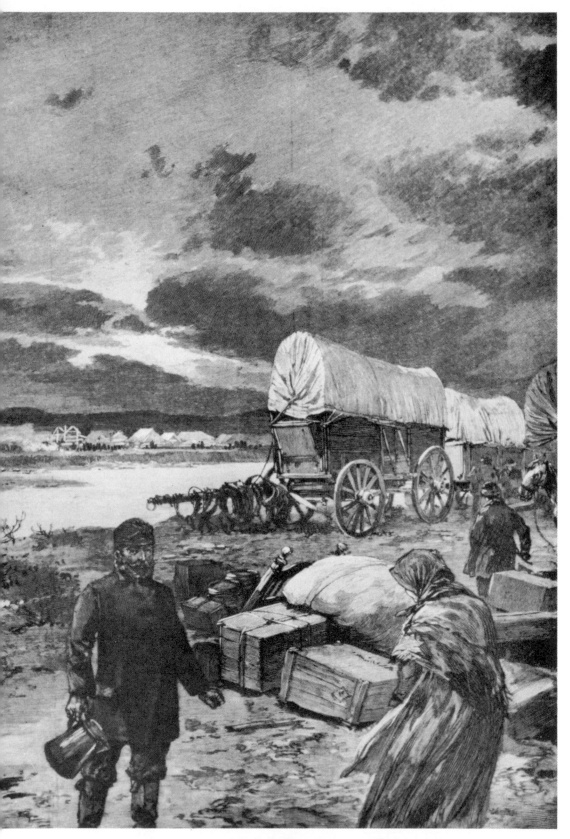

65. OPENING OF THE SIOUX RESERVATION—NEWLY ARRIVED SETTLERS IN THE TERRITORY (SOUTH DAKOTA, 1890)

CHARLES GRAHAM　　*From* HARPER'S WEEKLY

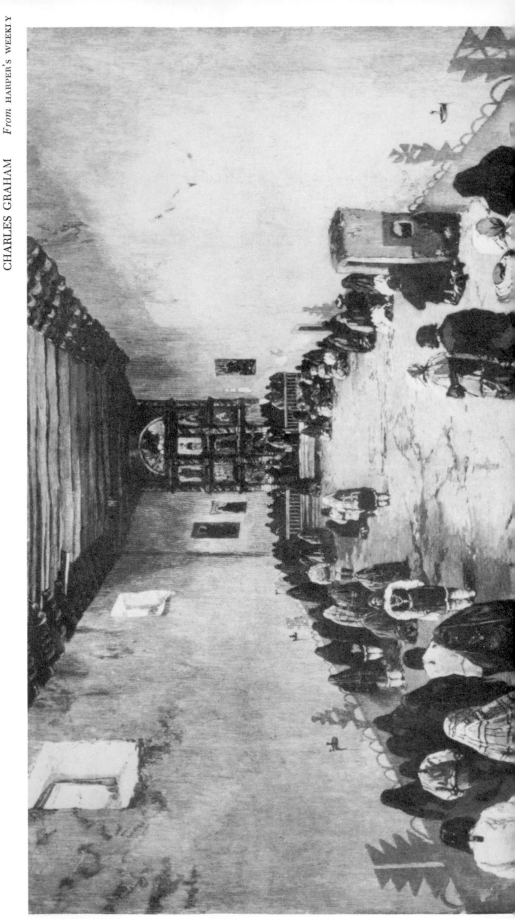

66. INTERIOR OF THE CHURCH AT ACOMA, NEW MEXICO, DURING THE HARVEST FEAST (1890)

CHARLES GRAHAM *From* HARPER'S WEEKLY

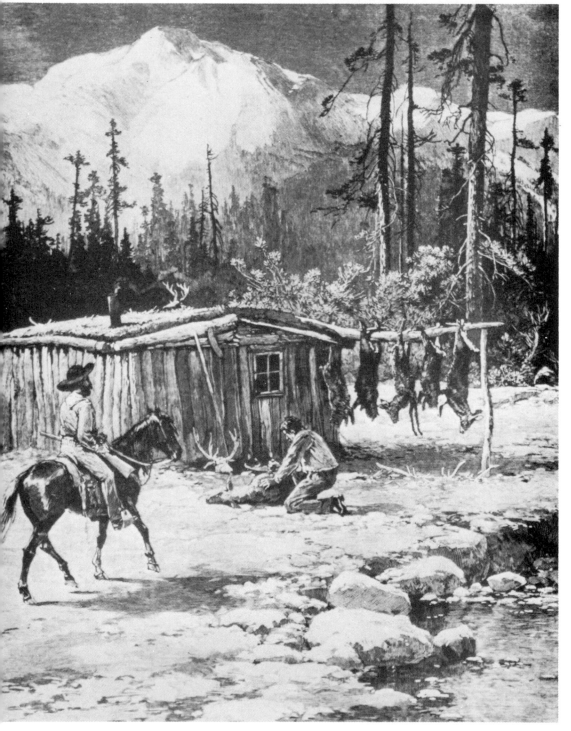

67. A HUNTER'S SHACK IN THE ROCKY MOUNTAINS (1890)

CHARLES GRAHAM *From* HARPER'S WEEKLY

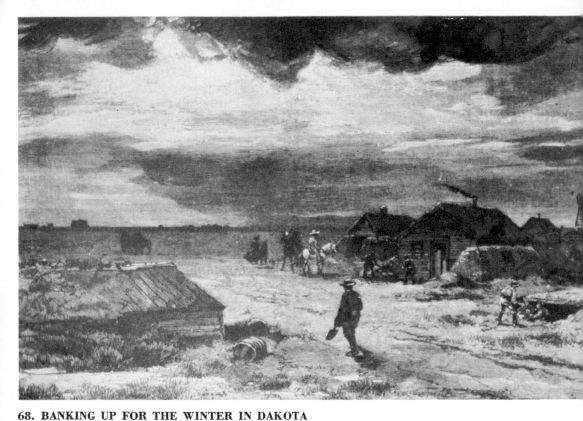

68. BANKING UP FOR THE WINTER IN DAKOTA

CHARLES GRAHAM *From* HARPER'S WEEKLY, 1886

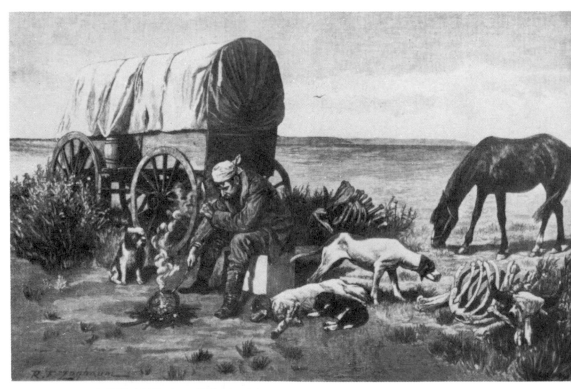

69. THE OLD BONE MAN OF THE PLAINS (1887)

RUFUS F. ZOGBAUM *From* HARPER'S WEEKLY

70. PAINTING THE TOWN RED (1886) RUFUS F. ZOGBAUM *From* HARPER'S WEEKLY

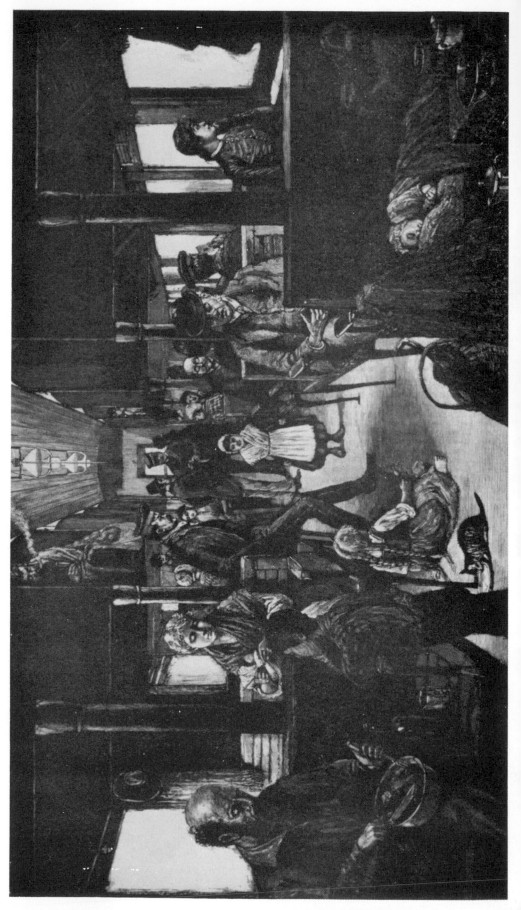

71. THE MODERN SHIP OF THE PLAINS (1886)

RUFUS F. ZOGBAUM *From* HARPER'S WEEKLY

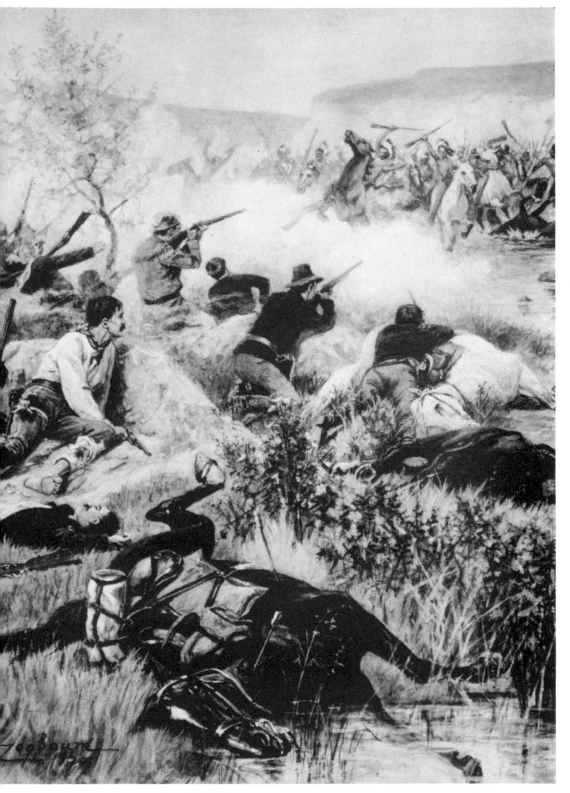

72. DEFEAT OF ROMAN NOSE BY COLONEL FORSYTH—ARICKAREE FORK OF THE REPUBLICAN RIVER, SEPTEMBER, 1868

As drawn by R. F. ZOGBAUM *in* 1901 *Courtesy,* THE LIBRARY OF CONGRESS

73. THE REMINGTON RANCH IN BUTLER COUNTY, KANSAS. A WATER COLOR SKETCH DRAWN IN 1883

FREDERIC REMINGTON *Courtesy*, THE REMINGTON ART MEMORIAL, OGDENSBURG, N. Y.

74. HERDING SHEEP, BUTLER COUNTY, KANSAS. AN ORIGINAL SKETCH DRAWN IN 1883

FREDERIC REMINGTON *Courtesy*, THE REMINGTON ART MEMORIAL, OGDENSBURG, N. Y.

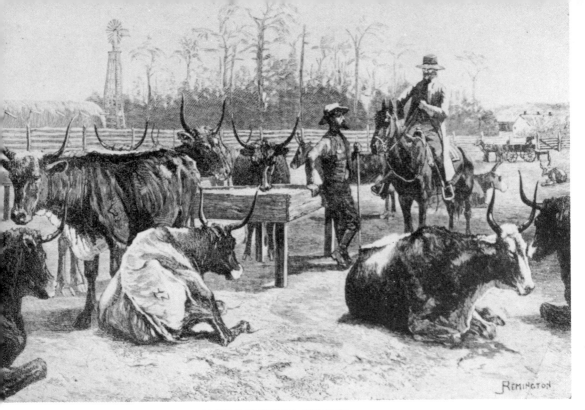

75. TEXAN CATTLE IN A KANSAS CORRAL

FREDERIC REMINGTON *From* HARPER'S WEEKLY, 1888

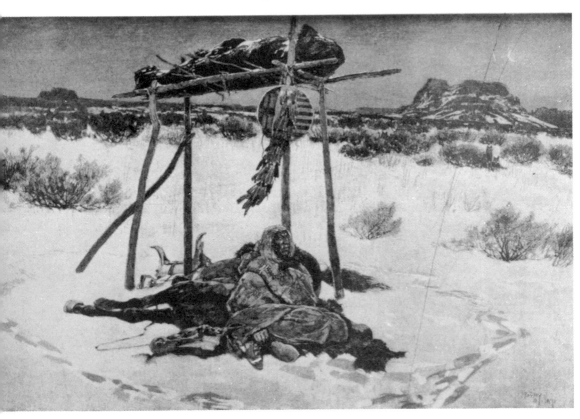

76. THE LAST VIGIL

HENRY F. FARNY *From* HARPER'S WEEKLY, 1891

77. THE SONG OF THE TALKING WIRE (1904)

HENRY F. FARNY *Courtesy*, THE TAFT MUSEUM, CINCINNATI, OHIO

78. THE CAPTIVE

HENRY F. FARNY *Courtesy,* THE CINCINNATI ART MUSEUM, CINCINNATI, OHIO

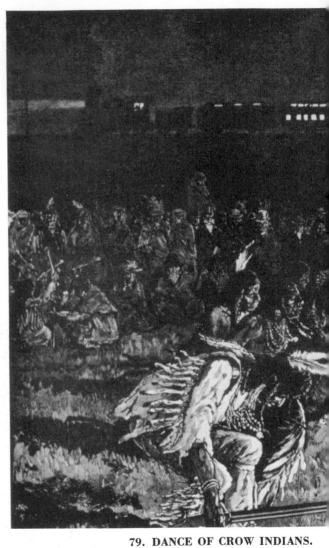

79. DANCE OF CROW INDIANS.

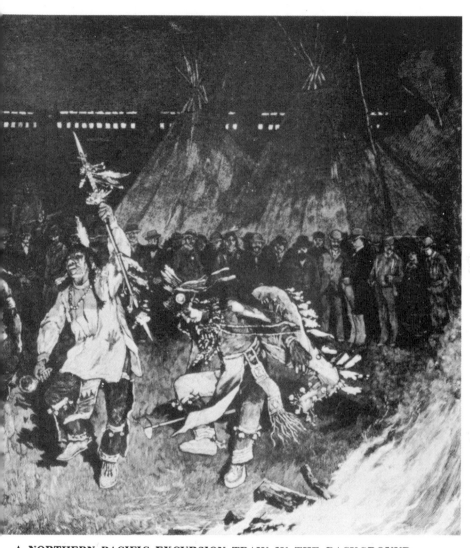

A NORTHERN PACIFIC EXCURSION TRAIN IN THE BACKGROUND

HENRY F. FARNY *From* HARPER'S WEEKLY, 1883

80. MY BUNKIE (1899)

CHARLES SCHREYVOGEL *Courtesy,* METROPOLITAN MUSEUM OF ART, NEW YORK CITY

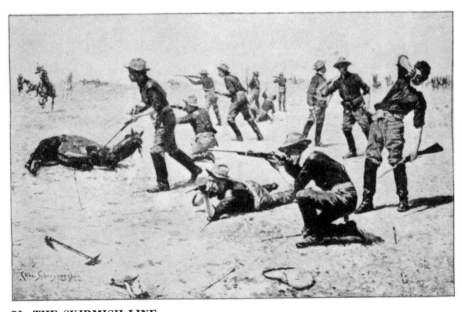

81. THE SKIRMISH LINE

CHARLES SCHREYVOGEL *From* MY BUNKIE AND OTHERS

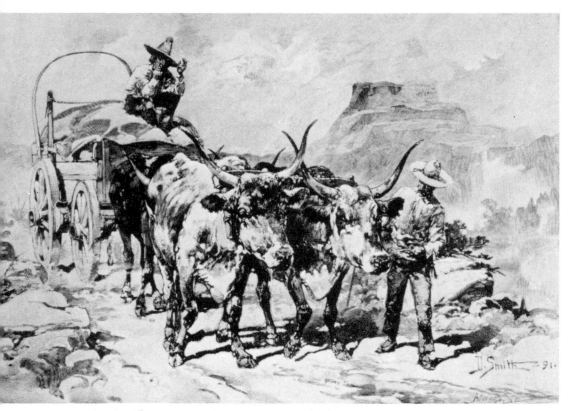

82. FREIGHTING SALT IN NEW MEXICO

DAN SMITH *From* LESLIE'S WEEKLY, 1891

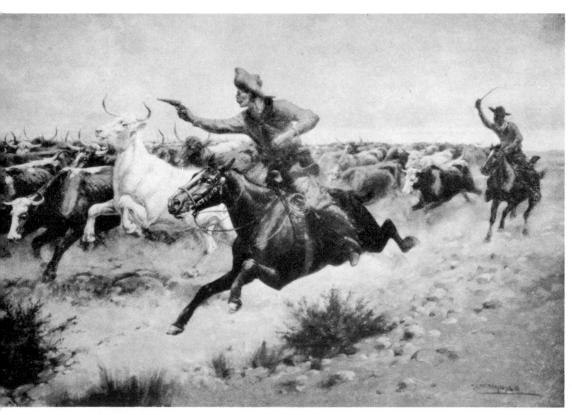

83. THE STAMPEDE

H. W. HANSEN *Courtesy,* MISS BEATRICE HANSEN

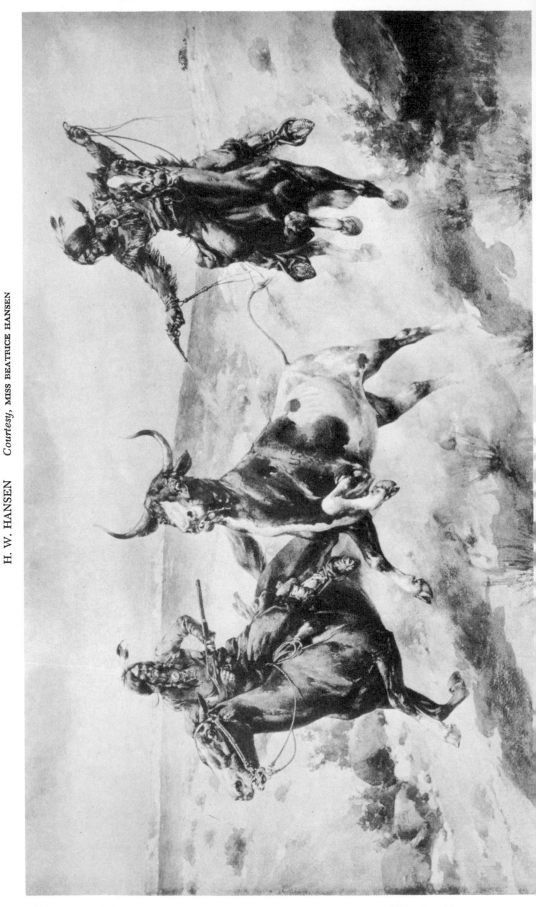

84. BEEF ISSUE

H. W. HANSEN

Courtesy, MISS BEATRICE HANSEN

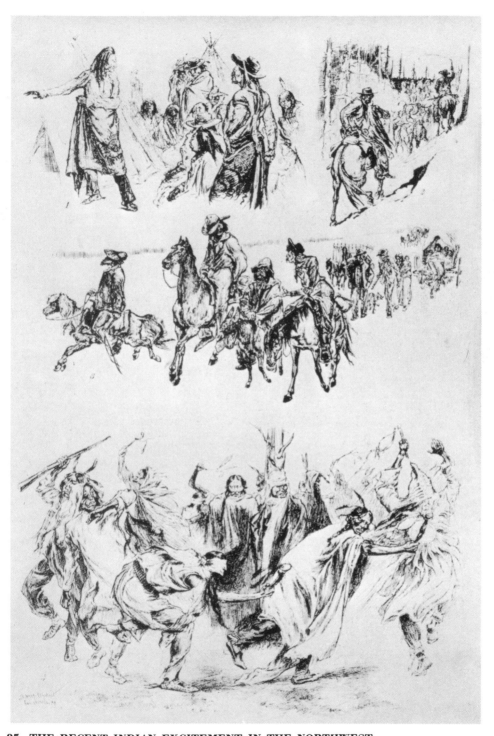

85. THE RECENT INDIAN EXCITEMENT IN THE NORTHWEST

J. H. SMITH *From* FRANK LESLIE'S ILLUSTRATED NEWSPAPER, 1890

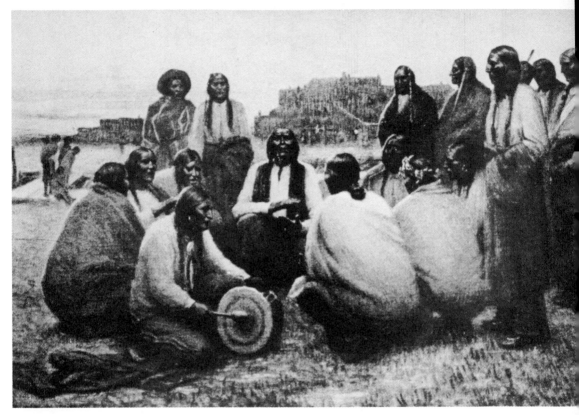

86. THE EVENING CHANT

J. H. SHARP *From* BRUSH AND PENCIL, MARCH, 1900

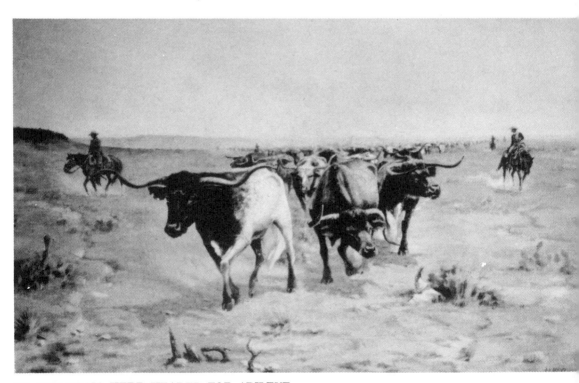

87. THE TRAIL HERD HEADED FOR ABILENE

H. W. CAYLOR *Courtesy,* MRS. H. W. CAYLOR

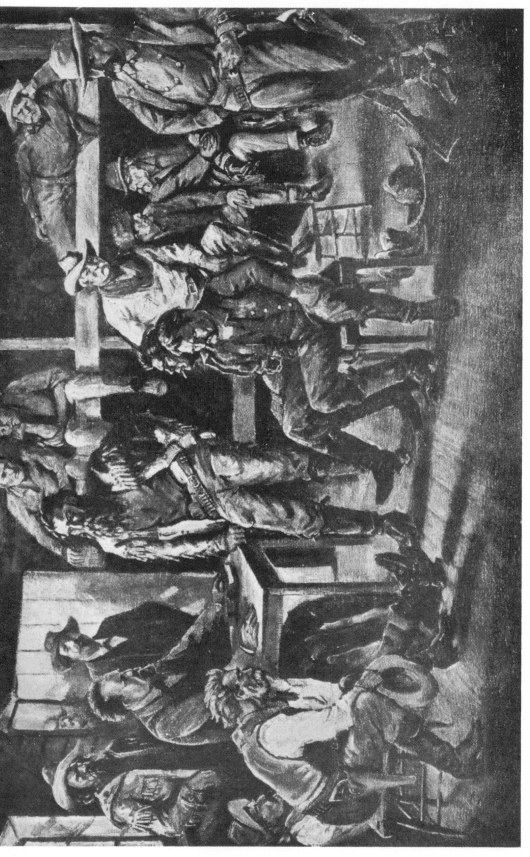

88. THE FRONTIER TRIAL

J. H. SMITH *Courtesy,* FRED T. DARVILL, BELLINGHAM, WASHINGTON

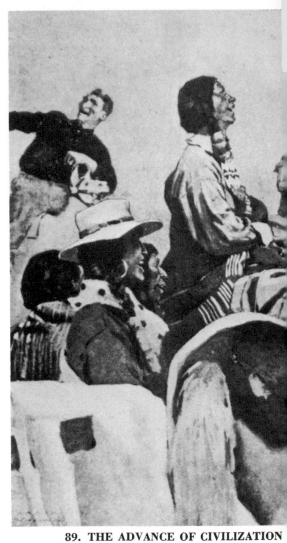

89. THE ADVANCE OF CIVILIZATION

IN NEW MEXICO—THE MERRY-GO-ROUND COMES TO TAOS (1899)

ERNEST L. BLUMENSCHEIN

From HARPER'S WEEKLY *Courtesy,* HARPER AND BROTHERS, NEW YORK

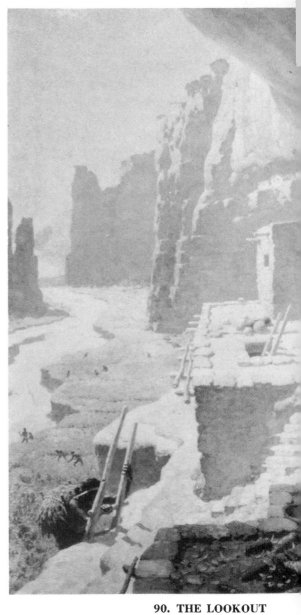

90. THE LOOKOUT

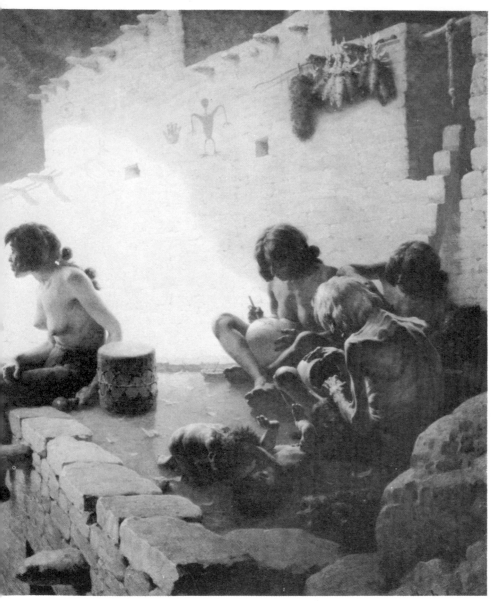

WILLIAM R. LEIGH *Courtesy*, WOOLAROC MUSEUM, BARTLESVILLE, OKLAHOMA

(*Copyright, W. R. Leigh*)

Index

Both text and notes have been indexed. The attempt has been made to include the name of every person to whom reference has been made including, of course, all authors cited. Titles of illustrations mentioned, in general, have not been included in the Index. Some attempt, however, has been made to index the illustrations described or listed in the text and notes *by types*. Reference to these classified illustrations may be found in the Index under the entry "Illustrations."

Starred names indicate Western artists or illustrators of the period under discussion who are discussed or recorded in this book. For a separate index of illustrations used in this volume *see* LIST OF ILLUSTRATIONS at the front of the book.

‡ Bayard Taylor should be added to our list of Western illustrators as the plates in his *Eldorado, or Adventures in the Path of Empire* (N. Y., 1850) are credited to him. Included in the plates are early views of San Francisco and Sacramento.

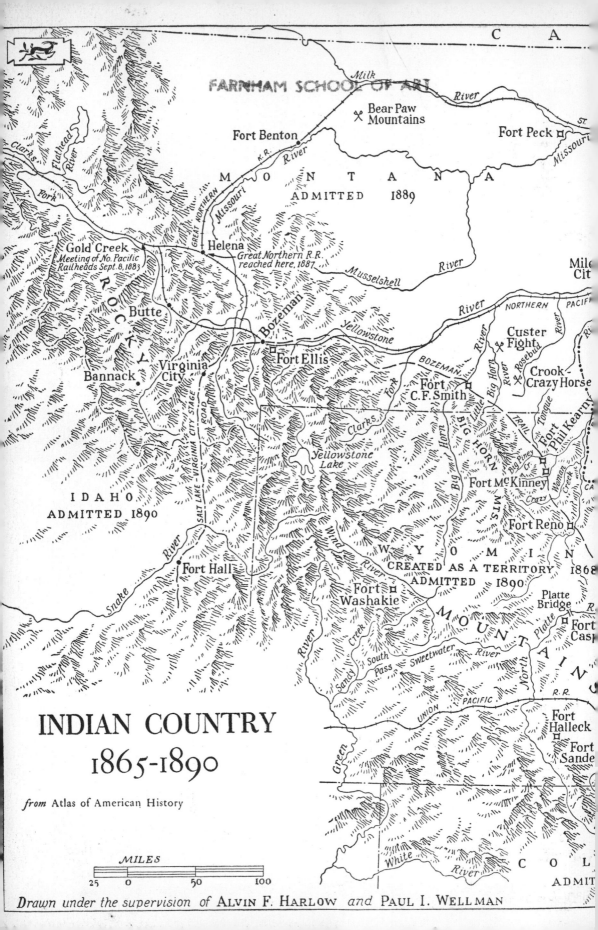

INDIAN COUNTRY
1865-1890

from Atlas of American History

Drawn under the supervision of ALVIN F. HARLOW *and* PAUL I. WELLMAN